PUBLIC SCULPTURE OF BRITAIN VOI

CW00740135

# Public Sculpture of Warwick
# Coventry and Solihull

Public Monuments and Sculpture Association
National Recording Project

PMSA

Public Sculpture of Britain Volume Six

# PUBLIC SCULPTURE OF WARWICKSHIRE, COVENTRY AND SOLIHULL

George T. Noszlopy

LIVERPOOL UNIVERSITY PRESS

First published 2003 by LIVERPOOL UNIVERSITY PRESS,
Liverpool L69 7ZU

This book has been produced as part of the Unversity of Central
England Public Sculpture Project with financial assistance from the
Birmingham Institute of Art and Design, UCE

*Project Director*: George T. Noszlopy

*Research Co-ordinators*: Sian Everitt (until June 2000),
Fiona Waterhouse (from June 2000)

*Research Assistants*: Clive Beardsmore, Rachel Cockett,
Noam Gordon, Trevor Green, David Hassell, Emma Hoult,
Brian Johnson, Andrew Pottinger, Helen Shiner, Anthony Spettigue,
David Stoker, Stephanie Tranter, Tony Viney

*Steering Group Members*: Professor George Noszlopy (Chair),
Revd Peter Berry, Dr Louise Campbell, Ron Clarke, Michael Diamond,
Geoff Dixon, Steve Field, Caroline Foxhall, Professor Francis Frascina,
Paul Gibbons, John Glaves Smith, Wendy Horton, Nicholas Kingsley,
George Learmonth, Nick Lloyd, Vivienne Lovell, David Patten,
Theodora Philcox, Dr Ken Quickenden, Tessa Sidey, John Slater-
Dickens, Paul Spencer Longhurst, Alan Taylor and A.M. Wherry

The National Recording Project is supported by the
National Lottery through the Heritage Lottery Fund

HERITAGE LOTTERY FUND

British Library Cataloguing-in-Publication Data
A British Library CIP record is available

ISBN 0-85323-837-5 (cased)
ISBN 0-85323-847-2 (paper)

Design and production, Janet Allan

Typeset in 9/11pt Stempel Garamond
by XL Publishing Services, Tiverton, Devon
Originated, printed and bound in Great Britain by
Henry Ling Limited, at the Dorset Press, Dorchester, DT1 1HD

# Preface

In 1998 George Noszlopy published his *Public Sculpture of Birmingham* as the second volume in this series, and this sixth volume completes his work on the public sculpture of the historic county of Warwickshire. He was one of the pioneers in the detailed study of public sculpture in Britain, starting work as early as 1983 in Birmingham with the committed and enthusiastic support of the University of Central England, which has continued to assist his research up to the present day. It was his work, together with a similar project in Liverpool, which convinced the Public Monuments and Sculpture Association on its foundation in 1991, that a series of volumes cataloguing public sculpture outside churches, cathedrals and museums in great detail was both possible and essential, if the Association's mission to conserve and explain public monuments and sculpture was to be achieved. Six volumes have now been published and work on a further twelve is well advanced. Within the next eight years all the larger British cities will have been covered except parts of the West End of London, and the public sculpture of many towns and villages will also have been catalogued in detail. The Association has not neglected new technology, and, along with these volumes, it has developed a database storing brief details of a much wider range of public sculpture than can be included in the volumes. This database is constantly being expanded and updated. Late in 2001, on the tenth anniversary of the Association's foundation, it went public online at www.pmsa.org.uk.

Public sculpture reflects the history of a county and few other areas have Warwickshire's variety and vitality. Coventry was one of the five largest and finest cities of medieval England and the celebrated exploit of Lady Godiva, one of its principal founders, has always been irresistible to artists. Its devastation in the Second World War encouraged much public sculpture related to regeneration. Nearly all the sculpture in Stratford-upon-Avon commemorates William Shakespeare with Ronald Gower's masterpiece displaying French panache in its mixture of portraiture and allegory. Nuneaton honours George Eliot and Rugby commemorates Thomas Hughes and Rupert Brooke, while at a more democratic level John McKenna's important relief illustrating Rugby's history is to be found not on the town hall, but on the façade of the town's North Street public toilets. Leamington's sculpture reflects the town's association with water and healing. Solihull has a *Horse Tamer* by J.E. Boehm, formerly owned by the Bird family still famous for their custard, while their former home, Tudor Grange, displays a complicated programme of imperialist sculpture commissioned by an earlier owner, Alfred Lovekin. Much public sculpture over the last fifty years has been the work of a group of local artists, giving a distinctive local flavour to public art in Warwickshire, but sculptors of national or even international importance, most notably Eric Gill and Jacob Epstein, are also represented.

No major research project of this type can succeed today without financial and other assistance from many sources. The Heritage Lottery Fund made a major contribution towards research costs throughout Britain in 1996, and the Henry Moore Foundation is supporting the publication of every volume in the series. The Leverhulme Trust has provided generous assistance to George Noszlopy's work on various occasions. West Midlands Arts, Warwickshire County Council and the North Warwickshire Borough Council have supplied grants towards research, travel, photography and other costs. The University of Central England, demonstrating an interest in its own environment now increasingly common in the new universities, has supported the project over many years. Robin Bloxsidge and Liverpool University Press have never lost confidence in the series, while Janet Allan has designed this and every other volume with splendid enthusiasm, care and artistry.

EDWARD MORRIS
Chairman of the Editorial Board

# Contents

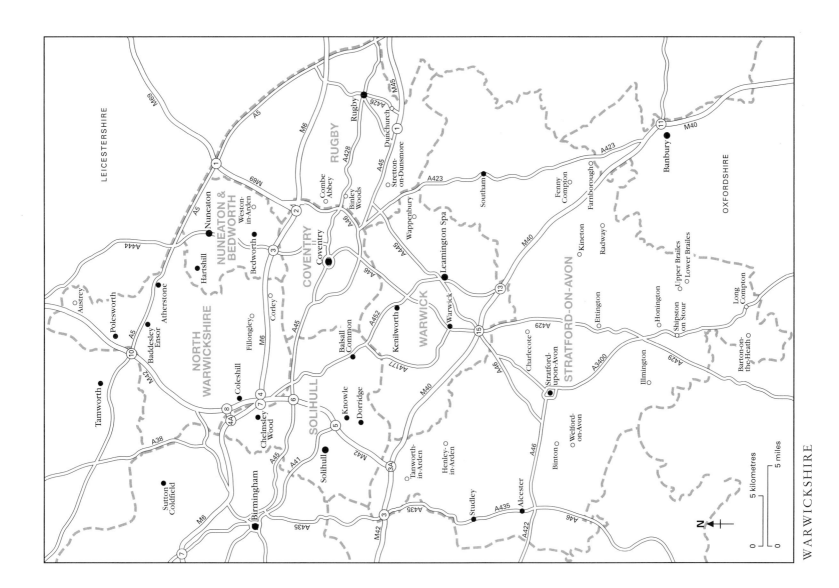

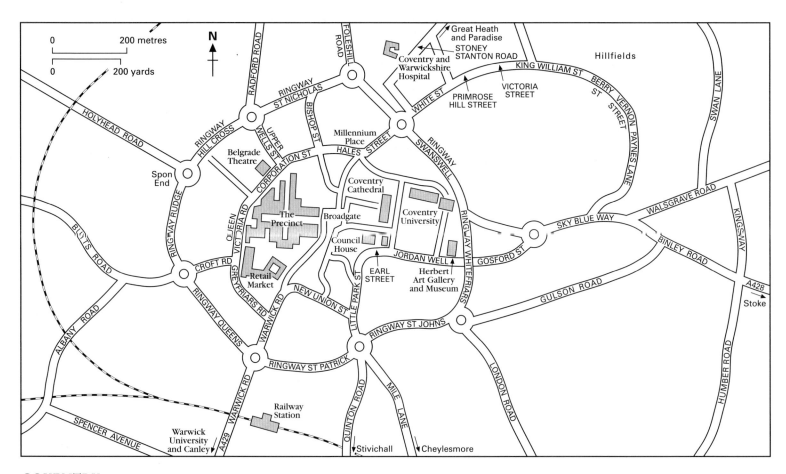

COVENTRY

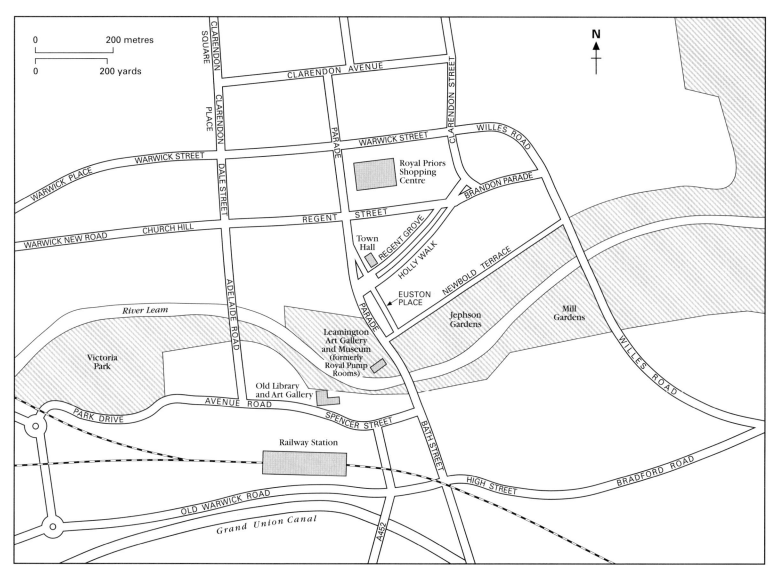

ROYAL LEAMINGTON SPA

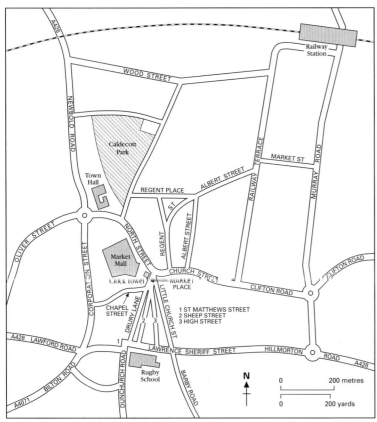

RUGBY

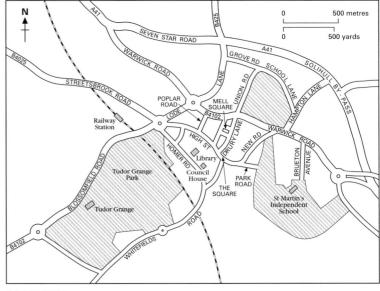

SOLIHULL

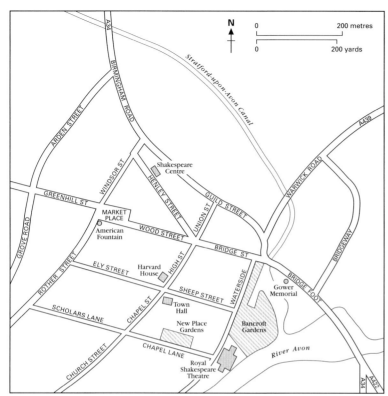

STRATFORD-UPON-AVON

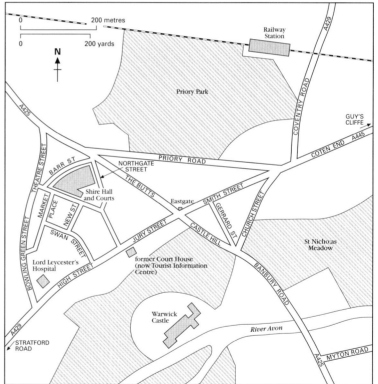

WARWICK

Maps    xiii

# Introduction

This volume discusses monuments and sculpture in public spaces within the rolling countryside of rural Warwickshire, in the historic towns and industrial centres of the county, as well as in the nearby metropolitan districts of Coventry and Solihull. The overall area covers approximately 871 square miles and has a population of 982,100. Geographically, the tree-fringed River Avon divides the area into two unequal parts from north-east to south-west. The larger part, lying to the north-west, drains mainly to the Trent, through a cluster of smaller rivers, the Cole, Blythe, Ra, Anker and some minor streams, irrigating a range of rich valleys. Between these valleys and also beyond the visually dominating flow of the Avon, the land rises in gentle undulations. Formed for the most part in a variety of picturesque rocky scarps ranging from honey-coloured limestone in the south and south-east, white-grey-blue chalky lias in a diagonal band in the middle of the area from east to west, and a red sandstone from Warwick to the north. There, from the northern banks of the Avon, at Guy's Cliffe and Warwick Castle, used to be the finest woodland of north Warwickshire, the ancient forest of Arden or Eardene. Camden called it woodland, in contrast to the open country of the south-east, historically known as Feldon, 'a plain champaign' (*sic*). The fault crossing the land from Kenilworth to Tamworth had once a stratum of coal in the north and east part of the area. This accounts for the industrial character of the northern part of the county. Despite such visual diversity, the geography of the region is unified by man-made structures. These include the extensive and complicated late-eighteenth- and early nineteenth-century system of canals (built for industry but now used for leisure), and the county's rich water and road network (the latter from the ancient Roman *Fosseway* to the modern motorway system). Indeed, they not only link town and country, but are also impressive venues for today's public sculpture.

## The 'Mid-Lands': a compromise

Nikolaus Pevsner was right to observe that in this region, the visitor is constantly reminded that they are in 'Mid-Land'. *The Cross* in the village of Meriden is erected at the place said to be the precise centre of England. He also noticed that Warwickshire, at the time, was 'about midway in size among English counties: twenty-fifth of forty-two (counting the Yorkshire ridings as three counties)'. He described the characteristics of its landscape as 'mid-land landscape': a friendly compromise between 'not too high hills… and not really flat flat-land'. Indeed, there are no important mountains. Apart from some low rocks, such as those upon which Warwick Castle stands above the River Avon, the highest hills range from Kenilworth northward to Tamworth. Conversely, there are almost no plains of a dead level, the whole region being gently undulating.

Even the climate of this region is more balanced than in neighbouring counties; mild, healthy and equally well suited for agriculture, industry and urban living. The soil is suitable for most of the usual crops, rich in pastureland and forests. The area has a living tradition in orchards and market gardening, as well as in the practice of arts and crafts.

In the Midlands both the past and a futurist present are joined in a harmonious heritage. Warwickshire is exceptionally rich in ancient Roman and medieval remains. Towns and cities in this region have been urbanised for a longer period than most of those in northern England. In particular, medieval Coventry had a large population of town artisans and craftsmen organised in guilds. Church and town had continental European industrial and cultural exchanges well before the city's destruction in the Second World War and its later role in international co-operation. With the rich mineral deposits of the northern parts of the region, the Midlands were at the centre of the Industrial Revolution. Although the character of local industry has changed from about the middle of the twentieth century, its memory survived and has a visible presence in public art and architecture, even in recently commissioned post-modern monuments and commemorative sculpture.

Although claims that the Midlands are the centre of 'Merrie England', 'Britain's industrial Heartland', 'the rural heart of England', or a combination of town and country 'in the heart of England's shires' may be overstated, they certainly capture the character of the place.

## Shakespeare Country

Images of England's greatest dramatist and poet, William Shakespeare, and those of his literary characters dominate the old market town of Stratford-upon-Avon. Shakespeare returned from London's Globe Theatre to his native town at the height of his fame in 1611, and died there five years later on his 52nd birthday. He was buried in the thirteenth-century Gothic chancel of the Collegiate Church of the Holy Trinity, where his life-size polychrome alabaster bust, carved by Gerard Johnson in 1623, is set in the wall above his gravestone. Quill in his right hand and resting his left on a manuscript, its iconography follows the type of

sixteenth-century humanist portraiture introduced earlier to the Tudor court by Holbein. The portrait bust is conceived within a typically High Renaissance lop-sided triangular composition, as if he were looking through an arched open window flanked by two Corinthian columns. Above is a fine carving of the family coat of arms with its motto: NON SANS DROICT ('Not Without Right'). The marble parapet below the bust bears the words: IVDICIO PYLIVM GENIO SOCRATEM, ARTE MARONEM, TERRA TEGIT, POPVLVS MAERET, OLYMPVS HABET – STAY PASSENGER, WHY GOEST THOV BY SO FAST, READ IF THOV CANST WHOM ENVIOVS DEATH HATH PLAST WITH IN THIS MONUMENT SHAKESPEARE, WITH WHOME, QVICK NATVRE DIDE WHOSE NAME DOTH DECK Y TOMBE FAR MORE THEN COST. SIEH ALL Y HE HAS WRITT, LEAVES LIVING ART, BVT PAGE, TO SERVE HIS WITT. The gravestone is inscribed: GOOD FRIEND FOR JESUSSAKE FOREBEARE – TO DIGG THE DUST ENCLOASED HEARE – BLESTE BE YE MAN YT SPARES THES STONES – AND CURST BE HE YT MOVES MY BONES. Nearby, there are also monuments to Shakespeare's wife Anne, and his eldest daughter and her husband, all of whom are buried in the church.

Not only is Shakespeare's assumed birthplace in Henley Street celebrated as 'the most honoured monument of the greatest genius that ever lived', but his cult is inescapable in this originally small market town. Along with the 1888 Gower Memorial, near the Royal Shakespeare Memorial Theatre, almost all of the numerous public sculptures in the town have Shakespearean associations. The variety in genre, iconography, style, material and technique is astounding, and they range from a clock tower with drinking fountain in the centre of Rothermarket to the group of life-size Shakespearean characters engraved in glass in the entrance to the Shakespeare Centre. Yet the cult of Shakespeare is not limited to Stratford-upon-Avon. Due to the efforts of the late-eighteenth-century actor and theatrical director David Garrick, the cult of Shakespeare has had an overall effect on the whole county. Indeed, recurring signposts remind the traveller that Warwickshire is 'Shakespeare Country', thus, by allusion, giving the region a central place in the nation's historical character and living culture.

## Myth and magic

Historical Warwickshire has a humane and friendly landscape. It was the forest of Arden which inspired the idyllic images of 'greenwood' in Shakespeare's *As you Like It*. Unlike the dark, dense forests of the Alps in Dante, where one can lose oneself, Shakespeare's forest has Arcadian associations. It was a place of leisure and joy, innocence, unspoilt by the corrupting effects of civilisation. Here one could remember the lost Golden Age and find one's true self. Such an environment made a deep impression on the inhabitants, and it is that living spiritual presence for

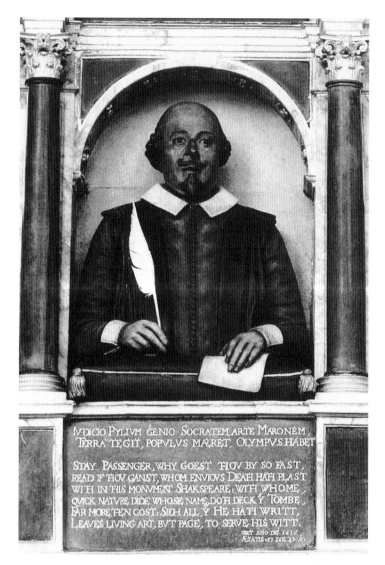

Gerard Johnson, *Bust of Shakespeare, Holy Trinity Church, Stratford-upon-Avon*

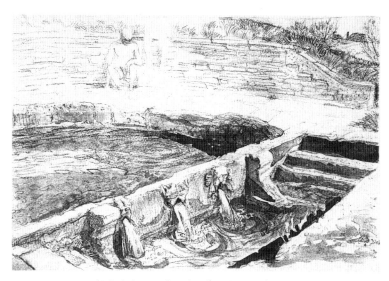

*Artist's impression, Southam's sacred spring*

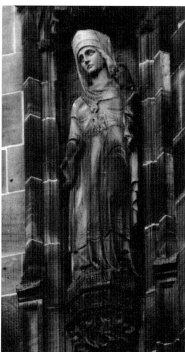

**Unknown,** *Godiva, St Michaels Church, Coventry*

**Coventry Telegraph,** *Annual Godiva Procession, Coventry*

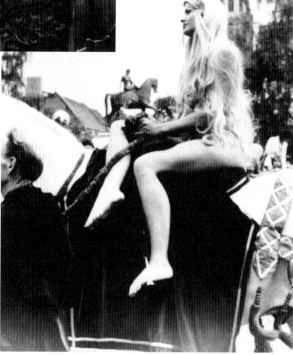

which most visitors to the region have been searching. The area is still deeply affected by magic, myth, legends and all sorts of spiritual cults and sectarian religious associations. The fame of medieval Warwick rested in her treasure of holy relics, which included a broken twig from Moses' burning bush, a drop of the Virgin's milk, a curl of her hair, and fragments of Christ's manger and the Holy Cross. Meanwhile, Coventry still celebrates annually the secular legend of Lady Godiva's equestrian 'self-sacrifice', together with the recently revived religious cult of Coventry's 'Our Lady of Mercy'; a modern copy of the medieval *Virgin and Child,* based on pre-Reformation drawings, was re-erected in Priory Gardens in 2001. In addition, the legend of Sir Guy, in which the knight slew a number of wild beasts to win the hand of Felice, is celebrated in both Alma Ramsey's *Sir Guy and the Dun Cow* (1952) in Coventry and Keith Godwin's *Guy and the Boar* (1964) in Warwick. In the depth of the rural countryside, joyous Midsummer Night rituals are still performed annually by members of amateur theatrical groups and local history societies. Although the ancient Stratford-upon-Avon custom of ox-roasting has long been substituted by the cheaper pig, it has remained a popular part of the yearly Mop Fair on 12 October.

The ambience of hills, meadows, forests, lakes and rivers has also contributed to the style of the visual arts in this region. The ethos of this landscape seems to yearn for the magisterial groups of Henry Moore and Barbara Hepworth. They would breathe with the same rhythm as the

earth and water. Alas, one has to go to Birmingham to see Moore's reclining bronze warrior in a museum setting and Hepworth's monumental abstract forms in the open air in the grounds of the University of Birmingham at Edgbaston.

## European and national perspectives

The most striking feature of public sculpture in the Warwickshire, Coventry and Solihull region is its rich diversity, vitality and generally high artistic quality. It spans almost all the European period styles in the visual arts, from the early medieval to the modern and post-modern. All the familiar sculptural genres, materials and techniques are well exemplified, while the range of subject-matter and iconography of extant works closely reflect the prevailing ideas and often the daily life of local people. They portray both the outstanding and the ordinary.

The historic towns of Warwick, Coventry and Stratford-upon-Avon made important contributions not only to English sculpture, but also to European sculpture. Warwick and Coventry, in particular, produced works of international significance and calibre. Thus the mid-fifteenth-century funerary monument of Richard Beauchamp (with the rest of the tombs and carvings in the magnificent late-Gothic architectural surroundings of the Beauchamp Chapel in the Collegiate Church of St Mary at Warwick), and Jacob Epstein's expressionistic and monumental *St Michael and the Devil* (in the context of Sir Basil Spence's avant-garde mid-twentieth-century cathedral) are both outstanding British contributions to European art history.

On the other hand, Stratford-upon-Avon's *Shakespeare Memorial* (1888) by Ronald Gower (1845–1916) is a fine and typical late-nineteenth-century commemorative monument of definite national significance. Beneath the alert, over life-sized figure of the seated Shakespeare, four laurel wreaths symbolise his literary achievements. In turn, the masks holding garlands of flowers and fruits in their teeth at the four corners of the pedestal are emblematic. Each of them corresponds to the life-size attendant statues of Hamlet, Lady Macbeth, Falstaff and Henry V, in their capacity as representatives of the disciplines of Philosophy, Tragedy, Comedy and History. The non-rhetorical handling of this complicated allegory and the overall style has a French flavour, perhaps a reminder that the high Bath stone drum pedestal was designed by French architects (Peignet & Marnay) and the bronze figures were cast in foundries in Paris. Its sheer size, scale, elegant yet naturalistic modelling, as well as its elaborate and complex fusion of portraiture and allegory make this sculpture group the leading commemorative monument in Shakespeare iconography.

There is a rich selection of allegorical as well as narrative cycles in the

Unknown, *St Michael as the Angel of the Expulsion, Beauchamp Chapel, Warwick*

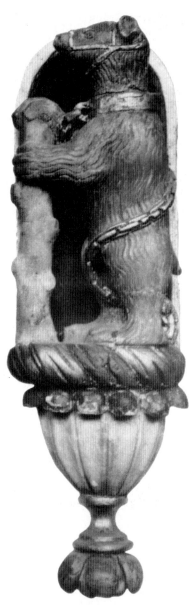

Unknown, *Ragged Bear and Staff (crest of the Earls of Warwick), Beauchamp Chapel, Warwick*

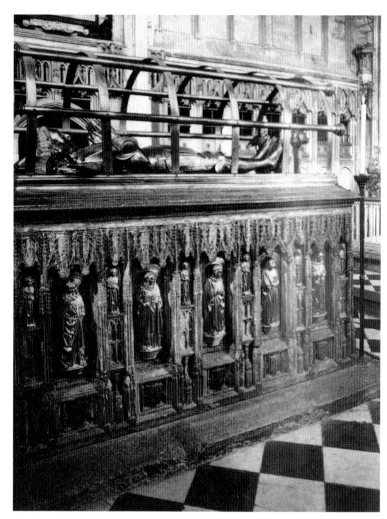

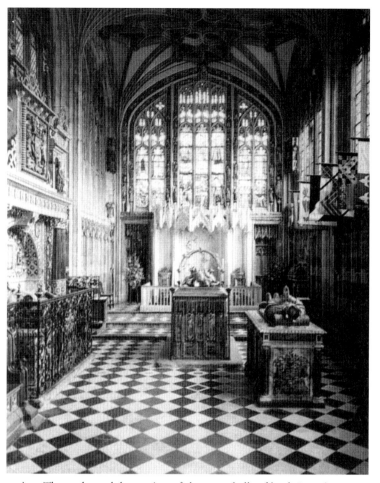

(above) Unknown, *Tomb of Richard Beauchamp, Beauchamp Chapel, Warwick*

(above right) Unknown, *Interior of the Beauchamp Chapel with tombs of Richard Beauchamp and Robert Dudley, Warwick*

region. The sculptural decoration of the town halls of both Leamington Spa and Coventry, though different, are most impressive. While the relief sculpture in Leamington celebrates the town's associations with healing and water, the free-standing figures of Leofric and Godiva on the façade of Coventry's town hall refer to the city's legendary medieval past. However, perhaps the most significant example of this genre of work within the region is the magnificent narrative relief cycle showing episodes from the life of the Shirley family on the façade of a hotel within the Warwickshire village of Ettington. The iconography of the narrative reliefs follows a fifteenth-century Italian Renaissance tradition, but the style is closely related to Pre-Raphaelite history painting with its love of naturalistic detail.

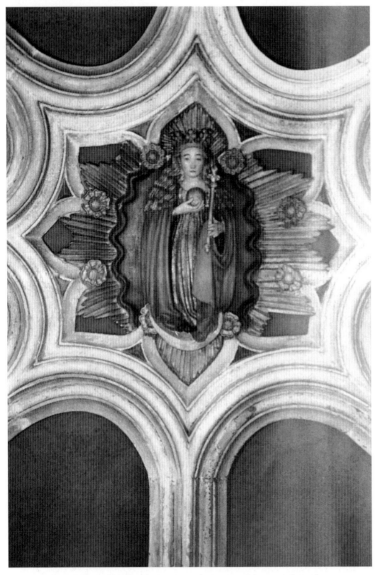

Much secular public sculpture in the rural districts of Warwickshire, both in quantity and quality, is generally quite disappointing. Yet architectural sculpture and funerary monuments in provincial ecclesiastic settings (excluded from this series of volumes) are exceptionally rich in rural Warwickshire. Indeed, a detailed analytical study of these works is long overdue and is absolutely essential before a comprehensive history of sculpture in this region can be undertaken. Relatively few of the four most popular genres in secular rural settings – roadside crosses, public fountains, commemorative obelisks and war memorials – have survived, and those that have tend to be either badly damaged and neglected, or access to the sites is difficult.

Commemorative sculptural monuments of national and local worthies in the larger towns, especially in Solihull, Leamington Spa, Nuneaton and Rugby, are of more than local interest. Yet it must be emphasised that the historical and artistic significance of this material is hardly reflected in the literature on English art. While the majority of monographic studies are addressed to the needs of the tourist trade, the rest tend to be divided between an antiquarian approach and the more mundane socio-economic concerns of local history.

## Sculpture and public space

Each of the larger towns in the region manifests a different ethos, which is displayed in their public art. While historically the origins of Warwick go back to the early tenth century, the remarkable visual homogeneity of the townscape is largely due to the great fire of 1694 and its consequent rebuilding in a Georgian style. Apart from an imposing figure of *Justice* (1731) in a niche on the Court House in Jury Street by Thomas Stayner (*c*.1668–1731), a fascinating personality and leading sculptor of his time,

Unknown, *Ceiling boss of the Virgin Mary as the Apocalyptic Woman, Beauchamp Chapel, Warwick*

(right) Herefordshire School, *Allegory of Man Pursued by Evil (dragon and snake) and Striving towards Purity (a dove), c.1140, All Saints Church, Billesley, Warwickshire*

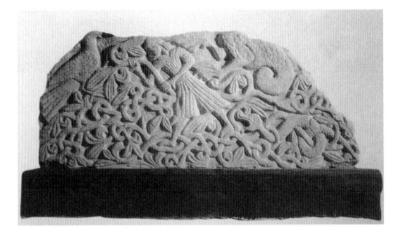

very little open air sculpture survived before the twentieth century. C.E. Bateman's very elegant lacy Gothic structure in front of the Athenaeum building stylistically recalls the previous century, but is in fact a *War Memorial* built in 1921. The only piece of public sculpture with clear associations with the town of Warwick is Keith Godwin's elongated figures of *Guy and the Boar* installed in 1964, which commemorates the legendary local hero.

As noted, Coventry also has medieval origins. Its roots are traced to the Benedictine priory, founded by Leofric, Earl of Chester and Countess Godiva in 1043. Recent excavations unearthed many sculptural fragments that show that it was the largest and one of the most richly decorated churches in the country. During the fourteenth and fifteenth centuries Coventry was also an important centre for mural painting and stained glass manufacture. They were patronised by the wealthy guilds who had their guild churches and chapels decorated by local artists, such as John Thornton, the master of York Minster's great East Window (commissioned in 1405). Yet, the city's medieval past had almost been forgotten until the late 1990s. From the early 1950s Coventry's public sculpture policy promoted a progressive and even radically modern image. Unfortunately, most of the sculptures produced by Peter Peri, Kenneth Armitage and the staff and students of the city's Art School during the 1950s and early 1960s have not survived. Peri, the charismatic, left-wing, central European artist, and hero of John Berger's novel *A Painter of Our Time* (1958), was commissioned by the Education Authority to create several monumental architectural works for the city's schools. Unfortunately, like so many public sculptures of this period, all his works were lost during the demolition of the school buildings during the 1980s. More recently, a large number of sculptures were commissioned by Groundwork Coventry on behalf of the local council for sites alongside Coventry's canals during the 1990s in an attempt to regenerate the area. These vary greatly in subject matter and style, but most of them commemorate the life of the bargemen and those who built the canals. An important example is James Butler's life-like statue of James Brindley who was the designer and engineer of the city's canals. In contrast to its nostalgic and neo-rococo style, Stephen Hitchin's *Journeyman*, representing motifs of the canal site and the tools used for its construction, combines biomorphic forms with allusions to Marcel Duchamp's readymades. Although the installation of these works, together with the increase in the number of holiday-makers using the canals, has encouraged the regeneration of the area and created a new audience for sculpture, there are difficulties in viewing many of the pieces because of the narrow towpath. While the viewer can walk right up to and around the *James Brindley* statue, other works are far less accessible. For example, the *Daimler Heritage Marker* by Robert Crutchley, one of the

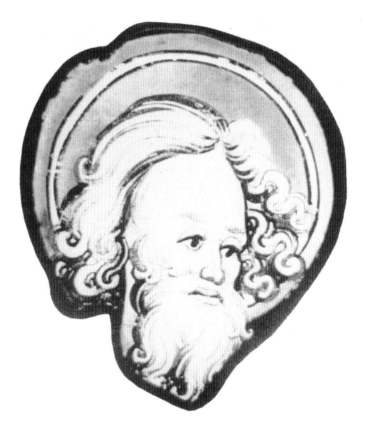

John Thornton (attributed to), *Stained glass head of a prophet, originally from former St Michaels, Coventry, and now installed in the new Cathedral*

most beautifully modelled works, stands on a tall plinth and is therefore extremely difficult to view due to the lack of distance. The best solution to this problem has been achieved in a work just outside Coventry, on the border with Rugby. *Bulrushes*, by Gill and Lee Brewster, is placed alongside the bank of the canal in the midst of real bulrushes. On one side of the bank, the sculptors provide a carved wooden bench from which to view the other element of the work, a free-standing piece depicting stylised bulrushes. These are linked to the bench by a wooden bridge.

Most writing about Leamington Spa acknowledges the fact that the town's character is closely related to its healing waters. The prefix of 'Royal' and the designation 'Spa' were bestowed on the town's name by Queen Victoria in 1838. Irrespective of subject matter or genre, the majority of public monuments and sculptures in the town have aquatic

and therapeutic associations. From the allegorical and emblematic imagery of the Town Hall to the Spa's numerous fountains, the works reflect the cult of water. In the centre of the pediment on the Town Hall is a swan with outstretched wings. In the mosaic lunette below, the waves and swans of the River Leam are shown below the personified figure of Leamington, while above the main entrance is the head of the river god Leam. The therapeutic qualities of music are symbolised by a still life of musical instruments within the pediment of the east wing, supported by two music-making putti. Two memorials in Jephson Gardens, the *Jephson Memorial* and the *Hitchman Fountain*, both commemorate doctors who advocated hydrotherapy. Similarly, Fleischmann's *Miranda Mermaid Fountain* in the grounds of Automotive Products' offices introduced the town's associations with the therapeutic qualities of water into a modern commercial environment. Yet, ironically, in the midst of the world-wide revival of alternative and homeopathic medicine, this once fashionable spa has been closed down and its Pump Room and Bath converted into a museum and art gallery. The original nineteenth-century drinking fountain that used to stand in an annexe of the Pump Room has become a museum exhibit. Today's visitors taste the salty, sulphurous water from an imitation rock wall fountain, David Jacobson's *Spring Celebration,* in the new museum café.

In neighbouring Rugby, there are a number of Victorian works commissioned by Rugby School and its alumni, for example Thomas Brock's statue of Thomas Hughes, author of *Tom Brown's School Days* (1899). Even more recent sculpture tends to commemorate past masters and pupils of the School, such as *William Webb Ellis* by Graham Ibbeson (1997) and *Rupert Brooke* by Ivor Robert Jones (1988). The town has relatively little contemporary sculpture. However, among the more important examples is a relief panel by John McKenna, citing fragmentary simultaneous images of Rugby's industrial heritage, decorating the façade of the town's North Street public toilet (2000). This frieze is a continuous narrative of historical moments in the development of Rugby's industries within a single unified shallow pictorial space. It includes references to Rugby's importance as a centre for the railway industry, the building of the Oxford canal in 1773, and the town's role as a centre for the BBC's worldwide broadcasting service during the Second World War. This exemplifies the growing trend towards sculpture that commemorates an area's social and cultural identity rather than focusing upon particular well-known individuals.

## A question of identity

With its size, population and industry, Birmingham is still considered to be the geographical and cultural centre of the county of historical Warwickshire. (However, in 1974, the boundaries of Warwickshire were greatly reduced on the east, and Birmingham became a separate metropolitan district.) Yet, contrary to expectation, the patterns of patronage, artistic production, public reception and the stylistic character of public sculpture have never been subservient to the influential role of the nation's 'second city'. It is interesting to note that, while William Bloye was the dominant sculptor in Birmingham between the wars, responsible for the majority of public commissions in the city, he has only one work in Warwickshire (the *Allegory of Painting* on the former Art Gallery in Leamington Spa). In Birmingham, the local production of public sculpture has had an almost unbroken continuity. It was maintained by generations of sculpture workshops closely connected with local industry and, between the 1880s and 1950s, by the staff and students of the municipal school of arts and crafts (cf. *Public Sculpture of Birmingham* by George Noszlopy, Liverpool, 1998, pp.xi–xiv). It was only in Coventry that such similar local art school contributions to the city's public sculpture were commissioned during the late 1950s and early 1960s, of which, alas, relatively few examples have survived.

## Materials and techniques

Apart from function and site, material and technique have had a fundamental importance in the history of sculpture. The sculptor's attitude and approach, in this respect, not only restricts the choice and treatment of the subject matter, but also has limitations on style. Traditional aesthetic concepts, such as the classical preference for the human figure, 'truth to material', intrinsic sculptural problems concerning volume and surface effects, and absolute artistic values generally have been for some time replaced by relativistic attitudes. The reasons for this include the Romantic glorification of artistic genius, the lower social expectations from public art and ever-increasing technological innovation in the sculptural use of man-made materials. Material and technique are often chosen for their novelty value rather than for their suitability for a particular medium and environment.

Nevertheless, local materials have historically contributed greatly to the characteristics of architecture and sculpture of the region. The medieval castles of Warwick and Kenilworth, as well as the ruined walls of Coventry's St Michael, are all built in local red stone. Most of the domestic architecture before the eighteenth century was timber framed, while locally manufactured red brick characterises the buildings of the eighteenth and nineteenth centuries. Monumental sculpture carved *in situ* directly into the living brick became a favourite regional material and technique during the early 1930s. Although the sculptural use of cut brick was a Dutch and North German avant-garde architectural tradition, it

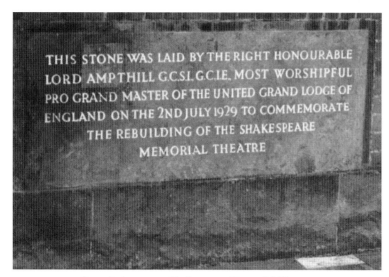

*Foundation stone, Shakespeare Memorial Theatre*

was a radical step in Britain when it was first used by Eric Kennington for a series of Expressionist allegorical Shakespearean scenes on Elizabeth Scott's Royal Shakespeare Memorial Theatre in Stratford-upon-Avon. Such cut brick has remained a recurring favourite sculptural medium and technique in the area, used in both Walter Ritchie's 1953 *Peter Pan and the Darling Children* at Kingsway Primary School in Leamington Spa and John McKenna's *Sagittarius* at Exhall Grange School in Coventry.

Traditionally, sculpture has been divided between carving, a reductive process, and modelling. The great traditions of wood and stone carving gradually changed with the painterly style of the Baroque and its disregard of the qualities of the material. The early twentieth-century reaction against this tendency came with Hildebrand's influential thesis *Das Problem der Form in der bildenden Kunst* (1893) in which he recommended artists to focus upon form rather than upon surface effects in the manner of archaic Greek sculptors. Translated into many languages, it encouraged the young generation of avant-garde sculptors to emphasise the morality and aesthetics of direct carving, and to abide by the inherent qualities of the material. This movement is represented in the area by Eric Gill's relief panel *The Good Samaritan* (1937) on the outside wall of the Coventry and Warwickshire General Hospital and Jacob Epstein's *Ecce Homo* carved in 1934 and installed in the ruins of the old cathedral in 1969. Preserving the integrity of the block, Epstein's work uses the massive quality of the stone successfully to convey the monumentality of

the idea that God became man. In this, he was influenced by Egyptian and archaic principles of art. These principles have also been applied to the carving of wood in John Wakefield's images of human figures, birds and animals within Coombe Abbey Country Park, the site of a former Cistercian abbey, on the outskirts of Coventry. For example, he illustrates the bond between the Cistercians and the natural world by carving the figure of a monk from a tree trunk still *in situ* among the woods. The contours of the monk's body preserve the natural lines of the trunk. However, this sculptural vision is occasionally lost, even when the sculptor has the technical skills to use the mallet and chisel. For example, Richard Perry's *Flame* in Leamington Spa is expertly carved, but he is apparently unaware of the sensual conflict between hot flame and cold stone. Moreover, the monumental qualities of the stone suggest the positive qualities of illumination and purification, thereby conflicting with the piece's function of commemorating the victims of fire.

For centuries, bronze was the medium that allowed the greatest freedom of sculptural expression, both in terms of depicting movement as well as the most subtle psychological characterisation. Unlike stone, bronze can be used to depict figures with arms extended or balancing on one leg. In his *Stratford Jester* (1994), James Butler makes full use of the properties of the material, depicting the figure balancing on his left leg and holding a mask of Comedy on the palm of his left, upraised hand. John Letts similarly uses the properties of bronze to great effect in his portrait bust of Queen Elizabeth II (1994) in the reception area of Nuneaton's George Eliot Hospital. This is an unflattering but sympathetic portrait of the ageing queen. Her pose and facial expression convey a sense of patience and a willingness to listen to those around her, while the dress has delicate textural modelling. This potential of bronze to employ complex surface effects is fully exploited in McWilliam's statue of Elizabeth Frink (1956) outside the entrance of the Herbert Art Gallery in Coventry. Through the determination on her face and the boldness of the textured surface of the slim figure, the piece successfully conveys both her fragile appearance and the robust quality of her work. Unlike stone, bronze is a reproductive medium, with the same cast providing the opportunity for producing several copies of the same piece. However, unlike many cities in America and the European continent, the towns in the region have not taken advantage of this quality to avail themselves of relatively inexpensive copies of works by outstanding artists such as Henry Moore, Barbara Hepworth and the school of younger sculptors that grew up around them. Perhaps the only exception, albeit in chromium rather than bronze, is the Jaguar motif seen at garages around the country.

The technique of welding metal was developed in the field of sculpture by Pablo Picasso with the technical help of Julio Gonzalez in the early

1930s. Picasso was the first to weld together metal sheets and found iron pieces to create self-contained sculptures. In the region, his influence is seen in Simon Evans' *Trigger* (1986), made from scrap metal, and now at Warwick Road roundabout in Coventry, near the railway station. The gaps in the body of the rearing horse enable the viewer to see into and through it, increasing the sense of movement by making it appear lighter and merge with the surrounding trees and flowers. The use of non-traditional materials is also appropriate where the artist wishes to convey the playful rather than the monumental qualities of the subject. In his *Children Playing* (1999), Mark Tilley uses welded steel to depict three anonymous figures that recall the country children playing in the works of Peter Brueghel the Elder. Together with the absence of a plinth, the use of an industrial material rather than one specifically associated with high art helps to emphasise the popular appeal of the group.

Other artists have used non-traditional materials to create pieces with more obvious links to popular culture than high art. In Coventry, Peter Peri used concrete as an alternative to bronze during the 1950s for works mainly sited in schools, not only on the grounds of cost, but also because he saw it as a material of the people that could increase the appeal of sculpture to a broader section of society. While many contemporary critics attacked his use of the material as 'desperately unsympathetic', Anthony Blunt (in the *Spectator*, June 1938) recognised that:

> One of Peri's great achievements is that he has found a medium suitable for the kind of thing which he wants to express. He has no need for the more expensive media of bronze or marble, both of which allow of a richness of material which would not entirely suit his themes. Instead he has exploited concrete, a rough medium which has many advantages: it can be modelled (and) .. it sets as hard as stone: it is cheap; and it can be used in several colours. Moreover, it is the most important modern medium for architecture; and if this kind of sculpture is to have its full effect it must be thought of as part of architecture, as part of a public activity, not as an object to be hoarded in the privacy of drawing-room or study.

Later, he pioneered the use of polyester resins in sculpture. Alas, such early use of these materials proved to be less resistant to the weather than bronze or stone, and most of his works have suffered greatly from the elements. In this region, where he had two major commissions, the *Flute Player* at Ernesford Grange Junior School (1965) and *Seated Boy and Girl* at Willenhall Wood Junior School (1957), all the examples of his work have been lost as a result of the demolition of school buildings. Another example of the use of a non-traditional material for similar reasons would be the fibreglass *Shark* by an anonymous maker that appears to break through the wall of a shop in Shirley. Created in the 1990s, its appearance recalls the imagery of shop signs and comic books. Fibreglass has also been used on the grounds of its flexibility and lower cost, as in Norelle Keddie's *Bryan Bailey Memorial* outside the Belgrade Theatre in Coventry.

The commemorative tradition to display military objects such as trophies and cannons as monuments goes back to ancient times. The northern part of Warwickshire draws upon this convention by displaying mining wheels as readymades in a number of towns and villages. Some of these are adapted or modified, but others appear in their original condition. These objects, by their very form, remind us of the hazardous nature of mining and the varied fortunes of the industry. In Coventry, the gate of the original Siddeley-Deasy company, manufacturers of motor cars, was erected on the original site of the factory. The form of the gate similarly recalls the rise and decline of the engineering industry in that it can be seen as both an entrance and an exit. The materials and techniques by which they were originally made bring to mind the modern industrial world.

Coventry in particular has a late medieval tradition of stained glass which, in the late twentieth century, developed into the more sculptural process of monumental glass engraving. Foremost among the practitioners of this technique was John Hutton, responsible for both the gaunt figures of angels and saints on the south-facing façade of Coventry Cathedral and the characters from Shakespeare's plays at the entrance of the Shakespeare Centre in Stratford-upon-Avon. In the case of the latter, he used differing engraving techniques to elicit different emotional responses in the viewer. By this means, he was able, for example, to contrast the roughly textured features of Richard III with Falstaff's fleshiness, achieved by polishing the glass with emery papers. As a sculptural material used in an architectural context, glass can increase the viewer's simultaneous experience of the internal and external space, with all its psychological and philosophical associations. This is especially explicit in the case of Coventry, where the diocese deliberately sought to create a single cathedral from the old and new buildings: the screen acts not as a 'wall to divide them, but an opening to unite them'. It successfully conveys the idea that worship is open to the world and its concerns.

The *Art Language* group within the Coventry College of Art was a significant pioneer of conceptual art during the second half of the 1960s. In many respects, conceptual art is a negation of both material and technique by emphasising the role of the underlying idea rather than the execution of the work. As such, examples tend to be readily overlooked by visitors to the area. However, there are at least two characteristic examples in Coventry, *The Corridor* by Mary Thomas (1977) and *Emergency* by Anna Best (1993). Both these works are at ground level,

and could easily be stepped over by passers-by without being noticed. The former consists of a line in shallow relief along the ground signifying the distance between Hastings, Coventry and Liverpool. The latter comprises a wire grille at ground level, suspended above a pit containing discarded keys. It is intended to convey the lack of freedom experienced by women in Coventry as a result of threats to their personal safety. However, without the written inscription that accompanies it (which has now disappeared), the meaning of the work remains obscure.

## The making of public sculpture

Medieval sculpture in the region was mainly produced by stonemasons' workshops attached to local cathedrals. Relatively little is known about the makers of the exquisite carvings of the recently excavated ruins of Coventry's Priory, but the quality of work suggests a workshop of national importance. While there is evidence of local craft industry thriving well into the nineteenth century, especially woodcarving in Warwick and clockmaking in Coventry, there seems to have been an unending competition between local and metropolitan architects and sculptors from about the seventeenth century. Perhaps the most revealing case is the rebuilding of the Collegiate Church of St Mary in Warwick after the great fire of 1694, when a local sculptor and builder, William Wilson of Sutton Coldfield, was preferred to the celebrated London architect, Sir Christopher Wren.

Traditionally, most of the sculpture in the historic towns and the rural areas in the county has been commissioned from fashionable London artists. Significantly, mainly since the 1950s, many public works have been commissioned from a handful of independent local artists. Among them Walter Ritchie (1919–61), John Bridgeman (b.1916), James Butler (b.1931) and John McKenna (b.1964) have been, perhaps, the most outstanding. While biographically they belong to three different generations, their activities tend to overlap each other and their ideas, attitudes and sculpture have several common characteristics.

All four of them have been living and working mainly locally (McKenna residing in nearby Worcester) and their works have strong affinities with the landscape, as well as the built environment. At various times in their lives they were all affected by British Arts and Crafts ideas and continental avant-garde experimental styles, yet their approach to sculpture can be best described as eclectic, perhaps even post-modern. In fact, Ritchie, like his older contemporary, the Birmingham sculptor William Bloye (1890–1975), studied in Eric Gill's London atelier. Although independently, both were impressed by Gill's eccentric personality and remained influenced by his Symbolist aesthetics

throughout their working lives. Yet Ritchie had no connection with Birmingham. He was trained in Coventry School of Art, and his early work was influenced by Rodin's spontaneous and painterly modelling technique, but like many of his young contemporaries, he soon began to learn direct carving. Although this was originally a modernistic technique of the international avant-garde, Ritchie pointedly learnt it from local stonemasons. He believed in the principle of 'truth to material' and the integrity of sound craftsmanship. He also shunned the pretentiousness of the fine art bias of the commercially inclined art gallery system. He rather collaborated with sympathetic local architects who identified with the region where they lived and worked.

The equally prolific and versatile John Bridgeman, on the other hand, settled in the village of Ufton (until his retirement to Leamington Spa) when he succeeded William Bloye as Head of Sculpture in Birmingham College of Art in 1956. Bridgeman's free-standing groups and figures, as well as his wide-ranging architectural sculptures, unusually provide a convenient link with public sculpture throughout the Midlands' metropolitan boroughs and counties.

Though James Butler is a generation younger, his sculpture combines rococo grace and playfulness with historicist and academic features, mainly determined by subject-matter, site and by the challenge to satisfy particular commissions. His spontaneously-modelled full-length statue of James Brindley (1716–72), looking at his plans for Coventry Canal Basin, shows nostalgia, evoked by his eighteenth-century attire and affirmed by the surrounding water and industrial architecture, while his *Jester* in Stratford-upon-Avon displays a sense of irony that typifies the post-modern condition.

Finally, among the younger generation of local artists, John McKenna deserves special mention. Educated and trained in sculpture in nearby Worcester, he too is a prolific and stylistically eclectic artist, who takes pride in 'rising readily to the challenge of a client's brief'. Since 1993 he has worked mainly on public art projects, collaborating with architects, developers, local authorities and public art agencies to strict deadlines, and producing mainly figurative work in almost all traditional and modern materials and techniques.

## Patterns of patronage

The number of sculptures installed in Warwickshire, Coventry and Solihull during the second half of the twentieth century exceeds the number of surviving works that were produced during the previous 500 years (see Figure 1). This feature is most pronounced in Coventry, where a large number of earlier sculptural works were destroyed either by short-sighted town planners during the pre-war years or by enemy action in

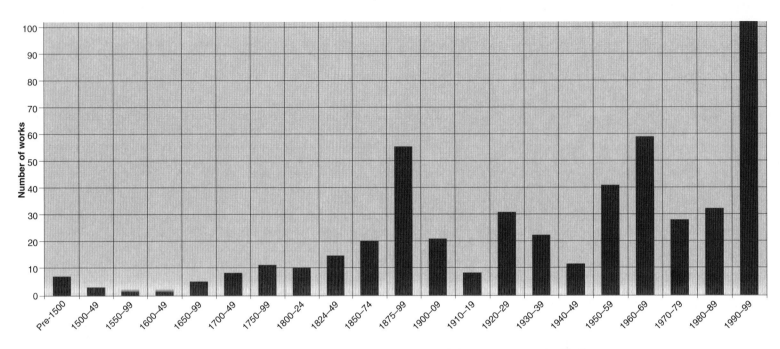

Fig. 1 Chronological span of works erected in Warwickshire, Coventry and Solihull

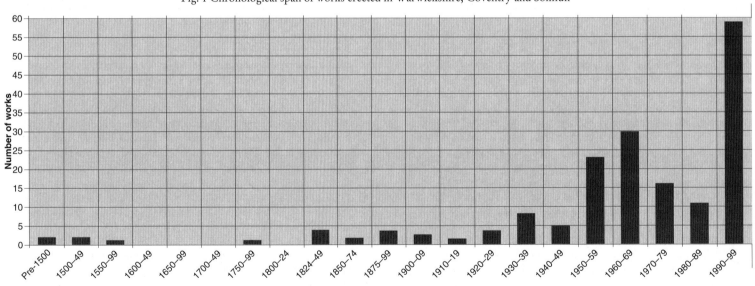

Fig. 2 Chronological span of works erected in the District of Coventry

Schein, *Millennium Clock, Coventry*

regenerating derelict and run-down urban environments, particularly in areas affected by high levels of unemployment. Coventry City Council claim that, with 39 works of art over 5.5 miles, they have created 'Britain's longest outdoor art gallery'. More recently, the Council has sought to transform the north-west part of the city centre through its Phoenix Initiative. This involves the development of Millennium Place with its gigantic multi-coloured digital clock showing the time in different parts of the world and the building of the Garden of International Friendship, which combines an architectural monument with the manipulation of plant forms.

Although the local authority is the largest single patron, other important commissioners of public art include the Cathedral, the two local universities, and a school for the blind and partially sighted, Exhall Grange. The University of Warwick has a large number of late twentieth-century sculptures exemplifying a wide range of modern (mainly abstract) styles which, at the time of purchase, reflected the latest developments in art. They saw this as signifying their commitment to cultural vitality. Examples include William Pye's *Narcissus* (datable to 1960s–70s) and Richard Deacon's *Let's Not be Stupid* (1991). In the case of Exhall Grange, the influence of the former headmaster, George Marshall, an educationalist who established his reputation in the post-war years with his progressive and experimental approach to the education of visually impaired children, was paramount. A number of the pieces are small enough to handle or have textured surfaces with obvious tactile qualities. Occasionally, pieces are commissioned by wealthy individuals in collaboration with institutions. For example, Josefina de Vasconcellos' *Reconciliation* (1995) was commissioned by Richard Branson with the Cathedral's permission for the work to be sited in the ruins of the old Cathedral. Depicting two figures on their knees linking their arms to create an arch, the work symbolises reconciliation between two previously hostile nations, the British and the Japanese. Between 1989 and 1999, the Public Art Commissions Agency (PACA) under the imaginative direction of Vivien Lovell, was instrumental in promoting the cause of contemporary public sculpture in Coventry.

In Warwickshire, the pattern is somewhat different. Many more of the works commissioned during the prosperous years of the late Victorian period have survived (see Figure 3). Moreover, the post-war increase in the number of works was by no means as dramatic as that in nearby Coventry. In part, this reflects the differing political and social make-ups of the two centres. In Coventry, the local authority saw public art as a means of improving a city that was faced by tremendous problems of poverty and dereliction during the immediate post-war years. Moreover, they were open to the progressive influence of the School of Art, commissioning many abstract as well as more traditional figurative works.

1940. The chart shows that there were two significant increases in the number of works commissioned (see Figure 2). The first was during the immediate post-war years when the town centre was being developed by two city architects with a particular interest in integrating public art into the urban environment, Donald Gibson and Arthur Ling. Gibson demonstrated his commitment to public art early on, with the installation of the *Levelling Stone* in 1946. Significantly, this was carved with a relief sculpture of a phoenix. The first building of the new era, Broadgate House, has relief carvings on its columns, such as *Princess Elizabeth's Column* (1950). Similarly, other buildings were decorated with architectural sculptures during his period as City Architect. When Gibson resigned in 1955, Ling's approach proved somewhat different. Under his advice, the Planning Committee moved away from sculptural relief panels towards standing sculptures outside buildings. Ling turned to the College of Art for assistance, and students' work was displayed in Smithford Way and Market Way. He was also an early exponent of using neon light in public artworks, such as *Coventry's Industries* in the Precinct (1961). The second increase in the number of works commissioned was more spectacular: from just over thirty during the 1980s to over ninety-five in the following decade. Of these, a large proportion were for the canal area and were implemented by Groundwork, a public body concerned with

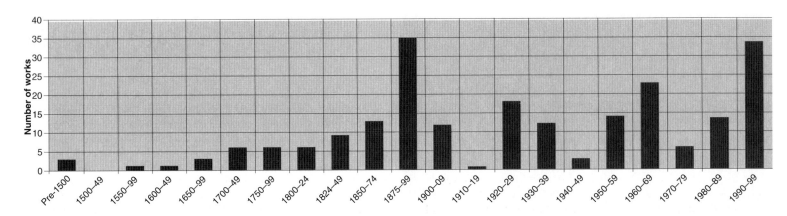

Fig. 3 Chronological span of works erected in the County of Warwickshire

Many other local councils were to follow their example of including artworks within their landscaping, development and community plans in the following decades. Groundwork's commissioning of the Coventry Canal works during the 1990s can be seen as a continuation of this development, which had been broken only by a lack of resources during the years of recession in the 1970s and early 1980s. By contrast, Warwickshire is a quieter, more rural area in which there is a greater sense of historical continuity and less political commitment to commissioning public art. Nevertheless, under the direction of the former County Architect, Eric Davies, the Council commissioned a number of works in schools during the post-war years, reflecting their openness to progressive educational ideas. These were, on the whole, figurative rather than abstract, and indicate something of their more cautious approach to artistic innovation. In this emphasis on works for schools, they shared the ideas of Leicestershire's Director of Education, Stewart Mason, who felt that art improved the general life of schools by adding a sense of energy and vitality to the environment, thereby stimulating pupils. Examples of the works commissioned for local primary schools include two by Walter Ritchie, *Shooting Star* (1953), emblematic of children's quest for the light of knowledge, and *Five Cows and a Team of Horses* (1961), a weather-vane in the style of the illustrations in traditional children's picture books.

## Conclusion

In hindsight, our most striking observation is the contrast in the development of public sculpture between metropolitan areas and smaller towns and rural areas. While there has always been more public sculpture in Coventry than in other parts of Warwickshire, this difference has become even more marked over the past ten years. Coventry's greater wealth, its post-war experience of commissioning public sculpture as part of the city's reconstruction, and its having the relevant cultural and commercial institutions for the commissioning of public art may perhaps explain this. However, there also appears to be a greater political and social will to communicate through the visual arts.

Coventry also seems to have been more willing to accept experimental and innovative works than the more traditionally-minded rural areas and smaller towns. Outside the larger towns, the sense of place that might encourage the commissioning of works related to the surrounding landscape seems to be sadly lacking.

Apart from some isolated sculpture by Eric Gill and Jacob Epstein, few or no works by leading mainstream avant-garde artists that might appear in accounts of international or even national art still exist in the area. Nevertheless, there are a number of outstanding monuments and sculptures within the region, including the tombs in the Beauchamp Chapel in Warwick, the Shirley Family narrative cycle in the Warwickshire village of Ettington and the *Gower Memorial* in Stratford-upon-Avon. Moreover, a number of talented and prolific mid twentieth-century artists have been forgotten or remain unrecognised, even within their own locality. These would include Walter Ritchie, Arthur Fleischmann, Georg Ehrlich and Peter Peri. The overall quality of the work is generally high and deserves greater critical attention. This should encourage more emphasis on the conservation of sculpture and the development of a more balanced relationship between preserving past works and commissioning new ones in order to avoid the loss of further examples of pioneering public art in the region.

# Acknowledgements

Firstly, we must record our gratitude to the Lottery Heritage Fund, the Henry Moore Foundation, the Leverhulme Trust, and West Midlands Arts for their generous grants towards the cost of this research project and the publication of this volume. A contribution towards salary costs was also made from the Birmingham Institute of Art and Design's Research Fund. The School of Theoretical and Historical Studies kindly provided office space for the research project.

Books of this nature involve the invaluable help, contribution and critical advice of many colleagues and friends. The first words of thanks must go to Fiona Waterhouse for undertaking the monumental task of detailed checking and correction in the final stages of the preparation of the typescript. A special debt is also owed to Sian Everitt for unflagging devotion and continued support in the earlier stages of the project, both for her own research work and her co-ordination of that of the volunteers. Practical advice and support was also given by Professor Mick Durman, Dean of the Faculty of Art and Design, and Professor Nick Stanley, Director of Research.

We would like to give special thanks to those people who gave up many hours of their own time to serve as members of the Western Central Counties Regional Archive Steering Committee and whose advice proved to be invaluable. Particular mention should be made of Ron Clarke generously providing access to his earlier research on public art in Coventry.

We also owe a very great debt of gratitude to all those volunteers who helped by making site visits and working in local archives, whose expertise and dedicated research was fundamental to the production of this volume and whose names appear on the back of the title page. In particular, Brian Johnson made several hundred photographs, each demonstrating a rare sensitivity to the sculptors' intentions.

Others who should be thanked for their advice and help in a number of ways include Eric Davies, retired Warwickshire County Architect, who gave valuable insights into the history of commissioning public sculpture for Warwickshire schools and freely provided a number of photographs for this volume; Jane Armer of the National Inventory of War Memorials; Sally Taylor, estate of the late Walter Ritchie, who gave access to archive material and the prolific oeuvre of this relatively little-known and until recently underestimated sculptor; and Alison Plumridge, Senior Curator, Leamington Art Gallery and Museum. We also wish to acknowledge the co-operation of St Mary's Hall, Coventry, and the Vicar of Holy Trinity Church, Stratford-upon-Avon, in the taking of photographs, as well as the active support of Warwick County Records Office, Stratford Records Office, Coventry City Archives, and the Local Studies Departments of Coventry City, Solihull and Warwick public libraries.

Thanks are also due to Jo Darke, Ian Leith, Benedict Read and Alison Yarrington of the Public Monuments and Sculpture Association, to Annie Ravenshill-Johnson and Laura Noszlopy for reading and advising on the typescript, and to Robin Bloxsidge of Liverpool University Press for his continuing belief in the project of which this volume is part. The last word of thanks is surely due to the patient forbearance and loving support throughout the production of this book to Edward Morris, Chairman of the Editorial Board, and to Janet Allan, designer and production editor.

GEORGE T. NOSZLOPY
University of Central England

# Sources of Illustrations

Grateful acknowledgement is made to the following for the supply of photographs and for permission, where it has been possible to contact the source, to reproduce them.

Eric Davies, former Warwick County Council Architect: Ritchie, *Tumbler* (p.2); Ritchie, *Alice in Wonderland* (p.16); Skeaping, *Polar Bear* (p.22); Ritchie, *Boy with Horses* (p.25); Ritchie, *Historystone* (p.34); Ritchie, *Through the Looking Glass* (p.78); Ritchie, *Growth* (p.78); Ritchie, *Three Aspects of a Young Girl's Education* (p.80); Ritchie, *Peter Pan and the Darling Children* (p.83); Ritchie, *Hurdlers* (p.199).

Herbert Museum and Art Gallery Collection: Stained Glass Head of a Prophet (xxi); Artist's impression, Southam's Sacred Spring (xvii);

Candey, *Woodland Scene* (p.130); Bloye, *St Nicholas Rescuing the Three Children* (p.220); Peri, *The Flute Player* (p.221); Peri, *Seated Boy and Girl* (p.224); Tietze, *Basketball Players* (p.226); Peri, *St Michael and Dancing Figures* (p.226).

Coventry Evening Telegraph: Annual Godiva Procession, Coventry (xvii); Mother Concordia, *Virgin Mary and Child* (p.142).

Coventry City Council: Schein, *Millennium Clock* (xxvi and p.227).

Jonathan Ford: Ford, *Schlanke* (p.78).

University of Warwick: Olins, Net II drawings (p.191).

All other photographs are by members of the project team.

# Warwickshire

## North Warwickshire

*Long Street*

*On the façade of 176 Long Street*

### Queen Victoria Jubilee Panel

**Designer: Henry Hugh Armstead (attributed to)**

Installed: 1897
Terracotta 1m high × 1m wide × 20cm deep
    approx
Inscriptions: (at top): 1897
    (around frame, clockwise): CANADA
    AUSTRALIA / NEW ZEALAND BURMAH / GIBRAL
    [*sic*] MALTA CYPRUS INDIA / AFRICA W.INDIES
    (across centre): EMPRESS OF INDIA
    (in circle around bust): VICTORIA 60 YEARS
    QUEEN OF GREAT BRITAIN & IRELAND
Condition: good
Status: not listed
Owner/Custodian: owners of 176 Long Street

The square relief panel above the entrance porch has a date in the small scrolled pediment on top, and shows a bust of Queen Victoria in profile surrounded by inscriptions listing her kingdoms.

The designer and manufacturer of this relief panel are not known. Several other identical examples exist, for example in Knowle (see entry for *Queen Victoria Jubilee Relief*, Kenilworth Road, Knowle) and Nottingham. Terracotta underwent a great revival in the late Victorian period, and a number of firms were

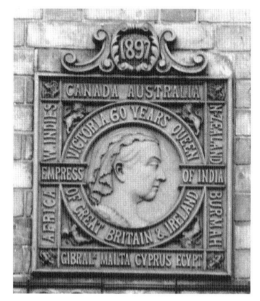

**Armstead,** *Queen Victoria Jubilee Panel*

producing commemorative and decorative relief panels for architectural settings.[1] Apart from its commemorative purpose, this panel reflects the imperialism of the 1890s. It must have been the spontaneous expression of the owner's patriotic and loyalist fervour.

Note
[1] Stratton, M., *The Terracotta Revival*, London, 1993.

*Market Street*

*Outside Warwickshire Probation Service*

### We are here

**Artist: Justin Sanders**

Installed: spring 1998
Ceramic tile 1.4m high × 1.6m wide approx
Signature: as if part of pub sign in upper left:
    J.A. SANDERS
Inscriptions: upper left (as pub sign): THE /
    LOADS / O' / PUBS
    on train: FACE TO FACE
    on map: WE / ARE HERE
    on barge: HEART OF ENGLAND
    on plaque to side of work: "WE ARE HERE" /

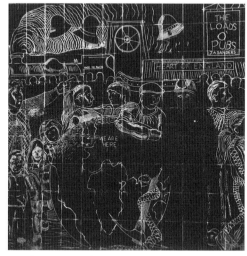

**Sanders,** *We are here*

Justin Sanders / 1998
Condition: good
Status: not listed
Commissioned by: North Warwickshire
    Borough Council
Owner/Custodian: Warwickshire Probation
    Service

This engraved ceramic mural is incised in white and grey on a dark ground, with very little indication of depth and shading. The work has been carved by a number of tools, including an angle grinder into the existing black tiles of the wall. The marks were then highlighted with grouting in various shades of grey. The mural contains emblematic depictions of local scenes and objects including pit head gear, a pick axe, a pub sign, a barge, a map of the world, a train, hats, a family group and a miner. It has been coated with an anti-graffiti varnish.

The artist was commissioned by North Warwickshire Borough Council through its outreach arts development scheme 'Face to Face'. The site outside the Probation Service office had become available and had been identified through the Atherstone Town Regeneration project as a potential site for public art.[1] The work was commissioned to celebrate the Borough's Heating and Mining Heritage.

Note
[1] Letter from Alan Freeman, Leisure Service Officer, North Warwickshire Borough Council, 3 February 2000.

*Southlands*

*Arden Hill Infant and Nursery School*

## *Tumbler*
### Sculptor: Walter Ritchie
### Architect: Charles Elkins

Executed: 1952
Darley Dale stone 1.52m high
Condition: fair
Status: not listed
Commissioned by: Charles Elkins, County
    Architect
Owner/Custodian: Arden Hill Infant and
    Nursery School

A circular stone pillar supports the life-size figure of a youth balanced on his shoulders with his arms clasping his knees.[1] In this work Walter Ritchie successfully fused the statue's original function (to signify the educational and

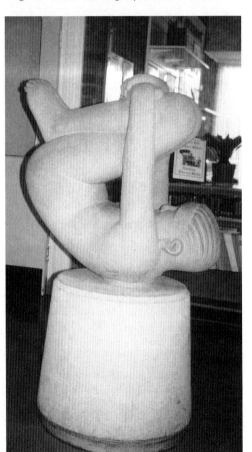

Ritchie, *Tumbler*

recreational purpose of the site) with the intrinsic sculptural problems (to create a harmonious balance between the shapes and masses of the youthful human body within an architecturally defined physical space). Even in its resited setting, the statue manages to retain its conceptual, symbolic and playful formal meanings.

The statue was commissioned for the opening of the school in 1953. Although originally sited in the school playing ground, it was resited indoors to prevent further damage from vandalism. It was restored c.1987 with a grant from the Arts Council.[2]

Notes
[1] Ritchie, W., *Walter Ritchie: Sculpture*, Kenilworth, 1994, p.77. [2] Letter from Mrs C.M. Stain, Headteacher, Arden Hill Infant and Nursery School, 16 February 2000.

## AUSTREY

*Church Lane*

*Outside Bird in the Hand Public House*

## *Village Cross*
### Sculptor: unknown

Executed: 1897
Steps: sandstone
Cruck stone: sandstone 50cm high × 1m wide
Cross: limestone 1.4m wide × 60cm wide ×
    30cm deep
Condition: fair
Status: Grade II
Owner/Custodian: Austrey Parish Council

The stone base and octagonal steps of this village cross are ancient. The bottom step has been partly buried by macadam. The original medieval cross, now lost, was replaced in 1897 by a Victorian impression of a Celtic cross to commemorate the Diamond Jubilee of Queen

**Unknown,** *Village Cross*

Victoria. There are no records as to why this design was chosen.[1]

Note
[1] Letter from Jayne Brookes, Austrey Parish Council, 9 February 2000.

## COLESHILL

*Church Hill*

*Grounds of Parish Church*

### War Memorial

**Sculptor: unknown**

Installed: after 1919
Stone 7.5m high approx
Inscriptions (on metal plaques on pedestal):

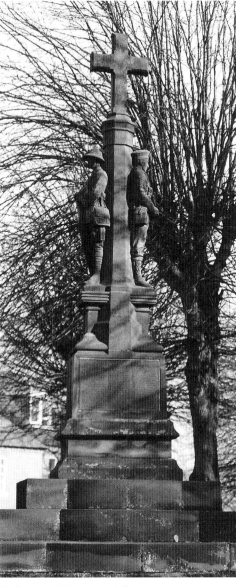

**Unknown,** *War Memorial*

1914–1918/ IN MEMORY OF THE MEN OF THIS PARISH WHO FELL IN THE GREAT WAR/ (54 names) IN MEMORY OF/ THE MEN OF THIS PARISH/ WHO GAVE THEIR LIVES/ IN THE SECOND WORLD WAR/ 1939–1945 (16 names)

Condition: good
Status: not listed
Owner/Custodian: Church of England

Sited in the churchyard but readily visible from the main street, this memorial consists of a tall cross mounted on a red stone pedestal standing on four stone steps. The pedestal is inscribed with the names of those who died during the First and Second World Wars. Above this there are two life-size statues, one of a First World War soldier in contemporary uniform, the other of a sailor from the same period. They stand back to back, their rifles lowered.

*Originally in grounds of St Gerard's hospital, now part of Father Hudson's Society grounds*

### Virgin and Child tondo, half-length Virgin and Child, Cherubim and Ornate Capitals

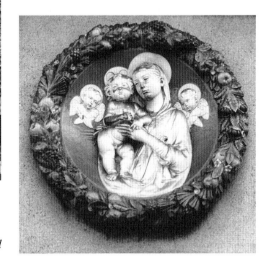

**Unknown,** *Virgin and Child*

## Sculptor: unknown

Installed: 1882
Painted and glazed terracotta, capitals carved in
    stone
Half-length Virgin and Child 1.5m high approx
    Tondi 45cm diameter approx
Condition: good
Status: not listed
Commissioned by: St Gerard's Hospital
Owner: Father Hudson Society

Visible from the main road, these enamelled
majolica reliefs are in the manner of the
fifteenth-century Italian sculptor, Luca della
Robbia, a style very popular in England in the
late nineteenth century.[1] The hospital is now
closed and the buildings have been taken over
by the Father Hudson Society, a charity
founded in 1882 under the auspices of the
Catholic Church as a children's rescue society.
The choice of colourful reliefs on the building
reflect this role, with the motif of the Virgin
and Child being particularly appropriate to a
society concerned with the care of

disadvantaged or orphaned children. The
Society owns and displays several full-length
life-size statues in its gardens, mainly of similar
religious subjects, but the grounds are no longer
open to the public. Today it is also a fostering
and adoption agency, supports a number of
community projects and offers residential and
day care services to older people and those with
disabilities.[2]

Notes
[1] An undated report by the Williamson Art Gallery
in Birkenhead notes that the della Robbia Pottery in
Birkenhead produced work inspired by della Robbia
between 1894 and 1906. In his article on the della
Robbia family for the 1910–11 *Encyclopaedia
Britannica*, J.H. Middleton noted that the Victoria
and Albert Museum had the best della Robbia
collection outside Italy at that time. [2] *Encyclopedia
of Charities*, 2000, p.186.

**Unknown,** *Ornate Capital*

*Corley Lane*

*Corley Residential School – wall of school
driveway*

## *Children, Cat and Elephant*
### Sculptor: James C. Brown

Executed: 1959
Brick 1.7m high × 4m wide approx
Condition: good
Status: not listed
Commissioned by: Education Committee of
    Coventry City Council
Owner/Custodian: Coventry City Council

This carved brick sculpture is inspired by
elements from the Coventry city coat of arms,

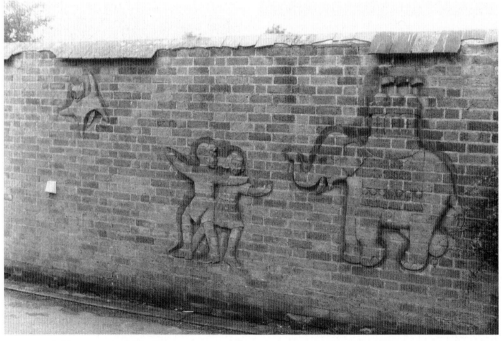

**Brown,** *Children, Cat and Elephant*

which have been treated in a simplified way in order to appeal to children. Here the wild cat from the crest is shown as a domestic cat leading a couple of children who are followed by the elephant bearing a triple-towered castle from the shield. The brick is carved to various depths with the outlines defined by deeply cut hollows around each figure. There is a great deal of detail shown, particularly on the elephant.

The sculpture was designed and carved by James Brown while employed in the Department of Architecture and Planning in Coventry. The school building was designed by Arthur Ling, Coventry City Architect. He intended the wall beside the entrance as a site for the city coat of arms, and commissioned Brown to make the design. The work was carried out in 1959 in advance of the Education Committee's approval.[1]

Note
[1] Herbert Art Gallery and Museum/City of Coventry Libraries, Arts and Museums Department, *A Survey of Public Art in Coventry*, 1980, p.127.

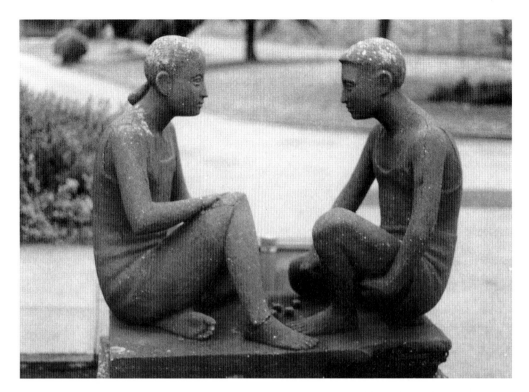

Dawson, *Children Playing Fivestones*

*Corley Residential School – lawn outside main entrance*

## Children Playing Fivestones
### Sculptor: Bob Dawson

Installed: 1959
Figures: cast cement 92cm high × 1.12m wide × 61cm deep
    Base: concrete with gravel aggregate 80cm high × 1.15m wide × 65cm deep approx
Signature: on base of figure group below male figure in raised lettering: DAWSON 58
Condition: poor
Status: not listed
Commissioned by: Coventry City Council
Owner/Custodian: Corley Residential School

The sculpture of two seated children playing the game fivestones appears to have been cast in sections in a mould and then assembled on its plinth. The surface of the figures has been rendered very smooth, and the facial features of the figures stylised in a way that relates this sculpture to the now lost sculpture of basketball players at Binley Park School by Boris Tietze of the same year.

It was in place for the opening of the school in 1959. The Head of the school stated that they had been visited by a sculptor, who was looking at the possibility of making a cast of the work to preserve it.[1]

Note
[1] Information provided by Head of school, 21 August 1999.

*Atherstone Road*
*Opposite junction with Trentham Road*

## Drayton Memorial
### Designer: John Sherwood

Executed: 1972
Stone 2.5m high × 6m wide approx
Inscription: MICHAEL DRAYTON POET 1563–1631 BORN ON THIS GREEN THIS MEMORIAL SHELTER CONCEIVED BY JOHN SHERWOOD BUILT 1972
Condition: fair
Status: not listed
Owner/Custodian: North Warwickshire District Council

Sherwood, *Drayton Memorial*

This uninviting castle wall-like shelter is built in random-shaped rusticated stone. The construction has a bastion-like formation at one end with slit arrow windows; at the other end is a concave wall enclosing a bench.

The memorial commemorates Michael Drayton (1563–1631), poet, who was born in Hartshill. His earliest work was *The Harmony of the Church* (1591), a metrical rendering of scriptural passages, which was condemned to be destroyed as it offended the authorities. Perhaps his best-known works are *England's Heroical Epistles* (1597), *Poly-Olbion* (1612–22), an ambitious description of the English countryside, and the celebrated sonnet 'Since there's no help, come let us kiss and part', from the *Idea* (1619).

## POLESWORTH

### *Grendon Road*
*In field to south of road, on hill*

## *Obelisk*
### Designer: unknown

Installed: 1846
Base: red brick 30cm high approx
Steps: stone 85cm high approx
Obelisk: stone 4.4m high approx
Inscription: site of Chapel of St. Leonard at Hoo/ Demolished 1538 / 30th Henry VIII
Condition: fair
Status: Grade II
Commissioned by: Sir George Chetwynd

This pyramid obelisk, set in a field on a hill, rests on a brick base from which four steps lead to its shaft. It carries an inscription near the base.

The obelisk was erected in 1846 to commemorate the finding of the ruins of the chapel of St Leonard of Hoo. The chapel was dedicated and endowed with land by a Roger de Grendon in the first half of the twelfth century. A later Roger de Grendon gave the chapel to the nuns of Polesworth Abbey. It was demolished in 1538 during the dissolution of the monasteries under Henry VIII's religious reforms. The graveyard for the chapel was rediscovered during the construction of the Trent Valley Railway Line. Originally erected on the opposite side of the Grendon Road, the obelisk was resited in 1901 when the railway line was widened.[1]

Note
[1] Polesworth Society information leaflet.

### *High Street*
*Outside Abbey Church of St Editha*

## *War Memorial*
### Sculptor: Henry Charles Mitchell

Unveiled: April 1921
Steps: stone 70cm wide × 30cm deep approx
Base: stone 1m wide × 1m deep approx
Cross: granite
Inscriptions: TO THE GLORY OF / CHRIST CRUCIFIED AND TO THE / MEMORY OF THE MEN WHO / MADE THE GREAT SACRIFICE / IN THE WORLD WAR / 1914–1919. / THESE NOBLY PLAYED THEIR PART / THEY HEARD THE CALL / FOR GOD, FOR KING & COUNTRY, / THEY GAVE THEIR ALL / THEIR NAME LIVETH ON EVERMORE./1939–1945/[names]/REMEMBER
Condition: good
Status: not listed
Owner/Custodian: Abbey Church of St Editha

This large wheel cross stands on a tapering stone base and five steep steps, pinned with iron. It is of rough-hewn granite with a sword carved on its front face. The roll of honour from the First World War appears on three

# Nuneaton and Bedworth

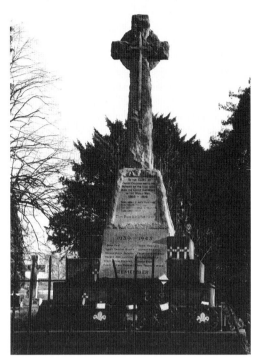

**Mitchell,** *War Memorial*

sides of the base and there is an inscription in the centre. Some of the steps have been cut into and a slab with the roll of honour from the Second World War has been added.

The war memorial was erected at a cost of £350 and was unveiled by Earl Ferrers.[1]

Note
[1] Letter from the Polesworth Society, undated (February 2000).

## *Coventry Road*

*Miners Welfare Park, in flowerbed*

### Memorial to William Johnson

Installed: after 1921
Marble 50cm high × 50cm wide × 30cm deep approx
Inscription: on plaque: In honour of / WILLIAM JOHNSON (1849–1921) / MP, Secretary and Agent of the / WARWICKSHIRE MINERS ASSOCIATION / formed in 1885, who laid out the park with / funds donated from the miners pension fund.
Condition: good
Status: not listed

**Unknown,** *Memorial to William Johnson*

Owner/Custodian: Nuneaton and Bedworth District Council

This rough-hewn boulder, akin to a large lump of coal, suggests William Johnson's close links with the mining industry and those employed in it.

*Miners Welfare Park*

### *The Miner*
### Artist: Stella Carr

Installed: July 2000
Metal 2.7m high approx
Condition: good
Status: not listed
Owner/Custodian: Nuneaton and Bedworth District Council

This work, standing on a raised wheel that is surrounded by a planting bed, takes the form of a monumental standing male figure wielding a pick and wearing a miner's safety helmet. The metal figure incorporates welded-in mining artefacts. He stares straight ahead, as if pausing in his work because something has caught his attention. From the distance, the figure has a futuristic robot-like appearance.

The sculpture replaces a temporary figure commissioned for the Britain in Bloom competition in 1998, and has many similarities to it. The temporary work was also in the form of a tall standing male figure with a robot-like appearance, and was shown wearing metal boots and a safety helmet. However, unlike Stella Carr's more recent work, the figure was shown leaning back as if caught in action and about to strike a blow with the tool he was carrying, and was set on a mound in a flowerbed that was strewn with pieces of scrap

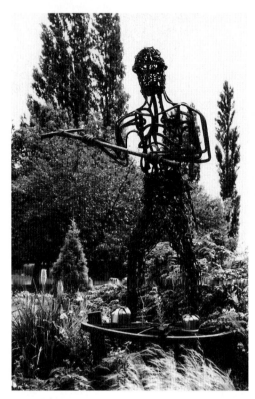

**Carr,** *The Miner*

metal, rusting industrial parts and large lumps of coal to emphasise the decline and loss of the mining industry in the Bedworth area. The new work conveys a greater sense of pride in the area's industrial heritage.

## Winding Wheel (Mining Memorial)

### Foundry: Thompson & Southwick Ltd

Unveiled: 27 March 1986
Wheel: iron, painted 4m diameter approx
Stone: stone 98cm high × 93cm wide × 36cm

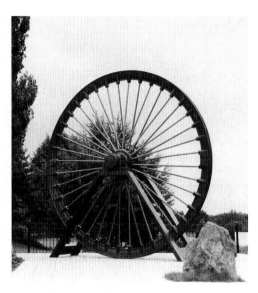

**Thompson & Southwick Ltd,** *Winding Wheel (Mining Memorial)*

deep
Inscriptions: (on rim of wheel): THOMPSON & SOUTHWICK LTD MAKERS TAMWORTH ENGLAND
(on bronze plaque on stone): Erected by the / NUNEATON and BEDWORTH BOROUGH COUNCIL/ to Commemorate and in Tribute to the Miners / of the local Coal Mining Industry / The Winding Wheel was donated by the NATIONAL COAL BOARD / and was in use at NEWDIGATE COLLIERY / the last working mine in the Borough, until its closure / on the 5th February 1982 / Unveiled by his Worship the Mayor Cllr. A.H. Walker J.P. / on the 27th day of MARCH 1986.
Condition: good
Status: not listed
Commissioned by: Nuneaton and Bedworth District Council
Owner/Custodian: Nuneaton and Bedworth District Council

This large winding wheel is black with red spokes. It is set in a paved area with a stone marker in front carrying a bronze plaque with an inscription on its rear face. As in the case of similar local mining memorials, this winding wheel is intended to remind the viewer of the ethos of the toil, comradeship and hazards of the life and work of past mining communities. While in most of the other examples the whole wheel is used as a kind of 'ready-made', this particular one resembles a construction or assemblage where fragments of manufactured objects are integrated to give a visual form to an ethical and aesthetic idea.

## The Charity Collieries Monument

Installed: 1896
Steps: stone
Base: marble
Urn: concrete
1.36m high from top step
Inscription: (around rim of marble drum support): ERECTED BY THE WORK PEOPLE OF THE CHARITY COLLIERIES AND FRIENDS 1896
Condition: fair

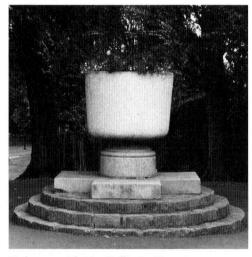

**Unknown,** *Charity Collieries Monument*

Status: not listed
Commissioned by: Charity Collieries and
    Friends
Owner/Custodian: Nuneaton and Bedworth
    District Council

This is a traditional elaborate commemorative
structure crowned by a funerary urn. It consists
of three circular steps below a cruciform
platform supporting a marble drum that in turn
supports a simplified cup-shaped urn. The latter
appears to have been cast from concrete in
segments which have then been cemented
together, so presumably it is a later
replacement.

## NUNEATON

### Abbey Gate

*Alliance and Leicester Building Society
building*

#### Ornate Façade

Executed: 1870s
Heads: wood 40cm high × 35cm wide × 25cm
    deep approx
Columns: wood 70cm high approx
Panels: terracotta (buff) 20cm high × 40cm wide
    approx
Condition: good
Status: not listed
Owner/Custodian: Alliance and Leicester
    Building Society

This timber-framed building has ornate
decoration on the first and second storeys. The
corbels are wooden heads, female and classical
in style. Above these are small slender barley-
sugar twist columns with capitals decorated
with acanthus leaves. Over the window lights
are terracotta panels of relief sculpture, with
foliage and fruit designs.

Unknown, *Ornate Façade*

### College Street

*Centre of roundabout, marker is at side of
car park to hospital*

#### Fountain

Installed: 1997
Work: pebbles, granite and water 2m high ×
    1.5m wide × 80cm deep approx
Marker: stone 50cm high × 37cm wide × 20cm
    deep
Plaques: metal, probably bronze
Inscriptions: (on upper oval plaque): HILL TOP
    FOOTBRIDGE / and / COLLEGE STREET /
    ROUNDABOUT / rebuilt by / WARWICKSHIRE /
    COUNTY COUNCIL / 1996
(on lower rectangular plaque): LANDSCAPE
    SCHEME / by / Nuneaton and Bedworth /
    Borough Council / and / Warwickshire
    County Council / 1997
Condition: good

Status: not listed
Commissioned by: Nuneaton and Bedworth
    Borough Council and Warwickshire County
    Council

The large boulder in a circle of pebbles between
four fountains symbolises past industry, which
once employed hundreds of men and women.[1]
At the roadside, separate from the roundabout,
is a small commemorative stone carrying two
plaques.

Note
[1] *Nuneaton and Bedworth Official Guide*, p.12.

*Reception, George Eliot Hospital*

#### Bust of Queen Elizabeth II
#### Sculptor: John Barry Letts

Executed: 1994
Bust: bronze 60cm high × 40cm wide × 30cm
    deep approx
Base: brick and stone 1.1m high × 60cm wide ×
    60cm deep approx

Unknown, *Fountain*

George Eliot Hospital

## *Family Group and Sign*
## Sculptor: John McKenna

Executed: 1990s
Brick and clay 4.5m high × 7m wide × 1.2m
    deep approx
Inscription: (on front, carved into brick and
    then filled with clay in contrasting colour):
    GEORGE ELIOT HOSPITAL NHS TRUST
Condition: fair
Status: not listed
Commissioned by: George Eliot Hospital NHS
    Trust
Owner/Custodian: George Eliot Hospital NHS
    Trust

This is a large signboard at the entrance of the
hospital on a base made of brick. It is triangular
and has a conical centrepiece containing a
figurative group within the gigantic fingers of
two hands carved in low relief into the
brickwork to form an enclosing wall. The
group is composed of physically separate,
almost three-dimensional clay statues of a male
figure, a female figure with suckling baby, a
young male child, a young female child and an
elderly female figure. The youth has classicising
features, resembling an ancient Greek 'kuroi'
figure of the late archaic period, whereas the
older characters are portrayed with uncom-
promising realism. While the expressions of the
adult figures convey suffering and sadness, the
giant hands suggest protectiveness and a
willingness to ease their pain, entirely approp-
riate to the sculpture's location outside a
hospital.

**(opposite) McKenna,** *Family Group*

Signature: (towards base of bronze, behind
    right elbow of figure): John Letts / 1994
Inscriptions: (on spine of book): GEORGE /
    ELIOT
(on front of book): ELIOT
Condition: good
Status: not listed
Owner/Custodian: George Eliot Hospital NHS
    Trust

This portrait bust, showing Queen Elizabeth II
in three-quarter profile, is an uncompromising
likeness of the ageing Queen. She is depicted
clasping a book by George Eliot. This brings a
narrative element to an otherwise iconic image.
She wears a patterned blouse with delicate
textural modelling, pearls and a brooch. Her
pose and facial expression suggest patience and
sympathy in a manner appropriate to the
sculpture's location in a hospital.

The bust was unveiled by the Queen herself
on a visit to open the third phase of the
hospital's development.

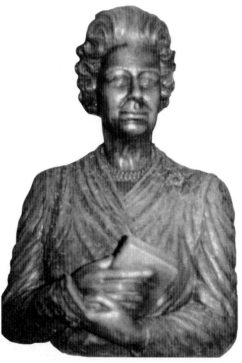

Letts, *Bust of Queen Elizabeth II*

## Coton Road

### Buller Memorial (South African War Memorial)

### Sculptor: Adolphus E.L. Rost

Unveiled: 28 January 1905
Pedestal: granite 1.73m high × 1.25m wide ×
    1.25m deep
Figure: bronze 1.7m high × 60cm wide × 60cm
    deep approx
Plaques: bronze each 54cm high × 55cm wide
Signatures: (on south side of base to bronze):
    ADOLPHUS E L ROST
(at bottom of plaque): A E L ROST SC
Inscription: (plaque on front (west face) of
    pedestal): ERECTED TO PERPETUATE THE

MEMORY / OF THE MEN OF THE NUNEATON /
DISTRICT WHO AT THE CALL OF / DUTY WENT
FORTH TO FIGHT THEIR / COUNTRY'S BATTLES
IN / SOUTH AFRICA DURING THE YEARS /
1899–1902. BY PUBLIC SUBSCRIPTION /
THROUGH THE AGENCY OF THE MIDLAND /
COUNTIES TRIBUNE NEWSPAPER / A.E.L.ROST
SC
Condition: fair
Status: not listed
Commissioned by: public subscription
Custodian: Nuneaton Council Parks
    Department

The mildly curved baroque style pedestal is of
pink granite, rough hewn in places and polished
in others, supporting a standing figure in
bronze. The animated figure is of a male soldier,
dressed in Boer War campaign dress with a
slouch hat, loading his rifle while staring
straight ahead. The roll of honour appears on
plaques on the sides of the pedestal, whilst on
the front the plaque carries a coat of arms with
the motto DIEU ET MON DROIT and the
inscription, which is bordered by laurels and
three Tudor roses. The memorial was unveiled
by General Sir Redvers Buller VC on 28
January 1905.[1]

Note
[1] Seftey, R., *The Weekly Tribune 1895–1995 Images
of Nuneaton*, Derby, 1995, p.50.

**Rost,** *Buller Memorial*

Source
Gildea, J., *For Remembrance and in Honour of those who lost their lives in the South African War 1899–1902*, London, 1911.

## King Edward Road

*George Eliot Memorial Gardens*

### George Eliot Obelisk

Installed: 1951
Lower step: stone 30cm high × 1.82m wide × 1.67m deep
Upper step: stone 38cm high × 1.18m wide × 1.10m deep
Obelisk: stone 1.56m high × 78cm wide × 70cm deep
Inscriptions: (front face, east): GEORGE / ELIOT / 1819–1880
(south face): MARY ANNE EVANS / BORN AT SOUTH / FARM ARBURY / 22 NOV 1819
(west face): LEST WE / FORGET
(north face): DIED THE WIFE / OF JOHN WALTER / CROSS AT 4 / CHEYNE WALK / CHELSEA / 22 DEC 1880
Condition: fair
Status: not listed
Commissioned by: Sir Francis Newdigate
Owner/Custodian: Nuneaton and Bedworth District Council

The two square steps support an upright slab obelisk incised with a victory wreath on the front face and with inscriptions on all sides. The massive form of the obelisk conveys something of the subject's strength and independence of mind.

George Eliot was the pseudonym used by the novelist Mary Anne Evans, who was born at Arbury Farm, Astley, near Nuneaton in 1819. After the death of her father in 1849, she travelled abroad, then settled in London and began to write for the *Westminster Review*. She became assistant editor and the centre of a literary circle, one of whose members, George Henry Lewes, she lived with for 24 years despite the fact that he was a married man. Whilst they considered their relationship to be equal to that of marriage, the arrangement alienated them from many of their friends and family and she spent much of her life in London. Despite her move away from her home town, her experiences of rural life in Warwickshire as a girl and young woman deeply influenced her novels and short stories, particularly *Scenes from Clerical Life* (1857). She remained attached to Nuneaton and used it in her novels as the town of 'Milby'. Her major novels were *Adam Bede* (1859), *The Mill on the Floss* (1860), *Silas Marner* (1861), *Middlemarch* (1871–2), and *Daniel Deronda* (1876). In each of these, the main character possesses a similar independence of mind to George Eliot herself. After Lewes's death in 1878, she married an old friend, John Cross, in 1880, but died soon after.

**Unknown,** *George Eliot Obelisk*

This memorial was originally in the park at Arbury Hall, having been erected by Sir Francis Newdigate, the son of George Eliot's father's employer and the great grandfather of the present Lord Daventry. In 1951 the George Eliot garden was constructed in Nuneaton, and Mrs Fitzroy Newdigate gave the memorial to the garden where it was resited. There are currently plans for the area around the memorial to be refurbished and repaved. The lettering will also be recut.

*King Edward VI College*

### Statue to King Edward VI
### Architect: Clapton Rolfe

Executed: 1878
Sandstone 1.7cm high × 80cm wide approx
Figure: 1.1m high approx
Condition: fair
Status: Grade II
Owner/Custodian: King Edward VI College

This full-length standing figure is set high up against the wall. It represents a youthful male in a doublet embroidered with fleurs-de-lys, breeches and a cloak, wearing a chain of office around his shoulders. He has a cap with a feather in it and holds a dagger in his right hand. The statue stands on a projecting platform supported by a slender clustered column with a canopy above. It conveys an impression of royal dignity combined with vulnerability through the sculptor's choice of facial expression and gesture. The rich naturalistic detailing of the face and cloth and the Gothicising features of the canopy are in the style of the Pre-Raphaelites. It was probably erected when the school was built in 1880, although the identity of the sculptor remains unknown.[1]

Note
[1] Letter from D.J. Paterson, Head of History, 10 February 2000.

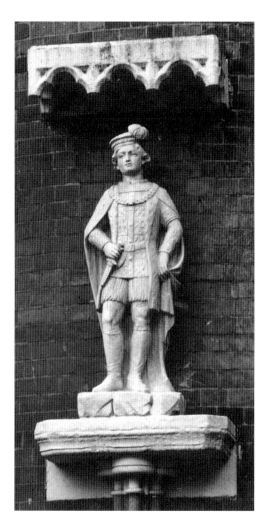

Rolfe, *King Edward VI*

## Market Place

### *Ornamental Façade of Barclays Bank*

**Builder: Stanley's Brickworks of Nuneaton (attributed to)**

**Architect: Wood and Kendrick**

Executed: 1896
Buff terracotta, semi-circular bays 1.5m
    diameter approx
Inscription: (above entrance): AD / 1896
Condition: good
Status: Grade II
Commissioned by: Birmingham, Dudley and
    District Banking Company
Owner/Custodian: Barclays Bank Plc

There are a number of bays to the windows on the first floor, three on the Coventry Street façade, three on the Market Place façade and one over the entrance, heavily ornamented with

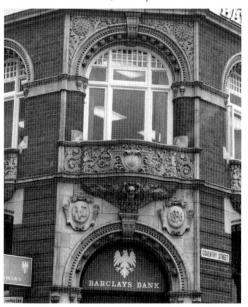

Wood and Kendrick, *Ornamental Façade*

flowers and foliage scrolls, blank shields, and S-shaped curves. Each bay is supported by an unclassical cherubic caryatid. Stylistically, the overall impression is eclectic, with neo-Baroque design being combined with neo-Renaissance floral detailing.

The history of this branch can be traced back to 27 July 1863 when the Midland Banking Company opened a branch in premises leased from Iliffe. In 1881 the Midland Banking Company was taken over by the Birmingham, Dudley and District Banking Company, which under its new name of the United Counties Bank was taken over by Barclays in 1916. In March 1895 the Directors of the Birmingham, Dudley and District Banking Company purchased the site adjoining their leased premises and approved plans for rebuilding the branch. An original plan marked 'May 1894 Wood and Kendrick architects, West Bromwich' survives in the Barclays Group Archives.[1]

Note
[1] Letter from Mrs Jessie Campbell, Senior Archivist, Barclays Group Archives, 29 February 2000.

### *Market Place Cascade*

**Designer: Rawstorne Associates**

Executed: 1985
Fountain: concrete or stone 7m diameter
    approx
Condition: good
Status: not listed
Commissioned by: Nuneaton and Bedworth
    District Council
Owner/Custodian: Nuneaton and Bedworth
    District Council

This fountain is formed from four large abstracted flower-like shapes, each of which is a bipartite basin. The unobtrusive design organically relates to the surrounding space and buildings both in form and colour. This water

**Rawsthorne Associates,** *Market Place Cascade*

feature formed part of a scheme that won the *Coventry Evening Telegraph* Design Award in 1985.[1]

Note
[1] *Coventry Evening Telegraph*, 10 June 1986.

## Newdegate Square
*Junction with Harefield Street*

### Statue to George Eliot
### Sculptor: John Barry Letts

Unveiled: Saturday, 22 March 1986
Statue: bronze 1.3m high × 1.2m wide × 1.2m deep
Plinth: brick 1.2m high × 1.2m wide × 1.2m deep
Signature: in base of bronze: John Letts / 1985
Inscriptions: (on front face of plinth): GEORGE ELIOT / 1819–1880 / BORN AT ARBURY, NUNEATON / UNVEILED BY / JOHNATHAN G. OUVRY / PRESIDENT OF THE GEORGE ELIOT FELLOWSHIP / GREAT GREAT GRANDSON OF G.H. LEWES / MARCH 22nd 1986 / ERECTED BY PUBLIC SUBSCRIPTION
(on left side of plinth): THE MAJOR WORKS OF GEORGE ELIOT / 1857–8 SCENES OF CLERICAL LIFE / 1859 ADAM BEDE / 1860 THE MILL ON THE FLOSS / 1861 SILAS MARNER / 1862–3 ROMOLA / 1866 FELIX HOLT / 1871–2 MIDDLEMARCH / 1876 DANIEL DERONDA

(on right side of plinth): MARY ANN EVANS (GEORGE ELIOT) / NOVELIST, ESSAYIST, JOURNALIST AND POET / LIVED AT GRIFF HOUSE UNTIL 1840 WHEN SHE / MOVED TO COVENTRY AND LATER TO LONDON / FROM 1854 TO 1878 SHE LIVED WITH G.H. LEWES / WHO ENCOURAGED HER TO WRITE FICTION. HER / NOVELS BROUGHT HER WORLD WIDE FAME. / IN MAY 1880 SHE MARRIED J.W. CROSS AND DIED / IN DECEMBER AT 4, CHEYNE WALK, CHELSEA / SHE IS BURIED IN HIGHGATE CEMETERY, LONDON
Condition: good
Status: not listed
Commissioned by: Nuneaton and Bedworth District Council / public subscription
Owner/Custodian: Nuneaton and Bedworth District Council

The statue depicts George Eliot in contemporary dress, seated on a low wall, with one arm on her knee, her face lowered to look at the viewer. She is shown as she was in real life, a plain woman with large features, and appears self-contained and deep in thought. The mood of the piece is very different from that of the *George Eliot Obelisk* in King Edward Road. It conveys a sense of gentleness and compassion rather than suggesting her strength of character and independence of mind. For details of George Eliot's life, see *George Eliot Obelisk*, King Edward Road.

This statue was unveiled by Mr Jonathon G. Ouvry. A time capsule was placed beneath it, containing the list of subscribers to the statue appeal, a biography of George Eliot by Kathleen Adams, the Fellowship secretary, photographs of the sculptor, a copy of the local paper *The Evening Tribune* from 17 March 1986, which contains an article on the statue, and a George Eliot postcard.[1]

A copy of this work was donated by the artist and erected in College Street alongside the main entrance to the George Eliot Hospital, in 1996.

Note
[1] *Evening Tribune*, 17 March 1986.

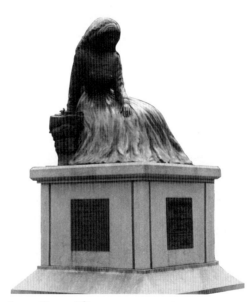

**Letts,** *George Eliot*

## WESTON-IN-ARDEN

## Weston Lane
*Weston Hall Hotel, on porch*

### Weston Hall Porch

Executed: 1893
Sandstone 2.2m high from above door × 2m wide approx
Inscription: AD 1893 / FA / EN / FOYALL … LOYALL [some of the inscription is illegible]
Condition: poor
Status: Grade II
Owner/Custodian: Weston Hall Hotel

The moulded cornice hood porch on this listed building features rich Jacobean ornamental

Unknown, *Weston Hall Porch*

strapwork patterns, two fleurs-de-lys motifs and a shield in the cartouche. There is a larger fleur-de-lys motif within an oval surround in the pediment, flanked by scroll-like curves. To each side of these are ball finials. Immediately above the main entrance is a relief panel containing decorative motifs. The date 1893 appears on a shield within the central cartouche, which is a smaller version of the one above. The inscription appears in a horizontal band beneath this relief panel. On each side of the door are two weathered pilasters with Ionic capitals.[1]

Weston Hall was originally built as the manor house for the De Zouche family in 1580.

Note
[1] Ministry of Housing and Local Government, *Provisional List of Buildings of Architectural or Historic Interest*, *Warwickshire*, Revised List (November 1959), 2/5, p. 1.

# Rugby District

*Friars Close*

*Binley Woods County Primary School*

## Alice in Wonderland

**Sculptor: Walter Ritchie**

**Architect: Geoffrey Barnsley**

Executed: 1956
Portland stone 2.13m long
Condition: fair
Status: not listed
Commissioned by: Warwickshire County
    Council
Owner/Custodian: Binley Woods County
    Primary School

This ovoid sculpture has relief carving on both sides. It is standing on a short and narrow pillar-like base, giving the overall impression of a slim modern television with an unusually-shaped screen. On the side facing away from the school the rim is formed by waves of a young woman's hair. Her head is depicted in profile on the right, and she appears to be sleeping. Another young girl is shown in profile running across the relief, her ponytail blending with the hair of the sleeping figure. At the left of the relief, the focus of the running figure's pursuit is a rabbit wearing a jacket and carrying a pocket watch, about to disappear through a hole, the surrounding to which has been painted with a dark colour to emphasise the recession. The reverse face also contains this pierced element. On the left of the relief a male figure wearing a large hat with a price ticket on it sits on a chair and holds a tea cup. A row of men kneels before the figure of a queen in a

billowing cloak who holds a flamingo, and next to her stands a knight. The figures bear the coloured symbols for suits within a deck of cards: the Queen has hearts along the hem of her skirt, the knight has clubs on his armour and the kneeling figures wear diamonds. The depiction of the figures in profile encourages a sequential and narrative reading of the subject matter.

The theme of the sculpture was inspired by the children's novel *Alice in Wonderland* by Lewis Carroll. On one side is depicted the 'real world' with Alice about to chase the White Rabbit down the hole, on the other are the Mad Hatter and Queen of Hearts, characters from her experiences in the fantasy world of Wonderland. The sleeping figure depicted in the 'reality' panel suggests that both scenes are in

Ritchie, *Alice in Wonderland*

the girl's dream and thus works of her imagination.[1]

Ritchie was given a free choice in the subject matter for this school commission. He had originally intended to have the story of Robinson Crusoe as his subject, but he decided to change it to the Lewis Carroll theme during friendly negotiations with the Education Committee.[2]

Notes
[1] Ritchie, W., *Walter Ritchie: Sculpture*, Kenilworth, 1994, pp.16–17. [2] Information provided by the sculptor's estate, Sally Taylor, 8 March 2000.

*Coventry Road*

*Coombe Abbey Country Park*

## Children Playing with Monkey (detail)

**Sculptor: John Wakefield**

Executed: 1997
Wood, life-size
Condition: good
Status: not listed
Commissioned by: Coventry City Council
Owner/Custodian: Coventry City Council

Seated high up amongst the branches of a dead tree is the carved figure of a young boy who appears to be holding a banana-shaped object. He is wearing a flat cap, a jacket, and trousers tucked into Wellington boots. The monkey is seated on another branch of the tree. The juxtaposition of the human and the animal reminds the viewer of the play that is common to both. This work is currently being repaired

Wakefield, John, *Children Playing with Monkey* (detail)

and at the time of photographing and writing only one of the figures was *in situ*.

This is one of a number of sculptures commissioned for Coombe Abbey Country Park during the late 1990s. Coombe Abbey has been a countryside park since 1970, and is owned and maintained by Coventry City Council despite being situated in Warwickshire. The 280–acre park contains woodlands and a lake as well as a children's adventure playground and a Visitor Centre opened in 1993. The Abbey itself, originally founded by Cistercian monks in 1150, is now a hotel. Appropriated by Henry VIII at the time of the dissolution of the monasteries in 1538, it was the girlhood home of King James I's daughter, Princess Elizabeth, who later became the

Electress Palatine, Queen of Bohemia and the direct ancestor of Queen Elizabeth II. The Craven family purchased Coombe Abbey in 1622 and were responsible for rebuilding a considerable portion of the house in the late seventeenth century. They lived at Coombe until 1923, when the house and grounds were bought by John Gray, a builder who used the land for cattle breeding. After his death in 1963, Coventry City Council purchased Coombe Abbey and its estate from his heirs. They initiated a ranger service in 1981 and have since developed natural history displays.[1] Many of the sculptures are intended to complement the wild life of the area.

Note
[1] Information provided by Coombe Abbey Country Park, letter dated 24 January 2000.

## *Cistercian Monk*
## Sculptor: John Wakefield

Executed: 1996
Statue: wood 2.7m high
Condition: good
Status: not listed
Commissioned by: Coventry City Council
Owner/Custodian: Coventry City Council

This piece is carved from the stump of a living redwood tree. The figure stands on a 3-metre section of tree with its bark left on, as if it were a plinth. Dressed as a monk, his hands are clasped in prayer and a crucifix hangs from his belt. The tree grows on an incline and thus the figure dominates and towers above the viewer below. John Wakefield's approach to the human figure and his concept and carving of wood, thoroughly exploring its organic qualities, is reminiscent of the art of the German expressionist sculptor, Barlach. This sculpture is appropriate to its site because Coombe Abbey was founded by Cistercian monks during the twelfth century.

Wakefield, John, *Cistercian Monk*

For further background information about Coombe Abbey Country Park, see the entry for *Children Playing with a Monkey*.

## *Owl*
### Sculptor: Katie-Jane Wakefield

Executed: 1997
Wood 80cm high approx

Wakefield, Katie-Jane, *Owl*

Signature: (carved into back, lower tail feathers): KW
Condition: good
Status: not listed
Commissioned by: Coventry City Council
Owner/Custodian: Coventry City Council

This work, depicting a large owl sitting on a tree stump, was carved from the stump of a living tree.

For further background information about Coombe Abbey Country Park, see the entry for *Children Playing with a Monkey*.

## *Sparrowhawk, Badger and Woodcock*
### Sculptor: John Wakefield

Executed: 1997
Wood 4m high approx
Signature: (carved into badger): JW (monogram)
Condition: fair
Status: not listed
Commissioned by: Coventry City Council
Owner/Custodian: Coventry City Council

The sparrowhawk is carved at the top of the trunk with the badger and woodcock further down the stump of a living sycamore tree. The work was seen as a way of preserving the tree. It has been reported that the City Leisure Services plan to transform other trees in the park into sculptures as they die naturally, thus creating a sculpture trail.[1]

For further background information about Coombe Abbey Country Park, see the entry for *Children Playing with a Monkey*.

Note
[1] *Coventry Evening Telegraph*, 15 August 1997.

**(top right) Wakefield, John, *Sparrowhawk***

**(bottom right) Wakefield, John, *Woodcock***

*Visitor Centre, Coombe Abbey Country Park*

## Heron Flying
### Sculptor: John Wakefield

Executed: 1999
Wood 2m wingspan approx
Condition: good
Status: not listed
Commissioned by: Coventry City Council
Owner/Custodian: Coventry City Council

**Wakefield, John,** *Heron Flying*

This carving of the heron in flight, with outstretched wings and neck, has been suspended from the roof of the Visitor Centre at Coombe Abbey Country Park.

For further background information about Coombe Abbey Country Park, see the entry for *Children Playing with a Monkey.*

*Coombe Abbey Lake*

## Fisherman and Nymph
### Sculptor: Percy George Bentham

Installed: 1968
Bronze 1.75m high
Inscription: (on plaque at side of pond):
FISHERMAN AND NYMPH/BY/P.G. BENTHAM A.R.B.S./PRESENTED TO THE CITY/BY THE/COVENTRY BOY FOUNDATION/1968
Condition: fair
Status: not listed
Commissioned by: Coventry Boy Foundation
Owner/Custodian: Coventry City Council

A fisherman seated on a rock clasps the naked figure of a water nymph. It is an appropriate theme for the lakeside setting and is a competent academic piece of sculpture, which was originally made in plaster and exhibited at the Royal Academy in 1922 when Percy Bentham was seeking membership of the Academy. It was later exhibited by the British Council in several cities in Europe. Percy Bentham died in 1936 and the plaster figures passed into the possession of his son Philip, also

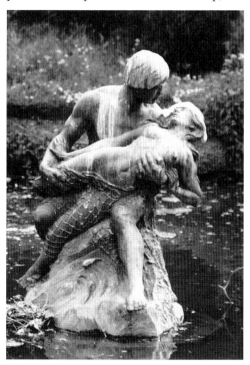

**Bentham,** *Fisherman and Nymph*

a sculptor. Alfred Harris of the Coventry Boy Foundation saw the figures at Bentham's studio during discussions about the *Coventry Boy* statue. The Foundation decided to have the *Fisherman and Nymph* cast in bronze and presented it to the city.[1]

For further background information about Coombe Abbey Country Park, see the entry for *Children Playing with a Monkey.*

Note
[1] Herbert Art Gallery and Museum/City of Coventry Libraries, Arts and Museums Department, *A Survey of Public Art in Coventry,* 1980, p.83.

## DUNCHURCH

*London Road*

*The Square*

## Lord John Douglas Memorial
### Sculptor: Joseph Durham

Executed: after 1860
Statue: limestone 2m high approx
Plinth: limestone 2m high approx
Inscription: on pedestal, incised lettering: RT. HON / LORD JOHN / DOUGLAS / SCOTT / BORN / 18 JULY 1809 / DIED 3 JAN 1860 / THIS STATUE WAS ERECTED BY HIS TENANTS IN AFFECTIONATE REMEMBRANCE OF HIM.
Condition: poor
Status: Grade II
Commissioned by: Lord Douglas's tenants

This full-length, life-size figure on a plain, corniced pedestal is standing with his right hand on his hip and holding a hat at his side with his left hand. A cloak or blanket is draped over his right arm. The statue shows Lord John Douglas Montagu Douglas Scott of the Duke of Buccleuch's family, who were wealthy and influential local landowners.[1]

This statue is dressed up each Christmas as a

**Durham,** *Lord John Douglas Memorial*

*In front of Dun Cow Hotel, at The Square*

### Milestone Obelisk with Duke of Buccleuch's Crest
### Sculptor: Unknown
### Restorer: Walter Ritchie

Erected: 1813 (restored 1953)
Sandstone Ashlar 5m high
Inscriptions: on north face: To LONDON / 79
    MILES / TO / HOLYHEAD /178 MILES
on east face: To / OXFORD / 43 MILES / To /
    LEICESTER 23 MILES
on south face: Erected / ANNO DOMINI / 1813
on west face: Restored / CORONATION YEAR /
    1953
Condition: fair
Status: Grade II

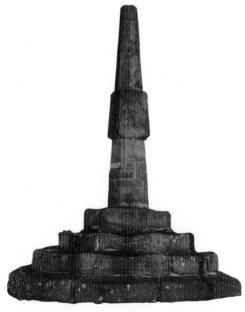

**Unknown,** *Milestone Obelisk*

This was originally the site of a wayside cross destroyed during the Reformation. Only a tapered shaft has survived, now bearing an inscription stating that it was restored and erected as a milestone in 1813[1]. The four octagonal steps with a short circular stump resting on them probably belong to the original cross. The stump is surmounted by a tapering stone, which forms a little over a third of its height and continues into a chamfered shaft forming an obelisk.

The milestone was further restored in 1953[2] by Walter Ritchie who recut the lettering and added the crest of the Duke of Buccleuch.

Notes
[1] *Birmingham Post*, 29 August 1953. [2] Sites and Monument Record, WA4114.

## RUGBY

*Abbots Way*

*Abbots Farm County Infant School*

### Five Cows and a Team of Horses
### Sculptor: Walter Ritchie

Executed: 1961
Metal sheet, painted, 7m high
Condition: good
Status: not listed
Commissioned by: Warwickshire County
    Council
Owner/Custodian: Abbots Farm County
    Infant School

This metal weather vane sculpture, with a fairytale humorous quality, consists of an ornate pole and two figurative groups in basically two dimensions. The shape of the triangular wedge and the stance of the horses give a sense of forward motion to the lower group. The five horned cattle in the upper group face in the opposite direction,

famous character or person. Past transformations include Bart Simpson and Father Christmas.

Note
[1] Rugby Borough Council, *Monuments, Public Sculptures and Public Arts Record*, Record No. 20.

Source
Darke, J., *The Monument Guide to England and Wales*, London, 1991.

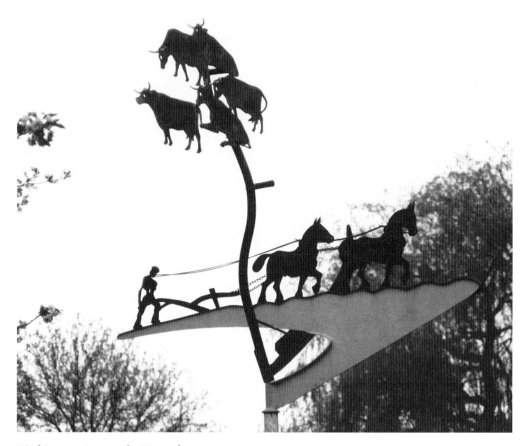

**Ritchie, *Five Cows and a Team of Horses***

strengthening the contrast of mood between the two groups of animals. The horses are alert and the cows relaxed and placid, dominating the small figure of the man, and thereby suggesting the power of nature. This feeling is intensified by the sculpture's location in an area of well-established trees, and by the way in which it towers over the head of the viewer. The subject is particularly suitable for its site close to a modern flat-roofed primary school in an originally rural area which had become increasingly urbanised by the 1960s.

*Anderson Avenue*

*Rokeby County Infant School, outside main entrance*

### *Shooting Star*
### Sculptor: Walter Ritchie
### Architect: Charles Elkins

Executed: 1953
Sculpture: Burma teak 1m high × 1.5m wide
    approx
Support: reinforced concrete 3m high approx
Condition: fair

Status: not listed
Commissioned by: Warwickshire County
    Council
Owner/Custodian: Rokeby County Infant
    School

There is a strong sense of forward motion in this sculpture at the top of a tall square shaft. The figure stands on a stylised cloud and moon formation, thrusting out an elongated right arm and hand (with especially stretched fingers) to reach out towards the small gold-coloured star. The left arm holds a long pole with which the figure again attempts to touch the star.

   Whilst there is no record of why this

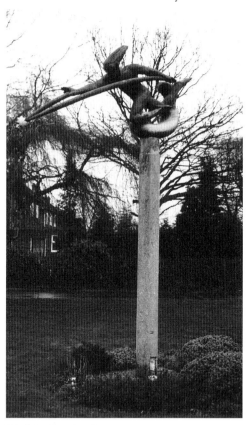

**Ritchie, *Shooting Star***

particular subject was chosen, one possible interpretation is that it depicts the way in which education aims to encourage the pupils at the school to reach out towards new horizons of knowledge. It is one of the most successful examples of the sculptor's interest in the mystical associations of celestial bodies and astronomical phenomena and the interpretation of this for the younger generation.

Source
Ritchie, W., *Walter Ritchie: Sculpture*, Kenilworth, 1994.

## Bawnmore Road

*Grounds of Bawnmore Secondary School*

### Polar Bear

### Architect: Eric Davies

### Sculptor: John Skeaping

Executed: *c*.1958
Concrete 2m long × 1m high approx
Condition: fair
Status: not listed
Owner/Custodian: Bawnmore Secondary
  School

This massive figure of a polar bear on all fours is built up in bold simplified forms. Interpreted as an embodiment of solidity, it is represented in a bare monumental style in which the form is reduced to its essential elements.

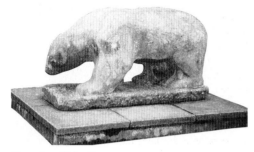

**Skeaping, *Polar Bear***

**Foster, *Abstract Relief***

## Church Street

*On the façade of HSBC building*

### Abstract Relief (Untitled)

### Sculptor: Don Foster

Executed: late 1960s
Concrete 1m high × 2m wide approx
Condition: fair
Status: not listed
Commissioned by: Midland Bank
Owner/Custodian: HSBC

The design of this large abstract panel on the side of the building is composed of rounded forms that are almost mechanical in aspect. It was intended to symbolise the relationship between banking and the local community. The bank commissioned the panel from Don Foster, then working at Coventry College of Art. According to the terms of the commission, 'The low relief of the panel forms an undefined but permanent landscape in which the illusion of movement and change is created by variations of light and perspective. A landscape embracing work and people, where agriculture, commerce, industry and transport are represented by the forms and imprints of the wheel and people by the word "TRAPEDZA" from the ancient Greek meaning "money and exchanging bills".'[1]

Note
[1] Letter from Gary Smith, Branch Manager, 20 January 2000.

## Clifton Road

*On the façade of Lawrence Sheriff School*

### Statue to Lawrence Sheriff and Shields

### Sculptor: unknown

Executed: *c*.1878
Stone, life-size
Condition: fair

Status: Grade II
Commissioned by: Lawrence Sheriff School
Owner/Custodian: Lawrence Sheriff School

The large canopied niche contains a life-size figure of Sheriff in the livery of the Worshipful Company of Grocers, of which he was a member, with three shields below. In the middle are the arms of Sheriff, granted by Elizabeth I in 1558, which include three griffin heads and, in a central band, a fleur-de-lys flanked by two roses. On the left are the arms of Henry Philpott, Bishop of Worcester 1861–90, and to the right are the arms of William, 2nd Lord Leigh of Stoneleigh. Philpott and Leigh were governors of the school when the new buildings were opened.

Rugby School was founded in 1567 as 'a free grammar schoole' for the boys of Rugby and Brownsover, in accordance with instructions attached to the will of Lawrence Sheriff. He left his 'Mansion House' in the centre of the town as a residence for a Master, £50 to build a school alongside, and as endowment, the rents of the Parsonage of Brownsover and eight acres of a field known as Conduit Close, in the County of Middlesex.[1]

As the school's reputation grew, and the proportion of pupils from outside Rugby increased, the local people seemed to benefit less and concern was raised. This led to the founding of a Lower School for local boys in 1878 with Foundation Scholarships to the main Rugby School.

The shields and the statue were *in situ* at the opening of the school in 1878, although the architect's and sculptor's names have not been recorded. Inside the school there is a wood carving of St George and the Dragon and a bronze reproduction from H.W. Gilbert's workshop of figures representing the Education of Achilles. The latter is a memorial to H.V. Whitehouse (1856–1935), Headmaster of Rugby School from 1890 to 1904. The works of art

**Unknown,** *Lawrence Sheriff and Shields*

inside the school are only accessible by appointment.[2]

Notes
[1] Wells, L. V. & Russell, A., *Lawrence Sheriff School 1878–1978*, Rugby, 1978, pp.75–6. [2] *Ibid.*, p.86.

## *Dunchurch Road*
See also *Rugby School*

*St Marie's RC School, on school buildings*

### *Statue to the Virgin and Child*
### **Sculptor: unknown**

Executed: *c.*1938
Limestone / blue York stone 0.6m high approx
Condition: poor
Status: not listed
Owner/Custodian: St Marie's RC School

In this traditional religious image, the Virgin stands within a canopied niche between two sets of windows. She holds the Christ Child in the crook of her left hand, while her right hand holds up her robe. The crown upon her head indicates that she is not only the mother of Christ, but also the Queen of Heaven. Her head is turned towards the Christ Child, thereby conveying a sense of both her humility and her compassion. Christ touches his mother with his right hand, but turns towards the viewer in a way that suggests that he is mindful of his future role as the Saviour of mankind.

## *High Street*
*Above entrance to Boots PLC*

### *Pharmaceutical Still Life*
### **Sculptor: unknown**

Executed: *c.*1930s
Stone 60cm high × 1m wide approx
Condition: good
Status: not listed
Commissioned by: Boots
Owner/Custodian: Boots

This rectangular stone panel set on the façade is carved with deep incisions delineating a pestle and mortar and other pharmaceutical paraphernalia. Still life is very unusual in

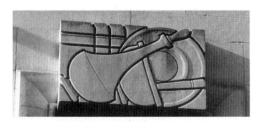

Unknown, *Pharmaceutical Still Life*

sculpture, and this can therefore be seen as contributing to the development of the genre.

The Boots store first opened in Rugby in 1897,[1] but stylistically it is unlikely that the panel dates from this period. The maker is not known.

Note
[1] Letter from Anita Logue, Boots Company Archives, 20 March 2000.

## Leicester Road

*Beside Oxford Canal, at junction with Brownsover arm*

### Bulrushes

#### Sculptors: Gill Brewster and Lee Brewster

Unveiled: 21 February 2000
Oak 3.5m high approx
Condition: good
Status: not listed
Commissioned by: British Waterways
Owner/Custodian: British Waterways

This is one of the most artistically successful works of public sculpture erected in recent years on the Oxford Canal. It consists of two parts, divided by the water of the canal: a monumental clump of otherwise realistically represented upright bulrushes carved from an old piece of oak, complemented by a sturdy wooden bench on the opposite bank, the seat of

which has been carved with a bulrush motif. The two sides are connected by a nearby footbridge.

This bold simplified design is entirely appropriate to its canalside setting in the midst of bulrushes and other coarse rush-like water plants. The sculpture combines traditional sculptural principles with twentieth-century avant-garde practices. It shows a harmonious interaction with the surrounding physical light and space as well as an understanding of the nature and potential of hardwood and of the relationship between material and technique used. Its subject matter is figurative but not

literal, and it provides some visible clues indicating the sculptor's concern with the individual contemplating act of the viewer.

The design was created by the artists working with local school children. The work was unveiled at the launch of a regeneration scheme for the Oxford Canal at Rugby, the Rugby Konver II scheme, which has been managed and part-funded by British Waterways with additional funding from Rugby Borough Council and the European Regional Development Fund.[1]

Note
[1] *Rugby Advertiser*, 24 February 2000.

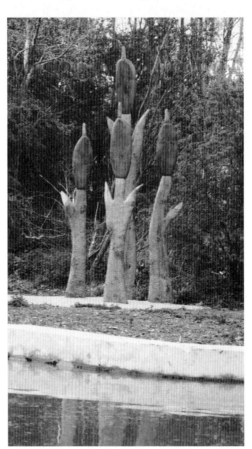

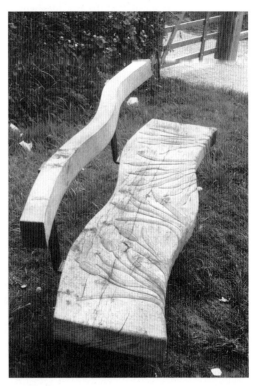

(left) Brewster, *Bulrushes*

(above) Brewster, *Seat*

## Magnet Lane

*Bilton Primary School*

### *Boy with Horses*

### Sculptor: Walter Ritchie

Executed: *c.*1938
Brick 6m high × 6.7m wide approx
Condition: good
Status: not listed
Commissioned by: Rugby Borough Council
Owner/Custodian: Bilton Primary School

This brick sculpture, carved into the wall of the school building, shows an energetic naked youth blowing a horn as he runs. He looks behind him, as if to call to the two capering horses in the distance. The horse is a significant recurring motif in Walter Ritchie's œuvre and it usually conforms to its traditional iconographical meaning of passion or the spontaneous bestial aspects of human nature. The motif of a horse led by a youth is a frequent subject in sixteenth-century Renaissance and early twentieth-century art. It signifies passion controlled by reason.

This is the first work that Walter Ritchie

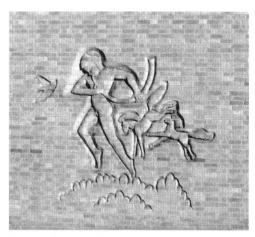

Ritchie, *Boy with Horses*

carved *in situ*. It has been claimed that the reasons for this were mainly financial as it meant there were no additional material costs. While such a utilitarian factor could have suggested this technique of carving into brick in this early work, aesthetic and sculptural considerations which have been even more influential. Carving into brick *in situ* was introduced into modern architecture by the so-called Amsterdam School, which flourished particularly between 1912 and 1922. It had a strong influence on British sculpture from the late 1920s, especially on Eric Kennington's expressionist sculpture which decorates the front of Elizabeth Scott's 1932 Shakespeare Memorial Theatre in Stratford-upon-Avon.

See the entry for *Treachery, Jollity, Life Triumphing over Death, Martial Ardour and Love*, Waterside, Stratford-upon-Avon.

## Market Mall

*Interior of Clock Towers Shopping Centre*

### *Ornamental clock*

### Designer: Farmer Studios, Leicester

Unveiled: 20 May 1995
Clock: 6m high approx
Signature: on small oval bronze plaque: FARMER
    STUDIOS LTD / 1995 / LEICESTER
Inscription: around dial, painted in Gothic
    script: More Haste, Less Speed
Condition: good
Status: not listed
Commissioned by: Healey and Baker, London
Owner/Custodian: Clock Towers Shopping
    Centre

This oversize, ornate chiming clock features a moving hare and tortoise racing around the dial on the hour and half-hour. It is loosely based on the traditional grandfather clock design

The subject matter for the clock is based on Aesop's *Fable of the Hare and the Tortoise* in

Farmer Studios, *Ornamental Clock*

which the tortoise's slow but steady perseverance enables him to beat the hare in a race. Aesop is a legendary Greek fabulist from *c.*550 BC, and the fables attributed to him are in all probability a compilation of tales from many sources. The stories were popularised by the Roman poet Phaedrus in the first century AD, and rewritten in sophisticated verse by La Fontaine in 1668. Most were translated into English by Rev. George Fyler Townsend (1814–1900) and Ambrose Bierce (1842–1914).

There was originally a companion piece to

this clock, a 'train' clock, which was removed in 1997/98 to make room for more shops.[1]

Note
[1] Rugby Borough Council, *Monuments, Public Sculptures and Public Arts Record*, Record No. 000012.

## Market Place
*Junction with North Street*

### The Clock Tower
**Architect: Goodacre**

**Clock designer: Evans and Sons, Soho Clock Factory**

**Builder: J Parnell & Sons of Rugby**

Unveiled: noon, Wednesday 30 January 1889
Tower: Darley Dale stone 17m high approx
Tower infill: Northampton ironstone
Base: grey Aberdeen granite
Inscription: on inlaid marble stone: ERECTED / BY THE / TOWN AND NEIGHBOURHOOD OF RUGBY / TO COMMEMORATE THE FIFTIETH ANNIVERSARY OF / QUEEN VICTORIA'S REIGN
Condition: good
Status: Grade II
Commissioned by: Public Committee for Queen Victoria's Golden Jubilee
Owner/Custodian: Rugby District Council

This impressive square-shaped tower is in the very centre of the town. Its base is made of white grit, with sandstone above, and it is topped by an octagonal cupola with a weathervane. The clock house is in *Tempietto*, featuring Doric pilasters, a frieze with triglyphs and floral metopes, and a triangular pediment over the entablature.

Mr Goodacre, architect of Leicester, won the bid for this clock tower after a competition organised by the Town Council in 1888. The total cost of the project was £500,[1] but the clock face was donated by a Mr Anthony Benn, after

Goodacre, *Clocktower*

the committee's funds had become seriously depleted. It was originally lit by gas. According to local tradition, supported by photographic evidence, the clock was dressed up on important national and local occasions.

Note
[1] Rugby Borough Council, *Monuments, Public Sculptures and Public Arts Record*, Record No. 000001.

## North Street
*On the façade of public toilets*

### Rugby's Industrial Heritage
**Sculptor: John McKenna, Art for Architecture**

Installed: February 2000
Brick 1.1m high × 5m wide
Condition: good
Status: not listed
Commissioned by: Rugby District Council
Owner/Custodian: Rugby District Council

What at first impression appears to be a wide frieze showing important episodes in the town's history is in fact a continuous narrative of historic events in a single unified shallow pictorial space. Its central motif is a piece of machinery with a steam engine and cooling towers on the left and a canal barge and bridge with radio masts on the right. The industrial towers on the left represent cement works, one of Rugby's major industries. The train refers to the railway history of the town where a locomotive testing station and several railway firms were based. The machine in the centre is a Williams steam turbine generator, built around the turn of the nineteenth century. The canal barge on the right is emerging from bridge Number 9 on the Oxford Canal, which was built round the town in 1773. The aeroplanes above are Gloster Meteor jets, and commemorate the designer of the jet engine

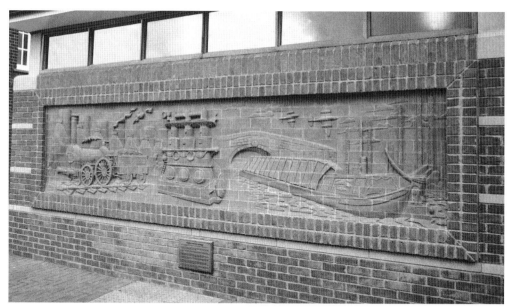

Frank Whittle making his first prototypes at the British Thomson Houston factory in Rugby. The radio masts in the background are those south of Rugby, near Daventry, which played a major role in the BBC's worldwide broadcasting service during the Second World War. The frieze was first modelled in clay and then fired in the brick kilns at Art for Architecture's studios. The artists claimed that: 'we have designed the work with great sculptural detail to create a complex relief surface'.[1]

When in 1999 Rugby Town Council decided to rebuild the public toilets at the North Street entrance to a public car park, they commissioned John McKenna from Art for Architecture to design and install a long rectangular sculptural relief facing North Street. Before the installation, a temporary painting of the design was *in situ* on the building to solicit and test public response.

Notes
[1] *Art for Architecture*, www.a4a.clara.net/rugby.htm

McKenna, *Rugby's Industrial Heritage*

Jones, *Rupert Brooke*

*Regent Street*

*In garden at junction with Regent Place*

## Statue to Rupert Brooke (1887–1915)

### Sculptor: Ivor Robert Jones

Unveiled: 3 September 1988
Statue: bronze 2m high approx
Base: Portland stone 1m high × 1m wide × 1m deep approx
Inscription: inscribed in black on base: RUPERT BROOKE / 1887 – 1915 / IF I SHOULD DIE THINK ONLY THIS OF ME / THAT THERE IS SOME CORNER OF A FOREIGN FIELD / THAT IS FOREVER ENGLAND
Signature: in polygonal base to bronze: IVOR ROBERT JONES C.B.E., R.A.

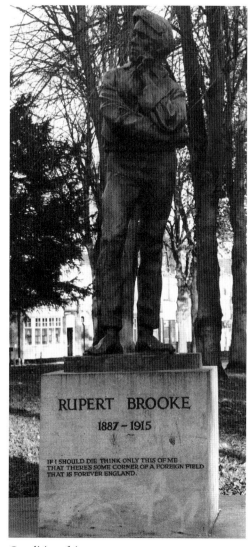

Condition: fair
Status: not listed
Commissioned by: Rupert Brooke Centenary Association
Owner/Custodian: Rugby District Council.

This full-length life-size bronze figure of the poet, Rupert Brooke, is shown standing on a

cuboid base in a pensive pose, with his right arm folded across his chest and the left raised to his cheek. He is casually dressed and shoeless, to demonstrate his 'back-to-nature' ideas and his hatred of shoes. The modelling of the figure seems quite spontaneous and shows a sensitive treatment and surface effects.

Rupert Brooke (1887–1915) was born in Rugby. He was a pupil at Rugby School, and a student at King's College, Cambridge. He travelled in Germany, the USA and Tahiti. During the war he was posted to the Dardanelles, but died of blood poisoning on the way. He was buried on Scyros. His war poetry was published posthumously in 1915. The five *War Sonnets* included *The Soldier*, from which the inscription is taken. His handsome appearance and untimely death made him a favourite poet among young people in the interwar period.[1]

The Rupert Brooke Centenary Association was founded in June 1985 with three aims, firstly the commissioning of a statue of Brooke, secondly the establishment of an annual school prize in Rugby and thirdly a series of events for the centenary year. The statue, which cost £7,000,[2] was funded by public subscription and unveiled by Mary and Jeffrey Archer.

Notes
[1] A & E Television Networks, Biography.com, www.biography.com [2] *Rugby Advertiser*, 9 and 11 August 1988.

## *Rugby School*

*In Barby Road, at entrance to The Close*

### *Armorial Bearing (Queen's Gates)*
### Designer: Keith Kellet
### Metal workers: George Lister & Son, and Henshaw & Son

Unveiled: 12 May 1967
Gates: wrought iron 5.5m high × 6m wide

Plaques: bronze 30cm high × 25cm wide approx
Inscriptions: on gates: ORANDO LABORANDO
    on left hand plaque: RUGBY SCHOOL / THIS GATEWAY / WAS GIVEN BY / OLD RUGBEIANS / TO COMMEMORATE / THE 400TH ANNIVERSARY / OF THE FOUNDATION OF / THE SCHOOL / 1567–1967
    on right hand plaque: RUGBY SCHOOL / THIS GATEWAY / WAS OPENED ON / 12TH MAY 1967 /
Condition: good
Status: not listed
Commissioned by: Old Rugbeians (Rugby School Old Boys)
Owner/Custodian: Rugby School

Rugby School's armorial bearing is sited above the wrought iron gates. Coloured in light blue and grey, it is flanked by scrolled designs also in wrought iron. Similar scroll-like designs appear at the edges of the gates, next to the brick piers. On a blue shield is a horizontal golden bar with scalloped edges between three griffins' heads torn off with jagged edges. On the horizontal gold bar is a blue fleurs-de-lys between two red roses with sepals and stamens. The shield has a gold border. Above the shield is an Esquire's

**Kellet, *Queen's Gates***

helmet, with a wreath in gold and blue, a band of twisted silk that held in place the mantling, the conventional representation of the cloth with which a knight covered the back of his helmet and body-armour to prevent its becoming overheated by the sun. Above the wreath is the crest, a lion's paw, torn off like the griffins' heads, with two roses upon it similar to those in the shield, and holding a branch of dates with golden fruit in silver pods and green stalk and leaves. The motto, *Orando Laborando*, may be translated as 'By prayer and work'. The Arms are identical to those of Lawrence Sheriff except for the golden border and the roses on the lion's paw. The griffins hint at the dragon-guarded treasures of the East. The dates symbolise the Founder's 'spicery', and the Tudor roses and fleur-de-lys indicate that he supplied spices to Queen Elizabeth I. These arms can also be seen on the *Temple Speech Rooms Plaque and Coat of Arms*, Barby Road.

The gates were unveiled by Queen Elizabeth II and unlocked with a silver key. They were designed by architect Keith Kellet and made by George Lister & Son of Cambridge at a total cost of £3,500. The bronze dedication plaques were made by Henshaw & Son (Edinburgh).[1]

See also entries for *Statue to Thomas Hughes*, Barby Road, *William Webb Ellis*, Dunchurch Road, and *Gargoyles and Shields*, Lawrence Sheriff Street.

Note
[1] Rugby Borough Council, *Monuments, Public Sculptures and Public Arts Record*, Record No. 000004.

*In Barby Road, on lawn in front of school library and opposite The Close*

### *Statue to Thomas Hughes*
### Sculptor: Thomas Brock

Unveiled: 24 June 1899
Statue: Carrara marble 2.2m high approx

Pedestal: Penrhyn granite 3m high × 1m wide × 1m deep approx
Inscription: on pedestal: THOMAS HUGHES / QC, MP. AUTHOR OF "TOM BROWN" / BORN OCT XIX, MDCCCXII / DIED MARCH XXII, MDCCCXCVI / WATCH YE / STAND FAST IN THE FAITH / QUIT YOU LIKE MEN / BE STRONG
Condition: fair
Status: Grade II
Commissioned by: Old Rugbeians (Rugby School Old Boys)
Owner/Custodian: Rugby School

Standing on a large plinth, this life-size full-length portrait figure of Thomas Hughes (1822–96) holds a pen in its right hand and a book in its left. The clothing depicted is somewhat peculiar in that the jacket has no buttons. At the figure's feet is a hat, similar in style to an American cowboy's hat, recalling his interest in promoting Anglo-American co-operation. The statue suggests a determined, somewhat pugnacious character, reflecting the subject's sporting interests as well as his abilities as a writer.

Hughes is primarily remembered as the author of *Tom Brown's School Days* (1856), based on his school experiences at Rugby under the headmastership of Arnold. He was born in Uffington, Oxfordshire, and after school went to Oxford University. He was called to the bar in 1848, and became a county court judge in 1882. His interests were varied and included boxing and cricket as well as legislation. He was a Liberal MP between 1865 and 1874 and was closely associated with the Christian Socialists. He helped to found the Working Men's College in 1854, of which he became principal (1872–83).

Judge Hughes died on 22 March 1896 and on 19 June the same year a meeting of Old Rugbeians was held in Jerusalem Chamber, Westminster. Resolutions were passed to erect 'a personal and permanent memorial'[1] at Rugby and that funds should be raised by subscription; accordingly a committee was formed. Thomas Brock, who had already executed a bronze bust of Lord Bowen for the school and, as *The Meteor* (the Rugby School magazine) put it, was 'well-known to some members of the Committee', would sculpt a life-size statue in marble 'for so small a sum as £1000'.[2] A total of £1270 6s. 11d. was raised by subscription during the next three years, with £32 4d. additional interest earned on the deposit account. Brock received £1000 and some £60 was spent on cutting the inscription, the carriage and erection of the statue; £55 was spent on administration. The balance of £187 7s. 3d. was donated to the Rugby School Missions.[3]

Although the statue was ready in 1898, it was deemed appropriate that the unveiling be on the School Speech Day, and thus it was delayed until 24 June 1899, when a number of notable Old Rugbeians attended the lavish unveiling ceremony. *The Meteor* favourably described the scene as 'a brilliant one, the tiers of seats occupied by the ladies in the vari-coloured summer costumes lending enchantment to the proceedings'.[4] The statue itself received similar praise: 'Mr Brock , the sculptor, has produced in his effigy … One of the few successful statues in present-day European costume… The pose is dignified but easy, and the face happily suggests the character of the man who, impatient of sham, yet schooled himself for charity's sake to "tolerate the intolerable" and who so combined the heart of a boy with the wisdom of a man.'[5] The statue was unveiled by the Archbishop of Canterbury, and additional eulogies to Hughes were given by the Lord Privy Seal, the First Lord of the Admiralty, the current (and a former) Headmaster of Rugby School and the Bishop of Hereford, who strangely admitted 'having somewhat of a prejudice against out-door statues in our English towns'.[6] The First Lord of the Admiralty, The Right Hon. G.J.

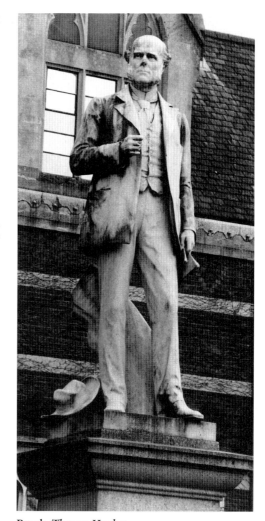

**Brock,** *Thomas Hughes*

Goschen, praised the statue thus: 'if they wanted it [Rugby School] to be represented, they should turn, not to mythological figures, not to any of those feminine statues which sometimes represent the emblematical figures of nations; if they wanted a man to represent the character of Rugby that man is Tom Hughes

and there he stands'.[7]

See also entries for *Queen's Gates*, Barby Road, *William Webb Ellis*, Dunchurch Road, and *Gargoyles and Shields*, Lawrence Sheriff Street.

Notes
[1] *The Meteor*, 24 June 1899, p.66. [2] *Ibid*. [3] *Ibid*. [4] *Ibid*, 11 July 1899, p.85. [5] *The Meteor*, 11 July 1899. [6] *Ibid*. [7] *Ibid*.

*In Dunchurch Road at junction with Lawrence Sheriff Street, outside Rugby School*

# William Webb Ellis
## Sculptor: Graham Ibbeson

Installed: September 1997
Statue: bronze 2.29m high
Plaque: bronze 18cm high × 66cm wide
Base: York stone 2m high × 1m wide × 1m deep approx
Railings: iron
Whole: 4.2m high
Inscription: on bronze plaque: THE LOCAL BOY WHO INSPIRED / THE GAME OF RUGBY FOOTBALL / ON THE CLOSE AT RUGBY SCHOOL IN / 1823. / SCULPTOR: GRAHAM IBBESON / 1997
Condition: good
Status: not listed
Commissioned by: William Webb Ellis Statue Appeal
Owner/Custodian: Rugby District Council

A young man is shown running with a ball in his left hand. The figure is realistically portrayed and conveys a strong impression of forward motion. It surmounts a plain pedestal base with a cornice which is surrounded by decorative iron railings and floral planting. The figure was cast using the lost wax technique.

The sculpture commemorates William Webb Ellis (1805–72), a British sportsman and

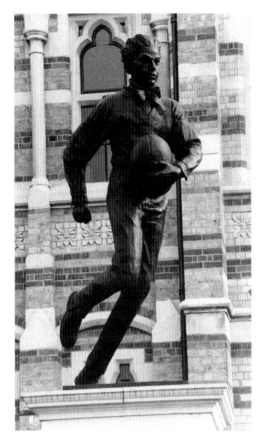

Ibbeson, *William Webb Ellis*

reputedly the inventor of rugby football. According to a rather doubtful tradition, he was a pupil at Rugby School in 1823 when he broke the rules by picking up and running with the ball during a game of association football, thus inspiring the new game of rugby.

Ibbeson was said to have modelled the statue on his own son. It was funded by a variety of local organisations in collaboration with various Rugby football associations,[1] and was unveiled by the England Rugby player, Jeremy Guscott.

An earlier stone tablet in the school also commemorates Ellis.

See also entries for *Queen's Gates*, Barby Road, *Statue to Thomas Hughes*, Barby Road, and *Gargoyles and Shields*, Lawrence Sheriff Street.

Note
[1] Rugby Borough Council, *Monuments, Public Sculptures and Public Arts Record*, Record No. 00015.

*In Lawrence Sheriff Street*

# Gargoyles and Shields
## Architect: Henry Hakewell

Executed: between 1826 and 1843
Gargoyles: stone various sizes up to 80cm high × 80cm deep
Shields: stone, some painted
Condition: poor
Status: Grade II*
Commissioned by: Rugby School
Owner/Custodian: Rugby School

On the oriel window and gabled section of the building are five richly carved ornamental shields, some of which are painted, and a number of heads and gargoyles. The central

Hakewell, *Gargoyles and Shields*

shield is surmounted by a crown, and shows three lions in the upper right and lower left quarters, and three fleurs-de-lys in the upper left and lower right quarters. This is flanked by two shields with the coat of arms of Lawrence Sheriff, whose 1567 will made provision for the founding of Rugby School.

The general impression is unequivocally Gothic with Ruskinian naturalistic detailing. This style was regarded as appropriate to the idea that secular education has monastic roots. Moreover, the Gothic style was the expression of the ethical and cultural values of the medieval burghers of Northern countries, and such historical traditions were deeply rooted among both the founders of Rugby School and their nineteenth-century successors. The school moved to its present site in the mid-eighteenth century, although much of the building dates from the first half of the nineteenth century.

See also entries for *Queen's Gates*, Barby Road, *Statue to Thomas Hughes*, Barby Road, and *William Webb Ellis*, Dunchurch Road.

## St Matthew's Street

*Junction with Lawrence Sheriff Street*

### Charles and Diana Wedding Clock

Unveiled: 29 July 1981
Tablet: stone
Clock: metal
Pole: 9.5m high approx
Clock: face 2m diameter approx
Inscriptions: on tablet set in pavement: THIS CLOCK WAS ERECTED / TO COMMEMORATE / THE WEDDING / ON 29TH JULY 1981, OF / H.R.H. THE PRINCE OF WALES / TO / LADY DIANA SPENCER / COUNCILLOR MRS DIANA TURNER / MAYOR OF RUGBY 1981–82
on clock: ICH DIEN
Condition: good
Status: not listed
Commissioned by: Rugby District Council

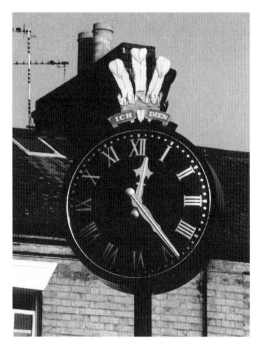

Unknown, *Charles and Diana Wedding Clock*

Owner/Custodian: Rugby District Council

This plain clock with three feathers and a motto above in gold is mounted on a thin black pole. An inscribed stone tablet is set into the pavement beside it.

It cost a total of £3,500, £1,000 of which was raised by the District Council, with the remaining £2,500 being donated by local businesses. The public reaction to this commemorative clock was mixed. Due to high unemployment at the time of its commissioning, it was regarded a waste of resources.[1]

Note
[1] Rugby Borough Council, *Monuments, Public Sculptures and Public Arts Record*, Record No. 000008.

## London Road (A45)

*In centre of roundabout at junction with Fosse Way*

### Crowned Obelisk to the XXIXth Division

**Sculptor: Robert Bridgeman & Sons of Lichfield**

Unveiled: Tuesday 24 May 1921
Portland stone 12.3m high
Inscription: (incised and coloured) (on north face of pedestal): HERE / IN THE CENTRE OF ENGLAND / WHERE TELFORD'S COACHING ROAD / FROM LONDON TO HOLYHEAD / IS CROSSED BY THE ROMAN FOSSE WAY / ON THE 12TH OF MARCH 1915 / HIS MAJESTY KING GEORGE V / REVIEWED HIS TROOPS / OF THE IMMORTAL / XXIX DIVISION / SHORTLY BEFORE THEY EMBARKED / FOR ACTIVE SERVICE / IN GALLIPOLI / IN MEMORY OF THEIR STAY IN WARWICKSHIRE / 1914–15 AND OF THEIR INCOMPARABLE SERVICES / SINCE THE AVENUE ON THIS ROAD WAS PLANTED / AND THIS MONUMENT ERECTED BY / INHABITANTS OF THIS COUNTY
around base: XXIX DIVISION/ ORDER OF BATTLE ON LEAVING ENGLAND MARCH 1915
followed by the names of the members of the division
Condition: good
Status: Grade II
Commissioned by: Dunchurch Avenue Society

The obelisk, which is topped by a cornice and a crowned urn, stands on a cornice pedestal. A recently erected information panel at the side of the road gives the history of the 29th Division and the monument.[1]

In 1916 a winter gale blew down most of the

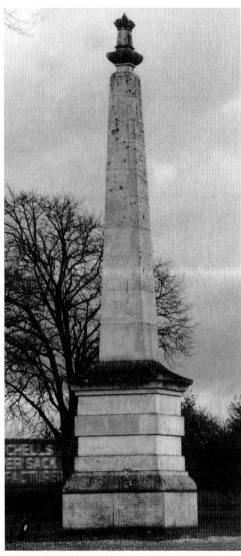

large elm trees in this area, and the following year the Dunchurch Avenue Committee negotiated for the refurbishment of the site. In 1918 funds were raised by public subscription. In 1920, two field guns were presented by the government, the monument was built at a cost of £646,[2] and the avenue replanted. The monument was unveiled by the Lord Lieutenant of Warwickshire, Lord Craven, and received by the Chairman of the County Council, Lord Algernon Percy, in front of a crowd estimated at 7,000.

Notes
[1] Darke, J., *The Monument Guide to England and Wales*, London, 1991, p.144. [2] Information provided by sign on site of work.

**Robert Bridgeman & Sons,** *Crowned Obelisk to the XXIXth Division*

# Stratford-on-Avon District

## Church Street

*On the façade of Angel House between first and second floor windows*

### *Tobias and the Angel*

### Sculptor: unknown

Executed: mid 1800s
Stone, painted white on blue, 50cm high × 70cm
    wide approx
Condition: fair
Status: Grade II
Owner/Custodian: Owner of Angel House

This relief depicts the head and shoulders of two figures, with halos, carved in high relief especially round the heads. The figure on the left has wings and is larger than the figure on the right which is more youthful. Although set slightly into the building, it stands proud of it, at first floor level above the present window head height. The building has been extensively refronted in Georgian style, and there are now only three bays where once there were five. The keystones of former flat arch windows can be seen and the relief is set into the keystone position of the central first floor window – although it is much larger. Along with the adjoining property, Angel House once formed the Angel Inn, a public house which can be traced back to at least to 1621 and which closed in 1865.[1]

Set on the façade of an old country inn called The Angel, the relief can hardly be anything but a representation of Tobias and the Archangel Raphael.[2] Originally an obscure story in the Bible, it became a popular subject matter in the Renaissance[3] and the imagery was later disseminated by prints. The story was one of a business journey[4], exemplifying the divine protection of travellers that may be invoked by prayers. This should be a reminder that such images of religious subject matter in a secular setting have often been part of the daily life of the labouring community.

Notes
[1] Saville, G.E., *Alcester: a history*, Studley, 1986, p.100. [2] Tobit, 6. 2ff. [3] Best known by the painting *Tobias and the Angel* by a follower of Verrocchio. [4] Mackowsky, H., *Verrocchio*, 1901, quoted by E.H. Gombrich, 'Tobias and the Angel', in *Symbolic Images*, p.26.

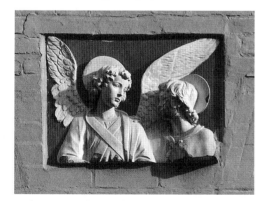

**Unknown,** *Tobias and the Angel*

## Priory Road

*In centre of roundabout at junction of Swan Street and Evesham Street*

### *Globe*

Installed: October 1996
Metal painted black 2.2m high × 1.5m wide ×
    1.5m diameter approx
Inscriptions: around Equator on globe, in gold
    coloured applied lettering: Goodwill to All /

**Unknown,** *Globe*

Peace on Earth
on plaque: THIS GLOBE / WAS PRESENTED TO THE
TOWN OF ALCESTER / BY / SEVERN LAMB LTD /
TO / COMMEMORATE 50 YEARS OF PEACE
AFTER THE SECOND WORLD WAR / 1945–1995
Condition: good
Status: not listed
Commissioned by: Severn Lamb Ltd
Owner/Custodian: Alcester Town Council

This work stands on a green base, with structural rods marking both degrees of longitude and the Equator, and sheet metal attachments for the major land masses.

The use of the globe is symbolic and works on many levels. It is an embodiment of the global nature of the sentiments of the peace movement, and a visual pairing with the setting

as motorists are circumnavigating the globe as they circle the roundabout. It is also a reminder of the Globe Inn which stood at this junction for 230 years before it was demolished to make way for the roundabout.

*In courtyard of Community Education Service building (former Magistrates' Court)*

## *Historystone*

### Sculptor: Walter Ritchie

### Architect: Eric Davies

Executed: 1950s
Blocks: Portland stone 2.44m high
Base: concrete 1.28m square
Each block: 71cm high × 74cm wide × 23cm deep
Condition: fair
Status: not listed
Commissioned by: Rugby Borough Council
Owner/Custodian: Rugby District Council

Standing on a shallow four-sided pyramidal base, three rectangular Portland stone blocks with rounded corners are balanced on top of one another. Each is rotated 60 degrees from the alignment of the one beneath, with relief carvings on each face. The bottom block shows three men in top hats struggling to push a large wheeled carriage or wagon, with a steam train along the top; on the reverse is a soldier holding a sword and a large circular shield, devoid of any ornamentation. The middle panel shows two geese on one side, and on the reverse a miller – a male figure shown in profile, striding forth, head bent and with an egg-shaped sack on his back. The relief is shallow, with simplified and rounded forms. The marks of a claw-tooth chisel are visible in the background, the miller's trousers and sack adding texture; in contrast his torso and head have been smoothed. The top panel shows a needle and a

stylised coil or spring, and on its reverse is a woman on horseback on whose hand a tethered hawk is alighting. Throughout the work the forms are static, simplified and rounded.[1]

In a personal statement the artist explained the underlying conception of this work:

The site needed a free-standing sculpture but a figure in the round was difficult for the money available. I resorted to double-sided relief panels illustrating the history of the town: – A Roman Soldier; A 14th century Miller; An Elizabethan Girl Hawking; Geese – reminder of an ancient Goose Fair; A coach being pushed out of mud while an early train trundles across the background and finally a pattern of Springs and Needles

**Ritchie,** *Historystone*

which are products of contemporary industry.'[2]

Notes
[1] Ritchie, W., *Walter Ritchie, Sculpture*, Kenilworth, 1994, pp. 79 and 82. [2] Ritchie, W., *Sculpture in Brick and Other Materials*, Kenilworth, 1997, pp. 60–1.

## BARTON-ON-THE-HEATH

*Wolford Road*

*On village green*

### *Well-house: Monument to R.W.M. Bird*

### Sculptor: unknown

Executed: 1870s
Well-house: limestone 3m high × 1m diameter approx
Trough: lined with lead
Inscriptions: on drum supporting urn: THIS FOUNTAIN / IS PRESENTED TO THE PARISH OF / BARTON ON THE HEATH / BY MAJOR AND MRS R.W.BIRD / IN MEMORY OF THEIR ELDEST SON / R.W.M. BIRD WHO DIED AT BARTON HOUSE ON 12 JULY 1874. / LOVED IN LIFE / HE LIVES IN LOVING MEMORY WHEN DEAD around spout to fountain: WHOSOEVER WILL LET HIM TAKE THE WATER OF LIFE FREELY / PEV. C22. V.17
Condition: fair
Status: Grade II.
Commissioned by: Major and Mrs R.W. Bird

This limestone well-house has a polygonal plinth and three columns supporting a hemispherical dome with moulded surround and ball finial. Inside the structure is an urn with carved grapes, drapery and foliage standing on an inscribed drum plinth. The well is fed by rain-water from Barton House, across

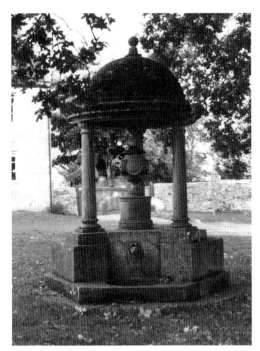

Unknown, *Monument to R.W.M. Bird*

the green. Gravity-fed into a reservoir below the structure, the spring exits from a lion's head.

Possibly a re-erection of a late seventeenth- or early eighteenth-century well-house, the building acts as a memorial.[1]

Note
[1] Pevsner, N., *Buildings of England: Warwickshire*, Harmondsworth, 1966, p.87.

## BINTON

### Main Road

*Niche in wall opposite church*

### Lion Fountain

**Sculptor: unknown**

Executed: 1868–70
Lion head: cast iron 15cm high approx
Surround: stone and brick 90cm high × 1m wide approx
Inscriptions: (on keystone): ERECTED/1868/WJ
(under scroll canopy): 1870
(main inscription, serif): WHOEVER DRINKETH BY/ THIS WATER SHALL THIRST AGAIN/ BUT WHOEVER DRINKETH/ OF THE WATER THAT I SHALL GIVE HIM/ SHALL NEVER THIRST. (in smaller letters) S-JOHN IV 13 14
Condition: fair
Status: not listed

Unknown, *Lion Fountain*

The fountain is set into an estate wall. The arch has a keystone bearing an inscription, and at the base of the niche is a trough filled from a bronze waterspout in the form of a lion's head, now mainly covered by vegetation, that still functions. An extension to the wall has been added in the form of a pediment. The apex is crowned with a large inscribed stone with scroll features.

## BRAILES

### Whatcote Road

*West side of road, near entrance to Compton Wynates*

### Compton Pike

**Maker: unknown**

Executed: 1500s
Ironstone rubble 9m high approx
hook: iron
Condition: good
Status: Grade II

This monument is of coursed squared ironstone rubble. The base of the square section tapers to a point surmounted by a ball finial with an iron hook at the apex.

It was probably erected as a beacon, one of the network covering the county to give warning of the landing of the Spaniards at the time of the Armada. The iron hook at the apex would have supported either a lantern or a flaming faggot.[1] It was subsequently used as a landmark.

Note
[1] Ministry of Housing and Local Government, *Provisional List of Buildings of Architectural or Historic Interest, Warwickshire*, Revised List (November 1959), 3/67.

## CHARLECOTE

*Charlecote Park*

### Ornate Gates, Boar and Griffin

**Sculptor: Thomas Parris**

**Designer: John Gibson**

Stone piers: early 1720s, 4m high approx
Wrought iron gates: executed 1861, 3m high ×
    4m wide approx
Condition: fair
Status: Grade II
Commissioned by: Henry Spencer Lucy
Owner/Custodian: National Trust

Charlecote Park contains a wealth of sculptural works. Among these are the ornamental wrought iron gates with stone piers topped by a winged boar's head from the Lucy crest on the left and a griffin on the right, which have been attributed to Thomas Parris.[1] The gates include crosslets from the Lucy arms, and were made by John Gibson in 1861.

Another pair of exquisite wrought iron gates flanking the forecourt walls bear the cipher of the Rev. William Lucy, who bought them from Thomas Parris in 1722.[2] These have sculptured posts with boars at the corners. Other sculptures include a figurative group of a shepherd and shepherdess in lead by John Cheere at the entry to the orangery from the forecourt, and black and white marble monuments in the Italo-Dutch manner in the chapel by Nicolas Stone, the leading English

Unknown, *Compton Pike*

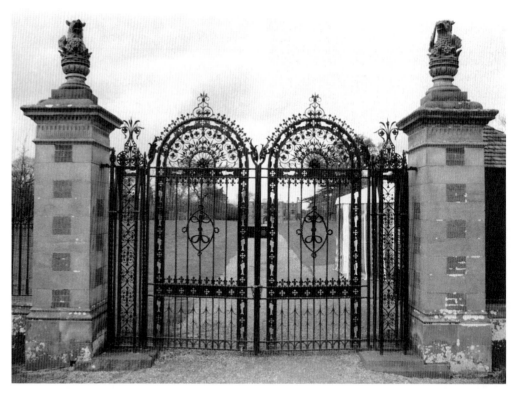

Gibson, *Ornate Gates*

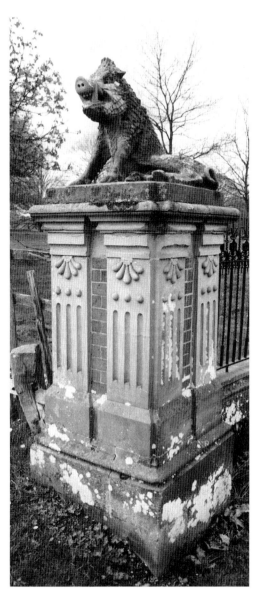

Parris, *Boar*

sculptor of the 1640s.

The present house at Charlecote was completed in 1559–60 for Thomas Lucy who had inherited the estate in 1551. He was later Sheriff of Warwickshire and was knighted by Queen Elizabeth I, whose coat of arms appears above the doorway.[3] The porch was added in 1572. The estate was handed to the National Trust in 1946.

Notes
[1] Pevsner, N., *The Buildings of England, Warwickshire*, Harmondsworth, 1966, pp.227–8. [2] *Country Life*, Vol. III, 11 April 1952. [3] Tyack, G., *Warwickshire Country Houses*, Chichester, 1994, pp.43–7.

## ETTINGTON

*Stratford Road*

*Ettington Park Hotel*

### Narrative Cycle of Shirley Family History

**Carver: Edward Clarke**

**Architect: John Pritchard**

**Designer: H.H. Armstead**

Executed: 1861–3[1]
Stone: various dimensions up to 2m wide
Condition: good
Status: Grade I
Commissioned by: Evelyn Philip Shirley
Owner/Custodian: Major John Shirley

This High Victorian house was built in a thirteenth-century Gothic style for Evelyn Philip Shirley by John Pritchard of Llanduff in 1858–62. Its decoration includes a magnificent series of narrative reliefs showing episodes in the Shirley family's history from the time of the family's Saxon founder to that of Cromwell. The iconography of the narrative reliefs follows a fifteenth-century Italian tradition, but the style is closely related to Pre-Raphaelite history painting and love of naturalistic detail. In total, there are 12 rectangular relief panels and two pediment arch friezes. They were carved by Edward Pearce to the designs of H.H. Armstead.

The relief over the entrance shows the foundation of the Church of Eatingdon, by Saswalo or Sewallis, the ancestor of the Shirley family, in the reign of William the Conqueror. He is represented with his family kneeling and offering a model of the church to the bishop, who is giving him the espicopal blessing. Above is the ancient coat of arms of the family, paly of six or and sable.

Over the western bay window, there are three narrative reliefs:

The first, taken from his great seal, shows Sir Sewallis de Eatendon, knight, grandson of the last Sewallis, on his horse with his shield. He died in the reign of Henry III, having been on the crusades. He is here represented with his coat of arms and with the cross borne before him

The second depicts Henry, grandson of Sewallis, selling his birthright to his younger brother, also called Sewallis, in the reign of Henry II. Above their heads are the coats of arms of Ireton and Shirley. The Shirleys are descended from the elder brother, the now extinct house of Ireton, and from the younger brother Sewallis.

The third relief shows Sir Ralph Shirley, grandson of Sir Sewallis, elected the first knight of the shire for the county of Warwick, in the reign of King Edward I. Above is the coat of arms of Shirley, impaled by those of his wife Margaret, daughter of Walter de Waldershef.

Over the eastern bay window are three more narrative reliefs:

The first depicts Sir Thomas Shirley, son of Sir Ralph, in the Holy Land. His page is bringing him the head of a Saracen, whom he is

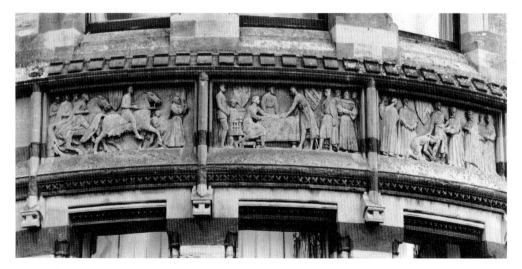

Clarke, *Narrative Cycle of Shirley Family History (detail)*

represented to have vanquished and decapitated. This is the traditional origin of the family crest. Suspended from a palm tree are the arms of Shirley, impaling Basset of Drayton. Sir Thomas was dead by 1363.

The second shows the death of Sir Hugh Shirley, son of Sir Thomas, at the battle of Shrewsbury, on Saturday, 20 July 1403. Sir Hugh was one of the four knights who, clothed in the royal armour, successively encountered and fell under the victorious arm of Douglas in single combat.

The third relief depicts Sir Ralph Shirley, son of Sir Hugh, on the eve of his departure with King Henry V for the wars in France. He gives his infant son and heir Ralph into the care of his mother, Beatrice, and asks Richard Elebet, clerk, and others, to take care of his estates.

Over the drawing room windows on the south side of the house are two further panels:

One shows the expedition of Sir Ralph Shirley, son of Sir Hugh, to France with his band of archers, before the siege of Honfleur and the Battle of Agincourt, 1415. Sir Ralph is represented taking leave of his mother. The

Clarke, *Narrative Cycle of Shirley Family History (detail) Sir Ralph Shirley being knighted by King Henry VI*

Clarke, *Narrative Cycle of Shirley Family History (detail) Sir Ralph Shirley leaves his son with his mother*

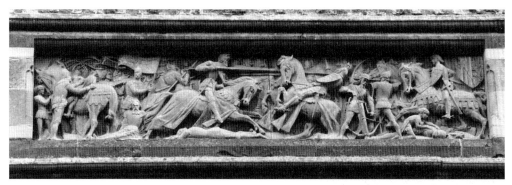

Clarke, *Narrative Cycle of Shirley Family History (detail) Sir Ralph Shirley with his archers at the Battle of Agincourt.*

arms of Shirley appear conspicuous on the banners of his archers and retainers: on a shield are the arms of Shirley impaling Basset of Brailesford.

The other depicts Sir Ralph Shirley, great-grandson of the preceding Sir Ralph, being dubbed a Knight by King Henry VII on the battlefield of Stoke in 1487. The Royal arms appear on the banner and horse trappings; on one side are the arms of Shirley, impaling the coat of Shetfield of Butterwick.

Over the library window are three panels, representing incidents in the lives of three celebrated Shirley brothers, the sons of Sir Thomas Shirley of Wiston, in Sussex, and representative of a younger branch of this family:

The first represents the attack by Sir Thomas Shirley, the youngest of the three brothers, on the Turks in 1603; the second Sir Anthony and Sir Robert Shirley, leading the Persians against the Turks in 1599, and teaching them the use of artillery; and the third Sir Robert Shirley's reception at the court of King James I, as Ambassador from Shah Abbas, King of Persia, in the year 1611.

Of the two remaining reliefs, one depicts the foundation of the Church of Staunton Harold, in Leicestershire in 1653 by Sir Robert Shirley, Baronet, great-great-grandson of the last Sir Ralph. Sir Robert and his wife, Katherine Okeover, and their son Seymour, are represented on one side; on the other are the clerical friends of Sir Robert during the persecution of the Church by Cromwell, namely Dr Hammond, Dr Gunning afterwards Bishop of Ely, Dr Sheldon afterwards Archbishop of Canterbury, and Dr Dolben afterwards Archbishop of York. Above the figures are the arms of Shirley, impaling Okeover, and the motto: 'He loved our country and hath built us a synagogue'. This was the text from which the funeral sermon was preached by Dr Sheldon on the death of Sir Robert in 1656.

The other relief shows the committal of Sir Robert Shirley, Baronet, to the Tower of London by Oliver Cromwell in 1656, in consequence of his loyalty to the Royalist cause.

Ettington Park is unique, being the only property in England still in the same family ownership since 1086, the time of the Domesday Book, when the manor was held by 'Saswalo' (or Sewallis): his grandson, another Sewallis, became 'de Shirley' from the village in Derbyshire where he held lands.

The house as we know it today owes much to Saswalo's lineal descendant, Evelyn Philip Shirley who, with his architect John Prichard, created one of the finest country houses of the Gothic revival. Evelyn Philip Shirley named his son Sewallis after his earliest known Shirley ancestor. Sewallis, the founder of the Kennel Club, was the last Shirley to live at Ettington Park. After his death in 1904, the house was leased first to Mr Robert Guinness, then to Constance, Duchess of Westminster. From 1935 onwards, it was used as a nursing home, public school, POW residence, hotel and even a disco, until the interior was devastated by fire in 1980. Three years later, with an injection of capital from interested parties, the house was restored to its former glory as one of the great hotels in England.

The present house is the third to occupy the site. The original was of Saxon construction, the second Tudor, with considerable additions and alterations made in 1740 by George Shirley before the current building was commissioned by Evelyn Philip Shirley in the 1850s. Major John Shirley, the present owner of Ettington Park, is the 33rd Lord of the Manor.

Sources
Read, B., *Victorian Sculpture*, Newhaven and London, 1982, pp. 261–2. Pevsner, N., *The Public Buildings of England: Warwickshire*, Harmondsworth, 1966, p.289. Shirley family website, www.innerworks.pacific-pages.com/shirley

## Figures of Royalty and Angels
### Sculptor: Edward Clarke

Executed: 1858–62
Stone, half life-size
Condition: good
Status: Grade I
Commissioned by: Evelyn Philip Shirley
Owner/Custodian: Major John Shirley

On either side of the principal window of the gallery are two statues carved in stone, representing King Edward the Confessor and

Clarke, *Figures of Royalty and Angels (detail)*

Clarke, *Royal Heads (detail)*

Queen Victoria. They stand in niches beneath angels, bearing shields charged with their respective arms. These statues represent the period during which the house of Shirley has flourished at Ettington.

## *Royal Heads*
### Sculptor: Edward Clarke

Executed: 1858–62
Stone, life-size
Condition: fair
Status: Grade I
Commissioned by: Evelyn Philip Shirley
Owner/Custodian: Major John Shirley

Over the entrance-door is the ancient coat of arms of Sir Sewallis de Ethindon (Ettington), with the legend 'Loyal je Suis'. Between the windows of the cloister or corridor, on either side of the entrance, are heads of the first eight kings after the Conquest. At one end of this cloister, which is roofed with glass, are the following lines on a small tablet: 'Four score and four, if God gives strength, The web of life is spun; Four score and four, the Cloister's length, A statute mile is run'. Under this tablet is an iron chest from the Spanish Armada.

## *Phoenix Rising: To Meet the Dawn of a New Millennium*
### Sculptor: Christine Lee

Executed: late 1990s
Plinths: stone – lower one 1.5m high approx, higher one 2.3m high approx
Sculptures: metal – one on higher plinth 1.5m high approx, the other 1.7m high approx
Condition: good
Status: not listed
Commissioned by: Major John Shirley
Owner/Custodian: Major John Shirley

**Lee,** *Phoenix Rising*

Two metal sculptures of birds stand on stone plinths of differing heights in the grounds at the back of the hotel. Both have outstretched necks and wings like butterflies. The work combines a sense of optimism and hope with a feeling of fragility, and is in striking contrast to the Victorian Gothic façade of the building behind it.

# FARNBOROUGH

## Southam Road

*Visible from public footpath, sited at the top of the terrace at Farnborough Hall*

### Obelisk

**Designer: Sanderson Miller (attributed to)**

Erected: 1751
Limestone ashlar 16.5m high
Condition: good
Status: Grade II
Commissioned by: William Holbech
Owner/Custodian: National Trust

This tall and very slender obelisk has a high pedestal featuring a moulded stepped base and cornice.

The park with the obelisk is considered a major example of eighteenth-century landscape design. The obelisk, which was rebuilt in 1823, may originally have been designed by Sanderson Miller for William Holbech (d.1777).[1]

Note
[1] Sites and Monument Record, WA643.

# FENNY COMPTON

## Avon Dassett Road

*Junction with Dog Lane*

### Bear and Ragged Staff

**Maker: unknown**

Executed: 1980s
Wood 1m high approx
Condition: good
Status: not listed

**Unknown,** *Bear and Ragged Staff*

Commissioned by: Warwickshire County
    Council
Owner/Custodian: Warwickshire County
    Council

A flat wooden bear and staff with a real chain are attached to the top of a wooden road sign. They depict part of the county coat of arms. Local tradition has it that this is a sixteenth-century road sign: however, the execution looks fairly recent although it could be a replacement of an earlier sign.

### High Street (A3400)

### Market Cross (remains of)

**Sculptor: unknown**

Erected: 1400s
Steps: stone 2m square at maximum point
    approx
Base: stone 1m square approx
Shaft: stone 1.7m high × 40cm wide × 40cm
    deep approx
Condition: fair
Status: Grade II

This is one of the few late medieval market crosses to have survived in Warwickshire. According to local tradition, supported by visual evidence, the head and top section of the shaft have decayed and been lost. The head was four-sided with recessed niches under cinquefoil-headed canopies resting on a ring and borne up by four angel figures at the angles, each holding a shield with a cross. It is now surrounded by wooden flower planters, which also sit on the top step. At the bottom, two

steps lead to a base stone and then a shaft. There is a circular iron collar around the top of the remaining shaft from which four iron bars with ornamental rope twists lead down and are bolted to the corners of the top step.

In the nineteenth century, the majority of the relief sculpture in the niches was still discernible. In the first was the Rood, in the second the Trinity, and in the third St Peter with his key.[1] Unfortunately the fourth niche was so badly weathered even by this time that its subject matter was not identifiable. It may have contained the Virgin and Child. The finials and crockets were also decorated. An illustration of 1863 shows that part of the head had mouldered away by that date,[2] although it did not fall off until 1894.[3] The remains of the shaft were secured with iron supports at the turn of the last century. Before the Reformation preaching would have taken place from the steps of the cross, with the niche sculpture acting almost as a sermon in stone, and reinforcing the preachers' words. After the Reformation the market cross remained at the centre of public life in the village, proclamations of all sorts being made at the Cross in front of the assembled populace including the bailiffs

and burgesses in their gowns.

Notes
[1] *The Gentleman's Magazine*, February 1815.
[2] Hannett, J., *Forest of Arden*, Birmingham, 1863, p.44. [3] Cooper, W., *Henley-in-Arden: an ancient market town*, originally published 1946, amended facsimile edition, Buckingham, 1992, pp.73–4.

### Honington Hall

### Gate with Sculptural Ornaments

**Sculptor: unknown**

Executed: c.1740
Gate piers: yellow limestone 30cm square
    approx
Condition: fair
Status: Grade I
Owner/Custodian: Owners of Honington Hall

The gate piers at the entrance to Honington Hall are decorated with sculpted heads and drapery forming garlands.

Honington Hall was originally built by Sir

Unknown, *Market Cross*

Unknown, *Gate with Sculptural Ornaments*

Henry Parker in the late seventeenth century (*c*.1685). The Townsend family succeeded the Parker family in the 1730s and replaced the Parker arms with their own. The Townsend coat of arms, surrounded by swags in the curved broken pediment, are impaled by Gore, which dates them after 1844, when Townsend married the heiress Judith Gore. Originally, the house was of thickened 'H' plan, with projecting bays, but it was modified in 1751, when an octagonal saloon with six Tuscan columns was inserted to fill the indent in its west side.

In niches on the entrance front between ground floor and first floor windows are the busts of six Roman Emperors. Four similar busts are on the garden front and two more are on the west front. Originally there were six on the east front, and six on the south. The erection of the octagonal saloon displaced two of the busts, which were repositioned on the west front at a later date. The busts are in marble of the Italian Carrara type, now well weathered. There is no evidence as to whether Henry Parker imported them from Italy or commissioned an English craftsman to carve them after prints or copies of busts. There are similar busts in niches at Ham House, Surrey.[1]

Note
[1] Catherine Storer (unpublished BA dissertation, University of London), London, copy also in Stratford Records Office.

## ILMINGTON

*Front Street*

### Commemorative Fountain
#### Sculptor: unknown

Executed: 1864 (restored 1920)
Fountain: Cotswold stone 2m high approx
Inscriptions: across top: "O all ye fountains bless ye the Lord"

Unknown, *Commemorative Fountain*

in tablet: This tablet commemorates the exertions of those who provided the blessing of pure water for the inhabitants of Ilmington. Their names are enrolled in the vestry of the Church. The originators were PHILIP HENRY HOWARD ESQ., JULIAN CHARLES YOUNG, M.A. RECTOR, TIMOTHY SMITH, JAMES BENNETT, GEORGE CROSSLEY, A.D. 1864.'
below: RESTORED IN 1920
Condition: fair
Status: not listed
Commissioned by: Philip Howard, Charles Young, Timothy Smith, James Bennett and George Crossley

The fountain is set against the rise of a small hill. An iron cross surmounts the stone structure.

One of the commissioners was the Rev. Julian Young, son of the well-known actor Maynard Young. He was rector of the parish from 1857 until 1872, when he was succeeded by his son. He was responsible for building the village's first school (completed in 1858) as well as promoting the building of its eight fountains, the one on the Upper Green being dated 1864.[1]

Note
[1] *History of Ilmington*, Gardner, S.M. and Ibbotson, E.M.H., Oxford, 1974, pp.70–1, 84.

## KINETON

*Banbury Road*

### Memorial to the Battle of Edge Hill
#### Maker: unknown

Unveiled: 23 October 1949
Base: stone
Pillar: stone 1.34m high
Plaque: bronze 46cm high × 32cm wide
Inscriptions: carved into stone on back of pillar:
ERECTED BY THE WARWICKSHIRE / COUNTY COUNCIL AND UNVEILED / BY THE LORD LIEUTENANT OF / WARWICKSHIRE THE RIGHT

Unknown, *Edge Hill Memorial*

HON / THE LORD WILLOUGHBY DE BRACE / MC AFC SUNDAY 23 OCTOBER 1949
around top: BATTLE OF EDGEHILL / AD 1642
on plaque: BETWEEN HERE / AND THE VILLAGE OF / RADWAY THE BATTLE / OF EDGEHILL THE FIRST / OF THE CIVIL WAR WAS / FOUGHT ON SUNDAY / THE 23 OCTOBER 1642 / MANY OF THOSE WHO / LOST THEIR LIVES IN / THE BATTLE ARE BURIED / THREE QUARTERS OF A / MILE TO THE SOUTH / OF THIS STONE
Condition: fair
Status: not listed
Commissioned by: Warwickshire County Council
Owner/Custodian: Warwickshire County Council

This simple unpretentious memorial consists of a stout pillar with inscriptions and a plaque mounted on a circular base which stands on round brick paving. There is a very similar memorial inside the nearby army base, but it is not accessible to the public.

## LITTLE COMPTON

*London Road (A44)*

*Junction with road to Great Walford*

### The Four Shires Stone
**Sculptor: unknown**

Executed: late 1700s
Limestone 4m high × 1m wide × 1m deep approx
Inscriptions: on side facing A44 (west): THE FOUR SHIRES / STONE / WORCESTERSHIRE
on side facing Great Walford road (north): GLOUCESTERSHIRE
on east side: WARWICKSHIRE
on south side: OXFORDSHIRE

Unknown, *Four Shires Stone*

Condition: fair
Status: Grade II

This sign consists of a late eighteenth-century square pillar with a moulded pedestal and plinth and a moulded cornice with an elaborate ball finial. It is set within railings at the side of the road. Inscribed on each face, it faces west to Worcestershire, north to Gloucestershire, east to Warwickshire and south to Oxfordshire.[1]

Note
[1] Ministry of Housing and Local Government, *Provisional List of Buildings of Architectural or Historic Interest, Warwickshire*, Revised List (November 1959), 4/54.

## RADWAY

*Edge of wood, near public footpath*

### Obelisk
**Sculptor: unknown**

Erected: 1854
Ironstone ashlar 6m high approx

Unknown, *Obelisk*

Inscription: inscribed on to north face of pedestal: THIS OBELISK WAS ERECTED BY / CHARLES CHAMBERS ESQre R.N. / IN 1854 TO COMMEMORATE THE / BATTLE OF WATERLOO WHERE THE VI INNISKILLIN DRAGOONS / WERE COMMANDED BY / LIEUT. COL. F.S. MILLER / WHO FOR HIS GALLANT CONDUCT / DURING THE ACTION IN WHICH HE WAS / VERY SEVERELY WOUNDED, / WAS MADE A COMPANION OF THE MOST / HONOURABLE ORDER OF THE BATH
Condition: poor
Status: Grade II
Commissioned by: Charles Chambers

This tall obelisk is erected on a high-stepped and moulded plinth and features a tall pedestal with a moulded cornice and a pyramid top. Standing on a rise below Edge Hill encircled by trees, it is visible from the village of Radway and the public footpath to it.

The commemorative function of the obelisk is clearly recorded in the inscription.

## SHIPSTON-ON-STOUR

### Darlingscott Road

*Junction with Telegraph Street*

### Drinking Trough
#### Maker: unknown

Installed: 1902
Limestone 80cm high × 2.5m wide approx
Inscriptions: on end: METROPOLITAN / DRINKING FOUNTAIN / & CATTLE TROUGH / ASSOCIATION
along side: SHEW MERCY TO ALL GODS CREATURES / AND YOURSELF HOPE FOR MERCY / THE GIFT OF RICHARD BADGER 1902
Condition: fair
Status: not listed
Commissioned by: Richard Badger

Unknown, *Drinking Trough*

This composite stone drinking trough consists of a drinking fountain and a small basin at one end and a lower trough for smaller animals at the other. The carving of the fountain, base and trough is simple, emphasising the structural elements with little attention to detail.

There is an identical drinking trough outside the Black Horse Inn in Station Road, also commissioned by Richard Badger, who was a local wine merchant. The inscription along the side reads: A GOOD MAN IS MERCIFUL TO ALL GODS CREATURES/THE GIFT OF RICHARD BADGER 1902

## SOUTHAM

### Park Lane

*800m west of Southam Church on public footpath*

### Holy Well with Heads
#### Sculptor: unknown

Executed: before 1600
Each head: stone 30cm square approx
Condition: poor
Status: Grade II

Three unidentified heads act as spouts from a semi-circular basin into a plunge pool. They are thought to be of medieval origin. The heads are very badly weathered and their features are not easily recognisable, but they appear to be male and to have had long flowing hair and beards. In the iconographical tradition, such features are attributes of river gods or water deities who, in contrast to earth deities, are always male.

The history and precise date of the well are unknown. Its importance to the town of Southam is clear from the fact that it was specifically excluded from the 1761 Enclosure Act to ensure public access to its site. It is hardly surprising that local tradition associates the well with witchcraft and the practice of white magic as the water from the well came to be regarded as a cure for eye ailments. It seems to have been mentioned first as Halewellene in the Warwickshire Feet of Fines in 1206 and may have belonged to the Abbey of Southam.[1] Until 1925, there was a clear spring flowing from the white lias, but the water was diverted to a reservoir and the spring virtually dried up.

Note
[1] Townsend, B., *Southam Through the Ages*, Warwick, 1979, p.31.

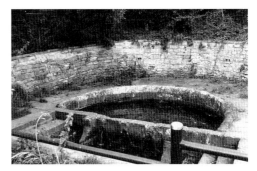

Unknown, *Holy Well with Heads*

## Warwick Road

*Approximately 50m SW of Stoneythorpe Hotel*

### Dispensary Urn

#### Sculptor: unknown

Installed: 1889
Pedestal: granite 1.85m high approx
Urn: limestone 60cm high approx
Inscriptions: to the front: THIS STONE / MARKS
THE SITE OF THE /DISPENSARY COTTAGE /
USED FOR THE PURPOSES OF THE FIRST SELF
SUPPORTING OR / PROVIDENT DISPENSARY /
IN THE KINGDOM, / ESTABLISHED HERE BY /
MR H. L. SMITH, / IN THE YEAR 1823 / UPON
THE PLAN AFTERWARDS / SUCCESSFULLY /
ADOPTED AT / COVENTRY, NORTHAMPTON /
AND MANY OTHER PLACES.
on the right side of the pedestal: THE

Unknown, *Dispensary Urn*

POPULAR / DISPENSARY / MAYPOLE HOLIDAY
WAS HELD HERE / TO THE ENJOYMENT / OF
THE INHABITANTS / OF THIS TOWN / FOR
MANY YEARS / "HERE FLOWRY GARLANDS
WERE ENTWINED / THE LOFTY POLE TO GRACE
/ AND MAY HAD ALL HERE CHARMS /
COMBINED TO DECORATE THE PLACE"
on the back of the pedestal: IN THE YEAR
1895 / A BEQUEST OF / £3000 WAS / LEFT TO
THE TRUSTEES OF / THE SMITH MEMORIAL
CHARITY / SOUTHAM / BY THE TWO CHILDREN
OF THE / FOUNDER IN PIOUS MEMORY OF /
THEIR FATHER & MOTHER / AND IN ORDER TO
ENABLE / THE TRUSTEES TO REOPEN / THE
INSTITUTION FOR THE BENEFIT OF THIS TOWN
/ AND NEIGHBOURHOOD
on the left side of the pedestal: BOYS /
GARDEN ALLOTMENTS / FOR THEIR EARLY
INSTRUCTION IN THE / MANAGEMENT OF
LAND / WERE ESTABLISHED HERE, / AND WERE
VISITED / BY THE HONBLE THE / SPEAKER OF
THE / HOUSE OF COMMONS, / SIR JOHN
FRANKLIN, THE / DOWAGER LADY BYRON AND
OTHERS.
Condition: fair
Status: Grade II
Commissioned by: Rev. William Lilley Smith,
son of Henry Lilley Smith
Owner/Custodian: Southam United Charities

This limestone monument stands on a granite
plinth with moulded base and cornice. Set
within an area of paving and gravel inside iron
railings, it has a square base below a pedestal
carved with inscriptions. Three of the
inscriptions refer to initiatives by a surgeon,
Henry Lilley Smith (1787–1859), during his
lifetime: the Dispensary in 1823, the maypole
holiday in 1825, and the allotments for boys
aged 8–14. The monument was erected by his
son, Rev. William Smith, in 1889.[1] The
inscription on the back of the pedestal would
have been added later.

The dispensary mentioned in the inscription

was established in a seventeenth- or eighteenth-
century thatched cottage by Dr Henry Lilley
Smith, founder of the former Eye and Ear
Infirmary, now the Stoneythorpe Hotel.

Note
[1] *Warwickshire*, article by Betty Smith, March 1976,
pp.28–9.

## STRATFORD-UPON-AVON

*Bancroft Gardens*

*Opposite Sheep Street*

### Country Artists Fountain

#### Sculptor: Christine Lee

#### Metal workers: BMD Engineering and Brian Harrison

#### Stonemason: Michael Twite

#### Architect: Lee Evans

Unveiled: 8 November 1996
Sculpture: marble and stainless steel 4.5m high ×
2.5m wide × 2.5m deep
Basin: York stone 6.5m diameter
Inscriptions: (east side) (centralised text):
INAUGURATED BY/ HER MAJESTY THE QUEEN
ON/ THE OCCASION OF THE VISIT OF/ HER
MAJESTY/ AND HIS ROYAL HIGHNESS/ THE
DUKE OF EDINBURGH/ IN CELEBRATION OF
THE 800TH/ ANNIVERSARY OF THE GRANTING
TO/ STRATFORD-UPON-AVON/ OF MARKET
RIGHTS BY KING RICHARD I/ AND OF
BOROUGH STATUS/BY THE BISHOP OF
WORCESTER IN 1196/ 8 NOVEMBER 1996
(on north side): MICHAEL TWITE [space] BMD/
LANDSCAPES [space] ENGINEERING
(west side, centralised): 1196 [Shield] 1996/
COUNTRY ARTIST [Ornate text] / FOUNTAIN/
IN CELEBRATION OF/ STRATFORD-UPON-

AVON'S/ 800TH ANNIVERSARY/ CHRISTINE LEE [Italics] / SCULPTOR

Status: not listed
Commissioned by: Stratford-upon-Avon
District Council
Owner/Custodian: Stratford-upon-Avon
Council

The centrepiece to the fountain depicts two swans rising into flight. The form of the swans and the positions of their wings and bodies are exaggerated and stylised to convey the effects of flight. Swans have enjoyed royal protection for many centuries and have a special symbolic significance in Stratford-upon-Avon.

The fountain was commissioned by Stratford-upon-Avon Council to celebrate the 800th anniversary of the granting of market rights to the town by Richard I, and the granting of borough status by the Bishop of Worcester, both in 1196. There was a controversy in the town about the siting of the fountain, and one councillor unfavourably compared the proposed design to a biscuit tin![1] Originally planned to stand 5.2m its height was reduced to 4.5m because of concern about its being out of scale. There was also concern that the Country Artists, who were contributing to

the £50,000 cost, were over-exploiting the commercial possibilities of the project.

The day before its inauguration, Brian Harrison, a welder and fabricator who had worked on the maquette with Christine Lee, claimed that they were jointly responsible for its design and that his contribution as co-author should be recognised. Harrison, who runs the Stratford company BCH Welding Services, was also in dispute over payment for his work.[2] His claim was disputed by Christine Lee and on 29 June 1998 they went to court. He presented his argument to Justice Jacob at Birmingham High Court but it was not accepted, and he was ordered to pay Christine Lee's legal costs of over £20,000.[3]

Notes
[1] *Stratford-upon-Avon Herald*, 6 June 1996.
[2] *Ibid.*, 23 November 1995. [3] *Ibid.*, 2 July 1998.

*Opposite entrance to Sheep Street, west of Country Artists Fountain*

## *Peace Memorial*
## Sculptor: Brent Hayward
## Assistant: Darren Hayward

Unveiled: 6 June 1995
Monument: Hornton stone (limestone with
iron content) 2.5m high × 87cm wide × 23cm
deep × other dimensions (irregular shape)
Signature: (west face below inscription):
SCULPTURE BY/ HORTON QUARRIES LTD
Inscriptions: (on front of sculpture): PEACE I
GIVE TO YOU
(on back of sculpture): THIS MONUMENT,
ERECTED BY / STRATFORD-UPON-AVON TOWN
COUNCIL, / COMMEMORATES 50 YEARS OF
PEACE / BETWEEN THE NATIONS OF / WESTERN
EUROPE / 1945~1995 / DESIGNED BY NAOMI
HAMER AND TREVOR BROWN / PUPILS OF
STRATFORD-UPON-AVON HIGH SCHOOL /
DEDICATED BY THE BISHOP OF COVENTRY /

THE RT. REVD. SIMON BARINGTON WARD / ON 6th MAY 1995 IN THE PRESENCE / OF YOUNG PEOPLE FROM EUROPE

Condition: good
Status: not listed
Commissioned by: Stratford-upon-Avon
District Council
Owner/Custodian: Stratford-upon-Avon
District Council

The monument has a relief of a shield bearing an inscription, the town coat of arms, a dove with an olive branch, and a figurative relief showing a soldier with a young male child who is carrying the number 50. Below the figures are two linked hands. The detailed inscription is on the back of the memorial.

The Dove, a traditional symbol of peace, is taken from the Biblical tale of the Flood when Noah sent out a dove to find dry land and it returned with an olive branch to signify that the flood had receded.[1]

After the local government reorganisation of 1974, the arms of the former Stratford-upon-Avon Borough were transferred by the Earl Marshal to Stratford-upon-Avon Town Council. The arms are gold, with a blue chevron between three leopards' faces. Another

Lee, *Country Artists Fountain*

Hayward, *Peace Memorial*

version made the field silver and the chevron red. The leopards' faces were probably derived from the Royal Arms which show three lions standing with their right paw raised, anciently termed *lions leopardés*. Several ancient towns placed the Royal Arms of England on their seals and when adopting arms of their own took the three royal lions as a basis, simply changing the colour of the field or making additions.[2] In the Middle Ages, the coat of arms used by bailiff and burgesses included three leopards' faces. The Charter of 1553 gave to bailiff and burgesses various privileges, among which was the right to a Common Seal. The first Common Seal of 1553 has on it a florid shield charged with a chevron between three leopards' faces.[3]

Notes
[1] Genesis, 8.11. [2] Scott-Giles, C.W., *Civic Heraldry of England and Wales*, London, 1953, p.378. [3] *The Coat of Arms*, vol.III, no.24, October 1995, p.314.

*At point where Stratford Canal meets River Avon*

## Youth at Stream
### Sculptor: John Henry Foley

Installed: 1932
Bronze 1.7m high approx
Signatures: J. H. Foley, Sculpt. London 1844. Cast in bronze by J. A. Hatfield, London 1851
Condition: good
Status: not listed
Commissioned by: donated to Stratford-upon-Avon Corporation by Mr Alfred Bullard, a resident, on 11 October 1932[1]
Owner/Custodian: Stratford-upon-Avon District Council

This figure of a young man, naked apart from a fig leaf and some drapery around his shoulders, stands on a rock and leans against a tree trunk, his right arm raised above his head to clasp the tree. The inscription, known from documentary sources,[2] is no longer visible and may be under the ivy established around the base.

The 1844 original plaster model was exhibited in Westminster Hall as a competition

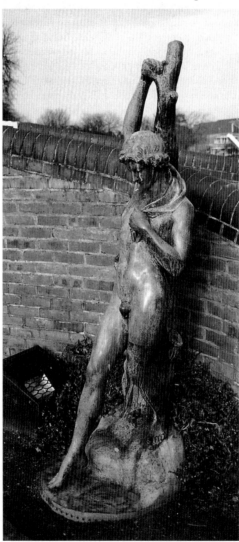

Foley, *Youth at Stream*

entry for the decoration of the new Houses of Parliament. Of this work, the Art Union wrote: 'The head is modelled in fine taste, and had such a figure been dug up in Rome, or near Naples, somewhat mutilated, it would have been pronounced a valuable specimen of classic Art.'[3] It was cast in bronze for the Great Exhibition at the Crystal Palace in 1851. Hatfield was also asked to produce a smaller version of the bronze for the Art Union of London, which was last known to be in a private collection in Sweden.[4]

Another copy of the work was discovered at the Royal Albert Hall in January 1985.[5] The plaster model is still in the collection of the Royal Dublin Society, to whom it devolved after Foley's death in 1874.[6]

Notes
[1] Wellswood, F., *An Inventory of the Civic Insignia and other Antiquities belonging to the Mayor and Corporation of Stratford-upon-Avon*, Stratford-upon-Avon, 1940, p.23. [2] *The Times*, 12 January 1985, letter from Patricia McFarland, Hon. Sec. Stratford-upon-Avon Society. [3] Read, B., *Victorian Sculpture*, New Haven and London, 1982. [4] *Stratford-upon-Avon Herald*, 6 October 1989. [5] *The Times*, 12 January 1985. [6] Read, B., *op. cit.*, p.29.

*Birmingham Road*

*Maybird Trading Estate, at the top (west) end of the car park near Boots the chemist*

## Olivier as Henry V
### Sculptor: John Blakeley
### Assistant: Martin Blakeley
### Stonemason: Hornton Quarries

Unveiled: 19 April 1990
Sculpture: patinated recycled bronze 2.5m high × 1.15m wide × 97cm deep
Plinth: Hornton stone 1.55m high × 1.35m wide × 2.14m deep
Signature: John Blakeley assisted by his son Martin

Inscriptions: (NW side of plinth, SE side of plinth): Olivier as Henry V Stratford upon Avon / 'GOD FOR HARRY, ENGLAND AND SAINT GEORGE'
(on attached brass plate, centred): THE STATUE IN HONOUR OF / THE LATE LORD OLIVIER / TO MARK THE OPENING OF THE MAYBIRD CENTRE / NAMED IN MEMORY OF MAY BIRD / THE WIFE OF TOM BIRD FOUNDER OF THE BIRD GROUP UNVEILED BY TIM PIGOTT-SMITH / on 19th April 1990 / The bronze used was recycled by the Bird Group / From Obsolete Military Equipment
Condition: good
Status: not listed
Commissioned by: Bird Group (Developers of the site)

The full length, larger-than-life-figure stands on his base clad in full armour and holding a helmet under his left arm. In his right hand he holds a sword horizontally above his head as if signalling victory.

Lawrence Olivier (1907–89) made his stage debut at the age of fifteen as Kate in a boys' performance of *The Taming of The Shrew* at the Shakespeare Festival Theatre in Stratford-upon-Avon. During the late 1930s he consolidated his role as a Shakespearean actor by playing a series of leading roles at the Old Vic theatre including Toby Belch, Henry V, Macbeth, Hamlet, Iago and Coriolanus. He played the leading role in a film version of *Henry V* made in 1943–4, lauded as the first successful Shakespeare film. After the Second World War, he was a joint-director of the Old Vic and continued to play leading Shakespearean roles. He became the first Director of the newly reformed National Theatre in 1963, and continued to act almost to the end of his life, although his stage career ended in 1974 as he began to focus more on films and television.[1]

The Maybird Centre is an out-of-town shopping area opened in 1990 by the Bird Group who developed the site. It was built on

Blakeley, *Olivier as Henry V*

the site of the original scrap metal yard of Tom Bird, who, although illiterate, founded the company that is today a multi-million-pound, multi-national business, based on metal recycling but with interests in many different fields including property development.

The sculpture, weighing 1¼ tons, seems to acknowledge the debt both Henry V and The Bird Group owe to military hardware. It cost £40,000 and was unveiled by Tim Pigott-Smith as part of the official opening of the shopping centre.

Note
[1] Stephens, L. and Lee, S. (eds), *Dictionary of National Biography*, London, 1986–90.

## *Chapel Lane*
### *The Great Gardens of New Place, east side*

## Old Town Hall Column
### Stonemason: John Page of Chipping Camden

Executed: *c.*1633–4
Column: stone 3m high × 40cm wide approx
Inscription: on plaque at base: COLUMN / FROM THE / FIRST TOWN HALL / OF STRATFORD ON AVON / BUILT A.D. 1633
Condition: fair
Status: not listed
Commissioned by: Stratford-upon-Avon Borough Council
Owner/Custodian: Shakespeare Birthplace Trust

This squat Doric column is one of seven original columns, two to the north (now Sheep Street), four to the east (now Chapel Street) and the corner column which, along with the two engaged columns (one to the north and one to the west), supported the eight round-headed arches of the original seventeenth-century Town Hall, built by John Page of Chipping Camden, who was a mason and owner of the Westington Quarries. It was severely damaged in 1643 by an explosion of gunpowder being stored there by the Parliamentary forces staying in town during the English Civil War. It was repaired in 1661 when funds were raised by public subscription. In 1713 the Mayor was granted the use of the building, but despite this official status, it fell into disrepair and by 1767 plans were afoot to replace the semi-derelict building with the current town hall.[1] A surviving sketch of the old Town Hall by James Saunders shows the columns in the ground-

**Page,** *Old Town Hall Column*

floor arcade, but as this dates from *c.*1810, within living memory of, but after the demolition of, the building, it is not particularly detailed.[2]

Notes
[1] MacDonald, M., *The Town Hall Stratford-upon-Avon*, Stratford-upon-Avon, 1986, p.3. [2] Shakespeare Birthplace Centre, Stratford Record Office files, ER1/27/77.

*The Great Gardens of New Place (west side)*

## *Shakespeare Monument*
### Sculptor: Thomas Banks

Installed: November 1870
Relief, 1789: stone
Plinth, 1870: stone 1.83m high
Whole: 5m high × 3m wide approx
Inscriptions: (on 1870 plinth) (centred) (serif):
THIS ALTO RELIEVO / REPRESENTING SHAKESPEARE SEATED BETWEEN THE DRAMATIC MUSE AND THE GENIUS OF PAINTING / (FORMERLY IN FRONT OF THE SHAKESPEARE GALLERY, PALL MALL, LONDON)/ WAS PRESENTED TO THE TOWN BY /

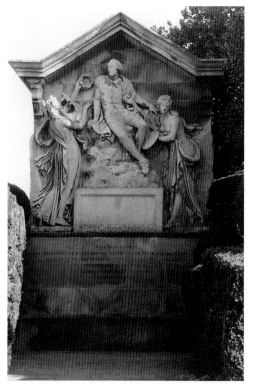

**Banks,** *Shakespeare Monument*

CHARLES HOLTE BRACEBRIDGE ESQ., / ATHERSTONE HALL, / 1871
on tablet in work: HE WAS A MAN. TAKE HIM FOR ALL IN ALL / I SHALL NOT LOOK UPON HIS LIKE AGAIN [*Hamlet*, Act I, Scene 2]
Condition: poor
Status: Grade II*
Relief commissioned by: John Boydell
Owner/Custodian: Shakespeare Birthplace Trust

The *alto relievo*, or high relief of the semi-reclining, full length, life-size figure of Shakespeare is raised up on a plinth of rocks on top of the inscription plaque which was erected for it in 1870. He wears a jacket with lace collar and cuffs with a drape over his left shoulder. Shakespeare supports himself with his right hand and looks to the right. His left hand rests on the shoulder of the Genius of Painting, represented as a full length, semi-nude, female figure. Her head is at Shakespeare's waist level and she looks out of the composition, slightly down and slightly to her left. Her right hand is raised towards Shakespeare and her left hand, which is turned into the centre of the composition, holds a painter's pallet and brushes. On Shakespeare's right side, and at the same level as Genius, is the Dramatic Muse. Again represented as a full length, semi-nude, female figure, she is turned towards Shakespeare and looks up at him. She offers Shakespeare a bay wreath with her left, up-raised hand, while her right hand is half raised towards the central figure. She supports a small harp on her chest.

John Boydell wanted to establish an English school of historical painting in London with emphasis on scenes from Shakespeare. His Shakespeare Gallery, designed by George Dance the Younger, opened in Pall Mall in 1789. Boydell commissioned the sculptor Thomas Banks RA to produce the relief. It adorned the façade of the building, which had

been owned by the British Institute since Boydell's death, c.1805, until it was demolished in 1868. The relief was then bought from the disposal agents Trollope & Sons for £75 by Charles Holte Bracebridge of Atherstone Hall with a view to presenting it to Stratford-upon-Avon.

Although nearly a century earlier the *European Magazine* had described the sculpture in 1791 as 'the most perfect piece of sculpture that has yet been produced by a native of Great Britain',[1] it took Bracebridge a while to overcome resistance in the town to such a monument; the general feeling was that any monument should be in the form of a theatre. Mr Halliwell, the trustee of the Great Gardens of New Place (Shakespeare's home) had stated that he would not have 'Boydell's rubbish' in New Place.[2] On the work's arrival in Stratford on 14 July 1870, it was discovered that two of the five strings of Poetry's lyre and a segment of the garland she held aloft were missing, but the missing pieces could not be found. Charles Flower loaned his brewery's dray horses to transport it from the railway station and a Mr Edward Gibbs supervised its unloading and erection. It was cleaned during that autumn with a mixture of soap, soda and lime to remove the accumulated grime.[3] There are no records of any formal unveiling ceremony, although the *Stratford-upon-Avon Herald* of 18 November 1870 records the work as having been completed.[4]

In 1882–3 a Mr Baker of Wellesbourne was employed to overhaul and restore the work, when a cornice was added 'for its better protection and preservation'.[5]

Notes
[1] *European Magazine*, XX, 1791, p.165. [2] Benton, M. and Norbett, C., *The Story of Stratford's Alto Relievo in the Great Garden of New Place*, Stratford-upon-Avon, unpublished article. [3] *Ibid*. [4] *Stratford-upon-Avon Herald*, 18 November 1870. [5] Kimberley, M., *Lord Ronald Gower's Monument to Shakespeare*, Stratford-upon-Avon Society, 1989.

Sources
Dorothy Stroud, *George Dance, architect, 1741–1825*, London, 1971; Smith, John Thomas (ed.), *Nollekens and his times: and memoirs of contemporary artists from the time of Roubiliac, Hogarth and Reynolds to that of Fuseli, Flaxman and Blake*, London and New York, 1920; Bell, C.F. (ed.), *Annals of Thomas Banks, sculptor, Royal Academician, with some letters from Sir Thomas Lawrence, P.B.A. to Banks' daughter*, Cambridge, 1938, pp.73–4, 85.

## The Great Gardens of New Place

# *The Tempest*
## Sculptor: Greg Wyatt

Unveiled: 23 April 1999[1]
Sculpture: bronze 2.2m high approx
Base: stone 1m diameter approx
Signature: (on the back of the sculpture, below the plaque to the right): Greg Wyatt 1999
Inscriptions: (quote on the back of the work:
EPILOGUE / fpoken by Profpero / Now my Charmes are allore-throwne / And what ftrength I have's mine owne, / Which is moft faint: now, 'tis true, / I muft be heere confinde by you, / Or fent to Naples, Let me not, / Since I have my Dukedome got / And pardon'd the deceiuer, dwell /In this bare-Ifland by your fpell; / But releafe me from my bands / With the helpe of your good hands: / Gentle breath of yours, my failes / Muft fill, or elfe my project failes, / Which was to pleafe.
Now I want / Spirits to enforce; art to cnchant, / And my ending is defpaire, / Vunleff I berelieu'd by praier, / Which pierces fo that it affaults / Mercy itfelfe and frees all faults. / As you from crimes would pardon'd be, / Let your Indulgence fet me free. / Exit.
plaque beneath: "THE TEMPEST" / BY GREG WYATT / PRESENTED TO THE / SHAKESPEARE BIRTHPLACE TRUST BY / MRS. JOHN C. NEWINGTON , CHAIRMAN, / AND THE TRUSTEES OF THE / NEWINGTON CROPSEY FOUNDATION, / HASTINGS-ON-HUDSON, NEW YORK, APRIL
Condition: good
Status: not listed
Commissioned by: Newington-Cropsey Foundation

Wyatt, *The Tempest*

Owner/Custodian: Shakespeare Birthplace
   Trust

A free-standing expressionistic bronze, patinated green and brown, on a polygonal pedestal. Elements of the bronze depict a tree, a ship's prow and masts, waves, a mature bearded male head, an eagle's wing and at the top a younger face. The overall design appears like a gnarled tree trunk from a few feet away and the narrative elements only become apparent on close inspection. From the far side of the gardens, the front of the work suggests a crouched, goblin-like creature, possibly a sneering Caliban. The whole composition depicts Prospero's island rising from the sea.

   *The Tempest* is the first of a planned series of about a dozen sculptures based on Shakespeare's plays to be commissioned from Greg Wyatt for the Great Garden of New Place. The site for this first work was formerly occupied by the carved stone base of a sundial, which was suffering frequent vandalism and had been moved into store.[2]

Notes
[1] *Stratford-upon-Avon Herald*, 29 April 1999.
[2] Information provided by Staff at New Place.

## *Chapel Street*

### *Corner with Ely Street*

## *Scenes from Shakespeare*
## Sculptor: Samuel Barfield
## Architect: Harris, Martin and Harris

Executed: 1885
Reliefs: terracotta (red) various up to 80cm
   wide approx
Decorative tiles: terracotta (red)
Inscriptions: on arch (Gothic Script): OLD BANK
Above arch (Midbank sans serif): MIDLAND
   BANK
On mosaic (left): THE / OLD / BANK

On mosaic (right): ESTB / 1810
Condition: good
Status: Grade II
Commissioned by: Birmingham Banking
   Company
Owner/Custodian: HSBC (formerly Midland
   Bank)

The bank, erected on the site of an earlier building in 1883, is one of Stratford's few Victorian Gothic buildings. It stands on the acute angle of the junction of two streets with a pyramidal spired angle turret at the point of convergence of the two façades. Entrance is through an arch supported on pillars of Peterhead granite with Corinthian capitals at the base of the turret. It is built of red brick, with stonework, especially around the windows, and decorated with red terracotta tiles of floral design. Fifteen terracotta relief tiles depicting scenes from Shakespeare's plays form a band around the building between the ground and first floors. They are distributed around the building, nine on the east side (Chapel Street), one larger than the rest, above the north-east entrance, and five on the north side (Ely Street). From far left the scenes represent:

1. King Lear and his fool being driven out into the storm.
2. Hamlet confronting Gertrude and Claudius with the poisoned cup.
3. Macbeth and the three witches.
4. Othello and the murdered Desdemona.
5. A scene in the forest of Arden from *As You Like It*.
6. Valentine, Silvia, Proteus, and Julia from *Two Gentlemen of Verona*, Act V, Sc. 4.
7. 'Bottom, thou are translated' from *A Midsummer Night's Dream*.
8. Viola and Sir Andrew Aguecheek nearly come to blows in *Twelfth Night*, Act III, Sc. 4.
9. Coriolanus with Virgilia and Volumnia.

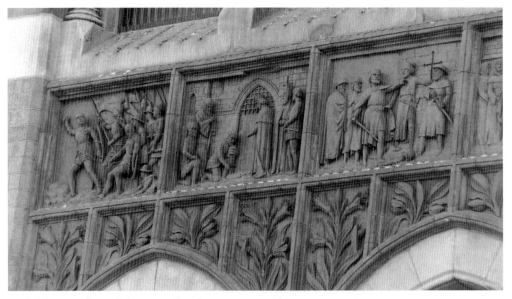

Barfield, *Scenes from Shakespeare* (detail – Nos 12, 13 and 14)

10. (Above main entrance) The casket scene from *The Merchant of Venice*.
11. *Anthony and Cleopatra*, Act IV, Sc. 4.
12. 'Once more unto the breach', *Henry V*.
13. Bolingbrook kneels to Richard before Flint Castle. The Bishop of Carlisle is in attendance, *Richard II*, Act III, Sc. 3.
14. The death of Prince Arthur, *King John*, Act IV, Sc. 3.
15. Gloucester asks Anne Neville to kill him, *Richard III*, Act I, Sc. 2.

Inside the arch above the main door is a mosaic of Shakespeare based on the half-length figure in the Holy Trinity Church overlooking Shakespeare's grave. The figure, said to have been made fairly soon after the poet's death, is probably based on the death mask. On the next level up the *Merchant of Venice* panel is flanked on either side by shields bearing the coat of arms of Birmingham on the left, and Stratford on the right. The style and execution of the building and of the panels shows Arts and Crafts influence, and the compositions of the narrative panels are reminiscent of Pre-Raphaelite paintings. They are illustrated in the *Building News*, 25 April 1884.[1] The inscriptions 'The Old Bank' and 'ESTB 1810' refer to a bank on 33 High Street owned by the firm Oldaker, Tomes, and Chattaway. The 'Old Bank' moved to the site in Chapel Street in 1830, and was taken over by the Stourbridge and Kidderminster Bank in 1834. This in turn was amalgamated with the Birmingham Banking Company in 1880, and then with the Midland Bank in 1914.[2] The Midland Bank has since become part of the HSBC group.

Notes
[1] *Building News*, 25 April 1885. [2] Bird, V., *I Know a Bank*, Midland Bank Group Newsletter, November 1972.

## Henley Street
*On the façade of Costa Coffee building*

### Ornate Façade
#### Carver: unknown

Executed: 1924
Wood, each figure 30cm high approx
Condition: good
Status: not listed
Owner/Custodian: Costa Coffee

Contemporary carved heads and figures with goats' legs adorn the angles of the building and act as corbels to the projecting second storey. On the Henley Street side are three heads: a king wearing a crown, and two female heads wearing ornate headpieces; and three figures: one has a crown and scroll, one has the characteristic features of Shakespeare with a hawk in one hand, and one, who could be Hamlet, holds a skull. On the Union Street side are three more heads: a man, a woman with ringlets, and a woman in a headdress; and four figures: one with horns and a bowl, one with folded arms, one with his hands on his knees, and one female with long hair and hands crossed between her legs. On the corner is the head of a bearded man holding a tankard. On the brackets below the heads are carvings of Tudor Roses. The first-floor window frames are decorated with vines, and the initials 'N' and 'P' are carved on shields on either side of the door. The lead downspouts bear the date 1924.

*Gardens of The Shakespeare Birthplace Trust*

### Sundial (Memorial to Alderman Leigh Dingley)
#### Sculptor: John Skelton

Installed: 1971
Plinth: polished grey slate 1m high approx
Sundial: bronze arc of circle that would have diameter of 1m

Unknown, *Ornate Façade*

Skelton, *Sundial*

Inscriptions: 1971
  on plinth: THE SUN/WITH ONE/ EYE/ VIEWETH/ ALL THE/ WORLD.
  on base: Remember Alderman Leigh Dingley 1896–1970 A trustee of Shakespeare Birthplace Trust
Condition: good
Status: not listed
Commissioned by: Mrs M. Marshall, as a gift to the gardens in memory of her father
Owner/Custodian: The Shakespeare Birthplace Trust

The sundial is constructed of simplified arcs with Roman numerals inscribed on its horizontal face 'VI, V, IV, III, II, I, XII, XI, X, VIII, VII, VI'.
  Alderman Dingley was a member of the executive committee of the Trust.[1] Skelton had already worked on several sculptural features of the 1964 Shakespeare Centre building, including the Shakespeare coat of arms on the façade.

Note
[1] Fox, L., *The Shakespeare Birthplace Trust a Personal Memoir*, Norwich, 1997, p.244.

*Wall of The Shakespeare Centre 1981 extension*

## Shakespeare Coat of Arms
### Sculptor: John Skelton

Unveiled: 26 April 1964
Fibreglass 2.7m high × 1m wide approx
Inscription: in motto: NON SANS DROICT
Condition: good
Status: not listed
Commissioned by: The Shakespeare Birthplace Trust
Owner/Custodian: The Shakespeare Birthplace Trust

This tripartite work includes separate pieces for the shield, the motto and the falcon. The shield is gold coloured with a diagonal chevron in black with a silver coloured lance on it. The falcon above also holds a lance. The design and production of coats of arms has been an important sculptural task for many generations. Here John Skelton has followed this tradition in function and concept, but has taken advantage of modern artistic freedom in his interpretation and visual presentation.
  The coat of arms is that of William

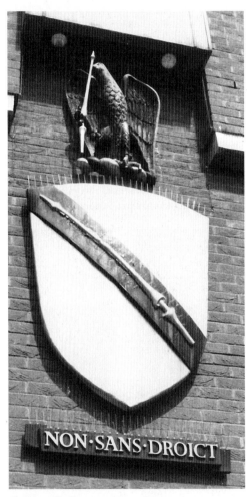

**Skelton,** *Shakespeare Coat of Arms*

Shakespeare (1564–1616), whose family arms were granted to William's father John in 1596, although he had first applied for them in 1568. The arms granted were a gold shield on a bend sables, a spear of the first steeled argent, and for his crest a flacon, his wings displayed argent, standing on a wreath of his colours, supporting a spear gold, steeled set upon a helmet with mantles and tassels. The falcon comes from the arms of his patron, the Earl of Southampton. The spear in the coat of arms may be an obvious pun on Shakespeare's name. Shakespeare is known to have used the motto 'non sanz droict'.[1]
  The Coat of Arms was erected on 26 April 1964, four days after the Centre opened. It was originally placed on a timber-clad wall to the left and at right angles to the curved wall of the Centre. The earliest photographic evidence of the shield in its current location is dated 1981.
  John Skelton also inscribed the 7-metre granite panel at the entrance to the original part of the Centre and carved a smaller cedarwood version of the Shakespeare coat of arms, which can be seen in the conference room inside the Shakespeare Centre.

Note
[1] Well, S., *Oxford Dictionary of Shakespeare*, Oxford, 1998, p.7.

*Wall of The Shakespeare Centre*

## Abstract Relief
### Sculptor: Douglas Wain Hobson

Unveiled: 22 April 1964
Bronze 1.5m high × 2m wide × 35cm deep approx
Condition: good
Status: not listed
Commissioned by: The Shakespeare Birthplace Trust
Owner/Custodian: The Shakespeare Birthplace Trust

This abstract relief is composed of spiral and cube motifs that form an effective contrast between the grey patina of the work and the red brick of the wall. The artist described its intended symbolism in the *Stratford-upon-Avon Herald* in 1964:

> I have tried to create in terms of a sculptured relief the abstract symbolism of Shakespeare's greatness. The sculptural blocks on the left represent the number of works produced by Shakespeare … the sonnets and poems being represented by one slightly larger block in the centre. These blocks are embraced by a large fan-like shape sweeping towards and encircling a round form that is meant to represent the world. The shape is the active power and genius of the man. The larger of the two rounded forms at the top is Shakespeare and the smaller one divine inspiration. The square shape behind all this, which is made up of boards, is meant to represent the theatre and I had, of course, the Globe in mind.[1]

Levi Fox, then Director of the Trust, described the commissioning of this relief in his memoirs:

> Lawrence Williams [the architect] and I considered the treatment of the approach to the building to be all important. From the

**Wain Hobson,** *Abstract Relief*

beginning, we had shared with the Trustees the feeling that the exterior brickwork of the curved end of the reading room facing Henley Street needed some kind of relief. Various suggestions were made and explored, and the solution was eventually found when the sculptor, Douglas Wain Hobson, an Associate of the Royal College of Art, was commissioned to produce a sculptured relief in bronze, abstract in design, to be fixed on the upper part of the curved, brickwork wall immediately to the left of the portico entrance. It is a striking piece of architectonic modelling, a visualisation of the influence of Shakespeare emanating from his plays and encircling the world.[2]

Notes
[1] *Stratford-upon-Avon Herald,* 10 April 1964.
[2] Fox, L., *The Shakespeare Birthplace Trust a Personal Memoir*, Stratford-upon-Avon Society, 1997, p.163.

*Entrance to The Shakespeare Birthplace Trust Gallery*

## Characters from the Works of Shakespeare ('Hutton's Glass Engravings')

### Sculptor: John Hutton

Unveiled: 22 April 1964
11 panels: glass, each 2.3m high approx
Condition: good
Status: not listed
Commissioned by: The Shakespeare Birthplace Trust
Owner/Custodian: The Shakespeare Birthplace Trust

The artist gave a detailed description of the panels and his working method to Levi Fox, Director of the Shakespeare Birthplace Trust at the time of the commission:

I was asked to design and engrave on glass some figures from Shakespeare's plays, and the first problem lay in deciding which characters could, without a detailed background, be instantly recognisable to people who were not deeply versed in Shakespearian scholarship. In the end, it was decided that I show only those figures from Shakespeare's tragedies, comedies and historical plays who could stand by themselves without distracting background detail. Those selected are:

Tragedies: Macbeth and Lady Macbeth, Hamlet and Ophelia, King Lear and Cordelia, Romeo and Juliet, Othello and Desdemona
Histories: Anthony and Cleopatra, Julius Caesar, King Richard III
Comedies: Falstaff, Titania and Bottom, Portia and Shylock

As the emotional scope of engraved glass is limited, I have concentrated on the heads and hands, without any particular accent on the dress of the period. Where two figures are shown on the same panel, I have chosen those which are strongly related by emotional tension. For instance, Othello is gripping Desdemona's arm, accusing her over the finding of the fatal handkerchief. In portraying Macbeth and Lady Macbeth, I have shown the hallucinations that their imaginations conjured up – in Macbeth's case the dagger, and in Lady Macbeth's case the blood on her hands, which was, of course, real enough in the scene where she smeared the grooms' faces so cold-bloodedly. The technique is a fairly realistic one, as I do not find it possible to see these figures as mere abstract patterns – they have for me too much humanity and passion. The engraving is done with a series of grindstones attached to a flexible drive, and the glass is ordinary plate glass. The

**Hutton**, *Characters from the works of Shakespeare – Lady Macbeth*

**(right) Hutton**, *Characters from the works of Shakespeare – Falstaff*

outstanding quality of engraved glass of this kind is the way it can change as one sees it in different lights and as the spectator moves to different parts of the room. It should be evanescent and not wholly visible from all points of view. Seen against different backgrounds, the faces change and reveal the different aspects of their expressions. I have used this particular quality of changeability of expression to try and pay tribute to the extraordinary variety of interpretation offered by Shakespeare's characters.[1]

The differing engraving techniques have been used to elicit different emotional responses in the viewer.[2] Thus the lines of Romeo and Juliet are far softer than the hard chiselled lines of Julius Caesar, and the deeply modelled and roughly textured features of Macbeth or Richard III appear harsh in contrast to Falstaff's fleshiness which has been achieved by polishing with emery papers.

Levi Fox explained in his memoirs why the commission came about:

> The architect and I felt it desirable to relieve the bareness of the large expanse of glass by engraving, and we suggested to John Hutton … that here was an opportunity to illustrate the theme of Shakespeare's understanding of humanity by portraying on glass panels his principal characters.[3]

John Hutton was enthusiastic about the project, quickly producing preliminary designs which were approved by the Trustees on 2 January 1963. Hutton devoted the following 15 months to the project, working on the panels in his studio in Maida Vale, London.

The panel of King Lear and Cordelia was broken in 1999 and has been replaced by a copy made by Jennifer Conway, the late John Hutton's pupil.

Notes
[1] Fox, L., *The Shakespeare Birthplace Trust a Personal Memoir*, Norwich, 1997, pp.165–7. [2] The

Shakespeare Centre, *Art Work and Design*, publicity leaflet, Stratford-upon-Avon, *c.*1999. [3] Fox, L., *op. cit.*, pp.164–5.

*The Shakespeare Centre entrance hall*

## Relief of Harry the King
### Sculptor: Angela Conner

Unveiled: 22 April 1964
Metal relief 80cm high × 30cm wide approx
Inscription: HARRY THE KING/ "A LARGESS
   UNIVERSAL, LIKE THE SUN"
Condition: good
Status: not listed
Commissioned by: The Shakespeare Birthplace
   Trust
Owner/Custodian: The Shakespeare Birthplace
   Trust

This shallow relief depicts a standing figure of the youthful Henry V in armour, over which he appears to be wearing a doublet. He holds a sword in his left hand and raises his right in a gesture intended to silence his followers. He is bareheaded, but a crown floats above his head to remind the viewer of his assumption of the throne on the field of battle. The crown is in higher relief than the other elements of the work. The bold but simplified style of the relief is entirely appropriate to the spirit of the character from Shakespeare's play that it portrays.

Conner, *Harry the King*

## Statue to William Shakespeare ('Wain Hobson Shakespeare')
### Sculptor: Douglas Wain Hobson

Unveiled: 22 April 1964
Bronze 2.2m high approx
Condition: good
Status: not listed
Commissioned by: Shakespeare Birthplace
   Trust
Owner/Custodian: Shakespeare Birthplace
   Trust

This over-life-size figurative statue depicts William Shakespeare as a middle-aged man, somewhat stout but strong with a truly monumental stature. He is standing and has a quill in his right hand and a slate in his left hand. On the back of his cloak are two emblematic signs: on the one side a fox's head (symbolic of Levi Fox, then Director of The Shakespeare Birthplace Trust) and, on the other, a flower (symbolic of Mr Flower of Flower's Brewery, patron of The Shakespeare Birthplace Trust).

   The Shakespeare Centre was built for The Shakespeare Birthplace Trust in the early 1960s. Levi Fox described the commissioning of this statue and the artist's methods in his memoirs:

   In June 1963 Douglas Wain Hobson, who was already working on the abstract plaque for the exterior of the centre, was commissioned to produce a statue of William Shakespeare in bronze, as a centre piece for the entrance hall, to be set against the background of an off-white marble screen. Raised on a plinth, the full-size standing representation of Shakespeare is a striking focal point for the entrance hall and looks straight across the garden of his birthplace. The dramatist is depicted as a powerful, almost dominating figure: a big character, portraying the all-embracing and

**Wain Hobson,** *Shakespeare*

3–dimensional impression and leading to a full-scale plaster model used for casting the bronze statue. When finished it was a considerable weight, and I well remember how it was transported from the foundry in London to the Shakespeare Centre, lying on a wooden cradle on a low-loading vehicle.[1]

For details of Shakespeare's life, see the entry for the 'Gower Memorial', *Bridge Foot*.

Note
[1] Fox, L., *The Shakespeare Birthplace Trust a Personal Memoir*, Norwich, 1997, p.167.

*In foyer of The Shakespeare Centre*

### Levi Fox Commemorative Plaque

### Letter carver: Richard James Kindersley

### Sculptor: Paul Vincze

Unveiled: 26 September 1989
Plaque: light coloured stone 35cm high × 25cm wide approx
Portrait medallion: bronze
Inscription: Dr LEVI FOX / OBE DL MA FSA FRHists FRSL / A true lover of Shakespeare / The Director / who administered / The Shakespeare Birthplace / Trust / with great wisdom & foresight / 1945–1989 / Si monumentum requiris circumspice. [the latter meaning 'If you require a monument, look around you.']
Condition: good
Status: not listed
Commissioned by: The Shakespeare Birthplace Trust
Owner/Custodian: The Shakespeare Birthplace Trust

The plaque incorporates a portrait of Levi Fox in profile, and an inscription composed by the Executive Committee of the Birthplace Trust,[1] and was unveiled by the subject himself on the

everlasting genius of a unique personality and symbolising the vitality of the first Elizabethan age. It was a fascinating experience for me to follow the progress of the sculptured figure, starting with an outline sketch illustrating the sculptor's idea, followed by a maquette designed to give a

occasion of his retirement as Director of the Trust.

Levi Fox was awarded a first class Honours degree in History from Oxford University. He was the first City Archivist of Coventry (1938–40), Director of the Shakespeare Birthplace Trust (1945–89), and then Director Emeritus (1989–). During these years he was also Deputy Keeper of the Records of Stratford-upon-Avon. He is recognised as an authority on the records and history of Stratford-upon-Avon and Warwickshire, and has a considerable number of publications to his credit. He was a Trustee of Harvard House (1949–91).

Note
[1] Fox, L., *The Shakespeare Birthplace Trust a Personal Memoir*, Norwich, 1997, pp.343–4.

**Kindersley,** *Levi Fox Commemorative Plaque*

*In The Shakespeare Centre Library, facing the librarian's desk*

## Decorative Wall Panel
### Designer: Nicolette Gray

Unveiled: 22 April 1964
English cherry wood, silver sycamore, rosewood, camwood, African redwood and ebony 1m high × 4m long approx
Condition: good
Status: not listed
Commissioned by: The Shakespeare Birthplace Trust
Owner/Custodian: The Shakespeare Birthplace Trust

This attractive panel in the natural colours of five different woods is inscribed with the names of poets and dramatists contemporary with Shakespeare. More rounded lettering is used for the names of writers of comedy, while the sharper letter shapes on the right-hand side of the panel are used for the names of writers of tragedy. The size of the names suggests the relative importance of the writers, with Shakespeare's name being written in far larger letters than those of the other authors. It dominates the centre of the panel, with relief lettering over the sphere in the middle representing his most active years at the Globe theatre.[1]

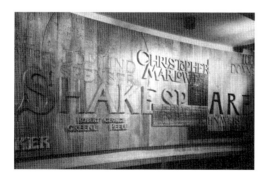

Gray, *Decorative Wall Panel*

Note
[1] The Shakespeare Centre information leaflet.

*Junction with Windsor Street*

## The Stratford Jester
### Sculptor: James Walter Butler
### Foundry: Mike Davis

Unveiled: 22 July 1994
Jester: bronze 2.24m high × 98cm wide × 1.15m deep
Plinth: Westmorland stone 92cm high × 88cm wide × 88cm deep tapering to 54cm wide × 54cm deep
Base: Hornton stone 1.09m high × 1.35m deep
Signature: JAMES BUTLER RA 1992 [by hand, monogram under signature]
Inscriptions: (serif) (title of play in smaller capitals): (NE side) FOOLERY, SIR, DOES WALK / ABOUT THE ORB LIKE THE SUN; / IT SHINES EVERYWHERE / (TWELFTH NIGHT)
SE side: O NOBLE FOOL! A WORTHY FOOL! / (AS YOU LIKE IT)
NW side: ALAS! POOR YORICK ./ I KNEW HIM HORATIO; / A FELLOW OF INFINITE JEST. / (HAMLET)
SW side: THE FOOL DOTH THINK HE IS WISE / BUT THE WISE MAN KNOWS / HIMSELF TO BE A FOOL. / (AS YOU LIKE IT)
on plaque inscription on plinth (SE side) (centralised): THE JESTER / BY JAMES BUTLER R.A./ UNVEILED BY THE LORD LIEUTENANT / OF WARWICKSHIRE / THE RT. HON. THE VISCOUNT DAVENTRY / ON 22ND JULY 1994 / A GIFT FROM ANTHONY P. BIRD O.B.E. / TO STRATFORD UPON AVON AS A TOKEN OF / HIS ESTEEM FOR THE TOWN IN WHICH HE / WAS BORN, LIVES AND WORKS AND WHICH / HAS GIVEN HIM SO MUCH FRIENDSHIP, / GOOD FORTUNE AND PLEASURE
on plaque on NE side of base, inscribed above and below a coat of arms: STRATFORD-UPON-AVON DISTRICT COUNCIL / that what in time proceeds May token to the future of our post deeds / opened by the chairman of the council / Councillor Mrs Ruth Styles on Wednesday, 10 May 1989 / Henley Street Pedestrian Priority Area
Condition: good

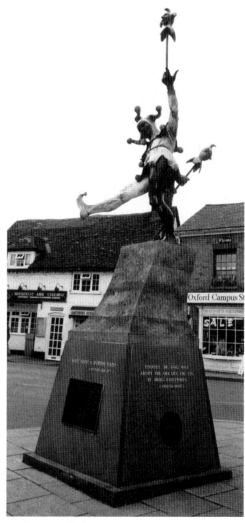

Butler, *Stratford Jester*

Status: not listed
Commissioned by: Anthony P. Bird
Owner/Custodian: Stratford-upon-Avon
    District Council

The figurative full length sculpture represents a jester in active stance. It is mounted on a pedestal comprising two blocks of machine cut and polished stone, one on top of the other. The Jester holds a poll (a small head on a stick) with the mask of comedy balanced on his upraised left hand. His right hand is behind his back concealing a poll with a mask of tragedy. The bronze has been chemically treated and heated during the manufacturing process to give a mature patina of rich greens and browns like the costume of a Harlequin. The design of the costume is based on drawings from theatre programmes of Shakespeare's time.

James Butler has explained his choice of the Jester as a subject:

The character of the Fool or Jester appears in many Shakespeare plays and I decided to portray him dancing – almost leaping off his plinth. He is holding two polls. One is smiling, one is grim. They represent the symbols of drama.[1]

Butler sees the Jester as symbolising the precarious balance of life: 'my point being that we dance through life finely balancing optimism above us, but tragedy lurks behind'.[2] This point is strengthened by means of the contrast between the rough stone base and the polished dancing figure with its finely modelled detail. The model for the Jester was the international mime artist John Mowat who danced and struck various poses to inspire Butler's final form.[3]

James Butler was approached by Anthony Bird, a member of a local family that now owns a multi-national company, after 'an aborted competition that produced nothing of interest'.[4] Butler first decided upon a figurative group portraying the seven ages of man from the

soliloquy by Jacques in *As You Like It* but the cost was prohibitive.[5] The work was modelled in clay, being based on sketches by John Mowat, and was then cast in six sections by Mike Davies at his specialist foundry near Milton Keynes.[6] The plinth was erected some time before the figure, (it was said because Anthony Bird did not want the Jester added until the end of the recession), and many people believed the plinth was the sculpture.[7] The unveiling 'took the form of a frame of wheels that was made to look like a Punch and Judy stall in bright coloured fabric that had curtains on the front that were opened to reveal the sculpture and then the frame was wheeled away'.[8]

Notes
[1] Letter from the artist/sculptor/ architect, James Butler, 26 June 1998. [2] *Ibid.*, 13 March 2000. [3] Press release, 1994. [4] Letter from the artist/ sculptor/architect, James Butler, 13 March 2000. [5] *Ibid.* [6] Press release, 1994. [7] *Stratford-upon-Avon Herald*, 14 July 1994. [8] Letter from the artist/ sculptor/architect, James Butler, 13 March 2000.

## High Street

*Next to Garrick Inn*

### *Ornate Façade*
### Sculptor: Unknown

Executed: 1596 and 1907
Wood, varying sizes
Condition: good
Status: Grade I
Commissioned by: Thomas and Alice Rogers
    (1596) and Marie Corelli (1907)
Owner/Custodian: Harvard University

This timber-framed building is decorated with ornamental patterns carved into the timbers. There is a carved frieze of vines and grapes along the bottom of the projecting first floor, a series of heads under the windows in the upper floor, and at ground-floor level a depiction of a

**Unknown,** *Ornate Façade*

dog standing in a heraldic manner with a rose around its collar and above its head. On the other side of the door are a cow and a face. Over the door are two Tudor roses, another in the centre of the ground-floor frieze, four more in the top-floor frieze, and two underneath the projecting-first floor window. At second floor level there are five heads: a knight in chain mail; a grotesque with his tongue out; a bearded man with curly hair; another grotesque, and a lady. Two grotesques are carved into the brackets supporting the upper floor. There is a fleur-de-lys pattern, forming crosses at both first- and second-floor levels. Much restoration has taken place, some of very poor quality. The woman's face on the right-hand side of the door is not matched on the left-hand side, which is obviously more recent. There are four spandrels below the first-floor window in the posts. WR is carved into the central fleur–de-lys behind the bracket holding the sign. In medallions above the first-floor frieze are the initials TR and AR.

The initials are those of Thomas Rogers and his wife Alice, who restored the building in 1596, after the Stratford fire. Amongst the elaborate carvings on the front of the house, is a bull's head, which may refer to Rogers' trade as a butcher. His daughter married Robert

Harvard of Southwark and their son, John, emigrated to New England in 1637, becoming, by his will, the major benefactor of the college which bears his name.

The house had many occupants and owners until it was sold in 1876 to H.W. Newton who undertook substantial restoration necessary because of subsidence. After his death Marie Corelli, the popular Stratford novelist, encouraged Edward Morris, the American millionaire, to buy the house, and she supervised its restoration in 1906–7. Morris subsequently vested the house in Harvard University.[1] A photograph in the *Illustrated London News* in 1909 shows a shield above the door, to the left of the bull's head, with the letters VE RI TAS on three open books within it. The shield is visible in a photograph taken in 1960 but it had disappeared by 1986.[2] Comparison of the photographs of Harvard House in 1899 and 1909 shows that it was the ground floor that was the focus of the restoration in 1907 and that the later brickwork was removed to reveal the original decorated half-timbering beneath. Apart from the bracket heads, all the carvings seen today were executed in 1907.[3]

Notes
[1] Harvard House public information leaflet. [2] The Shakespeare Birthplace Centre, Stratford Record Office files, DR 663/8. [3] Information obtained from photographs in Stratford Record Office.

*Ingon Lane*

*On the Welcombe Hills*

## Memorial to Mark Philips ('Welcombe Bank Obelisk')

### Sculptor: unknown

Installed: 1876
Obelisk: Welsh granite 36.6m × 5.6m
Inscriptions: (west side) (centralised) (sans serif): ROBERT NEEDHAM PHILIPS / BORN AT

THE PARK MANCHESTER / JUNE 20TH. 1815 / DIED AT WELCOMBE WARWICKSHIRE / FEBRUARY 20TH.1890 / HE WAS A MERCHANT AND MANUFACTURER IN MANCHESTER; / HE REPRESENTED BURY IN PARLIAMENT FOR 22 YEARS; / AND WAS INTIMATELY CONNECTED WITH THE NEIGHBOURHOOD, / WHERE HE PASSED THE CLOSING YEARS OF HIS LIFE. / HE WILL BE REMEMBERED AS / A PUBLIC SPIRITED CITIZEN, / A STRENUOUS POLITICIAN, AND / A WARM HEARTED NEIGHBOUR.
(east side) (centralised) (sans serif): ROBERT PHILIPS / FATHER OF MARK AND ROBERT NEEDHAM PHILIPS / A LEADING CITIZEN OF MANCHESTER / AND A LANDED PROPRIETOR AT / SNITTERFIELD IN THIS COUNTY / HE WAS A WISE AND A BRAVE MAN / A FRIEND OF LIBERTY IN EVIL DAYS / BORN APRIL 3RD. 1760 DIED MARCH 14TH. 1844.
(north side) (centralised) (sans serif): MARK PHILIPS / BORN AT THE PARK PRESTWICH LANCASHIRE NOVEMBER 4TH 1800 / DIED AT WELCOMBE STRATFORD ON AVON WARWICKSHIRE DECEMBER 23RD 1873 / ON THE PASSING OF THE REFORM BILL / HE WAS ELECTED IN 1832 THE FIRST MEMBER FOR MANCHESTER AND CONTINUED / TO REPRESENT IT FOR 15 YEARS WHEN THE STATE OF HIS HEALTH / COMPELLED HIM AGAINST THE URGENT WISH OF HIS CONSTITUENTS / TO RESIGN THE TRUST WHICH HE HAD SO ABLY FULFILLED / IN HIS PUBLIC CAREER HE WAS DISTINGUISHED / BY THE COURAGEOUS AND ENERGETIC SUPPORT WHICH HE GAVE / TO THE CAUSE OF EDUCATION AND CIVIL AND RELIGIOUS LIBERTY / BY THE ACTIVE PART HE TOOK IN THE PROMOTION OF COMMERCIAL FREEDOM / AND BY THE MUNIFICENT AID HE AFFORDED IN PROVIDING / PLACES OF RECREATION FOR THE PEOPLE / IN PRIVATE LIFE HIS KIND AND GENEROUS NATURE / COMBINED WITH HIS SOCIAL DISPOSITION AND RARE FLOW OF WIT AND HUMOUR / ENDEARED HIM TO A WIDE CIRCLE OF

FRIENDS / THIS MEMORIAL WAS RAISED IN 1876 / IN TOKEN OF THE DEEPEST ESTEEM AND AFFECTION / OF HIS ONLY BROTHER / ROBERT NEEDHAM PHILIPS
(south side) (family coat of arms) (sans serif, raised): "SIMPLEX HUNDITHS"
Condition: good

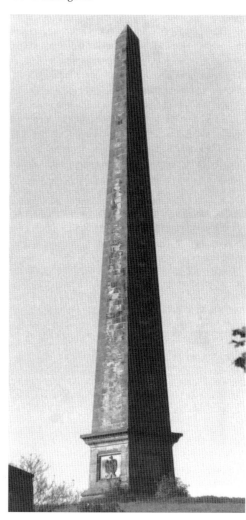

**Unknown,** *Memorial to Mark Philips ('Welcombe Bank Obelisk')*

Status: Grade II
Commissioned by: Robert Needham Philips of Manchester

This large obelisk, which cost £4,000,[1] dominates the surrounding countryside. It is constructed in three main sections: first, two steps and stylobate; second, a square tapered base, then a moulded base with a cornice and inscriptions on three sides and a relief of a coat of arms on the south side; and third, the main shaft of the obelisk gradually tapers to within a couple of metres of the top, before tapering sharply to a point.

The arms of Robert Needham Phillips, who inherited the Welcombe estate from his brother Mark, are: per pale, azure and sable, within an orle of fleur-de-lys, argent, a lion rampant, ducally crowned and holding between the paws a mascle or a canton ermine.[2]

Notes
[1] Pevsner, N., *Buildings of England: Warwickshire*, London, 1966, p.467. [2] *Burkes Landed Gentry*, 1875.

## Mason Road

*Fire station at south end of road opposite entrance to Lodge Road*

## Fireman

### Sculptor: Walter Ritchie

Executed: 1951
Carved brick 2m wide approx
Condition: good
Status: not listed
Commissioned by: Warwickshire County Council
Owner/Custodian: Warwickshire County Council

The relief is carved into the brickwork of the wall above the entrance. It shows a fireman in action, holding a hose. Stylistically, the figure is

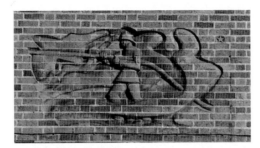

Ritchie, *Fireman*

devoid of naturalistic detail and has an enhanced monumental appearance.

The relief was carved *in situ* by the local artist Walter Ritchie, who was regularly commissioned by the Warwickshire County Council to decorate public buildings.

## Rother Street

*Junction with Wood Street*

## The American Fountain (The Memorial Fountain)

### Stonemason: Robert Bridgeman & Sons of Lichfield

### Designer: Jethro Cossins

Unveiled: 17 October 1887
Superstructure: Bolton wood (York) stone
Base and troughs: Peterhead granite
18m high approx
Inscriptions: (south side) (centralised) (serif): THE GIFT OF AN AMERICAN CITIZEN / GEORGE W. CHILDS. OF PHILADELPHIA / TO THE TOWN OF SHAKESPEARE, / IN THE JUBILEE YEAR OF QUEEN VICTORIA
(east side) (centralised) (serif): "IN HER DAYS, EVERY MAN SHALL EAT IN SAFETY / UNDER HIS OWN VINE, WHAT HE PLANTS; AND SING / THE MERRY SONGS OF PEACE TO ALL HIS NEIGHBOURS. / GOD SHALL BE TRULY KNOWN;

AND THOSE ABOUT HER / FROM HER SHALL READ THE PERFECT WAYS OF HONOUR, / AND BY THOSE CLAIM THEM GREATNESS, NOT BY BLOOD" / HENRY VIII, ACT., SCENE IV
(north side) (centralised) (serif): "HONEST WATER / WHICH NE'ER LEFT MAN I THE MIRE" (north east buttress): THIS STONE WAS LAID BY LADY HODGSON / JUNE 20TH, 1887 / ARTHUR HODGSON K.C.M.G. / MAYOR. (north west buttress): THIS FOUNTAIN WAS UNVEILED BY / HENRY IRVING / 17TH OCTOBER 1887
(west side) (centralised) (serif): "TEN THOUSAND HONOURS AND BLESSINGS / ON THE BARD / WHO HAS GUILDED THE DULL REALITIES OF LIFE / WITH INNOCENT ILLUSIONS" / WASHINGTON IRVING'S "STRATFORD-ON-AVON"
Condition: fair
Status: Grade II*
Commissioned by: George W. Childs
Owner/Custodian: Stratford-upon-Avon Town Council

The American Fountain is built in the form of a large clock tower with crocketed spire, turrets and foliate architectural decoration. There are alternating statues of the English lion with the Royal shield and the American eagle with the stars and stripes in the angles. There are numerous gargoyles on each façade of the spire taking the form of a monkey, demon, wolf, lion, boar, dog, owl and bat, as well as characters from *A Midsummer Night's Dream* standing above each clock face. In the lower section of each façade is a richly carved roundel, depicting a rose, thistles, a three-leaf clover and corn. Each central motif is surrounded by eight semi-circles including grapes, blackberry, clover, hawthorn, acorns, ivy, horse chestnut, roses and leeks.

*The Illustrated London News* discussed the fountain and its subject matter in some detail in June 1887:

A lofty, spire-like, and highly ornamental drinking-fountain, with clock tower … The base of the tower is square on plan, with the addition of boldly projecting buttresses placed diagonally at the four corners, terminating with acutely pointed gablets surmounted by a lion bearing the arms of Great Britain alternately with the American eagle associated with the stars and stripes. On the north face is a polished granite basin, having the outline of a large segment of a circle into which a stream of water is to flow constantly from a bronze spout: with four curved steps up on the east and west sides are large toughs of the same general outline and material, for the use of horses and cattle, and beneath these smaller troughs for sheep and dogs. On the south side is a door affording admission to the interior, flanked by two shallow niches … Immediately over the basins and the door are moulded pointed arches, springing from dwarf columns, with carved capitals. The tympanum of each arch is filled with geometric tracery profusely enriched with carvings of foliage. The next storey of the tower has on each face a triple arcade with moulded pointed trefoiled arches on slender shafts. The arches are glazed, and light a small chamber, in which the clock is to be placed. At the corners are cylindrical turrets terminating in conical spirelets in two stages, the surfaces of the cones enriched with scale-like ornament. In the next storey are the four dials of the clock, under crocketed gables, with finials representing 'Puck', 'Mustard-Seed', 'Pea-blossom' and 'Cobweb'. The clock-faces project slightly from a cylindrical tower flanked by four other smaller three-quarter attached turrets of the same plan: from the main central cylinder springs a spire of a slightly concave outline, and the four turrets have similar but much smaller spirelets, all five springing from the same level, and all

terminating in lofty gilded vanes. Immediately below the line of springing is a band of panelling formed of narrow trefoiled arches. The central spire has on four opposite sides gableted spire-lights, and, at about one-third of its height, a continuous band of narrow lights to spread the sound of the clock bells. The height from the road to the top of the vane is sixty feet. The materials of which the monument is being constructed are of the most durable kind, Peterhead granite for the base and troughs, and for the superstructure a very hard and durable stone of a delicate grey colour form Bolton wood, Yorkshire.[1]

George W. Childs was a newspaper proprietor from Philadelphia who responded to the general opinion of the time that there was no suitable monument to Shakespeare in England. Having already commissioned a stained glass window at Westminster Abbey to the poets Herbert and Cowper, as well as a window in St Margaret's Church, Westminster dedicated to the memory of Milton, he proposed a stained glass window in Holy Trinity Church, Stratford. This did not go ahead and it was suggested that an appropriate monument might be a drinking fountain for the market square. Childs agreed to fund the monument. Although originally conceived as a monument to Shakespeare, its year of inauguration coincided with Queen Victoria's jubilee so that both the great playwright and the reigning queen were commemorated in the inscription. The design of the fountain was a celebration of the common bonds, heritage and language of the American and English peoples which seems to have been particularly appreciated at the time.

When the fountain was unveiled *The Daily News* reported the proceedings:

the Mayor and Corporation in their official robes, accompanied by a number of

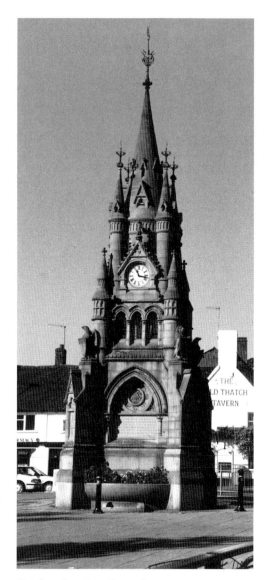

Cossins, *American Fountain*

distinguished guests, marched in procession to the fountain, where a large marquee was erected. Among those present, in addition to the Mayor, Sir Arthur Hodgson, and Mr Irving, were Mr Phelps, the American Minister, Lord Delawarr, Sir Theodore Martin, Lord Ronald Gower, Dr Macauley and Sir Philip Cunliffe Owen. Before dedicating the fountain, Mr Irving read some stanzas from a poem specially written by Dr Oliver Wendell Holmes and delivered a speech praising Mr Childs' generosity and recalling Shakespeare's contribution to English-speaking culture. The official party then went for lunch in the Town Hall, where toasts were given to Queen Victoria , Shakespeare, Mr Childs and Mr Irving.[2]

Although it is commonly known as the American Fountain, Mr D.L. Clarke in his book of 1890 refers to it as the Memorial Fountain to Shakespeare, or the Shakespeare Fountain.[3]

Notes
[1] *Daily News*, Baltimore, 18 October 1887. [2] *The Illustrated London News*, 11 June 1887. [3] Clarke, D.L., *The Story of the Memorial Fountain to Shakespeare at Stratford-upon-Avon*, Cambridge, 1890.

## Royal Shakespeare Theatre

*Bridge Foot, about 200m from front of Royal Shakespeare Theatre*

### Gower Memorial

**Sculptors: Donato Barcaglia and Ronald Gower**

**Assistant: Luca Madrassi**

**Architect: Peignet and Marnay**

**Foundries: E Tassel, Graux and Marley, and De Cauville and Perzinka**

**Contractor: Frederick Taylor**

Unveiled: 10 October 1888
Executed: Hamlet and Falstaff 1879, Prince Hal and Lady Macbeth 1880, Shakespeare 1887–8
Hamlet: bronze 1.45m high × 77cm wide × 76cm deep
Hamlet's plinth: York stone 55cm high × 83cm wide × 92cm deep
Falstaff: bronze 1.64m high × 76cm wide × 72cm deep
Falstaff's plinth: York stone 55cm high × 82cm wide × 90cm deep
Prince Hal: bronze 2.02m high × 70cm wide × 58cm deep
Hal's plinth: York stone 59cm high × 82cm wide × 92cm deep
Lady Macbeth: bronze 1.97m high × 69cm wide × 64cm deep
Lady Macbeth's plinth: York stone 51cm high × 83cm wide × 92cm deep
Shakespeare: bronze 1.93m high × 1.5m wide × 1.2m deep
Pedestal: boxground Bath stone 5.34m high × 7m wide × 7m deep
Signatures: on bronze plinth sections of each character: RG
on bronze plinth to figure of Hamlet: GRAUX-MARLEY FRES/ FONDEURS. PARIS
on bronze plinth to figure of Lady Macbeth: E.TASSE Fondeur/ A PARIS
Inscriptions: (NE side Rotunda) (sans serif): CONSIDERATION LIKE / AN ANGEL CAME / AND WHIPT THE OFFENDING / ADAM OUT OF HIM [from speech by Canterbury on Henry V's ascension to the throne, *Henry V*, Act I, Scene 1]
(base): (added in 1893) (centralised) (sans serif): RONALD GOWER / TO / STRATFORD.UPON.AVON
(SW side (facing theatre) Rotunda) (sans serif): LIFE'S BUT A WALKING SHADOW / A POOR PLAYER / THAT STRUTS AND FRETS / HIS HOUR UPON THE STAGE / AND THEN IS HEARD NO MORE [from speech by Macbeth on his wife's death, from *Macbeth*, Act V, Scene 5]

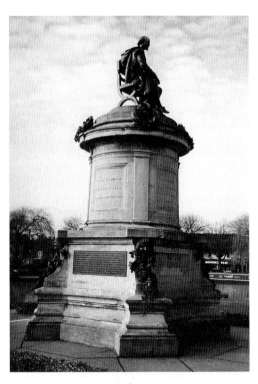

Gower, *Gower Memorial*

(base): (centralised) (sans serif): THIS MONUMENT / WAS UNVEILED ON THE 10TH OF OCTOBER 1888 / BY LADY HODGSON WIFE OF SIR ARTHUR HODGSON KCMG / IN THE FIFTH YEAR OF HIS MAYORALITY
(NW side Rotunda) (sans serif): GOOD NIGHT SWEET PRINCE: / AND FLIGHTS OF ANGELS / SING THEE TO THY REST [from speech by Horatio on Hamlet's death, from *Hamlet*, Act V, Scene 2]
(base): (centralised) (sans serif): THIS MONUMENT / WAS REMOVED FROM THE / MEMORIAL THEATRE GARDENS / TO THIS SITE IN THE YEAR / 1933
(base): (SE side) (bronze plaque): THESE FIGURES WERE DESIGNED AND MODELLED BY

LORD RONALD GOWER, WHO / PRESENTED THE MONUMENT TO THE TOWN OF STRATFORD-UPON-AVON IN 1888. / THE WORK WAS EXECUTED IN PARIS AND TOOK TWELVE YEARS TO COMPLETE / ASSOCIATED WITH LORD ROLAND IN HIS TASK WERE HIS ASSISTANT MONSIEUR L. MADRASSI; / THE FIRM OF TASSEL, WHO MADE ALL THE FIGURES SAVE THAT OF HAMLET, WHICH WAS / ENTRUSTED TO MESSIEURS GRAUX AND MARLEY; AND THE HOUSE OF CAUVILLE / AND PERZINKA, WHO CAST THE WREATHS, THE MASKS, THE FRUIT AND THE FLOWERS. / THE STONE USED IN THIS MONUMENT IS PARTLY BOXGROUND BATH, PARTLY YORK. THE GROUP / WAS ERECTED ON ITS ORIGINAL SITE BY MR FREDERICK TAYLOR, CONTRACTOR, UNDER / THE SUPERVISION OF THE ARCHITECT, MESSIEURS PEIGNET AND MARNAY OF PARIS.

(SW side rotunda): I AM NOT ONLY WITTY IN / MYSELF, BUT THE CAUSE / THAT WIT IS IN / OTHER MEN [from speech by Falstaff, from *Henry IV, Part 2*, Act 1, Scene 2]

Inscriptions on four characters: Prince Hal, front of pedestal: PRINCE HAL

Hamlet, front of pedestal: HAMLET

Lady Macbeth, front of pedestal: LADY MACBETH

Gower, *Hamlet (detail from Gower Memorial)*

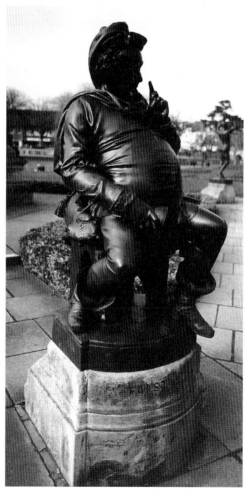

Gower, *Falstaff (detail from Gower Memorial)*

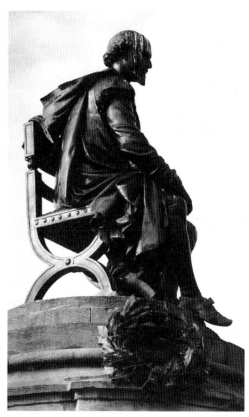

Gower, *Shakespeare (detail from Gower Memorial)*

Falstaff, front of pedestal: FALSTAFF
Condition: good
Status: Grade II
Gift from the artist Ronald Gower to the town;
masonry and installation paid for by public
subscription
Owner/Custodian: Stratford-upon-Avon
District Council

At the centre of the group is the life-size seated
figure of Shakespeare, set high on a stone
pedestal or rotunda surmounting a square block
with striking pedestals at each corner. Both
main sections have four inscriptions, the upper
quotations from the plays, and the lower
relating to the sculpture, its making and
unveiling. Shakespeare sits on the edge of his
cruciform chair, his left arm over its back and
hand holding a scroll. His right forearm rests on
his right knee, thumb and index finger together
(once holding a bronze quill). His head is
angled slightly downwards but his gaze is
straight ahead (north east). At his feet are four
bronze wreaths evenly spaced around the top of
the rotunda section of the pedestal. They appear
to be from the same mould. Directly below
them on the four striking pedestals are four
bronze masks with foliage and flowers. Each is
individually modelled. Two of the masks are
tragic and two comic. Each bunch of foliage and
flowers is symbolic of the character it is paired
with, and which stands directly in front, in turn
representing one of four themes. History is
represented by Prince Hal with English roses
and French lilies. Comedy is represented by
Falstaff with hops and roses. Lady Macbeth
represents Tragedy with poppies and peonies.
Philosophy is represented by Hamlet with ivy
and cypress. The iconic image of the poet is
thus accompanied by the main characters of his
imagination.[1,2]

William Shakespeare (1564–1616) was born
in Stratford-upon-Avon, the son of John
Shakespeare, a glover, and Mary Arden, of
farming stock. He was educated at the local
grammar school, and married Anne Hathaway,
from a local farming family, in 1582. She bore
him a daughter, Susanna, in 1583, and twins
Hamnet and Judith in 1585. He moved to
London, possibly in 1591, and became an actor.
The first evidence of his association with the
stage is in 1594, when he was acting with the
Lord Chamberlain's company of players, later
'the King's Men'. When the company built the
Globe Theatre south of the Thames in 1597, he
became a partner, living modestly at a house in
Silver Street until c.1606, then moving near the
Globe. He returned to Stratford c.1610, living
as a country gentleman at his house, New Place.
His will was made in March 1616, a few months
before he died. He was buried at Stratford.

This characteristically late nineteenth-
century conception of a commemorative
monument for a literary figure was the joint
production of an international response to
commemorate the greatest English and
universally acclaimed playwright and poet.
Ronald Gower, younger son of the immensely
rich 2nd Duke of Sutherland, was a keen
theatregoer and lover of Shakespeare, and first
thought of producing a memorial group to
Shakespeare in 1877, but Stratford, having just
laid the first stone for the Shakespeare
Memorial Theatre, had no funding for another
project. Gower, who could afford to pay all the
costs, persevered and worked on the models.
His original idea was to have the main pedestal
surmounted by a bust of Shakespeare flanked
by Tragedy and Comedy represented as two
female figures, with the characters from the
four plays set out below. In 1880, the figure of
Prince Hal was exhibited at the Paris Salon and
in 1881, the plaster model of the original
version of the whole was shown at the Salon as
the centrepiece of the sculptural exhibition. Five
years later, Gower's bronze of Lady Macbeth
was shown at the Salon.

In 1887, an American, Ignatius Donnelly
challenged Shakespeare's authorship of his
plays, claiming the true author was Bacon.
Attitudes in the town changed; the feeling in
Stratford was that a monument would show the
world their contempt for the Baconian theory,
and a place was allotted in the gardens of the
theatre for Gower's monument to be erected
the following year. It was now that Gower
radically changed his design for the central
pedestal bronze, replacing the bust with a
seated figure of the Bard. Kimberley puts this
dramatic change of mind down to the influence
of Gustave Doré's 1885 monument to
Alexander Dumas, père, in Paris.[3] The
monument was finally unveiled by Lady
Hodgson, wife of Sir Arthur Hodgson, then
Mayor of Stratford, having taken 12 years to
complete.

The work was received with mixed reactions.
The Stratford-upon-Avon Herald highly
praised the figure of the Bard: 'The face is
particularly pleasing, and displays great
intellectuality and delicacy in modelling. The
grace of the attitude of the figures is singularly
striking, and the conception remarkably
spirited.'[4] The Birmingham Post quoted Oscar
Wilde: 'beautiful green-and-gold bronzes …
Works of art of such an imaginative character
were not common in Europe, much less in
England… It was not often that a sculptor
passed beyond the imitative faculty and tried to
mirror in marble and bronze the great creations
of a great mind.'[5] The satirical magazine Punch
however, attacked the overall concept of the
monument: 'Shakespeare, says the description
of it in The Times, "is here represented seated
with a quill in his right hand", How original!
How clever, not behind his ear, or in his mouth,
but absolutely in his right hand, as he must
actually have used it, unless he were left-
handed. And to think that the renowned
sculptor was only twelve years over the great
design!'[6] The Paris press was equally critical. La
Défense Sociale et Religieuse wrote of the first

version of the monument exhibited at the Salon in 1881 that the six figures around the base distracted the viewer's attention from the figure of Shakespeare himself,[7] while the *Revue du Monde Catholique* made a similar point when the reviewer complained that the figure of the Bard had been treated as an accessory rather than the focus of the work.[8]

In the original 1888 setting at the rear of the theatre (which burned down in 1926), Shakespeare faced towards the church, down stream of the River Avon with Prince Hal positioned directly under his feet, and, like the other three characters, directly in front of his quote on the main pedestal. Prince Hal's upraised arms holding the crown drew the viewer to the main subject of the group, Shakespeare. After the theatre had been rebuilt the orientation of the Gower Memorial (as it had become known) was reversed in 1933 and Shakespeare now faces upstream to Warwick. The four characters were moved 45 degrees in an anti-clockwise direction, and forward by 7½ metres as well as being stepped down by 15cm. The newer layout makes the group hard to read as a whole, but does offer the opportunity to see the characters in the round.

Notes
[1] Ward-Jackson, P., 'Lord Ronald Gower, the Shakespeare Memorial and the Wilde Era of London and Paris', *The European Gay Review*, vol.2, 1987. [2] *Idem*, Lord Ronald Gower, 'Gustave Doré and the Genesis of the Shakespeare Memorial at Stratford-on-Avon', *Journal of the Warburg and Courtauld Institutes*, vol.50, 1987. [3] Kimberley, M., *Lord Ronald Gower's Monument to Shakespeare*, Stratford-upon-Avon Society, 1989, p.23. [4] *Stratford-upon-Avon Herald*, 12 October 1888. [5] *Birmingham Post*, 11 October 1888. [6] *Punch*, 20 October 1888, p.185. [7] *La Défense Sociale et Religieuse*, 16 June 1881. [8] *Revue du Monde Catholique*, 15 June 1881.

We are indebted to Philip Ward-Jackson for bringing the points in [6] to [8] to our attention.

*Bridge Foot, in the grounds of Trust House Forte hotel*

## Shakespeare Statue
### Sculptor: unknown

Executed: 1800s
Granite, life-size
Condition: good
Status: not listed

This standing figure of Shakespeare stands against a pillar on a granite plinth. Dressed in cloak, doublet and hose, he holds a scroll in his right hand and rests his left hand against his chin in a gesture that conveys the idea of thoughtful reflection. Within European iconographical tradition, this gesture is often used to suggest that the subject is of great intellectual stature.

*Waterside, high on the façade of Royal Shakespeare Theatre*

## Treachery, Jollity, Life Triumphing over Death, Martial Ardour, Love ('Kennington Brick Reliefs')
### Sculptor: Eric Kennington
### Architect: Elizabeth Scott

Unveiled: 23 April 1932
Five reliefs, each carved brick 1.4m × 60cm × 23cm
Signature: (at bottom and to left of the skull on central relief): EK
Condition: fair
Status: Grade II*
Commissioned by: Elizabeth Scott
Owner/Custodian: Royal Shakespeare Theatre

There are five figurative reliefs carved into the brickwork on the exterior of the balcony parapet at the front of the theatre. They are based on the emotions of Shakespeare's plays

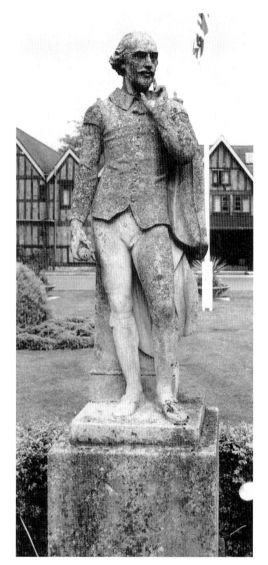

Unknown, *Shakespeare*

and from left to right depict: Treachery, Jollity, Life Triumphing over Death, Martial Ardour and Love. In the *Treachery* panel is a cloud at the top out of which a head appears, looking down. Beneath the cloud is a man who seems to be hiding his face from the God figure above. He has a dagger hanging from his belt and is about to stab a young man sleeping in a cornfield depicted below. In the *Jollity* panel are two figures, a man dancing and another who seems to be playing a concertina. In the panel depicting *Life Triumphing Over Death* is a naked young woman with long flowing hair down to the ground. She is kneeling, her hands

(left) Kennington, *Life Triumphing over Death*

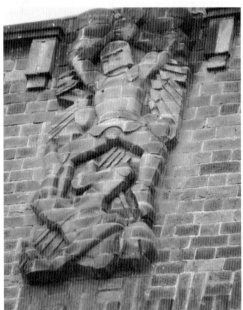

(below left) Kennington, *Martial Ardour*

(below) Kennington, *Love*

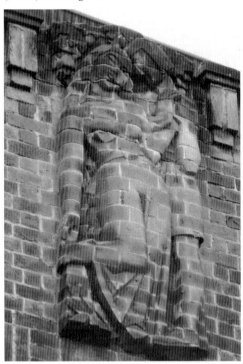

to either side in a devotional gesture and under her is a skull, and to the left of the skull are the initials of the sculptor 'EK'. In the panel representing *Martial Ardour* are two figures wearing armour, one of whom is lying crumpled on the ground at the bottom. The second figure is standing over him with hands above his head, clenching some kind of weapon, possibly a sword, about to strike the man on the ground. In the *Love* panel is a depiction of a standing couple. The female faces forward, the male is to one side of her with his arm around her shoulder, holding her hand, and his face is leaning towards her. She has one leg up in the air, bent at the knee and she leans slightly backwards in acceptance of his advances.

The first theatre on this site, built in 1879–81, was designed by William Unsworth, but was almost completely destroyed by fire in 1926, with only the library and art gallery and the shell of the building surviving. A competition was launched in January 1927 to select architects to design a new theatre building for the riverside site, and a design by the relatively unknown Elizabeth Scott was chosen. The material selected for the exterior of the theatre was red-sand brick, softened by interspersing patterns of silver-grey bricks, handmade by S. and E. Colliers Company. There is very little external decoration except for the five sculptural panels carved *in situ* by Eric Kennington. These sculptures illustrate Kennington's belief that sculpture must be an integral part of building, and for this reason the *Architectural Review* described them as Gothic in spirit.[1] The artist himself said he was inspired by the calendar carvings on Chartres Cathedral.[2] The Prince of Wales opened the theatre on Shakespeare's birthday.

It has been confirmed by the Royal Shakespeare Company management and the artistic director Adrian Noble that there are plans to build a new theatre on the site of the present building. It is envisaged that the 1930s

building will be demolished, leaving only the museum and gallery from the nineteenth century building unaffected. The Dutch architect Eric Van Egeraat has been appointed. This development will obviously affect the future of Kennington's work.[3]

Notes
[1] *Architectural Review*, June 1932, p.236. [2] Pringle, M.J., *The Theatres of Stratford-upon-Avon, an architectural history*, Stratford-upon-Avon, 1994, p.32. [3] *Stratford-upon-Avon Herald*, 3 September 1998.

*Waterside, in foyer of Royal Shakespeare Theatre*

## Bust of William Shakespeare
### Sculptor: Clemence Dane

Executed: after 1953
Bronze 40cm high × 30cm deep approx
Plinth: wood
Inscription: plaque on plinth: WILLIAM
    SHAKESPEARE / by / CLEMENCE DANE C.B.E.
Condition: good
Status: Grade II*
Owner/Custodian: Royal Shakespeare Theatre

Overlooking the *Mosaic Floor and Fountain* by Gertrude Hermes, the bust of Shakespeare's head and collar depicts a gaunt face and a receding hair line, conveying an impression of old age and suffering. The mood is quite distinct from that of other statues of Shakespeare in the town, which instead emphasise his great powers and strength of mind.
    Clemence Dane was the pseudonym of Winifred Ashton (1888–1965), a playwright and novelist who had originally planned to be a painter. She studied art at Dresden and the Slade in London, and continued working as an artist throughout her life. Her plays attracted unfavourable reviews, and it seems as though she transferred her own suffering at the poor

Dane, *Bust of William Shakespeare*

reception of her works to her subject.
    For details of Shakespeare's life, see the entry for the 'Gower Memorial', *Bridge Foot*.

*Waterside, in foyer of Royal Shakespeare Theatre*

## Mosaic Floor and Fountain
### Sculptor: Gertrude Hermes
### Architect: Elizabeth Scott

Unveiled: 23 April 1932
Fountain: Veridi de Prata marble, 2m diameter
    approx

Condition: good
Status: Grade II*
Commissioned by: Elizabeth Scott
Owner/Custodian: Royal Shakespeare Theatre

A circular mosaic basin in which a curved spiral form, echoing the spiral stairs above it, acts as the spout for the fountain. The vitreous mosaic is brightly coloured in gold, red, blue and green. It is often covered with coins, making it difficult to discern all the elements, which include a sea monster and a mask of Tragedy and a mask of Comedy.

*Waterside, on the façade of the Theatre Museum at first floor level*

## Comedy, History and Tragedy ('Kummer Reliefs')
### Sculptor: Paul Kummer
### Architect: F.W. Unsworth

Executed: 1886
Three reliefs, terracotta, each 1.5m wide × 90cm
    high approx
Inscriptions: on central panel: Building by /
    W.F.Unsworth / Architect / 1885
on central panel: P KUMMER S.    HISTORY
on right panel: TRAGEDY
on left panel: COMEDY
Condition: good
Status: Grade II*
Commissioned by: the architect and Mary
    Anderson, an actress
Owner/Custodian: Royal Shakespeare Theatre

Three panels on the façade of the building, in slightly contrasting colours of terracotta, depict the three types of Shakespeare play – comedy, history and tragedy.
    The centre panel, History, depicts a scene from *King John*. It is set in a chamber with shackles hanging from the walls. At the left is the figure of a man in chain mail under a cloak

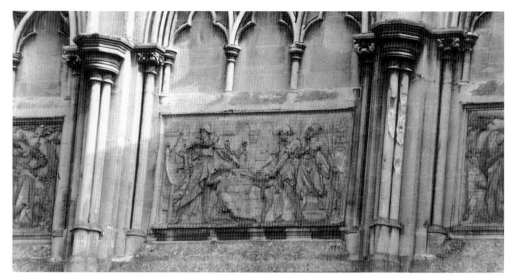

**Kummer, *Comedy, History and Tragedy***

and tunic, standing in front of a throne, rejecting the request of a young boy who is kneeling at his feet. On the right, two figures emerge from behind a curtain, one of whom also wears chain mail under his garments and is offering a brazier with iron tongs in it to the figures on the left. The other male figure stands behind him and has a rope over his shoulder. There is a bejewelled sword in a scabbard leaning against the throne.

The left hand panel, Comedy, depicts a woodland scene with the figures of two males and a female. On the right a man and woman are standing with their arms around each other. The man on the right points to the male figure on the left who is wearing tights and has a dagger and helmet hanging from his belt. The scene is taken from *As You Like It* and shows Rosalind disguised as Ganymede, persuading Orlando to woo her in the Forest of Arden.

The right hand panel, Tragedy, is taken from *Hamlet* and shows the Prince with the skull of Yorick.

On 25 June 1886 the *Stratford-upon-Avon Herald* reported that the panels of *King John* and *As You Like It* had been completed, and that of *Hamlet* was almost ready.[1] The designs for the terracotta panels were illustrated in *Building News* on 4 July 1889.[2] The stonework style is influenced by the guilds of handicrafts that grew up after John Ruskin founded the Guild of St George in the 1870s and which blossomed in the Arts and Crafts movement of the 1880s. The theatre's architect F.W. Unsworth presented the History panel. The actress Mary Anderson gave the £150 proceeds of a benefit performance of *As You Like It* in August 1885 to pay for the panels of Tragedy and Comedy.

These three panels were added to the Library and Art Gallery wing five years after it had been completed in 1881, and survived the disastrous fire of 1926.[3]

Notes
[1] *Stratford-upon-Avon Herald*, 25 June 1886.
[2] *Building News*, 4 July 1889. [3] Pringle, M. J., *The Theatres of Stratford-upon-Avon, an architectural history*, Stratford-upon-Avon, 1994, p.14.

*Waterside, adornments to gallery building of the Swan Theatre*

## Characters from A Midsummer Night's Dream (Gargoyles)
**Sculptor: Gilbert W. Seale**
**Architect: Frederick William Unsworth**

Executed: 1880
Stone 25cm high × 30cm wide × 50cm deep approx
Condition: good
Status: Grade II*
Commissioned by: Shakespeare Memorial Association
Owner/Custodian: Royal Shakespeare Theatre

Figures projecting from the wall of the theatre take the form of gargoyles and angels. Only three of the original seven figures survive, one at the front, and two at the rear of the building; they were described in the *Stratford-upon-Avon Herald* in 1880:

> The gargoyles of the exterior of the Memorial Theatre Buildings are by the celebrated London sculptor, Mr G.W. Seale, and have been completed within the last few days. The subjects have been taken exclusively from a Midsummer Night's

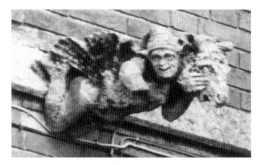

**Seale, *Characters from A Midsummer's Night Dream***

Dream, several of the characters of that play being both quaint and grotesque. The top figure represents Moonshine with bush and lantern, the subject being taken from the well-known passage uttered by the clown in the first scene of the fifth act. The middle gargoyle represents Puck carrying the ass head to Oberon, to be afterwards placed on the clown. The lowest gargoyle faces the main thoroughfare and represents Snug the Joiner, enveloped in his lion's skin and nursing his tail. Underneath the oriel window at the other end of the building, Mr Seale gives us the 'fairies' of the story, Pea-Blossom, Cobweb, Moth and Mustard Seed. Over the doorway in the turret facing the river is another gargoyle, that of a winged horse.[1]

The upper figure is that of Puck carrying the ass's head later to be fixed on Bottom's head whilst the lower figure is Snug the Joiner dressed for his role as the lion.[2]

The Swan Theatre was formed within the shell of the original Shakespeare Memorial Theatre, which caught fire in 1926.

Notes
[1] *Stratford-upon-Avon Herald*, 23 July 1880.
[2] Shakespeare, W., *A Midsummer Night's Dream*, Act 1, Scene 2.

## Sheep Street

*At first floor level on wall of Shipton & Co., Jewellers*

### Figure with Shield ('Everyman')

### Sculptor: Fred J Kormis

Executed: 1964
Base: concrete
Figure: bronze 2m high approx
Condition: good
Status: not listed
Owner/Custodian: Shipton & Co., Jewellers

The statue, commonly believed to represent the idea of 'everyman',[1] is of a young man in medieval costume supporting a shield. His stance is casual, and he is depicted in a simplified and elongated manner, wearing sandals, tunic, trousers and a cloak. The cloak is tattered and torn, as if in battle.

The shield is that of the former Stratford Borough. After the local government reorganisation of 1974 the arms of the former borough were transferred by the Earl Marshal to Stratford-upon-Avon Town Council. The coat of arms is gold, with a blue chevron between three leopards' faces. Another version made the field silver and the chevron red. The leopards' faces were probably derived from the Royal Arms which show three lions standing

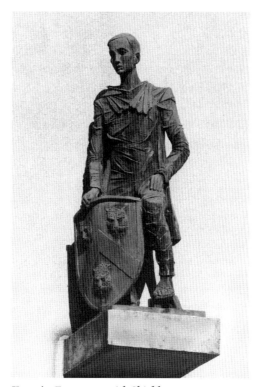

**Kormis, *Everyman with Shield***

with right paws raised, anciently termed *lions leopardés*. Several ancient towns placed the Royal Arms of England on their seals and when adopting arms of their own took the three royal lions as a basis, simply changing the colour of the field or making additions.[2] In the Middle Ages, the bailiff and burgesses included three leopards' faces in the coat of arms they used. The Charter of 1553 gave to bailiff and burgesses various privileges, among which was the right to a Common Seal. The first Common Seal of 1553, has on it a florid shield charged with a chevron between three leopards' faces.[3]

Notes
[1] Information provided by Shipton & Co., Jewellers, the present tenants of the building.
[2] Scott-Giles, C.W., *Civic Heraldry of England and Wales*, London, 1953, p.378. [3] *The Coat of Arms*, October 1995, vol.III, no.24, p.314.

*Town Hall, niche at first floor level*

### Statue to William Shakespeare (the 'Town Hall Shakespeare')

### Sculptors: John Cheere and Peter Scheemakers

Installed: 1769
Sculpture: cast lead 1.52m high × 76cm wide × 61cm deep
Plaque: stone 91cm high × 61cm wide
Signature: inscribed on the base of the pedestal: Jno Cheere fect
Inscriptions: on main plaque (serif): TOWN HALL SHAKESPEARE STRATFORD-UPON-AVON / Take him for all in all / We shall not look upon his like again
on main plaque (centralised): The Corporation / and Inhabitants of Stratford / Afsifted by / The munificent Contributions / of the Noblemen / and Gentlemen of the Neighbourhood / Rebuilt thei Ediface in the Year 1768 / The statue of Shakespeare / and his picture within / were given by David

Garrick Efq.
on later plaque below: 1952 – 1977 / TO COMMEMORATE / THE SILVER JUBILEE OF / HER MAJESTY QUEEN ELIZABETH II
Condition: good
Status: Grade II*
Commissioned by: David Garrick
Owner/Custodian: Stratford-upon-Avon Town Council

In a niche with a triangular pediment above and two plaques beneath, a male figure stands holding scrolls that are balanced on a pillar at the bottom of which is a crowned head of a man wearing a tunic. Behind the scroll is a stack of three books. Shakespeare is pointing down at the scroll and the head with his right hand. He is dressed in an attempt at Elizabethan costume, but the trousers and shoes are more eighteenth century in style. Around the base of the pedestal are small busts of Henry V, Richard III and Queen Elizabeth. Upon a scroll are inscribed lines from *A Midsummer's Night's Dream*: 'The poet's eye, in a fine frenzy rolling, / Doth glance from heaven to earth, from earth to heaven; / And as imagination bodies forth / The form of things unknown, the poet's pen / Turns them to shapes, and gives to airy nothing / A local habitation and a name'.[1]

The statue, with the exception of the verses on the scroll, is an exact replica of a stone statue commissioned by Lord Pembroke of Wilton House from Peter Scheemakers, which was itself a revised version of the statue erected in Poet's Corner in Westminster Abbey designed by William Kent and also carved by Peter Scheemakers.

David Garrick, a friend of Lord Pembroke, would have known of the Wilton House statue when he was invited by the Corporation to donate a bust of Shakespeare and portraits of both himself and Shakespeare in an attempt to boost the funds for the new town hall. The Corporation paid £192 for Gainsborough's

**Cheere and Scheemakers, *Shakespeare***

portrait of Garrick. As the total rebuilding costs for the town hall only amounted to £750, Garrick's 'gift' was a mixed blessing. On being asked to present a bust, Garrick decided on Scheemakers' full-length statue at Wilton House and the lead cast was made by John Cheere, the brother of Scheemakers' pupil Sir Henry Cheere. Although no records remain of how or when the statue was erected, it is assumed that it was officially presented to the town during, or just after, the Jubilee in September 1769.

In the summer of 1814 the whole of the statue was painted to simulate stone, with the exception of the inscription, which was added

sometime before 23 April 1816, the second centenary of the poet's death. The statue was again painted in June 1826.[2] On 2 May 1877 the tablet beneath the statue was ordered to be restored in Hopton Wood stone. The wording of the original was copied exactly except for the substitution of 'noblemen' for 'nobility'. In 1930 the many of layers of paint were removed by Mr G.S. Gibbs, revealing the detailed workmanship of the artist – even the stitches in the garments were clearly visible. The inscription was repainted in the same year with its original lettering and spelling, which were found to have been lightly inscribed with a graving tool on the leaden scroll.[3]

For details of Shakespeare's life, see the entry for the *Gower Memorial*, Bridge Foot.

Notes
[1] Wellwood, F., An Inventory of the Civic Insignia and other Antiquities belonging to the Mayor and Corporation of Stratford-upon-Avon, Stratford-upon-Avon, 1940, pp.21–2. [2] *Ibid.* [3] *Stratford-upon-Avon Herald*, 1930.

Source
Roscoe, Ingrid, 'Peter Scheemakers catalogue', *Walpole Society Journal*, vol.LXI, 1999.

*Union Street*
*On side of bank*

**Composite Emblem of Lloyds Bank**
**Sculptor: unknown**
**Architect: unknown**

Executed: *c.*1880–90
Stone *c.*1.5m square
Condition: good
Status: not listed
Commissioned by: Lloyds Bank
Owner/Custodian: Lloyds Bank

This composite relief has a beehive in the centre, surrounded by a number of heraldic

**Unknown, *Lloyds Bank Emblem***

badges and emblems, including those of Birmingham, Warwick and Stratford. The beehive is a symbol of industry and was the commercial emblem of Taylors and Lloyds, the founding partners of Lloyds Bank. There are six heraldic emblems around the beehive: the horse at the top right is the current emblem of Lloyds Bank; the three leopards and chevron at the bottom are the arms of Stratford; the emblem at the bottom left with four small towers surrounding a central larger tower and a crown in the top left-hand corner are the arms of Warwick; at the bottom right there are three towers above a lion and two smaller lions each side of the towers; at the top right a St George's Cross with another cross inside it and a dagger in the top left-hand quarter (pointing upwards) are the arms of the Corporation of the City of London; at the top left the shield has a band across the middle with six fleur-de-lys separated by a coronet, the top left and bottom right quarters have diagonal lines of four little squares from top left to bottom right, and the top right and bottom left quarters are divided

down the middle by a zigzag line from top to bottom. At the top the letters BSS are intertwined in ornate style.

## Waterside
See also *Royal Shakespeare Theatre*

*On east side of Waterside between Royal Shakespeare Theatre and Country Artists Fountain*

### The Israeli Lamp
**Sculptor: Frank Meisler**

**Founder: Arie Ovadia**

Unveiled: 15 November 1990
Owl: bronze 25cm high × 25cm wide
Figures: bronze 70cm high × 50cm wide
Lamp-post: cast metal (painted) 3.6m high × 1.5m wide
Inscriptions: Presented on behalf of / THE STATE OF ISRAEL / by the Jordan P. Snyder and / Irene Curly Snyder Foundation – USA
Frank Meisler / Sculptor
Arie Ovadia / Chef d'atelier
(on plaque below shield with Menorah):
DONATED BY / STATE OF ISRAEL
Condition: good
Status: not listed
Gift on behalf of state of Israel
Owner/Custodian: Stratford-upon-Avon District Council

Above the lamp is a statue of an owl. At the top of the post, as if seated on the cross bar, are statues of a man with an ass's head – the character Bottom from Shakespeare's *A Midsummer Night's Dream* – and a man playing the fiddle, a depiction of Tevye (or Topol) from *Fiddler on the Roof*, a story by Shalom Aleichem, the great comic writer of Yiddish culture. Below the lamp are olive branches around the Menorah, the national emblematic shield of Israel, a depiction of the

**Meisler, *Israeli Lamp***

Jewish flag and the word 'Israel' in Hebrew.

This is one of a series of foreign lamp-posts along Waterside. Indeed, Stratford has the only International Exhibition of Working Lamp-posts in the world. The visitor book of the Shakespeare Birthplace Trust revealed the high numbers and diversity of foreign visitors to the town, which prompted Keith Brodie, the County Street Lighting Engineer of the Planning and Transportation Department at Warwickshire County Council to devise a scheme whereby traditional lamp-posts would be donated to the town by various countries. A standard letter was sent from the chairman of

the County Council to 20 or 30 ambassadors in London on 3 November 1986,[1] with the result that there are a number of lamp-posts from various countries as well as examples from cities throughout the United Kingdom.

The Israeli approach to the scheme has so far been unique. The celebrated Israeli sculptor Frank Meisler, who had a studio in London, was contacted by the Israeli Ambassador, and commissioned to make sculptural figures to adorn a conventional period style Israeli lamp-standard. Meisler visited Stratford and modelled the figures of Bottom and Topol, which were then cast in bronze in Israel before being sent to Stratford to be fitted to the post that had already been erected.

Notes
[1] Stratford-upon-Avon District Council, *International Exhibition of Working Lampposts*, Stratford-upon-Avon, 1995.

## Wood Street

*White Swan Hotel*

### White Swan Pub Sign
#### Sculptor: unknown

Installed: between 1925 and 1931
Wood 1m high × 60cm wide approx
Condition: good
Status: Grade II
Commissioned by: proprietor of the White
    Swan Hotel
Owner/Custodian: proprietor of the White
    Swan Hotel

This cut out planar relief with incised details shows a chained swan with a crown around its neck standing on a green patch of ground. Such a swan ducally gorged and chained as depicted in this sign was the heraldic badge of the De Bohuns, Earls of Hereford and Essex. Through the marriage of the heiress of the last De Bohun, May Bohun, to Henry IV, the swan

passed as a badge to Henry IV, King of England (1413–22).[1]

Built as the home of a Stratford merchant in *c*.1450, the building first became an inn nearly one hundred years later. At that time it was not called the White Swan, and is referred to in a legal case of June 1608 as the Kings House. The front of the White Swan Inn was extensively remodelled in 1927[2] and photographic evidence shows that the sign was installed between 1925 and 1931.

The designation 'White Swan' was first used for an inn in Cambridge in 1556, and has since become a common name of an inn or hotel.

Notes
[1] Boutell, C., *Boutell's Heraldry*, London, 1983, pp.77 and 167. [2] Bearman, R., *Stratford-upon-Avon, A History of its Streets and Buildings*, Stratford-upon-Avon, 1988, p.47.

**Unknown,** *White Swan*

*Alcester Road*

*On the façade of stable block of Mountbatten House, 101 Alcester Road*

### Female Head and Ornate Entrance Gates

#### Sculptor: unknown

Executed: after 1680
Stone relief panel 70cm high × 40cm wide
    approx
Gateposts and urn: ashlar stone
Gatepost finials: 50cm high × 30cm wide ×
    30cm deep approx
Urn: 1.4m high × 1.7m diameter approx
Condition: fair
Status: Grade II*
Commissioned by: Thomas Chambers Esquire
Owner/Custodian: Royal Life Saving Society

The relief panel depicts a female head, obviously classical, in the gable of the stable block. There is a large and weathered urn at the centre of the forecourt. Two gatepost finials take the form of bowls of fruit. These works and the ornamental wrought iron railings and gates are possibly by Nicholas Parris.[1]

Currently home to the Commonwealth Headquarters of the Royal Life Saving Society, Mountbatten House was built as the Manor House for Thomas Chambers Esquire of Studley *c*.1680.

Note
[1] Pevsner, N., *Buildings of England: Warwickshire*, Harmondsworth, 1966, p.423.

## TANWORTH-IN-ARDEN

### Pond House Lane

*In field between lane and M40, on top of small hill*

### Umberslade Obelisk

**Designer: William Hirons**

Erected: 1749
Stone 13m high approx
Condition: good
Status: Grade II
Commissioned by: Thomas Archer

There are no documentary records to explain why this obelisk was erected. It stands on a hill and has a pyramid top with ball finial and lightning-conductor. The pediment base is surrounded by trees and thus is not visible. A laminated newspaper article displayed at the junction of a footpath and Pond House Lane gives details on the obelisk, which is a slimmer version of Cleopatra's Needle in London. The obelisk is in alignment with the East front of Umberslade Park (built in 1695–1700 for Andrew Archer) at the edge of the former 300-acre landscaped park, and is now separated from the park by the M40.

The Archers came to Britain with William the Conqueror (after 1066) and settled at Umberslade during the reign of Henry II (1154–89), the first family member to live at Umberslade being Robert Sagittarius (or Robert the Archer). The obelisk was erected for Thomas Archer, then owner of Umberslade Park. It has been suggested that the obelisk is connected with his interest in astronomy, but it is more likely that it was erected to commemorate his becoming the 1st Lord Archer, Baron Umberslade in 1747. It has also been suggested that the obelisk commemorates the defeat of the Jacobites, or the Peace of Aix la Chapelle. Lord Archer died in 1768 aged 73. The last Lady Archer died in 1801 and the house remained empty until Umberslade Park was bought by Edward King in 1826.[1] The obelisk is the sole surviving structure from Archer's landscaping.

Note
[1] Burman, J., *The Story of Tanworth*, Birmingham, 1930, pp.43–54.

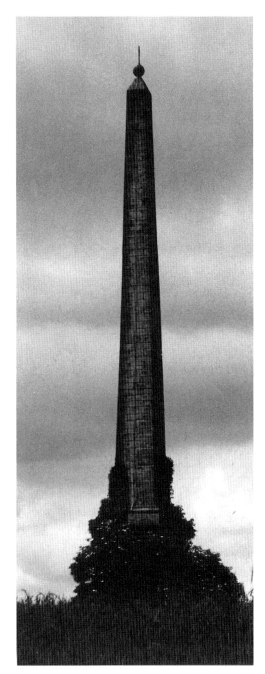

Hirons, *Umberslade Obelisk*

# Warwick District

*Church Lane*

*On gatepost to playing field*

### George V (1865–1936) Commemorative Plaque
**Designer: George Kruger Gray**

Executed: after 1936
Bronze 29cm high × 21cm wide

Gray, *George V Commemorative Plaque*

Inscription: George V / A.D. 1910–1936
Condition: good
Status: not listed
Owner/Custodian: Warwick District Council

This commemorative plaque is at the top of the gatepost to the playing fields. Inscribed at the bottom, it has in a frame a recessed heraldic device which shows a lion wearing a crown and holding a shield. The shield bears the Royal coat of arms. It is divided into four segments, showing the three lions of England in the top left and bottom right segments, the harp of Ireland in the bottom left and the single lion of Scotland in the upper right segment. A belt and buckle are visible in the bottom right hand corner and there is a monogram in the upper right hand corner.

There are over 495 playing fields in the country commemorating George V with similar pairs of heraldic panels designed by George Kruger Gray. The panels appear mostly on the entrance gate-piers to the playing fields and seem to be nationally uniform.[1]

Note
[1] Stuart, Sir Campbell, *Memorial to a King*, London, 1954.

Unknown, *Ornate Façade with two Musicians (details)*

*High Street*

*Watchbury House, on porch*

### Ornate Façade with Two Musicians
**Sculptor: unknown**

Executed: 1880s
Each: wood 59cm high × 28cm wide
Condition: good
Status: Grade II
Owner/Custodian: owners of Watchbury House

This is a well articulated timber-framed two-storey porch open at ground level with two barley-sugar twist columns according to Arts and Crafts principles.[1] The arched entranceway has two carved rectangular panels next to the spandrels of the arch. Each panel depicts a full-length medieval musician in profile in a simplified yet realistic manner. The porch itself and the bargeboards of the timber-framed brick house are richly carved with trefoils and other motifs.

Note
[1] Hadfield, John (ed.), *The Shell Book of English Villages*, London, 1985, p.182.

## GUY'S CLIFFE

*Warwick Road*

*Blacklow Hill*

### Gaveston's Cross

### Sculptors: Jos Fairfax, John Morris and George Parsons

Erected: 1823
Whole: sandstone 6m high approx
Pedestal: sandstone 1.09m high × 1.4m wide × 1.4m deep
Inscriptions: (on plaque): In the Hollow of this Rock,/ Was beheaded, / On the 1st Day of July, 1312,/ By Barons lawless as himself,/ PIERS GAVESTON, Earl of Cornwall:/ The Minion of a hateful King,/ In Life and Death/ A memorable instance of Misrule.
(Old inscription cut into the rock, now obscured): P. Gaveston, 1st. July, 1312
Condition: poor
Status: Grade II
Erected by: Bertie Greathead Esq. of Guy's Cliffe House

Almost lost in the woods on Blacklow Hill stands this large monument, a heavy short cross on a high pedestal of four mighty square piers. On five steps stands a square base, carrying an iron plaque with an inscription thought to be written by Dr Samuel Parr, a well-known scholar parson.[1] From this base spring the four square piers supporting a roof-like structure which in turn supports two further steps and a relatively squat cross. The whole is badly scratched and painted with graffiti, as well as being overgrown.

Piers Gaveston was Baron of Cornwall, closest ally and possibly lover of King Edward II. Hated by the barons, he was twice banished from the kingdom, but welcomed back on both occasions by the king. Led by Thomas Earl of

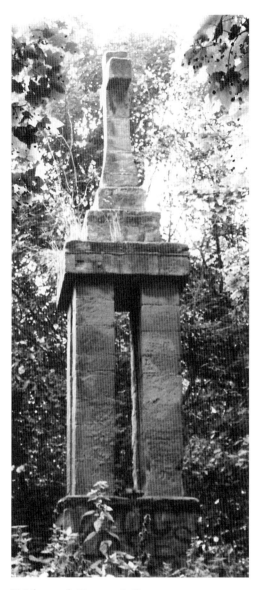

**Fairfax et al,** *Gaveston's Cross*

Lancaster, the barons plotted to have Gaveston killed, and he was captured and imprisoned in Warwick Castle by the Earl of Warwick. A council of barons was assembled who tried him and condemned him to death. The Black Friars took the body to Oxford, from where it was later moved to Langley in Hertfordshire.[2]

The monument is believed to mark the site of the execution.

Notes
[1] Bolitho, P., *Ripples from Warwickshire's Past*, p.4.
[2] Kemp, T., *A History of Warwick and its People*, Warwick, 1905.

## KENILWORTH

*Blackthorn Road*

*Thorns County Primary School*

### Alice Through the Looking Glass

### Sculptor: Walter Ritchie

### Architect: Geoffrey Barnsley

Executed: 1959
Painted steel plate, flame cut 3m high × 3.66m wide × 25cm deep
Condition: fair
Status: not listed
Commissioned by: Warwickshire County Council
Owner/Custodian: Thorns Primary School

From top left to bottom right, this two-dimensional piece depicts a girl stepping though an oval mirror, two groups of figures in battle with spears, an eight-pointed star, a brown horse grazing, a white figure in a dress wearing a crown, a similar figure in red, a bearded male figure in armour seated on the ground and scratching his head, a hippopotamus, and a small cat which stands at the feet of the girl. The cat is said to be a portrait of the artist's own cat.

**Ritchie,** *Alice through the Looking Glass*

unnaturalistically manipulated planes and rods, while the mock-heroic personalities of the characters in the story are suggested by the semi-abstract simplifications and distortions of the colourful figures in playful poses and expressions, reminiscent of the early surrealistic paintings of Joan Miro.

Note
[1] Ritchie, W., *Walter Ritchie: Sculpture*, Kenilworth, 1994, pp.77 and 81.

## *Leyes Lane*

*Kenilworth Grammar School, above entrance to upper school*

### *Growth*

### Sculptor: Walter Ritchie

### Architect: Eric Davies

Executed: 1965
High purity aluminium 6.1m wide
Condition: good
Status: not listed
Commissioned by: Eric Davies
Owner/Custodian: Kenilworth Grammar School

**(below) Ritchie,** *Growth*

The work is free-standing, but is placed just in front of a black wall that provides an effective background. The forms are cut out of plate metal with voids used to express details within the forms, and the only three-dimensional details are the metal rods used to depict the hair, mane and whiskers. This two-dimensionality, coupled with the simplified forms, gives the work a graphical character reminiscent of children's art, suitable to both the location and subject matter.[1]

The figures are not fully illustrative, but are freely adapted from Lewis Carroll's classic children's novel, *Alice through the Looking Glass*, the sequel to *Alice in Wonderland*. The changing and converging realities of the story are thus conveyed by the irrationally and

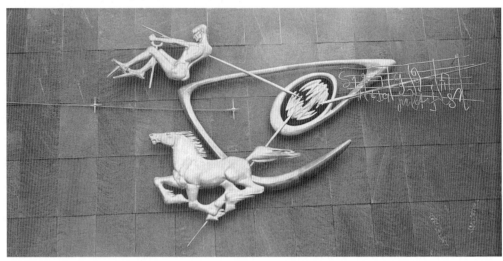

This large mural decoration combines simplified figurative elements with semi-abstract biomorphic forms and musical notation against a slate architectural background. The sculpture is a repoussé work, the forms having been beaten out from the reverse. The central motif is that of a cell dividing and reproducing itself – the most fundamental form of growth. The musical notation comes from Beethoven's *Missa Solemnis*.[1] There is a male figure sitting at the joystick control of an invisible craft. He signifies man's ambitions to explore the limits. The horse symbolises the beneficial power of nature when harnessed to man's endeavour.[2] The theme of the sculpture is inspired by science but the meaning of the work is symbolic: it conveys a humanistic concept of man's dialogue with the laws of nature.

Notes
[1] *Kenilworth Weekly News*, 26 March 1965.
[2] Information provided by sculptor's widow, Sally Taylor, 8 March 2000.

## Rosemary Hill

*In front garden*

### Sculpture For A Pool (Mermaid)
### Sculptor: Walter Ritchie

Executed: 1938
Portland stone 91cm long
Condition: good
Status: not listed
Not commissioned
Owner/Custodian: estate of Walter Ritchie

This beautifully curvilinear mermaid is lying on a rock that is covered with delicately carved fish and seaweed motifs. The shape of the female body and the modulations of the rock convey the waves of the sea. The ancient Graeco-Roman iconography of the mermaid was revived in Christian art, to symbolise the human soul floating from life to death.

Ritchie, *Mermaid*

However in later Renaissance art the 'recumbent mermaid' became an emblem of liberated physical desire. As such, she became extremely popular in late nineteenth- and early twentieth-century sculpture, and was a favourite theme in avant-garde art of the 1920s.

From a purely formal point of view, this piece is a fine essay in direct carving, the principle of which dominated British sculpture in the 1920s and 1930s.

Ritchie made this sculpture whilst still at school. It moved with him to Kenilworth in 1940 and remained in his possession.[1]

Note
[1] Ritchie, W., *Walter Ritchie: Sculpture*, Kenilworth, 1994, p.5.

## The Square

*In centre of road next to the roundabout*

### The Clocktower
### Maker: unknown

Installed: 1906
Tower: stone 7.5m high approx

Unknown, *Clocktower*

Fountain: marble basin and copper spout, semi-circular, 70cm diameter approx
Inscriptions: (on silver coloured plaque on east face): THE CROWN OF THE CLOCK TOWER WAS / DAMAGED BY A LANDMINE IN 1940, AND / RESTORED UNDER THE DIRECTION OF / KENILWORTH URBAN DISTRICT COUNCIL / IN 1973/74 / THE WORK WAS CARRIED OUT BY / WILLIAM SAPCOTE & SONS LTD.
on a bronze plaque above drinking fountain on south face: ERECTED BY / G.M. TURNER / ABBEY HILL KENILWORTH / TO THE MEMORY OF HIS / WIFE WHO DIED MAR 18 1891 / 1906
Condition: fair
Status: not listed
Commissioned by: G.M. Turner

This clocktower has a marble drinking fountain at its base. The upper section has canopied niches and crocketed spires. At alternate corners are statues, a bear and ragged staff, and a lion with a shield.

## ROYAL LEAMINGTON SPA

*Leamington College for Girls*

### Three Aspects of a Young Girl's Education

**Sculptor: Walter Ritchie**

**Architects: Eric Davies and Geoffrey Barnsley**

Installed: 1961
Aluminium sheet, 12 gauge, 99.7% purity
   3.96m long
Condition: good
Status: not listed
Commissioned by: Warwickshire Education Committee
Owner/Custodian: Leamington College for Girls

This is a complex composition consisting of three roughly oval forms, each showing a female figure. The ground to each figure is provided by the brickwork of the façade visible through the work. The subject matter, education, is conveyed through one legendary and two historical characters, the latter two with portrait-like features. The leftmost oval depicts Boadicea, a muscular woman in profile in ancient costume driving a chariot beside which a dog runs. Boadicea, described in ancient Roman and nineteenth-century literary sources, has no established iconography. Here she is treated as a representative of fortitude and the physical aspects of femininity. The lowest oval depicts Florence Nightingale seated with a lamp at the bedside of another figure. She appears as a representative of humanitarian virtues. Marie Curie is shown as a representative of the scientific virtues in the right top oval. She is depicted as a diminutive female figure, in profile, standing with a book. Above her are almost abstract depictions of scientific apparatus and chemical particles.

Each element is depicted in a slightly

**Ritchie, *Three Aspects of a Young Girl's Education***

different style appropriate to the subject matter. The physical scene bursts from the confines of its frame, the figure, horses and dog all have defined muscles and their composition contains complex rhythms and dynamism. The humanitarian scene is contained within its frame and the forms are soft and rounded. In the scientific scene the figure is more stylised symbol than human and is dominated by the scientific instruments and symbols that are depicted in linear clarity.

Boadicea, also known as Boudicca, (d. AD 62) was a warrior-queen, married to Prasutagus, king of the Iceni, a tribe inhabiting what is now Norfolk and Suffolk. On her husband's death in AD 60, the Romans seized her territory. She gathered a large army, destroyed the Roman colony of Camulodunum, took Londinium and Verulamium, and put to death as many as 70,000 Romans. She was finally defeated in battle.[1]

Florence Nightingale (1820–1910) was a hospital reformer and nurse. In the Crimean War, after the Battle of Alma (1854), she led a party of 38 nurses to organise a nursing department at Scutari. There she found grossly inadequate sanitation, but soon established better conditions. Returning to England in 1856, she formed an institution for the training of nurses at St Thomas' Hospital, and spent several years on army sanitary reform, the improvement of nursing, and public health in India. She is commonly known as the Lady of the Lamp.[2]

Marie Curie (1867–1934) was a physicist. She was born in Warsaw, worked in Paris with her French husband Pierre Curie on magnetism and radioactivity, and discovered radium. Pierre and Marie Curie shared the 1903 Nobel Prize for Physics with Becquerel for the discovery of radioactivity. In 1911 she was awarded the Nobel Prize for Chemistry. She died of leukaemia, probably caused by long exposure to radiation.[3]

This work was criticised in the local newspapers on its installation as 'money wasted on £500 experiment, housewives are angry'. [4]

Notes
[1] A & E Television Networks, www.biography.com. [2] *Ibid.* [3] *Ibid.* [4] *Leamington Spa Courier*, 31 March 1961.

## Adelaide Road

*Adelaide Bridge*

### Decorative Ironwork

#### Sculptor: unknown

Unveiled: August 1891
Wrought iron
Inscription: (on separate plaque at north east end): This bridge having been rebuilt, was opened by Mayor Councillor J. Hinks, JP in August 1891

**Unknown,** *Decorative Ironwork*

(on other side of bridge): (on plaque at other end): Adelaide Bridge renovated in 1993 by Warwickshire County Council
Signature: W. de Normanville, Engineer
Condition: good
Status: Grade II
Commissioned by: Leamington Spa Borough Council
Owner/Custodian: Warwickshire County Council

This cast iron bridge has four ornate cast iron lamps, each bearing the inscription at the bottom 'GFO Smith & Co Sun Foundry Glasgow'. On each side, the detailing includes a parmeter motif that recurs on many of Leamington's neo-classical buildings of the early nineteenth century. The shaft of the column has bows and floral reliefs.

## Athena Drive

*Orion House, outside offices of Christiani and Nielson*

### Thor's Footstool

#### Sculptor: Miles Davies

Executed: 1994
Stainless steel and granite 6m high × 9m wide approx
Condition: good
Status: not listed
Commissioned by: Christiani and Nielson
Owner/Custodian: Christiani and Nielson

Thor, the Norse god of thunder, was traditionally represented as a man of enormous strength, a kind of northern Hercules or Scandinavian David, who defended mankind against demons. However, to visualise a divinity of such immeasurable height and complexity would have been inappropriate for a modern suburban industrial estate. As befitting to the post-modern age, the god remained an

**Davies,** *Thor's Footstool*

invisible concept. Only his enormous footstool gives him a symbolic existence. Its tripod-like structure is reminiscent of Apollonian and Christian concepts of the sacred trinity. However, in the present context the three upright stainless steel tubes, bound by a ring at the top and supporting a great rock, work as a diagram of the industrial and commercial structure. This sculptural form, its concept and their mythological associations are appropriate for the corporate identity of one of the largest and most powerful Scandinavian civil engineering firms.

## Avenue Road

*Entrance of the Community Gallery of Art (formerly the Art Gallery)*

### Allegory of Painting

#### Artist: W.J. Bloye

Executed: 1929
Sandstone, life-size
Condition: good
Status: not listed

Commissioned by: Leamington Museum and
    Art Gallery
Owner/Custodian: Leamington Community
    Gallery

This young female nude figure stands in one of
three niches with her weight on her right leg.
Her attribute, a palette, is behind her, signifying
that she represents Painting. The formal
serenity of this figure alludes to painting as an
art of 'silent music'. She is standing in a
motionless position, with little variation in the
representation of musculature. Not plump but
rounded, like ripe fruit, she has close affinities
with sixth-century BC Archaic Greek goddesses.
When the statue was first put up in 1929, it was
suggested that Bloye's figure symbolised the
spirit of modern art. *The Leamington Spa
Courier* wrote that he had depicted 'a young
girl looking straight ahead, fearless,
unapologetic and entirely unashamed, denying
the right of uninformed opinion to judge her'.[1]

It was originally planned that the other two
niches under the pediments were to be filled
with sculptures of Architecture and Sculpture,
but it is not clear whether these statues were
ever installed.[2]

Notes
[1] *The Leamington Spa Courier*, 4 October 1929.
[2] Information from Alison Plumridge, Leamington
Museum and Art Gallery.

*Top of façade, Bath Assembly Hall*

### Female Figure

### Sculptor: unknown

Executed: 1926
Stone, life-size
Inscriptions: (in arch below figure): THE BATH
    ASSEMBLY
(below fan): BUILT HALL 1926
Condition: good
Status: not listed

The arch over the fanlight window above the
main entrance is surmounted by a standing
figure of a woman with her arms raised above
her head in a stylised gesture. Her breasts are
bare, but the lower half of her body is wrapped
in a single piece of drapery that nevertheless
reveals her left thigh and her knees. Her style of
dress reminds the viewer of the importance of
Leamington as a spa town while her pose
suggests that she symbolises the Source, which
would be entirely appropriate to the original
recreational function of the Assembly Hall.

Bloye, *Allegory of Painting*

Unknown, *Figure at the apex of the Bath
Assembly Hall*

*Baker Avenue*
*Kingsway Primary School*

### Peter Pan and the Darling Children

### Sculptor: Walter Ritchie

### Architect: Charles Elkins

Executed: 1953

Ibstock red rustic brick 3.72m high
Condition: good
Status: not listed
Commissioned by: Warwickshire Education
    Committee
Owner/Custodian: Kingsway Primary School

Carved in brick, Walter Ritchie has here fused
the painter Stanley Spencer's rustic realism with
James Barrie's idea of 'playing hide and seek
with angels'. This approach to children's play
was first put forward by the playwright in his
lecture 'Courage' at St Andrews University in
1922.[1] Ritchie not only resisted the temptation
to follow the precedents of the influential *Peter
Pan* statue in Kensington Gardens, London,
which established the popular iconography of
this literary character, but invented a new
iconographical type. The treatment of the
figures is emblematic rather than descriptive.
They appear as if in a dream, in a manner that
recalls Surrealist images.

Note
[1] Ritchie, W., *Walter Ritchie: Sculpture*, Kenilworth,
1994, pp.77 and 81.

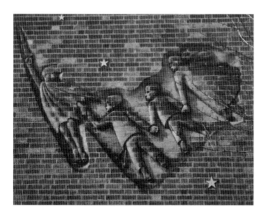

**Ritchie, *Peter Pan and the Darling Children***

*Bath Street*

*Entrance concourse to Royal Pump Rooms*

## *Spring Celebration*
## Sculptor: David Jacobson

Installed: 1999
Locharbriggs red sandstone 3.6m high approx
Condition: good
Status: not listed
Commissioned by: Leamington Museum and
    Art Gallery
Owner/Custodian: Leamington Museum and
    Art Gallery

Sited between the entrance hall and the café of
the new Museum and Art Gallery, this large-
scale abstract water feature combines
commemorative, decorative and practical
functions. Water cascades down the height of
the rock-like structure which is associated with
the town's past by coded references to key
dates and people in the history of Leamington.
These references are coded intentionally to
encourage visitors to discuss their meaning and
to go and find the answers in the library and
museum. At a lower level, three organically
shaped bronze spouts provide saline drinking
water.
    According to the artist:

I wanted to make a sculpture that would
allude to the various histories of the Royal
Pump Rooms as well as to its present use …
I wanted the fragmented architecture of the
sculpture, a stone mass assembled out of
solid blocks that plays games with
perspective, to at once appear to be imposed
on the site whilst also in time appearing to
belong to the site… The intention is for the
sculpture to be approachable in various
ways. By including the tiles from the original
floor in the pool, by referring to a number of
architectural styles, albeit some that are
foreign to the site, by including the

Jacobson, *Spring Celebration*

'window' as a view through the sculpture, by
making the 'drinking fountain' a separate
entity but one integral to the form of the
sculpture and by including the 'seat'. The
actuality, the shape of the sculpture should
be one, which encourages a tactile approach.
By carving the name Jephson, Murdoch and
Smith into certain faces, the months May to
October on the drinking fountain, by
including dates and the names and
percentages of Fixed, Hepatic and Miphitic
air onto the face of the pond without further
explanation as to their meaning it is my hope
that those that look further at the form of
the sculpture, at its reality, will question
what these things mean and perhaps be
motivated to find their meaning either in the
Art Gallery, Museum or Library.[1]

This fountain replaces the late eighteenth-century Wedgwood-like spa water fountain which was in use in the annexe until 1997 and is now in the Museum's store, deemed to be beyond restoration. The Royal Pump Rooms and Baths were built in 1814 to designs by the architect C.S. Smith of Warwick at a reputed cost of £30,000. The building was remodelled in 1863 by the local architect William Cundall, and again in 1889 by William de Normanville. Smaller scale renovations took place in the 1920s, 1940s and 1950s, and the Bath functioned for medical purposes in the NHS until 1950, when it was closed down along with the rest of the spas in the UK as British medical opinion no longer accepted the therapeutic value of artesian thermal water. This contrasts with the unfaltering popularity of spas in the rest of the Western world and increased interest in homoeopathy and alternative medicine. Thus the restoration of 1997–9 was the most fundamental and extensive, as it turned the Pump Rooms into the town's museum, art gallery, library and tourist information office, although the restored Assembly Rooms are still let to provide a venue for entertainment. As the Pump Rooms had originally been built to supply visitors with entertainment and spa water to drink, it was felt appropriate that a water feature providing the opportunity to drink the waters should be included in the restoration. Eight makers were shortlisted, among them Angela Conner, Bettina Furnee and William Pye. A selection panel including council officers, the project architect and a representative of both the Leamington Society and the Friends of the Leamington Art Gallery, then interviewed three of the makers who had been asked to submit proposals. The work was part funded by the Friends of Leamington Art Gallery.[2]

Notes
[1] Archive, artist's statement. [2] Information provided by Leamington Museum and Art Gallery.

Unknown, *Former Pump Room Fountain*

*In Royal Pump Rooms*

## *Two Pairs of Classical Statues*
### Sculptor: unknown

Executed: west side *c.*1780, east side *c.*1810
Earlier pair: papier mâché, life-size
Later pair: plaster of Paris, life-size
Condition: good
Status: not listed
Commissioned by: owners of the Pump Rooms
Owner/Custodian: Warwick District Council

Sited in their respective plain niches in the east and west sides of the Assembly Rooms, these

Unknown, *Classical Statue*

**(left, above and right) Unknown, *Classical Statues***

four female figures seem to be an integral part of the original design of the interior. They are datable by style and their fashionable dress, the pair on the west side as late eighteenth-century and the pair on the east side as early nineteenth-century. As they have only a wreath for

attribute, it is difficult to identify them and interpret their meaning. The successful identification of the flowers may provide the clue, which is likely to be in the realm of the cult of the therapeutic quality of water, as well as physical and mental health. Another possibility is that, like the two pairs of figures in the City Rooms at Leicester, they symbolise the four seasons.[1]

These sculptures appear in photographs of the Assembly Rooms from the 1920s onwards. It is known that there were four life-size sculptures in the building in 1840, but it has not been established whether these were the same figures that are there today.[2]

Notes
[1] Cavanagh, T. and Yarrington, A., *Public Sculpture of Leicestershire and Rutland*, Liverpool, 2000, pp.128f. [2] Alison Plumridge, Senior Curatorial Officer, Leamington Art Gallery, in *Royal Pump Room News*, 1999, front page.

## Dale Street

*Outside Warwickshire Fire and Rescue Service's Leamington headquarters*

### Flame
### Sculptor: Richard Perry

Unveiled: 26 November 1998
Marble 1.83m high
Condition: good
Status: not listed
Commissioned by: Warwickshire Fire and
    Rescue Service
Owner/Custodian: Warwickshire Fire and
    Rescue Service

This tall marble columnar sculpture is set into a circular area of grass. It was designed and carved out of a block of white Italian marble to resemble a spiralling pillar of flames. The artist said: 'A column provides the right balance between a monument to commemorate the 50 years provided by the service and an image that is forward looking and timeless. The marble has a coolness in tone which alludes to the idea of fire being quenched by icy water'.[1] Yet the sculpture's subject matter and form manifests a chain of contradictions. In spite of the original declared intentions of the commissioning competition, the sculpture seems to celebrate the kindling rather than the extinguishing of fire, which would be appropriate to commemorate the unfortunate victims and the sacrifice of firefighters. Neither is the choice of cold white marble consistent with the heat and spread generally associated with fire. Thus this emblematic image reflects one of the fundamental problems of commemorative public sculpture in the late twentieth century: how to convey universally valid social statements in a fundamentally non-naturalistic style. It also shows the effect of the breakdown of the ethical and technical aspects of sculptural practice. While this work still shows the ethic of

direct carving and truth to materials, these principles are only carried out in form, but no longer related to the underlying literary concept and function.

A shortlist of ten artists had been invited to submit ideas and models, from which the Nottingham-based Perry's column was chosen.[2] The sculpture, intended to be a tribute to Warwickshire's victims of fire, was part of a

**Perry, Flame**

£50,000 development scheme at the headquarters to mark the 50th anniversary of the Warwickshire Fire and Rescue Service; £37,000 of this sum came from the National Lottery through the Arts Council. The sculpture was erected ready for a July unveiling, but this had to be postponed as the landscaping of the forecourt was not finished. The statue was originally covered, but the coverings were removed by persons unknown in the months before the official unveiling.[3] It was re-covered and officially unveiled by Ray Sweet, Warwickshire County Council Chairman, and dedicated by Revd James Wilson of Quinton.[4]

Notes
[1] *Leamington Spa Courier*, 27 November 1998.
[2] *Coventry Evening Telegraph*, 23 May 1996.
[3] *Observer*, 3 December 1998. [4] *Coventry Evening Telegraph*, 27 November 1998.

## Euston Park

*Above Bradford and Bingley*

### Firemen and a Manual Pump
### Sculptor: unknown

Installed: 1965
Metal, painted 1m high × 1.2m wide approx
Plinth: stone
Condition: good
Status: not listed
Commissioned by: Birmingham Fire Office
Owner/Custodian: Bradford and Bingley

Two figures, wearing helmets and fireman's uniforms, stand on either side of a cart. They wear green coats, with blue trousers, black boots and helmets and are holding some sort of hose. In the middle, there is a painted model of a late eighteenth-century manual fire pump. This was the trademark of the Birmingham Fire Office, a fire insurance company. An authentic pump of a very similar type made by Stock & Taylor of Birmingham *c.*1770 is on display at

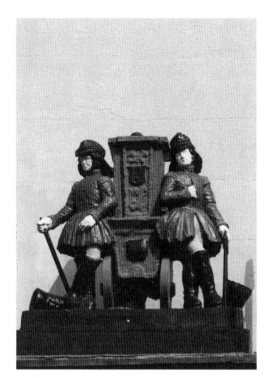

**Unknown,** *Firemen and a Manual Pump*

the Warwickshire Fire Brigade Headquarters in Warwick Street.[1]

This Birmingham Fire Office mark was originally over the porch at 166 Parade, the previous home of the Locke and England estate agents firm who moved to their present site in Euston Place in 1965. At one time Locke and England appealed in the local paper for information about the mark. All that is known is that the firm inherited it from the earlier occupiers of the building, when they moved to the premises, then bearing the address 33 Lower Parade, in 1875.

Note
[1] Gibbons, W.G., *Royal Leamington Spa – Images from the Past*, Coventry, 1985, p.153.

*Euston Place*

### Figure of a Soldier: War Memorial (detail)
#### Sculptor: Albert Toft

Unveiled: 27 May 1922
Pedestal: granite 3m high × 1.4m wide × 1.4m deep approx
Statue: bronze 1.8m high approx
Inscriptions: [Roll of honour around four sides] (on back): KOREAN WAR 1950–53 / FALKLANDS CAMPAIGN 1982
on front: TO OUR FALLEN HEROES / 1914–1918 / 1939–1945
Condition: good
Status: not listed
Commissioned by: public subscription

This figure of an infantryman in full uniform stands on a pedestal with an inscription that includes the names of those who died in the Falklands campaign. He is shown standing with his head bowed and his rifle pointing to the ground.

A memorial committee had been formed in 1919 chaired by Lieut.-Gen. Sir John Kier,[1] and a competition, which 33 architects entered, was held to select the design. The *Leamington Spa Courier* of 26 December 1919 published the winning design by architects T. Llewellyn Daniel and Raymond Alford of Ilford, Essex. The design illustrated is far more elaborate than the final work, consisting of a large cenotaph and 17-metre-long dwarf wall with bronze sculpture embellishments. It would have cost £5,000,[2] but as the original appeal only raised £2,332, it is likely that financial constraints led to the adoption of Toft's single-figure solution.[3] The memorial was unveiled by Lieut.-Gen. Sir Aylmer Hunter-Weston, and the artist and his wife were present at the unveiling. Toft produced an identical figure for a war memorial at Streatham, London, which was unveiled in October 1922.

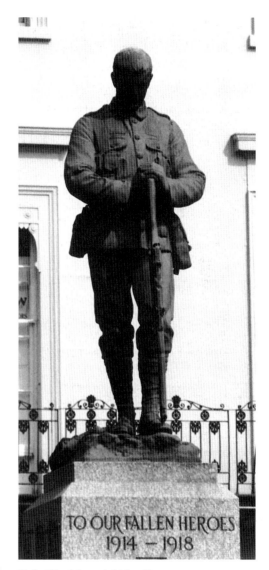

**Toft,** *War Memorial (detail)*

In 1983 stonemason David Leadbetter of Coventry added the name of Leamington's only victim of the Falklands War, Kevin Sullivan.[4] Following a vocal campaign by descendants, the names of two soldiers omitted from the Rolls of Honour, James Henry Walsh (died 1914) and John Jackson (died 1940), were added in 1997.[5]

Notes
[1] *Leamington Spa Courier*, 2 June 1922. [2] *Ibid.*, 26 December 1919. [3] Information provided by Leamington Spa Library. [4] *Leamington Spa Courier*, 15 July 1983. [5] *Ibid.*, 16 May 1997.

## Heathcote Lane

*Reception, headquarters of Wanzel UK*

### Stork

#### Designer: James Peachey

Installed: 1999
Stainless steel: 2.29m high with 1.8m wingspan
Inscription: (on base): Wanzel/ Changes in store/Where new ideas are born …
Condition: good
Status: not listed
Commissioned by: Wanzel UK
Owner/Custodian: Wanzel UK

This statue of a stork is standing with its wings raised in the main entrance to the reception area of the firm's headquarters. The body of the bird is a constructed frame, similar to the traditional armature which is normally hidden. The designer said 'we were looking for a millennium focus that would emphasise Wanzl as the birthplace of innovative ideas. As we are known throughout the world for shopping trolleys and baskets, it was natural the stork should be made using the same sort of robust construction'.[1] In medieval bestiaries and Renaissance emblem books storks are associated with purity and cleanliness. Indeed this is the general visual impact of the statue: bright and spotless in material and light and strong in structure,

Peachey, *Stork*

supported on a single pole.

The stork was conceived and designed by James Peachey, the in-house graphic designer for Wanzel UK, who claim to be the world's largest designer and manufacturer of retailing equipment.[2]

Notes
[1] *Coventry Evening Telegraph*, 22 December 1999. [2] *Ibid.*

## Jephson Gardens

### Jephson Memorial

**Sculptor: Peter Hollins**
**Architect: David Squirehill**

Unveiled: 29 May 1849
Figure: white Carrara marble
Pedestal: Sicilian marble
Pavilion: Bath stone 10m high × 8m diameter approx
Inscription: HENRY JEPHSON M.D. / 1798–1878
Condition: good
Status: Grade II
Commissioned by: public subscription
Owner/Custodian: Warwick District Council

The life-size statue of Dr Henry Jephson is sited in a circular, stone domed pavilion with eight attached columns of Corinthian order. There is a coat of arms above the doorway of the pavilion and a decorative frieze of laurel leaves and berries. Visible through the iron door is the standing figure of Jephson in breeches and robes, resting his right hand on a pillar. The coat of arms are those of the sixteenth-century Jephsons of Froyle, from which it was believed he may have been descended. These are ermine, with three black bugle horns. In this example there is an additional castle above the shield.[1] The centrally planned architectural setting seems to combine two originally unrelated Early Christian commemorative genres, both of which were revived in the nineteenth century, the idea of the *martyrium*, a centrally planned edifice dedicated to a hero, and the *baldachino*, a canopy supported by four or more pillars over a throne or altar.

Dr Henry Jephson, born in Sutton-in-Ashfield, Nottingham in October 1798, was in practice at 7 York Terrace, Leamington. He was a celebrated physician within Leamington and had a national reputation. He was also a

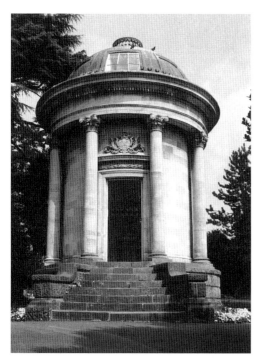

Hollins, *Jephson Memorial*

generous benefactor to the town. In 1847 his health broke down and the following year Jephson became blind and retired.[2] He died in May 1878 aged 80. Amongst his most famous patients were Princess Victoria, the Duchess of Kent, George IV, Florence Nightingale, W.E. Gladstone and John Ruskin.[3]

In 1845 the desire was first expressed in Leamington 'to perpetuate the remembrance of the eminent talents and private worth of Dr Jephson by the erection of some striking public testimonial'.[4] A pubic meeting was held in March 1845, a committee was formed and subscriptions solicited. In 1846 the Committee revealed that they had obtained a 2,000-year lease for the New Gardens at a nominal rent, and proposed a statue should be commissioned

from the Birmingham sculptor Peter Hollins, who had already sculpted a bust of Jephson.[5] A model of the statue was exhibited at the Royal Academy in May 1848. The pavilion of Bath stone was designed by David Squirehill (1808–63) and Hollins was paid £1,000 for a life-size statue.[6] The memorial was unveiled by Mr Sergeant Adams, and was adopted as the Leamington Society logo in 1956. It was restored in the late 1980s at a cost of £56,700.[7]

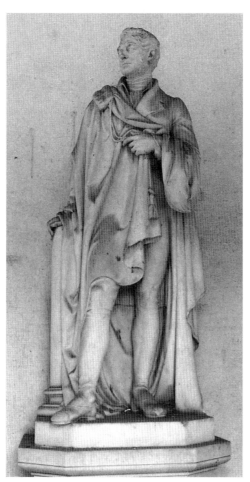

Hollins, *Jephson Memorial (detail)*

Notes
[1] Baxter, E.G., *Dr Jephson of Leamington Spa*, Leamington Spa, 1980, p.87. [2] *Leamington Spa Courier*, 18 May 1878. [3] Sites and Monument Record, *WA1398*. [4] *Leamington Spa Courier*, 18 May 1878. [5] *Ibid.* [6] Dudley, T.B., *A Complete History of Royal Leamington Spa*, Leamington Spa, 1901, p.422. [7] *Coventry Evening Telegraph*, 30 May 1989.

## Clock Tower ('Davis Clock')

### Artist: unknown

Installed: 1925
Clocktower: stone 12m high approx × 2m wide × 2m deep
Inscriptions: (plaque on rear): CHIMES REINSTATED 1986 / IN MEMORY OF / MRS. JOY BEEBY
(below panel): PRESENTED / BY / MRS WILLIAM DAVIS / TO THE MEMORY OF HER LATE HUSBAND / WILLIAM DAVIS.J.P. / 15 YEARS COUNCILLOR & 28 YEARS ALDERMAN / THREE TIME MAYOR & 22 YEARS CHAIRMAN / OF THE HIGHWAYS COMMITTEE
Condition: good
Status: not listed
Presented by: widow of Cllr. William Davies JP
Owner/Custodian: Warwick District Council

This square-shaped clock tower with cornice pediments stands on four steps. A panel on the rear of the clock is inscribed and decorated with wreath and laurels in relief. The clock face is simple, and there is a door in the north face. All in all, it is a pleasantly decorative architectural monument which, with its chime, successfully contributes to the ambience of this mainly Victorian park.

Known commonly as the Davis Clock, its chimes were silenced in 1933 to avoid disturbing local residents. The first suggestion to restore them came in 1977 from Councillor Bob Johnston, and it was costed at £2,000 by the Recreation and Amenities Department.[1] The

chimes were eventually reinstated in 1986 in memory of a Mrs Joy Beeby.

Note
[1] *Coventry Evening Telegraph*, 28 November 1977.

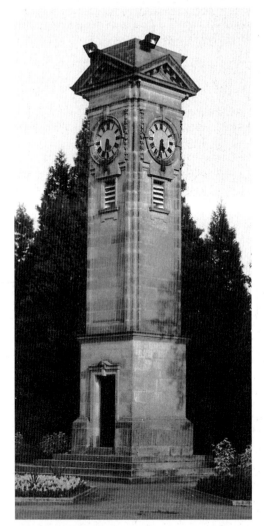

**Unknown**, *Clock Tower*

## *Czechoslovakian War Memorial Fountain*

### Sculptor: unknown

Unveiled: 26 October 1968
Fountain: granite 2m high × 1.3m diameter approx
Plaque: bronze
Inscriptions: (on plaque on stone pedestal behind fountain): IN TRIBUTE / TO ALL / CZECHOSLOVAK SOLDIERS AIRMEN AND PATRIOTS / WHO FELL IN WORLD WAR II. / FROM ROYAL LEAMINGTON SPA, IN 1941, / VOLUNTEERS FROM FREE / CZECHOSLOVAK FORCES / STATIONED IN THE TOWN WERE PARACHUTED INTO / THEIR HOMELAND TO RID IT OF THE TYRANT / PROTECTOR, S.S. GENERAL HEYDRICH. TWO OF / THEM – JAN KUBIS AND JOSEF GABCIK – / ACCOMPLISHED THEIR MISSION IN MAY 1942. / THEY AND THEIR COMPANIONS LAID DOWN THEIR / LIVES / FOR FREEDOM.
(around fountain, from front clockwise): JAN HRUBY ADOLF CPALKA JAROSLAW SVARR JOSEF VALCIK JOSEF BUBLIK JAN KUBIS JOSEF GABCIK
Condition: fair
Status: not listed
Owner/Custodian: Warwick District Council

This ornamental commemorative fountain in a round pool has a shield on the front with a rampant crowned lion and a twin-tailed lion with a shield on his chest. The fountain is shaped like a parachute and the stream of water falls from the top along grooves to simulate the cords. Behind the fountain is a bronze plaque on a stone pedestal. The whole is set with a sundial within a cruciform pathway. Form and content are here fully correlated: the underlying concept and principal motifs of this monument suggest an appropriate symbolic meaning. The truth-to-material handling of hard granite and the simplified details displaying the method of direct carving make this object characteristically modern in style.

During World War Two, part of the Czech Government in exile occupied the nearby Compton Verney estate and members of both the Polish and Czech armies in exile were billeted in the town. Plans for the assassination of General Heydrich, the Chief of the German forces occupying Prague, were first formed in a house in Newbold Terrace in Leamington.[1]

The memorial was unveiled by the Mayor, Alderman Miss E.I. England OBE.[2]

Notes
[1] Gibbons, W.G., *Royal Leamington Spa – Images from the Past*, Coventry, 1985, p.98. [2] *Ibid.*, p.97.

**Unknown**, *Czechoslovakian War Memorial Fountain*

## Hitchman Fountain
### Architect: John Cundall
### Stonemason: Thomas Price

Unveiled: 28 October 1869
Stone 6m high approx
Drum: granite or marble
Inscription: (around drum, almost
    indecipherable now): IN MEMORY OF JOHN
    HITCHMAN WHO DIED A.D. 1867
Condition: poor
Status: Grade II
Commissioned by: Hitchman Memorial
    Committee
Owner/Custodian: Warwick District Council

This large and ornate fountain near the roadside
in the north-east corner of the park is in a late
quattrocento early Renaissance style. It consists
of a round bowl, above which is an upper bowl

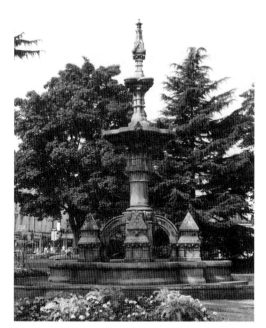

Cundall, *Hitchman Fountain*

and fountain. The supporting shaft has neo-
Gothic angled buttresses with tower finials that
are decorated as if tiled and with lion head
spouts. There are squat Corinthian columns
around the buttresses. The central structure has
shields at the join and then a marble drum
supporting clustered columns with oversize
acanthus capitals supporting the basins. The
forms are executed with great care though
somewhat mechanically suggesting the use of
modern industrial technology.

The fountain was erected in memory of Dr
Hitchman MRCS (1805–67), born at Chipping
Norton, who came to Leamington in 1840 from
Banbury, where he had been an assistant to a
surgeon. He became the associate and staunch
friend of Dr Jephson, who was also a firm
believer in hydropathic treatment. He built the
Arboretum in Tachbrook Road in 1864 in order
to put his ideas into practice. The building
would later become the Midland Counties
Home for Incurables.

Two years after Hitchman's death a
committee was formed under Dr Jephson to
raise funds for a memorial to him. It was
erected on the site of Strawberry Cottage,
where a Mr Jackson, architect, had been the
former occupant, at a cost of £300 and was
unveiled by Richard Jones, the surgeon, on
behalf of Dr Jephson.[1]

Note
[1] Leamington Spa Museum Service, Leamington Spa
Museum and Art Gallery Information Files.

Source
Burgess, Frederick, 'The Architectural History of
Leamington Spa', *Monumental Journal*, October
1957, p.609.

## Standing Stone (Monument to W.H. Auden)
### Sculptor: Richard James Kindersley

Installed: 1996

Kindersley, *Standing Stone (Monument to W.H. Auden)*

Slate 1.8m high × 45cm wide × 10cm deep
Inscription: (on front face at the top, incised in
    a decorative script): So / TO REMEMBER / OUR
    CHANGING / GARDENS WE / ARE LINKED AS /
    CHILDREN / IN A CIRCLE / DANCING
Signature: (on back face, inscribed in a plain
    script in italics at the bottom): W H Auden /
    Jephson Gardens / 1840 – 1996 / Richard
    Kindersley
Condition: good
Status: not listed
Owner/Custodian: Warwick District Council

This is a monolith, a single standing stone,
almost like a phallic image or a gravestone with
one straight-formed edge on one side, while the
opposite side seems to have been left natural.

The genre of monolith or standing stone is
generally associated with the practice of magic

and ritual, as well as prehistoric social and cultural conditions. Such associations seem to be confirmed by the inscribed dedication to the mid-twentieth-century English poet W.H. Auden, whose poetry was inspired by memories of childhood, nursery rhymes and the surrealist preoccupation with the concept of eternal return.

## Willes Obelisk (detail)

**Architect: John Cundall**

**Builder: Gascoyne & Sons**

Erected: 1875
Base: York stone 3m high × 1.5m wide × 1.5m
    deep approx
Plaque: bronze
Obelisk: polished granite 4.5m high × 50cm
    wide × 50cm deep
Steps: Derbyshire stone
Inscriptions: (on east face, and repeated on west
    face): ERECTED IN HONOUR OF / EDWARD
    WILLES ESQUIRE / OF NEWBOLD COMYN / TO
    WHOM LEAMINGTON IS INDEBTED / FOR THE
    SITE OF THESE GARDENS
(on south face and repeated on north face): 1875
Condition: fair
Status: Grade II
Owner/Custodian: Warwick District Council

Three steps, a pedestal and a base lead the eye to this square pyramid obelisk. There are shields on the base: that on the east face shows a chevron and three stars, while that on the west face shows a composite shield of the chevron and three stars on one side, and two falcons above a bar with a lion's head between two stars and a falcon below on the other. On the north and south faces are reliefs of a falcon, the family emblem of the Willes. The armorial bearings of the Willes family, silver with a black chevron between three stars, are above the pedestal.
    The Willes family had settled in

Cundall, *Willes Obelisk*

Warwickshire before 1330, originally at Compton Magna in Napton, and had lived continuously at Newbold Comyn in Leamington from purchasing it in 1538 until its disposal in 1966. By 1552 they held 100 acres. When the New Town was being developed in the early decades of the nineteenth century they were the largest landowners and the head of the family was a Mr Edward Willes, whose son was also called Edward. Little is known of Edward senior (1744–1820) except that he disliked the developments in the town and liked his privacy. However, since he owned most of the land north of the river, the business prospects did not escape him and he eventually sold some land at exorbitant prices.[1] His son Edward junior (1819–47) moved away from Leamington but continued to sell land as well as donating some to the town, most notably the area now known as Jephson Gardens in 1845–6.
    As a genre in architectural memorials,

obelisks are used to signify the virtue of a leading person supported by the people. The Willes obelisk has certain affinities with ancient Roman obelisks which were greatly admired by early nineteenth-century English visitors to Italy. The architect said 'It is not intended to partake of any particular style, but the details are somewhat after the Romanesque'.[2]

Notes
[1] Cave, L.F., *Royal Leamington Spa – Its History and Development*, Chichester, 1988, p.47. [2] *Leamington Spa Courier*, 26 June 1875.

## Ladder Bridge

*Behind Althorpe Industrial Estate*

### Commemorative Mosaic Sculpture

**Artist: Janet Vaughan**

**Arts Development Worker: Stella Carr**

Installed: March 1999
Cement mosaic, 3.9m long × 75cm wide approx
Condition: good
Status: not listed
Commissioned by: Smiths Concrete

This series of square mosaic panels has been set into the ground and framed by brickwork. Each square is brightly coloured and includes abstract patterns as well as tools and archaeological items from the British Waterways maintenance yard at Hatton. The work optimistically celebrates the regeneration of the canal and the industrial and archaeological heritage of the area. This is a pleasingly decorative piece with an iconography that combines in an emblematic manner the past and present function of its setting.
    The artwork was the result of a number of community workshops run by arts developer Stella Carr and artist Janet Vaughan. It was funded by Smiths Concrete as part of a £80,000

**Vaughan**, *Commemorative Mosaic Sculpture*

bridge replacement and canalside-landscaping scheme. Children from Clapham Terrace and Shrubland Street schools and representatives of British Waterways and Smiths Concrete attended its permanent siting at the end of March 1999.[1]

Note
[1] *Leamington Observer*, 1 April 1999.

## Parade

*On the façade of Barclays Bank, Refugee House*

### Beehive Pediment
### Artist: unknown

Executed: *c*.1903
Panel: stone 70cm high × 2m wide
Inscriptions: NOTHING WITHOUT LABOUR
Condition: good
Status: not listed
Commissioned by: Refuge Assurance Company
Owner/Custodian: Barclays Bank

This semi-circular tympanum contains a relief of a beehive surrounded by detailed foliate patterns. In emblematic literature beehives symbolise industry and the thrift that produces prosperity.

This branch was opened originally in 1903 by Midland Counties Bank who were taken over by Barclays Bank in 1904. The building was originally shared with Refuge Assurance Company and had the name 'REFUGE INSURANCE BUILDINGS' immediately beneath the beehive pediment. There is a building plan dated 1903 under the name of the Refuge Assurance Company's district manager in Warwick County Record Office. A beehive device was included in the Refuge Company's official coat of arms, which was granted in 1951.[1]

Note
[1] Letter from Nicholas Webb, Barclays Group Archives, 14 December 1999.

## Bright Obelisk
### Designer: John Cundall

Erected: 1880
Obelisk: pink granite 6m high approx × 1m wide × 1m deep
Base: stone 1.2m high × 1.6m wide × 1.6m deep
Pedestal: stone 1.7m high × 1.2m wide × 1.2m deep
Inscriptions: (on back face): 1880
(on front face): ERECTED / BY PUBLIC SUBSCRIPTION / TO RECORD THE SERVICES OF / ALDERMAN HENRY BRIGHT / TO WHOSE UNTIRING EXERTIONS / THIS TOWN IS CHIEFLY INDEBTED / FOR ITS SUPPLY OF / PURE WATER
Condition: fair
Status: Grade II
Commissioned by: public subscription

This tall and slender pyramid obelisk stands on

**Unknown**, *Beehive Pediment*

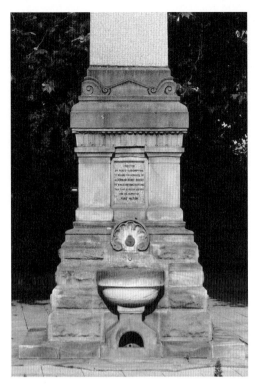

**Cundall, *Bright Obelisk (detail)***

Board to adopt the borehole plan.[1] In 1877 a new waterworks was begun, and Bright, by then Mayor of Leamington, laid the foundation stone at the works.

The obelisk was erected to commemorate Bright's influential role in the provision of clean water, and as one of the many reminders of Leamington's cult of pure water.

Note
[1] Cave, L.F., *Royal Leamington Spa – Its History and Development*, Chichester, 1988, p.129.

*Above entrance to former Regent Hotel*

## Coat of Arms and Supporters
### Architect: C.S. Smith

Executed: *c*.1819
Stone, painted 1.2m high × 1.9m wide approx
Inscriptions: (around shield): HONI SOIT QUI
   MAL Y PENSE
(in motto): ICH DIEN
Condition: poor
Status: Grade II*
Commissioned by: Mr John Williams,
   proprietor

This is one of the royal coats of arms in Leamington showing the town's close royal

**Smith, *Coat of Arms and Supporters***

connections. Flanked by two supporters, a lion and a unicorn, the Royal Arms are displayed in a round shield with an encircling laurel garland. The shield of the official arms of the royal family is divided into four quarters representing the United Kingdom. The three lions of England occupy the upper left and lower right quarters, the single lion of Scotland occupies the upper right, and the harp of Ireland, is placed in the lower left. Above are three feathers as a crest. There is a further depiction of three feathers on the Parade façade.

Built as the largest hotel in Europe with 100 bedrooms,[1] it opened on 19 August 1819 as the Williams Hotel, named after the proprietor Mr John Williams. Three weeks later, the Prince Regent (later King George IV), who was staying at Warwick, commanded that it should bear the title 'Regent Hotel' and his coat of arms.[2] These were presumably added in late 1819 and were restored and repainted in 1976. The hotel closed in 1999 and its future remains uncertain.

Notes
[1] Dudley, T.B., *A Complete History of Royal Leamington Spa*, Leamington Spa, 1901, p.138. [2] Cave, L.F., *Royal Leamington Spa – Its History and Development*, Chichester, 1988, p.63.

*Above interior of Whiteheads Court entrance to Royal Priors shopping centre*

## Peacock Clock
### Artist: Mike Harding
### Clockmaker: Sinclair Harding and Co.

Unveiled: 22 March 1989
Backdrop: painted on wall
Bird: steel 2m high approx without tail
Condition: good
Status: not listed
Commissioned by: MEPC Developments Ltd

a stepped rusticated base and an elaborate pedestal with inlaid marble panels and inscriptions. At the bottom, there is a basin with a shell decoration – this is no longer in working order and has been filled in with concrete.

Henry Bright was first listed, along with an Edward Bright, as a clock and watchmaker with premises in Charlecote Street and the Lower Parade in 1833. When in 1870 the Local Government Board in London had declared Leamington's water unfit to drink Henry Bright was instrumental in forming a group that planned to sink boreholes to tap underground sources of water. He was elected to the Local Board of Health in 1872 and persuaded the

Owner/Custodian: Royal Priors shopping
   centre

A painted landscape background fills the arched
wall space with a peacock automaton. On the
hour the bird's wings are raised as music plays,
the hour is told by the number of tail feathers
while the minutes between the hours are told
by a series of moving chicks swimming past
with flashing lights on them. The gently
nodding peacock has a wingspan of over five
metres and sits in front of a painted depiction of
Warwick Castle. The clock has a steel
construction and is operated by a system of
pneumatics controlled by a microcomputer.
Arbitrary in the choice of subject matter, gaudy
in its form and colour as well as insubstantial in
material, the Peacock Clock fails to live up to
the expectations of clocks in public places for
legibility.

Harding, *Peacock Clock*

The Peacock Clock was commissioned by
MEPC Developments Ltd, the developers of
the Royal Priors shopping centre, and installed
at a cost of £70,000. It was unveiled by Mrs
Ann Davis, who had also opened the shopping
centre in 1987 after winning a competition.[1] The
clock was not particularly well received;
shoppers claimed that it was difficult to work
out what time the clock was showing.[2]

Notes
[1] *Coventry Evening Telegraph*, 23 March 1989.
[2] *Leamington Spa Courier*, 7 April 1989.

*Inside Town Hall, in niche at head of stairs
at first floor level*

## Bust of King Edward VII
## (1842–1910)
### Sculptor: Albert Toft

Unveiled: 26 June 1902
Bust: Serrazza marble 60cm high × 80cm wide
   approx
Inscriptions: (on base): EDWARD VII,
   CORONATION MEMORIAL, JUNE XXVI
   MDCCCCII / CROWNED August IX.MDCCCCII
(on plaque): Presented by ALDERMAN
   WACKRILL, J.P. / First Mayor of Leamington.
Signature: (on side): ALBERT TOFT SC 1902
Condition: good
Status: Grade II
Commissioned by: Alderman S.T. Wackrill
Owner/Custodian: Warwick District Council

This portrait bust shows Edward VII in official
robes but without his crown.
   King Edward VII (1841–1910), the eldest son
of Queen Victoria and Prince Albert, reigned
from 1901–1910. He is particularly known as a
reformer of the military and the navy. He was
on friendly terms with Gladstone, Chamberlain
and other political party leaders and took a
close interest in political and social life. He was
related to many of the European members of

Toft, *Bust of King Edward VII*

royalty and became known as the 'Uncle of
Europe'.[1]
   Toft's rendition of Edward VII gained praise
from T.B. Dudley in his contemporary history
of the town: 'in fidelity of expression, delicacy
of workmanship and refinement, even in the
smallest details, the artist has achieved all that
may be conceived as possible to sculpture'.[2]

Notes
[1] Kings and Queens of England (And Later the
United Kingdom) since 802, www.royal.gov.uk/
history/since802. [2] Dudley, T.B., *A Complete
History of Royal Leamington Spa*, Leamington Spa,
1901, p.447.

*Outside Town Hall*

## Statue to Queen Victoria
## (1819–1901)
### Sculptor: Albert Toft

Unveiled: 11 October 1902
Statue: Sicilian Carrara marble 3m high approx

Pedestal: red Aberdeen granite 3.35m high
Inscriptions: (on front panel): VICTORIA, QUEEN
    EMPRESS, 1837–1901 SHE WROUGHT HER
    PEOPLE LASTING GOOD [Tennyson]
    (on back panel): ERECTED / BY THE PEOPLE
    OF / LEAMINGTON / OCTOBER 1902 /
    WILLIAM DAVIS / MAYOR
    (on plaque): A German bomb moved this /
    statue one inch on its plinth / on the 14th
    November 1940
Condition: good
Status: Grade II
Funded by: public subscription
Owner/Custodian: Warwick District Council

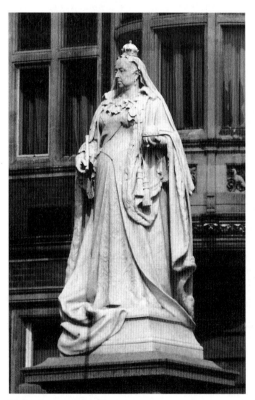

**Toft,** *Queen Victoria*

This over-life-size standing figure of Queen Victoria is set on a relatively plain corniced pedestal. Her head is slightly turned to the right, and she is holding the sceptre in her right hand and the orb in her left. She is dressed in the robes of state and wears the ribbon and star of the Order of the Garter and Albert and Victoria medals. Her cloak falls in folds over the base down the pedestal, enhancing the height and stature of the figure. She is depicted wearing a panel skirt, richly embroidered to include the symbols of her United Kingdom: the English rose, the Irish shamrock and the Scottish thistle.

The long reign of Queen Victoria coincided with the increasing industrial prosperity and imperial expansion of Britain. She was greatly mourned upon her death on 22 January 1901.

Leamington gained the title 'Royal' after Queen Victoria's visit to the town in July 1838, just weeks after her coronation, and the town felt a strong attachment to her. Funds for the statue were raised by a committee from public subscriptions following the suggestion of a Mrs Davis. The committee was chaired by Alderman William Davis, the town's Mayor, and Mr Alfred Turner, the Assistant Town clerk, was its Honorary Secretary. The memorial, which cost £1,400,[1] was praised at the time of its commissioning. In his 1901 history of the town, T.B. Dudley described it as 'a work on which it is impossible to bestow too much praise … the expression is pleasing and suggests firmness and strength of character, with an adequate recognition of the regal duties and privileges of exalted office'.[2] The statue was unveiled by Lord Leigh, Lord Lieutenant of Warwickshire, and the *Leamington Spa Courier* happily reported that 'as the ceremonial was approaching its completion the sun shone out with unwonted brilliancy for the month of October, the light falling full upon the face of the effigy of Her late Majesty, a circumstance which was noted as pleasingly significant in

character'.[3] The statue was cleaned in 1984 at a cost of £200,[4] and again in 1998 at a cost of £2,500.

Notes
[1] Dudley, T.B., *A Complete History of Royal Leamington Spa*, Leamington Spa, 1901, p.445.
[2] *Ibid.*, p.446. [3] *Leamington Spa Courier*, 17 October 1902. [4] *Coventry Evening Telegraph*, 6 November 1998.

*On the Town Hall*

## Town Hall Façade and two Allegories
### Architect: John Cundall

Executed: 1883–4
Camden stone, mosaic
Coat of arms relief, 90 cm diameter approx
Sculptures, varying sizes
Condition: fair
Status: Grade II
Commissioned by: Leamington Borough
    Council

The façade of the Town Hall is decorated with a complex iconographical programme of pediments, relief sculpture, sculpture and mosaic. A roundel on the upper façade has a relief of the Royal Leamington Spa coat of arms. The shield shows a lion rampant with a chevron across and three stars above with a border bearing eight fleur-de-lys. The crest is a serpent coiling around a staff crossed with a log, with two sprays of forget-me-nots. The motto is carved on a ribbon either side of the shield. As can be expected, the iconographical programme is determined by the town's cult of the beneficial qualities of water and the therapeutic effects of music and entertainment. In the centre at the top of the pediment is a swan with outstretched wings. This is symbolic of Leamington. In a lunette above the large window in the upper structure is a mosaic

telescope). These still-life motifs are both supported by stylised swans.

On the façade of the west wing, the pediment relief contains two putti, one holding a caduceus (symbolic of commerce), and the other a fasces, symbolic of security. Between them is a still-life consisting of a sceptre and a sword crossed over one another. Beneath them is an open book with a pair of scales above it. This relief is entirely appropriate to its site because the court rooms were on this side of the Town Hall. The theme of Justice becomes even more explicit over the corner, beneath the campanile, where there is another emblem with the inscription SOLA HONESTA BONA QUAE (which translates as 'Only those things that are honourable are good'). This emblem includes a flute and a ragged staff crossed, the whole entwined by a snake. Beneath this, over the

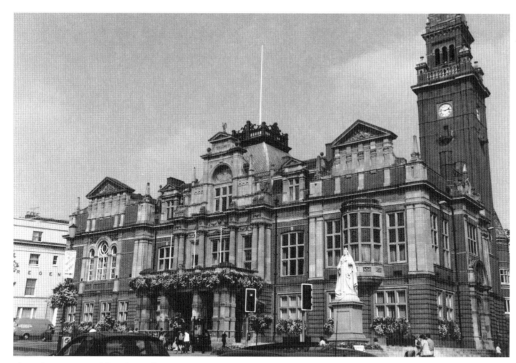

(left) Cundall, *Town Hall Façade*

(below) Cundall, *Music*

showing a personification of Leamington holding some of the attributes of Hygeia, namely a chalice in her right hand and a serpent in her left.[1] Below her are the waves and swans of the River Leam.

This upper section is also flanked by two lions, symbolic of mental and physical strength. Beneath the window between two garlands is the unhelmeted head of a domesticated Britannia (or Anglia), while above the main entrance is the head of the river god Leam. The pediment of the east wing shows a lyre among a selection of other wind and string instruments. These are supported by two seated music-making winged putti, one with a trumpet and the other with a tambourine. Beneath, there are two additional still-lifes above the first floor windows. One is of musical instruments (a lyre and a violin), the other shows geographical and astronomical instruments (a globe and a

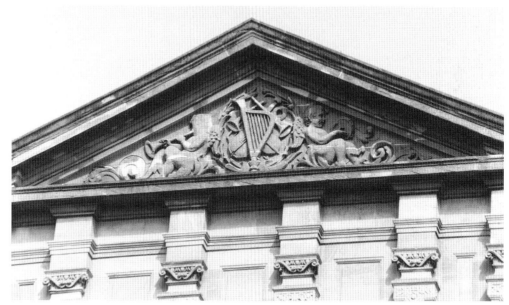

**Cundall,** *Commerce*

Notes
[1] Information from Alison Plumridge, Senior Curatorial Officer, Leamington Art Gallery.
[2] *Leamington Spa Courier*, December 1884.
[3] Lynda F. Cave, *Royal Leamington Spa*, Phillimore, 1998, p.135. [4] *Leamington Spa Courier*, 14 September 1984. [5] *Ibid.*, 8 October 1993.

## Tachbrook Road

*Pond outside administration and reception block, headquarters of Automotive Products Ltd*

### Miranda Mermaid Fountain
### Sculptor: Arthur John Fleischmann

Executed: *c*.1952
Bronze 90cm high × 1.5m wide approx
Condition: good
Status: Grade II
Commissioned by: Lockhead Hydraulic Brake
   Co. (part of Automotive Products Ltd)
Owner/Custodian: Automotive Products Ltd

entrance, in a semi-circular lunette there is a mosaic showing a half-length figure of blindfolded Justice holding a sword and a scale with a white lily on her right-hand side.

The Town Hall was officially opened by the mayor, Councillor Sidney Flavel, on 18 September 1884. Architects interested in designing the new town hall were invited to submit designs under a nom-de-plume. In 1881 46 sets of plans were submitted. Three architects, John Cundall of Leamington, Vincent Freeman of Bolton-Le-Moors and Messrs Scrivenor and Sons of Hanley were invited to send in more detailed plans. A public debate began between those favouring a Regency building on the site of the Pump Rooms, and those preferring a more Gothic style building on a plot of land south of the Regent Hotel. The choice of Cundall's plans was controversial. One of the other competitors, Vincent Freeman, complained that

Cundall's use of a perspective drawing had violated the conditions laid down and that he should have been disqualified from the competition. There were continued debates in the Council over the purchase of the site near the Regent Hotel, and it was only after approval by a public inquiry and the Local Government Board that the plans finally went ahead. The builder, John Fell, was a local man. The foundation stone was laid by the mayor, Alderman Henry Bright, on 17 October 1882, and the building was officially opened by the then mayor, Councillor Henry Bright on 18 September 1884. Public response was not favourable. The *Leamington Spa Courier* described the building as 'awkward and ugly'.[2] The façade facing the Regent Hotel caused the paper particular concern as it was 'utterly destitute of anything approaching architectural beauty'.[3] The Camden stone portico entrance was added later at the cost of £2,000.[4] The building was cleaned by Neale's of Sutton Coldfield at a cost of £22,000 in 1984, its centenary year.[5]

The work is sited on raised steps, in front of a low wall and surrounded on three sides by a pond. The fountain sits in the centre of a pool converted from a wartime static tank. The nude figure of a mermaid lies on her back with her arms in the air, balanced on a turtle. She has a fish on her right shoulder and two more on her lower legs, the fish and turtle acting as water spouts. Unusually for a mermaid, she has legs, but with fins instead of feet. In this respect she follows the iconography of the famous Little Mermaid statue by Edvard Eriksen in Copenhagen (1913), itself based on Hans Christian Andersen's fairy tale of 1836.

The artist replied to criticisms over the choice of legs instead of a tail by saying 'why should not a beautiful mermaid have nice legs? She can still swim with the fins on her feet.'[1] The ancient Graeco-Roman iconography was revived in Christian art, to symbolise the human soul floating from life to death. However in later Renaissance art the

'recumbent mermaid' became an emblem of liberated physical desire, a favourite theme in avant-garde art of the 1920s.

The original fountain took three months to complete. It was called Miranda after a popular film depicting a mermaid of that name in 1940. The models for the fountain were 20-year-old Joyce Taylor, a piano student, and an 18-year-old commercial artist who kept her name secret. This is part of a fountain originally exhibited at the 1951 Festival of Britain and which was inaugurated there by Mr W. Emmott, then Managing Director of the Automotive Products Group, parent company of Lockhead Hydraulic Brake Co., at that time Leamington's biggest employer. It was transferred to the Leamington factory site in late 1951, and is the only surviving sponsored piece of work from the 1951 Festival of Britain's Pleasure Gardens at Battersea Park.[2] It was cleaned and repaired in 1990. Unfortunately, the statue was stolen between 14 and 17 December 2001.

Notes
[1] *Observer*, 3 December 1998. [2] *Ibid*.

Source
Barnes, Joanna, *Arthur Fleischmann 1896–1970: A Centennial Celebration*, Fine Art, London, 1996.

## Warwick Street

*Whiteheads Court entrance to the Royal Priors shopping centre*

### Mahout and Elephants

### Sculptor: Nicholas Dimbleby

Installed: 1988
Bench: marble 70cm high × 2m diameter
Elephants: bronze 70cm high × 60cm wide × 1.2m deep
Inscription: (back of marble seat support):
NICHOLAS / DIMBLEBY / MCMLXXXVIII
Condition: fair
Status: not listed

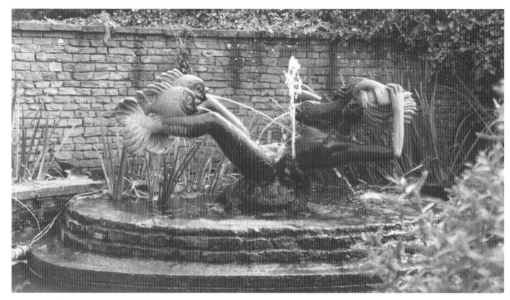

(above) Fleischmann, *Miranda Mermaid Fountain*    (below) Dimbleby, *Mahoot and Elephants*

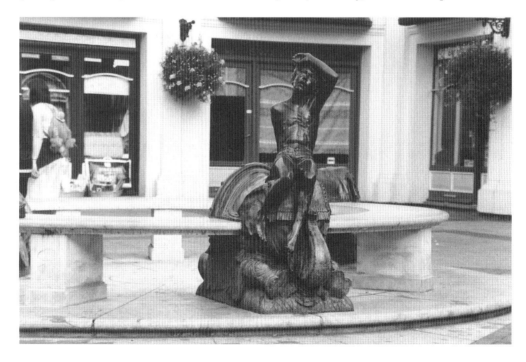

Commissioned and owned by: Royal Priors shopping centre

These three bronze statues of Indian elephants, kneeling down, with saddles and head gear, support a circular marble bench. On one of the elephants is a statue of a young boy, a mahout, who looks skyward.

A copy of the model used by the sculptor to create the *Boy on an Elephant* was bought by the town's Art Gallery and Museum in 1995 for a total of £1,092.[1] Twenty copies of the maquette were made, one of which was presented to the Queen when she unveiled the sculpture in 1988.[2]

**Unknown,** *Celtic Cross*

Notes

[1] *Coventry Evening Telegraph*, 7 August 1995.
[2] *Ibid.*

## WAPPENBURY

### *Celtic Cross*

### Sculptor: unknown

Executed: *c.*1300s
Base: stone 40cm high × 85cm wide × 85cm deep
Shaft: stone 60cm high × 25cm wide × 25cm deep
Condition: fair
Status: Grade II

**Unknown,** *Stucco Decoration*

This is a richly carved stone cross in the tradition of Celtic crosses. It is standing on a square base on octagonal steps. The base is decorated with unidentifiable male heads and shoulders. The cross has a number of broken and missing parts, and there has been damage to three of the four corners at the base.

## WARWICK

### *Bowling Green Street*
*On the façade of Westgate Primary School*

### *Stucco Decoration*

### Sculptor: unknown

Executed: *c.*1910
Stucco, painted white
Panels of varying sizes
Condition: good
Status: not listed
Commissioned by: Warwick Borough Council
Owner/Custodian: Westgate Primary School

This is an Arts and Crafts building with abundant white stucco decoration. In the tympanum, the motifs contain the emblem of Warwick and have local significance. The others seem to date from a later period (1910–20) and show stylised floral motifs. Two rectangular panels, one of pomegranates and the other of clematis, seem to be of an earlier, more naturalistic style.

## Church Street

### *War Memorial*

### Architect: C.E. Bateman

Unveiled: July 1921
Stone 10.5m high × 3.1m wide
Condition: fair
Status: not listed
Funded by: Warwick Borough Council

This is an unobtrusive simple structure in the form of a tall slim Gothic tower that provides a suitable background for the listing of the names of those who died in the two World Wars on plaques attached to the memorial. It is set in a key position in front of the Gothic church tower of St Mary's. During the First World War, casualty lists were pinned to the railings of the church where the footpath from The Butts enters Church Street. This determined the siting of the memorial when the conflict was over.[1]

Note
[1] Information provided by Eric Davies, retired County Architect, 13 July 2000.

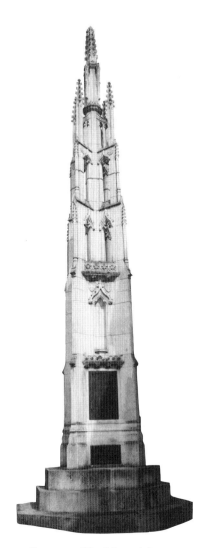

**Bateman, *War Memorial***

## *Coventry Road*

*On traffic island at junction with Guy's Cross Park Road*

### *Guy and the Boar*

### Sculptor: Keith Godwin[1]

Installed: July 1964
Statue: concrete and metal 2.1m high × 70cm
wide × 58cm deep
Base: concrete 25cm high × 68cm wide × 57cm
deep
Pedestal: stone and mortar 53cm high × 81cm
wide × 68cm deep
Inscription now missing: [A plaque bore the
town of Warwick's coat of arms,
commemorated the unveiling by the mayor,
and told the legend of Sir Guy.]
Signature: (on back of base to work), (incised):
Godwin 64
Condition: good
Status: not listed
Commissioned by: Annol Development
Company Ltd
Owner/Custodian: Warwick District Council

This mock heroic memorial to a legendary local hero is set in a square paved area in front of a group of trees. Resting on its concrete base is a projecting stone-built pedestal, which is supporting the sculpture in cast concrete. It shows the figure of a man, the naked Guy, holding a spear in his right hand and the tusks of the boar in his left hand. He is depicted as an elongated, gaunt figure having a simplified face with little characterisation except for deep-set eyes and a furrowed brow. There is little definition of the musculature except the upper torso on which the muscles have been defined in a precise, almost mechanical manner. Whilst the majority of the figure has a textured surface, revealing the tool marks, the head and torso are smooth and finished. In contrast, the body of the boar, whilst also elongated, appears naturalistic in its detailing.

Guy of Warwick was son of the steward to the Earl of Warwick. When he was 16 he fell in love with the Earl's only daughter, Felice, who stated that due to his low birth she would only marry him if he could prove his valour. Guy set out for Europe, on the way killing the dun cow that was ravaging Dunsmore Heath and a boar at Slough. After crossing Europe he fought the Saracens at Constantinople, and on his return to England killed a dragon for Aethelstan at York. These deeds convinced Felice of his bravery and she consented to marry him. On the death of the Earl of Warwick shortly after their marriage he inherited the Earldom. Guy, his conscience

**Godwin, *Guy and the Boar***

troubled by the blood he had spilled, left Felice to make a pilgrimage to the Holy Land. On this journey he found Aethelstan besieged at Winchester by the Danes, and a duel to decide the outcome was arranged between Guy and Colbrand the Danish champion. On his return to Warwick he led the life of an ascetic hermit in a cave at Gibbeclyve, now the village of Guy's Cliffe. Felice, unaware of his return, only found him on his death bed. Shortly after his death Felice jumped from Guy's Cliffe into the Avon, at a place now known as Guy's Leap. Their son Remburn survived them to carry on the family line.

This sculpture was presented to the town by Mr W.H. Lewis, managing director of Lewis and Watters, the estate building contractors. The statue caused some controversy, and the town councillors debated whether to accept the gift.

Note
[1] Pevsner, N., *Buildings of England: Warwickshire*, Harmondsworth, 1966, p.465.

## *Eastgate*

## *Drinking Fountain*

### Sculptor: unknown

Installed: 1859
Surround: sandstone 1.76m high × 97cm wide × 24cm deep
Fountain: pink granite 92cm high × 66cm wide × 40cm deep
Inscription: (on surround), (incised lettering): 1859 / PRESENTED BY / RICHARD GREAVES
Condition: fair
Status: Grade II
Commissioned by: Richard Greaves
Owner/Custodian: Warwick District Council

This drinking fountain is made of pink granite with a shallow pediment and semi-circular basin on a rectangular surround within a niche at foot level. Presumably it was originally

**Unknown, *Drinking Fountain***

operated by a foot pedal. Set into the fifteenth-century stone base of Eastgate, built in the reign of Henry VI, it is to the right of the 1856 pillar box. The fountain was presented to the town by Richard Greaves, who was a quarry owner and a former mayor of Warwick.

## *On pavement*

## *Pillar Box and Plaque*

### Foundry: Smith & Hawkes

Installed: 1856
Cast iron 1.5m high × 55cm wide at top
Inscriptions: (on plaque attached to gate nearby): THE PILLAR BOX / CAST IN 1856 IN THE S HAPE OF A DORIC COLUMN AT THE/

Unknown, *Pillar Box*

EAGLE FOUNDRY OF MESSERS SMITH AND
HAWKES, BROAD / STREET, BIRMINGHAM, IS
ONE OF A PAIR INSTALLED AT / THE EAST AND
WEST GATES OF WARWICK.
(around pillar box near the top): V[crown]R
POST OFFICE V[crown]R POST OFFICE
Condition: fair
Status: Grade II
Commissioned by: Post Office
Owner/Custodian: Warwick District Council

This red pillar box is cast in the form of a fluted
Doric column, which narrows as it reaches the
'capital' which bears the inscription. The top
forms a low cone. The post hole is small and is
placed vertically to fit in with the fluted design.

The designer's choice of the simple and solid
upright forms of the Doric column can hardly
be accidental. In the architectural tradition this
order has been associated with masculine
qualities such as security and reliability, which
in those days could not have been left
unnoticed by the Royal Mail and its clients.

This pillar box is one of two identical versions
which survived in Warwick. The other is in
High Street, by the West Gate. They are two of
eight remaining in the country. The vertical slot
let in rain and the pillar boxes were redesigned.

## Europa Way

*Outside main entrance of Cheltenham &
Gloucester Building Society offices*

### Tree of Fortune

#### Sculptor: Sarah Tombs

Unveiled: 3 March 1992
Bronze forged steel, welded and patinated, 4.2m
    high × 3.75m wide
Condition: good
Status: not listed
Commissioned by: Public Art Commissions
    Agency, Heart of England Tourist Board
    and Heart of England Building Society
Owner/Custodian: Cheltenham & Gloucester
    Building Society

This large sculpture is in the form of a tree,
abstracted and simplified in an emblematic
manner. The Money Tree was the logo of the
Heart of England Building Society, and this was
the sculptor's point of departure. The tree as a
motif in literature and art is symbolic of
growth. The sculpture's theme is both growth
and security, concepts that are directly relevant
to the corporate identity of building societies.
The trunk and branches are made up of
irregular pieces, all delicately detailed and
smoothly finished, absorbing and reflecting the
natural light and yet strongly affirming its own

Tombs, *Tree of Fortune*

existence in the surrounding open space. Three
main branches emerge from the solidity of the
trunk. Upon close inspection, these are seen to
be figures whose heads and shoulders are
pushing heavily-laden 'arms' of money-bearing
branches into the sky.

The *Tree of Fortune* was unveiled by Tim
Renton, Minister for the Arts, as part of the
opening ceremonies for the Warwick Arts
Festival.[1]

Note
[1] *Leamington Spa Courier*, 13 March 1992.

## Gerrard Street

*Annexe to Baptist Church*

### Statue to St Nicholas

#### Sculptor: unknown

Installed: *c.*1885
Stone, life-size
Condition: fair
Status: not listed
Owner/Custodian: Baptist Church

A full length life-size statue of St Nicholas stands in a Gothic niche on the façade of the annexe of the Baptist church above a mullioned window to the right of the main entrance. He is shown dressed as a bishop, carrying a staff.

Nicholas was probably bishop of Myra in the fourth century. His reputation for generosity and kindness gave rise to legends of miracles he performed for the poor and unhappy. He was reputed to have given marriage dowries to three girls whom poverty would otherwise have forced into lives of prostitution, and to have restored to life three children who had been chopped up by a butcher and put in a brine tub. He became the patron saint of Russia and Greece as well as of children, sailors, unmarried girls, merchants, and pawnbrokers. Nicholas's miracles were a favourite subject for medieval artists.

## High Street

*15 High Street, English Antiques entrance*

### *Carved Portal*
### Carver: T.H. Kendall

Executed: 1892
Oak 3m high × 1.7m wide
Condition: good
Status: Grade II
Owner/Custodian: English Antiques

Two carved wooden pillars have pineapples with strings of beads as capitals to support an arched door hood with abstract decorative carving and a large keystone. The whole doorway is dark in colour and is obviously a later addition to the 1791 building.

The carved decorative details of the doorway have Masonic associations. They are based upon the description of the nature of the ornamentation of King Solomon's Temple in the Bible.[1] In simple terms, the door pillars represent the paired opposites of duality. On entering the building, masons were reminded that the entrance to the inner temple lay on the middle way.[2] The building was used for Masonic Lodge meetings before the present Temple was taken over by commercial owners. This explains the obscure iconography, which is no longer appropriate for the present use of the building by a firm of antique dealers.

Notes
[1] *The Warwick Advertiser*, 1892, quoted in Ann Stevens, *The Woodcarvers of Warwick*, 1980.
[2] MacNulty, W.K., *Freemasonry: a Journey through Ritual and Symbol*, London, 1991, p.62.

## *Jury Street*

*Court House, now Tourist Information office*

### *Figure of Justice and Coats of Arms*
### Architect: Francis Smith of Warwick
### Sculptor: Thomas Stayner

Unknown, *St Nicholas*

Stayner, *Justice*

Executed: 1731
Lead coated in cement, with coats of arms
    painted and gilded
Figure of Justice, 4.8m high × 1.55m wide
Condition: good
Status: Grade I
Commissioned by: Warwick Borough Council
Owner/Custodian: Warwick District Council

Carved in the round, the late Baroque figure of
blindfolded Justice is standing in the large semi-
circular niche in the centre of the façade. She is
an over-life-size full length figure of
monumental appearance with a sword in her

right hand and a scale in her left. This would be
a conventional iconography, but is here given a
national and local significance by the inclusion
of the royal crest above her niche and the
Warwick coat of arms below it.

The Court House was built 1725–8 by
Francis Smith of Warwick.[1]

Note
[1] Pevsner, N., *Buildings of England: Warwickshire*,
Harmondsworth, 1966, p.458.

## *Market Place*

### *In ornamental pond outside entrance of Shire Hall*

## *Heron Catching Perch*
## Sculptor: Rachel Higgins
## Architect: Eric Davies

Unveiled: 19 July 2000
Steel 2m high
Condition: good
Status: not listed
Commissioned by: Warwickshire County
    Council
Owner/Custodian: Warwickshire County
    Council

This mechanical metal sculpture features a
moving 2-metre-high heron as well as two static
herons and a shoal of fish in an ornamental
pool. The concrete base of the work, including
the three circular shapes with fountains at their
centre, was designed by the former County
Architect, Eric Davies. The sculpture was
officially unveiled by Maureen Hooper, Mayor
of Warwick.[1]

Note
[1] *Observer*, 13 July 2000.

Smith, *Coats of Arms*

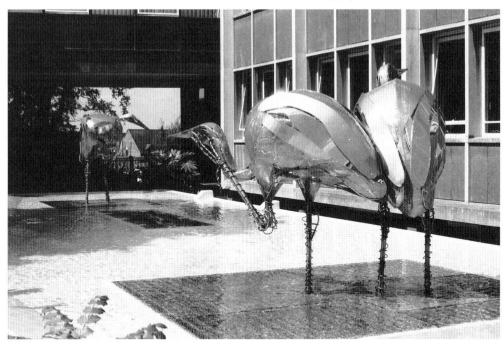

Higgins, *Heron Catching Perch*

*On side wall of 40 Market Place*

## Three Abstract Panels
### Designer: Eric Davies

Executed: 1964
Each panel: stone 1.2m high × 1m wide approx
Condition: fair
Status: not listed
Owner/Custodian: Woolworths Plc

The reliefs are at the opposite end of the square to the water feature outside the main entrance of Shire Hall. Each of the three rectangular abstract panels is recessed into the wall. The forms in each are in various sizes of rectangular stones, several of which project proud of the surface. In conception and style the three panels belong to the movement of geometrical abstraction, which had a brief period of revival during the early 1960s.

*New Street*

*Above front door of 3 New Street*

## Bust in Niche
### Sculptor: unknown

Installed: c.1986
Plaster
Plinth 30cm high approx
Bust 60cm high approx
Condition: fair
Status: Grade II
Owner/Custodian: Susannah Lewis

This bust of a man with long hair and Victorian sideburns stands on a small plinth within an alcove over the main entrance of the house. Like the door at ground level, it is flanked by bay windows. The rounded shape of the niche is echoed by the semi-circular window in the attic above.

The bust is very weathered, and the nose is missing. The front of the plinth is decorated with the figures of three classical maidens who appear to be carrying instruments. The sides of the plinth are carved with a grotesque monk's face on one side and a Greek youth with a sad expression on the other. This iconography suggests that the bust is that of a composer of dramatic musical works. Stylistically, the bust appears to date from the 1880s, when Wagner was very popular, but there is no firm evidence that the bust is of him. It is a cast of a marble work, and may have come from one of the Oxford colleges.[1]

Note
[1] Information provided by current owner, 6 July 2000.

Davies, *Three Abstract Panels*

Unknown, *Bust in Niche*

## Northgate

*Northgate House, at junction with Cape Road, on side of building*

### Sundials
### Sculptor: unknown

Sundial on front of house: *c.*1698 (probably installed later than this construction year)
Sundial on side of house: twentieth-century construction
Stone 2.8m high × 1.8m wide × 1m deep
Bronze rods, 70cm high × 1.09m wide × 15cm deep approx
Inscription: (in upper left hand corner of each sundial): 1698
Condition: fair
Status: Grade II*
Owner/Custodian: owners of Northgate House

The plain sundial within a roundel on the central pediment of the main façade of the house is in keeping with the architectural period of the building, but the sundial on a triangular projection on the east side, although it appears older than the building by some 30 years, is obviously a later addition as the remains of a bricked-in window are visible on the façade beneath the neo-Baroque supporting corbel masonry. It was actually made some 200–250 years later,[1] despite the date in an elaborate raised script in the upper left hand corner below which is a raised animal-like head, possibly a fox or a lion although it also has human characteristics. The hours are marked by raised Roman numerals.

Northgate House is an early example of a semi-detached building. As the sundials were placed there at a later date and were not designed for the site, they do not tell the time.[2]

Notes
[1] Department of the Environment, *List of Buildings of Special Architectural or Historic Interest, Borough of Warwick.* [2] Measures, A., *Visitor's Guide to Warwick*, Warwick, 1995, p.7.

Unknown, *Sundials*

## Northgate Street

*Second courtyard of Shire Hall and Courts complex*

### Abstract Relief with Medallion of Bear and Staff Emblem
### Designers: Eric Davies and Alfred Merricks

Executed: 1964
Hornton stone, bronze and coloured glass, 3.3m high × 9.6m wide
Condition: good
Status: Grade I
Commissioned by: Warwickshire County Council
Owner/Custodian: Warwickshire County Council

This abstract panel is constructed from geometrical shapes including a roundel from which the bear and ragged staff of Warwickshire protrude. The large circle symbolises the County Council, the smaller circle the Standing Joint Committee (a Police Committee), the small rectangle the Magistrates' Court Committee, and the horizontal stripes and vertical blocks the three county boroughs, six municipal boroughs, two urban and eight rural district councils within the historical county of Warwickshire.[1] The whole panel forms the façade of a projecting first floor level gallery. The work successfully combines a fundamentally modernistic abstract design with the Renaissance idea of showing heraldic emblems within a medallion.

The Warwickshire County coat of arms features a standing muzzled bear against a red background. The bear has been collared and chained, and supports a ragged staff. The chain is stretched over his back and encircles the staff. Above the bear are three red double crosses on a gold background. Above the shield is a gold castellated crown.

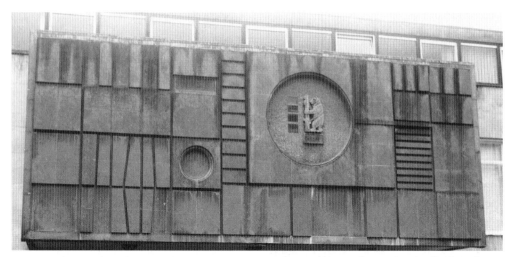

Davies and Merricks, *Abstract Relief with Medallion of Bear and Staff Emblem*

Note
[1] Information from Eric Davies, former County Architect, 26 July 2000.

## Stratford Road

*Outside The Racehorse public house, at the junction with Noble Close*

### The Racehorse

### Sculptor: unknown

Installed: 1980s
Base: wood
Horse: painted wood 1.8m high × 2m wide
    approx
Condition: good
Status: not listed
Owner/Custodian: proprietors of The
    Racehorse public house

This life-size figure of a horse stands on a wooden platform at the roadside in front of The Racehorse public house. The origin of the horse is unknown, but it was probably originally made as a 'dummy horse' for the display of bridle, saddle and other riding equipment for a saddler's shop. It is not, however, an image of a racehorse in action as it seems to be standing still and has no rider, bridle or saddle.

Unknown, *Racehorse*

## The Butts

*Punch Bowl Inn public house*

### Ornamental Bracket

### Maker: unknown

Executed: 1700s
Bracket: wrought iron, painted black, 3m high
    approx
Condition: good
Status: Grade II
Owner/Custodian: Punch Bowl Inn public
    house

This eighteenth-century decorative wrought iron bracket has elaborate scrolls and floral imagery including tulips from which hangs a later painted sign for the Punch Bowl Inn public house.

Unknown, *Ornamental Bracket*

# West Midlands

## COVENTRY

### Allesley Old Road  CHAPEL FIELDS

*Outside, against wall of St Christopher's Primary School*

### St Christopher

**Sculptor: Walter Ritchie**

**Architect: Donald Gibson**

Executed: 1952
Monks Park sandstone 1.83m high × 1.5m high
   × 38cm deep
Condition: fair
Status: not listed
Commissioned by: Coventry Borough Council
   Education Committee
Owner/Custodian: St Christopher's Primary
   School

A figure of St Christopher bears the naked
Christ Child on his shoulder as he struggles
against a storm that causes heavy waves to form
at his feet, through which he strides with a
billowing cloak held above the water and
holding a staff that sprouts oak leaves. An early
work by Ritchie, it clearly shows the influence
of Eric Gill with whom Ritchie had studied,
particularly in the treatment of the figures and
in the use of low relief.

   St Christopher (*c.* AD 250) was a Syrian
Christian martyr. According to tradition, he
was a man of gigantic stature, whose name in
Greek (Christophoros) means 'Christ-bearing',
which gave rise to the legend that he had carried
the Christ Child across a river. He is said to
have suffered martyrdom under Emperor

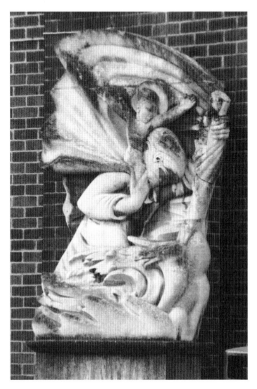

**Ritchie, *St Christopher***

Decius (reigned 249–251). He is the patron saint
of wayfarers, and now motorists.[1]
   Ritchie was commissioned to make the
sculpture by the Education Committee during
the planning stages of the school building. The
name of the school was probably inspired by a
bequest from Christopher Winser, a young
airman, who was killed over Egypt in 1941, and
who had left a sum of money 'To the city he

loved' which his parents contributed towards
the work and to whom it is a memorial.[2]

Notes
[1] A & E Television Networks, Biography.com,
www.biography.com [2] Ritchie, W., *Walter Ritchie:
Sculpture*, Kenilworth, 1994, pp.77 and 81.

### Ash Green Lane  ASH GREEN

*Outside wall of Exhall Grange School*

### Sagittarius the Bowman

**Sculptor: John McKenna**

Installed: 1997
Brick 1.9m high × 1.45m wide (with frame)
Condition: good
Status: not listed
Donated by the sculptor
Owner/Custodian: Exhall Grange School

This brick relief sculpture set into a frame
protruding from the wall of the school shows
Sagittarius, the archer, as a naked youth, his
cloak billowing out behind him as he takes an
arrow out of his quiver with his left hand. He
holds his bow in his right hand. The overall
impression is of the youth's sensuality rather
than his preparedness for battle. This is one of
three monumental pieces at the school that
symbolise different signs of the Zodiac (the
other two are entirely abstract).
   Exhall Grange is a special school for visually
impaired children and the sculptor donated the
work hoping that 'youngsters will literally get
to grips with it by feeling its contours and
working out what it represents'.[1] Although it
looks as though the brick has been carved, this

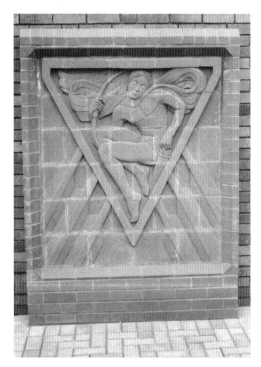

**McKenna**, *Sagittarius the Bowman*

relief sculpture was in fact modelled in clay and then fired.[2] The work was installed free of charge by the construction company Laing, which was working at the school. The sculptor heard about the school whilst working on another project in Coventry's War Memorial Park in 1997. He explained his choice of which work to donate thus:

> It was created as a tribute to an adopted 'uncle' of mine, who was partially sighted and helped to pay for me to try this brick technique when I was a student on hard times. He died not long afterwards but this sculpture has gone on display all over the place in his memory. Unfortunately, each time it goes somewhere else it risks getting damaged. Now I'm glad to find it a

permanent home, among other pieces of art, where it will be appreciated.[3]

Notes
[1] *Coventry Evening Telegraph*, 14 September 1998. [2] Information from Bob Stanier, Head of Art at the school. [3] *Coventry Citizen*, 18 September 1998.

*Grounds of Exhall Grange School*

## *Libra*

### Sculptor: Jessie Watkins

Executed: 1975
Steel, painted, 2.65m high × 1.58m wide
Condition: poor
Status: not listed
Commissioned by: George Marshall, former
    headmaster
Owner/Custodian: Exhall Grange School

This abstract work is one of three pieces on the theme of the signs of the Zodiac. Apart from McKenna's *Sagittarius*, they do not conform to ancient symbols or medieval and Renaissance images, but have used abstract shapes that

**Watkins**, *Libra*

nevertheless visually suggest the concepts and themes for which the signs stood. Thus *Libra*, traditionally symbolised by the scales, suggests the balance of opposites by the juxtaposition of a cube with two circular shapes. The suggestion of weightlessness is conveyed by the dynamic effect of the cube resting diagonally on its edge.

## *Nile: River God*

### Sculptor: unknown

Executed: late 1970s
Limestone 75cm high × 60cm wide
Condition: fair
Status: not listed
Owner/Custodian: Exhall Grange School

The head sits on a cylindrical neck that seems to grow out from a rectangular slab-like block that represents the chest and shoulders of the figure.

**Unknown**, *Nile River God*

The face is mask-like with large open eyes, devoid of emotion or expression. The only asymmetrical detail is the hair, which is swept to her right side, thus upsetting the overall solidity of this monolithic work. It is roughly carved, clearly showing the marks of the chisel. This is a clear example of modern twentieth-century primitivism.

The artist was a past student of the school, who at the time of carving this piece was studying at the Royal Academy School.[1]

Note
[1] Information from Bob Stanier, art master at the school, July 2000.

## Precinct
### Designer: Geoffrey Greetham

Installed: mid-1970s
Steel, painted red, 1.5m high × 4.3m long × 1.25m deep
Condition: good
Status: not listed
Owner/Custodian: Exhall Grange School

This abstract painted steel construction is a full-size model of the work originally erected in the Precinct in Market Way, Coventry in 1966 and removed from that site in the early 1970s[1]. It is a striking and uncompromisingly abstract sculpture that conveys a purely plastic spatial experience. The pure red colour is used here not for its imitative value, but because it neutralises some of the forward and backward movement of lines, planes and incomplete circles.

Note
[1] Information provided by Ron Clarke, Herbert Art Gallery and Museum, October 2000.

*On lawn at the side of the school*

## Scorpio
### Sculptor: Jessie Watkins

Installed: 1990s
Steel, painted white, larger arc 4.2m high × 3.6m wide, smaller arc 2m high × 2.03m wide
Condition: fair
Status: not listed
Commissioned by: George Marshall, former headmaster

Owner/Custodian: Exhall Grange School

This is a monumental work whose boldly modelled curves convey a sense of power and aggression. Although the smaller of the two arcs is shaped like a crescent moon, the larger one is reminiscent of the tail of a scorpion. It is from this that the sculpture obtains its title of Scorpio.[1]

Scorpio is one of the twelve astrological signs of the Zodiac that have been used in art since medieval times. People born under this star sign are alleged to be strong and courageous, but also ruthless. The sculpture suggests both qualities.

Note
[1] Rosenburg, E. and Cook, R., *Architect's Choice: Art and Architecture in Britain since 1945*, London, 1992, p.45.

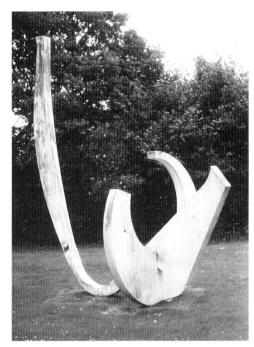

Greetham, *Precinct*

Watkins, *Scorpio*

## *In Balance*
### Sculptor: Bob Ross

Executed: mid 1970s
Steel, painted red, 1.75m long
Condition: poor
Status: not listed
Owner/Custodian: Exhall Grange School

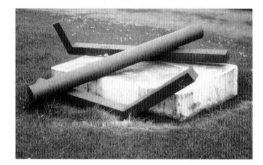

**Ross,** *In Balance*

Perpetual motion created by the interaction of separate red-painted industrial metal parts on a plain concrete surface is both actuality and subject matter in this abstract sculpture.

*Outside main block*

## *Barquentine*
### Sculptor: Margaret Lovell

Executed: 1970s
Bronze 1.29m high × 50cm wide × 14cm deep
Concrete base, 50cm high × 50cm wide × 50cm
    deep
Condition: fair
Status: not listed
Owner/Custodian: Exhall Grange School

The artist chose this title because the form of the sculpture reminded her of a particular type of sailing boat with unusually shaped sails. Although abstract and emblematic, the motif is still evocative of such wind-blown sails. Fine

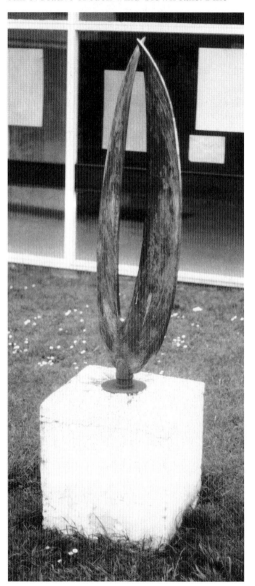

**Lovell,** *Barquentine*

texture and surface effects contribute to the delicate lyrical quality of this abstract piece. Hollow space is balanced by relief, the salience of the sculpture with the depth of the void. As the viewer looks at the work from different angles, his sense of this space changes.

*At the side of Art Block*

## *Two Figures*
### Sculptor: Enid Mitchell

Executed: 1973–4

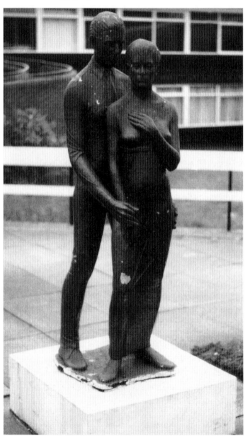

**Mitchell,** *Two Figures*

Cold cast resin 1.76m high × 48cm wide × 41cm
    deep
Condition: poor
Status: not listed
Owner/Custodian: Exhall Grange School

This sculptural group shows a lyrical
interpretation of the young adult male and
female body and a fine synthesis between form
and subject matter. The sinuous grace of the
contours of the body and the sensuousness of
their linear composition are outstanding
qualities of this work. The artist was a member
of staff at the time.

*In main entrance hall*

## Female Nude (Caryatid)
## Sculptor: Yoltah Sasburgh

Executed: 1970
Wood, 1.04m high × 30cm wide
Condition: good
Status: not listed
Owner/Custodian: Exhall Grange School

This carving is of a woman kneeling on a
wooden plinth with her hands raised above her
head as if to support something on them. The
graining of the wood suggests the flowing
contours of the female body.

## Head of a Woman
## Sculptor: Michael Ayrton

Executed: 1968
Bronze 39cm high × 35cm wide × 22cm deep
Condition: good
Status: not listed
Owner/Custodian: Exhall Grange School

In a Cubo-Futurist manner, Ayrton shows
different significant aspects of the woman's
head, suggesting the correlation between space

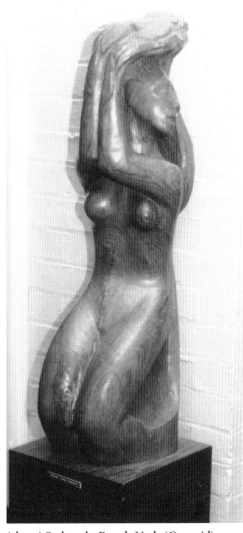

(above) Sasburgh, *Female Nude (Caryatid)*

(above right) Aryton, *Head of a Woman*

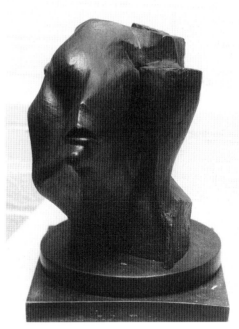

and time. The head rests on a rotating plinth
that helps the viewer to see it fully in the round
and to contemplate the interaction of form and
space. Both in the underlying concept and its
actual form, the work shows the strong
influence of Boccioni's aesthetic.

## Metal Construction
## Sculptor: Geoffrey Clarke

Executed: mid-1970s
Aluminium 24cm high × 1.7m long approx
Base 16cm high
Condition: fair
Status: not listed
Owner/Custodian: Exhall Grange School

The form and material of this abstract sculpture
recall the world of industry, with its emphasis
on the machine-made and its attendant lack of
delicacy and sensitivity.

**Clarke,** *Metal Construction*

Source
Black, P. (ed.), *Geoffrey Clarke: Symbols for Man:
sculpture and graphic work* 1949–94, Ipswich
Borough Council Museums and Galleries in
association with Lund Humphries, London, 1994.

## King Lear Relief Tondo
### Sculptor: John McKenna

Executed: 1997
Resin, painted in brown colour, 1.6m diameter
Inscriptions: KING LEAR (at top) *Legendary
    King of Leicester* [*sic*] (at bottom)
(beneath the tondo on a separate copper
    plaque): In grateful memory of George H.
    Marshall OBE/1916–84 The founding force
    behind/Exhall Grange Special
    School/Headmaster 1953–81.
Condition: good
Status: not listed
Owner/Custodian: Exhall Grange School

The relief seems to be allegorical rather than
representing any actual scene in Shakespeare's
*King Lear*. The crowned King Lear is here
represented seated at the moment of this fateful
judgement with his fool sitting cross-legged at
his feet. On his right are his two cruel daughters
Goneril and Regan with a dead tree trunk,
while Cordelia is on his left with a living tree. A
scroll showing the map of Britain is at his feet.

**McKenna,** *King Lear Tondo*

This image suggests that, despite having good
eyesight, Lear cannot see the truth, namely that
it is Cordelia who truly loves him. Only his
fool and the blind Gloucester are able to 'see'
that the King's view of his daughters is a
mistaken one.

George Marshall was an educationalist who
established his reputation in the post-war years
within the progressive and experimental
approach to the education of visually impaired
children. He made great efforts to secure special
education and training for them. By providing
the advantage of good education, he hoped to
ensure that they would overcome their
disability and be enabled to lead a useful and
interesting life. The school's choice of the
seated Lear to commemorate their first
headmaster was felt to be appropriate because
he was not only a great lover of Shakespeare,
but also because of the significance assigned in
the play to the anomaly between vision and
blindness.

## *Fish*
### Sculptor: Mark Folds

Installed: 1970s
Painted oak 56cm high × 1.38m wide × 20cm
    deep
Condition: fair
Status: not listed
Owner/Custodian: Exhall Grange School

**Folds,** *Fish*

This piece of solid direct carving resembles a
large fish. It has no obvious symbolical or
metaphorical intentions. The dark blue paint
suggests the colour of the sea: this stylisation of
the optical experience is surrealistic. The marks
of the artist's chisel create varied textural and
surface effects that resemble scales.

*Interior*

## *Torso*
### Sculptor: Duncan Johnson

Executed: 1970
Wood 99cm high × 35cm wide
Condition: good
Status: not listed
Owner/Custodian: Exhall Grange School

This sculpture is an essay in wood: it is about
the perfect fusion between the motif, the
contours of the female body, and the

meticulously polished, richly grained wooden block. The statue is conceived and carved entirely in the round, giving a complete view of the figure from all possible angles. The figure seems to be organically emerging from the volume of the wood. Its knots and grain are used to emphasise curves and hollowed forms,

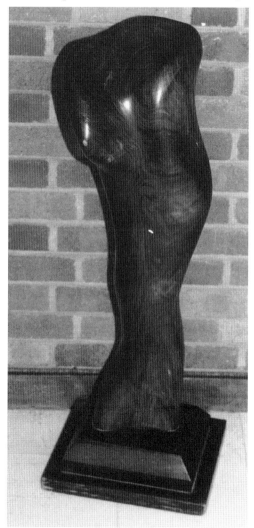

Johnson, *Torso*

breasts, knees and elbows. While this approach to form and material is entirely concerned with plastic idiom, it still shows vestiges of sentiments and emotions.

*Bankside Lane*                                   PINLEY

## *Jaguar*
### Sculptor: Richard Ormerod

Designed: 1935
Metal 90 cm high × 2m long approx
Condition: good
Status: not listed
Commissioned by: Jaguar
Owner/Custodian: Jaguar

This chrome-plated sculpture of a jaguar stands on a concrete base on which the words 'JAGUAR CARS' have been painted. This symbol is used by the Jaguar car company and can be seen at some of the major Jaguar showrooms throughout the country. The name and motif were first adopted in 1935, when the company launched the new SS Jaguar model. The smooth light-reflecting surface is modelled in juxtaposed mildly geometrical planes that give the work a Cubo-Futurist appearance in the

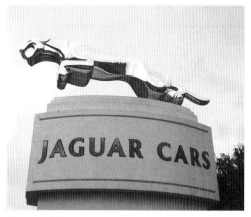

Ormerod, *Jaguar*

sunlight. The sculpture is thus modern in both concept and form. It also conveys both the grace of the jaguar and the animal's remarkable power and agility. The company wanted to suggest that their cars also combined these qualities of elegance and high performance.[1]

Note
[1] Jaguar website, www.jaguarscars.com/uk

*Bayley Lane*                                   CITY CENTRE

*On façade of buildings, 22 and 23 Bayley Lane*

## *Foliate Carvings*
### Artist: unknown

Executed: 1500s (No. 23 refronted in late
   eighteenth century)
Wood, varying sizes
Condition: good
Status: No. 22 – Grade II*; No. 23 – Grade II
Owner/Custodian: owners of 22 and 23 Bayley
   Lane

These two small timber-framed cottages have traceried woodwork consisting of Gothic arches, foliate motifs and, above the doorway of No. 22, grotesque faces. These are excellent examples of the relatively few surviving pieces of a local tradition of woodcarving of the sixteenth century. The grotesque faces seem to combine the medieval Gothic delight in the representation of monsters and distorted figures (some of which decorated St Michael's Church in its original condition) and the late Renaissance-Mannerist interest in caricature portraits.

The ornate window and bargeboarding on the end of No. 22 were taken from the neighbouring Buttery building directly adjoining St Mary's Hall shortly after 1821. A drawing by Cornelius Varley in or around 1821 shows these two features still on the Buttery

Anon, *Foliate Carvings (detail)*

while No. 22 already had its ornate Gothic corner posts at both ground and first floor level. The magnificent woodwork currently above the doorway on the end of No. 22 is nowhere to be seen on Varley's view, and its origin is unknown.[1]

Note
[1] Ron Clarke, 'Art as a Source for Local History', *Local History Bulletin*, March 1986, p.7.

*Peace Garden*

## *Peace Stone*
## Sculptor: unknown

Unveiled: 14 November 1990
Base: stone 60cm high approx
Plaque: bronze 80cm diameter approx
Inscriptions: (on bronze plaque on base): This
    garden/is dedicated to peace/and
    international friendship/Her Majesty Queen
    Elizabeth/The Queen Mother/ on the
    occasion of the fiftieth anniversary/of the
    bombing of Coventry/on 14th November
    1940
    (in centre of bronze disk): 1940 COVENTRY
    1990/forward in friendship

Unknown, *Peace Stone*

Condition: fair
Status: not listed
Commissioned by: Coventry City Council
Owner/Custodian: Coventry City Council

The cylindrical stone base with incised carving is surmounted by a bronze disk, which details the distances and directions of cities and towns twinned with Coventry.

## *St Mary's Hall*
## Sculptor: unknown

Executed: 1340s
Stone, varying sizes
Condition: good
Status: Grade I
Commissioned by: Merchant Guild of St Mary

St Mary's Hall was built in 1340–2 as the guild hall for the newly-established Merchant Guild of St Mary. The façade and entrance porch of this listed building feature several instances of sculptural decoration. To the right of the main entrance is a large Gothic window with elegant tracery surmounted by a relief panel of the head and shoulders of a male figure and crocketed decoration. To each side of the window are two saints standing in Gothic niches, one above the other. Three of the saints are male; the one at top right is female.
    The porch has a tierceron-star vault that is thought to date from the building of the original Gatehouse. The central boss represents the Coronation of the Virgin. Two of the four smaller bosses that surround it depict a green man and a woman's head. Although the subject of the centre panel suggests a strong link with the merchant guild of St Mary, the style indicates a date later than 1340, possibly the 1390s. The two corbels on either side of the inner porch as one enters the courtyard are badly weathered.
    Within the courtyard there is a frieze of

sculptural decoration below two rows of trefoil arch panels. The designs include angels, grotesques, monsters, fleurs-de-lys and foliage.[1]

Note
[1] Lancaster, J., *St Mary's Hall, Coventry: A Guide to the Building, its History and Contents*, Coventry, 1948, p.27.

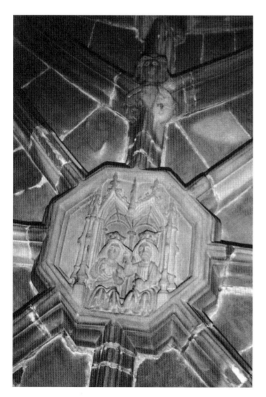

Unknown, *Ceiling boss, St Mary's Hall*

*Peace Park*

## *The Corridor*
## Artist: Mary Thomas

Executed: May 1977
Copper and granite 2.6m long × 23cm wide × 10cm deep
Inscription: Donated to the inhabitants of the corridor region by Mary Thomas 1977.
Condition: fair
Status: not listed
Work donated by: the artist
Owner/Custodian: Coventry City Council

This work represents a map, etched in copper, of a thin section of the British Isles that connects Hastings and Coventry with Liverpool and the Isle of Man. The two copper strips were mounted on granite curbstones and set in the lawn outside the reference library.[1] This is an example of conceptualist art, a movement Coventry College of Art was closely associated with from the late 1960s.

By 1995, the sculpture was mostly covered by ivy.[2] Thomas was an art student at Coventry (Lanchester) Polytechnic at the time the work was made.

Notes
[1] Herbert Art Gallery and Museum/City of Coventry Libraries, Arts and Museums Department, *A Survey of Public Art in Coventry*, Coventry, 1980, p. 94. [2] Herbert Art Gallery and Museum, Coventry Public Art Database.

## *Belgrade Theatre*                CITY CENTRE

*Outside the theatre*

## *Two Sides of a Woman*
## Sculptor: Helaine Blumenfeld

Executed: 1985
Bronze, dark green patina, 2.4m high × 3.2m wide × 1.5m deep approx

Thomas, *The Corridor*

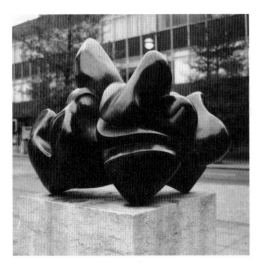

**Blumenfeld, *Two Sides of a Woman***

Condition: fair
Status: not listed
Commissioned by: Coventry City Council
Owner/Custodian: Coventry City Council

In this sculpture, different views of a female body are juxtaposed in the round. Although the shapes are not strongly geometrical, the concept of showing a figure from different viewpoints within a single work is fundamentally Cubist. As in free-standing Cubist sculptures combining different aspects of the figure that can only be viewed from different angles, this sculpture also includes the concept of time.

A catalogue on the work of Helaine Blumenfeld states with regard to this project that the work extends a theme that has preoccupied her over many years. In her early work she explored this theme in terms of a woman who was part of a family, related to a man, dependent, whilst still asserting her independence, her essential need for individuality. In the present piece she feels that her views have visibly changed. One side of the sculpture is sensual, even erotic; although it is an abstraction, it is clearly a female form. The other side is complex and convoluted, going beyond the notion of Woman as such to a concept of the mystery of all beings. She feels that this sculpture represents a great advance in her thinking, both about women in general and about her in particular. It is about 'having and giving, about keeping and letting go, about physicality and spiritually, about the dilemma that confronts every creative woman'.[1]

Note
[1] Anon, *Blumenfeld Catalogue for Whitefriars exhibition*, Coventry, 1986.

*Exterior wall, facing Corporation Street*

## Belgrade
### Sculptor: James C. Brown

Installed: March 1958
Relief: cast ciment fondu with Penmaenware granite chippings for aggregate 3.05m high × 2.3m wide
Signature: (in bottom left hand corner): JCB
Condition: good
Status: not listed
Commissioned by: Coventry Planning and

**Brown, *Belgrade***

Redevelopment Committee
Owner/Custodian: Belgrade Theatre

This sculptured concrete panel over the main entrance to the Belgrade Theatre represents a stylised bird's eye view of the city of Belgrade. The image is based on a 1684 engraving by Giacomo de Rossi.[1] The relief shows a fortress on a hill above a walled city, surrounded by the river Danube. The city arms and its name in Cyrillic script on a banner are at the top of the relief. The dark colour of the textured panel provides a visual interruption from the smoothness of the surrounding windows.

The theatre in Coventry was named after the capital of Serbia, then Yugoslavia, as a gesture of friendship between the two cities and in recognition of a gift of timber to furnish the interior of the building.

The Yugoslav Embassy was consulted about the project, and they supplied the Giacomo de Rossi engraving upon which Brown based his design. He first made the relief in brick clay and then had it cast in ciment fondu with Penmaenware granite.[2]

Notes
[1] *Coventry Evening Telegraph*, 11 March 1998.
[2] Clarke, Ron, *Public Sculpture of Coventry*, p.54, Coventry.

*In courtyard outside the theatre*

## Belgrade Fountain
### Designer: Rawstorne Associates

Executed: 1986
Fountain: stone, concrete, coloured blue and white, 5m diameter approx
Condition: good
Status: not listed
Commissioned by: Coventry City Council
Owner/Custodian: Belgrade Theatre

The fountain, which includes three giant cascades shaped in the form of 'the heart of a

**Rawstorne Associates,** *Belgrade Fountain*

fish',[1] can best be viewed from the first floor
windows of the Belgrade Theatre.

A letter to the *Coventry Evening Telegraph*
accused the work of being 'The most boring
fountain of them all'.[2] The project cost £25,000.

Notes
[1] *Coventry Evening Telegraph*, 10 June 1986.
[2] *Ibid.*, 19 August 1992.

*Outside the theatre*

## Bryan Bailey Memorial
### Sculptor: Norelle Keddie

Executed: after 1960
Fibreglass and epoxy resin 1.73m high x.81cm
   wide × 81cm deep

Inscription: (on plinth): a memorial to Bryan
   Bailey first director of this theatre
Condition: good
Status: not listed
Commissioned by: Mrs Bailey, the subject's
   mother
Owner/Custodian: Belgrade Theatre

A human figure with raised arms is enclosed by
the comic and tragic masks signifying the two
main genres of the theatre. The overall
impression is one of emotion. It recalls the
dancing figures that were a favourite theme of
Surrealist artists of the 1920s and 1930s. The
enclosed figure also resembles Henry Moore's
preoccupation with incarcerated figures,
reminiscent of a seed in the kernel, during the
1950s.

Bailey was appointed to the Belgrade
Theatre before its opening in 1957 and became
well known as a director, introducing modern
socialist theatre, especially Arnold Wesker's
plays, to its stage.

The sculpture was commissioned following
Bailey's death in a road accident in 1960, and
the city Policy Advisory Committee paid for its
installation.[1]

Note
[1] Herbert Art Gallery and Museum/City of
Coventry Libraries, Arts and Museums Department,
*A Survey of Public Art in Coventry*, Coventry, p.71.

**Keddie,** *Bryan Bailey Memorial*

*Director's office*

## Dove

### Sculptor: Walter Ritchie

Installed: 1957
Dove: limewood 75cm wingspan
Olive leaf: silvered bronze
Condition: good
Status: not listed
Part of Richard Lee School Commission
Owner/Custodian: Belgrade Theatre

The dove and the olive leaf are both symbols of peace, taken from the Old Testament story of the dove's return to the ark with an olive branch in its beak as a sign of God's reconciliation with Man after the Flood (Gen. 8.11).

The work was produced at the time of Ritchie's commission to produce a dove for Richard Lee School in Coventry (see the entry for the *Richard Lee Memorial Sculpture*, the Drive). It is carved directly from a single block of wood. Ritchie took great care in this work to display the natural grain as a structural and decorative element, thereby establishing himself as a major exponent of this sculptural medium and technique.[1]

Arthur Ling, the City Architect, had seen the

**Ritchie,** *Dove*

work at Ritchie's studio in 1956 and arranged for it to be purchased for the theatre. Ritchie then made the olive leaf to accompany it.

The carved dove was removed during the refurbishment of the theatre foyer, but will be re-erected shortly.

Note
[1] Ritchie, W., *Walter Ritchie: Sculpture*, Kenilworth, 1994.

*Broadgate*                    CITY CENTRE

*Entrance to Upper Precinct*

## Broadgate Standard

### Metal worker: British Pressed Panels Ltd

Installed: March 1948
Standard: aluminium, elephant, gold leafed, 2m high
Mast: 15m high
Inscription: (originally an inscription was cut into the base recording that the donation had come from Coventry industries, all that is legible reads): THIS STANDARD ... (and the compass points): S / N
Condition: good
Status: not listed
Commissioned by: Donald Gibson, the City Architect
Owner/Custodian: Coventry City Council

This standard depicts the elephant and castle from the Coventry City coat of arms, mounted on a tall mast. The Coventry flag and the Union Jack usually fly from the pole, below the standard. The elephant is seen to symbolise strength and to be the symbol of Christ's redemption of the human race. In one of the *Bestiary* stories, a young elephant uses his trunk to pull up an animal that dropped asleep leaning against a tree and fell helpless to the ground when hunters chopped the tree down. The elephant can thus be seen as an appropriate

**British Pressed Panels Ltd,** *Broadgate Standard*

symbol for Coventry's own rebuilding after the destruction of the war. On the other hand, in post-Renaissance emblem literature, the elephant is symbolic of industry. Both interpretations signify Coventry's importance as an industrial city.

The standard was set up in 1948 to

commemorate the Civic and Saving for Reconstruction exhibition. It was intended to commemorate the skill of Coventry's craftsmen and the rebuilding of the City centre.

On 18 February 1948, the City Architect, Donald Gibson, informed the Planning and Redevelopment Committee that various firms in the city had offered to present parts of the city standard, and were prepared to deliver them to Broadgate by 1 March 1948. The industrial donors apparently wished to remain anonymous, but it was agreed that a suitable inscription should be added to the base to record the fact that contributions where made by Coventry industries, and the Mayor would visit the various firms concerned to thank them for their gifts.[1] However the *Coventry Evening Telegraph* of 24 February 1948 lists the contributors as Sir W.G. Armstrong Whitworth Aircraft Ltd (the mast), and Motor Panels (Coventry) Ltd (the elephant and castle). The aluminium and gold colouring were provided by John Astley and Sons Ltd, and the flags by Holbrooks (Coventry) Ltd.[2] On 17 March 1948, it was reported that the Finance Committee had approved expenditure of £220 to provide the concrete base and erect the standard. The Committee approved arrangements for painting the standard and purchasing the necessary gold leaf for gilding the elephant on 16 March 1949. The work was carried out by Messrs British Pressed Panels Ltd, the makers of the elephant.[3] Recently some of the workers involved in building the standard talked about the work in local papers. A retired metal worker recalled making the elephant: 'I was one of a team (*sic*) of sheet metalworkers at Motor Panels in Holbrook Lane involved in the making of the model. The firm belonged to Rubery Owen ... And the boss Alfred Owen ... offered to construct the model at no cost to the city.'[4]

Notes
[1] Coventry City Council Records, Minutes of the Planning and Redevelopment Committee, 18 and 24 February 1948. [2] *Ibid.*, 17 March 1948. [3] *Ibid.*, 16 March 1949. [4] *Coventry Evening Telegraph*, 2 April 1997.

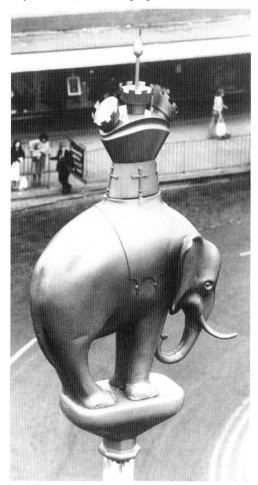

**British Pressed Panels Ltd,** *Broadgate Standard (detail)*

*Broadgate House*

### *Godiva and Peeping Tom Clock*
## Sculptor: Trevor Tennant

Installed: July 1953
Figures: wood, painted 2m × 2.5m
Condition: good
Status: not listed
Commissioned by: Coventry Planning and Redevelopment Committee
Owner/Custodian: Coventry City Council

Below the clock face are two sets of wooden doors, one above the other. The mechanism is arranged so that on the hour the doors open and Godiva emerges astride a white horse travelling the short track from one side to the other. Meanwhile, Peeping Tom appears above, placing his hands over his eyes. These wooden figures have a cheerful, fairground like appearance. The style is intended to evoke the essential folkloric character of the legend. More

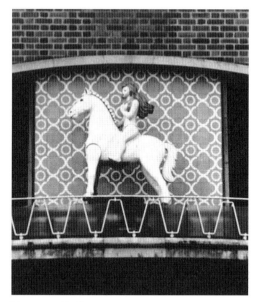

**Tennant,** *Godiva*

**Tennant,** *Peeping Tom*

than any other representation of the legend, these figures evoke the naïve qualities of the original 1586 Adam van Noort painting, avoiding the trap into which many other representations fall.[1]

A local story that has changed little over time tells that Lady Godiva, wife of Leofric, Earl of Mercia, pleaded with her husband to lower the heavy taxes on the people of Coventry. Leofric said that he would lower taxes after she rode naked through the city. Lady Godiva ordered the people of Coventry to stay indoors with their windows and doors barred and, using her long hair as a cloak, rode naked through the streets. Later versions of the story include the figure of 'Peeping Tom', who was struck blind as he tried to look at her. On her return Leofric kept his part of the bargain. The tale has also been interpreted to mean that Leofric may have asked Godiva to ride without the finery of nobility, such as her jewellery, rather than without her clothing. Nonetheless, the story has given a legendary status to an ancient manufacturing and industrial town.

Broadgate House was the first building in Coventry to be completed under the post-war building programme, then under the control of the City Architect, Donald Gibson. Like many other architects of the period, he sought to incorporate artworks into his projects. On 16 March 1949 he told the Planning and Development Committee of a suggestion that the former Market Hall clock should be installed on one of the buildings on Broadgate, and should incorporate small heraldic figures of Lady Godiva and Peeping Tom.[2] The City Architect consulted the Principal of the Technical College on the possible incorporation of moving figures, and on 8 June 1949, the Town Clerk was able to report that the Markets and Baths Committee had offered the former Market Hall clock for installation in the 'bridge' over Hertford Street.[3]

Contemporary public reaction to the figures accompanying the clock was hostile. The figures have since gained some acceptance and are now popular with tourists. Clarke and Day 'are of the opinion that this work is the only twentieth-century masterpiece of sculpture yet created on the subject'.[4]

The Corporation at one stage was making moves to replace the present figures. In 1983 concern about the deterioration of the mechanism eventually prompted the Corporation to allocate a provisional budget to restore the clock, and to replace the figures. In August 1998 it was reported that the City Council was to commission experts to consider how best to refurbish both the Victorian clock and the 1950s mechanism, which had been designed by city apprentices. They did not rule out replacing Lady Godiva and Peeping Tom, believing that, 'it needs to be upgraded for the new millennium, but its basic character should remain'.[5] The following week the *Coventry Evening Telegraph* reported that there was considerable opposition among local people to the idea of the old wooden figures of Lady Godiva and Peeping Tom being replaced.[6]

Notes
[1] Wood, G., *Public Sculpture in Coventry. A*

*Selected Critique*, unpublished BA dissertation, Coventry (Lanchester) Polytechnic, 1986.
[2] Coventry City Council Records, Minutes of Planning and Development Committee, 16 March 1949. [3] Coventry City Council Records, Minutes of Markets and Baths Committee, 8 June 1949.
[4] Clarke, R.C. and Day, P.A.E., *Lady Godiva Images of a Legend in Art & Society*, Coventry, 1982.
[5] *Coventry Evening Telegraph*, 28 August 1998.
[6] *Ibid.*, 2 September 1998.

*Cathedral Lanes shopping centre, first floor*

## Peeping Tom
### Sculptor: unknown

Executed: late fifteenth century
Wood, traces of original paint, life-size, 2m high approx
Condition: fair
Status: not listed
Owner/Custodian: St Martin's Property Corporation

This full-length standing wooden statue is of a bearded male in armour (a breastplate, which has been partially altered with the addition of buttons at a later date, helmet and greaves) with arms bent at the elbow, but cut off at that point. The legs appear bent, as if the figure was originally portrayed thrusting a spear downwards as if to impale a dragon at his feet. The head is turned to the left. In its present position, the figure, protected in a glass case, is overlooking the life-size equestrian statue of Lady Godiva.

On the basis of style, technique and costume, the figure has been dated to the late fifteenth century. It is thought originally to have been carved to represent a warrior saint, probably St George. By the seventeenth century its use as a saint seems to have become redundant, for it was at this time that it was adopted as a Peeping Tom figure. It is known to have been on display as such since 1744 (and most probably even since 1659) and had various

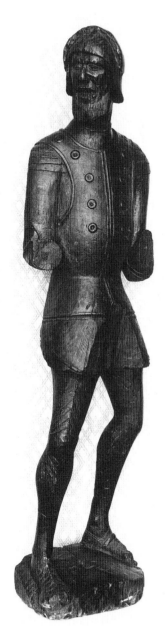

homes until 1879, when it was put on show on the outside of the newly-erected King's Head Inn, where it was sited in a specially built niche, visible from the waist up. It was removed for safe keeping some time during the Second World War, by which time it bore little resemblance to a warrior saint, being garishly painted, attired in a tricorn hat, gold buttons, and what appear to have been naval medals. At an unknown later date, its medals, buttons, hat and paint were removed. The figure was afterwards displayed at the Leofric Hotel in a glass case until 1990 when it was moved to its present location.[1] At some stage, presumably after the figure started to be used as a Peeping Tom, a number of copies were made, which retain the central row of rivets on its breastplate that were visible in earlier photographs and which are now missing.

A resin copy is in the Herbert Art Gallery and Museum, Coventry.

For details of the legend of Lady Godiva and the part played by Peeping Tom, see the entry for *Godiva and Peeping Tom*, Broadgate House.

Note
[1] Information Board, Cathedral Lanes shopping centre.

*Broadgate House, north-east corner*

## Princess Elizabeth's Pillar

**Sculptors: John Skelton and James C. Brown**

**Architect: Donald Gibson**

Executed: 1950–1
Blue Horton stone 3.05m high × 53cm wide
Inscriptions: (on north face below Coventry
    Coat of Arms): This stone was laid by HER
    ROYAL HIGHNESS the PRINCESS ELIZABETH at
    the opening / of the new Broadgate and to
    mark the beginning of the shopping centre /

**Unknown, *Peeping Tom***

Skelton, *Princess Elizabeth's Pillar*

22nd May 1948 / Commemorated by Mr Bob Taylor LORD LIEUTENANT OF THE WEST MIDLANDS / 22nd May 1998

Condition: fair
Status: not listed
Commissioned by: Coventry Planning and Redevelopment Committee
Owner/Custodian: Coventry City Council

The pillar supporting the north-east corner of Broadgate House is carved with an incised line drawing on its south face and an inscription and further carving on its north face, which depict the city coat of arms, spring flowers, the initials of King George VI and the then Princess Elizabeth with the date of their visit. On the south face are symbols of the cloth and wool industry, Coventry's first important source of wealth in medieval times. The images depict scissors, a teasel, a cap and a loom, linked by a spiralling thread; they represent the tasks of textile cutting, teasling, capping, weaving and ribbon making.

In the lower right hand corner of the south face, Skelton carved the symbol of the Egyptian pharaoh Akhnaton, which relates to the pharaoh's fame as a city builder and was used by the city architect, Donald Gibson, on buildings in the redeveloped area.[1] Akhnaton abandoned Thebes as his capital and built a new capital on a virgin site at Akhetaton, which he dedicated to the sun god Aton, with splendid palaces, houses and tombs. He was motivated by a desire to undermine the old deities and replace their worship by the worship of Aton. His symbol was probably included because of its associations with building anew.[2] Skelton did not sign his work.

The inscription and city coat of arms were carved by J.C. Brown. In early 1951 John Skelton was commissioned to carve suitable motifs on the other side of the same column. This was to be the first in a series of such columns on Broadgate House recording the city's industries,[3] but the scheme was not carried further.

Notes
[1] Herbert Art Gallery and Museum, Coventry Public Art Database. [2] *Encyclopaedia Britannica*, vol.8, p.36. [3] Herbert Art Gallery and Museum, various files, correspondence relating to 1980 Public Art Project.

*In front of entrance to Broadgate shopping centre*

## Self Sacrifice (Lady Godiva)
**Sculptor: William Reid-Dick**
**Designer: Edwin Lutyens**
**Foundry: Singer Morris Foundry**

Unveiled: 22 October 1949
Equestrian statue: bronze, life-size
Pedestal: stone 2.5m
Signatures: (base of bronze, south face): W REID DICK 1944
    (base of bronze, north side): CAST BY MORRIS SINGER CO
Inscriptions: (on north face of the plinth): GODIVA / THEN SHE RODE BACK CLOTHED ON WITH / CHASTITY … SHE TOOK THE TAX AWAY / AND BUILT HERSELF AN EVERLASTING NAME / Tennyson
    (on south face of plinth): GODIVA / SHE RODE FORTH CLOTHED ON WITH / CHASTITY. THE DEEP AIR LISTEND ROUND / HER AS SHE RODE AND ALL THE LOW WIND / HARDLY BREATHED FOR FEAR / Tennyson
    (head of plinth): SELF-SACRIFICE
    (tail end of plinth): This statue / is dedicated / TO THE CITY'S BENEFACTRESS / OF A BYGONE / AGE AND IS / PRESENTED BY / W.H. BASSETT-GREEN / TO HIS FELLOW / CITIZENS / 1949.
Condition: good
Status: Grade II
Commissioned by: W.H. Bassett-Green
Owner/Custodian: Coventry City Council

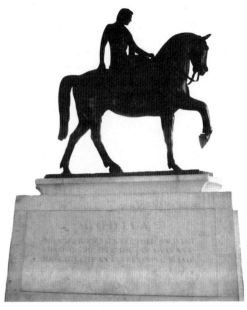

Reid-Dick, *Self-Sacrifice (Lady Godiva)*

Lady Godiva is depicted naked except for her hair, which drapes over her left breast, and is sitting side-saddle upon a horse. She holds the reins in her left hand, and her right hand rests on the horse's hindquarters. The horse, which is depicted walking, its head turned slightly to the left, has a folded piece of cloth across its back instead of a saddle, and a decorative martingale around its shoulders. The plinth has decorative moulding around its top and base. The inscriptions are taken from Tennyson's *Godiva*, first published in his *Poems* (1842).

Reid-Dick's *Godiva* is in the tradition of nineteenth-century naturalism and is primarily a memorial equestrian statue. The naked figure on the horse is of course readily identifiable as Godiva, but the more abstract concept of 'Self-Sacrifice' in the original title is not really conveyed in visual terms.

The legend of Godiva's ride through the

Coventry has been known and cherished since the late Middle Ages, and in later years Godiva processions were organised and the Peeping Tom legend evolved. The only memorial statue before 1949 seems to have been the figure that was added to the Coventry Cross in 1608, replacing one of Christ, thus changing the work to a secular piece. There were at least two attempts to erect a statue to Godiva in the nineteenth century: the first was in 1860 when an unknown sculptor exhibited a maquette in a London gallery with a view to being commissioned to execute a full-size version at a cost of £600; the second was in 1870 when Liverpool Corporation offered a Godiva statue, which had been in store at Derby Museum, where it remains. In both cases the statues were examined but turned down because of siting problems.

W.H. Bassett-Green (1870–1960) was a Coventry industrialist with interests in stone quarries and cinemas. He commissioned William Reid-Dick to make the Godiva statue, and later gave Landseer's painting of the Godiva story to the City. The sculptor had various discussions about the statue, including changing the proposed material from Purbeck stone to bronze. He initially produced models showing the figure astride the horse as well as sitting side-saddle. However, Bassett-Green insisted on a side-saddle pose, possibly for reasons of decency, but also in reference to Adam van Noort's painting of 1586. Reid-Dick had presented Godiva's hair as braided, but was instructed that the legend be followed accurately, and was at pains to explain how clumsy the figure would look veiled in brown hair down to her waist. This was to remain a contentious point for sixteen months, and there were further arguments about the age of the figure represented, the cladding and the weight of the horse.[1]

Reid-Dick began work on the sculpture during the war and had it cast at the Morris Singer foundry in 1944. Audrey Ursula Beeching, niece of Dr Richard, later Lord, Beeching sat as model for the figure. She appears elsewhere in Reid-Dick's work holding a bugle on the Reuters building and as a guardian angel on the tomb of King George V and Queen Mary. A portrait bust of her entitled 'Ursula' dated 1938 confirms her identity.[2]

On 21 February 1946, the City's Planning and Redevelopment Committee approved the proposed site for the statue, the centre of the new Broadgate development, where it was to have been in the direct line of the Cathedral vista.[3] On 24 February 1949, the Committee rejected a proposal that there should be a paved approach to the statue to minimise the risk to pedestrians who crossed the road to inspect it.[4] Sir Edward Lutyens, then President of the Royal Academy, was commissioned to design the pedestal for the statue, which was unveiled in front of thousands of people by Mrs Lewis Douglas, wife of the American Ambassador to Britain.[5]

There have been several conservation problems with the statue. On 30 April 1955 it was reported that a crack had appeared in one of the hind legs of the horse. The work was repaired by Morris Singer.[6] In 1960 concern was expressed about the staining of the plinth, which had become worse after a winter of heavy rainfall.[7] The statue was cleaned in 1982 and coated with a protective varnish to prevent graffiti, which cost the council £450. In 1984 the reins were broken off, and a Mr Lennox carried out repair work, refurbishing the bronze inside the mouth and fitting a new clasp. The following year, models of the elephant and castle, and the phoenix from the Coventry coat of arms, cast in aluminium by students at Coventry's Lanchester Polytechnic,[8] were placed on fencing surrounding the Godiva statue. In 1995 the statue was placed under a canopy and resited at right angles to the entrance of the shopping centre.

For details of the legend of Lady Godiva, see the entry for *Godiva and Peeping Tom*, Broadgate House.

Notes
[1] Wood, G., *Public Sculpture in Coventry. A Selected Critique*, unpublished BA dissertation, Coventry (Lanchester) Polytechnic, 1986. [2] *Ibid.* [3] *Coventry Evening Telegraph*, 15 July 1982. [4] Coventry City Council Records, Minutes of the Planning and Redevelopment Committee, 26 February 1949. [5] *Coventry Standard*, 29 October 1949. [6] *Coventry Evening Telegraph*, 30 April 1955. [7] Coventry City Council Records, Minutes of the Planning and Redevelopment Committee, 21 February 1946. [8] *Coventry Evening Telegraph*, 30 April 1985.

## Bull Yard    CITY CENTRE

## *Thread Through Time*

### Sculptors: Robert Conybear and Uta Molling

Executed: 1999
Cast recycled concrete, stone and brick, painted, 3.9m
Laser beam: 6m
Condition: fair
Status: not listed
Commissioned by: Coventry City Council Development Directorate
Owner/Custodian: Coventry City Council

This cone is made of recycled rubble extracted from the old Rolls Royce factories at Parkside and Cheylemore, Coventry, and, carved with medieval churches, the elephant and castle, a bull and a sun, is intended to represent the city's past. A laser should emit a beam some 6 metres up into the night sky, but this no longer works.

*Thread Through Time* was chosen by the people of Coventry from a range of models exhibited in the Escom shop in the Bull Yard for two weeks in June 1998, when Steve Field from the Dudley Public Art Unit was on hand

to explain the proposals and encourage the public to complete short questionnaires.[1]

Note
[1] *Coventry Evening Telegraph*, 14 August 1998.

**(right) Conybear and Molling,**
*Thread through Time (detail)*

Conybear and Molling, *Thread through Time*

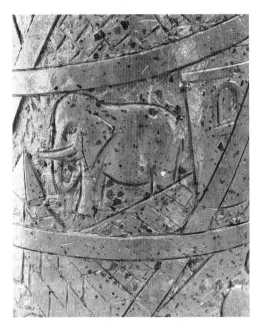

*Frontage of Three Tuns public house*
## *Untitled Abstract Panels*
## Sculptor: William George Mitchell

Executed: late 1960s
Concrete cast with pebble aggregate 4m high × 11.5m long approx
Condition: good
Status: not listed
Commissioned by: W.S. Hattrell & Partners, architects
Owner/Custodian: Bass Breweries

The panels form the entire visible frontage of the Three Tuns public house, surrounding the windows. The name of the public house is a later imposition and sits uncomfortably over the high relief panels which incorporate abstract motifs resembling industrial components including cogwheels and spirals. The overall design can also be interpreted as a map of an

Mitchell, *Abstract Panels*

urban area. The mural, cast in one piece, was moulded, with deeply cut polystyrene blocks inside the shuttering into which the concrete was poured. The work, with its design reminiscent of Central American art, and its pronounced surface texture, forms an effective contrast with the smoothness of the glass façades of the surrounding shops. This strongly textured appearance is continued through to the interior where the back of the panel is revealed as a more subtle form of the façade.[1]

The work was commissioned from Mitchell by W.S. Hattrell & Partners, the architects working on the Three Tuns pub. In 1995, Bass Breweries planned to replace the mural with a more traditional brick and timber façade, but conservationists applied to have the work listed,[2] and it was eventually decided that the work be retained, news welcomed by the Twentieth-Century Society. The piece is mentioned in a publication entitled *Coventry – New Architecture*.[3]

Notes
[1] Herbert Art Gallery and Museum/City of Coventry Libraries, Arts and Museums Department, *A Survey of Public Art in Coventry*, Coventry, 1980, p.81. [2] *Observer*, 10 December 1995. [3] Billingham, R., and Lewison, G., *Coventry – New Architecture*, Warwick, 1969.

## Canley Ford          CANLEY

*Community wildflower meadow down single track road from the A45*

## Resting Kestrel
### Sculptor: Walenty Pytel

Installed: 10 June 2000
Steel 2.4m high approx
Condition: good
Status: not listed
Commissioned by: Friends of Canley Ford

This stylised rendition of a kestrel emphasises the bird's head, wings and hooked beak. The

Pytel, *Resting Kestrel*

body and legs of the bird are indicated merely by the tapering of the work down to a point at its base. The choice of subject was influenced by the fact that there actually is a kestrel at Canley Ford.

The sculpture is part of a £140,000 Millenium Green project of work on the ford, a city beauty spot.

## Mushrooms
### Sculptor: Members of Arts Exchange

Installed: June 2000
Wood 90cm high approx
Condition: good
Status: not listed
Commissioned by: Friends of Canley Ford

There were originally four carvings including a conker, an acorn and a fir-cone as well as the mushrooms on this site. However, the others were removed by the Friends of Canley Ford following the theft of the mushrooms, which were subsequently returned. The artists' choice of subject reflects the local flora in this Coventry beauty spot.

Arts Exchange is an artists' co-operative, based in Coventry.

**Unknown**, *Mushrooms*

## Canley Road

*Canley Railway Station*

### Canley Railway Station Decorative Programme

#### Sculptor: John McKenna

Executed: 1995
Name plaque: bronze
Gable: steel 1.2m high × 3m wide
Other: brick, cast aluminium
Kangaroo: painted blue 1m high
Condition: good
Status: not listed
Commissioned by: Centro
Owner/Custodian: Centro

This integrated project includes roof decoration, bollards, free-standing sculpture, a name plaque and paving designs. At the early stages of its design McKenna discovered a local legend about a shepherd boy and his bull, which he incorporated into the roof decoration: 'In 1837, when the London to Birmingham Railway Line was opened, a young boy taking a bull to market became so absorbed by the passing trains that he neglected the bull. When he finally returned to the farm he was reprimanded for his inattention.'[1] Other associations used by the project included the local car manufacturing industry. On the gable end is a fretwork steel panel depicting a stage-coach and horses against a sky that includes a sunburst, clouds and a crescent moon, possibly referring to the availability of transport night and day. The name plaque incorporates Australian themes in reference to Sir Henry Parkes, a local man who created the modern federated state of Australia.

This project was co-funded by the British Rail Community Unit, as part of an initiative by Centro, 'to make catching a bus or train an enjoyable experience'.[1]

#### Note
[1] Centro, *Public Art in Public Transport.*

#### Source
John McKenna, Art for Architecture website: a4a.clara.net/a4a.htm

McKenna, *Canley Railway Station Decorative Programme*

## Cannon Hill Road

*Canley Crematorium, inner Garden of Rest*

### Pax

#### Sculptor: Georg Ehrlich

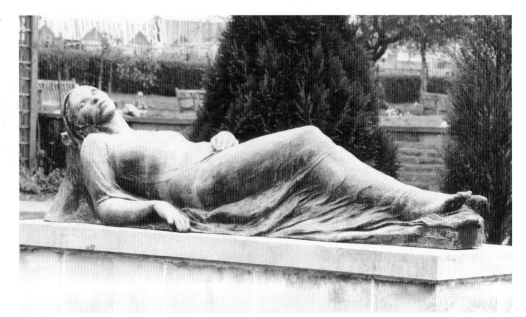

Ehrlich, *Pax*

Executed: 1943–5
Figure: bronze 49cm high × 49cm wide × 1.68m long
Plinth (which continues down into pond): stone 67cm high from pavement × 66cm wide × 1.83m deep
Signature: (on bronze, below head on left side of figure): G:EHRLICH. 43–45
Inscriptions: On one side of plinth: PAX
(on other side of plinth): THE GIFT OF/ SIEGFRIED / AND ANNIE / BETTMANN / MAYOR AND / MAYORESS / OF COVENTRY / 1913–1914 [below Bettmann the inscription is almost illegible]
Condition: fair
Status: not listed
Commissioned by: Siegfried and Annie Bettman
Owner/Custodian: Coventry City Council

The recumbent bronze figure of Pax (Peace) on a stone plinth is sited beside a lily pond, lying on her back with one knee raised, her right arm hanging at her side whilst her left hand is on her stomach. She wears simple drapery. Her head is turned to the right and her eyes are closed. The expression on the face creates a sense of ambiguity as to whether it represents a figure in repose or in death.

Siegfried Bettman (1863–1951), a German-born cycle manufacturer and Mayor of Coventry at the beginning of the First World War, commissioned the sculpture as an embodiment of peace during the Second World War. This was Ehrlich's first major public commission after coming to Britain in 1937 and was one of his largest bronze sculptures.

The maquette and preparatory studies for *Pax* were exhibited at the Bruton Gallery in London in 1978.[1]

Note
[1] Herbert Art Gallery and Museum/City of Coventry Libraries, Arts and Museums Department, *A Survey of Public Art in Coventry*, Coventry, 1980, p.37.

Source
Ehrlich, Bettina, *Georg Ehrlich, 1897–1966: bronzes, early drawings, lithographs and etchings: 19th April – 6th May 1972*, London, O'Hana Gallery, 1972.

## Clifford Bridge Road  WALSGRAVE

*Walsgrave Hospital*

### Arch and Column

#### Sculptor: Hideo Furuta

Executed: 1980s
Stone, arch 2.2m high, column 3m high approx
Condition: good
Status: not listed
Commissioned by: Walsgrave Hospital
Owner/Custodian: Walsgrave Hospital

**Furuta, *Arch and Column***

Two sculptural arrangements, an arch and a column, are each enclosed in a gravel bed planted with shrubs. In each group is a large flat stone with wavy lines carved into its surface.

An extract from a catalogue of 1988 published to accompany the sculptor's appointment as sculptor-in-residence at Powis Castle, Welshpool declares: 'My sculpture arises in direct relation to both landscape – the visible, horizontal element surrounding the stone, and the gravity – the visible, vertical element within the stone'.[1]

Note
[1] Herbert Art Gallery and Museum, Coventry Public Art Database.

## Coat of Arms Bridge Road
STIVICHALL

*Apex of bridge on either side*

### Coat of Arms Bridge

#### Architect: London and Birmingham Railway Company

Executed: 1844
Bridge: local stone
Panels: 2m high × 2m wide approx
Condition: poor
Status: Grade II
Commissioned by: London and Birmingham Railway Company

There are two coats of arms on the bridge carrying the railway line to Leamington. Those on the east side depict the arms of Arthur Francis Gregory of Styvechall Hall, with the Gregory lion above four horizontal bands. The

**London and Birmingham Railway Company,** *Coat of Arms Bridge*

crest shows the top half of a standing boar above a helm and mantling. The motto beneath the shield is 'Vigilanter', and the supporters are a crowned lion and a boar. The arms on the west side are those of his wife. The Gregory lion appears in the top left corner, while the three crescent moons (for Hood) appear in the top right corner, above two bands of lightning. The crest, motto and supporters are the same as those on the coat of arms on the east side.

These two coats of arms are reminders of an early phase of railway history, when landowners were ambivalent in their attitudes to allowing rails laid by the new entrepreneurs to run through their property. The coats of arms were included in fulfilment of the conditions under which Gregory would permit the railway to cross his land.[1]

Note
[1] Herbert Art Gallery and Museum/City of Coventry Libraries, Arts and Museums Department, *A Survey of Public Art in Coventry*, Coventry, 1980, p.16.

*Stivichall Infant School – wall of school entrance*

## Woodland Scene
### Sculptor: Victor Candey

Executed: 1951
Plaster and hessian 1.43m high × 90cm wide × 8cm deep
Signed by the artist
Condition: fair
Status: not listed
Commissioned by: Coventry Education Committee
Owner/Custodian: Stivichall Infants School

This irregular shaped relief panel is modelled in natural coloured plaster against a hessian-based

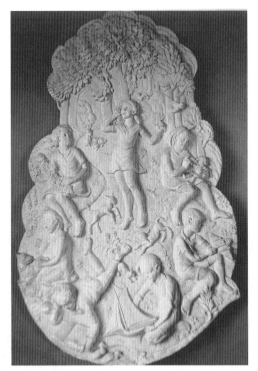

**Candey,** *Woodland Scene*

background. It shows a woodland scene filled with happily playing children. The central figure is a young girl larger proportionately than the rest of the group, standing surrounded by seated figures of other children, filling the rest of the scene.[1]

Note
[1] Herbert Art Gallery and Museum/City of Coventry Libraries, Arts and Museums Department, *A Survey of Public Art in Coventry*, Coventry, 1980, p.107.

## Cook Street                    CITY CENTRE

## Cook Street Gate Gargoyle and Boss
### Artist: unknown

Executed: 1400s
Gargoyle: sandstone 25cm high × 25cm wide × 45cm deep approx
Boss: wood 40cm high × 50cm wide × 40cm deep approx
Condition: fair

**Anon,** *Cook Street Gate Boss*

Status: Grade I
Owner/Custodian: Coventry City Council

The boss inside the medieval gate's archway is especially important as it is the earliest known example of Coventry's coat of arms. Its main surface depicts the elephant carrying three towers on its back. On the sides is the cat from the arm's crest, and a ribbon with text upon it runs around the upper edge.

*Corporation Street*     CITY CENTRE

## Horse Benches

### Maker: unknown

Executed: 1980s
Cast-iron frame with wooden slats, 1.1 m high × 2m long approx
Condition: good
Status: not listed
Commissioned by: Coventry City Council
Owner/Custodian: Coventry City Council

Unknown, *Horse Bench*

Each end of these two functional benches has been cast in the shape of a stylised horse with a long neck, clearly delineated mane and curving tail. The legs of the bench represent the legs of the horse; the armrest represents its body, and the edge of the back support represents its neck and head. The design combines practicality with a sense of fun.

## *Rebuilding Coventry and the Co-op's Activities*

### Sculptor: John Skelton

Executed: November 1956
Each relief: Hornton stone 3.66m high × 61cm wide
Condition: fair
Status: not listed
Commissioned by: Coventry and District Co-operative Wholesale Society
Owner/Custodian: Coventry and District Co-operative Wholesale Society

Three of the eight columns that support the Co-operative Wholesale Society buildings have incised line drawings upon them, depicting the rebuilding of Coventry and emblems of the Co-op's activities as a worldwide organisation; holiday facilities for employees; grocery provision, transport and coal; and flower seeds and nursery supply. Whilst some of the images are clear and informative for the general viewer, others suffer from the constraints of the subject matter. The first column has one face with depictions of farm buildings, fruits or tomatoes, a sunflower, a haystack, farm track and gate. These countryside motifs relate to the theme of flower seeds and nursery supply. On the other face are depictions of pit head gear and slag heaps, a wheel and dividers, an eye, what could be a tool for carding flax (though it also looks like a paint brush) and flames rising up from burning coals. This signifies coal and industry. The second column has on one face a fish, a

Skelton, *Rebuilding Coventry and the Co-op's Activities (detail)*

chopper, a bull's head, eleven milk bottles shown in perspective, bread and ears of wheat, referring to grocery provision. The other face depicts a bird flying over waves, a diver, a beach with bathing huts, cricket stumps and six balls increasing in size (the three largest are cricket, football and beach balls), thus suggesting holiday facilities for employees. The third column shows on one face a stylised map of the globe suggesting both lines of longitude and trade routes, a dove, a sheaf of wheat and a three-storey building with two doors. Dotted lines connect each design. This represents the worldwide growth of the Co-operative movement with a carving of its Rochdale premises at the base rising to a globe at the top; the other images typify the amenities of the store. The other face has an inscription on a tablet above a pair of glasses and, at the bottom, perfume and medicine bottles with a small glass for taking medicine. Dotted lines suggesting vision pass from the tablet through the glasses towards the base, leading the eye upwards to the Co-op sign on the tablet.

The Co-operative Society was founded in Rochdale in 1844. By 1851, there were around 130 stores in the North of England and Scotland, and within twenty years their methods had spread to wholesale trading as well as retail, and to production as well as distribution. The Co-operative Wholesale Society was formed in Manchester in 1864. Membership of the English Societies rose from 250,000 in 1871 to 805,000 in 1889,[1] but sadly, the Co-operative movement has been declining since the 1980s.

The City Planning Committee decided that the façade of the proposed Co-op building should have some form of sculptural decoration. The designs of the panels were restricted by the subject matter chosen by the Co-op architects' department. John Skelton's carvings are similar to his earlier work on *Princess Elizabeth's Pillar* on nearby Broadgate House.[2]

Notes
[1] Thornson, D., *England in the Nineteenth Century*, London, 1991, p.150. [2] *Coventry Evening Telegraph*, 10 November 1956.

## Coventry Canal

*Coventry Canal towpath adjacent to Prince William Henry public house*

### The Coil
### Sculptor: Frank Triggs

Unveiled: 1 May 1997
Wood 80cm high × 2m long approx
Condition: good
Status: not listed
Commissioned by: Groundwork Coventry
Owner/Custodian: Development Directorate, Coventry City Council

This sculpture has a practical function: it provides a seat for boating people and other visitors to the canal. Made of wood, it resembles a giant mooring capstan with coiled ropes. Its solidity and practicality provide a striking contrast to the playful spiral forms of Dhanjal's *Grown in the Field*, which is situated in the grounds of University of Warwick campus.

In 1993 Coventry City Council and British Waterways published 'Regenerating Coventry's Canal', a strategy for the canal corridor between the Canal Basin and Hawkesbury Junction. Public art works were seen as intrinsic to a three-pronged approach alongside access and environmental work and the improvement of bordering industrial premises. Following a feasibility study, Groundwork Coventry and the City Council successfully applied to the National Lottery and were awarded £200,000 of the £334,000 cost of a four-year project to create a canal art trail. The programme started with an exhibition of 30 proposals in the Canal Vaults in the summer of 1996. Visitors to the exhibition were asked to complete

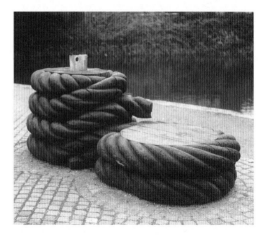

**Triggs, *The Coil***

questionnaires about the proposals which helped to inform the selection process. A Steering Group including representatives of the City Council, the Canal Basin Trust, Coventry and Warwick Universities, British Waterways, the regional Arts Board and Dudley Public Art Unit made selections on a quarterly basis.[1]

The 5½-mile canal trail has now been completed and includes statues, murals, mosaics and sculptural seats.

Note
[1] Groundwork Coventry, *Coventry Canal Heritage Trail Briefing Note*, Coventry, September 1998.

*Alongside canal, opposite Sandy Lane Business Park*

### Daimler Heritage Marker
### Sculptor: Robert Crutchley

Unveiled: 1 June 1997
Bronze 80cm high approx
Plinth, granite 5m high approx
Condition: good
Status: not listed
Commissioned by: Groundwork Coventry

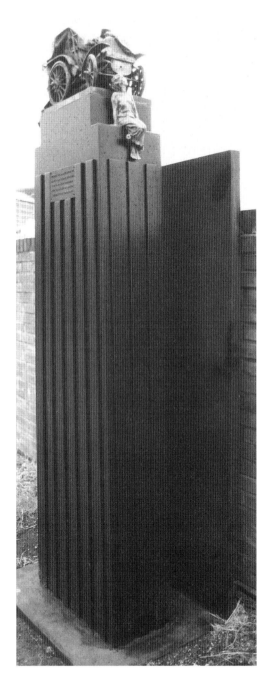

Owner/Custodian: City Development
    Directorate, Coventry City Council

This bronze sculpture of a Daimler car and two figures commemorating Britain's first production car stands near the site of the first Daimler factory built in the city in 1896, only six years after Gottlieb Daimler's founding of the company in Germany. Production was given a significant boost when the Prince of Wales (later Edward VII) bought the first of many royal Daimlers in 1900. The company continued to make up-market cars until 1960, when Jaguar purchased the Daimler name and business.[1]

The car is a recurrent motif in the artist's oeuvre. In this sculpture, he seeks to combine a celebration of engineering achievement with a sense of irony that recognises the car as a culturally complex and problematic artefact. At the front of the car, a young woman is draped across the bonnet in a manner that acknowl-edges the car's links with sexuality. At the back there is a skeleton crouching, reminding the viewer that the car is also a lethal weapon.[2]

Notes
[1] Coventry City Council web site, www.coventry.org.uk/heritage2/industry/motor/daimler [2] Artist's statement, www.coventry.org.uk/canalbasin/daimler

## Lady Lane                                      LONGFORD

*Coventry Canal towpath*

### *The Stone Sofa*
### Sculptor: Tim Shutter

Unveiled: 31 May 1997
Sandstone 1.4m high × 2.4m wide × 1m deep
    approx
Condition: fair
Status: not listed
Commissioned by: Groundwork Coventry

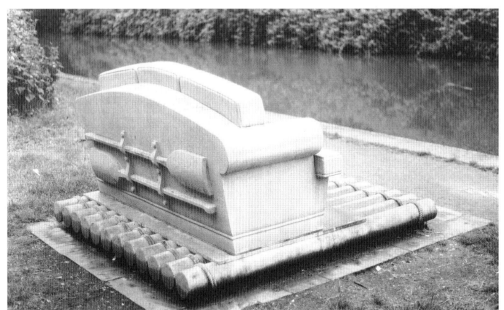

(left) Crutchley, *Daimler Heritage Marker*          (above) Shutter, *Stone Sofa*

Owner/Custodian: City Development
   Directorate, Coventry City Council

This sculpture in solid sandstone represents a
three-seat sofa, with a pair of realistically carved
paddles that appear to be attached to its rear,
conceptually relating it to its surroundings, the
water in the canal. The infantile absurdity of the
idea of a 'soft' sofa in stone that is associated
with a vessel on water, and that nonetheless
invites the tired visitor on the towpath to sit on
it, is a surrealistic idea. In this respect, it is
comparable to such surrealist objects as Meret
Oppenheim's classic fur covered *Cup, Saucer
and Spoon* (1936), in the Museum of Modern
Art, New York, which confuses the normal
function and texture of one article with the
form of another. An even closer analogy is
Oscar Dominguez's *Armchair* (1937), now lost
but known from a Man Ray photograph, in
which an actual wheelbarrow was upholstered
with satin. However, what in the 1930s was
intimate in scale and confined to the sphere of
the art gallery is now presented life-size or even
monumental in public space.

   For details of the commissioning of the
works along Coventry's Canal Art Trail, see the
entry for *The Coil*, Foleshill Road.

## Leicester Row    CITY CENTRE

*Coventry Canal Basin*

### *James Brindley*
### Sculptor: James Walter Butler

Unveiled: 18 September 1998
Bronze, one-and-a-quarter times life-size
Condition: good
Status: not listed
Commissioned by: Groundwork Coventry
Owner/Custodian: City Development
   Directorate, Coventry City Council

This full-length standing figure of James
Brindley in contemporary eighteenth-century

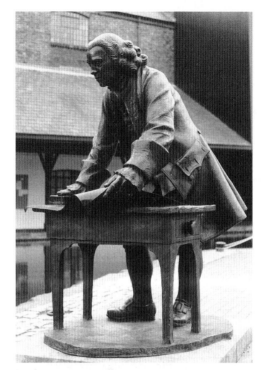

Butler, *James Brindley*

dress shows him consulting his working
drawings whilst facing the bridge he designed.
Freely, almost naturalistically modelled, the
figure is shown in an informal pose and appears
completely at one with the surroundings. There
seems to have been a recent revival of such
spontaneously modelled bronze sculpture,
presenting figures at ground level without an
elaborate plinth, with natural and informal
poses, gestures and expressions, and as if
entirely immersed in their environment. An
example of this genre is Sioban Coppinger and
Fiona Peever's *Thomas Attwood* (1993) in
Birmingham's Chamberlain Square, where
Attwood is depicted casually seated on the
steps, surrounded by papers and the soap box
off which he has presumably just stepped.

James Brindley (1716–72) was born in
Thornsett, Derbyshire. Apprenticed to a
millwright, he became an engineer, and
contrived a water engine for draining a coal-
mine (1752). In 1759 Francis Egerton, 3rd Duke
of Bridgewater, employed him to build the
canal between Worsley and Manchester, a
difficult enterprise he completed in 1772. He
was employed during the 1760s on the building
of the Coventry Canal Basin, and also started
the Grand Trunk Canal, and completed the
Birmingham, Chesterfield, and other canals. He
was illiterate, solving most of his problems
without writings or drawings.[1]

   The statue took a year to complete, and cost
£40,000.[2]

   For details of the commissioning of the
works along Coventry's Canal Art trail, see the
entry for *The Coil*, Foleshill Road.

Notes
[1] A & E Television Networks, www.biography.com
[2] *Coventry Citizen*, 18 September 1998.

*Overlooking Foleshill Road roundabout*

### *Lock Gates*
### Sculptor: Ondre Nowakowski

Unveiled: 31 August 1997
Oak and steel 4m high
Condition: good
Status: not listed
Commissioned by: Groundwork Coventry
Owner/Custodian: City Development
   Directorate, Coventry City Council

This large oak structure is made of the same
materials as the set of lock gates it resembles,
and also incorporates the silhouette of a house.
Although sited in an unobtrusive position, it
has become an important landmark in the
region. Its honest material qualities and simple
structure combine the tradition of
craftsmanship with a sense of modernity. It was
one of the most successful outcomes of the

**Nowakowski,** *Lock Gates*

Regeneration of Coventry's Canals Project.

For details of the commissioning of the works along Coventry's Canal Art trail, see the entry for *The Coil*, Foleshill Road.

*Immediately north of Bridge No. 1, Coventry Canal*

## The Journeyman
### Sculptor: Stephen Hitchin

Unveiled: 25 September 1999
Column: bronze 4m high
Condition: good
Status: not listed
Commissioned by: Groundwork Coventry
Owner/Custodian: City Development
    Directorate, Coventry City Council

This imposing, partly constructed piece of sculpture of the array of tools used in constructing the canal is mounted on an ornate bronze column. The sculptural representation

of such a conglomeration of tools forms a kind of industrial still life that, by the power of guided association, evokes images of the laborious efforts of the journeymen who designed and built these canals.

For details of the commissioning of the works along Coventry's Canal Art trail, see the entry for *The Coil*, Foleshill Road.

**Hitchin,** *The Journeyman*

*North of Bridge No. 1, Coventry Canal*

## Wave Seat
### Sculptor: Michael Grevatte

Unveiled: 30 July 1998
Stone 80cm high × 2m long approx
Condition: good
Status: not listed
Commissioned by: Groundwork Coventry
Owner/Custodian: City Development
    Directorate, Coventry City Council

This is an undulating stone seat, echoing the flow of water in the canal. Standing on a brick pavement, it is set against a solid stone wall. There is a striking contrast between the wavelike treatment of the surface and the solid

**Grevatte,** *Wave Seat*

material. The overall effect is a pleasing unity between the function of the seat and the aesthetic effect of proportions and imitative detail.

For details of the commissioning of the works along Coventry's Canal Art trail, see the entry for *The Coil*, Foleshill Road.

### Longford
*Planted woodland area on the Oxford Canal Arm, Longford*

## Folding Wedges
### Sculptor: Jim Partridge

Executed: June 1998
Oak 40cm high × 1.8m long approx
Condition: good
Status: not listed
Commissioned by: Groundwork Coventry
Owner/Custodian: City Development
    Directorate, Coventry City Council

The sculpture of two wooden wedge-shaped forms balanced on top of one another is inspired by the material and forms of lock gates.

For details of the commissioning of the works along Coventry's Canal Art Trail, see the entry for *The Coil*, Foleshill Road.

## Wall Walk
### Sculptor: Arts Exchange

Installed: July 1995
Wood, varying heights
Condition: good
Status: not listed
Commissioned by: Groundwork Coventry
Owner/Custodian: City Development
    Directorate, Coventry City Council

This work consists of an undulating 'climbable'

timber wave made of logs cut to varying sizes, some of which are carved with illustrations of local flora and fauna, including lizards and bull-rushes. Children from Foxford School helped the artists from Arts Exchange to create it.

*Oxford Canal Arm, access via Hollybush Lane*

## The Bridge that Flows
### Sculptor: Michael Fairfax

Installed: autumn 1998
Wood 2m high approx
Condition: good
Status: not listed
Commissioned by: Groundwork Coventry
Owner/Custodian: City Development
    Directorate, Coventry City Council

Partridge, *Folding Wedges*

Arts Exchange, *Wall Walk*

This vertical wooden heritage marker celebrates the life of the canal. The upper section of it is curved like the bows of a boat, and the sides are carved with a wave-like design that echoes the flow of water in the canal. The step-like construction on the front face refers to the mechanism used for winding the lock gates up and down to allow the water levels in different sections of the canal to be changed.

## Old Church Road    LITTLE HEATH

*Coventry Canal Towpath – opposite Courtaulds PLC*

### Pipework Bench

**Sculptor: Mary Jane Opie**

Unveiled: 31 May 1997
Painted steel pipes 12m long approx
Condition: fair
Status: not listed
Commissioned by: Groundwork Coventry
Owner/Custodian: City Development
   Directorate, Coventry City Council

A plain polychrome sculptural seat constructed from painted steel pipes, visually responding to the piping of the chemical factory opposite.

This work was commissioned as part of Groundwork Coventry's strategy for regenerating Coventry's canal.
  For the general background of the commission, see the entry for *The Coil*, Foleshill Road.

*Entrance to Navigation Bridge*

### Children Playing

**Sculptor: Mark Tilley**

Unveiled: 10 November 1999
Galvanised steel, life-size
Condition: good
Status: not listed
Commissioned by: Groundwork Coventry
Owner/Custodian: City Development
   Directorate, Coventry City Council

This group of two figures with a single figure a few metres apart from them, shows children playing on the bank of the canal. Their stylised caps, hats and costume suggest the early nineteenth century. The two figures on the left hand side seem to be working class, while the cylindrical shaped hat of the isolated right hand figure seems to suggest a middle class background. The faces of the two figures are

Fairfax, *The Bridge that Flows*          Opie, *Pipework Bench*          Tilley, *Children Playing (detail)*

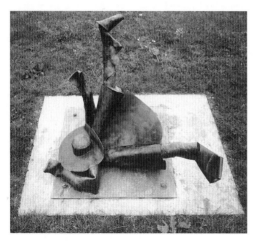

**Tilley, *Children Playing (detail)***

Condition: good
Status: not listed
Commissioned by: Groundwork Coventry on
   behalf of Coventry City Council
Owner/Custodian: City Development
   Directorate, Coventry City Council

*The Navigator* has been attached to the inside wall of a low eighteenth-century canal bridge on the side opposite the towpath. It comprises a semi-circular tube that houses fourteen 12–volt lights and has 14 slits. The work, powered by a solar panel mounted on a lamp-post on the street above, is interactive: sensors in the roof detect the approach of pedestrians or barges and switch on the lights in sequence. The effect is

that a curve of light then passes down the tube and the roof and sweeps along the bridge. The sculptor wished to emphasise the use of solar power, a power independent of the electricity network. He originally proposed a large 'sod-off solar panel' at the front[1], but had to tame down his ideas to get the project approved by the Committee.

For details of the commissioning of works along Coventry's Canal Art trail, see the entry for *The Coil*, Foleshill Road.

Note
[1] Public Lecture by Charles Quick, Coventry, 18 March 1999.

invisible as they are hidden by the overlapping headgear – thus they are anonymous and bear a close resemblance to the playing country children of Peter Brueghel the Elder. The overall appearance of this divided group is playful and witty in arrangement and yet monumental in appearance. It is one of the two most successful sculptures along the Coventry Canal Trail.

For details of the commissioning of works along Coventry's Canal Art Trail, see the entry for *The Coil*, Foleshill Road.

*Under Navigation Canal bridge*

## *The Navigator*
## Artist: Charles Quick

Unveiled: 14 May 1999
Sculpture: stainless steel 14m long × 40cm wide
   × 20cm deep
Control: micro electronics
Power supply: cell battery
Lights: 12–volt, 50–watt, tungsten halogen
   lights

**Quick, *The Navigator***

*Sutton Stop*         HAWKESBURY

*Hawkesbury Junction – near lock gates on Coventry Canal Towpath*

## *Hawkesbury Lock Seat*

### Sculptor: William Glanfield

Unveiled: 9 December 1997
Oak 1.2m high × 2m long approx
Condition: good
Status: not listed
Commissioned by: Groundwork Coventry
Owner/Custodian: City Development
   Directorate, Coventry City Council

This solid oak bench, sculpted to look like a lock gate, has the image of a fish carved at each end, and is modelled on the timber beams of the lock gates next to which it is sited. The material quality of oak, the simple structure, visible joints and carving all display a 'truth to materials' and the honesty of the direct carving approach.

   For details of the commissioning of works along Coventry's Canal Art trail, see the entry for *The Coil*, Foleshill Road.

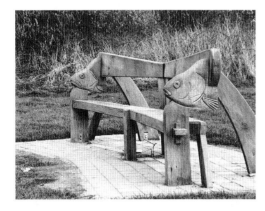

**Glanfield,** *Hawkesbury Lock Seat*

*On footbridge over canal near Hawkesbury Junction*

## *Hawkesbury Gateway Feature*

### Sculptor: Walenty Pytel

Unveiled: 23 September 2000
Steel
Commissioned by: Groundwork Coventry
Owner/Custodian: City Development
   Directorate, Coventry City Council

This steel sculpture of a swan with outstretched wings and kingfishers in flight is on the overhead railings of a footbridge over the canal.

   For details of the commissioning of works along the Coventry Canal Art Trail, see the entry for *The Coil*, Foleshill Road.

*Heath Crescent pocket park between Red Lane Bridge and Swan Lane, beside canal*

## *Seats by the Water*

### Sculptor: Avtarjeet Dhanjal

Installed: October 1998
Stone, including limestone
Columns 80cm high approx
Inscriptions: (on column in group nearest
   canal): A TABLE IS A TABLE IS A TABLE IS
(On semi-circular form in group nearest canal):
   When you don't know whether you are
   coming or going it's time to sit, relax and
   think. It's time to sit, relax and think, relax
   and think, relax, rela
Condition: good
Status: not listed
Commissioned by: Groundwork Coventry
Owner/Custodian: City Development
   Directorate, Coventry City Council

This series of stone seats is linked by curved arching limestone paths. Beside a path which zigzags in gentle curves across the towpath and the bank of grass, stand two large engraved

stones showing in relief the *Traveller* and the *Stream*. In the two upper returns of the path are a single column and a group of five columns, all of seat height, and a flat disc in a circle. At the end of the path near the canal is a grouping of a semi-circular seat and another column seat, both with carved wavy-ridged tops and inscriptions around the upper edge. The repetition of the word 'table' in the inscription may have been inspired by the American poet Gertrude Stein's avant-garde line: 'a rose is a rose, is a rose'.

   For details of the commissioning of works along Coventry's Canal Art Trail, see the entry for *The Coil*, Foleshill Road.

## *The Traveller and the Stream*

### Sculptor: Avtarjeet Dhanjal

Installed: October 1998
York stone, varying sizes
Inscriptions: (on one of two large stones):
   Traveller asks the stream / how old are you
   mother? / Stream replies / I feel each drop of
   time / is as fresh as a dew drop / Only way /
   as a mother / I can continuously / regenerate
   life / by Nimal Arpan / Panjabi poet
On the other large stone is an inscription in an
   Indian script.
Condition: good
Status: not listed
Commissioned by: Groundwork Coventry
Owner/Custodian: City Development
   Directorate, Coventry City Council

This work consists of two large standing stones and a flat stone embedded in the grass, each linked to the others by a pathway. It represents a traveller and his interaction with his waterside environment. One of the large stones has an inscription in English carved into one face and a delineation of a man walking with a bag on his back on the reverse. The other large stone has an inscription in an Indian script on one edge,

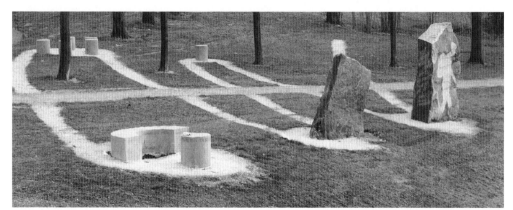

**Dhanjal**, *The Traveller and the Stream*

### Snake in the Grass

**Sculptors: Lizzie Murphy, Tanya Matthews, Dave Cooper, Janet Vaughan, Lorella Medici and Jonathan Ford of Arts Exchange**

Unveiled: 31 August 1997
Broken ceramic plates 3.6m long approx
Coloured cement
Condition: good
Status: not listed
Commissioned by: Coventry City Council
Owner/Custodian: City Development
    Directorate, Coventry City Council

This sculptural seating in the form of a snake is made of a ceramic mosaic and coloured cement. It is a witty, decorative colourful arrangement.

and a silhouette of the man walking with his bag on the reverse face. These two large stones are contained within the zigzag paths of *Seats by the Water* by the same artist. The third element is a flat stone, with the imprints of a man's boots carved into it to look like footsteps. Dhanjal explained that 'the work is about a traveller moving along the path and taking time to rest and assess his journey'.[1] The three stones represent a sequence, with the traveller at first motionless and then moving off again, represented by the footprints. At the time of installation the artist decided to change the order of the stones, so that the stone that is now in the centre is the one that was originally designed to be furthest from the footprints.[2]

For details of the commissioning of works along Coventry's Canal Art Trail, see the entry for *The Coil*, Foleshill Road.

Notes
[1] Artist's statement. [2] Information provided by Ron Clarke, Herbert Art Gallery and Museum, 19 July 2000.

**Arts Exchange**, *Snake in the Grass*

Families living in the Hillfields area of Coventry were asked to donate broken crockery to be transformed into a seat in the shape of a Loch Ness Monster by the artists of Arts Exchange and local groups. The project was part funded by Barclay Sitesavers and by Lottery money.[1] It is part of the Coventry Canal Public Heritage Trail.

For details of the commissioning of works along Coventry's Canal Art Trail, see the entry for *The Coil*, Foleshill Road.

Note
[1] *Coventry Evening Telegraph*, 20 June 1997.

## *Valley Road* STOKE HEATH

*Various locations between canal basin and Hawkesbury Junction to draw attention to canal*

### *Entry and Parapet Markers*
### Artist: Jon Mills

Installed: February 1999
Metal, painted
Six entry markers 1.8m high approx, 4 bridge
    parapet markers
Condition: good
Status: not listed
Commissioned by: Groundwork Coventry
Owner/Custodian: City Development
    Directorate, Coventry City Council

Six free-standing entry markers and four bridge parapet markers bear quotations from local people and have corresponding sculptural

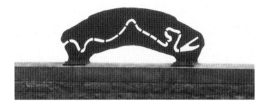

Mills, *Parapet Marker*

themes such as news, coal lorries, barges and bombs. Mill's design not only accentuates the entry to this section of the canal, but also conveys the idea of the winding map of the canal intersected by bridges.

The work is part of Coventry City Council and British Waterways' Regenerating Coventry's Canal project. For details of the commissioning of works along Coventry's Canal Art Trail, see the entry for *The Coil*, Foleshill Road.

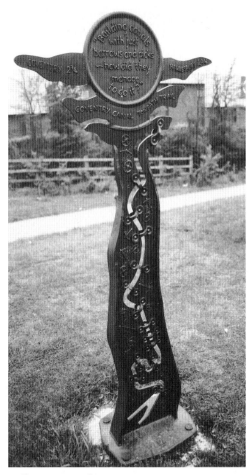

Mills, *Entry Marker*

## *Waterman Road* PARADISE

*Approach to Red Lane footbridge*

### *Lady Scurrying*
### Sculptor: Mark Tilley

Executed: July 1999
Steel 2.5m high approx
Condition: good
Status: not listed
Commissioned by: Groundwork Coventry
Owner/Custodian: City Development
    Directorate, Coventry City Council

This steel sculpture of a canal lady is sited on a semi-circular section of paving stones, next to a footbridge over the canal. Her pose suggests the

Tilley, *Lady Scurrying*

idea of forward motion as she hurries back to her boat after a shopping trip.[1] The work shows the influence of Boccioni's futurist sculptures of his mother. This, and its companion sculpture, *Children Playing*, were inspired by an outdoor costume performance on the theme of the lives of boat people, which was witnessed by the artist.

For details of the commissioning of works along Coventry's Canal Art Trail, see the entry for *The Coil*, Foleshill Road.

Note
[1] Information from Ron Clarke, Herbert Art Gallery and Museum, 19 July 2000.

## Coventry Cathedral    CITY CENTRE

*On red sandstone column in the priory ruins, at west end of Priory Gardens*

### Our Lady of Coventry

### Sculptor: Mother Concordia, Order of St Benedict

Executed: 2000
Bronze with gilding on halo and jewellery, life-size
Inscription: (on base): OUR LADY/OF/COVENTRY
Condition: good
Status: not listed
Commissioned by: Coventry City Council

This bronze seated figure of the Virgin with the Child on her lap with his right hand raised in blessing is based on sketches of a statue which existed before the Reformation, when it was sited in Coventry's original medieval cathedral. The Virgin is shown in her role as Queen of Heaven, with a crown upon her head and wearing a jewelled necklace made of glass beads, which represents the jewels worn by Lady Godiva and thus makes an important reference to Coventry's cultural heritage. The Virgin's elongated fingers convey a sense of delicacy and nobility. Her expression is one of

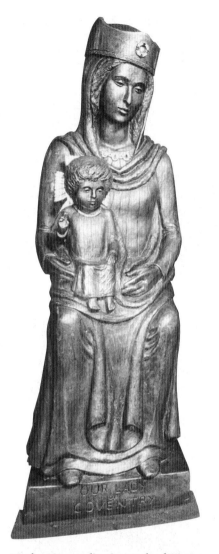

**Mother Concordia, *Our Lady of Coventry***

gentleness and compassion as she looks down upon the viewer. In this way, it reminds them of her role as intercessor for the faithful. As in other medieval depictions, her role as a human mother is not emphasised in that she does not look at the infant Christ, who is portrayed as a miniature adult rather than as a baby. His head is surrounded by rays of light that emanate from it in the form of a crucifix to remind worshippers of his future ordeal on the Cross. Like the Virgin, he looks down upon the viewer with a benevolent expression on his face.

The significance of this piece for the Phoenix Initiative lies in the fact that the Virgin is the patron saint of Coventry.

*East wall of Cathedral*

### St Michael and the Devil

### Sculptor: Jacob Epstein

### Foundry: Singer Morris Foundry

Unveiled: 1960
St Michael: bronze 5.94 metres high
The Devil: bronze 3.43 metres long
Condition: good
Status: Grade I
Commissioned by: Coventry Cathedral Reconstruction Committee
Owner/Custodian: Coventry Cathedral

The Archangel Michael stands with his wings and arms spread wide in triumph, holding an upright spear. He is clothed in a draped piece of cloth that leaves his chest bare. The top of his head is 9.14 metres from the ground. The Devil, cast as a separate statue, lies beneath St Michael's feet. He is depicted with horns, but is otherwise human in appearance. The position of the Devil is unusual, taken from the well-known Romanesque reclining Eve at Autun, in France; he almost appears to be reclining, elbows supporting his back as he looks up at the angel. His head, in contrast to the smooth

figure of St Michael, is coarse and has the exaggerated facial features of a medieval demon. Epstein has resolved the uneasy contrast between the conventionalised wings and fierce treatment of the head and torso of the devil by treating the whole figure in a schematic way and using a stylised muscle structure. The wilful arrangement of the drapery on the devil is controlled by sweeping it across the body instead of leaving it static.

The sculpture depicts the triumph of the Archangel Michael over the Devil, a common subject of medieval art, which frequently depicted the Archangel Michael leading the war against the rebel angels. It is also one that is linked with Epstein's preoccupation with Old Testament subjects depicting physical and moral struggles during the Second World War. Epstein's brief outlined the theme: 'Michael in conflict with the Devil is part of the whole field of Angelic activity. The Devil represents all evil – in the universe and in man; Active against man, individually and socially. Destructive of body, mind and soul. Malignant. Defeated.'[1] The size of the sculpture reflects the concern of the architect, Basil Spence, that it should not look puny against the sheer mass of the Cathedral. It provides a powerful image of the eternal struggle between good and evil for visitors approaching the cathedral from the east.

The idea for a figure of St Michael came originally from Basil Spence. His early elevations for the building show a roughly sketched figure sitting beside the steps, and he first approached Epstein in 1955. The Cathedral Reconstruction Committee approved the maquette in 1956. Epstein, who had already started work, changed the sculpture from that portrayed in the maquette almost at once – removing the piece of ground on which he had placed both figures and changing the angle of St Michael's arms to create a more strongly controlled composition based on a three-dimensional triangular structure. Epstein used

Wynne Godley as the model for the head of St Michael, and for the torso of the Devil he worked from a muscular athlete. The sculpture is one of Epstein's last major works in bronze

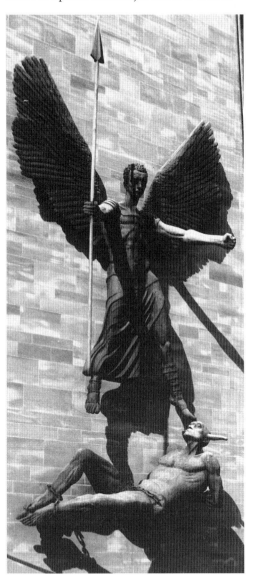

Epstein, *St Michael and the Devil*

and his last religious sculpture.[2] It is arguably one of his finest bronze sculptures, as he had argued it would be when he started working on it. Because of its scale, the figure of St Michael was constructed in two separate pieces in the artist's studio. It was cast in 1958 and unveiled after the artist's death by Lady Epstein, when the Bishop of Coventry described it as 'deeply challenging'.[3]

It was cleaned by volunteers in mid-1990, when it was reported as being badly weathered.[4] In 1996 a series of letters was published in the local press in response to an earlier letter complaining that the depiction of the devil was 'monstrous'.[5]

Notes
[1] Campbell, Louise, *Coventry Cathedral: art and architecture in post-war Britain*, Oxford, 1996, pp.142f. [2] Strachan, W.J., *Open Air Sculpture in Britain*, London, 1984, p.160. [3] Howard, R.T., *Ruined and Rebuilt: The Story of Coventry Cathedral*, Coventry, 1962, p.113. [4] *Coventry Evening Telegraph*, 7 August 1990. [5] *Ibid.*, 24 February 1996 and 26 February 1996.

Sources
Silber, Evelyn: – [i] *The Sculpture of Epstein: With a Complete Catalogue*, Oxford, 1986; [ii] *Jacob Epstein: sculpture and drawings*, Whitechapel Art Gallery, London, 1987; [iii] *Rebel Angel: Sculpture and Watercolours by Sir Jacob Epstein 1880–1959*, Birmingham Museums and Art Gallery, 1980.

*West entrance to Cathedral– doorhandles*

## *Cherubs' Heads*
### Artist: Jacob Epstein
### Designer: Louis Osman

Installed: 1961
Each handle: bronze 12.5cm high × 10cm wide
Condition: good
Status: Grade 1
Donated by: sculptor's widow
Owner/Custodian: Coventry Cathedral

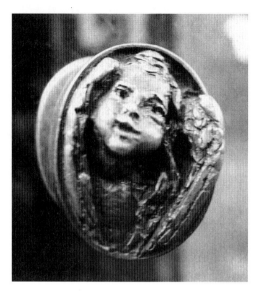

**Epstein**, *Cherub's Head*

The ten doorhandles are each adorned with a cherub's head, enclosed in wings. Originally designed by Louis Osman, they were cast in 1956 for the Convent of the Holy Child Jesus in Cavendish Square, London, where Epstein had earlier designed his *Madonna and Child*. This second cast was given to the Cathedral by Epstein's widow in November 1960. The cherubs' heads were drawn from four children's heads he had previously made in bronze, although here, to create lively animated figures, he has given the cherubs a freer treatment than the original portraits. They are more closely related to the angel designs initially produced by John Hutton in the mid-1950s than the gaunt figures they were placed next to eventually .[1]

Note
[1] Herbert Art Gallery and Museum/City of Coventry Libraries, Arts and Museums Department, *A Survey of Public Art in Coventry*, Coventry, 1980, p.65.

Sources
Silber, Evelyn: [i] *The Sculpture of Epstein: With a Complete Catalogue*, Oxford, 1986; [ii] *Jacob Epstein: sculpture and drawings*, Whitechapel Art Gallery, London, 1987; [iii] *Rebel Angel: Sculpture and Watercolours by Sir Jacob Epstein 1880–1959*, Birmingham Museums and Art Gallery, 1980.

*Entrance wall of new Cathedral*

## Glass engravings
## Glass worker: John Hutton

Executed: 1958–61
Glass, with frame of manganese bronze alloy
Window 21.33 metres high × 13.71 metres wide

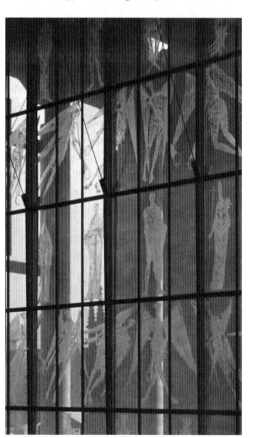

Condition: good
Status: Grade 1
Commissioned by: Coventry Cathedral Reconstruction Committee
Owner/Custodian: Coventry Cathedral

The west wall of the cathedral is completely of glass, upon which Hutton engraved eight rows of saints and angels. The long gaunt figures, with gestures exaggerated in an Expressionist way, are more stylised than those of Epstein's *St Michael and the Devil* alongside them. The top row depicts Old Testament saints and prophets, the third row shows the New Testament saints Paul, James, Peter, John the Baptist, the Madonna and Child, John, Luke, Mark and Matthew, and the fifth and seventh rows feature saints connected with the British Isles. The local saints Chad and Osburga appear on the seventh row, closer to eye level. Alternate rows show lines of angels, with six larger angelic figures flanking the doors.[1]

It had been intended that Hutton's figures should refer to the victims of the blitz as well as to those buried in the churchyard on which the new cathedral was to be built. This explains the change in the character of his saints and angels between 1952 and 1954. With their small heads and shroud-like draperies, the saints are clearly related to Henry Moore's wartime drawings of shelters in the Tube – a subject which Hutton also tackled in 1940. Another source may have been the huge Hiroshima Panels by Iri Maruki and Toshiko Akamatsu, which depict the naked figures of the dead and the survivors of Hiroshima, and which received critical acclaim when they toured Britain in 1955.

Hutton, who undertook most of the engraving himself, started work in 1958 and developed a new system of engraving which allowed him to produce the greater variety of

**Hutton**, *Engraved Glass Window*

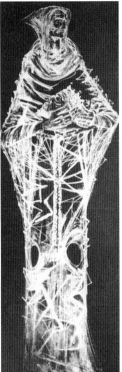
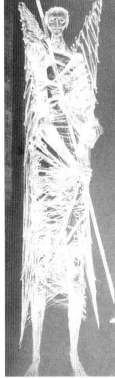

**Hutton,** *Engraved Glass Window (details)*

tone and texture which he desired. The deliberate variety of depth and texture helps to extend the expressive range of the figures as well as distracting attention from the metal framework.[2]

Notes
[1] Campbell, Louise, *Coventry Cathedral: art and architecture in post-war Britain*, Oxford, 1996, pp.124–8. [2] *Ibid.*, pp.188–9.

*In Cathedral ruins*

## Christ
### Sculptor: Alain John

Executed: after 1943
Figure: concrete 2.5m high × 40cm wide × 40cm deep
Stepped column: masonry 3.6m high × 85cm wide by 50cm deep
Inscription: (on plaque beneath work): THE STATUE OF CHRIST / This is a second casting in concrete, of a statue at Blundell's / School in Devon. It was created by an 18 year old pupil. / Alain John. The headmaster, Neville Gordon, later became Bishop / of Coventry and on the death of Alain John, an RAF navigator / in 1943 at the age of 23, the statue was recast for Coventry as / a memorial to those who lost their lives in the war. /
Condition: fair
Status: not listed
Commissioned by: Neville Gordon, Bishop of Coventry
Owner/Custodian: Coventry Cathedral

This slender full-length standing figure of a bearded Christ, with a halo and light drapery, upon a pillar set against the ruined cathedral wall, shows his hands with the stigmata. Iconographically, this is an Ecce Homo figure.

*North-east aisle of Cathedral ruins*

## Dr Yeatman Biggs, Bishop of Coventry
### Sculptor: William Hamo Thornycroft
### Restorer: E. Roland Bevan

Unveiled: July 1925
Statue: bronze 63cm high × 2.42m wide × 80cm deep
Plinth: masonry with metal top 75cm high ×

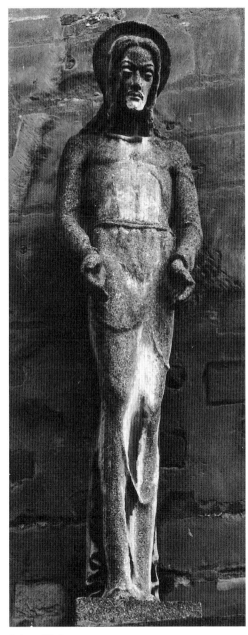

John, *Christ*

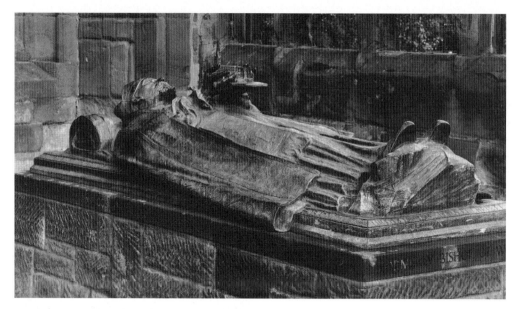

The bishop is shown lying on a sarcophagus in full robes with mitre, holding a model of the cathedral. His head rests on a bolster behind which are two books. His feet rest on a boulder. The iconography is quite traditional, the modelling is free and almost impressionistic in parts. This is one of the sculptor's last works.

Dr Yeatman Biggs was bishop of Coventry when the diocese was revived in 1918. This monument was designed to be placed in the aisle of his cathedral, but the bombing left it in the open air, shifting its original function and extending it into the realm of public sculpture.[1]

Note
[1] Clarke, Ron, *Public Sculpture of Coventry*, Coventry, p.27.

Source
Manning, Elfrida, *Marble and Bronze: The Art and Life of Hamo Thornycroft*, London, 1982, p.212.

**Thornycroft**, *Tomb of Dr Yeatman Biggs, Bishop of Coventry*

2.6m wide × 95cm deep
Inscriptions: (on monument): Deo adjuvante resurgo + Huyshe Wolcott Yeatman Biggs propositi tenax par ardua sedis Coventrea resistor idem et primus eps. + od. AD MCMXXII + LUCEM AETERNAM Dona Ei Christe.
(on plinth): HUYSHE WOLCOTT YEATMAN-BIGGS FIRST BISHOP OF THE REVIVED SEE OF COVENTRY
1918–22 FORMERLY BISHOP OF WORCESTER
(on headrest): Yeatman Biggs 1923
(later inscription on base of the figure): Damaged in the raid on Coventry 14th November 1940. Restored under the supervision of E. R. Bevan, Sculptor at the Morris Singer Foundry 1951.
Signature: (bronze signed): Hamo Thornycroft RA Sc. 1924
Condition: fair
Status: Grade 1
Commissioned by: the Bishop's children
Owner/Custodian: Coventry Cathedral

**Thornycroft**, *Tomb of Dr Yeatman Biggs (detail)*

*South wall of Cathedral ruins*

## Ecce Homo

### Sculptor: Jacob Epstein

Unveiled: 19 March 1969
Subiaco marble 3.35m high
Condition: fair
Status: not listed
Donated by: the trustees of the estate of Canon Mortlake at the request of the sculptor's widow
Owner/Custodian: Coventry Cathedral

The sculptor intended the simplified forms of this work to be seen from a single frontal viewpoint. The form of the block is maintained in the finished sculpture by the use of simple modelling and flat carved planes, creating a sense of mass and solidity. The use of a single frontal viewpoint is not derived from the European tradition of sculpture and has more affinity with Mexican or Toltec art, which may also have been the source for its vision of a non-

European Christ. The architectural form and massive appearance of the sculpture are seen to good advantage against the soft sandstone ruins of the old cathedral. Weathering has now softened the original forms, and there has been a significant loss of detail, especially the texturing left by the chisels.

Epstein, who worked on the sculpture in 1934–5, said: 'I wished to make in "Ecce Homo" a symbol of a man, bound, crowned with thorns and facing with a relentless and

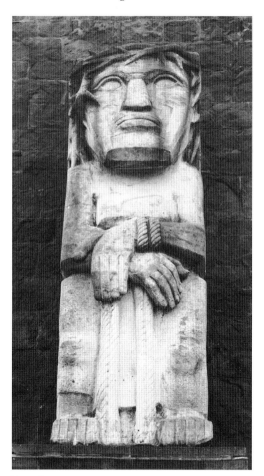

Epstein, *Ecce Homo*

overmastering gaze of pity and prescience on our unhappy world. Because of the hardness of the material I treated the work in a large way, with a juxtaposition of flat planes, always with a view to retaining the impression of the original work.'[1] When the piece was exhibited in an unfinished form (breaking with his usual practice) at the Leicester Galleries in 1935, it received a mixed reception. Anthony Blunt was one of the few critics properly to assess the piece, but Thomas McGreevy declared that, while Epstein's sculptures were extremely powerful, they lacked grace.[2]

The work remained unsold and stayed in his studio, until an attempt was made to erect it at Selby Abbey in 1958, but this met with much opposition and the plan was shelved. When the artist died the work passed along with disposal rights to Canon C.B. Mortlake. When he died in 1969 the piece was given to the City Cathedral and erected in the grounds on a plinth paid for by the Coventry Boy Foundation.

Notes
[1] Epstein, Sir Jacob, *Epstein: An Autobiography*, London, 1975, p.45. [2] *The Studio*, vol.118, August 1939, p.77.

Sources
Silber, Evelyn: [i] *The Sculpture of Epstein: With a Complete Catalogue*, Oxford, 1986; [ii] *Jacob Epstein: sculpture and drawings*, Whitechapel Art Gallery, London, 1987; [iii] *Rebel Angel: Sculpture and Watercolours by Sir Jacob Epstein 1880–1959*, Birmingham Museums and Art Gallery, 1980.

*Cathedral ruins*

## *Reconciliation*

### Sculptor: Josefina de Vasconcellos

Unveiled: 6 August 1995
Figures: bronze 1.12m high × 2.51m wide × 54cm deep
Plinth: masonry and concrete 88cm high ×

3.11m wide × 1.13m deep
Inscriptions: (incised lettering, cream on bronze plaque): in 1995, 50 years after the end of the Second World War this sculpture / by Josefina de Vasconcellos has been given by Richard Branson as a token of reconciliation. / An identical sculpture has been placed on the behalf of the people of / Coventry in the Peace Garden, Hiroshima, Japan. / Both sculptures remind us that, in the face of destructive forces, human / dignity and love will triumph over disaster and bring nations together / in respect and peace.
(in a separate column on same plaque there is an inscription in Japanese)
Condition: good
Status: not listed
Commissioned by: Richard Branson
Owner/Custodian: Coventry Cathedral

These two figures embrace, kneeling opposite each other with their arms around each other's shoulders. Their faces are hidden from the casual viewer, but on closer inspection are visible from beneath, although still lacking in detail and characterisation. The bodies of the figures are simplified, arranged in the general shape of an arch. The plinth is made of stones reclaimed from the cathedral ruins, with examples of its architectural ornament set into the corners and two grilles in the back. This masonry is topped with a concrete slab on to which is screwed the bronze group.

Controversy greeted the installation of this piece. A former prisoner of war suggested that it represented a phoney reconciliation, and the secretary of the Japanese Labour Camp Survivors claimed that the work was in bad taste, after the great ordeal to which prisoners of war were subjected.[1] The 91-year-old sculptor designed a model for this sculpture just after the declaration of peace ending the Second World War. She had heard a story of a wife who had travelled on foot across Europe to find

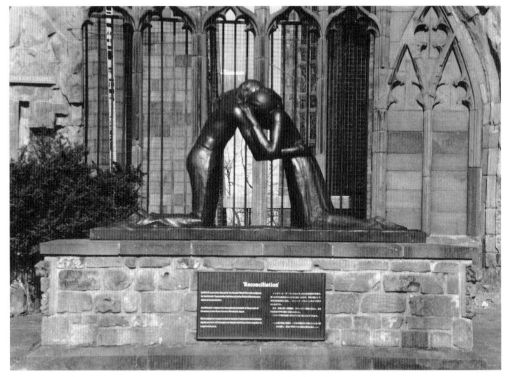

**De Vasconcellos,** *Reconciliation*

her husband, and she had wanted to show how the couple would have embraced when they met. She felt the sculpture to be symbolic not only of two people but also two nations. 'They are on their knees praying that it will never happen to their children or, most important, anyone else's children, whatever colour, creed or religion.'

Note
[1] *Coventry Evening Telegraph*, 30 June 1995 and 5 July 1995.

---

*Cuckoo Lane*      CITY CENTRE

## *Coventry Cross*

**Sculptor: George Wagstaffe**

**Architect: Rolf Helberg**

**Sculptors: Philip Bentham, Wilfred Dudeney and George Ford**

**Contractor: Girlings FerroConcrete Company**

**Builder: Albert Gale**

Formally gifted: 23 April 1976
Main: ferro-concrete, red 17.4m high
Figures (some): Hollington stone
Pennants: anodised aluminium
Flags: fibreglass

---

Inscriptions: (on a series of plaques around the base):
plaque 1: Designer: Rolf Hellberg / Crown & pennons: George Wagstaffe
plaque 2: Sculptors: Philip Bentham / Wilfred Dudeney / George Ford
plaque 3: Contractor: Girlings FerroConcrete / Company, Kirkintilloch
plaque 4: THE COVENTRY CROSS / of which this is a replica / was erected in 1541
plaque 5: by Sir William Holles / Lord Mayor of London / 1539–1540
plaque 6: Though repaired in 1668 / it fell into ruins and / was demolished in 1771
plaque 7: BUILDER ALBERT GALE / WYKEN COVENTRY
plaque 8: The gift of the Cross / was formally made / on 23rd April 1976
plaque 9: to Councillor Charles Ward / Lord Mayor of Coventry / by Sir Philip Allen G.C.B.
plaque 10: on behalf of the donors / The Coventry Boy Foundation / Founded by Alfred Harris
Condition: good
Status: not listed
Commissioned by: The Coventry Boy Foundation
Owner/Custodian: Coventry City Council

This is a modest version in ferro-concrete of the mid-sixteenth-century cross, which stood in Cross Cheaping until its destruction in the eighteenth century, and probably replaced an even earlier one in the style of an Eleanor cross.[1] Eleanor crosses were richly sculptured memorial crosses erected between 1291 and 1295 at various towns in England to mark the resting places of the body of Eleanor of Castile (1244–90), Queen of Edward I, on her funeral journey to London. Most of them were destroyed in the late sixteenth century. The most notable extant examples are at Waltham in Hertfordshire (designed by Roger de Crundale and Nicholas Dymenge de Ligeri) and

Hardingstone and Geddington in Northamptonshire.

The architect of the new Coventry Cross followed the instructions of the original 1542 contract, and produced a hexagonal structure rising to over 17 metres with storeys of niches for figures topped by a lantern. He also included the heraldic beasts and small naked boys with shields as pennant bearers. However the new cross differs fundamentally from the description in that contract, and from medieval practice, in many other respects. Most fundamentally it is made from cast ferroconcrete with stone only used for a few statues instead of all being of free stone. Structurally too, it is not authentic, being built on an internal frame that does away with the need for supporting buttresses at its lower level, reducing them to thin pilasters with no function. The lack of solidity of the lower stage is further emphasised by the shallow tracery carved on the base panels. The cross has twenty niches with figure statues. In the lower section are statues of Henry VI, King John, Edward I (in armour), Henry II, Richard I and Henry IV; on the second storey are St George, Edward III, John, St Michael, Christ and Henry III and boys with pennons; on the third storey are saints and monks – St Peter, a Benedictine monk, a White Friar, St James the Less, and a Grey Friar, with beasts with pennons including a lion, a bull, a dragon and a greyhound. The finial lantern has six angels of virtue, including the allegorical figures of Liberty and Justice.[2]

In December 1541 Sir William Hollis, a former mayor of London, had left £200 in his will to erect a new cross in Cross Cheaping in Coventry, a city with which he had close associations.[3] The historian Sir William Dugdale visited Coventry to see the cross and described it as 'one of the chief things wherein this city most glories, which for workmanship and beauty is inferior to none in England'.[4] Several statues from the original cross and written

descriptions survive, including the original contract for its building in 1541–3 which itemises its proportions and certain of its parts and describes it as being based closely on Abingdon's cross from the late fifteenth century. Drawings and engravings of the original cross survive, but most date from after its destruction and so cannot be relied upon. Abingdon's cross was also destroyed and no representations of it before its major restoration in 1605 are known.

The plans for the cross were first drawn up in 1971 when the The Coventry Boy Foundation approached the Civic Amenities Society

**Wagstaffe,** *Coventry Cross*

and the church authorities for comment before applying for planning permission. Despite initial reservations about the siting of the work, and its form, the city authorities granted planning permission without requiring any alteration to the design even though it was to be sited in a conservation area. Alfred Harris of the Foundation suggested that the city should, for the sake of authenticity, bear the cost of the pennants for the Cross as it had done in the sixteenth century. The city authorities agreed, and decided they should be made of anodised aluminium with fibreglass flags for reasons of maintenance. Some of the casts for the figures are in the Herbert Art Gallery.

It has been posited that it might have been more interesting and of greater relevance to the city if the Foundation had commissioned a twentieth-century design of the Cross rather than attempting to recreate an original in a historicist manner.[5]

Notes
[1] Pugh, R.B. (ed), *Victoria County History of Warwickshire*, vol.8, Oxford, 1969, pp.143–4.
[2] *Coventry Cross presentation programme*, Coventry, 1976, p.1. [3] McGrory, D., *Coventry History and Guide*, Stroud, 1993, p.58. [4] Quoted in *ibid.*, p.58. [5] Herbert Art Gallery and Museum/City of Coventry Libraries, Arts and Museums Department, *A Survey of Public Art in Coventry*, Coventry, 1980, pp.91–2.

*Earl Street*                    CITY CENTRE

*Opposite the Council House*

### Beacon Europe
### Maker: John Astley & Sons Ltd

Unveiled: 3 December 1992
Beacon: steel 4m high approx
Inscriptions: (on plaque near top of Beacon):
    BEACON EUROPE/ 31.12.92/ 24h00
    (on plaque at base): BEACON EUROPE/ 3rd
    December 1992/ THIS BEACON DESIGNED
    AND BUILT BY 6th FORM PUPILS/ Austin Hall,

Anthony Matusz, Matthew Murphy, Jane Portlock, Mark Sellors, Michael Stokes, Jon Tyrell, Lee Wright,/ of Coventry Schools/ CALUDON CASTLE, FINHAM PARK and WOODWAY PARK/ with MANUFACTURING ASSISTANCE and SPONSORSHIP from/ John Astley & Sons/ Ltd/ Holyhead Road/ COVENTRY/ Dept of Construction/ COVENTRY/ TECHNICAL/ COLLEGE/ Le Bas Tube Co Ltd/ +GF+/ Hinckley Rd./ COVENTRY/ ENGRAVED BY COVENTRY SILVERCRAFT CO LTD/ 673 LAMB STREET COVENTRY

Condition: fair
Status: not listed
Commissioned by: Coventry City Council
Owner/Custodian: Coventry City Council

Three vertical shafts rise from a small conical base with a plaque to support an inverted cone, the Beacon that can be lit. Three plaques near the top of the Beacon each have an inscription, in turn: the Coventry coat of arms, the emblems of the three schools involved, and the short inscription detailed above.

Originally, beacons were bonfires lit at night to send warning messages in times of danger. Most famously, they were used during Elizabeth I's reign to warn people of the approach of the Spanish Armada. However, they have also been lit at times of national celebration such as coronations, royal weddings and the end of both World Wars.

*Council House façade*

### Council House Reliefs and Statuary
**Sculptor: Henry Wilson**
**Architect: Garrett and Simster**
**Restorer: Norman and Underwood**

Executed: 1913–26
Coats of arms: Runcorn stone/paint
Statues: Portland stone, life-size

**Garrett and Simster,** *Council House façade*

St Michael: Oak and lead 1.8m high
Condition: good
Status: Grade II
Commissioned by: Coventry Borough Council
Owner/Custodian: Coventry City Council

Heraldic sculpture is displayed in horizontal and vertical panels in the centre bay of the building. Carved in low relief in the same stone

**John Astley & Sons,** *Beacon Europe*

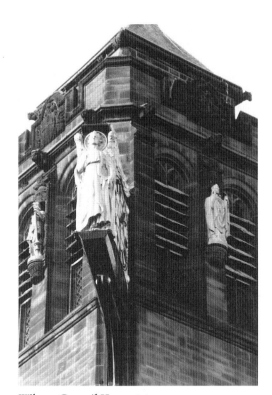

**Wilson,** *Council House statues*

as the building, it is painted and gilded. There are also numerous smaller panels featuring for instance an elephant's head, (from the city's arms). The overall programme has a decorative unity, but iconographically it merely refers to characters associated with the city rather than amounting to a systematic unified theme. Figures of Lady Godiva and Justice accompany those of Edward the Confessor, the Black Prince, Ranulf, Earl of Chester and Leofric. A figure of St Michael surmounts the clock tower, and the figures of the four patron saints of the British Isles (St George, St Patrick, St Andrew and St David) adorn the clock, alongside a gilded angel.[1]

The design of the Council House was chosen as a result of a competition held in 1911, and included provision for a separate town hall that was not built. The plans included panels of heraldic sculpture in the central bay and porch, and a free-standing sculpture in a series of niches on the façade. The architectural sculpture was undertaken in two phases. The first, the heraldic sculpture, coats of arms of royalty and nobility associated with the city, was provided after consultation in 1913 between the council and the architect. Painting and gilding of heraldic devices are not common in a building from this date in Britain, although they are seen in drier climates. This first phase of the architectural sculpture was completed by the opening of the Council House in 1920 and the second phase was started shortly afterwards. In 1924 the architects commissioned the figures for the niches on the new building from Henry Wilson, who had previously been responsible for making the stalls and canopies in the council chamber in 1920. The figures of Godiva and Justice were ordered in 1924 and sited by 1926. During restoration work in 1983 it was discovered that the head and hands of St Michael might be eighteenth-century or older.[2]

Notes
[1] Herbert Art Gallery and Museum/City of Coventry Libraries, Arts and Museums Department, *A Survey of Public Art in Coventry*, Coventry, 1980, p.25. [2] *Coventry Evening Telegraph*, 20 April 1983.

*Opposite the Council House*

## *Flywheel*
## Sculptor: Michael Farrell

Installed: 1987
Sculpture: stone 1.5m high approx
Condition: poor
Status: not listed

This abstract sculpture is composed of concentric organic forms, including a wheel-like shape that has similarities to a shell or fossil. It was made with the intention of being sited out of doors and brings together two of the sculptor's favourite subjects, Celtic and Christian symbols. The stone surface bears the marks of the mason's chisel.

It was installed as part of the On the Town, Midland View 4 Sculpture Show, which was held in the centre of Coventry 12 September – 31 October 1987.[1]

Note
[1] Wood, G., *On the Town – Midland View 4 Sculpture*, exhibition catalogue, 1987.

**Farrell,** *Flywheel*

*In courtyard of City Architects' department*

## *Naiad*

### Sculptor and restorer: George Wagstaffe

Executed: 1981–3 (replacing 1958 original)
Bronze 1.3m high approx
Condition: good
Status: not listed
Commissioned by: City Architects'
    Department
Owner/Custodian: City Architects'
    Department

The naiad, a naturalistically modelled life-size adolescent girl, is set at ease on a rock in the pool of the Council Office's courtyard. Her legs are in the water. The spontaneity of the young seated figure is hardly surprising as the sculpture was developed from a drawing done by Wagstaffe in 1957 as part of a series of impressionistic beach studies in which the pose and drapery are very similar. The rectangular pool is pleasantly enclosed by the building and provides a quiet place for rest and pleasure. Unfortunately, the courtyard is not regularly cleaned and maintained, the water is covered with green algae, and the pool is full of debris.

The 1958 original of this sculpture, in fibre glass, had to be removed in the late 1970s due to damage from weather and vandalism, and was finally destroyed in 1976. It was replaced in cast bronze, with the assistance of George Wagstaffe, the £1,000 cost of the casting coming from the Planning Department's maintenance funds. The work had a hostile reception in the press, being criticised particularly for having incomplete legs that finish where they enter the water.[1]

Wagstaffe exhibited the plaster model of the sculpture at the Young Contemporaries Exhibition in 1958 and at the Coventry and Warwickshire Artists exhibition and the Belgrade Theatre two years later.[2] The Herbert Art Gallery holds two studies for the first

Wagstaffe, *Naiad*

version of the *Naiad*, and others were included in the 1984 retrospective exhibition of Wagstaffe's work at the gallery.[3]

Notes
[1] *Coventry Evening Telegraph*, 10 May 1981.
[2] Herbert Art Gallery and Museum/City of Coventry Libraries, Arts and Museums Department, *A Survey of Public Art in Coventry*, Coventry, 1980, p.67. [3] Information from Ron Clarke, Herbert Art Gallery and Museum, 19 July 2000.

*East Street*                     HILLFIELDS

*In playground of Southfields Primary School*

## *Artistic Play Structure*

### Sculptor: Daniel Cremin

Executed: 1997
Concrete base, wooden seats and table tops,
    wooden play tunnel
Seats and table tops 1.2 m high × 2m long
    approx

Condition: good
Status: not listed
Commissioned by: Southfields Community
    Action Group/Community Link/school
    governors
Owner/Custodian: Southfields Primary School

There are five tables with curved concrete bases and attached wooden seats. Nearby is a wooden play structure that resembles a series of large rubber car tyres set on end, and through which children are able to crawl.

Southfields Community Action Group was awarded £4,500 from the Arts for Everyone scheme run by the Arts Council of England to make an outdoor sculpture in a school playground in Hillfields. Marcia Jarrett, a Community Link worker and Jane Emery, a parent-governor, helped plan the project. Older pupils worked with the sculptor to design the play structure on a piece of derelict land. Parents helped with the construction. The school marked the opening of the work with a Community Sculpture and Arts Festival.[1]

Note
[1] *Coventry Citizen*, 19 September 1997.

**Cremin, *Artistic Play Structure***

*Southfields Primary School – outdoor play area*

## *Tiger Sculpture*
### Sculptor: Daniel Cremin

Unveiled: 7 November 1997
Tube: sewage pipe 2m long × 1m diameter approx
Snakes: wrought iron
Tiger: concrete, wire mesh, paint, 2m long approx
Condition: good
Status: not listed
Commissioned by: Southfields Primary School
Owner/Custodian: Southfields Primary School

The sculpture is situated on what was once a piece of derelict ground at the edge of the school's playground. The grinning tiger is lying on a tube through which children can crawl; a marble run stretches from the tiger's eyes to its tail. Various snakes also form part of the sculpture, and these too act as marble runs. The sculpture incorporates different textures over its surface and these produce different sounds when tapped. It is brightly coloured in yellow, black and white; the tube is painted blue.

The sculpture formed part of a series of events for a Community Sculpture and Arts Festival funded by the Arts for Everyone scheme.[1] The artist was briefed to create 'something imaginative and useful – maybe incorporating seating, or a climbing or playsculpture',[2] and he worked with the children over a period of time producing various drawings and clay models, before drawing up designs for the play sculpture. The sewer pipe that forms the body of the tiger was donated by a local building contractor. Health and Safety inspectors decided that the sculpture was too near a wall for children to play on, so the play sculpture is officially just a sculpture. It was unveiled by the Lord Mayor, Cllr John Mutton.

Notes
[1] Information provided by Jo Hallet, the Head of Southfields, 8 March 1999. [2] *Coventry Evening Telegraph*, 10 November 1997.

**Cremin,** *Tiger*

*Near to railway station, in foyer of Newman Building*

## *Chesspieces*
### Artist: Nicola Linford

Executed: after May 1997
Chess pieces: plastic 1.2m high approx
Condition: good
Status: not listed

Inside the entrance door are two chess pieces, a white knight on the left and a black knight on the right. At the top of the steps on the right inside the foyer are four more chess pieces – a white pawn with a smiling face inscribed upon it, a black bishop, a white queen and a black king. The floor tiles have been painted to resemble a chessboard. Against the back wall is a painted mural depicting a chess game in progress, with the inscription 'Kasparov resigns

**Linford,** *Chesspieces*

... IBM "Deep Blue" v. Kasparov 5th May 1997'. This is a very imaginative, witty and highly decorative work visible from the outside through the glass doors of the entrance. It makes an immediate and memorable impression on entering the building.

This piece commemorates the victory of an IBM 'Deep Blue' computer over Kasparov, a Russian chess grand master.

## Foleshill Road                FOLESHILL
See also *Coventry Canal*

*At roundabout*

## Coventry Blue Ribbon Sculpture ('Foleshill's Past')

### Designer: Andrew Dwyer

### Artists: Carl Fleischer and Tanya Matthews

### Builder: Andrew Langley

Executed: 1998
Steel 12m high
Condition: good
Status: not listed
Commissioned by: Groundwork Coventry
Project managed by Free Form Arts Trust
Owner/Custodian: Development Directorate,
    Coventry City Council

This is an extremely large light blue cone-shaped construction that depicts three ribbons merging into one, occupying the whole of a roundabout at the crossing of two major roads. Its spiralling form was inspired by the constant circular movement around the site, and it towers over the roundabout, making it visible from afar in all directions. Its underlying theme is the ribbon industry that used to exist in Coventry. However, the visual message it conveys is confusing because of the dilemma of conveying the significance of ribbon-making

Dwyer, *Coventry Blue Ribbon Sculpture*

and ribbons in abstract non-representational terms while using metal for suggesting the material quality of textile. This must be an irresolvable sculptural problem.

Large-scale ribbon making in Coventry was started by Major Bird who set up a works in 1705, most probably with the help of refugee French Huguenot craftsmen. By 1756 he employed some 2,000 hand loom weavers, and other manufacturers were starting up.[1] Coventry became the centre of ribbon making in the Midlands and was particularly known for the quality of its blue ribbon. An exceptionally large collection of locally-made ribbons is in the collection of the Herbert Art Gallery and Museum. The sculpture is thus intended to celebrate Foleshill's textile heritage, and aims to create a gateway that highlights the community's cultural vitality and rich local history.

Groundwork Coventry secured £20,000

from the government's single regeneration budget and £16,000 from the RETEX scheme which rejuvenates areas with textile links; additionally Coventry City Council spent £30,000 of European funding on the structure.[2] The Foleshill Environmental Action Group was also involved. During October 1997, Freeform Arts Trust ran workshops in local schools and with youth associations to develop ideas for a sculpture on this site, and a number of designs were shown to local people on the open day. The spiral form was the preferred design. Among reasons given for this were that the spiral could be seen from a distance and would symbolise hope.

Notes
[1] McGory, D., *Coventry History and Guide*, Stroud, 1993, p.80. [2] *Coventry Evening Telegraph*, 6 November 1997.

## Greyfriars Green          CITY CENTRE

## The James Starley (1830–1881) Memorial

### Artist: Joseph Whitehead and Sons

Unveiled: 8 November 1884
Plinth: granite, red and grey, 3.66m wide
Figure: Ravaccione marble, white, 1.5m high
Panels/second stage: Ravaccione marble, white,
    2m high × 96cm wide × 96cm deep
Column: granite, red and grey, 0.8m high
    approx
Overall 6m high
Inscriptions: (front panel around bust): JAMES
    STARLEY
    (rear panel: JAMES / STARLEY / 1884
    (front face of base): INVENTOR OF THE
    BICYCLE / 1870
    (left face of base): AWARDED ROYAL WARRANT
    / 1885
    (rear face of base): INVENTOR OF THE
    DIFFERENTIAL GEAR / 1877

(right face of base): FOUNDER / COVENTRY
SEWING MACHINE COMPANY / 1865
(all inscriptions are incised in serif)
Condition: fair
Status: not listed
Commissioned by: Committee for the Starley
    Memorial
Owner/Custodian: Coventry City Council

The memorial commemorates James Starley (1830–81), an early pioneer of the bicycle industry, who lived and worked in Coventry. He designed various improvements and made several modifications to bicycle design. He provided two bicycles on the order of Queen Victoria.

The memorial has a heavy four-sided base: a bust of Starley in an oval frame is on the front,

**(left) Joseph Whitehead and Sons,** *James Starley Memorial*

**(below) Joseph Whitehead and Sons,** *James Starley Memorial (detail)*

two engraved line drawings of Starley-improved cycles occupy the side panels, and the rear panel has an inscription. There are attached Corinthian columns at the corners, and pediments with small reliefs. These show a gear wheel in bronze protruding at 90 degrees from the front face; heraldic shield and emblems including the city coat of arms on the left face; the initials 'JS' on the rear face; and a deteriorated depiction of three columns on the right face. There is a further inscription on the base, which is surmounted by a column with attached shafts and a stone capital supporting a small statue of Fame personified as a female figure in classical garb, but without her traditional attribute, the trumpet. The figure only occupies a quarter of the whole height of the memorial, and is disproportionately small. This achieves the desired focus on the base and its panels, but is not a particularly successful solution. Considering that this is a portrait memorial of an early inventor and entrepreneur, it is a very conventional late nineteenth-century piece of memorial sculpture, completely lacking feelings of modernity, freedom, democracy and sexuality that became associated with cycles and cycling at the turn of the twentieth century.

The Memorial Committee was formed by men who had worked with, or known Starley. They raised the £300 cost by public subscriptions, and collections at cycleworks and sporting events.[1] The statue was damaged during the Second World War and only restored in 1979 after a long campaign by Starley's great grandson and interested locals. The statue has since suffered from vandalism. It lost both arms, one of which was once replaced in glass reinforced plastic.[2] Starley's funerary monument in Coventry Cemetery has the same portrait on its front face, designed by the same artist.

Notes
[1] Herbert Art Gallery and Museum/City of Coventry Libraries, Arts and Museums Department,

*A Survey of Public Art in Coventry*, Coventry, 1980, p.20. [2] *Coventry Evening Telegraph*, 26 April 1979, 12 July 1979 and 11 October 1979.

Source
Leith, Ian, 'The Sculpture of the Third Exchange' in Ann Saunders (ed.), *The Royal Exchange*, London Topographical Society, 1997, pp.336–48, discusses Joseph Whitehead's work in more detail.

## The Thomas White Memorial
### Artists: W.W. Wills and T.W. Wills

Unveiled: 11 October 1883
Pedestal: Cornish granite 3.05m high
Statue: Sicilian marble 2.28m high
Inscriptions: (on front face of plinth): SIR
    THOMAS WHITE
    (on rear face of plinth): 1883
Signature: (on left face of plinth): W H T WILLS /
    SCULP / LONDON
Condition: fair
Status: not listed
Commissioned by: Sir Thomas White Memorial
    Committee
Owner/Custodian: Coventry City Council

This memorial features the figure of Sir Thomas White standing on a simple plinth that is surrounded by ornate iron railings. He is depicted in mid-sixteenth-century costume with a chain of office around his neck. On a separate brick plinth in front of the work is a glass box containing an open Bible with 'Matthew XXII 21' highlighted in pink. This pedestal has a city trail plaque on it.

Sir Thomas White, who died in 1566, was a benefactor of Coventry, and several other towns and cities of England. He was the founder of St John's College, Oxford, and served as Lord Mayor of London in 1555.

A memorial committee was set up in 1878, with plans for a grand scheme, which would have included the Coventry Cross and several other statues of particular benefactors of the city, as well as emblems of the city's industries.

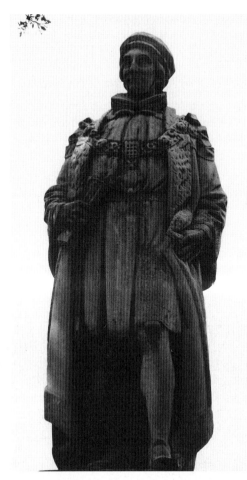

**Wills and Wills, *Thomas White Memorial***

The cost of such a grand scheme proved prohibitive, and it was scaled down to the solitary statue of White that cost £600.[1] In their estimate the Wills brothers stated that they would 'spare no pains in studying a good and pleasing likeness and the correct costume of the period'.[2] In 1883 the maquette for this work was reproduced in the *The Illustrated London News*,[3] and it was also mentioned in the October edition of *The Art Journal* that year.[4]

Notes
[1] Herbert Art Gallery and Museum/City of Coventry Libraries, Arts and Museums Department, *A Survey of Public Art in Coventry*, Coventry, 1980, p.19. [2] Herbert Art Gallery and Museum, Coventry Public Art Database. [3] *The Illustrated London News*, 20 October 1883, no.2322, vol. LXXXIII, p.381. [4] *Art Journal*, October 1883, p.379.

## *Greyfriars Lane*
*On the façade of Ford's Hospital, external walls and internal courtyard walls*

### *Ford's Hospital*
### Carver: unknown

Hospital founded: 1529
Bargeboards and panelling: wood, painted
    brown, various sizes
Condition: good
Status: not listed
Commissioned by: founders of Ford's Hospital

The timber-framed building consists of a street front and two wings which enclose a courtyard. The street front has tracery over the windows, and bargeboards carved with stylised foliage. The lintels and spandrels of all the doors are also carved, including a worn representation of a face on the left of the main entrance. Together with the early sixteenth-century carvings in 23–25 Bayley Street, Coventry, these are the best preserved and finest examples in the region of an important late medieval tradition of carved architectural decoration.

Pugin described the building as 'sufficiently decorated with proper ornaments, to relieve it from the appearance of meanness'.[1] The buildings were founded as a hospital in 1529.[2] They were bombed during the Second World War, and were restored using timber from other buildings of the period that were destroyed.

Notes
[1] Herbert Art Gallery and Museum/City of Coventry Libraries, Arts and Museums Department,

*A Survey of Public Art in Coventry*, Coventry, 1980, p.12. [2] Pevsner, N., *Public Buildings of Warwickshire*, Harmondsworth, 1966, p.268.

Unknown, *Ford's Hospital*

*Hales Street*                    CITY CENTRE

*Between Lady Herbert's Garden and Hales Street*

## Garden of International Friendship

### Artists: Dominic Scott of Robert Rummey Associates and Kate Whiteford

Opened: 23 August 2000[1]
Glass, sandstone, gravel, hedges, trees, grass,
  lavender and landscaping
Commissioned by: Coventry City Council

The Garden of International Friendship is part of Coventry's Phoenix Initiative for the regeneration of central Coventry. Visitors will eventually enter it via a glass spiral bridge that will take them over Lady Herbert's garden at treetop level (see entry for *Glass Spiral Bridge*, Millennium Place). The garden includes a viewing tower and a large red sandstone wall with 'windows' that echo the remnants of Coventry's city wall nearby. In addition there is a low semi-circular hedge maze in clipped box on white spar chippings in the northern part of the garden. Designed by Kate Whiteford, it is based on an elaborate floor tile design in which concentric rings radiate from one corner of the tile in such a way that four placed together form concentric circles. This design was often found in medieval cathedrals, including Coventry's St Mary's.[2] The concentric arcs of hedging and gravel roughly correspond with arcs in shallow relief on a gently curved wall opposite the maze across an intervening footpath. In the southern part of the garden, a sculpted triangular earth mound adjoins the viewing platform. The

Whiteford, *Garden of International Friendship*

theme of international friendship is picked out in lettering on the walls and viewing platform.[3]

Notes
[1] Phoenix Initiative Photo Library, 23 August 2000, www.coventryphoenix.org.uk/phoenix/library
[2] Robert Preece, 'UK's Million Pound Art Bonanza' in *Sculpture*, May 2000. [3] *Coventry Evening Telegraph*, 12 February 1999 and 9 June 1999.

## *Halford Lane*  WHITMORE PARK
*Whitmore Park Junior School – wall in main entrance hall*

## *Unicorn*
### Sculptor: Clifford A. Rowe

Executed: 1950
Wood, painted 2.5m × 1.2m
Condition: good
Status: not listed
Commissioned by: Coventry Education Committee
Owner/Custodian: Whitmore Park Junior School

The figure of a unicorn is mounted on a wall of the school hall with its feet balanced on the city's coat of arms. The work is in relief against an irregular shaped painted panel, and stands proud of the wall by just a few centimetres. It is built up from a series of contoured flat pieces of different woods overlaid above each other to create a strongly three-dimensional effect. It has a cheerful, fairytale-like appearance. Its colour and simplified forms give a characteristically modern feeling to the image.

The unicorn is used as the official emblem of the school.[1]

Note
[1] Information provided by Mary O'Farrell, Headteacher 18 March 1999.

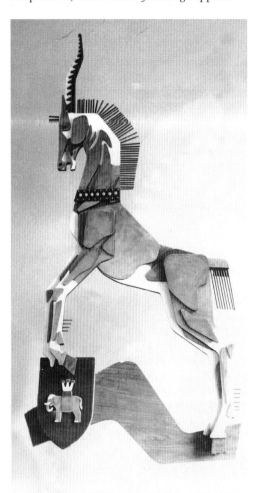

**(right)** Rowe, *Unicorn*

## *Hertford Street*  CITY CENTRE
*In shopping centre*

## *Peeping Tom*
### Sculptor: unknown

Installed: 1972
Figure: wood, painted
Base: stone 80cm wide × 1m high
Plaque: oval, 60cm wide × 30cm high approx

Inscriptions: (engraved in black on stone base):
Peeping Tom
(on an oval plaque to right of work, the text is in Roman letters, in white on a black concrete ground behind glass): Peeping Tom. In the Godiva legend Peeping Tom was a / tailor who disobeyed Lady Godiva's order to the citizens / to stay behind shutters while she made her / famous ride naked through Coventry. He looked out / and was stricken with blindness. Effigies of him were displayed in the upper windows of several buildings in / the City Centre before 1940. This figure was then on the / Railway Inn at the end of Hertford Street.
Condition: good
Status: not listed
Owner/Custodian: Coventry City Council

This sculpture of a bearded male figure, cut off above the elbows, is sited in a protective box that looks like a window, the stone base appearing as a sill. The box has the same width and depth as the abstract panel above. He is dressed in a brightly coloured uniform with a striped shirt beneath some sort of breastplate. Wearing a cap, the head of the figure is turned to the right and leans over at an angle. Its mouth is open.

The work was previously displayed above a window at the Railway Inn in Bull Yard and was moved during the redevelopment of that area. The figure's earlier history is not known, but it is thought to be related to, or possibly derived from, the full-length figure now at the Cathedral Lanes shopping centre, but with the shoulder plates of the armour shown as stripes on an undershirt, and with the head turned to the right instead of to the left. Whilst it is not known whether either of the other two copies were shown, the Hertford Street Tom does appear in a photograph of 1859 where it is obvious that the figure in an opening in Piggott's shop, next to the old King's Head Inn,

Unknown, *Peeping Tom*

## *Phoenix*
### Sculptor: George Wagstaffe

Executed: 1983 (to replace a version dated 1962)
Original: resin on metal
Replacement: bronze 2.37m high × 1.5m wide × 60cm deep
Plinth: brick with bronze plaque
Signature: (base of bronze, incised): Wagstaffe
Inscriptions: (bronze plaque set into base, engraved): THE PHOENIX / by /GEORGE WAGSTAFFE. 1962
   This sculpture which symbolises the / rebuilding of Coventry was unveiled May 1962 by / H.R.H. Princess Margaret. / Re-cast in bronze in 1983, and unveiled June 1984 / by the Right Worshipful the Lord Mayor of Coventry, / Councillor W.S. Brandish JP, re-sited here 1987.
Condition: good
Status: not listed
Commissioned by: Coventry Planning and Redevelopment Committee
Owner/Custodian: Coventry City Council

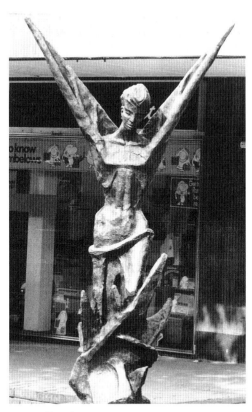

Wagstaffe, *Phoenix*

looks to the right. Earlier evidence of the display of Tom figures is found in engravings from the eighteenth and early nineteenth centuries, but these are insufficiently accurate to determine which figure is displayed.[1]

   This character of Peeping Tom is modelled on the archetypal image established by the late fifteenth-century statue; see the entry for *Peeping Tom* in Broadgate, and for details of Peeping Tom's role in the Godiva legend, see the entry for *Godiva and Peeping Tom* in Broadgate.

Note
[1] Herbert Art Gallery and Museum/City of Coventry Libraries, Arts and Museums Department, *A Survey of Public Art in Coventry*, Coventry, 1980, pp.86–7.

The traditional iconography of this mythical bird is here altered to suit the topical needs of post-war Coventry. It symbolises the young of the new city rising from the flames of the old city. In comparison with the majority of phoenix images in the post-war city, Wagstaffe's version is a very personal and complicated iconographical solution. Traditionally, a woman is used to personify a city, but Wagstaffe's Phoenix is depicted as a lithe young figure of indeterminate gender. While the lower body is shaped like a woman's, the upper body is that of a youth. The phoenix has very pointed wings raised high above the figure's head, and stands erect amongst stylised flames looking down at the viewer. The work is placed on a stepped brick base or plinth to which is attached an explanatory plaque.

   Wagstaffe was commissioned to make the sculpture as part of the planning committee's proposal to have works of art in the new precinct. Donald Gibson, the City Architect, had intended that a number of sculptural reliefs would be placed on the main blocks of the precinct, with the responsibility for their provision left to the stores that occupied them. Discussions between the occupants of this block, F.W. Woolworth, and the planning committee took place over the years 1954 to 1960. During this time the form of the work was changed to a free-standing sculpture rather than reliefs, as a result of Gibson's replacement by Arthur Ling and the conversion of Market Way back to a pedestrian area. In 1959 Alma

Ramsey was asked to submit maquettes of figure sculptures. However they were not acceptable and the matter was deferred until 1960 when George Wagstaffe submitted his scheme. The *Phoenix* was in fact his second design for the work submitted after an earlier scheme in which the concept of reconstruction, expressed as a female figure giving birth to a dove, had been rejected.

In March 1981, a report commissioned by the Director of Homes and Properties stated that the penetration of surface moisture and rising damp were causing the iron framework to corrode and flake, and subsequent expansion of the metal distorted and fractured the resin. The report concluded that the condition was dangerous and that the work could only be satisfactorily preserved by being re-cast in a more durable material, preferably by the artist or in consultation with him,[1] and so it was recast in bronze.

Studies for the *Phoenix* were included in Wagstaffe's retrospective exhibition at the Herbert Art Gallery in 1984. The gallery also holds several maquettes for the first and second versions of the statue.[2]

Notes
[1] Director of Homes and Properties, Coventry, *Condition Report*, 1981. [2] Herbert Art Gallery and Museum, *George Wagstaffe, Drawings and Sculpture 1960–84*, exhibition catalogue, Coventry, 1984.

*Broadgate House, facing Hertford Street*

## The People of Coventry

### Sculptor: Trevor Tennant

Installed: January 1953
Each group: Doulting stone 3m high × 91cm wide × 46cm deep
Condition: fair
Status: not listed
Commissioned by: Coventry Planning and Redevelopment Committee

Owner/Custodian: Coventry City Council

Each of the four panels placed between the windows of the former Bridge Restaurant shows two standing figures depicting Coventry past, present and future. According to Tennant, two male figures personify planning and working; two figures, male and female, holding an infant, personify the family; two other figures, male and female, personify creative maturity; and two female figures personify youth and vitality.[1]

The figures are treated in a heavy, massive manner that emphasises the bulk and size of the blocks of stone from which they were carved. The simplified carving of the faces and the massive treatment of bodies, perhaps derived from Mexican, or possibly Cycladic sculpture, relate the figures, although not free-standing, to Henry Moore's figure groups of the 1930s and 1940s.[2] The representation of *The Family* in particular shows a similar treatment to Moore's alabaster *Madonna and Child* for the Church of St Matthew, Northampton.

The decision to commission Trevor Tennant to undertake this sculptural work was taken by the City Council Planning and Redevelopment Committee on 24 October 1949, on the recommendation of Donald Gibson.[3] Tennant's designs for the sculpture were submitted in person on 8 November 1950.[4] The first panel was lifted into place on 28 January 1953 and Tennant was expected to return to Coventry within a fortnight to complete the work.[5]

In concept the siting of the figure panels is effective, conveying a sense of integration between architecture and sculpture. However, Tennant was unhappy with the original siting of this work – he saw it as being placed too far from the people it addressed. When Broadgate House was first completed, the figures surmounted the bridge over Hertford Street, which was then in regular use by traffic. The precinct was so successful that it was decided to

pedestrianise Hertford Street, leaving the bridge redundant. Bank premises were built in its place, with the effect that from ground level only two sets of Tennant's figures can be seen, one at each side of the building. The only place the sculpture can be seen in its entirety is from the balcony of a shop, which is not accessible to the public. With the added distraction of trees

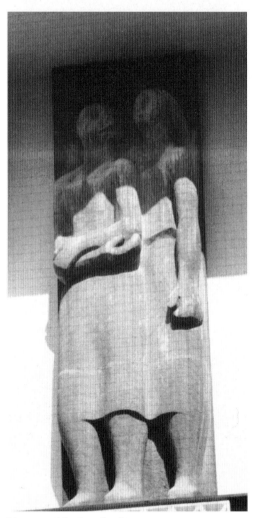

Tennant, *The People of Coventry*

and lights, few people are aware of its presence at all. The intended meaning is, therefore, subverted by its present context.

Notes
[1] Wood, G., *Public Sculpture in Coventry. A Selected Critique*, unpublished BA dissertation, Coventry (Lanchester) Polytechnic, 1986. [2] Herbert Art Gallery and Museum/City of Coventry Libraries, Arts and Museums Department, *A Survey of Public Art in Coventry*, Coventry, 1980, p.47. [3] Coventry City Council Records, Minutes of the Planning and Redevelopment Committee, 24 October 1949. [4] *Ibid.*, 8 November 1950. [5] *Coventry Evening Telegraph*, 28 January 1953.

*On west side of façade, at first-floor level above shops*

## Untitled Panels
### Sculptor: William George Mitchell

Installed: 1967–9
Each panel: fibreglass and bronze powder
   27.5m high × 70cm wide × 25cm deep approx
Condition: fair
Status: not listed
Commissioned by: W.S. Hattrell and Partners
   (architects)

Sited between the windows at first floor level above the shops along the length of the west

**Mitchell,** *Untitled Panels*

side of Hertford Street, this series of 54 panels is in shallow relief. It appears that only one abstract design has been used, each alternate panel being rotated 180 degrees, to provide a sense of rhythm and continuity to the scheme. The panels were moulded in fibreglass and given the appearance of cast bronze by the addition of bronze powder to the mixture. The size of the panels, in both height and depth, causes them to dominate the upper parts of the buildings and creates a unified appearance in contrast to the necessary differentiation in the shop façades beneath. Unfortunately any view of the panels is obscured by a glass overhang directly beneath them.

The panels were installed in two groups, the first in 1967 and the second in 1969, each group costing approximately £3,000.[1] They play an important part in the design of the building. It is unfortunate that this is not recognised now,

as several panels have been disfigured by the addition of surveillance cameras, alarm boxes and warning signs.

Note
[1] Herbert Art Gallery and Museum/City of Coventry Libraries, Arts and Museums Department, *A Survey of Public Art in Coventry*, Coventry, 1980, p.82.

## High Street     CITY CENTRE

*On the façade of National Westminster Bank*

## National Westminster Bank: Symbols of Industry
### Architects: F.C.R. Palmer and W.F.C. Holden
### Sculptor: G. & A. Brown

**Brown,** *Symbols of Industry*

## Metal workers: Birmingham Guild of Handicrafts and Mr Pearson

Executed: 1930
Each roundel: Portland stone 40cm diameter approx
Entrance doors: nickel chromium steel 3m high × 2.2m wide approx
Condition: good
Status: not listed
Commissioned by: National Westminster Bank
Owner/Custodian: National Westminster Bank

The main entrance portico of the bank features Tuscan columns and metopes showing circular symbols based on coins that are decorating the architrave. The symbols depicted include mythological emblems. Two further roundels between the pairs of windows arranged vertically on either side of the entrance door display representations of a watch escapement and a sparking plug, symbols of Coventry's industries. Further similar roundels are found between the windows of the Hertford Street façade and feature a hypoid gear, a crankshaft and pistons, a screw jack, a vice and tap.

The silver-coloured entrance doors contain a number of panels, each with a studded border containing a relief based on one of the metopes. The doors are four panels wide by five panels high with four additional panels inside the recess, jointed to concertina back when open. While there are many ornate wrought iron gates in stately homes and public buildings throughout Warwickshire, these are the only doors in the West Midlands to follow the great European tradition of grand doors incorporating sculptural reliefs. (The gate of the Jewellery Business Centre in the Jewellery Quarter in Birmingham is only an ornamental device, which does not open or shut.[1]) The sculptural reliefs are based on Egyptian, Assyrian and ancient Greek motifs. The overall meaning of this complex iconographical programme is obscure, but there are clear references to the arts and industry. Two of the reliefs show Hercules performing his labours (the killing of the Nemean lion and the killing of the serpent), while another is of St George

Holden, *National Westminster Bank door*

Holden, *National Westminster Bank door (detail)*

killing the dragon. Two other reliefs depict the lyre and the tripod of Apollo, god of the arts. There is a smaller pair of similar doors at the side entrance.

The architects designed both the exterior and interior of the building and all the furnishings. The entrance doors were designed by Holden, and made by Mr Pearson of the Birmingham Guild who chased the reliefs on the panels.[2]

Notes
[1] Noszlopy, George T., *Public Sculpture of Birmingham*, Liverpool, 1998, p.121. [2] Herbert Art Gallery and Museum/City of Coventry Libraries, Arts and Museums Department, *A Survey of Public Art in Coventry*, Coventry, 1980, p.30.

## Lloyds Bank Emblem and Allegorical Figures

### Sculptor: unknown

### Architect: Buckland and Haywood

Executed: 1932
Portland stone 2.2m high × 3.4m wide approx
Condition: good
Status: not listed
Commissioned by: Lloyds Bank
Owner/Custodian: Lloyds Bank

The main façade is dominated by a large arched opening that encloses the doorway and its tympanum, which features a high relief of the coat of arms of the bank with two supporting seated male nude figures, one holding a bunch of keys and the other a ship. They probably personify Security and Commerce. A swag is draped beneath the coat of arms and is held by both supporters. These figures have been given a heavy massive treatment and block-like form, conforming to the neo-classicist style which was fashionable during the 1920s and 1930s all over Europe.

The tympanum was probably designed by the architects for this purpose-built building.

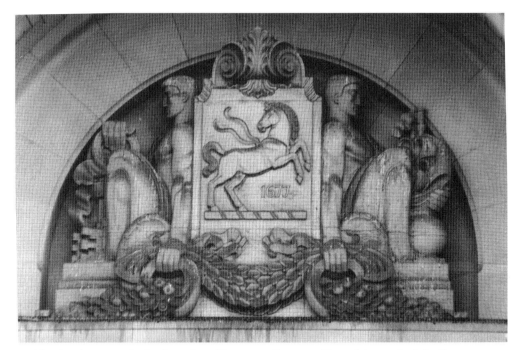

Buckland and Hayward, *Lloyds Bank Emblem and Allegorical Figures*

## Hill Street                    CITY CENTRE

*Bond's Hospital/Bablake School*

## Coats of Arms

### Carver: unknown

Executed: 1832[1]
Sandstone, smaller shields 20cm high approx, central shield 30cm high approx
Condition: poor
Status: Grade II*
Commissioned by: Bond's Hospital

This large entrance gate has three shields over the archway. The central shield shows the Coventry Coat of Arms, the left a lion or dragon-like creature, the right a chequered chevron and stars. The gate has quatrefoil motifs at the corners. The two timber-framed buildings are from three sides of a courtyard, with the oldest extant secular building, Bablake School, on the east side. Bond's hospital has the most elaborate carvings. The carved bargeboards on the buildings depict stylised foliage, masks and small figures. Tracery forms are used on the windows and bargeboards.

A considerable amount of restoration work was undertaken in the 1830s and 1840s when the west end of the building was largely rebuilt, at which point the woodwork was restored.[2]

Notes
[1] Pevsner, N., *Public Buildings of Warwickshire*, Harmondsworth, 1966, p.267. [2] Herbert Art Gallery and Museum/City of Coventry Libraries, Arts and Museums Department, *A Survey of Public Art in Coventry*, Coventry, 1980, p.11.

**Unknown,** *Coats of Arms*

*Holbrooks Lane*     HOLBROOKS

*St Paul's Cemetery*

## Tom Farndon Memorial
### Artist: Richard Ormerod

Executed: 1935
Sculpture: black granite 1.22m high × 25cm
    wide × 55cm deep
Signature: (bottom of wheel): R.Ormerod
Inscription: My dear husband / Tom Farndon, /
    National Speedway/ Champion / 1934–5. /
    Died August 30th 1935. /
    Aged 24 years.
Condition: good
Status: not listed
Commissioned by: Mrs Farndon, wife of
    subject
Owner/Custodian: St Paul's Cemetery

This memorial is in the form of a streamlined
motorcycle and rider mounted on an irregularly
shaped base. Structure, form and surface are
here manipulated to convey the dynamism of
speed, light and freedom. Rider and machine are
fully united, like a twentieth-century centaur.
At one with his machine, the rider enjoys a

thoroughly modern Futuristic experience of
liberty and speed.

Tom Farndon (1911–35) was a Coventry-
born motorcycle speedway rider who rapidly
achieved championship status, and was killed in
a practice run in the Star National Speedway
Championship final in 1935. At the time of his
death he was considered the best English
speedway rider.

The sculptor, Richard Ormerod, who also
designed the Jaguar motif (see *Jaguar*, Bankside
Lane), had a long-standing interest in
motorcycles, having started his career as a
motorcycle builder. He had met Tom Farndon
and was approached by his widow to design
this commemorative monument. In 1936
Ormerod showed a half-size model of the
Farndon Memorial at the Coventry and
Warwickshire Annual Art Exhibition.[1]

Note
[1] Herbert Art Gallery and Museum/City of
Coventry Libraries, Arts and Museums Department,
*A Survey of Public Art in Coventry*, Coventry, 1980,
p.34.

**Ormerod,** *Tom Farndon Memorial*

*Jordan Well*     CITY CENTRE
*On south wall of Herbert Art Gallery and
Museum*

## City of Coventry Coat of Arms
### Sculptor: John Poole

Executed: 1960
Stone 2m high × 3m wide approx
Condition: good
Status: not listed
Commissioned by: Coventry City Council
Owner/Custodian: Coventry City Council

The Coventry City Coat of Arms shield depicts
an elephant with three towers upon its back.
This is surmounted by a knight's helmet with
the visor closed, on top of which a wild cat is
standing. On either side of the shield are
supporters: on the left an eagle, on the right
side, a phoenix rising from the flames. The
motto below reads 'CAMERA PRINCIPIS'.

The elephant is seen as both a symbol of
strength (because he can carry a tower) and as a
dragon slayer. In the early seals of Coventry,

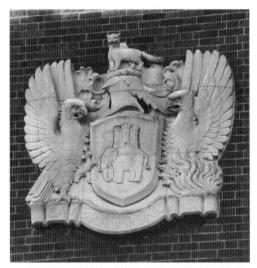
**Poole,** *Coventry Coat of Arms*

from which the coat of arms derives, the combat between the archangel Michael and the dragon is shown on one side, and, on the other, the elephant and castle. The wild cat symbolises watchfulness, while the eagle of Leofric (husband of Lady Godiva) represents the ancient Coventry. The phoenix rising from the flames represents the new Coventry born out of the ashes of the old.[1]

The work was intended to be painted.[2]

Notes
[1] CWN, News and Information for Coventry and Warwickshire, www.coventry.org.uk/heritage2/history/coventry_coat_of_arms1.htm [2] Herbert Art Gallery and Museum, City of Coventry Libraries, Arts and Museums Department, *A Survey of Public Art in Coventry*, Coventry, 1980.

*Outside Herbert Art Gallery*

# Elizabeth Frink
## Sculptor: F.E. McWilliam

Executed: 1956
Bronze 1.83m high × 59cm wide × 46cm deep
Signature: (stamped): McW 2
Condition: good
Status: not listed
Commissioned by: Herbert Art Gallery and Museum
Owner/Custodian: Herbert Art Gallery and Museum

This full-length female figure in bronze depicts Dame Elizabeth Frink, (1930–92) in a simplified yet realistic style, and is an excellent but uncharacteristic work of a sculptor who is best known for her abstract imagery. The figure was probably conceived as a tribute to Elizabeth Frink, in a style which closely resembles the subject's own modelling. McWilliam has thus been able to capture something of the character as well as the likeness of his subject. At its present site, the figure is standing on a very narrow plinth at ground level, exploring and

affirming its informal surroundings.

The sculpture was made in 1956 and first cast for the Harlow New Town open air display. This second cast was commissioned through Waddington Galleries and was cast in 1965. It was shown in the major 'Metamorphosis' exhibition at the Herbert Art

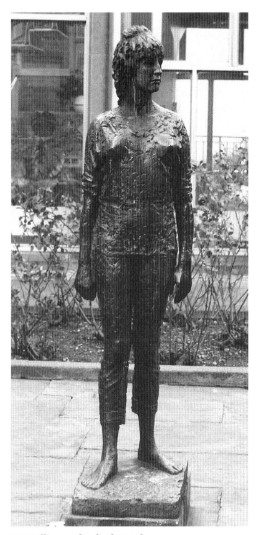

McWilliam, *Elizabeth Frink*

Gallery in 1966 and was then placed for permanent display outside the gallery.[1]

Note
[1] Herbert Art Gallery and Museum/City of Coventry Libraries, Arts and Museums Department, *A Survey of Public Art in Coventry*, Coventry, 1980, p.76.

Sources
Waddington Galleries, *F.E. McWilliam 1909–1992*, exhibition catalogue, London, 1963; Gooding, Mel, *McWilliam, F.E.: sculpture 1932–1989*, London, Tate Gallery, 1989.

*South wall, exterior of Herbert Art Gallery and Museum*

# Man's Struggle
## Sculptor: Walter Ritchie
## Architects: Donald Gibson and W.S. Hattrell & Partners

Unveiled: 22 August 1959
Installed at present site: 1994
Each relief: Portland stone, background painted with red Arpax, 4.13m square
Condition: good
Status: not listed
Commissioned by: Coventry Planning and Redevelopment Committee
Owner/Custodian: Coventry City Council

The two panels are carved in relief with the ground painted red, partly for compositional reasons and also as protection for the stone.

The panel on the right, entitled *Man's Struggle to Control the World Outside Himself*, is dominated by the image of a wild horse with a figure of a man trying to restrain it. The image is treated in a similar way to Boccioni's painting *The City Rises*, with the imagery intended to convey the idea of man striving to control the natural world. The rest of the panel is made up of smaller images representing this struggle in terms of everyday life: coal-miners drilling

before planting a charge; a trawlerman in a storm; a builder climbing a ladder; a surgeon performing an operation; a man carrying a sack; a gardener; the hands of a textile operative; a woman reading Braille, with a representation of an eye above her; a developing foetus exposed to radiation; the pattern of shock waves made by a rocket travelling at supersonic speed; images of blood cells and the virus of the common cold; and a plant and magnified cell in the process of division. The red ground is used solely behind the horse and accompanying figure, which range diagonally across the composition. This panel was originally sited on the north abutment of the precinct bridge.

The panel on the left, entitled *Man's Struggle to Control the World Inside Himself*, originally sited on the south abutment, is a more elaborate image with the central portion surrounded by smaller groups. The imagery is also more complex, depicting the inside of a man's brain containing the Past moving into the Future, and the fight between good and evil, represented by a man and a three-headed serpent respectively. The surrounding scenes refer to the influences brought to bear on the mind, scenes relating to the Creation and the many roles of woman in her relationship with man. The main image is surrounded by smaller images including God's creation of Adam; the legend of Prometheus; the Good Samaritan bandaging a man's head; a man playing a violin representing music; Hamlet thinking about Death; a male nude lying in a small boat gazing upwards, from D.H. Lawrence's 'Ship of Death'; a hybrid winged figure with the head and torso of a woman, a horse's front legs, claws and a tail – a traditional representation of woman symbolising the many roles she plays in her relationship with man; and a winged figure of Cupid shooting an arrow. Ritchie's report to the Planning and Development Committee describes the background episodes in relative detail. He described his intentions as follows:

Ritchie, *Man's Struggle (detail)*

Ritchie, *Man's Struggle (detail)*

Man's mind is opened to reveal his thoughts and the Past is shown moving through his mind and on into the Future. Man is pointing to the present moment when Past becomes Future and round which is a fight between his Good and Evil natures. As long as Good wins this fight Man has a future of unlimited growth, but if Evil wins, there will be no Future. In the background are represented some of the ideas conceived by Man to help him in the fight. Genesis in the bottom right corner suggests direct responsibility to a personal God who may intercede in earthly affairs. The hand of God is creating Adam, beginning with the pelvis and hip joint and the bones and flesh are shown growing into the complete man. Prometheus suggests the antithesis of the first scene – the attitude of the man of free will and confident of achieving immortality by his own forces and capable of desperate endurance. Hamlet is shown comtemplating Death and symbolises Man's search for philosophy. The Christian ethic is

summarised by the Good Samaritan – a Black Man bandaging a White Man. Music is represented by a violinist. The man in a small boat in a raging sea derives from D.H. Lawrence's poem 'The Ship of Death' – 'Launch out the fragile soul in the fragile ship of courage'. Some of the many ways Women may influence Man are suggested in the top right corner – 'The Woman in all Tales'. Venus directing Cupid's aim, winged to demonstrate her power to inspire, the tail of a lioness to indicate her strength. Over her head is the moon symbol of Diana the huntress and she will no doubt find the talons with which she has been provided very useful.[1]

The plan to have panels of relief carving on the abutments of the bridge in the precinct was included in City Architect Donald Gibson's early plans for the new area and panels were shown *in situ* on the model in 1947. Walter Ritchie was asked to submit designs for panels in 1954 and began work that year. His choice of

themes for the two panels was approved in principle by the Planning and Redevelopment Committee on 23 June 1954,[2] and the designs were finally approved on 10 November that year. The design for the first of the panels to be installed (*Man's Struggle to Control the World Inside Himself*) differed from the final work in that the positions of the *Creation* and the *Good Samaritan* were reversed, the representation of Hamlet was different and written quotations were included. The Creation was accompanied by the words of Gerard Manley Hopkins, 'Thou hast bound bones and veins in me, fastened me flesh'; Prometheus by words from Byron's poem 'Prometheus', 'Thy God-like crime was to be kind, and strengthen Man with his own mind'; Hamlet by Shakespeare's words, 'I will find where Truth is hid, though it were hid indeed within the centre'; the violinist by Edna Hampson's words, 'Music, mutation of joy and pain on whole wings we seek the Infinite'; Lawrence's 'Ship of Death' by his words, 'Launch out the fragile soul in the fragile ship of courage'; the Good Samaritan by Ritchie's own paraphrase of the New Testament story; the representation of woman by Swinburne's words, 'I am found the woman in all tales'.[3] The panel was installed unpainted on the Precinct Bridge on 14 May 1957, but by October 1958 Ritchie had to remove two sections for recarving because they had been damaged by a water and salt solution leaking from the bridge on to the stone. He then applied a silicon solution to the whole sculpture to prevent repetition of the damage. Workmen were by this time putting up his second panel on the opposite abutment of the bridge.[4]

Both panels had been carved in Ritchie's Kenilworth studio and brought to Coventry in sections. They were officially unveiled by the Lord Mayor of Coventry, Alderman W.H. Edwards, and after the ceremony Ritchie told the press, 'When I first submitted the drawings they attracted a certain amount of controversy,

but no-one has criticised lately. I modified one panel slightly, but not because of the criticism.' He added that he would have preferred the panels to be erected in a different setting, away from the overshadowing bridge. The work was praised by many of the people who attended the unveiling, though some were confused as to its meaning. One said, 'I would like a notice nearby to show what the sculpture means'.[5] Ritchie opted not to include an explanatory notice near the panels,[6] but the reliefs are now accompanied by an explanatory plaque.

Notes
[1] *Coventry Evening Telegraph*, 10 November 1954. [2] Coventry City Council Records, Minutes of Planning and Redevelopment Committee, 28 June 1954. [3] *Coventry Evening Telegraph*, 11 November 1954. [4] *Ibid.*, 29 October 1958. [5] *Ibid.*, 22 August 1959. [6] Coventry City Council Records, Minutes of Planning and Redevelopment Committee, 9 September 1959.

Sources
Ritchie, W., *Walter Ritchie: Sculpture*, Kenilworth, 1994; Ritchie, W., *Sculpture in Brick and Other Materials*, Kenilworth, 1979.

*East wall of Herbert Art Gallery and Museum*

## Painting, Archaeology, Sculpture, and Natural History
### Architect: Albert Herbert & Son

Unveiled: 9 March 1960
Each relief: stone 2m high × 3m wide
Condition: good
Status: not listed
Funded by: estate of Sir Alfred Herbert
Owner/Custodian: Herbert Art Gallery and Museum

These panels represent aspects of the collection of the Herbert Art Gallery and Museum; painting, archaeology, sculpture and natural history, with elements of the City coat of arms

Albert Herbert & Son, *Painting*

Albert Herbert & Son, *Archaeology*

Albert Herbert & Son, *Elements from the City Coat of Arms*

in the centre. They are carved in a schematic style with simple imagery. Set high up on an otherwise blank east wall, they serve to identify the building and its function.

The models for the proposed sculpted reliefs were submitted to the Libraries and Museums

Committee for approval on 13 February 1957, when the architects suggested that there should be five sculpted reliefs depicting painting, sculpture, archaeology, and natural history, with the City coat of arms in the centre. The proposal was approved.[1] The architects were related to Sir Alfred Herbert who donated the funds to establish the gallery. On 8 April 1959, it was agreed that his widow, Lady Herbert, would perform the opening ceremony.[2]

There is also a coat of arms on the south wall of the lecture theatre. This is a later addition.

Notes
[1] Coventry City Council Records, Minutes of Libraries, Art Gallery and Museums Committee, 13 February 1957. [2] *Ibid.*, 8 April 1959

*Peace Garden – outside the Estates Office*

## Mother and Children
### Sculptor: Gary Galpin

Executed:1986
Bath stone 1.8m high
Condition: fair
Status: not listed
Commissioned by: Coventry City Council
Owner/Custodian: Coventry City Council

The mother holds the hand of one child, who in turn holds the hand of the next. The children encircle the mother. The sculpture bears the marks of the sculptor's chisel.

The sculpture was re-sited when work began on the West Orchards shopping centre. The work was one of the winners of a competition run by the Council, the result of which was to give four students from Coventry College of Art the opportunity to have their work displayed in the City. The work cost £300.[1]

Note
[1] Herbert Art Gallery and Museum, Coventry Public Art Database.

**Galpin,** *Mother and Children*

## The Enfolding
### Sculptor: Jean Parker

Executed: 1985
Bath stone 1.8m high
Inscription: (plaque on base): This statue / formerly in Smithford Way/ was relocated in this Peace Garden/ On 14th November 1990/ In recognition of Coventry's Commitment/ to international friendship/ and reconciliation.
Condition: fair
Status: not listed
Commissioned by: Coventry City Council
Owner/Custodian: Coventry City Council

**Parker,** *The Enfolding*

This sculpture depicts two figures of undefined gender partially moulded together in an embrace.

The work, which was re-sited due to redevelopment, was one of the prize winners of a competition organised by the Coventry Council to give students the opportunity to display their work in a public space.[1] It cost £300.

Note
[1] *Coventry Evening Telegraph*, 25 April 1985.

## Kenilworth Road      STIVICHALL

*War Memorial Park – behind the bowling green*

### Emergency

**Sculptor: Anne Best**

Unveiled: 1 October 1993
Trenches: brick-lined 5.1m long × 1.5m wide
Condition: good
Status: not listed
Commissioned by: West Midlands Arts
Owner/Custodian: Coventry City Council

This work comprises brick-lined trenches, laid with gravel and covered with grilles, under which are sets of keys that cannot be recovered. Entitled *Emergency*, the work seeks to convey the lack of personal safety felt by women within our cities and the ensuing curtailment of their freedom. The materials used were meant to be evocative of the bricks, concrete and subways that are features of Coventry life.[1]

A booklet stating its aims was produced after completion of the project, which was started as a community arts endeavour to enable women to learn and use traditionally non-feminine skills, the outcome of which should be a piece of public sculpture. Anne Best, a professional sculptor who had graduated from Coventry University, was appointed to create and oversee the work with an art group of 17 other women. Funded by West Midlands Arts and many other sources, this work cost £4,000, and caused a public outcry. Letters to the local newspaper claimed that the work was a complete waste of money. No one knew the source of the funding and it was widely presumed that the Council had paid for it. Opinions were canvassed from passers-by,[2] but more claims were made that the work had taken money away from the public purse. The participating art group countered that the money had been brought into the City by attracting sponsorship that would otherwise have gone elsewhere in the country. They stressed the learning of skills for Coventry people,[3] but debate continued in much the same vein.[4]

Best, *Emergency*

Notes
[1] Herbert Art Gallery and Museum, Coventry Public Art Database. [2] *Coventry Evening Telegraph*, 11 Oct 1993. [3] *Ibid.*, 16 Oct 1993. [4] *Ibid.*, 18 Oct 1993, 20 Oct 1993, 27 Oct 1993, and 29 June 1994.

*War Memorial Park – outside tennis pavilion*

### Poppies

**Sculptor: John Wakefield**
**Designer: Katie-Jane Wakefield**

Executed: after 1990
Cedar tree stump 3.6m high approx
Condition: good
Status: not listed
Commissioned by: Coventry City Council officers
Owner/Custodian: Coventry City Council

This work was carved from the stump of a dying cedar tree, which has its natural bark covering on the lower section. The upper section has been stripped of its bark and shaped into a rectangular shaft, the front face of whch has been carved into three giant poppies and their leaves.

The work is intended as a memorial to two Coventry soldiers killed in the Gulf War, Fusiliers Lee Thompson and Jason McFadden, Royal Corps of Transport. The men, both aged 19, were killed when their transporters were hit by gunfire from US fighter planes days before the end of the war.[1]

The tree was amongst an avenue of cedars planted after the First World War in memory of local people, and was irreversibly damaged in 1990.

Note
[1] *Coventry Evening Telegraph*, 8 Oct 1997.

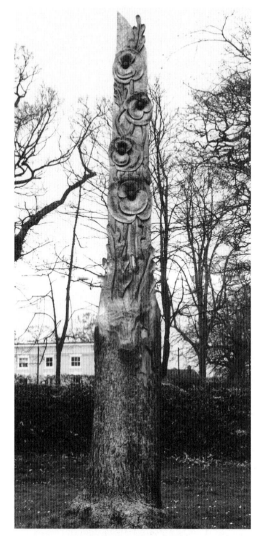

**John and Katie-Jane Wakefield,** *Poppies*

## War Memorial Park

### *The Cenotaph*

### Architects: T.F. Tickner and T.R.J. Meakin and Son

Dedicated: 8 October 1927 (re-dedicated 1947)
Portland stone 26.5m high
Condition: fair

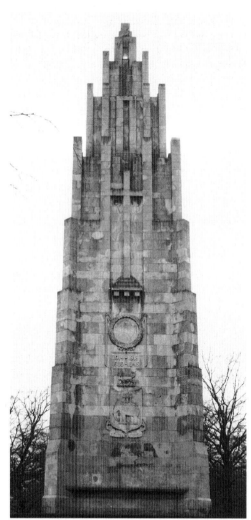

**Tickner,** *Cenotaph*

Status: not listed
Commissioned by: Coventry War Memorial
    General Committee
Owner/Custodian: Coventry City Council

The cenotaph is a tall square structure with stepped angled buttresses and two recessed upper stages, each with tall pilasters rising above the top of each stage as square pinnacles, and an irregular shaped top pinnacle. A cross is depicted above the carved stone wreath and the City coat of arms on the front face with a second cross on the opposite face. On one of the remaining faces, a pair of doors opens into an inner chamber in which is kept the Roll of Honour. The bronze doors to the inner chamber incorporate the dates of World War Two.

The Coventry memorial for the First World War was originally opened in 1921 in the form of a public park. In 1923 plans were made for 38 acres of the park to be made into ornamental grounds, with a monument at the centre. One of 16 entries for a competition to design the monument, Tickner's design was selected by William Haywood, LRIBA on behalf of the Coventry Society of Architects. The design was published in the *Coventry Herald* on 22 May 1924 and an appeal for funds followed in the September of that year.[1] Tickner died in 1924 and Meakin and Son took over his practice, building the monument to the same designs. It was dedicated by Field-Marshall Earl Haig, and re-dedicated by Lord Montgomery of Alamein for the Second World War.[2]

Notes
[1] *Coventry Herald*, 22 May 1924, 20 September 1924. [2] Clarke, Ron, *A Survey of Public Art in Coventry*, Coventry, 1980, p.28.

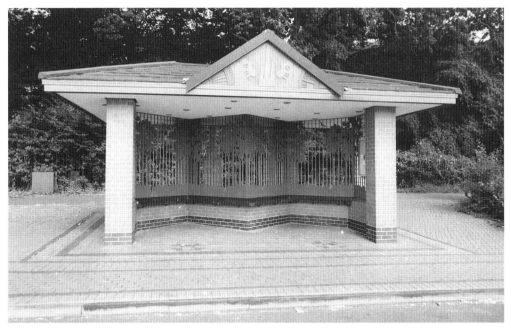

*War Memorial Park*

## Bus Boarding Point

### Designer: John McKenna

Executed: late 1990s
Brick with steel reliefs 3.5m high × 4.5m wide
   approx
Condition: good
Status: not listed
Commissioned by: Coventry City Council
Owner/Custodian: Coventry City Council

This work includes a large paved section, cycle stands and site bollards as well as the bus shelter itself. The local community was involved in the design of the artwork through Arts Exchange, a local community arts group. The design reflects the immediate environment of the park: the trees on the decorative screen echo those in the park, while the shape in the centre of the triangular gable recalls the three spires of Coventry cathedral. The cog to the left and the

**McKenna,** *Bus Boarding Point*

section of a clock face to the right of this motif remind the viewer of the local engineering and watch-making industries.[1]

Note
[1] John McKenna: Art for Architecture website: a4a.clara.net/a4a.htm

## Lamb Street     CITY CENTRE

*Beside city wall*

## Untitled

### Sculptor: John Bridgeman

Installed: September 1973
Sculpture: resin, bronze powder 2.19m high ×
   65cm wide × 30cm deep
Pedestal: concrete 26cm high × 1.12m wide ×
   94cm deep

Condition: poor
Status: not listed
Owner/Custodian: Coventry City Council

This organically shaped abstract sculpture is coloured in muted tones. Near the base, its texture suggests the graining of wood. Combined with its phallic form and the organic shapes that are shown as if moving up and over it, this creates a feeling of the surging of new life.

   John Bridgeman also created an imposing sculpture of the Madonna, now sited in Coventry Cathedral.

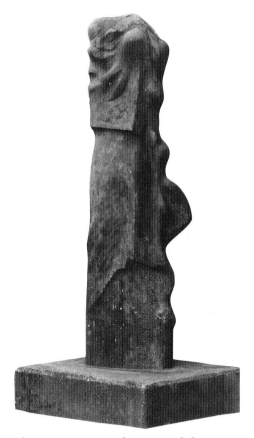

**Bridgeman,** *Organic Sculpture (untitled)*

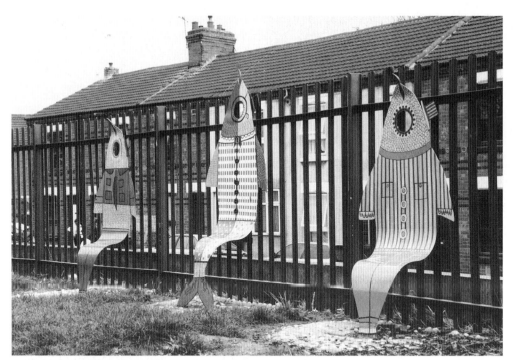

*Leicester Causeway*
BISHOPGATE GREEN

## Fish Seats

### Sculptor: Kate Turner of Arts Exchange

Installed: March 1997
Rolled metal painted with enamel, 2m high ×
    70m wide approx
Condition: good
Status: not listed
Commissioned by: City Development
    Directorate, Coventry City Council
Owner/Custodian: City Development
    Directorate, Coventry City Council

Three rolled metal and enamel painted seats in
the shape of fish have a colourful and playful
appearance. The sculptor was helped by the
children of Eagle Street Play Centre.

**Turner,** *Fish Seats*

## *Waterwall*

### Sculptors: Kate Turner, Tim Pryke, Dave Cooper and Lizzie Murphy of Art Exchange

Executed: 1995
Ceramic mosaic panels of varying sizes
    embedded in cement
Condition: fair
Status: not listed
Commissioned by: Groundwork Coventry
Owner/Custodian: City Development
    Directorate, Coventry City Council

A series of mosaic reliefs on the wall along the
side of the road depicts scenes from life on the
canal: barges filled with people feature
prominently, though only the heads and hands
of those on board can be seen; a bicycle and the
legs of those walking along the towpath and
wildlife living on or beside the canal, including
swans, ducks and dragonflies. All the reliefs
have been made in a naïve style in keeping with
the popular art of the barge men themselves.
The artists were assisted by members of the
local community.

**Turner et al.,** *Waterwall*

## *London Road* CHEYLESMORE

*London Road Cemetery*

### *Funerary Chapel*
### Architect: Joseph Paxton

Executed: 1840s
Brick, dressed in stone
Sculptural ornaments of varying sizes
Condition: good
Status: Grade II
Commissioned by: Coventry Borough Council
Owner/Custodian: Coventry City Council

This richly carved mid-nineteenth-century chapel is built in the Norman style, with a tower and pyramid roof. Overall, the proportions of the building are squat. Two Corinthian columns support arches decorated with a zigzag pattern above both the main entrance and the windows at ground floor level. There is a carved head above the keystone of the arch over the main entrance. Above this, a row of animals' heads and gargoyles separates the lower level from the higher reaches of the tower which, like the main body of the chapel, ends in a pyramid roof. At one end of the

(above left) Paxton, *Pelican, Funerary Chapel*

(above right) Paxton, *Holy Lamb, Funerary Chapel*

chapel there is a rose window with elaborate sculptural decoration. Unfortunately, many of the glass panes have been smashed. To each side of it are small roundels of the Lamb of God and a pelican feeding her chicks.

### *The Paxton Memorial*
### Sculptor: Samuel Barfield
### Architect: Joseph Goddard and Son

Executed: 1867–70
Column: Portland stone 12m high
Small shafts: granite, pink
Cross: ironwork
Plinth: 5m high × 5m wide
Inscription: (on base): Sir Joseph Paxton. Died
    8th June 1865
Condition: fair
Status: Grade II
Commissioned by: Paxton Memorial
    Committee
Owner/Custodian: Coventry City Council

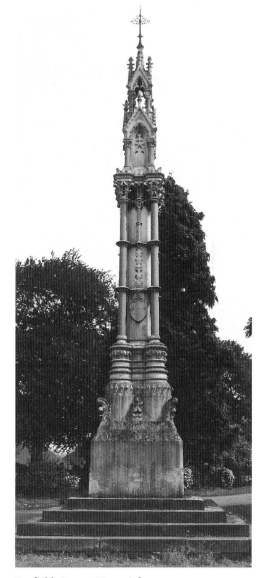

Barfield, *Paxton Memorial*

Goddard's grand design is purely architectural and does not feature a portrait or any figurative element. This Gothic Revival memorial is formed by a tall Portland stone column, with shafts in pink granite attached by annulets that support a double tier of niches with crocketed gables on small shafts. The whole is topped with an iron cross. The capitals and sculptural decoration are also of Portland stone and have the crispness and precision that characterises this neo-Gothic style and generally medievalising period.

Sir Joseph Paxton (d.1865) started his career as a landscape gardener and architect. In 1845, he was commissioned by the Corporation to transform the London Road cemetery from a disused stone quarry. He sought to produce something which had 'more of the air of a gentleman's park than of a city of the dead'.[1] He was twice knighted, by the Emperor of Russia at Chatsworth, and by Queen Victoria, for his work planning the Great Exhibition of 1851. He was Coventry's MP for ten years.

As Paxton is not buried here, the memorial monument is intended to be commemorative rather than funerary, a fact made obvious by its siting opposite the original main entrance, which is clearly visible from the main road. It was erected within five years of his death by a committee formed for the purpose under the chairmanship of John Gulson, which held a competition to choose a design for the memorial.

There was debate in the local press as to whether Paxton deserved a memorial, in the light of the fact that Sir Thomas White had benefited the city more in his representation of Coventry.[2]

Notes
[1] 'Paxton Memorial', *Builder*, vol.xx, 24 May 1862.
[2] *Coventry Standard*, 15 September 1865.

## *Tomb of James Starley*
### Architect: Joseph Whitehead and Sons

Executed: *c*.1881
Stone 2.4m high
Inscribed: (on top slab): JAMES STARLEY
Condition: good
Status: not listed
Owner/Custodian: London Road Cemetery

The tomb takes the form of an obelisk mounted on a four-sided base, one side of which shows a portrait bust of James Starley, the bicycle

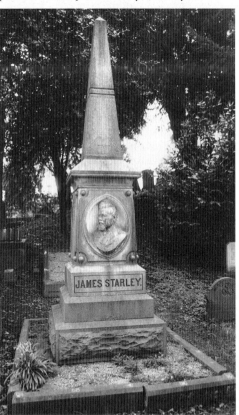

Joseph Whitehead and Sons, *Tomb of James Starley*

manufacturer. The base rests on three steps, the top one of which is inscribed. The bottom step is rusticated, its rough texture conveying something of his strength of character and tenacity, qualities already apparent in his portrait.

For further details of his life, see the entry for the *James Starley Memorial*, Greyfriars Green.

*Facing new road outside Coventry University Technocentre*

## *Siddeley-Deasy Gate*
### Maker: unknown

Installed: 1997
Wrought iron and paint
Condition: good
Status: not listed
Commissioned by: Siddeley-Deasy company
Owner/Custodian: Coventry University

This decorative gatehead has been positioned to face a new road giving access to the Technocentre. Although these were formerly gates for the Siddeley-Deasy factory, the monogram 'AS' at the centre reads stands for Armstrong Siddeley, suggesting that the centre part may have been changed.

The original factory on the Parkside site opened in 1906, when it was known as the Deasy Motor Car Manufacturing Company. John Davenport Siddeley joined it in 1909. By 1912, he had taken control of the company, which became known as Siddeley-Deasy. The company later merged with Armstrong Whitworth of Newcastle upon Tyne, changing its name to Armstrong Siddeley. It became a significant manufacturer of cars, aero engines and aircraft, but closed in 1995 following earlier mergers with the Bristol Aero Engine Company in 1959 and Rolls-Royce in 1966.[1] The gates were on display in the Herbert Art

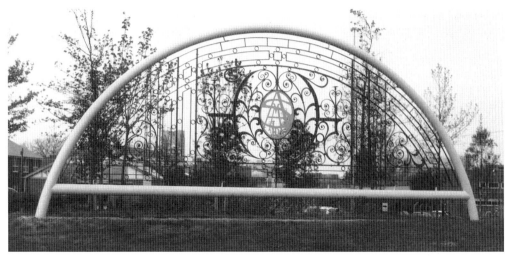

Unknown, *Siddeley-Deasy Gate*

Gallery and Museum from 1994 until 1997 before being erected in their current position.[2]

Notes
[1] Rolls Royce web site, www.rolls-royce.com/history/ [2] *Coventry Evening Telegraph*, 8 August 1998.

*Lower Precinct*  CITY CENTRE

*Above shops on the upper level*

## Coventry's Industries
### Architect: Arthur Ling

Executed: 1958 and 1961
Each panel: neon tubes 2m high × 3m wide approx
Condition: poor
Status: not listed
Commissioned by: Coventry Planning and Redevelopment Committee
Owner/Custodian: Coventry City Council

The architect's ideas and design should be seen as an example of the experimentation with new technologies and materials, including electrically-operated and light devices, which were popular in Britain during the late 1950s and early 1960s. Neon tubes were not only seen for their spectacular motion and colour effects, but the tubes with their delineation of form were appreciated both for their kinetic polychrome and for their plastic sculptural qualities.

The upper walls of the shops in the Lower Precinct are illuminated at night by a series of designs in coloured neon tubes, representing Coventry's industries. It had originally been planned that the first four panels, on the south block, would represent the car, watch, textile

Ling, *Coventry's Industries*

and cycle industries, and the second group, on the north side, the electrical, aircraft and machine tool industries and space research. However, when the second group of panels was ready to be installed, two panels from the south side were swapped with two intended for the north to alter the balance of the composition. As now installed, on the south side the panels depict the watch, cycle, electrical and space research industries. On the north side they represent the car, aircraft, machine tool and textile industries.[1]

The City Architects Department had planned that the upper parts of the shops should have some decoration on them to enliven the precinct at night, and the shops were let subject to these panels remaining free of advertisements. The panels were originally to be restricted to the south block for reasons of cost. On 5 February 1958 the Planning and Redevelopment Committee asked the City Architect to investigate the possibility of using neon to illuminate the panels, multiple rows of electric light bulbs having already been rejected as too expensive.[2] A month later the Committee rejected the City Architect's proposal that the panels should be contemporary designs depicting the elements in favour of designs based on the industrial history and life of Coventry.[3] The first four panels were ready by 1958, the second four in 1961. At the same time as the final group was made an additional panel of a racing car was made for the Climax public house, in the City Arcade. This panel has since been lost.

Notes
[1] Herbert Art Gallery and Museum/City of Coventry Libraries, Arts and Museums Department, *A Survey of Public Art in Coventry*, Coventry, 1980, p.58. [2] Coventry City Council Records, Minutes of Planning and Redevelopment Committee, 5 February 1958. [3] *Ibid.*, 5 March 1958.

*Fish Market, Victoria Buildings*

## *Mermaids, Sailor and Neptune*
### Sculptor: James C. Brown

Installed: first group November 1958, second
  group January 1959
Each: pattern makers stone mix Titanite,
  painted, 75cm high approx
Condition: poor
Status: not listed
Commissioned by: Coventry Planning and
  Redevelopment Committee
Owner/Custodian: Coventry City Council

A series of iron columns was retained when the
Victoria Buildings were converted to a fish
market. Figures appropriate to the trade were
modelled on the columns, arranged in groups of
four, each made up of two mermaids, a dancing

sailor and Neptune. The designs are based on
those of ships' figureheads, and their liveliness
is enhanced by their colouring. The figures are
in a poor condition: on the first column three
figures have arms missing, the sailor's arm is
about to fall off, Neptune's arm is loose and his
trident is missing. On the second column
Neptune has a damaged hand and loose arm
and no trident, one mermaid has no arms and
the other mermaid's arms are loose. On the
third column Neptune has lost his arm and
trident and one mermaid has had an arm
replaced askew and the other arm is missing.
On the fourth column Neptune is missing an
arm and a trident, one mermaid has lost both
arms and the other has only one badly restored
arm. On the fifth column, Neptune has one arm
hanging loose. On the final column one of the
mermaids is missing, the other has no arms, the
sailor has a hand missing and Neptune has lost
an arm and his trident. With allegorical,

mythological and fairytale associations, the
groups in their original condition had a light-
hearted illustrative quality.

James Brown was asked by Coventry City
Council to design figures appropriate for a fish
market. He intended that the completed figures
resemble Staffordshire China figures and did
not mean them to be painted. The figures were
cast in moulds, the arms being cast separately
and attached with dowels.

The market is due to be demolished shortly.[1]

Note
[1] Conversation with Markets Manager, 26 July
1999.

*Outside the County Courts*

## *Basilica*
### Sculptor: Paul De Monchaux

Unveiled: 18 February 1991
Purbeck and Portland limestone and Frankland
  grey granite 2.8m high × 3m wide × 2.3m
  deep approx
Condition: good
Status: not listed
Commissioned by: Lord Chancellor's
  Department

The artist has described his work thus:

> The sculpture uses the displacement of two
> stacks of identical (in plan) triangular stone
> slabs to produce a six sided arch with curved,
> flush and stepped surfaces. The 12 triangular
> units fuse at the top in a square slab spanning
> the arms of the arch. The arch faces due
> north and is designed to register seasonal and
> daily light changes. For example, in winter
> the back light will emphasise the stepped
> arch space while the top summer light will
> stress the solids. Also as its plan lies
> diagonally to the daily east-west track of the

Brown, *Mermaid and Sailor*

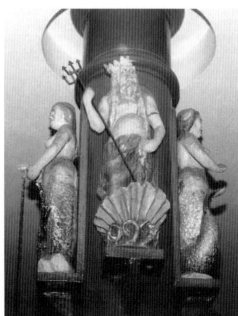

Brown, *Neptune*

**De Monchaux,** *Basilica*

sun, the light should animate in turn each face of the sculpture throughout the day. At night the street lights flatten the mass and strengthen the outline. The piece is intended to be self-contained but it nevertheless does pick up on the façade of the building in terms of the colour, layering and relief of its materials. The stone comes from three different quarries and from four different beds. It is arranged in the sculpture in approximately the same order it lay in the ground. The top four tiers are Purbeck Limestone from the Thornback and Wetsom beds; the second tier is from the Purbeck Spangle bed and the first course is Portland basebed. There is a thin drainage course of Frankland grey granite between the sculpture and brick base.[1]

Such arch structures have a well-established iconographical tradition in the Midlands going back to the nineteenth century.

The title of the work, which has been likened to a judge's wig, is taken from the Greek 'basilike' meaning king's house, a word which also refers to the Roman law courts where the judge and jurors sat in the apse of a basilica under an archway, and which is likewise used to describe one of the first legal codes in Britain, James I Basili. Built at a cost of £20,000, the stone was supplied by W.J. Haysom and Son, H.F. Bonfield and Sons, Easton Masonry Ltd and Frank England and Co. Ltd. The foundations, brick base, landscaping and installation were done by Parker and Morewood Ltd, while the site work was supervised by Frank Brophy of the John Madin Design Group, architects of the court buildings. The sculpture was officially unveiled by the Lord Mayor of Coventry, Councillor W.A. Hardy. The work was commissioned 'in the plan for Coventry's £6 million Combined Court Centre in recognition of the importance of the building in its immediate architectural environment'.[2]

Notes
[1] Information provided by the artist, 30 January 1991. [2] *Coventry Evening Telegraph*, 27 September 1990.

## Northbrook Road   CITY CENTRE

*Entrance hall of Coundon Court School*

## Millennium

### Sculptor: George Wagstaffe

Installed: December 1999
Bronze on circular base, 1.8m high approx
Condition: good
Status: not listed
Commissioned by: David Kershaw, headteacher
Owner/Custodian: Coundon Court School

The artist has explained this work by stating that 'the sculpture is about broken forms, trees that I see that are decayed or struck by lightning, but can give new life'.[1] The form of the sculpture conveys the idea of new leaves emerging from the seared branches of a damaged tree.

Wagstaffe was working on it for himself when he was approached by the headmaster, who wanted a sculpture for the school that would suggest its transformation from a failing school to one of the more successful comprehensives in Coventry. The name was suggested by the work's associations with new beginnings.

Note
[1] *Coventry Evening Telegraph*, 13 December 1999.

**Wagstaffe,** *Millennium*

*Phoenix Way* ROWLEY'S GREEN

## *Decorative Brickwork*
### Artist: Derek Fisher

Executed: 1997
Bricks 8m high × 2.2km long
Condition: good
Status: not listed
Commissioned by: Coventry City Council
Owner/Custodian: Coventry City Council

More than two kilometres of walls are faced with brickwork comprising over 1.5 million bricks. The brickwork and colours reflect the character of the surrounding area. The detailed design refers to the history and culture of Coventry, and specifically to the silk ribbon weaving industry, which flourished from the mid-eighteenth century until the late nineteenth century. The brick patterns are based on ribbon patterns in the Herbert Art Gallery and Museum. According to the artist, each of the four distinct patterned areas has a separate

theme, based on the central pattern of each panel. The three vertical patterns in each panel refer to the three spires on the Coventry skyline.[1] This vertical emphasis in very large panels enables the patterns to be seen by drivers approaching them at speeds of up to 50 miles per hour.

Note
[1] Letter from the artist, 13 May 2000.

*Prior Deram Walk* CANLEY

*Henry Parkes Junior School – beside main entrance*

## *Kangaroos*
### Sculptor: Peter Peri

Executed: 1950s
Concrete 1m high × 1.1m wide approx
Condition: good
Status: not listed
Commissioned by: Coventry Education
    Committee
Owner/Custodian: Henry Parkes Junior School

This highly-textured relief panel attached to the

**Peri,** *Kangaroos*

exterior wall of a building shows two kangaroos standing beside a tree in which a spider has woven its web.

The rough textured surfaces are characteristic of Peri's work during the 1950s, when he had started on a series of concrete figures, both on an architectural scale and in miniature. This is atypical of Peri's work, in that he made few animal sculptures. Its clarity and simplicity reflect his belief that sculpture should be a popular art form, easily understood by all.

*Priory Street* CITY CENTRE
See also *Coventry Cathedral*

*Coventry University –outside students' union*

## *Phoenix*
### Sculptor: Van Nong

Executed: 1993
Platform: concrete paving 2.39m square
Statue: stone 1.93m high × 75cm wide × 75cm
    deep
Inscriptions: (on bronze plaque attached to
    paving stones): PHOENIX / VAN NONG / 1993

**Fisher,** *Decorative Brickwork*

Condition: good
Status: not listed
Commissioned by: Coventry University
Owner/Custodian: Coventry University

This piece, set on a square paved platform, shows an idiosyncratic image of this mythical bird emerging from flame-like motifs that in turn grow out of a stone base. The representation of its plumage is also stylised. The apparent conformity to the limits of the original stone block and the chisel marks suggest that the statue was conceived and produced in the spirit of 'direct carving' and the

**Van Nong,** *Phoenix*

ethos of 'truth to material'. Both in iconography and style the conception and form of *Phoenix* are unprecedented in the city that has made an emblematic use of this symbol of revival since the mid-1940s.

*On Coventry University F Block*

## Phoenix
### Designer: Negus and Negus of London

Executed: 1995
Gilt incised into grey marble 77cm high × 77cm wide approx
Condition: good
Status: not listed
Commissioned by: Coventry University
Owner/Custodian: Coventry University

The phoenix is incised and gilded in a single calligraphic line which starts from the lower part of the top left flame and ends in the hook which forms the body of the bird. The stylised flames also form its wings, expressing the sense of continuity that the mythical bird symbolised – a sense of continuity also visually conveyed by the use of the unbroken line.

This modern version of the phoenix was adopted as the official corporate identity of the new University of Coventry in 1987. It is believed to have been inspired by a piece of calligraphy by David Bethel, who was

**Negus and Negus,** *Phoenix*

appointed Head of the Department of Design and Crafts and Deputy Principal of Coventry College of Art in June 1955.[1]

Note
[1] Information from Ron Clarke, Herbert Art Gallery and Museum, 19 July 2000.

*Opposite cathedral*

## Coventry Boy
### Artist: Philip Bentham
### Foundry: Morris Singer Foundry

Unveiled: September 1966
Statue: bronze 2.05m high × 1m wide × 83cm deep
Plinth: sandstone 75cm high × 1.19m wide × 98cm deep
Inscription: (raised lettering on bronze plaque on plinth): COVENTRY BOY / THIS BOY HAS NO NAME / BUT REPRESENTS ALL BOYS OF / ALL TIME WHO ARE PROUD TO / BELONG HERE REACHING OUT AS / ALWAYS FROM ROUGH SPUN TO CLOSE / WEAVE FOR FAMILY AND FOR CITY.
Condition: good
Status: not listed
Commissioned by: Coventry Boy Foundation
Owner/Custodian: Coventry City Council

This bronze statue stands on an octagonal plinth bearing an inscription on a plaque. A standing figure of a boy holds a scroll aloft with his left hand, while his right hand holds a spanner that rests on a diminutive factory. The scroll is a traditional symbol of unknown birth; however, in this context it could also refer to learning. Whilst his left foot is bare, there is a shoe on his right foot, which is resting on steps that lead upwards: in the iconographical tradition, this signifies elevation through learning. Whilst one sleeve is rolled up, the other is fastened with a cuff-link. There is a discrepancy between the modern simplicity

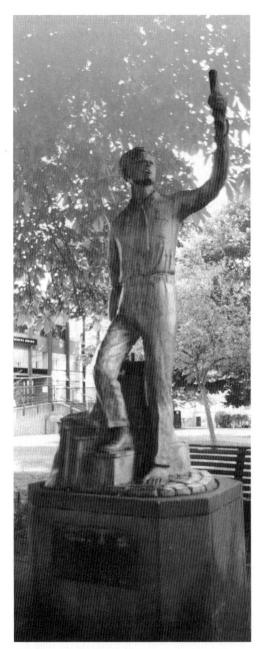

**Bentham,** *Coventry Boy*

with which the boy, especially his face, is depicted and the naturalism with which the still life details and architecture are represented. The statue represents the industrial and craft skills embodied in modern Coventry, and was subsequently adopted as the logo of the Coventry Boy Foundation.

In October 1965 the Coventry Boy Foundation, an anonymous group of local benefactors, offered to present the city with a statue of a Coventry boy, to symbolise the contribution of the city's boys to Coventry's development. The statue was to be a scaled up version of a silver statuette that the foundation had previously given to the Mayor. Bentham modelled his sculpture on a sketch by a former Coventry Art School student, Reg Rudge, with the imagery devised by the Coventry Boy Foundation. It was unveiled in the presence of local dignitaries.[1]

In 1988 the statue was the focus of a land dispute between the Polytechnic and the Council.[2] A reader of the *Coventry Citizen* suggested that the work was wrongly sited, noting that the inscription could no longer be seen.[3]

Notes
[1] Herbert Art Gallery and Museum/City of Coventry Libraries, Arts and Museums Department, *A Survey of Public Art in Coventry*, Coventry, 1980, p.77. [2] *Coventry Evening Telegraph*, 26 October 1988. [3] *Coventry Citizen*, 7 June 1990.

*Ringway, St Patrick's*    CITY CENTRE
*Traffic island*

### *The Coventry Martyrs Memorial*
### Architect: G. Maile and Sons

Unveiled: 15 September 1910
Cross: granite 5m high overall
Wreath: metal
Coat of arms: metal
Base: 1.38m high × 90cm wide × 75cm deep

Step: 2m high × 3.2m wide
Inscriptions: It is recorded that the martyrs were burned in the little park. "The same place where the Lollards suffered." The martyrs' field [now built upon] was situated 200 yards from this spot in an easterly direction. The last words spoken by Laurence Saunders were: "Welcome the cross of Christ: welcome everlasting life".
This memorial was erected by public subscription in the year 1910. William Lee. Mayor
Near this spot 11 persons, whose names are subjoined, suffered death for conscience' sake, in the reigns of King Henry VIII and Queen Mary. Vis. In 1510 Joan Ward. On April 4th 1519. Mistress Landall (or Smith) Thomas Landsdall, hosier. Master Hawkins, skinner. Master Wrigsham, glover. Robert Hockett, shoemaker. Thomas Bond, shoemaker. In January 1521 Robert Selkeb (or Silksby) also, on February 8th 1555 Laurence Saunders. On September 20th 1555 Robert Glover and Cornelius Bongey.
Condition: good
Status: not listed
Commissioned by: Committee for Martyrs Memorial
Owner/Custodian: Coventry City Council

The memorial in the form of a Celtic wheelhead cross is mounted on a stepped plinth, with a wreath and the City's coat of arms mounted on the front face.

The Coventry martyrs were burned at the stake between 1510 and 1555 on a site in Little Park Street. From the fourteenth century the Midlands became a focus of the religious revival associated with John Wycliffe and the Lollards. The Lollards were regarded by the church authorities as heretics, and in the Act of 1401, *De Heretico Comburendo*, convicted Lollards were condemned to be burnt to death. Between 1512 and 1522 nine Lollards were burnt at the stake in Coventry, having been found guilty of teaching their children English versions of the Lord's Prayer, the Ten Commandments and the Apostles' Creed. The nine Lollard martyrs were

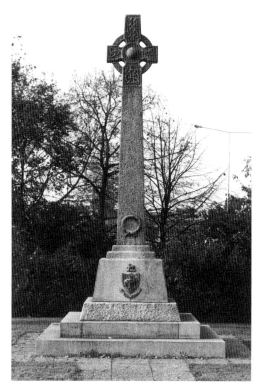

**G. Maile and Sons,** *Coventry Martyrs Memorial*

Joan Ward, Master Archer, Thomas Bond, Master Hawkins, Robert Hockett, Thomas Lansdail, Master Wrigsham, Mistress Smith and Robert Silkeby. More than thirty years later, during the reign of the Catholic Queen Mary, it was Protestant Reformers who were persecuted. Three Reformers were burnt at the stake in Coventry in 1555, Laurence Saunders, Robert Glover and Cornelius Bongey.[1]

The idea for a monument to the Coventry martyrs was first proposed in a letter from 'Spectator in Warwickshire' to a local newspaper. A committee was appointed and, chaired by the Mayor William Lee, first met in September 1908. Nearly £200 was raised for the monument by public subscription, mainly from Coventry but some from further afield, including America. The cross was unveiled by the Mayor at a ceremony conducted by the Revd F.M. Brodie, vicar of Christ Church, in the presence of nearly one thousand people.[2]

Notes
[1] Munden, A., *The Coventry Martyrs*, Coventry, 1997, pp.7–9. [2] *Ibid.*, p.10.

## *Shelton Square*      CITY CENTRE
*Above pavement between Shelton Square and Bull Yard in the precinct*

## *Sir Guy and the Dun Cow*
## Sculptor: Alma Ramsey

Installed: March 1952
Stone mix covered in paint 2m high × 2.5m wide
Inscription: (on scroll below figures and partially illegible): GUY OF WARWICK, A LEGENDARY HERO OF WARWICKSHIRE, IS RENOWNED FOR HIS VALOUR IN RESCUING / PHELICE DAUGHTER OF … AFTER A DESPERATE ENCOUNTER / GUY SLEW THE MONSTER …
Condition: fair
Status: not listed
Commissioned by: Coventry Planning and Redevelopment Committee
Owner/Custodian: Coventry City Council

Sir Guy is depicted in chain mail and sheet armour, his sword raised above his head. The dun cow prances in front of him, its rolling eyes looking towards the viewer. In the background is the small figure of Phelice, daughter of the Earl of Warwick, who was rescued by Guy. It is a light-hearted treatment of the subject, with the figures given a lively cartoon-like quality.

The relief depicts the legend of the slaying of the monstrous dun cow by Guy of Warwick, son of the steward to the Earl of Warwick.

When he was 16 he fell in love with the Earl's only daughter Felice, who stated that due to his low birth she would only marry him if he could prove his valour. Guy set out for Europe, on his way killing the dun cow that was ravaging Dunsmore Heath and a boar at Slough. He fought the Saracens at Constantinople, and on his return to England killed a dragon for Aethelstan of York. These deeds convinced Felice of his bravery and she consented to marry him. On the death of the Earl shortly after their marriage he inherited the Earldom.[1]

The sculpture was originally attached to the wall at the top of the steps leading from the south-east side of the precinct to its upper level. As the upper walkways were little used, the sculpture was not well known, and it was resited as part of a facelift that includes floodlighting and landscaping from Broadgate House to Shelton Square.[2] Alma Ramsey was commissioned to make the sculpture as part of City Architect, Donald Gibson's scheme to have works of art associated with the new Broadgate House. Along with Tennant's figures on the clock on the front of Broadgate House, this work provides an effective contrast to the

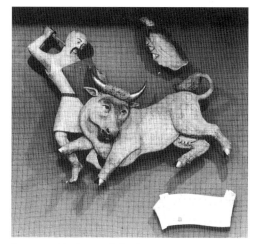

Ramsey, *Sir Guy and the Dun Cow*

other art works, the more serious *People of Coventry* sculpture and the *Martyrs Mosaic*.

For more details of the legend, see the entry for *Guy and the Boar*, Coventry Road.

Notes
[1] Herbert Art Gallery and Museum/City of Coventry Libraries, Arts and Museums Department, *A Survey of Public Art in Coventry*, Coventry, 1980, p.46. [2] *Coventry Evening Telegraph*, 31 October 1983.

## St Agnes Lane CITY CENTRE

*Lady Herbert's Garden, behind Millennium Place*

### *Pergola*
### Architect: unknown

Executed: 1935–7
Brick, with remnants of interior roof decoration
Inscriptions: (one in each chamber):
IN SPRING THE GARDEN BIDS US HOPE
IN SUMMER IT IS AT ITS BEST
IN AUTUMN STILL SOME JOY REMAINS
WINTER GARDENS TAKE THEIR REST
Condition: fair
Status: not listed
Commissioned by: Alfred Herbert
Owner/Custodian: Coventry City Council

The brick pergola is divided into four concave chambers, originally with seats, in which the remnants of the interior roof decoration, symbolising the four seasons, and accompanied by partially gilded lettering, are still visible. This work reflects the Arts and Crafts ethos, with its emphasis on high standards of craftsmanship and a love of nature. It appears quiet and unpretentious, in striking contrast to the modern development of Millennium Place nearby.

The garden also contains a stone bird bath, presumably carved at the same time. A circular bowl is set on a hexagonal base and is decorated with four stone frogs. The stone is weathered and has been stained by guano and the growth of lichen, but is otherwise in good condition.

## Station Square CITY CENTRE

*Beside taxi rank*

### *The Worker*
### Sculptor: Ian Randell

Executed: 1986
Plinth: kerb stones and granite bricks 1.24m
    wide × 2.77m long × 16cm deep
Figure: stone 87cm high × 71cm wide × 2.14m
    long
Condition: fair
Status: not listed
Commissioned by: Coventry City Council
Owner/Custodian: Coventry City Council

This sculpture depicts a heavily-built figure of undefined gender raised on its arms, with its right leg bent and the other leg extending behind it, as if it were trying to stand up. The figure is heavily abstracted into both curved and angular planes with the tool marks left visible as a series of parallel grooves. This angular appearance animates the figure, adding a sense of movement and dynamism in its struggle. If the title and the abstraction of the figure are intended to signify the anonymity of the working class, the sculpture can be interpreted in socio-political terms as conveying the power of the rising working class that is claiming its birthrights.

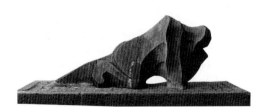

**Randell,** *The Worker*

A competition was set up to offer students the opportunity to display their work in the public arena as part of Industry Year 1986, and the sculpture was intended to mark Industry's involvement with the Arts. The artist, one of four winners, refused to accept the £25 book token offered as a prize, believing that £1,000 had been on offer. The council claimed that this sum had been set aside to cover the cost of materials.[1]

Note
[1] *Coventry Evening Telegraph*, 22 May 1989.

## Stoke Green STOKE

*In park at junction with Binley Road (A428)*

### *Joseph Levy Memorial Clock*
### Maker: unknown

Erected: 1904
Metal, painted cream 4m high × 1m wide × 1m
    deep approx
Inscriptions: (west face): GOLDEN CROSS
    SOCIETY / FOUNDED 1859 / HILLFIELDS
    SOCIETY / FOUNDED 1888 / STOKE SOCIETY /
    FOUNDED 1904 / CHARTERHOUSE SOCIETY /
    FOUNDED 1925
    (north face, under portrait): JOSEPH LEVI
    (on base): FOUNDER / OF THE /
    PHILANTHROPIC SOCIETIES / IN / COVENTRY /
    PRESIDENT / ALD. A.H. DRINKWATER J.P.
    (on shaft): ERECTED / BY / PUBLIC
    SUBSCRIPTION / 1904
    (east face): THE COVENTRY SOCIETY /
    FOUNDED 1854 / CHAPEL FIELDS SOCIETY /
    FOUNDED
Condition: poor
Status: not listed
Funded by: public subscription
Owner/Custodian: Coventry City Council

A neo-classical corniced pedestal supports a shaft with attached Corinthian pillars at all four

Unknown, *Joseph Levy Memorial Clock*

angles and temple pediment tops. Above this, the four-faced clock is surmounted by a roof with scale-like decoration and a spire with a ball half-way up it. There are inscriptions on three of the four faces, and on the north face is a portrait bust of Joseph Levy in relief. The whole is set upon two large concrete steps. There is a drinking fountain at the base of two of the four sides.

## Stoney Stanton Road
### CITY CENTRE TO BISHOPGATE GREEN

*East exterior wall of physiotherapy block, Coventry and Warwickshire Hospital*

## The Good Samaritan
## Artist: Eric Gill
## Restorer: John Skelton

Executed: 1937
Panel: Artificial stone 1.2m × 1.4m
Condition: poor
Status: not listed
Commissioned by: A.H. Gardner
Owner/Custodian: Coventry and
    Warwickshire Hospital

The Samaritan is depicted supporting the body of the injured man on his lap. The composition is triangular with the Samaritan's head forming the apex and his feet the base. The M-shape formed by the spread of the injured man's body emphasises the diagonality of the relief and focuses attention on the two heads which, although in profile, are cut more deeply than the rest of the relief. The bas-relief treatment of the figures, enveloped in soft folds of drapery, reflects the softening of Gill's style from the more modernistic severe classicism of earlier works such as the *Stations of the Cross* of 1913–18 in Westminster Cathedral to the softer curves of his 1925 sculpture, *Girl*.

The relief illustrates the parable of the Good

Samaritan, in which a man travelling from Jerusalem to Jericho was attacked by robbers, who beat him and left him half dead by the side of the road. After being ignored by a priest, and a Levite, it was a Samaritan who took pity on him, attended to his wounds and took him to a nearby inn to recuperate, paying for the room himself.[1] The story's theme of care and compassion for the injured is particularly suited to this panel located on the façade of a hospital building.

This panel is one of a pair Gill carved for the original hospital building. The drawings for these pieces are dated 15 and 17 November 1937 respectively. Gill came to Coventry on 31 October 1938 and carved the works *in situ* for 13 days in November. The panel's companion piece, *The Good Shepherd*, was destroyed during an air-raid on the hospital in 1941 which also damaged *The Good Samaritan*. Photographs of the relief in its original setting show that it appeared almost inconsequential

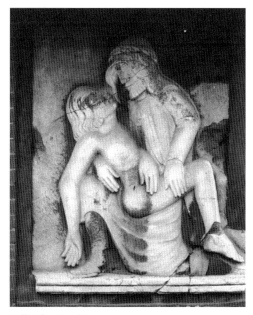

Gill, *The Good Samaritan*

and squashed amongst a long façade of windows, emphasising Gill's own earlier comment that 'there is no justification for sculpture on modern buildings because the two things belong to radically different worlds ... and the architect who drags in sculpture ... is only confessing his architectural weakness and timidity'.[2] This begs the question about why Gill accepted the commission.

The damaged pieces of the panel lay in St Mark's churchyard opposite the hospital until on 31 August 1957, it was reported by the *Coventry Evening Telegraph* that the *Good Samaritan* had been resited on a wall of the new out patients' department being built at Stoney Stanton Road. Skelton, a relative of the sculptor, had given advice on repairing the panel, which remains incomplete. It was resited by A. Matts and Son Ltd, the same Coventry contractors who placed it in position originally[3], and was left with its damage visible to stand as the hospital's war memorial. Reports from 1979 gave details of the poor state of the relief at that time, recording several cracks and weathering. There was some discussion of the possibility of moving the relief, but it was concluded that the cost would be too high and that the sculpture was in a very poor state making moving it complex and risky.

Notes
[1] Luke, 10.30–7. [2] Shewring, W. (ed.), *The Letters of Eric Gill*, 1947, p.325. [3] *Coventry Evening Telegraph*, 31 August 1957.

## Stoneleigh Road    GIBBET HILL
*Grounds of Wainbody Wood School*

### Schlanke Meth

### Sculptor: Jonathan Ford

Executed: 1997
Metal 15m long
Condition: good
Status: not listed

*Ford, Schlanke Meth*

Commissioned by: Arts Exchange, Coventry
Owner/Custodian: Wainbody Wood School

Made out of scrap metal parts, this sculpture takes the form of a gigantic kneeling stegosaurus with its neck outstretched and its head upon the ground. The design is playful and recalls children's drawings of dinosaurs. Children are able to clamber on to the sculpture and play on it. The large red letter W affixed to its head presumably stands for Wainbody Wood, the name of the school in whose grounds it is sited.

## Swan Lane    HILLFIELDS
*Exterior of Co-operative Model Dairy*

### Dairy Cow

### Designer: unknown

### Architect: Coventry CWS Architects Department

Executed: 1913

Cow's head: painted stone, life-size
Condition: fair
Status: not listed
Commissioned by: Co-operative Wholesale Society

Originally, there was a stone panel at the entrance to the dairy, painted blue and with the word 'Dairy' carved upon it. Above it was the carved head of a cow, painted brown and white. The edges of the panel were adorned at the top with swags attached to large knots of ribbon from which further ribbons were suspended. The knots at the ends of these ribbons enclosed bundles of fruit and vegetables. The window, too, was framed by bundles of fruit carved in relief. Today, only the cow head survives, attached to a plain brick wall.

The Co-operative Wholesale Society described the work as showing 'a representative type of dairy cattle' in a contemporary pamphlet.[1]

Note
[1] Herbert Art Gallery and Museum/City of Coventry Libraries, Arts and Museums Department, *A Survey of Public Art in Coventry*, Coventry, 1980, p.24.

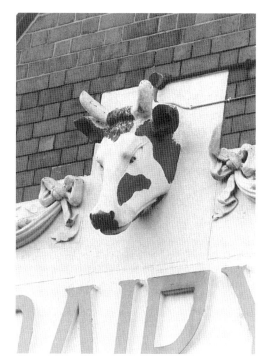

Unknown, *Dairy Cow*

(above and left) Steane and Steane, *Masks*

Steane and Steane, *Foliage and Lettering*

*Frederick Bird School – above entrance doors to building and on gables*

## Masks, Foliage, Bird and Mottoes
### Architects: G. Steane and I. Steane

Executed: 1905
Panels: terracotta 40cm high × 2m long approx
Condition: good
Status: not listed
Commissioned by: Coventry Education
    Committee
Owner/Custodian: Frederick Bird School

The Art Nouveau panel from the top gable of the old school is now a self-contained panel at the entrance to the new building. Carved masks and small birds decorate the three points of the windows. Two small birds, built into the fencing walls at the entrance to the site, are an allusion to the school's name.

The architectural decoration of the original Arts and Crafts brick-built school consisted of five terracotta panels above the entrance doors and on the gables. The panel originally above the entrance to the girls' school had the title set against a panel of stylised foliage with masks at either side and a motto, 'Her prize is above rubies'. The boys' school entrance had a similar panel but with more masculine masks and the motto 'Be strong and of good courage'. A further mask of a younger child within a simple border was inset in the infants' building. The date of the building was placed on a panel with a shield and a motto in Latin, *Pax Vobiscum*, ('peace be unto you'). The name of the school was placed on the top of the gable. The original building has been demolished.

Note
[1] Herbert Art Gallery and Museum/City of Coventry Libraries, Arts and Museums Department, *A Survey of Public Art in Coventry*, Coventry, 1980, p.101.

## The Butts

*On the façade of Technical College*

### Coat of Arms and Symbols of Local Industry
**Designer: Walter Ashworth**
**Architect: A.W. Hoare**

Executed: *c.*1935
Clipsham stone, reconstructed
Roundels 90cm diameter approx
Condition: good
Status: not listed
Owner/Custodian: Coventry Technical College

The sculptural work on the main façade of this large neo-classical building consists of a series of small roundels on the architrave and between the windows of the portico. The four roundels on the architrave are, from the left, represent-ations of a rotary saw, a watch escapement, a micrometer and a ball-bearing race, all symbols of Coventry's industries. The lower roundels have more complex imagery, each being crowded with carving. The left lower roundel symbolises Coventry's involvement with car and aircraft construction. It shows an eagle flying over an aeroplane propeller, a hypoid gear, a comet, a steering wheel and a laurel plant. The centre lower roundel bears images alluding to telecommunications, including a winged head of Mercury, with stylised waves emerging from his mouth and ear, and a telephone handset in the foreground. The right lower roundel depicts a bicycle chain encircling a micrometer, an eye, a hand with a pencil and three drills. It symbolises Coventry's engineering industries. The City coat of arms is also carved in the stone of the façade.

The architect produced his plans for the building in 1913, having won a competition for its commission. Due to delays, the building work was not started until 1933 and was finished in 1935. He commissioned Walter Ashworth, principal of the Coventry Art College, and Chairman of the Coventry and Warwickshire Society of Artists, to produce designs and models for the roundels. Ashworth does not appear to have carved the roundels himself.[1]

Note
[1] Herbert Art Gallery and Museum/City of Coventry Libraries, Arts and Museums Department, *A Survey of Public Art in Coventry*, Coventry, 1980, p.33.

## Trinity Street

*J. Sainsbury Ltd – entrance to building*

### Growth of the City
**Sculptor: John Skelton**

Executed: 1964
Swedish pearl granite, painted in parts, 3.35m × 2.75m
Condition: good
Status: not listed
Commissioned by: J. Sainsbury Ltd
Owner/Custodian: J. Sainsbury Ltd

This diagrammatic map shows the growth of the city of Coventry from early times until the mid-twentieth century. The city boundaries at each period are shown as a series of incised lines filled with colour, and the river Sherbourne is shown as a blue line crossing the whole of the map. At the centre of the map is a tree, Cofa's tree, from which the City of Coventry allegedly derives its name. It is surrounded by small representations of the city gates, based on engravings. Roads out of the city to major

Ashworth, *Mercury with Telephone Emblem*

(right) Ashworth, *Propeller, Wheels and Comet*

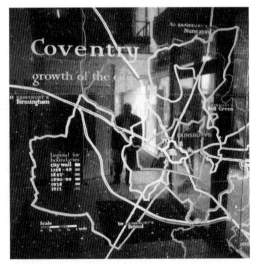

Skelton, *Growth of the City*

towns are marked and identified, with the addition of Sainsbury's name in company script where appropriate, as a refined form of advertising for Sainsbury's stores in the region. Viewing of the panel is affected by a glass wall that forms part of a new access to the store.

Skelton based the details of his map on old plans of the city he borrowed from the Herbert Art Gallery. The drawings were submitted to Sainsbury's and passed with minor modifications. The plans were enlarged and traced on to the granite and the incised lines cut by machine. Skelton then carried out the painting and gilding, and supervised the installation of the work before finishing it *in situ*.

This was the second map Sainsbury's had commissioned from Skelton, the first being for their Chichester store in 1961. The company also planned a series of heraldic devices around their store entrance and asked Skelton to design them in 1964, but the scheme was not carried out.[1]

Note
[1] Herbert Art Gallery and Museum/City of Coventry Libraries, Arts and Museums Department, *A Survey of Public Art in Coventry*, Coventry, 1980, p.75.

## Ulverscroft Road  CHEYLESMORE

*Manor Park Primary School – outside wall facing Ulverscroft Road*

### Falcon Relief

**Sculptor: Trevor Tennant**

Installed: 1950
Leicestershire facing brick 3m high × 4m wide approx
Condition: good
Status: not listed
Commissioned by: Coventry Education Committee
Owner/Custodian: Manor Park Primary School

---

Tennant, *Falcon Relief*

The falcon is shown in flight, gathering its wings, talons extended as if it is about to descend upon its prey. It is deeply carved in brick and dominates the façade of the building. The bird of prey was chosen because the school is built upon the fourteenth-century hunting grounds of what was the Manor of Cheylesmore. The falcon is also used as the school logo.[1]

The sculpture was part of the original design for the school building, and was highly praised by the City Art Director in his report of c.1960. Tennant also worked on the Coventry coat of arms on the school. Both works were in place in time for the school's official opening in March 1950.[2]

Notes
[1] Letter, T.A. Hewitt, Headmaster of Manor Park Primary School, 8 March 1999. [2] Herbert Art Gallery and Museum/City of Coventry Libraries, Arts and Museums Department, *A Survey of Public Art in Coventry*, Coventry, 1980, p.104.

Schottlander, *3B Series I*

---

## University of Warwick  CANLEY

*Gibbet Hill Road, beside Rootes Residences*

### 3B Series 1

**Sculptor: Bernard Schottlander**

Installed: 1968
Gauge 16 steel, painted scarlet 2.62m high × 4.8mwide × 2.47m deep

Condition: good
Status: not listed
Owner/Custodian: University of Warwick

The simple forms of the square, circle and rectangle are enlarged, contrasted,[1] and juxtaposed in different combinations to create a sense of play with the internal forms and spaces of the piece. This architectonic work is the focus of the square and its bright red colour contrasts with the surrounding grey stone of the amphitheatre and angular 1960s student residences.

The work was purchased from the sculptor in 1968 with the assistance of the Arts Council of Great Britain 'Works for Public Buildings' Scheme.[2]

Notes
[1] University of Warwick, *Sculpture Trail Brochure*, Coventry, 1997. [2] *Ibid.*

Sources
Arts Council of Great Britain, *Sculpture in a City*, touring exhibition catalogue, London, 1968; Strachan, W.J., *Open Air Sculpture in Britain*, London, 1984, p.163.

*Gibbet Hill Road, near Social Studies*

## Dark at Heart
### Sculptor: Peter Randall-Page

Installed: 1987
Bardillio marble 40cm high approx
Condition: good
Status: not listed
Purchased from the artist
Owner/Custodian: University of Warwick

This piece of sculpture is the visual manifestation of the fundamental aesthetic principles of abstract art. It shows the ethical concept of 'truth to material' and direct carving. Although it makes no representational references, the inter-relationship of concentric shapes suggest containment and motion, especially when viewed in the round from

**Randall-Page,** *Dark at Heart*

different angles, and this seems to be confirmed by the original title and the artist's statement about this work: 'I have tried to make the sculptural equivalent of an emotional state – the dark knotted centre, the consciousness of being alone'.[1]

This work was purchased by the University from the artist in 1987.

Note
[1] University of Warwick, *Sculpture Trail Brochure*, Coventry, 1997.

*Gibbet Hill Road, Social Sciences building quad*

## Grown in the Field
### Sculptor: Avtarjeet Dhanjal

Installed: 1977
Spirals: anodised aluminium, height from 2.2m to 4.3m

Condition: good
Status: not listed
Commissioned by: Alcan Aluminium (UK) Ltd
Owner/Custodian: University of Warwick

Five vertical anodised aluminium spirals of varied height have been constructed from sheets of aluminium. The five coils are intended to respond to the atmosphere like natural vegetation and sway in the breeze. The five different sizes of coil are meant to represent the various stages of a tree's life. According to the artist: 'My work is very much nearer nature and has life like a tree or a plant. My pieces respond to atmosphere like natural vegetation. They grow under the sun, breathe open air, swing like trees and vibrate like leaves.'[1]

Note
[1] University of Warwick, *Sculpture Trail Brochure*, Coventry, 1997.

**Dhanjal,** *Grown in the Field*

*Gibbet Hill Road, Arts Centre*

## Hawser, Higham Bight, Funnel, Kentish Fire, The Final Flourish

### Sculptor: Keir Smith

Executed: 1984
Jarrah wood railway sleepers, each 1m long approx
Condition: good
Status: not listed
Donated by: the artist
Owner/Custodian: University of Warwick

These four carvings are part of a five-piece frieze entitled *Variations on a Braided Rope* and are made from railway sleepers that were originally used in the London Underground. The forms manifest the combined aesthetic principles of 'truth to material' and direct carving.

The artist described their subject matter:

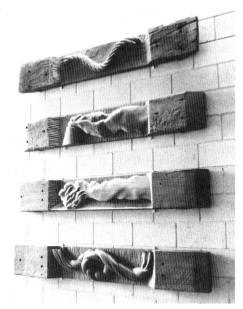

**Smith,** *Hawser*

The first in the series (*Hawser, Higham Bight*) was a carving of a sinuous length of rusted steel hawser; the *Final Flourish* was the last and depicts a coil of rope. Between these carvings were images describing aspects of the landscape along the Thames Estuary; *Funnel* showed the superstructure of a cargo ship truncated by the sea wall, *Kentish Fire* represented the stubble burning in the fields ... Like the sleepers from which they were carved, the *Variations on a Braided Rope* evoke a journey through a much used land.[1]

Keir Smith successfully brings together a sophisticated iconography with an expressionistic formal language and sound craftsmanship.

These carvings were presented to the University by the artist in memory of his brother who had studied there.

Note
[1] University of Warwick, *Sculpture Trail Brochure*, Coventry, 1997.

*Gibbet Hill Road, outside Senate House and Arts Centre*

## Koan (White Koan)

### Sculptor: Liliane Lijn

Installed: 1973
Painted steel 3.6m diameter × 6m high with kinetic light and sound effects
Condition: good
Status: not listed
Commissioned by: Peter Stuyvesant Foundation City Project
Owner/Custodian: University of Warwick

The shape of the sculpture is a pun on the Zen Buddhist concept of a Koan, a question without an answer. The Koan is the embodiment of a Buddhist Mantra, a word or syllable used to aid concentration in order that the difference

**Lijn,** *White Koan*

between mind and matter cease to exist. It revolves at eight revolutions per minute. At night its luminous rotation is intended to pull the viewer towards the centre of the University. It also gives a quiet murmuring sound. The combination of shape, concentric motion, fluctuating light and monotonous sound effect has cosmological associations (similar to the unrealised original concept of Tatlin's monumental Tower).

This work was commissioned as part of the Peter Stuyvesant Foundation City Project,

1972, for Plymouth, and it was purchased from the artist in 1973 with assistance from the Arts Council of Great Britain, A.G. Gale & Co. Ltd, M. & G. Glesson Ltd, Sir Maurice Laing Personal Trust and Robert McAlpine Ltd.[1]

Note
[1] University of Warwick, *Sculpture Trail Brochure*, Coventry, 1997.

*Gibbet Hill Road, on edge of car park opposite the Arts Centre*

## *Let's Not Be Stupid*
### Sculptor: Richard Deacon

Installed: 1991
Stainless steel 5m high × 15m wide approx
Painted mild steel
Condition: good
Status: not listed
Owner/Custodian: University of Warwick

The forms of this work have been conceived and presented to give ever-changing visual experiences as the viewer approaches and walks around and through it.[1] While according to the artist the forms are not intended to be a metaphor for human experience, and are not supposed to have narrative references, the sculpture with its original title is entirely site-specific.[2]

This work was commissioned in 1989 and was presented to the University of Warwick by Nyda and Oliver Prenn Foundation in 1991.[3]

Notes
[1] Rosenburg, E. and Cook, R., *Architect's Choice: Art in Architecture in Great Britain since 1945*, London, 1992, p.33. [2] University of Warwick, *Sculpture Trail Brochure*, Coventry, 1997. [3] Eustace, K. and Pomery, V., *The University of Warwick Collection*, Warwick, 1991, p.36.

**(above right)** Deacon, *Let's Not be Stupid*

**(right)** Furnee, *Moon Pool*

*Gibbet Hill Road, next to Business School*

## *Moon Pool*
### Sculptor: Bettina Furnee

Executed: 1995
Stancliffe stone 3m diameter approx
Inscription: 'Here the foot prints stop, Here the moon was in labour, Glass rings and blue bracelets'

Condition: good
Status: not listed
Commissioned by: Warwick Business School, University of Warwick
Owner/Custodian: University of Warwick

The rim of this circular basin with a quiet fountain is inscribed with lines from the poem *After Twenty Years* by Fadwa Tuqan. The lines suggest that the passer-by is entering a place of

peace and quiet, and evoke associations with the regulating force of the moon over tides and the ideas of rebirth and renewal. 'Glass rings and blue bracelets' reflects the movements created by water in the pool.[1] Concept and image are here entirely correlated. As in many early examples in the Midlands, sculptural form and inscription both contribute to the literary-philosophical and visual meaning: as the moon reflects the light of the sun, the surface of the water reflects the light of the moon. The moon has long been associated with knowledge and by association the *Moon Pool* invites the passer-by to stop and reflect on his life and the world around him. It is thus entirely appropriate to its site.

Note
[1] University of Warwick, *Sculpture Trail Brochure*, Coventry, 1997.

*Gibbet Hill Road, inside International Manufacturing Centre*

## Net II

### Sculptor: Rob Olins

### Architect: Edward Cullinan

Executed: 1995
Mixed media, wire mesh nets of varying sizes
Condition: good
Status: not listed
Commissioned by: Prof. Kumar Bhattacharyya, International Manufacturing Centre
Owner/Custodian: University of Warwick

This kinetic mobile features two parallel kite shapes made from wire mesh and suspended from a square aluminium plate. Geographical markings reflect the building's international role and the parallel grids symbolise the partnership of industry and education. The ceiling grid contains typographical devices and lines detailing the exact location of the building and the precise angles used in this construction.

The mesh grids hanging from the ceiling relate to the grids and wire frame forms used in the computer analysis of three-dimensional volumes. It is a mixed media work and is constructed of alucobond panels, a gearbox, a motor, hard wire lights and drive, and cable roll.[1] A working drawing for this project is displayed beneath it.

The creation of the elaborate iconographical programme and the technological realisation of this mobile involved the contribution of several members of university staff, who are acknowledged on the inauguration leaflet as follows: Warwick Manufacturing Group: Pat Rabbitt, John Fielden, Paul Grimley, Mike Robertson, Malcolm Graham; Engineering Workshops: George Pemberton, Graham Robertson, John Roe, David Thompson; Electrical Workshops: Stewart Edris, Andy Elliott, Jonathan Meadows; Curator of the

Mead Art Gallery: Sarah Shagolsky; Commission Organiser: Dr Anthea Callen, Department of the History of Art.[2]

Notes
[1] Herbert Art Gallery and Museum, Coventry Public Art Database. [2] Anon, Inauguration leaflet for Rob Olin's sculpture *Net II*.

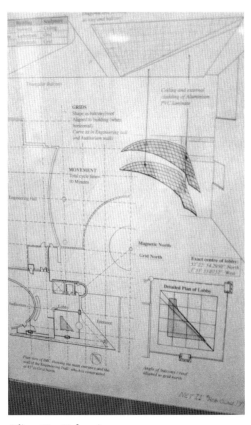

Olins, *Net II drawings*

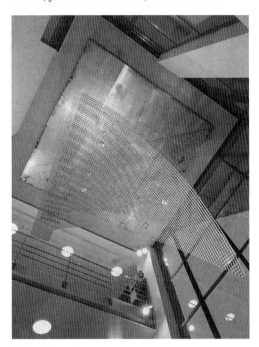

Olins, *Net II*

*Gibbet Hill Road, inside Arts Centre*

## *Op. Mobile No. 10*
### Sculptor: Nechemia Azaz

Installed: 1974
Aluminium tubing, painted 2.07m × 2.03m
Condition: good
Status: not listed
Purchased from: the artist
Owner/Custodian: University of Warwick

The construction of this delicately structured mobile recalls the 1950s works of Kenneth Martin, which used metal rods welded into logically conceived spirals. Martin used mathematical systems, such as the Fibonacci sequence, root rectangles or the Golden Section. While Martin's work is logical rather than organic, Azaz's work is more fanciful and poetically playful. Machine-made materials were painted in a variety of colours to heighten the sense of movement and to reflect the original colour scheme of the Arts Centre in its 1970s form.[1] It is hung vertically to work as a perpetuum mobile that has a subtle, sinuous, flowing and colourful effect.

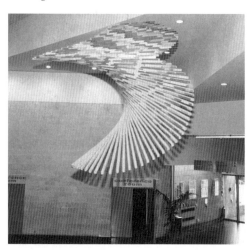

**Azaz, *Op. Mobile No. 10***

Note
[1] University of Warwick, *Sculpture Trail Brochure,* Coventry, 1997.

## *The Warwickshire Dials*
### Artist: Richard Wentworth
### Engineers: H.S. Walsh & Sons Ltd

Executed: 1999
Metal and glass, each dial 50cm diameter approx
Condition: good
Status: not listed
Owner/Custodian: University of Warwick

This work consists of four clocks, each of which has half of the face blacked out. In the first, it is the left hand side of the face that is missing; in the second, the lower half; in the third, the right hand side of the face; and in the fourth, the upper half. The work refers to the Warwickshire tradition of clock-making, but also alludes to the idea of the measurement of time in hours and minutes being an artificial concept introduced by man, as distinct from the idea of cyclical time as represented by the seasons and the following of night by day.

**Wentworth, *Warwickshire Dials***

*Gibbet Hill Road, near Social Studies Faculty*

## *Sensedatum: Hour Glass II*
### Sculptor: David Hugo

Executed: 1988
Mixed media 2.03m high × 70cm wide × 70cm deep
Condition: good
Status: not listed
Presented by: the sculptor
Owner/Custodian: University of Warwick

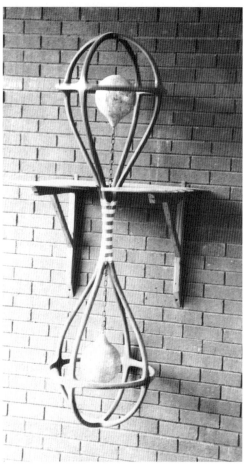

**Hugo, *Sensedatum: Hour Glass II***

This work is constructed out of mixed media including laminated and carved wood, paint and collage, painted metal powder, plastic balls and chain. The artist suggested that this work was about 'death, death of a relationship',[1] which helps to explain the form and title. While the vertical plane suggests the idea of 'being laid to rest', the suspended globes portray the human spirit; 'the floating world', refers to the 'elevated spirit', while the hanging one suggests the spirit yielding to gravity. Both the floating and the hanging globes are confined within a skull-like cage, the overall appearance being of an hour glass, giving the suggestion of time having run its course.

Note
[1] University of Warwick, *Sculpture Trail Brochure*, Coventry, 1997.

## Gibbet Hill Road, outside Arts Centre

### Slab and Bar Relief
### Sculptor: Geoffrey Clarke

Executed: 1964
Cast aluminium 1.4m high × 1.3m wide approx
Condition: good
Status: not listed
Commissioned by: National Westminster Bank
Owner/Custodian: University of Warwick

Clarke has chosen to work in subtle monochromatic grey tones in this abstract relief which focuses the viewer's attention on the surface of the work and its contrast to the surrounding architecture. On close inspection the imprints of the polystyrene shapes used to cast the work are visible. The forms in the relief are inspired by characters in Chinese calligraphy; they also suggest the armature, or skeleton, of the building. Although this is a purely abstract work suggesting an equilibrium of horizontal and vertical forms penetrating the plane by the careful manipulation of light and

Clarke, *Slab and Bar Relief*

shadow, this display of pure architectonic elements is permeated with deep human feelings.

This work was originally commissioned by the architects R.D. Russell and Partners for the lobby of the Westminster Bank in New Bond Street in London in 1964. When the bank was demolished in 1992, the sculpture was donated to the University of Warwick.[1]

Note
[1] University of Warwick, *Sculpture Trail Brochure*, Coventry, 1997.

Source
Black, P. (ed.), *Geoffrey Clarke: Symbols for Man: sculpture and graphic work 1949–94*, Ipswich Borough Council Museums and Galleries in association with Lund Humphries, London, 1994.

## Gibbet Hill Road, Library

### Spring Sixty Seven
### Sculptor: William Pye

Installed: 1968
Nickel plated steel 1.37m high × 1.12m wide × 64cm deep
Stainless steel and wood
Condition: good
Status: not listed
Owner/Custodian: University of Warwick

This sculpture incorporates a curved sheet of steel which is highly polished to reflect the viewer and surrounding elements of the work from many viewpoints, adding a sense of dynamic movement.[1] Such wholehearted acceptance of modernistic industrial materials and polished surfaces is counterbalanced by a bold and confident vocabulary of form that conveys a powerful dramatic spirit.

Pye, *Spring Sixty Seven*

It was purchased from the sculptor with the assistance of the Arts Council of Great Britain.

Note
[1] University of Warwick, *Sculpture Trail Brochure*, Coventry, 1997.

*Gibbet Hill Road, Senate House lawn*

## Narcissus

## Sculptor: William Pye

Executed: *c.*1960s–70s
Aluminium 1.4m high × 80cm wide approx
Condition: good
Status: not listed
Owner/Custodian: on loan to University of
   Warwick

The vertical element of this abstract metal sculpture rises from a rectangular base in a series of curves before straightening. It is

**Pye,** *Narcissus*

attached at its top to a rectangle of the same size as the base. Its highly polished reflective surfaces are typical of William Pye's work.[1] Its abstract form and use of industrial materials give the work a modernistic feel that suggests progress and an openness to new technology and ideas. As such, it is entirely appropriate to its university location.

The artist's use of reflective surfaces suggests the water that is central to the Narcissus myth. A nymph called Echo fell in love with Narcissus, but he rejected her. When the goddess Nemesis heard the rejected girl's calls for vengeance, she arranged for Narcissus to fall in love with his own reflection in a pool and to spend all his time admiring his own beauty. As a result, he died and was transformed into a flower.[2]

Notes
[1] Information from the curator at the Mead Art Gallery, University of Warwick, 20 June 2000. [2] Online encyclopedia of myths and legends, www.pantheon.org/mythica/articles/n/narcissus.html

*Milburn Hill Road, Viscount Centre, University of Warwick Science Park*

## In the Stillness

## Sculptor: Jean Parker

Installed: May 1995
Limestone 1.5m high approx
Condition: good
Status: not listed
Commissioned by: University of Warwick
   Science Park
Owner/Custodian: University of Warwick
   Science Park

A statue of a woman sitting upright on a concrete plinth is supported by a slightly elevated brick-built base. Boldly carved from a single block of limestone, with no attention to naturalistic detail, the life-size figure suggests an archetypal calm and solidity. According to the artist, the figure was inspired by the lines of a

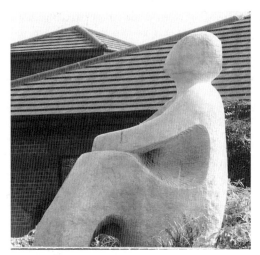

**Parker,** *In the Stillness*

haiku, a Japanese poem by Lum Woon Fung, as confirmed by the original title of the statue and a label attached to the plinth. The poem reads: 'Endless, restless toils, Searching for truth and meaning, Found but in stillness.' The sculpture successfully contributes to the park's aim to create a perfect working place by providing a relaxed environment. The tools were heavy to work with and it took five months to complete the work.[1]

Note
[1] *Coventry Evening Telegraph*, 6 May 1995.

*Upper Precinct*           CITY CENTRE

## The Levelling Stone

## Artist: Trevor Tennant

## Architect: Donald Gibson

Unveiled: 8 June 1946
Central panel: Westmorland green slate 2.67m
   high × 2.7m wide
Perimeter: Hopton Wood stone
Plate: bronze

Inscriptions: (around perimeter): THIS STONE commemorating the official inauguration of the REBUILDING OF COVENTRY after the ENEMY ATTACKS of 1940–1942 was laid by COUNCILLOR JOHN CHARLES GORDON Mayor of Coventry 8 June 1946. MAYOR COUNCILLOR J.C. GORDON / DEPUTY MAYOR Councillor G. BRIGGS. THIS LEVELLING STONE IN THE CENTRE OF THE WAR DAMAGED AREA WAS CONSTRUCTED AS A GUIDE TO THE REDEVELOPMENT OPERATIONS. MEMBERS of the CITY REDEVELOPMENT COMMITTEE 1945–1946 ALDERMAN ANNIE E. CORRIE SIDNEY STRINGER J.A. MOSELEY VINCENT WYLES COUNCILLORS JOHN FENNELL CHARLES PAYNE VICTOR A HAMMOND FRANCIS WHITE FREDERICK SMITH TOWN CLERK ERNEST H. FORD CITY ENGINEER DONALD E.E. GIBSON ARCHITECT. THE LEVELLING STONE was presented by the RT HON LORD KENILWORTH Member of the City Council 1923–1926. THE CITY REDEVELOPMENT COMMITTEE Chairman Councillor A. ROBERT GRINDLAY Vice Chairman Alderman GEORGE E. HODGKINSON

Condition: good
Status: not listed
Commissioned by: Coventry Planning and Redevelopment Committee
Owner/Custodian: Coventry City Council

The levelling stone is an irregular slab of slate, with a bronze plate at its centre, incised with a phoenix rising from the flames and the compass points West, South and East with a sunburst to mark the North. The phoenix carries in its beak a scroll bearing the plans of the new precinct. Unveiled on the first anniversary of VE day, the stone was intended to mark the redevelopment of Coventry and represent an official celebration of peace.

The phoenix was sacred to the ancient Egyptians, who called it the Benu or Boine. Seen as an embodiment of the sun god and

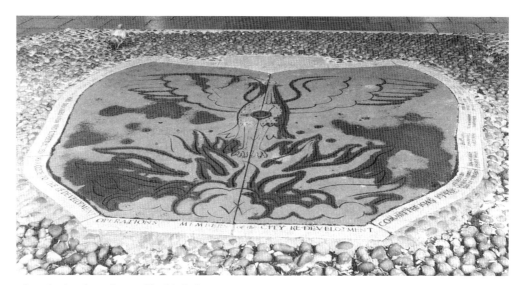

Tennant, *The Levelling Stone*

often depicted as a heron-like bird, the Benu was associated with the daily rebirth of the sun. This use of the phoenix as a symbol of constant renewal was continued by the Greeks, Romans and the fathers of the Christian Church. For example in the Greek *Physiologus*, a book on the characteristics of animals and plants dating to 200–150 BC, the phoenix is interpreted as symbolic of renewal. Herodotus, Ovid and Pliny the Elder all recounted the bird's ability to live to a great age before finally sacrificing itself on an altar fire, from the ashes of which a new young phoenix would arise. In an elegiac poem attributed to Lactantius, a scholar during the reign of the Emperor Diocletian (284–305 AD) when Christians were persecuted, the phoenix is treated as a symbol of the sacrifice and resurrection of Christ.

The concept of the Levelling Stone was first put forward by the City Architect, Donald Gibson, at a meeting of the Planning and Redevelopment Committee on 5 March 1946, as a way of marking the official inauguration of the Redevelopment Scheme. A small sunken area would be finished in stone, with a few steps leading down to the Levelling Stone,

which was intended to be the theodolite point from which all other levels in the new area were to be measured. Its main purpose was to mark the start of the redevelopment and focus public attention on the new work. The surrounding pavement would be in different colours, carved with symbolic aspects of the city's life. The Levelling Stone itself, which would be slightly raised and surrounded by a stone plinth on which the necessary lettering would be inscribed in a continuous frieze running around the Stone, would have symbolic carvings in low relief. Appropriate metal work for the theodolite point could be introduced in the levelling plate and in the north point, and under it in a small brick-walled pit a casket would be buried containing contemporary records about the history of Coventry's wartime experiences and the Redevelopment Scheme. Part of the unveiling ceremony would be the sealing of the pit containing the casket.

At the opening ceremony Alderman J.A. Moseley would seal the casket, Councillor A.R.

Grindlay would lay the mortar under the Stone, and the Mayor would use a gavel to level it, which would be checked by Alderman G.E. Hodgkinson. A special stone would record the event, and there would be an inscription around the margin of the Stone recording its purpose, the names of the dignitaries involved, as well as Lord Kenilworth's participation in the scheme through his donation of £1,300, the cost of the stone.[1] The idea of holding the ceremony on 8 June 1946[2], the first anniversary of VE day, was deliberate and formed the city's official celebration of peace.

The Stone was originally set below the pavement, rather than raised as originally planned. In 1956 the Planning and Redevelopment Committee authorised the City Engineer to raise it so that it would lie flush with the pavement.[3] The subsequent wear necessitated the restoration and recutting of the stone in 1975 because the writing had become obscured.[4]

Notes
[1] Coventry City Council Records, Minutes of Planning and Redevelopment Committee, 25 March 1946. [2] Ibid., 5 March 1946. [3] Ibid., 11 January 1956. [4] Coventry Evening Telegraph, 23 November 1979.

*Behind Community centre, in new community garden*

## Giant Vacuum Cleaner, Chainset and Handlebars

### Sculptor: Jonathan Ford

Installed: August 1998
Painted metal 1.4m high × 2.5m long approx
Condition: good
Status: not listed
Commissioned by: Groundwork Coventry
Owner/Custodian: City Development
   Directorate, Coventry City Council

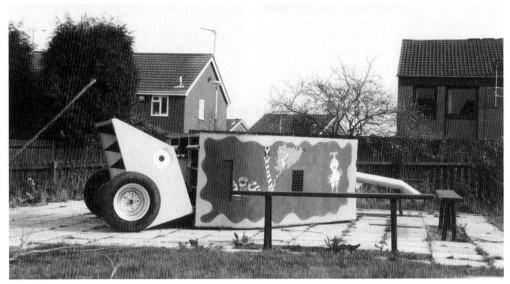

Ford, *Giant Vacuum Cleaner*

There are two main influences upon the creation of this giant metal vacuum cleaner. The size and the choice of material reflect the work of Claes Oldenburg, while the surreal flavour owes something to Miro. The vacuum cleaner appears to suck up a trail of bicycle parts embedded in the ground, reflecting the city's links with bicycle manufacture. The choice of a vacuum cleaner is a literal metaphor for the regeneration of the derelict land. It is decorated in vigorous colours with pictures of bugs, which younger children imagined lived inside it and digested the rubbish it consumed. The vacuum has car wheels and painted teeth, and in its mouth it has a bicycle. There are two other parts to the work, a large cogwheel with pedal-type attachments and a tubular piece that could represent a bicycle frame.

Sponsored by Barclay's Bank, British Telecom and the Single Regeneration budget, the scheme cost a total of £22,000.[1] Groundwork Coventry helped to transform a derelict area at the back of Stoke Heath Community Centre into a new community garden. Local sculptor Jonathan Ford, a member of Coventry Arts Exchange, worked on the project for several months with around 40 local children, who suggested objects they would like to see featured in the work.

Note
[1] Coventry Evening Telegraph, 24 August 1998.

## Warwick Road     CITY CENTRE

*Outside station, on the ring road*

## Steel Horse

### Sculptor: Simon Evans

### Restorer: R. Jones & Co. (Blacksmiths)

Executed: 1986
Scrap metal (coated black) 4m high × 4.5m wide
   approx
Inscriptions: (on plaque attached with screws):
   THIS SCULPTURE HAS / BEEN TREATED WITH /

ANTI-VANDAL PAINT. / DO NOT CLIMB. (on bronze plaque attached by screws to chest): RESTORED BY / R.JONES & CO. (BLACKSMITHS) / BURTON HASTINGS / WARWICKSHIRE / AUGUST 1998.
Condition: fair.
Status: not listed
Commissioned by: Coventry City Council
Owner/Custodian: Coventry City Council

This statue of a rearing horse is constructed out of overlapping irregular-shaped steel plates. The artist's choice of pose conveys a sense of energy and passion. It stands on a brick platform set into the slope of a small hillock in a roundabout, facing south-east towards the A429.

This work cost £600. The artist, one of four winners in a council-run competition to mark Industry Year 1986, was reportedly insulted by the offer of a £25 book token as prize money. The Council claimed that the prize money was simply to cover the cost of the materials. Other winners of the competition include Gary Galpin's *Mother and Child*, Jean Parker's *The Enfolding* and Ian Randell's *The Worker*.[1]

The work was restored in 1998 and coated with an anti-vandal paint to try and prevent people climbing on it.

Note
[1] *Coventry Evening Telegraph*, 29 May 1986.

*Foyer of Friars' House*

## Cofa's Tree
### Sculptor: Deborah Ford

Executed: 1990
Bronze bas-relief, 4.5m high × 2.7m wide
Condition: good
Status: not listed
Owner/Custodian: managing agents of Friars' House

This impressive bas-relief commemorates Cofa's Tree, which was named after a local Saxon chieftain and became a local meeting place. It is claimed that the city of Coventry derives its name from Cofa's Tree, which originally formed part of the city's armorial bearings, but has since been dropped from the coat of arms.

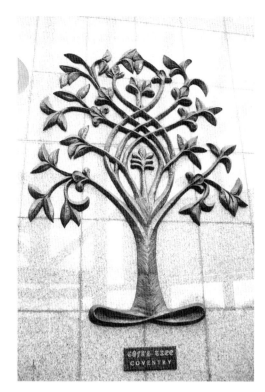

Ford, *Cofa's Tree*

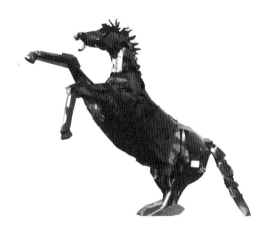

Evans, *Steel Horse*

# Solihull

## BALSALL COMMON

*B4101 (Balsall Street)*

*Outside Ye Olde Saracen's Head public house*

### Saracen's Head
### Sculptor: unknown

Executed: *c.*1992
Frame: iron
Moon: iron
Figure: bronze or copper
Whole: 1.2m high × 90cm wide approx
Status: not listed
Condition: good
Commissioned by: Ansells Ltd

This pub sign hangs under a canopy roof on a post in front of the main entrance. A linear frame encloses a male bust with a curled beard, a moustache and a turban, and the outline of a crescent moon in the upper left corner. The figure is made from bronze or copper repoussé work on two pieces, which have then been joined. The back of the figure joins the frame, between the front of the figure and the frame is empty space.

A photograph taken in the late 1980s shows the previous inn sign, a painted depiction of a Saracen with the same post and canopy as the present sign.[1] There has been an inn on this site since the thirteenth century and the Crusades in which the Knights Templar were fighting the Saracens. The Knights Templar were based at the nearby manor of Temple Balsall, which Roger de Mowbray had granted them in the twelfth century. In 1314 the Knights Templar were suppressed and disbanded, and their place

**Unknown,** *Saracen's Head*

at Temple Balsall was taken by the Knights Hospitaliers, who were in turn disbanded by King Henry VIII in the sixteenth century.[2]

In 1992 the owners, Ansells Brewery reputedly spent half a million pounds on renovations to the public house.[3]

Notes
[1] Woodhall, J., *The Book of Greater Solihull*, Buckingham, 1990, ill. on p.48. [2] West Midlands Federation of Women's Institutes, *The West Midlands Village Book*, Newbury, 1989, pp.19 and 151. [3] Balsall Parish Council, *Balsall Parish Council – the first one hundred years 1894–1994*, Balsall Common, 1994, p.30.

## CASTLE BROMWICH

*Chester Road*

*Castle Bromwich Hall, upper porch (now Bovis Homes office)*

### Peace and Plenty, Bridgeman Coat of Arms and Lion
### Sculptor: W. Wilson
### Architect: William Winde

Executed: *c.*1697
Figures: stone 1.52m high approx
Lion pediment: stone 96cm high at the apex × 2.74m wide
Coat of arms: stone 1.04m high × 1.37m wide
Condition: fair
Status: Grade I
Commissioned by: Sir John Bridgeman (1631–1710)
Owner/Custodian: Bovis Homes Ltd

Two slender female allegorical figures stand in arched niches supported on semi-spherical corbels carved with acanthus leaves, either side of the upper window in the two-storey porch. On the left a personification of Peace holds her attribute, an olive branch, on the right there is a personification of Plenty holding a cornucopia. Each figure is dressed in classical garb and faces the centre.

The main doorway is framed by two pairs of Corinthian columns, the inner one of each having a barley sugar twist. The columns support a broken pediment with the Bridgeman Coat of Arms carved in relief on a central cartouche framed by squat Doric pilasters and a cornice. The Bridgeman Arms are ten roundels arranged in an upside-down triangle with a lion

**Wilson,** *Peace and Plenty*

passant in gold, and a crest above of a lion standing on its rear legs, holding a wreath of laurel between its paws.

Castle Bromwich Hall was built for Sir Edward Devereux at the turn of the sixteenth century to replace an older manor house. In 1657 it was sold to Sir John Bridgeman (1631–1710), eldest son of one of the country's leading lawyers Sir Orlando Bridgeman, who started remodelling the house in 1685 under the direction of William Winde who was married to his cousin. The porch was added to the house in a second phase of redevelopment c.1685–1702.[1] The porch statues, and presumably the coat of arms and lion, are the work of the distinguished Leicester born sculptor, William Wilson.

The Hall ceased to be the main country seat of the Bridgemans in 1762 when the family moved to Weston, and the last of the family to live there was Lady Ida, who died in 1936. The Hall was then let to the General Electric Company, and was finally sold in 1969. Since

1972 it has been the regional headquarters of Bovis Homes Ltd who have refurbished and restored the property.

Note
[1] Beard, G.W., 'Castle Bromwich Hall, Warwickshire', *Country Life*, 9 May 1952, p.1408.

## *Water Orton Road*

### *On the façade of Park Hall School*

### *Hurdlers and Climbers*

### **Sculptor: Walter Ritchie**

### **Architect: Charles Elkins**

Executed: *Hurdlers* 1949, *Climbers* 1951
Each panel: Darley Dale stone 2.28m high × 2.28m wide
Condition: fair
Status: not listed
Commissioned by: Charles Elkins, County Architect and W.H. Perkins, Director of Education
Owner/Custodian: Park Hall School

*Hurdlers* and *Climbers* comprise two relief panels.

*Hurdlers* depicts three young people in the act of jumping a hurdle. In the front plane is a male youth running up to take off, in the middle plane is the figure of a young girl in full flight over the hurdle, and in the far plane is a second male youth in the act of landing. The three figures are jumping the same hurdle, and although inhabiting different recessed planes within the relief, their figures overlap. The effect is of a collage of time-lapse photographs. The limbs of the figures are held quite rigidly at precise angles and their muscles are flexed and taut. The composition is very angular, with a heightened use of shadow to emphasise both the hurdle and the movement of the figures.

In the second panel, *Climbers*, there is less use of shadow and a much shallower relief. In

**Ritchie,** *Hurdlers*

the front plane is the figure of a young man with a pronounced quiff using a rope to climb a steep rock face. The rope forms a strong zigzag pattern as it wraps around his thigh and chest. This angularity and use of the zigzag is reflected in the folds of the young man's clothes and the articulation of his chest muscles. Behind him are three smaller figures, almost cartoon-like with their exaggerated hairstyles and in the way they are laced rather than roped together as they walk up a shallower slope. These three figures are shown in profile and their ascent adds another accent of angularity to the composition. The central figure is shown in a short skirt, unrealistic and unsuitable for her activity, rather as a signifier of her gender.[1] The mysterious beauty of the self-possessed adolescent young female body has always had a strong attraction for Walter Ritchie.

The depiction of *Hurdlers* and *Climbers* is appropriate for a school setting in many ways, most obviously the stress on physical exercise as an example to the school children. The panels can also be read as a literal depiction of encouragement to overcoming difficulties in life

and education – literally to jump the hurdles and climb the mountains.

When Park Hall School was built as Castle Bromwich Secondary Modern in the late 1940s, part of the building fund was used to provide art works for the building.

Note
[1] Ritchie, W., *Walter Ritchie: Sculpture*, Kenilworth, 1994, p.76.

## CHELMSLEY WOOD

### Meriden Park

*In peace garden*

### Ceolmund

### Sculptor: unknown

Executed: late 1980s
Bog wood and resin, painted
6m. high, top 1m diameter approx
Inscription: CEOLMUND
Condition: poor
Status: not listed
Owner/Custodian: Solihull Metropolitan Borough Council

A cluster of six long thin poles with smooth surfaces culminates in a 'capital' made of richly moulded knotty wood that bears the inscription, on top of which crouches a frog-like creature with only one eye, painted in yellow, white and brown. This is surrounded by three circles of stool-like seats, the tops of which have been painted in oil. Those in the inner circle are painted red, those in the middle circle blue, and those in the outer circle yellow. The circle arrangement recalls magic circles, while the colours are reminiscent of those in Mondrian's mature works. The sculpture is set within a circle of poplar trees, with two conifers on the north side. It is rotting and has been

Unknown, *Ceolmund*

damaged by vandalism. A young beech tree has seeded itself on the top.

The *Anglo-Saxon Chronicle* relates that Ceolmund was a Saxon chief who fought for King Alfred against the Danes during the summer of AD 897. He was Bishop of Rochester from 897–904 and held lands at Kemerton, Worcestershire, with the permission of Offa, king of Mercia. There seems to be no obvious link between his life and the form of the work, and no apparent reason for the choice of title.

## KNOWLE

### Kenilworth Road

*Jubilee House, 17 Kenilworth Road, above entrance porch*

### Queen Victoria Jubilee Relief

### Sculptor: Henry Hugh Armstead (attributed to)

Executed: 1897
Buff terracotta 1m high × 1m wide × 10cm deep approx
Inscriptions: (at top): 1897
(around frame, clockwise): CANADA
AUSTRALIA / NEW ZEALAND BURMAH /
GIBLRAL [*sic*] MALTA CYPRUS INDIA / AFRICA
W.INDIEE
(across centre): EMPRESS OF INDIA
(in circle around bust): VICTORIA 60 YEARS
QUEEN OF GREAT BRITAIN & IRELAND

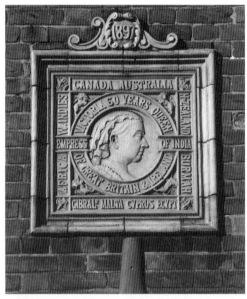

Armstead, *Queen Victoria Jubilee Relief*

Condition: good
Status: not listed
Owner/Custodian: owners of Jubilee House

This square relief panel above the entrance porch, in which the date appears in a small scrolled pediment on top, shows a bust of Queen Victoria in profile surrounded by inscriptions listing her kingdoms.

It is generally held that the building now known as Jubilee House was built to celebrate Queen Victoria's Diamond Jubilee in 1897. However there is no mention of this in the *Knowle Journal* of the period, and the *Parish Magazine* records that the official celebration in Knowle was a fête and fund raising to pay for three of the church bells to be recast and for three new bells to be added.[1] In 1935 the building, then known as Sunnyside, became the police station, which moved to new premises in 1960.[2]

Several other examples of the same panel exist, for example in Atherstone (see entry for Long Street, Atherstone) and Nottingham. They seem to have been part of the great revival of terracotta in the late Victorian period, and a number of firms were producing such architectural pieces.[3]

Notes
[1] *Knowle Parish Magazine*, July 1931. [2] Wotton, E., *The History of Knowle*, Kineton, 1972, p.73. [3] Stratton, M., *The Terracotta Revival*, London, 1993, pp.229–31.

*Attached to exterior of churchyard wall*

## King George V Coronation Fountain

### Architect: William Henry Bidlake (attributed to)

### Sculptor: unknown

### Builder: Messrs H.C. Mitchell & Son of Tamworth (attributed to)

Unveiled: 24 February 1912
Stone 1.25m high × 82cm wide × 14cm deep
Inscription: TO COMMEMORATE / THE / CORONATION / OF / KING GEORGE V / JUNE 22 / A.D. 1911
Condition: fair
Status: not listed
Commissioned by: Reverend Downing and Mr G.F. Jackson
Owner/Custodian: Knowle Parish Church

This plain drinking fountain is set against the exterior of the churchyard wall. A central basin rests on a large moulded slab supported by a demi-octagonal attached pillar with slight moulding at its base, resembling the treatment of a Doric semicolumn. The spout is set into a niche and the top of the fountain is gently curved. Despite its simple form, the fountain's overall design is sculptural and monumental. The simple Doric capital underlines the commemorative function of the fountain as it signifies the strength of character and heroism

Bidlake, *King George V Coronation Fountain*

of the monarch, King George V.

The firm of Corbett & Son submitted an invoice for a total of £10. 5s. in March 1912 for connecting mains water to both the 'Guild House and Fountain' in Knowle.[1] Although there is no other mention of the fountain in the accounts for the restoration of the Guild House, it can be presumed that the Fountain was part of the restoration project.

Note
[1] *Knowle Guild House records*, Warwick County Record Office, DBR 56/88.

## *Warwick Road*

*Guild House, 1715 Warwick Road, either side of first floor window*

## Seals of Guild and College of St Anne

### Architect: William Henry Bidlake

### Sculptor: unknown

### Builder: H.C. Mitchell & Son of Tamworth

Unveiled: 24 February 1912
Each relief: sandstone 80cm high × 45cm wide approx
Inscriptions: left hand panel: S'frat'nitat' gilde [illeg.] johis baptiste & laurenij ac [illeg.] Anne de Knoll
   right hand panel: Sigillum + commune + capelle + ad + Knoll
   The building carries an inscription carved into the wood of the gable above: 1412 DEO CHRISTAS 1912
Condition: good
Status: Grade II*
Commissioned by: Reverend Downing and Mr G.F. Jackson
Owner/Custodian: Knowle Parish Church (Church of England)

Two panels depict seals.

In the left-hand panel the seal of the Guild of St Anne of Knowle has a gothicised pointed oval shape. In the centre of the panel is a female figure with a younger female figure looking at a book, a representation of St Anne instructing the young Virgin. In two smaller niches to either side are male figures, to the left an elderly man and to the right a man holding a book and pointing to a model of a church. These figures represent St John the Baptist and St Lawrence the Martyr. At the base are two kneeling figures, one male and one female, representing the donors and members of the Guild. The inscription between the cabled borders when roughly translated reads: 'the fraternal guild of Saints John Baptist and Laurence and Saint Anne of Knoll'.

The right hand panel is the elaborate seal of the College of Saint Anne. It is a pointed oval shape with three ducal shields in its base, the outer two of which include two church bells. In a richly canopied niche the figure of St Anne is shown instructing the Virgin. Between cable borders is an inscription in Latin, which roughly translates as 'seal of the collegiate chapel of Knowle'.

The seals for the Guild and College are illustrated in the surviving second Register for the Guild, and the matrix of each is now held in the British Museum. The panels differ slightly from the original seals in that there is a greater sophistication in the depictions and subtler characterisation in the figures, hardly surprising given that they were produced some 500 years after the originals.

The church was built under the direction of William Cook, a native of Knowle, who had an illustrious career in the church, holding the offices of Archdeacon and Treasurer of St Paul's, among others. The church was consecrated as the Church of St John the Baptist, St Lawrence the Martyr and St Anne, despite being unfinished, in 1402. On 24

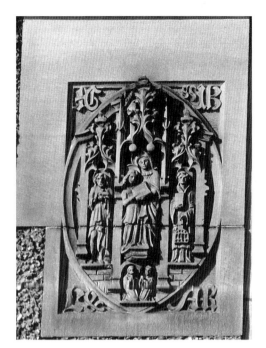

**Unknown,** *St Anne's Seal*

February 1412 Cook and six other men founded the Guild of St Anne of Knowle, a religious and social organisation to encourage charity and useful living. Four years later he and Lady Elizabeth Clinton[1] founded a College at the church. It was set up with a number of chaplains and ten Chantrey chapels in which prayers were to be offered for the good estate of the founders in life and their souls in death, and for those of their parents and friends. The triple dedication of the church and guild is rare. It was probably originally dedicated to St John the Baptist, and William Cook added Saints Anne and Lawrence. St Anne is reputedly the mother of the Virgin, and although there is no mention of Anne or Joachim her husband in the Bible, she appears in the *Golden Legend*.[2] The celebration of St Anne was especially popular in

the fourteenth century. Pope Urban VI had expressly ordered the celebration of her feast day to popularise the marriage of Richard II (1377–99) to Anne of Bohemia in 1382. St John the Baptist, the forerunner and herald of Jesus, and itinerant preacher who washed those who confessed their sins in the river Jordan, was beheaded to please King Herod's niece and step-daughter Salome.[3] St Lawrence the Martyr, one of the most popular Roman Saints, was one of the seven deacons under Pope Sixtus II put to death during the reign of Valerian AD c.258. His emblem is the gridiron.[4]

The Guild House was sold during the reign of King Henry VIII, and over the years it was subdivided and used as both domestic dwellings and commercial premises, until in 1911 Mr G.F. Jackson of Springfield House, Knowle bought the property and had it restored. It would appear from the surviving correspondence that the Reverend Downing was more closely involved in the restoration than Mr Jackson.[5] He commissioned reproduction medieval furniture and contacted a number of different authorities to try and identify the appropriate seals and correct heraldry to adorn the exterior. In a letter on 1 January 1912 local historian Mary Dower Davis recommended that as the building had been a Guild Hall, the seal of the Guild of St Anne be used.[6] Downing contacted the Birmingham Archaeological Society who had wood engravings of the seals, and by 15 January a Mr Bickley of the Society reported 'I am glad to hear Mr Bidlake is making some use of the seals'.[7] Thomas Lewis of Birmingham was commissioned to record the completed restoration and the two panels can clearly be seen in his photographs.[8]

Mr Jackson presented the Guild House back to the church on the 500th anniversary of the founding of the Guild, 24 February 1912.[9] The official opening by Dr Wakefield, Bishop of Birmingham,[10] was followed by a celebratory

supper at the Wilson Arms.[11] The building underwent further repairs in 1968.

Although not part of the remit of this survey, the Church building itself rewards further examination – in particular the restored fifteenth-century carved Rood Screen is one of the finest in the Midlands.[12] Also of note are the richly decorated chapel and tomb now known as the Soldiers Chapel and the weather vane by Reginald Cooper.

Notes
[1] Wotton, E., *The History of Knowle*, Kineton, 1972, p.9. [2] Attwater, D., *The Penguin Dictionary of Saints*, Harmondsworth, 1965, p.186. [3] *Ibid.*, p.191. [4] *Ibid.*, p.214. [5] *Knowle Guild House records*, Warwick County Record Office, DBR 56/88 and DBR 56/89. [6] *Ibid.*, DBR 56/89. [7] *Ibid.*, DBR 56/89. [8] *Ibid.*, DBR 56/88. [9] *Victoria County History of Warwickshire*, vol.IV, 1947, p.98. [10] *Birmingham Post*, 27 February 1912. [11] *Knowle Guild House records*, Warwick County Record Office, DBR 56/88. [12] Pevsner, L., *The Buildings of England: Warwickshire*, Harmondsworth, 1966, p.330.

*Above entrance to chemists, 1709 Warwick Road*

## Chemist Sign

### Sculptor: unknown

Executed: 1985
Plaster, painted in parts, 70cm high × 90cm wide approx
Inscription: CHEMIST
Condition: fair
Status: Grade II
Commissioned by: Dudley Taylor

The inscription on this shallow relief of a dark brown mortar bowl with a yellowish-beige pestle is in raised green letteringin the Art Deco manner. Whilst the background to the panel is flat, the frame is raised like a picture frame. Simple in form and colour, the image combines tradition with modernity.

Unknown, *Chemist Sign*

The eighteenth-century listed building has been refaced in modern roughcast. The sign was made by an anonymous local plasterer.

*Felon and Firkin public house*

## Bracket and Lion

### Metal worker: Reginald Cooper

Executed: *c.*1920s
Lion: 90cm high × 1.1m wide approx
Bracket: Netherton iron, wrought 3m high × 3m wide approx
Condition: good
Status: not listed
Commissioned by: White Swan public house (bracket)
Owner/Custodian: proprietors of Felon and Firkin public house

This fine wrought iron sign bracket, made for the earlier timber-framed White Swan, has stylised depictions of leaves from which hangs a sign with a red heraldic-style lion.

When the White Swan was demolished after 1939,[1] the sign was moved to the Red Lion Inn which was eventually taken over and renamed by the Firkin pub chain.

Mr Cooper and his son Reginald were

Cooper, *Bracket and Lion*

blacksmiths in Knowle. The White Swan was run by Sydney Jessop, Jnr in 1936.[2]

Notes
[1] Information provided by the artist's granddaughter, Mrs Jean Woolley. [2] *Kellys Directory of Warwickshire*, 1936, p.247.

*On the façade of National Westminster Bank building, between ground and first floor levels*

## Swan and Heraldic Reliefs

### Sculptor: unknown

Executed: before 1939
Sandstone, each panel 65cm high × 40cm wide approx
Condition: good
Status: not listed
Commissioned by: the White Swan
Owner/Custodian: National Westminster Bank

On either side of the entrance to the bank between ground and first floor levels are two relief panels. That on the left is a heraldic device showing barley, grapes, a tankard and wineglass in sectors formed by two crossed churchwarden's pipes. The right hand panel shows a swan swimming in stylised flowing

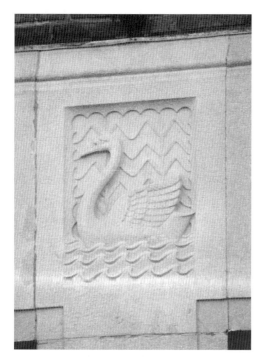

Unknown, *Swan Relief*

water with a zigzag background. The panels, in Art Deco style, are strongly two-dimensional. The simplification of space and motif indicates that they are probably following a graphic work, possibly a book illustration.

The reliefs refer to the White Swan public house, which stood on this site until demolished after 1939.

## *The Green*

### *Village Cross*

### Sculptor: unknown

Executed: *c.*1400s
Sandstone 3m high approx
Inscriptions: bronze plaque on plinth: THIS ANCIENT WAYSIDE CROSS / HAS STOOD IN THE VILLAGE / FOR SOME 500 YEARS AND BY / TRADITION IT MARKS THE CENTRE OF ENGLAND / THE CROSS WAS REBUILT ON THE SITE WHEN THE GREEN / WAS IMPROVED IN CELEBRATION / OF THE FESTIVAL OF BRITAIN / A.D. 1951
on smaller plaque in base of railing: PRIOR TO ITS RE-ERECTION THE CROSS WAS LOANED / AS THE CENTRE-PIECE FOR A MODEL VILLAGE BUILT / IN THE IDEAL HOME EXHIBITION OLYMPIA LONDON / DURING MARCH 1952
Condition: poor
Status: Grade II

The stepped octagonal plinth has three very worn stone steps supporting a plain square base stone, which is broached to the octagonal top under a tapering octagonal shaft. The cross has

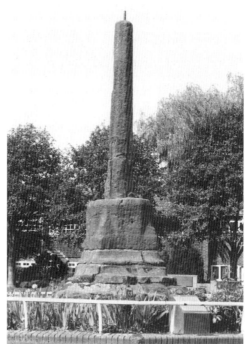

Unknown, *Village Cross*

a missing crosspiece. It is set in a flowerbed behind railings. There is an inscription plaque on the cross shaft and a second smaller plaque on the railings.

The cross is reputed to mark the centre of England. It was lent to the 1952 Ideal Homes Exhibition, and on its return was sited in the middle of the green, having previously been at the road junction.[1]

Note
[1] Information provided by Sue Bates, Solihull Local Studies Librarian, 25 May 1999.

## SHIRLEY

### *Hasluck's Green Road*
HASLUCK'S GREEN

*On the façade of Comdean Ltd, first floor level*

### *Sculpture: The Shark*

### Sculptor: unknown

Executed: 1990s
Fibreglass and bricks, 80cm high × 80cm wide × 90cm deep approx
Condition: good

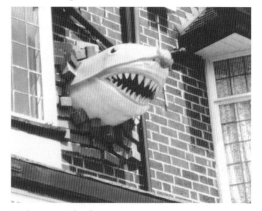

Unknown, *Shark*

Status: not listed
Owner/Custodian: Comdean Ltd

This fibreglass shark, painted in a realistic manner, protrudes amongst additional bricks from the first floor of the building, giving the appearance of having bitten or forced its way through the wall.

The history and original function of this decoration are not known, but it was possibly used as a sign for a fishmonger's or a fishing equipment shop. In the present context, its role is purely aesthetic, and its theoretical justification is provided by surrealist and pop art ideologies that depend on the shock value of seeing a commercial image in an unexpected context.

## SOLIHULL

### Blossomfield Road

*Tudor Grange, annex to Solihull College*

### Façade of Tudor Grange

#### Sculptor: White & Sons (South Yardley)

#### Designer: T.H. Mansell

Executed: 1887
Stone, statues life-size
Condition: fair
Status: not listed
Commissioned by: Alfred Lovekin
Owner/Custodian: Solihull College

This complex programme of architectural decoration consists chiefly of foliate and abstract relief, but also includes some ornamental heads, full-length statues and several coats of arms. Most of the sculptural decoration is on the north front, facing Blossomfield Road.

The entrance porch has a keystone head in the arched portico, relief panels of foliate design in the spandrels, a frieze including a number of male heads and decorative panels like Elizabethan strapwork patterns. Above this porch, the central gable has a panel with the date '1887', a large shell and, at the apex, a stylised lion holding a blank shield: similar lions' heads appear as decorative detail on both sides of the main building. At either side of the central gable are pyramid obelisk finials on four ball feet.

There are three full-length figures on the balustrade at the roofline at the front of the building, and four at the back. At the front, the western block has a male figure in medieval dress with a sword at his waist, his right hand raised and his cheeks distended as if he were blowing a horn or drinking from a long vessel, which is now missing. East of the central block is the figure of a knight in full armour with a feather-decorated helmet, a large shield propped against his leg and a sword at his waist. He stands as if holding the remains of a lance. Since the shield is decorated with the cross of St George, he could represent either St George, the patron saint of England, or King Arthur,

**White & Sons, *Knight, Tudor Grange façade***

another legendary dragon slayer who is often represented with a shield bearing the St George's cross. At the eastern angle there is a more classical figure, naked except for a loincloth, pointing a bow towards the sky. The arrow is missing, but there is a second arrow attached to his waist. He may represent Hercules at his sixth labour, shooting the man-eating Stymphalian birds with poison-tipped arrows.

At the top of the central gable on the façade at the back there is a figure of an owl, symbolic of learning and wisdom. The west gable shows Brutus as a mustachioed medieval warrior with a battle axe, together with a helmeted figure in fifteenth-century armour, who probably represents William the Conqueror. On the east gable is a figure holding a hunting horn, with a hound at its feet, and a man with a crossbow, who could be William Tell. A single storey extension to the west of the north front is crenellated in a decorative fashion, with a number of Tudor roses and a frieze of panels similar to those on the main frontage, and a number of heads. A worn shield still has the remnants of a coat of arms discernible on it.

A small extension to the east of the north front has a pediment enriched with a foliate design, a head and a now blank oval shield which may have once displayed a specific a coat of arms. This may have been that of the Bird family, whose shield depicts two popinjays on a gold background, surmounted by three sheaves of wheat against a pale green background. The family motto is 'Copia ex industria' (From industry plenty).[1] The pediment is surmounted by the emblem of Warwickshire, a chained bear standing next to a tree trunk. This looks like a modern addition or a replacement of an earlier sculpture in view of its iconography and style.

Further east is the arched entrance to the stable block. Again the façade is decorated, this time with a central cartouche of an oval shield carrying a chevron with smaller blank shields in

**White & Sons**, *Owl, Tudor Grange façade*

nineteenth century in an Elizabethan style 'from designs and under the superintendence of Mr T.H. Mansell without regard for expense' for Alfred Lovekin.[3] The house was later bought by Sir Alfred Frederic Bird, son of the inventor and leading manufacturer of custard powder.[4] Sir Alfred was born in 1849, was Conservative MP for Wolverhampton from 1910, and was killed in an accident in London in 1922. Comparison of the catalogue[5] for the sale of Tudor Grange in 1900 and a Souvenir Programme for a garden party held in 1913 by Alfred Bird[6] reveals that he had extended the house to the east, refaced a section to the west (which he used as his study) and added a number of sculptures to the balustrade and roof line. Illustrations in the programme also reveal the spandrels. A hunched old male figure stands atop the triangular pediment. He has a grossly enlarged head, is bearded and carries a bundle of sticks on his back and a staff in his hand. He is probably a personification of Winter or Time. There is a decorated sundial at the back of the house, which is inscribed with the words 'I only count ye Sunny Hours'. This probably dates from around 1913.

The difficulty in identifying and interpreting these standing figures is due to their seemingly unorthodox iconography. However, what at first sight seems to be the fanciful product of late Romanticism, is in fact a carefully designed and elaborate iconographical programme promoting the idea of English imperialism as well as the social aspirations of the family who commissioned them. The iconography of the figures seems to be based on late sixteenth- and early seventeenth-century English engravings of heroes of Greek mythology, ancient Roman emperors, and characters from English legend. If this hypothesis is correct, the armed figures on both sides of Tudor Grange can be identified as the successful conquerors whose descendants ruled over Britain. These characters underwent a double transformation: first, they were made to suit the roles originally assigned to them by Elizabethan and Jacobean engravers such as William Hole, the designer of Michael Drayton's *Polyalbion* (1612–22)[2] and, second, they were transformed by the fancy of the romantic imagination.

The recurring motif of the Tudor rose, rather than the decorative elements that are mainly Jacobean in style, gives the building its name. Tudor Grange was built in the late

**White & Sons**, *Clock, Tudor Grange façade*

that the baroque clock decorated with a cherubic head that is now on one of the gables at the back, once stood at the entrance to the stables. This further strengthens the reading of the figure above as an embodiment of Time. It is also possible to reconstruct Coat of Arms on the shield on the exterior of the study from this programme. It shows a Tudor rose with a chevron and two fleur de lys above, the whole topped with a knight's helm as a crest.

During Bird's time the gardens at Tudor Grange contained a number of sculptural works: 'dotted here and there are many interesting old vases, seats, ornaments, cannons and curios, included among the last named being the original figure-head of the Old Queen Anne warship, the "Royal Anne" … [in the new Italian garden] A graceful dripping vase occupies the centre, presided over by an exquisite bronze figure of that imp of mischief, Puck … Just a touch of romance is given by the two Delightful Watteau figures in bronze entitled "The Lady and her Beau".'[7] Most of these garden sculptures were sold after the death of Alfred Bird's widow at an auction of 1944.[8] The bronze group *Horse and Horse Tamer* (see Park Road, Malvern Park) came from Tudor Grange. It was bought at the auction by Alfred Bird's son who donated it to Solihull.

Notes
[1] Fox-Davies, A.C., *Armorial Families: A Directory of Gentlemen of Coat-Armour*, London, 1930, p.157.
[2] Corbett, M. and R.W. Lightborn, *The Comely Frontispiece, The Emblematic Title-Page in England 1550–1660*, London, Henley and Boston, 1979.
[3] Florence, J.W., Tudor Grange Sale Catalogue, Solihull, 1900. [4] Lines, C., *Britain in Old Photographs: Solihull*, Stroud, 1998, p.99.
[5] Florence, J.W., *Idem.* [6] West Wolverhampton Unionist Association, *Souvenir Programme Open-Air Demonstration and Garden Party*, Tudor Grange, Solihull, 19 July 1913. [7] *Ibid.* [8] Edwards, Bigwood & Mathews, Auctioneers, *Tudor Grange Solihull, Catalogue of the Furnishings, Contents of the House and Objets D'Art*, 18 – 21 April, 1944, Solihull, 1944.

*Brueton Avenue*

*Frieze to entrance bay, St Martin's Independent Day School (formerly Malvern Hall)*

## *Frieze of Bulls' Heads*
### Architect: John Soane
### Designer: Inigo Jones

Executed: *c.*1784
Each head: 30cm high approx
Condition: good
Status: Grade II*
Commissioned by: Henry Greswolde Lewis
Owner/Custodian: St Martin's Independent
   Day School

The frieze around the central semi-circular entrance porch to the building consists of eight bulls' heads with ribbon tassels from their ears and garlands of flowers and fruits, which

Soane, *Frieze of Bulls' Heads*

visually continue the line of balustrades of the two balconies that flank it. The combination of the bulls' heads and the garlands of fruit symbolises hospitality.

The Rector of Solihull, Henry Greswolde bought the Malvern estate adjacent to his rectory, and his son Humphrey, who died in 1712, built Malvern Hall. Greswolde Lewis, who inherited the Hall in 1773, began remodelling and extending it from 1784.[1] Frank Greswolde Williams, a descendant of the Greswoldes, sold it in 1896 to a Mr David Troman, who demolished the third storey and remodelled the wings. The Hall was bought by Solihull Rural District Council in 1926, and it became successively Malvern Hall Girl's School, a high school, a comprehensive school, and it is now St Martin's Independent Day School for Girls.[2]

When in *c.*1784 John Soane altered Malvern Hall for a cost of £3,083,[3] he was still a

relatively inexperienced architect. He published an engraving of the front elevation with its frieze of bulls' heads on the segmented bowed Ionic portico in 1788.[4] He seems to have created the porch and its frieze decoration by combining two different designs he saw in *The Designs of Inigo Jones consisting of plans and elevations for Public and Private Buildings*, published by William Kent in 1770, in which appear a frieze combining identical bulls' heads and garlands in the elevation drawing of 'a plan for a palace',[5] and the curved portico with a single bull's head directly over each pilaster in the elevation drawing for a different 'design for a palace'.[6]

Notes
[1] Tyack, G., *Warwickshire County Houses*, Chichester, 1994, p.122. [2] Lines, C., *Britain in Old Photographs: Solihull*, Stroud, 1998, pp.107-8. [3] *Ibid.*, p.123. [4] Soane, J., *Plan, Elevations and Sections Of Buildings*, London, 1788. [5] Jones, I. and Kent, W., *The Designs of Inigo Jones consisting of plans and elevations for Public and Private Buildings, with some additional designs*, London, 1770, vol.II, pl.33. [6] *Ibid.*, pl.46.

*In niches on back of gate posts, St Martin's Independent Day School (formerly Malvern Hall)*

## *Knowledge and Prudence*
### Designer: after Inigo Jones

Executed: *c.*1811
Each figure: stone 1m high
Condition: good
Status: Grade II
Commissioned by: Henry Greswolde Lewis
Owner/Custodian: St Martin's Independent
    Day School

These two full length figures are sited either side of the entrance in a niche on the rearside of the gateposts. Both figures are female, wearing classical dress. The figure on the right, a personification of Knowledge, holds a torch in

(above) After Inigo Jones, *Gatepost with Garlands*

(right) After Inigo Jones, *Prudence*

her left hand and a scroll in her right hand. The hands of the figure on the left are positioned in the characteristic 'pudica' pose, indicating that she personifies Prudence. The seventeenth-century stone gatepiers have entablatures, ball finials and statuettes in the niches facing the house. Two isolated posts mark the forecourt of

the building. On the front face and inner-sides of each is a panel of relief sculpture depicting a hanging garland festooned with leaves, flowers, fruit and ribbons.

The 'old design by Inigo Jones' referred to by Greswolde Lewis is most probably the mid-1630s *Sketch elevation for a niche with a*

*voussoired architrave surround containing a statue* attributed to Jones' work to relocate some of Charles I's antique statues in the gardens of Somerset House and St James's Palace.[1] The articulation of the architrave and surmounting ball finial of the gateposts at Malvern Hall shows a marked similarity to Inigo Jones's sketch, although Lewis appears to have taken considerable licence with the design with regard to the scale of the niche, pillar and statue.

For the history of Malvern Hall, see the entry for *Frieze of Bulls' Heads*.

Note
[1] Harris, J. and Higgott, G., *Inigo Jones: Complete Architectural Drawings*, New York, 1989, pp.204–5.

## Drury Lane

*On supporting pillar of Mell House*

### Memorial to W. Maurice Mell LL.M.

#### Sculptor: John Bridgeman (attributed to)

Unveiled: 17 December 1984
Bronze 60cm high × 60cm wide approx
Inscription: applied cream coloured lettering:
    W. MAURICE MELL, LL.M. / Town Clerk 1946–1965 / who planned / modern Solihull.
Condition: fair
Status: not listed
Commissioned by: Solihull Metropolitan Borough Council

This circular medal-like plaque features a portrait bust in relief of Maurice Mell, wearing glasses and a barrister's wig, in three-quarter profile. There is an inscription beneath the portrait.

Maurice Mell was the first borough clerk when Solihull was given county status, and was the mastermind behind the Mell Square

Bridgeman, *Memorial to W. Maurice Mell LL.M.*

development. He died on 19 March 1965, aged 56.

The Mell Square shopping development was built between 1962 and 1965 after the demolition of many old buildings in Drury Lane and Mill Lane. In 1966, it was named after (William) Maurice Mell, and this plaque was officially unveiled by Solihull's Mayor, Cllr Geoffrey Gibbons, in the presence of Mell's two daughters.[1] The square was refurbished in the 1980s.

Note
[1] *Solihull Times*, 14 December 1984.

## Grove Road

*The Grove Surgery, 3 Grove Road, on wall by entrance*

### The Unicorn and the Serpent

#### Sculptor: Walter Ritchie

#### Architect: Brian Rush and Associates

Executed: 1970
Dark green Westmorland slate 74cm high × 1.14m wide × 10cm deep
Condition: good
Status: not listed
Commissioned by: Partners in Grove Road Practice
Owner/Custodian: The Grove Surgery

This low relief panel depicts the rescue of a male figure from a serpent by a unicorn. The male is to the right of the panel, his head thrown back and his left arm raised as he reaches with outstretched right arm for the horn of the unicorn. The snake is along the bottom of the panel, its tail coiled around the figure while its head is being trampled under the rear feet of the unicorn, which is shown in profile, lowering its head to proffer its horn to the struggling figure. Whilst the background is

Ritchie, *Unicorn and Serpent*

textured and pitted, the figurative elements of the scene are smoothed. The shape of the panel is uneven, and the figure composition unnaturalistically stylised.

The artist described the subject of this panel thus: 'There is an ancient belief in the medicinal properties of the Unicorn's horn, especially as an antidote to poison. Here the Unicorn is rescuing a patient from a very nasty situation!'[1] The earliest description in Greek literature of the purifying properties of the unicorn's horn comes from the historian Ctesias (c.400 BC), who related that the Indian wild ass was the size of a horse with a single horn on its forehead, and that those who drank from its horn were thought to be protected from stomach trouble, epilepsy, and poison.[2] The association of the serpent with evil is found in many ancient mythologies. It is perhaps most familiar from the Bible, where it is a serpent who tricks Eve into eating the fruit of the Tree of Knowledge, leading to Adam and Eve's expulsion from the Garden of Eden.[3]

The work was commissioned by the partners of the practice at the end of 1969, just before the opening of their new surgery building. One of the partners knew Walter Ritchie, who produced a selection of ten drawings, 'the particular subject being chosen because of the historical connection between the unicorn's horn as an antidote to poison, and clearly the serpent constricting the human form was designed to symbolise the evils of disease'.[4] The work is regularly cleaned, but has had no restoration or conservation work done to it. The partners have now adopted the work as the emblem of the practice, using a representation of it as the watermark on their letterhead.

Notes
[1] Ritchie, W., *Sculpture in Brick and Other Materials*, Kenilworth, 1978, p.102. [2] *Encylopedia Britannica Online,* http://members.eb.com [3] Genesis, 3.1–19. [4] Letter from Dr P.J. Travis, 1 June 1999.

## Homer Road
*Library courtyard*

### *Cupid with Needle and Fishing Net*
#### Sculptor: unknown

Executed: late 1700s
Marble 55cm high × 63cm wide × 31cm deep
Condition: good
Status: not listed
Owner/Custodian: Solihull Metropolitan Borough Council

This Cupid with small wings is sitting with one leg outstretched and the other bent. Between his legs he holds a fishing net in his left hand; in his right hand he holds a needle for making and mending nets. This is an obscure iconography. Cupid, either with a magnetic needle or a net, is a recurring motif in seventeenth-century Dutch emblem literature, but the combination of these

Unknown, *Cupid with Needle and Fishing Net*

attributes seems to be unprecedented. Its meaning must be connected with the finding, retaining and reconciling of the beloved.

This late eighteenth-century work was taken from Malvern Hall (see the entries for Brueton Avenue above) by the Solihull Metropolitan Borough Council when they vacated the premises for St Martin's School.[1] The report on the proposed disposal of valuables from the Hall was accepted at a meeting of the Education Committee on 7 June 1988.[2]

Notes
[1] Information provided by Sue Bates, Solihull Local Studies Librarian, 25 May 1999. [2] *Solihull Metropolitan Borough Council Minute Book*, Education Committee, 7 June 1988, vol.19, p.130.

### *Little Flute Player*
#### Sculptor: Sean Crampton

Executed: 1950s
Bronze over a steel frame 1.6m high × 1m wide × 30cm deep approx
Condition: fair
Status: not listed
Owner/Custodian: Unknown, in care of Solihull Metropolitan Borough Council

This standing figure playing a flute has no base. It stands in the gravel of a flower bed, its feet together, wearing a simple semi-spherical shepherd's hat and a coat. The garments are stylised into abstracted shapes and rectangular blocks that still evoke the fall of drapery. On closer inspection the decoration of the coat becomes evident, swirls and lines of metal representing buttons and embroidery. The strikingly delicate surface pattern connects the work with the mainstream of the mid-twentieth-century European avant-garde. The figure is tall, thin and attenuated. In contrast to the verticality of the figure, the hands are large and the arms and shoulders have a breadth and sense of strength. The face is long and thin, the

**Crampton,** *Little Flute Player*

eyes partially hidden under the brim of the hat and there is little characterisation. The work is moulded from pierced and folded metal. It has an overall sense of fluidity that seems paradoxical in juxtaposition with the crispness of the general forms.

The iconography of the flute player has a long-standing tradition in European art going back to the fourteenth century, from wandering minstrels to the Pied Piper.

This statue was originally sited in a small green space outside the former Sefton Marks shop on Warwick Road, Solihull.[1] There are no records of its move to the Library courtyard, or of its original erection in Warwick Road.

Note
[1] Information provided by Sue Bates, Solihull Local Studies Librarian, 25 May 1999.

*Library, first floor*

## *Two Allegorical Figures*

### Sculptor: unknown

Executed: late 1700s/early 1800s
Larger figure: Coade stone 1m high × 40cm
  wide × 40cm deep
Smaller figure: Coade stone 80cm high × 40cm
  wide × 40cm deep
Condition: good
Status: not listed
Owner/Custodian: Solihull Metropolitan
  Borough Council

Two seated young girls of slightly different sizes, carved in a neo-Classical style, are datable to the late eighteenth or early nineteenth centuries. The larger figure, in classical dress but with the upper part of her body exposed, is seated on a tree stump, holding flowers in her robes and wearing a garland of flowers in her hair. At the bottom of the tree stump is a small snake against a plant. The smaller figure is seated on a cushioned stone with a dead bird on her lap and rubbing the tears from her eyes with her right hand. Although their subject matter does not seem to conform to any classical iconographical convention, the context of their poses, gestures, facial expressions and attributes suggests an allegorical meaning on the theme of Fall and Punishment, or Retribution.

These works were taken from Malvern Hall (see Brueton Avenue entries above) by the Solihull Metropolitan Borough Council when they vacated the premises for St Martin's School.[1] The report on the proposed disposal of valuables from the Hall was accepted at a meeting of the Education Committee on 7 June 1988.[2]

Notes
[1] Information provided by Sue Bates, Solihull Local Studies Librarian, 16 June 1999. [2] *Solihull Metropolitan Borough Council Minute Book*, Education Committee, 7 June 1988, vol.19, p.130.

**Unknown,** *Allegorical Figures*

## Lode Lane

*Junction of Station Road and Lode Lane*

### *Jubilee Stone*

### Sculptor: unknown

Executed: 1897

Red granite 1m high × 1.7m wide × 1.2m deep
approx

Inscriptions: incised and coloured black, in two
sections: TO COMMEMORATE / THE FIFTIETH
YEAR OF / THE BENEFICENT REIGN OF / HER
MAJESTY / QUEEN VICTORIA / THE OAK TREE
CROWNING HEREBY WAS PLANTED / A.D. 1887
THIS STONE WAS SET / AS A PERMANENT
RECORD / OF THE QUEEN'S REIGN HAVING
BEEN / HAPPILY PROLONGED / TO THE CLOSE
OF / ITS SIXTIETH YEAR / A.D 1897.

Condition: good

Status: not listed

Commissioned by: public subscription

Owner/Custodian: Solihull Metropolitan
Borough Council

This large boulder with inscriptions on its front
face is set in cobbles on the green space at the
road junction next to a young oak tree.

The Jubilee Stone was moved slightly from
its original setting as part of a road traffic
improvement scheme in 1959,[1] and again in 1999
during the refurbishment of Yates Wine Lodge.[2]

**Unknown,** *Jubilee Stone*

Notes
[1] *Solihull Borough Council Minute Book*, Public
Works Committee, 8 September 1959, vol.59/60,
p.318. [2] Information provided by Sue Bates, Solihull
Local Studies Librarian, 25 May 1999.

## Mell Square

*Opposite Savoy Tailor's Guild shop*

### *Family Outing*

### Sculptor: John Ravera

Executed: 1985

Sculpture: bronze 1.5m high × 1.8m wide ×
40cm deep approx

Base: stonework semicircular, 1m diameter ×
60cm high approx

Inscription: bronze plaque on base with incised
lettering: Family Outing / John Ravera
F.R.B.S. / 1985 / Commissioned By /
NORWICH UNION / INSURANCE GROUP

Condition: good

Status: not listed

Commissioned by: Norwich Union Insurance
Group

Three smaller than life-size figures of a man, a
woman and a child, linked by their hands, are
looking at one another. The woman and child in
particular exchange a look of contented
intimacy as the child is being swung aloft by the
two adult figures. The adults' feet rest directly
on the stone plinth whilst the child rests one
foot on the man's leg, suggesting that they are
integral to the surrounding environment. They
are depicted in simple casual contemporary
dress and with 1980s hairstyles, echoing the
informality and intimacy of their pose. The
sculptor has conveyed the sense of motion and
activity through the folds in the woman's dress.
The effect is as if a moment in time has been
frozen, allowing the viewer to contemplate an
intimate and private episode of the family's
outing. Yet the group has some allegorical
allusions: the family as a fundamental social

**Ravera,** *Family Outing*

unit, the parents as equal and solid foundations
of a happy and playful childhood.

Mell Square was refurbished in the 1980s. At
a meeting of the council's Land Sub-Committee
in December 1987 the Town Clerk reminded
the committee that in the contract for the Mell
Square improvements a sum of £10,000 had
been set aside for a sculpture, and
recommended that: 'If it was thought right to
place a work in the centre of the town, it should
be a piece of real merit and worth, something
which would stand the critical view of
posterity. It would perhaps be better to have
nothing than to accept something that was not
of that worth.'[1] The Councillors decided to
approach local businesses for contributions to
enable a sculpture 'of worth' to be sited and
Norwich Union agreed to fund the work.

Note
[1] *Solihull Metropolitan Borough Council Minute
Book*, Land Sub-Committee, 1 December 1987, p.909.

## Fountain
### Sculptor: unknown

Installed: 1987
Cast iron, painted 2m diameter × 4.5m high
   approx
Condition: poor
Status: not listed
Owner/Custodian: Solihull Metropolitan
   Borough Council

This ornamental fountain has four oriental fish heads forming spouts at the base. Above them is an organic-shaped basin from which rises a shaft shaped like a flower stem with leaf shapes at its top. This supports a second basin with petal-like detailing from which rise three herons and a number of tulips to support the uppermost spout, which again is shaped like a flower bud or stem. Herons were protected royal birds and signify purity. The fountain dates from the nineteenth century yet is in the style of the late fifteenth-century Florentine early Renaissance.

The Mell Square shopping development was built to the designs of architects Henry W. Weedon and Partners, Birmingham, between 1962 and 1965 after the demolition of many old buildings in Drury Lane and Mill Lane. It was officially named in 1966 in honour of (William) Maurice Mell, Town Clerk 1947–65 (see the entry *Memorial to W. Maurice Mell*, Drury Lane), and refurbished in the 1980s.

When the Square was first opened in May 1967 there were four large fountains in a rectangular pool in the centre of the square.[1] However, they were not popular. In 1982 the Chair of Solihull Chamber of Trade and Commerce, Mr Martin Canning, called for their removal as '[they] hardly ever work – they are often choked up with rubbish and look a mess'.[2] When the square was redeveloped in 1987 it was decided to replace them with 'a smaller ornamental fountain [which] will be built to provide an interesting and relaxing focal

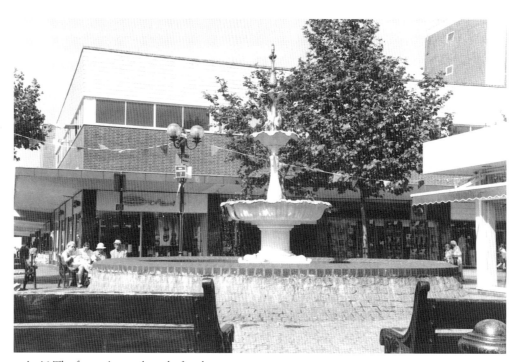

Unknown, *Fountain*

point'.[3] The fountain was bought for the Council by Stan Stellars from the architectural supplier Crowther of Syon Lodge Ltd, Isleworth, Middlesex.[4]

This fountain, too, has had its detractors. In 1993 a local resident, Mr David Ball, wrote to the *Solihull News* to complain: 'Many towns have beautiful fountains bubbling away with movement, unlike the unfortunate example of civic embarrassment in Mell Square. No more than a trickle of brownish liquid has been seen for over 12 months. If a fountain is a symbol of life, then it is no wonder Mell Square seems as dead as the proverbial dodo … At one side of the square there is a magnificent bronze statue, but at the other is this pathetic attempt at a fountain.'[5] A spokesman for the Town Clerk's Department retorted: 'we have been very disappointed with the wanton vandalism which the fountain has suffered … The fountain is a genuine antique which was found and rebuilt as

part of this attractive feature.'[6] As a result of public criticism, the fountain was overhauled in 1993 by the Council's Technical Services Department and Ford Water Pumping Services.[7] However calls for its removal continue in the local press, mainly because of vandalism and the cost of constant repairs, and the fountain's future remains uncertain.[8] In October 1997 Solihull Council's Land and Economic Development Committee considered a motion to dismantle it and replace it with a flowerbed at a cost of £5,000 to £10,000. It was considered that this would save money in the long run in comparison to the running costs, which in 1996 had amounted to £6,000.[9] No decision was reached and it appears that the Council are still considering their options.

Notes
[1] *Solihull News*, 27 May 1967. [2] *Ibid.*, 18 June 1982. [3] *Ibid.*, 24 August 1987. [4] Information provided by Carole Walker, Department of Environment Services, Solihull MBC. [5] *Solihull News*, 15 October 1993. [6] *Ibid.*, 15 October 1993. [7] *Ibid.*, 20 October 1993. [8] Solihull Metropolitan Borough Council, *A Walk Around Solihull*, Solihull, 1999. [9] *Solihull Metropolitan Borough Council Minute Book*, Land and Economic Development Committee, 7 October 1997, 50.

## New Road

*On the façade of St Alphege Church of England Nursery and Infant School at ground floor level*

### St Alphege

**Sculptor: William James Bloye**

**Restorer: Robert Bridgeman & Sons of Lichfield**

Executed: 1959
Stone 1m high × 40cm wide × 25cm deep
   approx
Condition: good
Status: not listed
Commissioned by: Bragg Bros Ltd
Owner/Custodian: St Alphege Church of
   England Nursery and Infant School

This standing male figure dressed in bishop's vestments, his right hand raised in the act of blessing, has a heraldic shield at his feet. The figure's pale colouring contrasts vividly with the brick façade of the building. In a neo-Romanesque style, the figure is architectonic in conception: it is elongated and the drapery is stylised, revealing little of the body beneath, and showing Bloye's versatile mature figure style.

A Saxon saint, Alphege was Archbishop of Canterbury, 1006–12, and was martyred by the Danes at Greenwich. Also known as Elphege or Ælfheah, he was born about 953, during the second major period of Viking raids against England. He became a monk and then a hermit, before being appointed Abbot of Bath. In 984 he became Bishop of Westminster and in 1005 Archbishop of Canterbury. In 1011 the Danes overran much of southern England, despite the tribute agreed on, the Danegeld. That September they captured Canterbury and held Alphege and other prominent persons for ransom. The latter were duly paid for and released, but the price demanded for Alphege, 3,000 pounds, was so high that, knowing the poverty of his people, he refused to pay or let anyone else pay for him. At the end of a drunken feast, the Danes pelted him with objects before an axeman delivered the deathblow. When the Dane Cnut (Canute) became King of England in 1016, he adopted a policy of conciliation, and in 1023 brought Alphege's body back to Canterbury, where he was long remembered as a martyr, one who died, not for professing the Christian faith, but for exercising the Christian virtue of justice. In art, he is shown with an axe, the instrument of his death, or as a shepherd defending his flock from wolves, or in his pontifical vestments.[1]

St Alphege School was founded on this site in 1850 as the local Elementary School. From 1954 onwards the school buildings were completely modernised, and rebuilding was undertaken in several distinct phases, starting in 1957 with the building of a school hall.[2] The final phase was the demolition of the façade of the original school in August 1966[3] and its replacement with the present building which was opened on 8 July 1967[4]. Photographs in Solihull Library Local Studies department show the figure of St Alphege on the façade of the school hall.[5] It was presumably moved to the new façade in 1967. An entry in William Bloye's ledger reveals that the firm Bragg Bros Ltd paid £50 for the statue in April 1959,[6] which underwent restoration in 1994, when its broken right arm was replaced.[7]

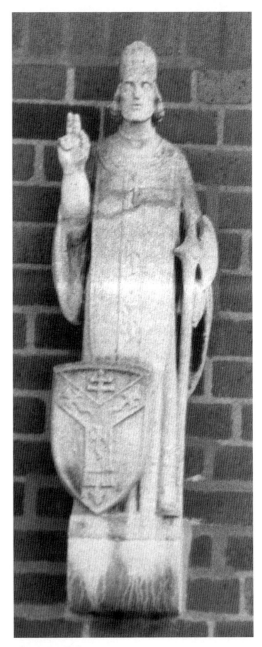

Bloye, *St Alphege*

Notes
[1] Keifer, J.E., *Biographical Sketches*, www.justus.anglican.org/resources, 2000, "Aplhege"
[2] *Solihull News*, 16 July 1966. [3] *Ibid.*, 27 August 1966. [4] *Ibid.*, 15 July 1967. [5] *Photograph Collection*, Solihull Library, SC 5764. [6] Bloye, W.H., *Sales Ledger 1932–68*, p.165. [7] Information provided by Mr Alan Norman, school governor.

## Northdown Road

*On grass area at side of road between houses*

## Woman and Child

### Sculptor: Bryan Blumer

Executed: 1963–4
Figures: concrete 1.4m high × 1.6m wide approx
Plinth: engineering brick 70cm high × 90cm
    wide × 90cm deep approx
Condition: fair
Status: not listed
Commissioned by: Bryant Homes Ltd

A brick built plinth supports a woman seated with her legs in the air and balancing a small child with her feet. The figures are simplified,

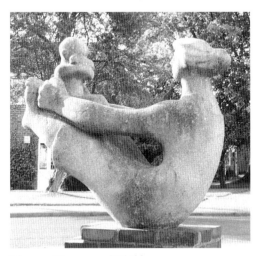

**Blumer, *Woman and Child***

rounded and with little individual characterisation.

Despite a note in Solihull Library Local Studies subject index recording that this work was done by Brian Blumer for Bryant Homes Ltd, the Council has claimed in the past that the work is by Elizabeth Frink. It is not listed in the Frink Catalogue Raisonné or any exhibition catalogue of her work, and stylistically it does not fit any stage in her oeuvre. There is no mention of the work in the local newspaper or council minute books for the period.

The sculptor was a part-time member of the school of sculpture at Birmingham College of Art and Design during the 1960s, whose style was reminiscent of the grandeur and purity of Maillol's monumental female nude figures. Photographs provided by his widow, Mary Allan, confirm that the work is by him.[1]

Note
[1] Information provided by Mary Allan, widow of Bryan Blumer, 10 July 2000.

## Park Road

*Malvern Park*

## Horse and Horse Tamer

### Sculptor: Joseph Edgar Boehm
### Foundry: H. Young & Co

Unveiled: 15 December 1953
Plinth: stone 1.7m high × 2.06m wide × 1.64m
    deep
Plaque: bronze 40cm high × 70cm wide
Sculpture: bronze 2.7m high × 2.2m wide ×
    1.64m deep
Signatures: at base of bronze on the north face:
    J. E. Boehm / fecit 1874
    at base of bronze, on the west face: H.
    YOUNG & CO / ART FOUNDERS / PIMLICO
Inscription: (on a bronze plaque on the west
    face of the plinth, in raised letters): THIS
    STATUE WAS GIVEN TO SOLIHULL BY /
CAPTAIN OLIVER BIRD M.C.J.D. / HIGH
SHERIFF OF WARWICKSHIRE 1943–44 / IN
MEMORY OF HIS FATHER / SIR ALFRED H. BIRD
BARONET. D.L. / OF TUDOR GRANGE
SOLIHULL / FROM WHICH PLACE IT WAS
REMOVED IN 1953.
Condition: fair
Status: Grade II
Owner/Custodian: Solihull Metropolitan
Borough Council

The sculpture of a rearing muscular horse restrained by a standing male is set on a plinth on paving within a rose bed protected by railings. There is a bronze plaque on its west face, a shield in a wreath on its north face and a stylised rose on the other faces. The horse is sturdy, has a thick neck and shows similarity to the baroque tradition of depicting horses. The male figure is depicted bare foot and with his shirt sleeves and trouser legs rolled up, identifying him as a worker or servant. He is holding the halter of the horse, restraining it. Based on the famous Dioskouri in Rome, the motif was revived in Renaissance painting, medals and bronze statuettes as an allegorical group signifying passion (the horse) restrained by reason (man).

The sculptor, a Hungarian, was a favourite of Queen Victoria, and made a very similar horse and groom for the 1st Duke of Westminster.[1] In 1874 he exhibited a bronze statue called *The Horse and His Master* as item 1520 at the Royal Academy summer exhibition.[2]

Sir Alfred Frederic Bird, son of the inventor of the famous custard powder, was born in 1849. He was Conservative MP for Wolverhampton from 1910, and made a notable collection of statuary at Tudor Grange. He was killed in an accident in London in 1922, and on the death of his wife in 1944 Tudor Grange was sold. In the sale catalogue it was described as an 'Exceedingly Fine Life Size Bronze Statue of

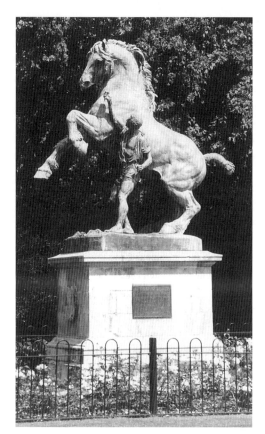

**Boehm, *Horse and Trainer***

allotments be levelled and the land incorporated into the park.[6] The statue was formally presented to the Council at a short ceremony.[7]

Notes
[1] Lines, C., *Britain in Old Photographs: Solihull*, Stroud, 1998, p.101. [2] Graves, A., *Royal Academy Exhibitors 1769–1904*, London, 1905, p.219. [3] Edwards, Bigwood & Mathews, Auctioneers, *Tudor Grange Solihull, Catalogue of the Furnishings, Contents of the House and Objets D'Art*, 18–21 April, 1944, Solihull, Lot 874. [4] *Solihull Urban District Council Minute Book*, General Purposes Committee 13, 1953, p.45. [5] *Ibid.*, General Purposes Committee, 21 May 1953, 306, p.71. [6] *Ibid*, Parks, Allotments and Cemeteries Committee, 7 September 1953, 54, p.190. [7] *Ibid*, General Purposes Committee, 1 December 1953, 67, p.423.

Source
Stocker, Mark, *Royalist and Realist: The Life and Work of Sir Joseph Edgar Boehm*, London, 1988.

## Poplar Road

*On the façade of Lloyds Bank, between first-floor windows*

### Lloyds Bank Heraldic Emblem

### Sculptor: unknown

Executed: *c*.1877
High relief polychrome stone or terracotta 1.2m
   high × 50cm wide approx
Condition: good
Status: not listed
Commissioned by: Lloyds Bank
Owner/Custodian: Lloyds Bank

This coat of arms, with a beehive in the place of a crest, consists of a shield divided into four sections, set against a background of acanthus leaves. The foliage is reminiscent of Arts and Crafts architectural ornamentation in its stylisation and delineation. Beehives are traditional symbols of industry and a wise use of resources. In the upper half of the shield, the left quarter shows a castle with three towers

with a trumpeter standing on top of each of the outer towers, and the right quarter depicts a single tower. In the lower half, the left quarter shows a castle with many towers below two knots, and the right quarter shows three leopards' heads. The whole work has been brightly painted.

This branch of the bank was the first purpose-built bank in Solihull. It opened on 3

**Unknown, *Lloyds Bank Emblem***

Prancing horse with man by J.E. Boehm, 1874, on stone pedestal, having Tudor Rose and Shield Ornaments',[3] and was bought by Captain Oliver Bird who donated it and £500 for the cost of its removal to Solihull Urban District Council in the spring of 1953.[4] The Captain and Mrs Bird met the Chairman and officers of the council in Malvern Park to select a site for the statue in May of that year,[5] but the Parks Allotments and Cemeteries Committee decided in the September that allotments near the chosen site were not 'satisfactorily cultivated' or attractive. It was decided that the

September 1877 as a small office of the Lloyds Banking Company Ltd. Its façade was severely damaged by two suspected IRA bombs on 29 August 1973.[1]

Note
[1] Jones, R., *A Solihull Century*, Studley, 1997, p.125.

## The Square
*At junction with High Street*

### War Memorial
### Designer: William Henry Bidlake

Unveiled: 21 June 1921
Base: stone slabs
Five steps: stone
Cross: stone or marble 6m high approx
Inscriptions: [Rolls of honour on lower and middle sections of memorial]
   on plaque on lower section: 1914–1918 / IN ETERNAL REMEMBRANCE OF / THE MEN OF SOLIHULL WHO / WENT FORTH AT THE CALL OF / KING AND COUNTRY TO FIGHT / IN THE GREAT WAR. MANFULLY / THEY FACED HARDSHIP, DANGER, / DEATH ITSELF, IN THE CAUSE / OF LIBERTY. THE NAMES OF / THOSE WHO RETURNED NOT / AGAIN ARE HERE INSCRIBED. / THEIR BODIES ARE BURIED / IN PEACE AND THEIR NAME / LIVETH UNTO GENERATION / AND GENERATION. ECCLES. XLIV.14.
   on plaque on middle section: IN ETERNAL / REMEMBRANCE / OF THOSE WHO GAVE / THEIR LIVES IN THE / WORLD WAR / 1939–45 / AND IN THE / KOREAN WAR / 1950–53.
Condition: fair
Status: not listed
Owner/Custodian: Solihull Metropolitan Borough Council

On an octagonal base five steps lead to a neo-Gothic memorial in the form of an Eleanor cross with an octagonal lower section on which there are alternating plaques and relief panels.

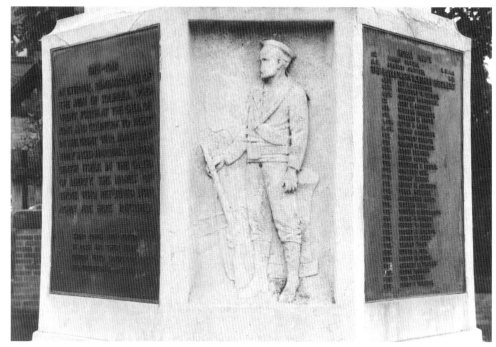

Bidlake, *War Memorial*

These show representatives of the services: a nurse, standing next to a bed and cupboard on which there is a jug; an airman in uniform, holding his gloves, standing next to the propeller end of a plane; a sailor with a rifle on a deck next to the ship's railings; and an infantryman in full uniform carrying a pack and sheltering a small child whilst the barbed wire of the trenches is visible in the lower left hand corner of the panel. These modernistic carved relief panels form an uneasy complement to the traditional gothicising structure of the cross. The middle section has further plaques. The upper section has empty canopied niches with an open crown surmounted by a Latin cross.

The Square was probably the site of the original market cross from the time when Solihull was created as a market town in the twelfth century by the de Limesi family, Lords of the Manor of Ulverlei (now nearby Olton). The earliest reference to the market cross is in 1358, and a deed of 1629 refers to it as the High Cross.[1]

Although the Great War ended with the Armistice in November 1918, it was not until the following December that the design for Solihull's War memorial was announced in the Parish magazine.[2] A committee under Dr A. Vaughan Bernays as Chairman and J.H. Braithwaite, the manager of Lloyds Bank in Solihull, as Treasurer, sent out a circular calling for donations, publishing a list of current subscribers and a picture of Bidlake's design,[3] and in January 1920, the Parish magazine repeated the call for contributions.[4]

The War Memorial was unveiled by the Earl of Craven, Lord-Lieutenant of Warwickshire and owner of Coombe Estate, in front of a crowd of 500 parishioners who had marched in

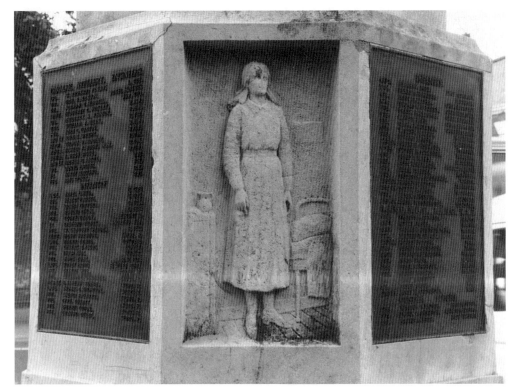

**Bidlake,** *War Memorial (detail)*

*Warwick Road*

*In Brueton Gardens*

### Brueton Gardens Commemorative Stone

#### Sculptor: unknown

Executed: 1938 or later
Welsh slate 1.7m high × 80cm wide × 80cm
   deep approx
Inscription: on inset plaque with incised
   lettering in gold colour: BRUETON GARDENS /
   THESE GARDENS WERE / PRESENTED TO
   SOLIHULL BY / COUNCILLOR HORACE J.
   BRUETON /
Condition: fair
Status: not listed

procession behind the band of the Norton
Homes from Malvern Park. During the
ceremony, a firing party fired three volleys, the
Last Post was sounded and Dr Bernays read the
list of the fallen.[5] The hymn 'O God Our Help
in Ages Past' was then sung by the assembled
crowd after which the Bishop of Birmingham
dedicated the monument and handed it over to
the district council. The lower section was
draped with the Union Flag throughout.

   In 1984 the memorial was cleaned and four
new plaques were added, recording the names
of those killed in World War Two and Korea.[6]
In 1994 the War Memorial was moved over 4
metres from its original position at a cost of

£25,000 as it was believed that people 'were
putting their lives in their hands to see the
names on the memorial' which 'was acting like
a traffic bollard'.[7]

Notes
[1] Skipp, V., *The Origins of Solihull*, Birmingham,
1964, p.20. [2] *Solihull News*, 18 November 1994.
[3] *Solihull War Memorial Subscription Leaflet*, 1920,
WRO DRB 64/304. [4] *Solihull News*, 18 November
1994. [5] Lines, C., *Britain in Old Photographs:
Solihull*, Stroud, 1998, p.78. [6] *Solihull News*, 18
November 1994. [7] *Ibid.*, 22 April 1994.

**Unknown,** *Brueton Gardens Commemorative Stone*

Commissioned by: Roger Ballard for Solihull
    Metropolitan Borough Council
Owner/Custodian: Solihull Metropolitan
    Borough Council

This slab of stone is rough and unfinished on
three sides, and forms a jagged object similar in
effect to pre-historic standing stones. Its simple
shape and display of its material quality gives a
basic archetypal impression that appeals to
modern primitivist sentiments. It stands in the
middle of a flower bed in the centre of a circular
paved area.

Brueton Gardens, with a brick shelter,
wrought iron gates and eight teak seats, were a
gift to Solihull as a memorial following the First
World War. They were formally opened by
Mrs Brueton using a key presented to her by
the Architect, Mr Bernard G. Watts, and the
local newspaper reported at the time that the
development was 'the best thing that has been
done in Solihull for years'.[1] Whilst the paper
records the names of those present at the
ceremony, including Mr P. Cane (of London)
who laid out the gardens and shrubbery and Mr
G. Pitchford who 'was in charge of the
craftsmanship of the shelter', no mention is
made of the boulder stone with its inscription.
It may therefore be of a later date.[2]

Notes
[1] *Solihull and Warwick County News*, 9 July 1938.
[2] *Ibid*.

## *Whitefields Road*
*Outside wall of St Augustine's RC Primary
School*

### *'The Four Gospels' (Symbols of the Four Evangelists)*

### Sculptor: Walter Ritchie

### Architect: Rush Davies

Executed: 1991
Acastor stone 1.84m high × 1.01m wide × 20cm
    deep
Condition: good
Status: not listed
Commissioned by: Rush Davies Design
    Partnership, the architects
Owner/Custodian: St Augustine's RC Primary
    School

This work in high relief is framed by a double
arch of bricks, below which is a table, creating
the impression that the work is an altarpiece. At
the bottom is an eagle with a halo in flight;
above the eagle is a bull shown in profile, also
with wings and a halo; above the bull is a
winged lion with a halo; and at the top is a
winged human figure with a halo in flight with
its hands together as if in prayer. The work is
carved with rounded, simplified forms. The
marks of the claw-toothed chisel are visible on
most the work, giving it a rich texture and
suggesting feathers and fur where appropriate.
Only the faces, horns and feet have been
smoothed.

This work depicts the emblems of the four
evangelists of the Christian church, Saints
Matthew, Mark, Luke and John, who wrote the
four gospels. The emblem of the divine man
was assigned to St Matthew in ancient times
because his Gospel teaches the human nature of
Christ. St Mark is symbolised by a winged lion
because of the long-standing association
between lions and royalty, the lion being the

Ritchie, *Symbols of the Four Evangelists*

'king of the beasts', and St Mark's gospel
preaches the royal dignity of Christ. St Luke is
symbolised by a winged ox or bull, in reference
to his gospel, which discusses the sacrificial
aspect of Christ's life. St John is traditionally
symbolised by a rising eagle because his gaze is
reputed to have pierced further into Heaven
than that of any man.[1] Ritchie's version,
showing the eagle with broadly spread wings,
provides a well-rounded base for the whole
composition.

St Augustine's School was founded in 1885,
and moved to new buildings on its present site
in 1991.

Notes
[1] Post, Ellwood W., *Saints, Signs and Symbols*,
London, 1962, p.11. [2] Ritchie, W., *Walter Ritchie:
Sculpture*, Kenilworth, 1994, p.48.

# Lost Works

## WARWICK

### Market Place

### *Jubilee Fountain*

### Architect: C.D. Greenaway

Executed: 1858
Status: not listed

Erected for Queen Victoria's visit to Warwick, this fountain stood on a stepped base. It was demolished in 1962 when the Market Place was redesigned.[1]

Note
[1] Sites and Monument Record, WA2196.

## COVENTRY

### Blackberry Lane          ASH GREEN

*Lyng Hall School*

### **Three Figures**

### Sculptor: George Wagstaffe

Executed: 1960
Ciment fondu 1.08m high × 1.99m wide × 63cm deep
Status: not listed
Commissioned by: Coventry City Council Architects Department

A group of three female figures with arms linked was entitled *Dancers* in the sculptor's preparatory studies. He later changed the title to *Three Figures*, and described the purpose of the work 'as a focal point of interest to contrast with the straight and regular outlines of the school buildings'.[1]

The sculpture was commissioned by the City Architects Department, which also designed the school, and it was George Wagstaffe's first commission in the city. He produced it in the same year as the *Naiad* in the Council Office's Pool. As the statue was vandalised and the school was unsuccessful in gaining any funding for its restoration, it was scrapped due to its deteriorated state.[2]

Notes
[1] Herbert Art Gallery and Museum/City of Coventry Libraries, Arts and Museums Department, *A Survey of Public Art in Coventry*, Coventry, 1980, p,132. [2] Letter, Mrs J. Lonergan, secretary of Lyng Hall School, 1 March 1999.

### Briscoe Road          HOLBROOKS

*John Shelton School – above main entrance door*

### **St Nicholas Rescuing the Three Children**

### Sculptor: William Bloye (attributed to)

Executed: 1936
Stone 60cm high × 1m wide × 10cm deep approx
Condition: fair
Status: not listed
Commissioned by: Coventry Borough Council Education Committee
Owner/Custodian: John Shelton School

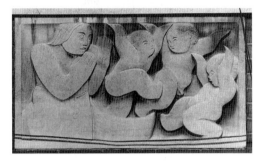

**Bloye,** *St Nicholas Rescuing the Three Children*

A relief of a robed figure to the left standing beside a well and three winged infants to the right shows St Nicholas rescuing three children from the well into which their mother had thrown them. The relief is in a style not unlike that of Eric Kennington, or possibly a minor follower of Eric Gill.

No records survive to explain the sculpture, and the artist and origins of the relief are unknown. However, it has been attributed to William Bloye on the basis of its strong stylistic similarities to one of his lost works, *Bacchanalia* (1936), a frieze which used to adorn the walls of the cocktail bar in the Golden Eagle public house, Hill Street, Birmingham, demolished in 1989.[1] The school, which was built in 1936 by Helberg and Harris, with Kelly and Son as building contractors,[2] was demolished when the school moved to new buildings in June 1999. The panel has since been lost.

Notes
[1] Noszlopy, George T., *Public Sculpture of Birmingham*, Liverpool, 1998, p.166. [2] Herbert Art

Gallery and Museum/City of Coventry Libraries, Arts and Museums Department, *A Survey of Public Art in Coventry*, Coventry, 1980, p.103.

## Foxton Road                    BINLEY

*Ernesford Grange Junior School – beside playground*

### *Flute Player*
### Sculptor: Peter Peri

Executed: *c.*1968
Resin 2.44m high × 1.02m wide
Status: not listed
Commissioned by: Coventry Education
    Committee
Owner/Custodian: Coventry City Council

The slender over-life-size figure of a flute player was delicately modelled in the artist's characteristic mature style. It originally stood beside a wall on which there was a figure in relief of a girl holding a piece of music and singing. The wall and second figure fell on the flute player in a gale, damaging it and destroying the wall.

A photograph of Peri working on the sculpture was included in the memorial exhibition catalogue in 1968 at Swiss Cottage.[1] It was the last work that Peri did in Coventry.

Note
[1] Herbert Art Gallery and Museum/City of Coventry Libraries, Arts and Museums Department, *A Survey of Public Art in Coventry*, Coventry, 1980, p.133.

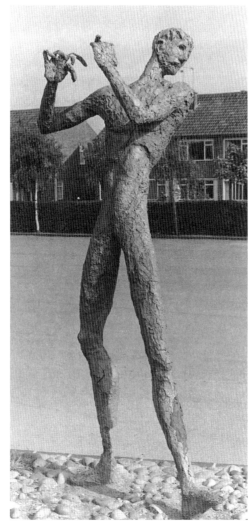

*Peri*, **The Flute Player**

*Coventry Zoo*

### *Zulu*
### Designer: unknown

Executed: 1960s
Fibreglass 7m high × 3m wide approx
Status: not listed
Commissioned by: Fantasy Décor of Scunthorpe

This immense Zulu warrior with a shield and spear and wearing a horned head-dress stood by, and dwarfed, a series of palm trees also made from fibreglass. It dominated the zoo and was visible for a considerable distance.[1]

The figure was given to or commissioned by the zoo in the 1960s, probably as an added visitor attraction. Soon after that the zoo closed, an attempt was made to remove *Zulu* to another site outside Coventry, but it broke up, possibly because it had been constructed *in situ*.[2]

Notes
[1] Herbert Art Gallery and Museum/City of Coventry Libraries, Arts and Museums Department, *A Survey of Public Art in Coventry*, Coventry, 1980, p.85. [2] Information from Ron Clarke, Herbert Art Gallery and Museum, 19 July 2000.

## Hales Street                    CITY CENTRE

### *Three Nude Figures*
### Architect: Stanley Hattrell

Executed: 1937
Status: not listed
Commissioned by: Coventry Hippodrome

There were originally three nude classical figures over the windows above the main entrance of this Art Deco building. The central male figure had both arms raised and was shown playing the cymbals. The other two figures were both female, the one on the left having long flowing hair and the one on the right holding her hair up with her left hand and

holding a piece of drapery in her right.

The figures disappeared in 1971 when the building changed its name from the New Hippodrome to *The Coventry Theatre* and it has been used as a bingo hall until recently.[1] Plans have since been drawn up for its demolition. The figures' current situation is not known.

Note
[1] Smith, Albert and Fry, David, *The Coventry we have Lost,* Coventry, 1991, p.27.

## *Façade of Art Schools*
### Sculptor: Mr Boulton of Worcester

Executed: 1863
Stone
Status: not listed
Commissioned by: Coventry Borough Council

A School of Art and Design to teach design for the ribbon and watch trades in Coventry was opened in 1863. It was damaged by bombing in October 1940, and although re-opened after the War, the building was not used after 1959. There were figurative reliefs of craft activities in the arches above the windows of the main façade.[1] These included life-size figures personifying Architecture, Sculpture, Painting, Pottery and Engineering. Above each figure there was a bust representative of each of the arts: Raphael for painting, Michelangelo for sculpture, Giotto for architecture, Watt for engineering, and Palissy for pottery.[2] All the tympani were damaged when the Art School was demolished during the construction of the inner ring road. The reliefs of Architecture and Sculpture are now kept in the Herbert Art Gallery and Museum.[3]

Notes
[1] Smith, Albert and Fry, David, *The Coventry we Have Lost,* Coventry, 1991, p.29. [2] *Art Journal,* 1863, p.205. [3] Information from Ron Clarke, Herbert Art Gallery and Museum, 19 July 2000.

## *Market Way*
## *Abstract Forms*
### Sculptor: Elizabeth Greenwood

Executed: 1961
Stone 2.2m high approx
Status: not listed
Commissioned by: Coventry Planning and Redevelopment Committee
Owner/Custodian: Coventry City Council

This abstract sculpture was composed of three biomorphic shapes, balanced one on top of the other. The crescent-shaped hollow in the bottom stone was mirrored by the shape of the inner curve of the top stone. The work suggested a powerful but primitive life form.

The sculpture was commissioned as the result of a competition organised in 1961 by the City Planning Committee and Coventry Art College to find sculpture for Smithford Way that would allow the best student's work to be publicly displayed, and at the same time provide the city with public sculpture at little cost. The city architect Arthur Ling's plans for Smithford Way had included the provision of a number of free-standing sculptures, but the funds allocated were nominal and therefore the committee decided to involve the art college in the project. Six prizes were offered, and the judges recommended four sculptures for prizes, but the committee reduced this to three. *Abstract Forms,* unlike the other two winning works, was sited in Market Way not Smithford Way. The work cost £150, including £50 in prize money.[1] It was removed before 1980, when Coventry Point was built, and its present situation is not known.

Note
[1] Herbert Art Gallery and Museum/City of Coventry Libraries, Arts and Museums Department, *A Survey of Public Art in Coventry,* Coventry, 1980, p.70.

## *Untitled*
### Sculptor: Geoffrey Greetham

Executed: 1965
Welded box section steel 1.5m high × 4m wide × 1.5m deep approx
Status: not listed
Commissioned by: Coventry Planning and Redevelopment Committee

Greetham described this work as 'a sculpture in space relationships; it is not figurative or representational but a visual presentation of space and tensions'.[1]

It was commissioned as a result of an award scheme set up in 1964 for students of sculpture at Coventry Art College. This scheme was supplementary to the competition held in 1961 for sculpture at Smithford Way and was intended to introduce a system of changing the sculpture in the precinct by rotation. The intention was that each piece would remain on site for three years and that new pieces would regularly be displayed. Unfortunately the scheme was discontinued in 1966.

The award scheme was launched in November 1965 although only two sculptors were eligible for entry. The size and theme of the work were suggested to the entrants, who both submitted maquettes. Greetham's scheme was selected.

The sculpture was sited outside the Canadian Fur shop in Market Way, but was removed in 1974 to make way for a series of maple trees donated by the shop.

A version of the work can be seen at Exhall Grange School, although it is believed this is not the original but the lighter steel full size model that was made at the Art College.

Note
[1] Herbert Art Gallery and Museum/City of Coventry Libraries, Arts and Museums Department, *A Survey of Public Art in Coventry,* Coventry, 1980, p.80.

## Priory Street

*Lawn to east of Cathedral*

## Pandarus

### Sculptor: Kenneth Armitage

Executed: 1962–3
Bronze 2.23m high × 1.05m wide × 54cm deep
Signature: monogram: KA
Status: not listed

This sculpture was one of a number in Armitage's *Pandarus* series from the early 1960s. It consisted of an upright panel or column with trumpet shaped projections that either pierced the structure or were mounted on top of it. It most closely resembled *Pandarus* * from 1963, which was exhibited in the Tate Gallery's *54 – 64 Painting and Sculpture of a Decade* exhibition. It shared with *Pandarus 8* the smooth surface texture broken by a few horizontal seams and the positioning of the trumpets in the top section of the work, features not found in the other works in the *Pandarus* series, from which the sculptor moved away in 1965.

It is no longer known when the *Pandarus* was placed on the lawn beside the Cathedral, but it was removed from the Cathedral grounds in 1982. Its present situation is unknown.[1]

Note
[1] Herbert Art Gallery and Museum/City of Coventry Libraries, Arts and Museums Department, *A Survey of Public Art in Coventry*, Coventry, 1980, p.73.

## Yoko by John and John by Yoko

### Artist: John Lennon
### Architect: Yoko Ono

Executed: June 1968
Seat: wrought iron, painted white
Status: not listed

The sculpture was originally sited in the garden surrounding the cathedral.[1] Acorns were planted in the centre of a white wrought-iron seat to symbolise world peace, and the seat gave people the opportunity to sit and contemplate.[2] The acorns were stolen two days after being planted, Lennon's seat was thrown into shrubbery and the plaque bearing the title of the piece was removed.[3]

Notes
[1] *Coventry Evening Telegraph*, 1 Nov 1997.
[2] Herbert Art Gallery and Museum, Coventry Public Art Database. [3] *Coventry Evening Telegraph*, 27 June 1968.

## Smithford Way

## Civic Sculpture

### Sculptor: Ted Atkinson

Executed: 1965
Polyester resin 3m high × 3.05m wide × 61cm deep
Status: not listed
Commissioned by: Coventry Planning and Redevelopment Committee

The sculptor described his work as 'three totem-like shapes standing side by side … to form a sculptural screen'.[1] The bulbous form of the work and its smooth machine-like finish relate this work to the sculptures by Joannis Avramidis of the late 1950s and early 1960s.

This piece was commissioned after twelve years of discussion between the planning committee, British Home Stores and Marks and Spencer, who had taken premises in the Upper Precinct on the understanding that they would provide some sort of sculptural work associated with their buildings. Donald Gibson, the city architect, had planned that this work would take the form of sculptural reliefs in Caen stone installed on the exterior walls of the two buildings. However, his successor, Arthur Ling,

changed the plan, first to free-standing pieces projecting out from the walls, and then to a free-standing work in Smithford Way. BHS pulled out, but Marks and Spencer made £1,000 available. In 1962 Arthur Ling suggested Elizabeth Frink's work, but the Committee were unable to agree to this idea. Instead the City Architect, Art Director and Art College principal were asked to suggest alternative ways of selecting a piece of sculpture, and suggested a piece of sculpture based on the theme of future technological progress by a 'younger sculptor of potential reputation'.[2] Ted Atkinson was asked to submit a maquette and was then commissioned to carry out the work.

It was shown at the *VAT 68* exhibition in Coventry in 1968. The central, tall element had long been missing[3] and the work was removed in c.1985.

Notes
[1] Wood, G., *Public Sculpture in Coventry. A Selected Critique*, unpublished BA dissertation, Coventry (Lanchester) Polytechnic, 1986. [2] Herbert Art Gallery and Museum/City of Coventry Libraries, Arts and Museums Department, *A Survey of Public Art in Coventry*, Coventry, 1980, pp.78–9.
[3] Herbert Art Gallery and Museum, Coventry Public Art Database.

## Divided Column

### Artist: Christina Lewis

Executed: 1961
Resin on metal 2.37m high × 80cm wide × 80cm deep
Framework: wire mesh
Status: not listed
Commissioned by: Coventry Planning and Redevelopment Committee

This work consisted of a series of curved panels mounted on an internal framework in a vertical pile, with the surface of the panels treated to simulate the appearance of stone.

The sculpture was commissioned as the

result of the competition held by the city planning committee and Coventry Art College in 1961 to find sculpture for Smithford Way. *Divided Column* was built by Ian Speight and Martin Grove at the Coventry Art College. The work cost £150, including £50 in prize money.[1]

A report dated 11 March 1981, which had been commissioned by the Director of Homes and Properties, stated that the penetration of surface moisture and rising damp were causing the iron framework of the sculpture to corrode and flake. Subsequent expansion of the metal was distorting and fracturing the resin, and it was considered to be in a dangerous condition and on the verge of collapse, should no remedial action be taken. This would have involved removing and probably recasting the framework. As a result of the report, the sculpture was removed at an unknown date.[2]

Notes
[1] Herbert Art Gallery and Museum/City of Coventry Libraries, Arts and Museums Department, *A Survey of Public Art in Coventry*, Coventry, 1980, p.70. [2] Director of Homes and Properties, Coventry, Condition Report, 11 March 1981.

## *The Climber*
### Sculptors: Maurice Abercrombie and Derek Biddlecombe

Executed: 1961
Welded steel 2.39m high × 1.2m wide × 1.2m deep
Status: not listed
Condition: fair
Commissioned by: Coventry Planning and Redevelopment Committee
Owner/Custodian: Coventry City Council

This abstract piece of sculpture made up of welded steel rods suggested a standing automaton.

The sculpture was commissioned as the result of the competition organised in 1961 by the city planning committee and Coventry Art College to find sculpture for Smithford Way. *The Climber* cost £150, including £50 in prize money.[1]

A report on its condition recorded that the sculpture was suffering from surface corrosion (rust) on about 90 per cent of its surface. The core, however, had good strength and stability, so treatment was not believed to be necessary for a few years.[2] Following the report, the sculpture was removed.[3]

Notes
[1] Herbert Art Gallery and Museum/City of Coventry Libraries, Arts and Museums Department, *A Survey of Public Art in Coventry*, Coventry, 1980, p.69. [2] Director of Homes and Properties, Coventry, Condition Report, 11 March 1981. [3] Herbert Art Gallery and Museum, Coventry Public Art Database.

## *St James Lane*   WILLENHALL
*Willenhall Wood Junior School – inner courtyard*

## *Seated Boy and Girl*
### Sculptor: Peter Peri

Executed: 1957–9
Resin 1.06m high × 1.82m wide × 63cm deep
Status: not listed
Commissioned by: Coventry Education Committee

This sculpture of two life-size figures of children seated on a wall showed one of them reading and the other looking over his shoulder at the book. The figures were conceived as large-scale versions of Peri's miniature figure sculptures, but they had a smoother texture and did not have the elongation of his other figures.

Peri worked closely with the school headmaster during its creation.[1]

Note
[1] Herbert Art Gallery and Museum/City of

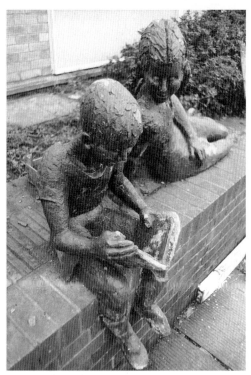

Peri, *Seated Boy and Girl*

Coventry Libraries, Arts and Museums Department, *A Survey of Public Art in Coventry*, Coventry, 1980, p.124.

## *The Drive*   CHURCH END
*Richard Lee School – beside entrance to school*

## *Richard Lee Memorial Sculpture*
### Sculptor: Walter Ritchie
### Architect: Anthony Cox

Unveiled: 13 September 1955
Bronze, slate and steel, 4.57m high
Inscription: (on stone around the base):

[R. Lee's dates and a quotation from the Sermon from the Mount]
Status: not listed
Commissioned by: Alderman Richard Lee's two daughters and the Coventry Education Committee

This sculpture depicted a dove issuing from the hand of God on a pole 4 metres high with stones around the base bearing an inscription. It formed a memorial to Alderman Richard Lee (1873–1950), the pacifist after whom the school is named.[1]

The sculptor, who was a close family friend, made a wooden image of a dove now in the Belgrade Theatre (see entry for *Dove, Corporation Street*) before casting the bronze group.[2] The wooden model used for casting the hand is still in the collection of the Walter Ritchie estate. The cost of the memorial was met jointly by Lee's daughters and the Education Committee.[3]

Notes
[1] Herbert Art Gallery and Museum/City of Coventry Libraries, Arts and Museums Department, *A Survey of Public Art in Coventry*, Coventry, 1980, p.115. [2] Ritchie, W., *Walter Ritchie: Sculpture*, Kenilworth, 1994, pp.77 and 82. [3] *Coventry Standard*, 16 September 1955.

## Whitley Common playing field
WHITLEY PARK

*Above door of Sports Pavilion*

## Butlin's Plaque
### Sculptor: John Skelton

Unveiled: 24 October 1953
Portland stone 92cm high × 71cm wide
Inscriptions: THIS PAVILION / AND PLAYING / FIELD KNOWN / AS BUTLIN HOLIDAY CAMPERS' PLAYING FIELD, / PROVIDED BY THE GENEROSITY OF MESSRS./ BUTLIN'S LTD. AND SPONSORED BY THE / NATIONAL PLAYING FIELDS ASSOCIATION, / WAS OPENED ON 24TH OCTOBER 1953 BY / H.R.H THE DUKE OF EDINBURGH
below main inscription is smaller letters: PARKS & ALLOTMENTS COMMITTEE 1953–54 / The Lord Mayor – Alderman HBW Cresswell J.P. / The Deputy Lord Mayor – Alderman J. Fennell / Chairman – Councillor T. Meffen – Vice Chairman / Councillor H. Stanley – Alderman H.H.K. Winslow / Councillors R.V. Brown, E.A. Hull, L. Lamb, C.S. Melbourne / W. Parfitt, G. Rees, C. Ward – Town Clerk – Charles Barratt / City Treasurer – A.H. Marshall – Director of Parks W. Shirren.
Status: not listed
Commissioned by: Butlins Ltd
Owner/Custodian: Coventry City Council

Sections of the plaque above the door of the pavilion were carved with emblems of sporting activities. The top right section showed a flag, trophy, rugby goal posts, a football and football boots, the gloves, cap, pads worn by cricketers as well as a cricket bat, ball and wicket. The lower left section depicted an archery target and arrows, a hockey stick and ball, a tennis racket, a polo stick, a rope, the laurels of victory, a spiked running shoe and a net of balls. The emblems of sports were presented in a linear style, set in an horizontal plane, as if in a sculptural frieze.[1] The inscription covered the rest of the plaque.

The Whitley Common playing field and sports pavilion was gifted to the City of Coventry by Butlins Ltd. The opening ceremony was attended by a large crowd and included a parade by the Coventry Sea Cadet Corps and a display of physical training by the Coventry Ladies Physical Culture Association. Speeches were made by the Duke of Edinburgh, the Chairman of the Parks and Allotments Committee, Councillor Meffen and Mr W.E. Butlin.[2]

The plaque is no longer *in situ*. According to employees it has been missing for at least 12 years and may have been taken down during modifications to the pavilion.[3]

Notes
[1] Archive, photocopied illustration. [2] *Coventry Evening Telegraph*, 24 October 1953. [3] Information provided by employees at Whitley Playing Field Sports Pavillion, 4 August 1999.

## Binley

*Binley Park Comprehensive School – courtyard*

## Basketball Players
### Sculptor: Boris Tietze

Installed: 1960
Ciment fondu 3.5m high × 1m wide × 75cm deep approx
Status: not listed
Commissioned by: Coventry City Council Education Committee

The sculpture was of two basketball players. The figure holding the ball in both hands was in the act of scoring a basket while the other defended. The elongated figures were made of smooth concrete with their dress suggested by minimal modelling. The faces were stylised to create a modernistic non-naturalistic image.

The sculpture, which was for a specific site in the school, was completed in time for the school's opening in 1960. It was destroyed when the school was demolished in the early 1990s.[1]

Note
[1] Herbert Art Gallery and Museum/City of Coventry Libraries, Arts and Museums Department, *A Survey of Public Art in Coventry*, Coventry, 1980, p.131.

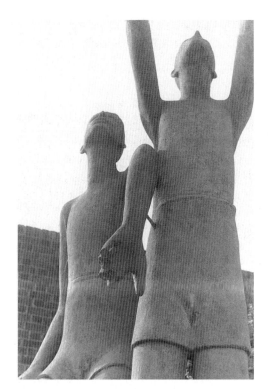

Tietze, *Basketball Players*

*Frank Pledge Road*

*St Michael's Primary School – exterior wall facing road*

## St Michael and Dancing Figures

### Sculptor: Peter Peri

Executed: 1959
Concrete and brick 3.35m high × 12.2m wide
Status: not listed
Commissioned by: Coventry Education
      Committee

The relief was in concrete, dyed yellow, on a blue exterior wall of the school. Peri first carved out the approximate size of each figure in the brick before building them up in concrete. They were arranged in a long curve across the wall, linked by their hands to the winged figure of St Michael to create the appearance of a dance. The movement of the figures, flying draperies, exaggerated poses and gestures suggested speed and duration of time, a reflection of the artist's earlier interest in futurist theory. The figures were moulded in low relief, using a similar technique to that Peri used from the mid-1930s.

   The Education Committee made a grant of £250 for the work in 1959.[1]

Note
[1] Herbert Art Gallery and Museum/City of Coventry Libraries, Arts and Museums Department, *A Survey of Public Art in Coventry*, Coventry, 1980, p.130.

**Peri,** *St Michael and Dancing Figures*

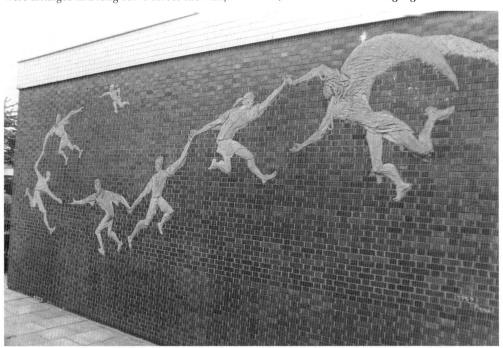

# Not Sited Works

## COVENTRY

### *The Phoenix Initiative*

The City of Coventry has commissioned a variety of public site-specific artworks as part of its £20 million scheme for the regeneration of central Coventry. The area included in the project includes the excavation site of Coventry's original medieval cathedral, Lady Herbert's Garden and the Museum of British Road Transport. Two new squares, Priory Place and Millennium Place, are being built and three new gardens are to be designed. Due for completion in the autumn of 2001, the overall scheme is being designed by architects MacCormack, Jameson and Pritchard.

### *Millennium Place*

*On a slope across most of Millennium Place*

### *Millennium Clock*

### **Artist: Françoise Schein**

Due to be installed: 2001
Glass and blue lights in stainless steel strips set
   in black slate pavement
Monumental, larger than Big Ben in London
Commissioned by: Coventry City Council

This huge 24-hour clock will run from the entrance of the Museum of British Road Transport to the site of the former Hippodrome in Hales Street. The design is based on the 24-hour time zone diagram found on the front of short-wave radios. Twenty-four glass tubes

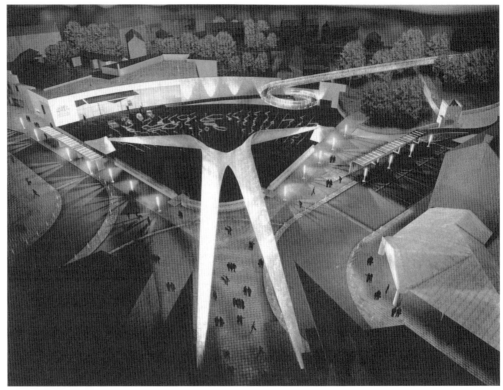

Schein, *Millennium Clock*

set in stainless steel strips light up to show the time on a fan-shaped world map tilted slightly upwards to face the new Millennium Boulevard. An additional 200 illuminated spots show the time in the 26 cities with which Coventry is twinned, as well as all the capitals of the world. As the lights of the clock pass through the various time zones, people passing by will be able to hear the recorded voices of children whispering in different languages. Whenever the cathedral clock sounds the hour, all the time zone lights come on for a few seconds.

The artist has stated that her aim is to convey the idea of the endlessness of time and to remind the people of Coventry of their local watch-making industry,[1] but there has already been considerable criticism of the Millennium Clock in the local press, with readers arguing that it is 'truly monstrous' and that the £300,000

it cost would have been better spent on education and road safety.[2]

In July 2000, the current owners of the former Hippodrome, Scala Bingo, made a legal challenge in the High Court to the Department of the Environment's decision to allow demolition of their building.[3]

Notes
[1] *Coventry Evening Telegraph*, 4 December 1998 and 14 May 1999. [2] *Ibid.*, 12 December 1998, 20 May 1999 and 31 May 1999. [3] *Coventry City Council News*, 17 July 2000, www.cwn.org.uk/politics/coventry-city-council

*Priory Place*     CITY CENTRE

*Top end of Priory Place*

## *Fountain*

### Sculptor: Susannah Heron

Yet to be installed
Mixed media, including slate and copper
Commissioned by: Coventry City Council

This modernist-influenced fountain aims to create a 'window in a wall' effect. Viewed from the footpath, the window appears to be normal in shape, but in reality the perspective is askew.

A mock-up of the fountain in the artist's studio suggests that she was influenced in her treatment of perspective by the work of Simone Martini. The window appears to have been glazed with a sheet of cloudy glass, but in reality this is a sheet of water falling undisturbed into a slate-lined pool in front of a large sheet of copper.[1] The work reflects the Mill Pool and the River Sherbourne near the original St Mary's Cathedral.

Note
[1] *Independent on Sunday*, 9 January 2000.

# Appendix: Minor Works

Owing to the considerable number of sculptural works surveyed, it was not possible to give each one a full catalogue entry in the present volume. The following is a list of all those coats of arms, commemorative plaques, commercial emblems and war memorials without figurative sculpture that were surveyed but are not covered by a full catalogue entry.

## *Warwickshire*
## Coats of Arms and Heraldic Devices

*Coat of Arms* Outside wall of Queen Elizabeth School, Long Street, Atherstone. 1973. Stone, painted, 1.1m high × 70cm wide. Inscription: 1573 / LOYAL SUISIE. Condition: good. Status: not listed. Custodian: Queen Elizabeth School
*Emblem of Digby family* Built into south wall of the Civic Centre, Parkfield Road, Coleshill. 1800s. Stone 60cm diameter approx. Inscription: DEO NO FORTUNA. Status: not listed. Condition: poor. Owner: North Warwickshire District Council
*Colehaven Coat of Arms* North side of almshouses, above central entrance, Sumners Road, Coleshill. Architect: H. Weedon. 1931. Hollington stone, 90cm high × 60cm wide approx. Inscriptions: (below shield) COLEHAVEN / FOUNDED BY / JOHN SUMNERS / A.D. MCMXX; (around shield) LABORINONES RISOLUM. Condition: good. Status: not listed. Commissioned by: John Sumners. Owner: Colehaven Trust
*Nethersole and Goodere Coat of Arms* North side, at junction with Bridge Street, High Street, Polesworth. Architect: Joseph Potter Jnr. 1818. Sandstone, 2m square approx. Inscriptions:

(above crest) SOLI DEO GLORIA; (below crest) SCHOLA PAUPERUM / PUERORUM PUELLARUM [which translates as 'School for Poor Boys and Girls']. Condition: fair. Status: Grade II. Commissioned by: Nethersole Foundation Trustees. Owner/Custodian: Nethersole Centre
*Coat of Arms and Griffins* Chamberlaine Almshouses, All Saints Square, Bedworth. Designer: Thomas Larkin Walker. Builder: John Toone. 1840. Griffins: stone, 50cm high approx. Coat of arms: stone, 70cm square approx. Inscription: (beneath coat of arms) Rebuilt and Enlarged A.D. 1840. Condition: fair. Status: Grade II. Commissioned by: executors of Nicholas Chamberlaine's will
*Town Coat of Arms* Town Hall, Coton Road, Nuneaton. Before 1974. Stone, painted 60cm high × 60cm wide approx. Inscription: (below shield) PRET D'ACCOMPLIR. Condition: good. Status: not listed. Commissioned by: Nuneaton Borough Council. Owner/Custodian: Nuneaton and Bedworth District Council
*Heraldic Emblems and Ornaments* Newdigate Street, Nuneaton. 1898. Stone, 8m high × 1.3m wide approx. Inscriptions: (on each of the lower shields) LB; (on shield on chimney) 1898. Condition: fair. Status: Grade II. Owner/Custodian: HSBC
*Pediment with Coat of Arms* Coombe Abbey, near Rugby, west front, Coventry Road. Carver: Edward Pearce. c.1691. Stone, 1.5m high × 4m wide approx. Condition: fair. Status: Grade I. Commissioned by: William Winde. Owner/Custodian: Coventry City Council
*Heraldic Shield* On façade of Ashlawn School, Ashlawn Road, Rugby. Between 1932 and 1974. Limestone, 1m high × 90cm wide approx.

Inscription: FLOREAT RUGBEIA, Condition: fair. Status: not listed. Commissioned by: Rugby Borough Council. Owner/Custodian: Ashlawn School
*Coat of Arms* At junction with Hilmorton Road, on façade of Temple Speech Rooms, Barby Road, Rugby. Architect: T.G. Jackson. 1909. Stone, gilt and painted, 1.4m high × 1.1m wide approx. Inscription: ORANDO LABORANDO. Condition: good. Status: Grade II. Commissioned by: Rugby School
*Coat of Arms* Top of façade of Marks & Spencer Building, High Street, Rugby. Architect: R. & B. North & N. Hawke of London. c.1908. Yellow sandstone, 60cm high × 1.8m wide approx. Condition: poor. Status: not listed. Commissioned by: Rugby Borough Council. Owner/Custodian: Marks & Spencer
*Warwickshire County Council Coat of Arms* Priory Road, Stratford-upon-Avon. 1960s. Metal, painted, 1m high × 1m wide approx. Inscription: (in scroll at bottom, in raised lettering) NON SANZ DROICT. Condition: good. Status: not listed. Commissioned by: Warwickshire County Council. Owner/Custodian: Stratford Community Education Services
*Coat of Arms of Sir Edward Walker* Façade of Clopton House, Clopton, near Stratford. c.1665–70. Stone, various sizes. Condition: fair. Status: Grade II*. Commissioned by: John Clopton
*Boar's Head* 1 The Yew Trees, Henley-in-Arden. 1930s. Stone, painted white, 30cm high × 46cm wide × 7cm deep. Condition: good. Status: Not listed
*Badgers* Gate piers to Ellen Badger Community

Hospital, Stratford, Shipston-on-Stour. *c.*1896. Stone, 65cm high × 35cm wide × 35cm deep approx. Inscriptions: (on shield held by left gate pier statue) COTTAGE / HOSPITAL; (on shield held by right gate pier statue) OPENED / 22 OCTOBER / 1898. Condition: fair. Status: not listed. Commissioned by: Richard Badger. Owner/Custodian: South Warwickshire NHS Trust Combined Care

***Warwickshire Coat of Arms*** On façade of police station and court building, High Street, Southam. Sculptor: Walter Ritchie (attributed to). After 1957. 1m high approx. Inscription: (in scroll for motto) NON SANZ DROICT. Condition: fair. Status: not listed. Commissioned by: Warwickshire County Council

***Stratford-upon-Avon District Council Coat of Arms*** Elizabeth House, Stratford-upon-Avon District Council, Church Street, Stratford-upon-Avon. After 1984. Painted stone, 1.2m high × 80cm wide approx. Condition: good. Status: not listed. Commissioned by: Stratford-upon-Avon District Council

***Trinity College Emblem*** Church Street, Stratford-upon-Avon. Unveiled: 27 January 1872. Stone, 1.3m high × 1.3m wide approx. Inscription: TRINITY COLLEGE SCHOOL / FOUNDED BY / JOHN DAY COLLIS. D.D. / VICAR OF STRATFORD ON AVON / A D 1870. Condition: good. Status: Grade II. Commissioned by: Rev. John Day Collis

***Civic Hall Royal Arms*** Above entrance to Civic Hall, Rother Street, Stratford-upon-Avon. Unveiled: 13 September 1998. Stone, 50cm high × 80cm wide approx. Condition: good. Status: Grade II. Commissioned by: Royal Engineers. Owner/Custodian: Stratford-upon-Avon District Council

***Stratford-upon-Avon Coat of Arms*** On Chapel Street façade of Town Hall, Stratford-upon-Avon. Builder: Robert Newman of Whittington. *c.*1767. Stone, 90cm diameter approx. Condition: poor. Status: Grade II*. Commissioned by: Corporation of Stratford-upon-Avon

***Royal Leamington Spa Coat of Arms*** Art Gallery, Avenue Road, Leamington. *c.*1902. Sandstone, 80cm high × 80cm wide approx. Inscription: (motto) SOLA BONA QU... O ... EST [complete motto: Sola Bona Quae Honesta]. Condition: fair. Status: not listed. Commissioned by: Leamington Spa Borough Council

***Royal Leamington Spa Coat of Arms*** Library façade, Avenue Road, Leamington Spa. Architect: J. Mitchell Bottomley. 1902. Terracotta, 1m high × 1m wide approx. Inscription: SOLA BONA QUAE HONESTA. Condition: good. Status: not listed. Commissioned by: Leamington Spa Borough Council

***Jephson Park Iron Gates with Shields*** Bath Street, Leamington. Foundry: Netherton & Best. 1948. Cast iron, 7m wide × 2m high approx. Signature: (on side of pedestrian gates) NETHERTON & BEST. Inscription: (on back on shield in small raised letters) THESE GATES WERE PRESENTED BY / ALDERMAN / ROWLAND SYDNEY SALT / CHAIRMAN / PARKS & GARDENS COMMITTEE / 1948. Condition: good. Status: not listed. Commissioned by: Alderman Rowland Sydney Salt, Chairman, Parks & Gardens Committee. Owner/Custodian: Warwick District Council

***Royal Coat of Arms with Supporters*** Above entrance to Pump Rooms, Bath Street, Leamington. *c.*1840. Painted stone, 90cm high × 2m wide approx. Condition: good. Status: not listed.

***Bear and Ragged Staff*** Above entrance to police station, Hamilton Terrace, Leamington. *c.*1965. Metal, coloured, 1m high × 60cm wide. Condition: good. Status: not listed. Commissioned by: Warwickshire County Council

***Royal Leamington Spa Coat of Arms (Gate Pier Carvings)*** Newbold Terrace, Leamington. After 1876. Stone, 94cm high × 62cm wide. Inscriptions: (on each) JEPHSON /GARDENS.

Condition: good. Status: not listed. Commissioned by: Leamington Spa Borough Council. Owner/Custodian: Warwick District Council

***Two Shields*** Estate Agents Institute, 21 Jury Street, Warwick. 1960s. Resin, painted, 60cm high × 30cm wide approx. Inscriptions: (on scroll) FOR MANS GOOD ESTATE. Condition: good. Status: Grade II. Commissioned by: National Association of Estate Agents

***Bear and Ragged Staff*** Lord Leycester's Hospital, High Street, Warwick. 1970s. Bear: wood, painted, 1m high × 50cm wide approx. Crown: wood, painted, 60cm square approx. Condition: good. Status: not listed. Owner/Custodian: Lord Leycester Hospital

***Entrance Gates with Shields*** Myton Road, Warwick. 1931. Wrought iron, 4.5m high × 3.4m wide approx. Inscription: (on inset plaques) COUNTY OF WARWICK/19/NON SANZ DROICT/31. Condition: good. Status: Grade I. Commissioned by: Warwickshire County Council

***Warwickshire Coat of Arms, Floral Garlands and Lion's Head*** Crown and County Court Building, Warwick. Designer: Sanderson Miller. Builders: David and William Hiorn, Job Collins. 1753–8. Stone pediment 9m wide approx., with painted coat of arms, 90cm high × 4.5m wide. Floral garlands along length of building up to Corinthian pilasters at each end, 24m approx. Inscription: (in scrolls on pediment) NON SANZ DROICT. Condition: good. Status: Grade II. Commissioned by: Warwickshire County Council

***Bear and Ragged Staff Emblem*** First courtyard of Shire Hall and Courts complex, Northgate Street, Warwick. Sculptor: Charles Walsgrove. 1929. Sandstone, 1m high × 2.5m wide × 20cm deep. Condition: good. Status: Grade I. Commissioned by: Warwickshire County Council

***Pediment Bear and Staff Emblem*** Second courtyard of Shire Hall and Courts complex,

Northgate Street, Warwick. Architect: Arthur Charles Bunch. 1932–3. Sandstone, 1.4m high × 1.4m wide × 45cm deep. Condition: fair. Status: Grade I. Commissioned by: Warwickshire County Council

*Warwickshire County Council Coat of Arms* Shire Hall, Old Square, Warwick. Sculptor: Walter Ritchie. Architect: Geoffrey Barnsley. *c.*1957. Phospher bronze, 80cm high approx. Inscription: (on scroll) NON SANZ DROICT. Condition: fair. Status: Grade I. Commissioned by: Geoffrey Barnsley. Owner/Custodian: Warwickshire County Council

*Three Shields* Upper façade, rear of Tourist Information Office Building, Pageant Gardens, Warwick. Mid nineteenth century. Each shield: concrete, 70cm high × 60cm wide × 15cm deep approx. Condition: Good. Status: Grade I. Owner/Custodian: Warwick District Council

*Bear and Ragged Staff* Police station façade, Priory Road, Warwick, 1970s. 1m high × 50cm wide approx. Condition: good. Status: not listed. Commissioned by: Warwickshire Constabulary

## Commemorative Plaques, Stones and Boulders

*Commemorative Plaque* Temple Speech Rooms, Barby Road, Rugby. Unveiled: 3 July 1909. Plaque: bronze. Panel: stone, 1.5m high × 90cm wide approx. Inscription: (on plaque) THIS HALL OPENED BY / HM KING EDWARD VII / ON JULY 3 1909 WAS / BUILT FOR THE SCHOOL / BY RUGBEAINS AND FRIENDS / OF RUGBY AND WAS NAMED / THE TEMPLE SPEECH ROOM / AT THE DESIRE OF / ARCHBISHOP TEMPLES PUPILS / WHOSE MEMORIAL TO THEIR / MASTER MERGED IN THIS. Condition: fair. Status: Grade II. Commissioned by: Rugby School

*Russelheim Twinning Stone* Caldecott Park, Evreux Way, Rugby. 1997. Plaque: aluminium, 28cm high × 45cm wide. Stone, 30cm high × 1.2m wide × 90cm deep. Inscription: (on plaque) TO COMMEMORATE THE / 20th ANNIVERSARY OF / TWINNING BETWEEN / RUGBY & RUSSELHEIM / 1977 – 1997. Condition: good. Status: not listed. Commissioned by: Rugby District Council

*Commemorative Plaque* At junction of Leicester and Boughton Road, Rugby. Unveiled: 10 June 1978. Plaque: bronze. Support: brick, yellow, blue, 80cm high × 80cm wide × 60cm deep approx. Inscription: (on plaque, raised lettering) THIS PLAQUE WAS UNVEILED ON 10th JUNE 1978, / IN THE PRESENCE OF / COUNCILLOR PHILIP A. BLUNDELL / (MAYOR OF THE BOROUGH OF RUGBY) / DR. KARL HEINZE STORSBERG / (BURGERMEISTER OF THE CITY OF RUSSELHEIM) / AND MONSIEUR ROLAND PLAISANCE / (MAYOR OF THE TOWN OF EVREUX) / TO COMMEMORATE THE TWINNING BETWEEN / RUGBY AND RUSSELHIEM AND THE / STRENGTHENING OF THE LONG ESTABLISHED / TWINNING OF THESE COMMUNITIES WITH EVREUX. Condition: good. Status: not listed. Commissioned by: Rugby District Council

*Commemorative Boulder* Park Drive, Leamington. After 1945. Boulder: stone, 94cm high × 1.78m wide. Plaque: bronze, 46cm high × 53cm wide. Inscription: (on plaque, in raised lettering) BOROUGH OF / ROYAL LEAMINGTON SPA / THIS AVENUE OF TREES WAS PLANTED / IN MEMORY OF THOSE MEN & WOMEN / OF LEAMINGTON SPA WHO FELL / IN THE WORLD WAR 1939 – 1945. Condition: good. Status: not listed. Commissioned by: Leamington Spa Borough Council. Owner/Custodian: Warwick District Council

## Commercial Emblems

*Crown Hotel Emblem* On gable of Fettlers & Firkin public house, Bond Street, Bedworth. Stanley's Brickworks of Nuneaton (attributed to). 1890s. White stone, 2.5m high × 2m wide approx. Inscription: (raised lettering) THE / CROWN / HOTEL. Condition: good. Status: not listed. Commissioned by: Crown Hotel. Owner/Custodian: Firkin Brewery

*Beehive Emblems* Façade of Lloyds Bank, Church Street, Rugby. *c.*1904. Stone, 75cm × 50cm wide approx. Condition: poor. Status: Grade II. Commissioned by: Lloyds Bank

*Barclays Eagle Emblem* North Street, Rugby. After 1981. Metal, 2m high × 2m wide approx. Condition: good. Status: not listed. Commissioned by: Barclays Bank

*Lloyds Emblem: Black Horse* Stratford Place, Stratford-upon-Avon. After 1921. Stone, painted black on white, 40cm high × 40cm wide approx. Condition: fair. Status: Grade II. Commissioned by: Lloyds Bank

*Bank Insignia* High Street, Kenilworth. *c.*1885. Red local sandstone, 80cm square approx. Inscription: (on scroll) BANK. Condition: fair. Status: Grade II. Commissioned by: Leamington Priors and Warwickshire Banking Company

*Phoenix* Above entrance to Classics salon, High Street, Kenilworth. *c.*1860s. Stone, 80cm high × 80cm wide approx. Condition: poor. Status: not listed. Commissioned by: Robert Hubbard. Owner/Custodian: Classics salon

## Mining Memorials

*New Street* At junction with Maypole Lane, Baddesley Ensor. 1991. Base: concrete, 22cm high × 5.15m wide × 1.8m deep. Wheel: metal, painted, 1.94m diameter. Pedestal: stone and mortar, 34cm high × 4.25m wide × 1.32m deep. Inscription: (on plaque recessed into base and covered by Perspex) THIS WHEEL WAS ERECTED / BY THE / BADDESLEY ENSOR PARISH COUNCIL / IN 1991 / IN MEMORY OF ALL THE MINERS / WHO FOR 200 YEARS WORKED AND / MANY OF WHOM DIED IN THE MINES / AT BADDESLEY ENSOR. / THE LAST MINE CLOSED IN MARCH 1989. Condition: good. Status: not listed.

Commissioned by: Baddesley Ensor Parish Council

***High Street*** The Nethersole School, Polesworth. 1991. Wheel: iron, 4m diameter approx. Condition: good. Status: not listed. Commissioned by: Nethersole School

## War Memorials

***Ornate Cross War Memorial*** Outside church yard of St Mary and All Saints, Fillongley. *c.*1919. Base: stone, 47cm high × 63cm wide × 63cm deep. Support: stone, 85cm high × 22cm diameter. Cross: iron, 1.30m high × 85cm wide approx. Inscriptions: [Roll of honour around sides and upper chamfer of base]; (on front face of base) THEIR GLORY / SHALL NOT BE / BLOTTED OUT / MCMXIV MCMXVIII/; (on chamfer of front face of base) [names] MCMXXXVIII MCMXLV [names]; (plaque on cross) INRI. Condition: fair. Status: not listed. Owner/Custodian: parish church of St Mary and All Saints

***War Memorial*** Formal garden outside Museum and Art Gallery, Riversley Park, Nuneaton. After 1919. Steps and base: grey stone, 6m high approx. Memorial cross: pink stone, 6m high approx. Inscriptions: (on front (south) face) IN MEMORY OF THE BRAVE MEN / OF NUNEATON AND NEIGHBOURHOOD / WHO GAVE THEIR LIVES FOR THEIR / KING & COUNTRY IN THE GREAT WAR / 1914-1918 / AND IN LOVING MEMORY OF ALL / WHO FELL IN THE WORLD WAR / 1939-1945 / THEIR NAMES SHALL LIVE FOR EVERMORE; (on east face) THEY HAVE FOUGHT / A GOOD FIGHT; (on north face) THEY WROUGHT TO SAVE US / AND TO SAVE US DIED; (on west face) NO GREATER LOVE / HATH MAN THAN THIS. Condition: fair. Status: not listed. Owner/Custodian: Nuneaton and Bedworth District Council

***War Memorial*** Approach to Holy Trinity Church, Old Town, Stratford-upon-Avon. After 1919. Stone, 12m high approx. Condition: fair. Status: not listed. Owner/Custodian: Holy Trinity Church

***Warwickshire Royal Horse Artillery Memorial*** Playing field, corner of Lillington Road, Kenilworth. 1967. Plaque: bronze. Base: granite, 91cm high approx. Inscription: Warwickshire Royal Horse Artillery T.F./ FLANDERS 1914 COLOGNE 1918/To all who served/lest we forget/Unveiled by R.Hon. Earl of Avon K.G.M.C. 1967. Condition: good. Status: not listed. Commissioned by: Warwickshire Royal Horse Artillery

***War Memorial*** In centre of gardens, Church Lane, Whitnash. After 1919. Obelisk: stone, 1.82m high × 52cm wide × 52cm deep. Pedestal: stone, 1.13m high × 83cm wide × 84cm deep. Base: stone, 9cm high × 1.22m wide × 1.22m deep. Plaque on base: white marble on grey marble, 13cm high × 61cm wide. Inscriptions: (on obelisk in applied letters) TO THE / GLORY OF GOD / AND IN / GRATEFUL / MEMORY OF / THE MEN FROM / THIS PARISH WHO / SUFFERED AND / GAVE THEIR LIVES / FOR THEIR / COUNTRY; (on plaque at bottom of pedestal in incised letters) THESE STEPS WERE LAID / TO COMMEMORATE / 50 YEARS PEACE/20th AUGUST/1995. Condition: fair. Status: Not listed

## Miscellaneous

***Decorative façade of the Abbotsford*** Old Square, Warwick. Builder: Francis Smith of Warwick. Sculptor: Walter Ritchie. Restorer: Eric Davies. 1714. Window decoration: Hollington stone, each 1.5m high × 50cm × 10cm deep approx. Corner pilaster capitals: Hollington stone, each 1m high × 80cm wide approx. Entrance pilaster capitals: Hollington stone, each 40cm high × 40cm wide × 40cm deep approx. Condition: fair. Status: Grade II. Commissioned by: Francis Smith's father-in-law

## *Coventry*

## Heraldic Devices and Coats of Arms

***Drapers Company Coat of Arms*** Holy Trinity Church Centre, Bayley Lane, Coventry. Architects: Thomas Rickman and H. Hutchinson. *c.*1832. Sandstone, 60cm high × 90cm wide approx. Condition: poor. Status: Grade II. Commissioned by: Drapers Company. Owner/Custodian: Holy Trinity Church

***Coventry City Coat of Arms and Foliage*** Former Broad Heath Primary School, Broad Street, Coventry. Architect: G. & I. Steane. 1910. Stone, 1m high × 2m wide approx. Inscription: AD and 1910. Condition: poor. Status: Grade II. Commissioned by: Coventry Borough Council

***City of Coventry Coat of Arms*** Belgrade Theatre, Corporation Street, Coventry. Designer: James C. Brown. Unveiled: 27 March 1958. Copper, 3m high approx. Inscription: (motto) CAMERA PRINCIPIS. Condition: good. Status: not listed. Commissioned by: Coventry Planning and Development Committee. Owner/Custodian: Belgrade Theatre

***University of Warwick Coat of Arms*** University of Warwick, Gibbet Hill Road. 1960s. Metal, painted, 1m high × 75cm wide approx. Inscription: (on book) MENS TAT AGI MOLEM; (motto below shield) UNIVERSITAS WARWICENCIS. Condition: good. Status: not listed. Commissioned by: University of Warwick

***Coventry City Coat of Arms*** Old fire station, Hales Street, Coventry. 1902. Stone, painted various colours, 1.05m high × 85cm wide approx. Condition: fair. Status: not listed. Commissioned by: Coventry Borough Council

***Royal Arms*** Façade of County Courts, Much Park Street, Coventry. 1960s. Polished steel, 1.5m high × 2m wide. Condition: good. Status: not listed. Commissioned by: County Courts

***Coventry City Coat of Arms*** Manor Park

School, Ulverscroft Road, Coventry. Sculptor: Trevor Tennant. 1950. Terracotta, painted, 60cm high × 40cm wide approx. Condition: fair. Status: not listed. Commissioned by: Coventry Education Committee. Owner/Custodian: Manor Park Primary School

*Coat of Arms* Façade of King Henry VIII School, Warwick Road, Coventry. Architect: Edward Burgess. 1885. Condition: fair. Status: not listed. Owner/Custodian: King Henry VIII School

## Commemorative Plaques, Stones and Boulders

*Commemorative Plaque* Memorial Park, Kenilworth Road, Coventry. Unveiled: 19 June 1972. Slate plaque with incised lettering, attached to stone wall, 20cm high × 90cm long approx. Inscription: This plaque was unveiled by the Mayor of Lidice/Madam M. Jarosova in the presence of His Excellency/the Czechoslovak Ambassador Dr. M. Zemla and/the Right Worshipful the Lord Mayor of Coventry/ Councillor W. Spencer on Monday the 19ᵗʰ June 1972/to mark the naming of this area 'Lidice Place' as/a symbol of the friendship link between Lidice/and Coventry born out of war time destruction and/now devoted to international understanding and peace. Condition: good. Status: not listed. Commissioned by: Coventry City Council

*Commemorative Plaque* Coventry Cathedral ruins, Priory Street, Coventry. Unveiled: 3 March 2000. Slate, 2m diameter approx. Inscriptions: (on slate) In/gratitude to God/and to commend/to future generations/the self-sacrifice of/all those who served/on the Home Front/during the Second/World War; (around edge of stone base) EACH OF YOU LOOK NOT TO YOUR OWN INTERESTS BUT TO THE INTERESTS OF OTHERS. Condition: good. Status: not listed. Owner/Custodian: Coventry Cathedral

## War Memorials

*War Memorial (Cross)* London Road Cemetery, Coventry. After 1919. Cross and plinth: stone. Sword: bronze. Inscription: TO THE HONOURED MEMORY OF THOSE SAILORS AND SOLDIERS WHO GAVE THEIR LIVES FOR THEIR COUNTRY IN THE GREAT WAR 1914-18 AND WHO LIE BURIED IN THIS CEMETERY./THEIR NAME LIVETH FOR EVERMORE. Condition: good. Status: Not listed

*War Memorial (Obelisk)* London Road Cemetery, Coventry. After 1919. Obelisk: granite. Base: sandstone. Inscriptions: (on stone base) W. SMITH & SONS; (on top slab) ERECTED IN LOVING MEMORY OF OUR COMRADES WHO GAVE THEIR LIVES FOR LIBERTY IN THE GREAT WAR OF 1914-1918 BY THE STAFF & EMPLOYEES OF THE TRIUMPH AND GLORIA COMPANIES/he was a man and nothing that affected the human race was foreign to him. Condition: good. Status: not listed. Commissioned by: W. Smith & Sons. Owner/Custodian: Coventry City Council

## *Solihull*
### Heraldic Devices and Coats of Arms

*Solihull Crest* Civic Centre, Homer Road, Solihull. Sculptor: Sydney Perry. Installed: July 1961. Pre-cast terrazzo, 2.2m high × 1.75m wide approx. Inscription: (on scroll) URBS IN RURE. Condition: good. Status: not listed. Donated by the artist. Owner/Custodian: Solihull Metropolitan Borough Council

## War Memorials

*Cyclists War Memorial* The Green, Meriden. Designer: White & Sons (South Yardley). Unveiled: 27 May 1921. Granite, 6m high approx. Inscriptions: (on shaft of obelisk in gilt lettering) TO THE / LASTING MEMORY / OF THOSE / CYCLISTS / WHO DIED IN THE / GREAT WAR / 1914-1919; (on inscribed bronze plaque) IN REMEMBRANCE / OF THE / CYCLISTS / WHO GAVE THEIR LIVES / IN WORLD WAR II / 1939–45. Condition: good. Status: Not listed

## Commercial Emblems

*Barclays Bank Emblem: Spread Eagle* High Street, Solihull. 1967–9. Stone, 80cm square approx. Condition: good. Status: not listed. Commissioned by: Barclays Bank

# Glossary

**abacus**: the flat slab on top of the *capital* of a *column*.

**acanthus**: an architectural ornament, derived from the Mediterranean plant of the same name, found mainly on *capitals*, *friezes* and *mouldings* of the *Corinthian order*.

**accretion**: the accumulation of extraneous materials on the surface of a sculpture, for example, salt, dirt, pollutants or *guano*.

**aedicule**: a statue *niche* framed by *columns* or *pilasters* and crowned with an *entablature* and *pediment*; also a window or door framed in the same manner.

**alabaster**: a sulphate of lime or gypsum. As a material for *sculpture* it can be polished smooth and take paint directly on to its surface.

**allegory** (literally: 'another way'): a literary or artistic genre which gives a narrative description of a subject in the guise of another. It uses personifications, usually female, as the embodiments of abstract concepts; and representatives such as mythological, biblical, legendary or historical figures renowned for such qualities. An allegory also often makes use of metaphor.

**aluminium**: a modern, lightweight white metal obtained from bauxite. On exposure to the atmosphere it rapidly develops an inert and protective film of aluminium oxide which protects the surface of the metal from corrosion.

**annulets**: a group of projecting rings usually encircling the base of the *echinus* of a Doric capital.

**apse**: a semi-circular or semi-polygonal termination to a building, usually vaulted; hence **apsidal**.

**arcade**: a range of *arches* carried on *piers* or *columns*, either *free-standing* or attached to a wall (i.e., 'a blind arcade').

**arch**: a curved structure, which may be a *monument* itself or an architectural or decorative element within a monumental structure.

**architrave**: the main beam above a range of *columns*; the lowest member of an *entablature*. Also the *moulding* around a door or window.

**archivolt**: a continuous *moulding*, or series of mouldings, framing an *arch*.

**armature**: the skeleton or framework upon which a modelled *sculpture* is built up and which provides an internal support.

**Art Deco**: an elegant style of decorative art popular in the 1920s and 1930s, similar in some regards to the earlier Art Nouveau style, but with a more Modernist aesthetic. It is characterised by streamlining motifs in architecture.

**Art Nouveau**: a decorative style that flourished in all fields of design in Europe and America c.1890–1910, characterised by asymmetry and sinuous lines. The willowy, elongated female figure with flowing locks and the fantastic curves of stylised flowers is a typical motif. In Britain it is much influenced by the *Arts and Crafts Movement*'s emphasis on truth to nature and materials and on the idea of the craftsman as artist.

**artificial stone**: a substance, usually cement or reconstituted stones, moulded and then fired rather than carved.

**Arts and Crafts Movement**: British social and artistic movement of the second half of the nineteenth century. Widespread dissatisfaction with the quality of manufactured goods after the 1851 Great Exhibition led to the likes of Pugin, Ruskin and Morris advocating a return to guild-like practices and an emphasis on crafts skills. The movement advocated truth to materials in design and architecture and looked largely to medieval art for its models. Morris made a successful business out of decorating the homes of the rich with designs created on these principles.

**ashlar**: masonry cut into squared, smoothed blocks and laid in regular courses.

**attic course / attic storey**: the course or storey immediately above the *entablature*, less high than the lower storeys.

**attribute**: a symbolic object by which an *allegorical* or sacred personage is conventionally identifiable.

**avant-garde**: a term derived from military terminology which has been used since the middle of the nineteenth century to describe art which rejects the conventional in favour of the novel and strange.

**baldachin / baldacchino**: in monumental architecture, a *canopy* carried on *columns* or *piers*.

**baluster**: one of a series of short posts carrying a railing or coping, forming a **balustrade**.

**bargeboard**. See *gableboard*.

**Baroque**: an art historical term which has two principal meanings. (1) A period of style in art history between the late sixteenth century and the early eighteenth century. (2)

A non-technical descriptive term meaning 'florid' or 'overwrought'. The emphasis of Baroque design is on balance through the harmony of parts in subordination to the whole, achieved through contrasts of mass, light and details.

**barrel vault**: a continuous vault of semi-circular section.

**basalt**: a dark, hard igneous rock, commonly greenish- or brownish-black.

**base**: the lowest visible course of masonry in a wall; the lowest section of a *column* or *pier*, between the *shaft* and *pedestal*; the lowest integral part of a *sculpture* (sometimes mounted on a pedestal). Loosely, the lowest portion of any structure.

**basement**: the lowest storey of a building or architectural *monument*, sometimes partly, sometimes wholly, below ground level. If wholly above ground level, the basement storey is of less height than the storey above.

**bas-relief**. See *relief*.

**Bath stone**: a honey-coloured *oolitic limestone* from Bath, Avon, ideal for carving.

**battered**: of a wall, inclined inwards.

**bay**: a vertical division of a building or architectural *monument*, marked by supporting members such as *pilasters*, *buttresses*, *engaged columns*, etc.

**bestiary**: a medieval collection of descriptions of animals that emphasises their moral rather than physical qualities and is intended to teach moral lessons.

**black encrustation**: a black crust-like deposit forming on stone where there is atmospheric pollution.

**bollard**: a thick post of stone, wood, or metal, for securing ropes, etc., commonly on a quayside or ship.

**boss**: architectural term. A roof boss is a block of wood or keystone that masks the junction of vaulting ribs in exposed roof spaces.

**brass**: an alloy of copper and zinc, yellowish in colour.

**broached**: when an octagonal spire or shaft rises from a square tower or base it often has **broaches**, that is, half-pyramidal masses of masonry attached to those faces of the spire or shaft which stand above the corners of the tower or base. The broaches smooth the transition from octagon to square.

**bronze**: alloy of copper and tin, with traces of metals which affect the surface *patination* as the sculptural work weathers. A very responsive, strong and enduring substance, it is easily handled and has become one of the most common materials for *sculpture*.

**bronze resin**. See *cold-cast bronze*.

**bust**: a representation of the head and upper portion of the body.

**buttress**: a mass of masonry or brickwork projecting from a wall, or set at an angle against it, to give additional strength.

**cable moulding**: a *moulding* imitating the twisted strands of a cable.

**caduceus**: attribute of Hermes and Mercury, messenger of the Gods. A staff, culminating in a pair of intertwined snakes, surmounted by two wings. As an emblem on its own, in post-Renaissance secular *iconography* it is a symbol of peace, justice, art or commerce.

**Caen stone**: a pale beige *limestone* from Caen, Normandy.

**campanile**: a bell tower, especially a free-standing one in Italy.

**canopy**: a hood or roof-like structure, projecting over a *niche*, or carried on *columns* or *piers* over a *monument* or sculpture, etc.

**capital**: the transition between a *column* and the ceiling or arch above it. It can either be free-standing or attached to the wall.

**Carrara marble**. See *marble*.

**cartouche**: an ornamental *panel* in the form of a scroll or sheet of paper with curling edges, often oval and usually bearing an inscription or emblem.

**caryatid**: a sculptured female figure, used in place of a *column* or *pier* as an architectural support.

**cast**: to reproduce an object by making a negative mould or moulds of it and then pouring material (e.g., liquid plaster, molten metal) into the moulds. A cast is an object made by casting. An 'after-cast' or 'recast' is a subsequent cast taken from moulds, not of the original object, but of the first, or even later, cast (and often not authorised by the artist). A metal after-cast is inevitably slightly smaller than its original since metal shrinks on cooling.

**cast iron**. See *iron*.

**castellated**: fortified with battlements. By extension, the term is descriptive of something that is ornamented with a battlement-like pattern, e.g., a castellated crown.

**Celtic cross**. See *cross*.

**cenotaph**: a *monument* which commemorates a person or persons whose bodies are elsewhere; a form of First World War memorial popularised by Sir Edwin Lutyens' precedent at Whitehall, London.

**chamfer**: a bevelled surface at an edge.

**ciment fondu**: a cement-like material which is easily moulded and can be coloured.

**cire perdue** (Fr. 'lost wax'): metal-casting technique used in sculpture, in which a thin layer of wax carrying all the fine modelling and details is laid over a fire-proof clay core and then invested within a rigid-fixed, fire-proof outer casing. The wax is then melted and drained away ('lost') through vents, and replaced with molten metal. The resulting cast is an extremely faithful replication of the wax original.

**classical**: in its strictest sense, the art and architecture of ancient Greece and Rome, especially that of Greece in the fifth and fourth centuries BC and later Roman work copying it or deriving from it. By extension,

any post-antique work that conforms to these models. **Neo-classical** describes work of this sort produced across Europe from the mid-eighteenth to the mid-nineteenth centuries.

**Clipsham stone**: the hardest of the so-called Lincolnshire *limestones* quarried around Clipsham in north-east Rutland, close to the Lincolnshire border. An *oolitic* limestone, usually pale cream, pale brown or buff-coloured, it contains a large number of shell fragments; it can, however, be rubbed down to produce an extremely smooth surface if necessary. Its characteristic colouring easily harmonises with older stonework and thus it has been used in the twentieth century for the restoration of a number of England's cathedrals, for the colleges of Oxford, and for the post-Second World War restoration of the Houses of Parliament.

**clock tower**: usually a square tower with a clock at the top with a face on each exterior wall having a commemorative function and/or sculptural elements.

**Coade stone**: an artificial stone of extreme durability and, importantly, resistance to frost, manufactured and marketed by Mrs Eleanor Coade. Her firm, operating from Lambeth, was a highly successful supplier of cast sculpture and architectural ornaments from 1769 to 1833.

**cold-cast bronze (bronze resin)**: a synthetic resin that has been coloured by means of a powdered bronze filler to simulate, and so provide a cheaper substitute for, a work in *cast bronze*.

**colonnade**: a range of *columns* supporting an *entablature*.

**colonnette**: a small, usually ornamental, *column*.

**column**: upright structural member with a *shaft*, topped by a *capital* and usually rising from a *base*. Whatever the shape of the capital or base, the shaft is usually round or octagonal in plan. In *classical* usage the columns generally conform to several main types, or Orders: Corinthian, Doric, Ionic and Tuscan (see *order*).

**Composite order**. See *order*.

**Conceptual art**: a form of art in which the idea for a work is considered more important than the finished work itself. The 'true' work of art is seen not as a physical object produced by the artist, but consists of ideas or concepts.

**concrete**: a composition of stone chippings, sand, gravel, pebbles, etc., mixed with cement as a binding agent. Although concrete has great compressive strength it has little tensile strength and thus, when used for any free-standing *sculpture*, must be reinforced with an *armature* of high tensile steel rods.

**console**: a decorative bracket with a compound curved outline, resembling a figure 'S' and usually taller than its projection.

*contrapposto* (It. 'set against', 'opposed'): a way of representing the human body so as to suggest flexibility and a potential for movement. The weight is borne on one leg, while the other is relaxed. Consequently the weight-bearing hip is higher than the relaxed hip. This is balanced by the chest and shoulders which are twisted in the opposite direction.

**conversation piece**: a class of composition, especially common to eighteenth-century English painting, in which portraits of individuals are grouped together in a life-like manner and usually engaged in discussion.

**coping**: a protective capping or covering to a wall, *parapet*, etc., often sloping to shed water.

**copper**: a naturally occurring red-coloured metal. Characteristically malleable, it is often used for *repoussé* work. As an alloy, it is the main constituent of *brass* and *bronze*.

**corbel**: a brick or stone which projects from a wall and supports a feature on its horizontal surface.

**Corinthian order**. See *order*.

**cornice**: (i) the overhanging *moulding* which crowns a *façade*; (ii) the uppermost division of an *entablature*; (iii) the uppermost division of a *pedestal*. The sloping mouldings of a *pediment* are called **raking cornices**.

**cornucopia** (pl. **cornucopiae**): the horn of plenty.

**corona**: the overhanging vertical-faced member of a *cornice*, above the bed-moulding and below the *cymatium*.

**corrosion**: a process in which metal is gradually eaten away through chemical reaction with acids, salts, etc.; the process is accelerated when these agents combine with moisture.

**couchant**: heraldic term indicating an animal lying on its belly with its head raised.

**crazing**: a network of minute cracks on a surface or in a coating.

**crocket**: an ornamental architectural feature, usually in the shape of a bud or curled leaf, projecting at regular intervals from the inclined side of pinnacles, *spires, canopies* or gables.

**cross**: structure with intersecting horizontal and vertical members that may be either a monumental form in its own right or a decorative or architectural element. May be divided into three main types: (i) Calvary, Wayside cross. A sculptural representation of the Crucifixion, sometimes with a *canopy*; (ii) Celtic cross. A cross with a tall shaft and a circle centred on the point of intersection of its short arms; (iii) Latin cross. A cross whose shaft is much longer than its three arms.

**crucifix**: type of *cross* with figure of Christ.

**cruck**: a pair of inclined timbers, usually curved, extending from the ground or low side walls to the ridge of the roof. They are the chief load-bearing members that support the roof.

**Cubism**: an art movement that developed in Paris between about 1908 and 1912 in collaboration between Pablo Picasso and George Braques. The key concept of Cubism is that the essence of objects can only be captured by showing them from multiple points of view simultaneously. Although only short-lived, it influenced a number of twentieth-century art movements, including Orphism, Purism, Futurism and Constructivism.

**cupola**: a small dome.

**cusp**: in *Gothic tracery*, a projecting point at the meeting of two *foils*.

**cymatium**: in a *classical entablature*, the uppermost member of a *cornice*.

**dado / die**: on a *pedestal*, the middle division above the *plinth* and below the *cornice*.

**Darley Dale stone**: a range of *sandstones* from Derbyshire. All are even-grained and, owing to their high silica content, are relatively hard. The predominant colour is yellow-brown.

**delamination**: the splitting away of the surface layers of stone.

**dentils** (from Fr. *dentilles*, 'little teeth'): small square blocks used in series on *cornices* of the Ionic, Corinthian and Composite (rarely in the Doric) orders of architecture.

**Doric order**. See *order*.

**dormer**: vertical-faced structure situated on a sloping roof, sometimes housing a window.

**dormer head**: gable or pediment above a dormer window.

**dressed**: of masonry, worked to a desired shape, with the exposed face brought to a finish, whether polished, left matt, or moulded.

**drops**: pendant architectural ornaments, either cone- or cylinder-shaped. Known in classical architecture as *guttae*.

**drum**: (i) a cylindrical *pedestal*, supporting a *monument* or *sculpture*; (ii) a vertical wall, circular in plan, supporting a dome; (iii) one of the cylindrical stone blocks making up the *shaft* of a *column*.

**earthenware**: descriptive of articles made of baked clay which remain porous unless treated with a glaze.

**earthwork**: a term which gained currency in the late 1960s to describe outdoor abstract sculptural works, often large in scale, which rather than representing the landscape are constructed out of it.

**echinus**: the plain convex *moulding* supporting the *abacus* of a *Doric capital*; term used also for the decorated moulding of similar profile on an *Ionic* capital.

**écorché** (Fr. 'flayed'): a representation of a human figure or animal, with the skin removed to show the musculature.

**effigy**. See *sculpture*.

**egg and tongue**: classical moulding of alternated egg and arrow-head shapes (also called **egg and dart**).

**Eleanor Crosses**: a series of twelve monumental crosses erected between 1291 and *c*.1296 by King Edward I after the death of his queen, Eleanor of Castile, in 1290. The crosses, each containing stone statues of Eleanor, marked the stopping places of her funeral cortège on its journey from Lincoln (she died at nearby Harby) to Westminster Abbey. The sites are Lincoln, Grantham, Stamford, Geddington, Hardingstone, Stony Stratford, Woburn, Dunstable, St Albans, Waltham, Cheapside and Charing. Of these, only the crosses at Geddington and Hardingstone in Northamptonshire and Waltham in Hertfordshire survive. Records of payments (with names of the masons and sculptors) survive for all the crosses except that at Geddington which is consequently believed to be the latest of the series.

**electroplating**: the application of a metal coating to a surface by means of an electric current. Discovered in the early nineteenth century, it was first used for sculpture in 1839.

**engaged column**. See *column*.

**entablature**: in *classical* architecture, the superstructure carried by the *columns*, divided horizontally into the *architrave*, *frieze* and *cornice*.

**equestrian statue**. See *sculpture*.

**erosion**: the gradual wearing away of one material by the action of another or by, e.g., water, ice, wind, etc.

**façade**: front or face of a building or *monument*.

**faience** (Fr. name for Faenza in Italy): *earthenware* with a tin glaze.

**fasces**: composed of an axe in the middle of a bundle of rods, the fasces were carried in procession by lictors in front of the chief magistrates as a symbol of their power over the lives and liberties of the people of ancient Rome. As an emblem, it symbolises order, republican sentiments, the common good and concordance. Fasces were adopted by the Fascists as their badge.

**fascia** (pl. **fasciae**): in *classical* architecture, one of the two or three plain, overlapping, horizontal bands on an *architrave* of the *Ionic*, *Corinthian*, and *Composite orders*.

**festoon**: a sculptured ornament representing a garland of flowers, leaves, fruit, etc., suspended between two points and tied with ribbons. Also called a **swag**.

**Fibonnacci sequence**: a sequence of numbers in which each number other than the first two is the sum of the two previous terms, i.e., 1, 2, 3, 5, 8 and so on.

**fibreglass**: a material made of resin embedded with fine strands or fibres of glass woven together to give it added strength. As it does not shrink or stretch, has high impact strength and can withstand high temperatures, it has become a popular material for modern *sculpture*.

**finial**: an architectural ornament which finishes a vertical projection such as a *spire* or gable.

**fluting, flutes**: shallow concave grooves of

semi-circular section, especially those running longitudinally on the *shafts* of *columns*, *pilasters*, etc.

**foil**: in *Gothic tracery*, an arc- or leaf-shaped decorative form which meets its neighbour at a *cusp*.

**foliate**: decorated with leaf designs or *foils*.

**foundation stone**: a stone situated near the base of a building or *monument*, bearing an inscription recording the dedicatory ceremony.

**founder's mark**: sign or stamp on a *sculpture* denoting the firm or individual responsible for casting.

**fountain**: a structure with jets, spouts and basins of water for drinking or ornamental purposes. Component parts may include sculptural decoration or *inscription*.

**free-standing**: of sculpture, not attached to any kind of support, except for a *base* or *plinth*.

**freestone**: any *limestone* or *sandstone* which is sufficiently homogeneous and fine-grained to be cut or sawn 'freely' in any direction.

**frieze**: in *classical* architecture such as Greek temples, the frieze was the middle division of the *entablature*, between *cornice* and *architrave*, which was often used for *relief* sculpture. Modern usage extends the concept of a frieze to any long, narrow sculptural relief incorporated into an architectural work, excluding medallions and roundels in their own right.

**frontage**: the front face of a building.

**frontispiece**: (i) the main *façade* of a building; or (ii) its decorated entrance *bay*.

**Futurism**: an *avant-garde* art movement, founded in 1909 by Marinetti in Milan. Futurism in art and sculpture glorified speed, modernity and violence. The most important of the Futurist sculptors was Umberto Boccioni, whose *Unique forms of Continuity in Motion* can be seen in Tate Modern, London.

**gableboard** (also called a bargeboard or vergeboard): a board which hangs from the slope of a roof gable, masking the ends of the horizontal roof-timbers; often elaborately carved and ornamented.

**galvanise**: to immerse a metal in molten zinc to give it a protective coating against rust.

**galvanised steel**: *steel* coated with zinc as a protective barrier against atmospheric *corrosion*.

**gargoyle**: a spout in the form of a carved *grotesque* human or animal head, projecting from the top of a wall to throw off rainwater.

**gazebo**: a small summer house, or similar structure, usually in a garden or park.

**genre**: originating from the French, in art historical terminology genre denotes a 'kind' or 'type' of visual art. A second meaning of the term applies to scenes of everyday life or activities depicting socially less privileged classes.

**giant order**: an *order* whose *columns* or *pilasters* rise through two or more storeys. Also called a colossal order.

**gilding, gilt**: to gild is to cover a surface with a thin layer of gold, or with a gold-coloured pigment; gilding is the golden surface itself.

**glass-reinforced concrete**: cement which has been mixed with chopped, *c.*50mm-long strands of glass fibre for enhanced strength.

**glass-reinforced polyester**: a polyester resin strengthened with glass fibres.

**glory**: light radiating from a sacred personage.

**glyptic**: of sculpture, carved rather than modelled (cf. *plastic*).

**gnomon**: a pin or triangular plate on a sundial, the shadow of which indicates the time of day.

**Golden Section, Golden Mean**: a proportion long believed to express the essence of visual harmony. Euclid called it 'extreme and mean ratio' and defined it as a straight line bisected such that the lesser is to the greater part as the greater part is to the whole. Its fascination lay in the fact that it cannot be expressed in whole numbers, that is, it is an irrational proportion. There was a revival of interest in the Golden Section in fifteenth-century Italy: for instance, the architect and theorist Leon Battista Alberti appears to have employed it to determine the proportions of his façade for Santa Maria Novella, Florence (1456–70), and the mathematician Luca Pacioli wrote a book on it entitled *Divina Proportione* (1509). There has also been much interest in the Golden Section from twentieth-century abstract artists.

**Gothic**: a term used to denote the style of medieval art and architecture that predominated in Europe *c.*1200–*c.*1450. In architecture it is characterised by the pointed arch and an overall structure based on a system of ribbed cross vaulting supported by clustered columns and flying buttresses, giving a general lightness to the building. In *sculpture* the figure is generally treated with naturalistic detail, but is often given an exaggerated elegance through elongation and the use of an 'S' curve. Although the style had an almost uninterrupted history in northern countries, especially in England, it had a major revival in the architecture of the nineteenth century.

**Gothic Revival**: a revival of the forms of Gothic art and architecture, beginning in the mid-eighteenth and lasting throughout the nineteenth centuries.

**graffiti**: unauthorised lettering, drawing, or scribbling applied to or scratched or carved into the surface of a *monument* or *sculpture*.

**granite**: an extremely hard crystalline igneous rock consisting of feldspar, mica and quartz. It has a characteristically speckled appearance and may be left either in its rough state or given a high polish. It occurs in a wide variety of colours including black, red, pink, grey-green.

**grit, gritstone**: name often used for the coarser types of *sandstone*, i.e., *Millstone grit*.

**grotesque**: a type of decorative *sculpture* or painting in which human figures and/or animals are fancifully interwoven with plant forms. Popular in ancient Rome, the rooms that were decorated thus were buried for centuries. When excavated they were known in Italian as *grotte* ('caves') and so the style of their decoration became known as grotesque. By extension, this term is now applied to any fanciful decoration that involves distortion of human or animal form.

**Groundwork Coventry**: an environmental trust set up to regenerate run-down urban areas. They commissioned the works along Coventry Canal's Public Art Trail.

**guano**: bird excrement.

**guilloche**: a running pattern formed by two or more bands which interweave like a plait to form circular openings sometimes filled with circular ornaments.

**guttae**: pendent ornaments, generally in the form of truncated cones, sometimes cylinders, found in series on the undersides of the *mutules* and *regulae* of *Doric* entablatures.

**high relief**. See *relief*.

**historicism**: the use of a historical artistic style rather than one in a contemporary idiom.

**hood-mould**: a projecting *moulding* placed above a window, doorway, or archway to throw off the rain.

**Hopton Wood stone**: a *limestone* from Derbyshire, occurring in light cream and grey. In common with other polishable limestones it is sometimes referred to incorrectly as a *marble*.

**iconography**: the visual conventions by which traditional themes are depicted in art under changing historical and cultural conditions. The term is also used for that method of art history which traces those transformations, often in relation to their literary sources.

**in situ**: (i) of a *monument* or *sculpture*, still in the place for which it was intended; (ii) of an artist's work, executed on site.

**inscribed stone**: boulders, monoliths, sarsens, slabs, etc.

**inscription**: written dedication or information.

**intercolumniation**: the intervals between the lower parts of the shafts of adjacent *columns*.

**Ionic order**. See *order*.

**iron**: a naturally occurring metal, silver-white in its pure state, but more likely to be mixed with carbon and thus appearing dark grey. Very prone to rust (taking on a characteristic reddish-brown colour), it is usually coated with several layers of paint when used for outdoor *sculptures* and *monuments*. As a sculptural material it may be either (i) **cast** – run into a mould in a molten state and allowed to cool and harden; or (ii) **wrought** – heated, made malleable, and hammered or worked into shape before being welded to other pieces.

**jamb**: one of the vertical sides of a door, window, or archway.

**keystone**: the wedge-shaped stone at the summit of an *arch*, or a similar element crowning a window or doorway.

**kinetic sculpture**. See *sculpture*.

**lamp**: street light with decorative elements or commemorative function.

**landscape format**: of panels, etc., rectangular, and wider than they are high (cf. *portrait format*).

**lantern**: a small circular or polygonal windowed turret, surmounting a dome, *cupola* or *canopy*.

**Latin cross**. See *cross*.

**lettering**: characters which comprise the *inscription*. The following types are commonly found. **Applied**: metal letters stuck or nailed. **Incised**: letters carved into stone or etched in metal. **Relief**: low relief letters. **Raised**: high relief letters.

**limestone**: a sedimentary rock consisting wholly or chiefly of calcium carbonate formed by fossilised shell fragments and other skeletal remains. Most limestone is left with a matt finish, although certain of the harder types can take a polish after cutting and are commonly referred to as *marble*. Limestone most commonly occurs in white, grey, or tan.

**lintel**: a horizontal structural member, usually of stone or wood, placed over a doorway or window, to take the weight of the superincumbent masonry.

**lost wax**: See *cire perdue*.

**lozenge**: a four-sided diamond-shaped figure.

**lunette**: semi-circular surface on, or opening in, a wall, framed by an *arch* or *vault*.

**mahogany**: a very hard, fine-grained, reddish-brown wood obtained from certain tropical trees and capable of taking a high polish.

**maquette** (Fr. 'model'): in *sculpture*, a small three-dimensional preliminary sketch, usually roughly finished.

**marble**: in the strictest sense, *limestone* that has been recrystallised under the influence of heat, pressure, and aqueous solutions; in the broadest sense, any stone (particularly limestone that has not undergone such a metamorphosis) that can take a polish. Although true marble occurs in a variety of colours, white has traditionally been most prized by sculptors, the most famous quarries being at **Carrara** in the Apuan Alps, Tuscany, and on the island of Paros (i.e., **Parian** marble) in the Aegean. Also prized is **Pentelic** marble, from Mount Pentelikos on the Greek mainland, characterised by its golden tone (caused by the presence of iron and mica). Other types include **Grestela** marble, a dark-veined white marble, found in the Carrara quarries; and **Sicilian** marble, a term applied to all marbles that are white with cloudy and irregular bluish-grey veins.

**mausoleum**: a monumental tomb. The term

derives from the Tomb of King Mausolus (one of the Seven Wonders of the Ancient World) at Halicarnassus, *c.*350 BC.

**meander pattern**: a continuous geometric pattern of alternated vertical and horizontal straight lines joined at right angles.

**medallion**: in architecture, a circular frame (i.e., shaped like a medallion or large medal) within which relief sculpture may be situated.

**memorial**. See *monument*.

**metope**: the square space between two triglyphs (blocks with vertical grooves) in a Doric *frieze*.

**mild steel**: *steel* containing only a small percentage – up to 0.15% by weight – of carbon. Mild steel is noted for its strength and toughness.

**milestone**: waymark, breadstone, Coal-Tax post, etc.

**modello** (It. 'model'): a small-scale, usually highly finished, sculptor's (or painter's) model, generally made to show to the intended patron.

**monolithic**: of a large *sculpture*, *pillar*, *column*, etc., made from a single stone.

**monument**: a structure with architectural and / or sculptural elements, intended to commemorate a person, event, or action. The term is used interchangeably with *memorial*.

**mosaic**: a design comprised of small, coloured, pieces of glass, *marble*, stone, tile, etc., cemented to a surface.

**moulding**: in architecture, a decorative contour designed to enrich a projecting or recessed member.

**mullion**: one of the vertical stone or timber members dividing a window into lights.

**mural**: large-scale decoration on or attached to a wall.

**Muses**: ancient Greek goddesses who preside over specific arts and sciences. They are the daughters of Zeus and the Titaness Mnemosyne ('Memory'), are nine in number, and live with Apollo on Mount Parnassus. Each has her own sphere of influence. Clio is the Muse of history, Euterpe of music and lyric poetry, Thalia of comedy and pastoral poetry, Melpomene of tragedy, Terpsichore of dancing and song, Erato of lyric and love poetry, Urania of astronomy, Calliope of epic poetry, and Polyhymnia of heroic hymns.

**mutule**: projecting square block above a *triglyph* and on the underside of a *Doric cornice* decorated on its underside with a series of *guttae*.

**Neo-classical**. See *classical*.

**New Sculpture**: a movement in British sculpture 1877–*c.*1920 away from the relative blandness of mid-nineteenth-century practice towards a type of work that was both more naturalistic and more imaginative. *Athlete Wrestling with Python* (RA 1877) by the painter Frederick Leighton is customarily regarded as the starting point, although the term was first coined in 1894. The naturalistic side of the movement is best exemplified by the work of Hamo Thornycroft and John Tweed, the imaginative, symbolist side by the work of Alfred Gilbert. The two, however, were not necessarily mutually exclusive as is clear from, for instance, Gilbert's monument to Queen Victoria, Newcastle, with its sensitive modelling of the old queen and strange, fantastical treatment of the throne and pedestal. The deaths of Harry Bates and Onslow Ford and the virtual exile of Gilbert at the turn of the century are sometimes posited as the moment when the New Sculpture ran out of steam. However, the continued energy and invention of sculptors like William Reynolds-Stephens and William Goscombe John even after the First World War suggests that a later date for its demise may be more accurate.

**newel-post**: the terminal post at the head or foot of a flight of stairs.

**niche**: a recess in a wall, often semi-circular in plan, used as a setting for a *statue*, *bust* or ornament.

**obelisk**: a monumental tapering shaft of stone, rectangular or square in section, ending pyramidally, usually *free-standing*.

**oculus**: a circular opening or window. A **blind oculus** is one where the circular surround is applied to a wall where there is no aperture.

**ogee**: a line with a double curve resembling a letter 'S'; descriptive of a *moulding* with such a shape. An ogee *arch* is one with lower concave and upper convex curves meeting at a point.

**ogee arch**: a type of archway consisting of two S shaped curves meeting at their apex. Introduced in the late thirteenth or early fourteenth century, this *arch* was commonly used in the late Middle Ages.

**oolitic**: descriptive of *limestones* whose structure is largely composed of ooliths, small rounded granules of carbonate of lime.

**open-work**: any kind of decorative work which is pierced through from one side to the other.

**order**: in *classical* architecture, an arrangement of *columns* and *entablature* conforming to a certain set of rules. The Greek orders are (i) **Doric**, characterised by stout columns without *bases*, simple cushion-shaped *capitals*, an entablature with a plain *architrave*, and a *frieze* divided into *triglyphs* and *metopes*; (ii) **Ionic**, characterised by slender columns on bases, capitals decorated with *volutes*, and an entablature whose architrave is divided horizontally into *fasciae* and whose frieze is continuous; and (iii) **Corinthian**, characterised by even slenderer columns, and a bell-shaped capital decorated with *acanthus* leaves. The Romans added **Tuscan**, similar to the Greek Doric, but with a plain frieze; and **Composite**, an enriched form of Corinthian with large *volutes* as well

as acanthus leaves in the capital. They also had their own **Roman Doric**, in which the columns have bases.

**oriel window**: a bay window corbelled out from the wall of an upper storey.

*palazzo*: in Italian architecture, an imposing civic building or town house.

**palmette**: an ornament, somewhat resembling the splayed fingers of a hand, derived from a palm leaf.

**panel**: a distinct part of a surface, either framed, recessed, or projecting, often bearing a sculptured decoration or an inscription.

**pantheon**: originally, a temple dedicated to all the gods, specifically the Pantheon in Rome, completed *c.* AD 126. By extension, the name came to be used for places where national heroes, etc., were buried or commemorated (e.g., the Panthéon, Paris).

**parapet**: a wall bordering the edge of a high roof, or bridge, etc.

**Parian marble**. See *marble*.

**patina**: surface coloration of metal caused by chemical changes which may occur either naturally, due to exposure for example, or by processes employed at a foundry.

**pavilion**: a light, ornamental and often open building or temporary structure used for shelter, exhibits, concerts, etc.

**pavilion roof**: a roof inclined equally on all four sides to form a pyramidal shape.

**pedestal**: the *base* supporting a *sculpture* or *column*, consisting of a *plinth*, a *dado* (or die) and a *cornice*.

**pediment**: in *classical* architecture, a low-pitched gable, framed by the uppermost member of the *entablature*, the *cornice*, and by two raking cornices. Originally triangular, pediments may also be segmental. Also, a pediment may be open at the apex (i.e., an open-topped or broken-apex pediment) or open in the middle of the horizontal cornice (an open-bed or broken-bed pediment). The ornamental surface framed by the pediment and sometimes decorated with sculpture is called the *tympanum*.

**pergola**: a garden arbour usually formed by trailing climbing plants over a wooden trellis.

**personification**: the visual embodiment (often in the form of a classically-robed female figure) of an abstract idea (e.g., Britannia).

**phosphor bronze**: a type of *bronze* with *c.*1% phosphorus added, giving enhanced strength.

**pier**: in architecture, a free-standing support, of rectangular, square or composite section. It may also be embedded in a wall as a *buttress*.

**pilaster**: a shallow *pier* projecting only slightly from a wall.

**pilaster strip**: a *pilaster* without a *base* or *capital*. Also called a lesene.

**pillar**: a free-standing vertical support which, unlike a *column*, need not be circular in section.

**pits/pitting**: small holes and other faults in a metal surface caused either by imperfections in the *casting* process or by *corrosion*.

**plaque**: a plate, usually of metal, fixed to a wall or *pedestal*, including *relief* and / or an *inscription*.

**plaster**: a range of materials ideal for casting. The type most often used by sculptors is specifically known as **plaster of Paris**, a mixture of dehydrated gypsum and water. It is mixed together as a liquid and may be poured into negative moulds (which themselves may be made of plaster) to make positive casts of a fragile clay model, or as a studio record of a finished work. Plaster of Paris sets in a compact mass of even consistency and, most importantly, can reproduce fine details from the mould, since it expands slightly in setting. When a sculptor's model is referred to as a plaster, or as a plaster cast, it is usually understood that it is specifically plaster of Paris that is referred to.

**plastic**: (i) any synthetic substance that can be modelled and will then harden into some permanent form; (ii) a term descriptive of *sculpture* that is modelled rather than carved (cf. *glyptic*).

**Plexiglas**: proprietary name for a material made from clear acrylic resin, used as a stronger, more durable, substitute for glass.

**plinth**: (i) the lowest horizontal division of a *pedestal*; (ii) a low plain *base* (also called a *socle*); (iii) the projecting base of a wall.

**podium**: a raised platform.

**pointing machine**: a sculptor's device for the exact replication of a statue or full-sized model, or the enlargement of a small-scale model to a full-size *sculpture*. It consists of an upright frame with moveable arms equipped with adjustable measuring rods to enable the sculptor to mark precisely and replicate at the same or other scale, any number of points on the form to be copied.

**polychromy**: the practice of finishing a *sculpture*, etc., in several colours.

**polyester resin**: a commercially-produced synthetic material capable of being moulded. Its chief virtues are its tensile strength (which can be enhanced through the addition of glass fibres, i.e., *glass-reinforced polyester*) and its versatility: it can either be allowed to retain its natural transparency through the addition of transparent dyes, or it can be made opaque through the addition of powder fillers (e.g., *cold-cast bronze*) or opaque pigments.

**portico**: a porch consisting of a roof supported by *columns*.

**Portland stone**: a *limestone* from Dorset, characterised by its bleached white appearance when exposed to the elements.

**portrait format**: of panels, etc., rectangular, and higher than they are wide (cf. *landscape format*).

**Public Art Commissions Agency (PACA)**: a private, charitable company which was

created to facilitate the 'per cent for art' scheme based around the redevelopment of Centenary Square in Birmingham in the early 1990s, for which it holds a great many slides and models. It completed a number of national projects, including the Channel Fish scheme (designed by Jean-Luc Vilmouth) in the Waterloo International Rail Terminal. Its aims also included the promotion of training for public art and its integration into architectural and environmental designs.

**putto** (pl. **putti**): decorative child figure, derived from *classical* art, often signifying mankind in a state of innocence and lost innocence.

**pylon**: strictly, the monumental gateway to an ancient Egyptian temple, consisting of a pair of rectangular, tapered towers connected by a lower architectural member containing the gate; more loosely, a tapering tower resembling one of the towers from such a gateway.

**pyramid**: a square-based structure with four inward sloping triangular sides meeting at an apex.

**quadriga**: a chariot drawn by four horses abreast, sometimes represented as a sculptured group surmounting a Triumphal Arch.

**quattrocento**: the fifteenth century, literally the 1400s.

**rail**: a horizontal member in the framework of a door.

**raking cornice**. See *cornice*.

**ready-made**: a form of *sculpture* in which a manufactured object is given the status of a work of art by removal from its original utilitarian context and placed into a new non-functional context. Pioneered by Marcel Duchamp in 1913, it became an accepted genre of sculpture in Dada and *Surrealist* art.

**regula** (pl. **regulae**): short band between the *taenia* and *guttae* beneath a *triglyph* on a *Doric entablature*.

**relief**: a sculptural composition with some or all areas projecting from a flat surface. There are several different types, graded according to the degree of their projection. The most common are (i) **bas-relief**, or low relief, in which the figures project up to less than half their notional depth from the surface; and (ii) **high relief**, in which the main parts of the design are almost detached from the surface. Many reliefs combine these two extremes in one design.

**repoussé** (Fr. 'pushed back'): *relief* design on metal, produced by hammering from the back.

**reredos**: strictly, a decorated screen or wall rising behind and above an altar; more loosely, an altarpiece.

**return**: the continuation of a structure or member in a different direction, usually at a right angle.

**Rococo**: the elegantly decorative style which predominated in France in the eighteenth century during the reign of Louis XV, characterised by asymmetry; shell, rock, and plant motifs; and the use of S-curves and C-scrolls. The term is used to describe any later work which embodies those characteristics.

**Roman Doric**. See *order*.

**Romanesque**: a style of medieval art which prevailed in Europe c.1050–c.1200; in England it is also known as Norman. In architecture it was characterised by round headed *arches*, heavy continuous wall surfaces and a wealth of simple decorative geometric patterns. In sculpture and painting the figure was simply-drawn with drapery and hair treated as a decorative element.

**rosette**: a rose-shaped decorative motif.

**rostral column** (*columna rostrata*): originally in ancient Rome, a free-standing *column* erected to celebrate a naval victory, decorated with representations of the prows (*rostra*) of ships.

**rostrum**: a platform.

**rotunda**: a circular building, usually domed.

**roundel**: circular or oval frame within which a *relief* sculpture may be situated.

**Royal Academy of Arts**: teaching and exhibiting society based in London. Founded in 1768 by Joshua Reynolds and other leading artists of the day, it was the pivotal institution of English art until the late nineteenth century. Since then the letters 'RA', denoting that an artist is an elected member of the Academy, have lost much of their prestige due to a widespread perception of the Academy as out of touch with significant tendencies in contemporary art.

**Runcorn stone**: a type of fine-grained *sandstone* obtained from quarries at Runcorn, Cheshire.

**Ruskinian**: influenced by the writings of John Ruskin, a leading spokesman for the Arts and Crafts Movement who stressed the importance of high standards of craftsmanship and a detailed study of nature.

**rustication**: stonework cut in massive blocks, separated from each other by deep joints. The surfaces are often left rough to suggest strength or impregnability. A rusticated *column* has a *shaft* comprising alternated rough (or textured) and smooth *drums*.

**Sacred Monogram**: any one of a number of monograms for Christ. It may be a combination of *chi* and *rho*, the first two letters of the Greek word Χριστος (Christ), or *iota* and *chi*, the initial letters of Ιησους Χριστος (Jesus Christ), or *iota, eta, sigma*, IHS or IHC, the first two letters and last letters of Ιησους (Jesus).

**sandstone**: a sedimentary rock composed principally of particles of quartz, sometimes with small quantities of mica and feldspar, bound together in a cementing bed of silica, calcite, dolomite, oxide of iron, or clay. The nature of the bed determines the hardness of the stone, silica being the hardest.

**scagliola** (It., from *scaglia*, 'scales or chips of

marble'): imitation *marble*, much used for *columns*, *pilasters* and other interior features.

**screen**: a wall or other dividing element, often semi-circular, placed behind a *statue* or *monument*.

**scroll**: a spiral architectural ornament, either one of a series, or acting as a terminal, as in the *volute* of an *Ionic capital*.

**sculpture**: three-dimensional work of art which may be either representational or abstract, relief or free-standing. Among the many different types are: (i) **bust** – strictly, a representation of the head and shoulders (i.e., not merely the head alone); (ii) **effigy** – representation of a person, the term usually implying that of one who is shown deceased; (iii) **equestrian** – representation of a horse and rider; (iv) **kinetic** – a sculpture which incorporates actual movement, whether mechanical or random; (v) **relief** – see separate entry; (vi) **statue** – representation of a person in the round, usually life-size or larger; (vii) **statuette** – a small-scale statue, very much less than life-size; (viii) **torso** – representation of the human trunk without head or limbs.

**seat**: bench with a commemorative function or sculptural elements.

**sejant**: in heraldry, descriptive of a quadruped sitting with its forelegs upright.

**serpentine**: a metamorphic rock, consisting chiefly of hydrous magnesium silicate, usually green in colour and sometimes spotted or mottled like a serpent's skin. When polished it is commonly referred to as serpentine marble.

**sgraffiti**: decorative design incised whilst the plaster is still wet.

**shaft**: main section of a column, between the *capital* and the *base*.

**Sicilian marble**. See *marble*.

**silicon bronze**: alloy of *copper* and *c*.1–3% silicon and often a small amount of manganese, tin, *iron*, or zinc. Originally

developed for the chemical industry because of its exceptional resistance to *corrosion*, its other chief characteristics are strength, hardness, and ease of welding.

**slate**: a metamorphic rock of sedimentary origin, its chief characteristic is the ease with which it can be split into thin plates.

**smalt glass**: coloured glass or enamel, generally cut into small cubes or pieces, for use in mosaic work.

**socle**: a low undecorated *base* or *plinth*.

**spalling**: in stone or brick, the splitting away in slivers or fragments parallel to the surface.

**spandrel**: the surface, roughly triangular in shape, formed by the outer curves of two adjoining *arches* and a horizontal line connecting their crowns. Also the surface, half this area, between an arch and a corner.

**splay**: a sloping surface making an oblique angle with another surface. The term usually refers to the widening of a doorway or window, etc., by slanting its sides.

**stainless steel**: a chromium-*steel* alloy. The alloy is rendered stainless because its high chromium content – usually between 12–25% – protects its surface with a *corrosion*-resistant chromium oxide film.

**Stancliffe stone**: a siliceous *sandstone* from *Darley Dale*, Derbyshire, chiefly prized for its hardness.

**statue, statuette**. See *sculpture*.

**steel**: an alloy of *iron* and carbon, the chief advantages over iron being greater hardness and elasticity.

**stele, stela** (pl. **stelae**): an upright slab of stone, originally used as a grave marker in ancient Greece. It may bear sculptured designs or inscriptions or carry *panels* or *tablets*.

**steps**: often included in architectural elements of a *monument* or *sculpture*. For example, a stepped base.

**stoneware**: a hard, dense, non-porous clay fired at a temperature – 1,200°c to 1,400°c – sufficiently high to vitrify it partly.

**stop**: projecting stones, sometimes sculptured, at the ends of a *hood-mould*, acting as terminals.

**strapwork**: ornament consisting of interlaced bands generally used on ceilings, screens and panelling. It was especially popular in Elizabethan England.

**string course**: a continuous horizontal band projecting from or recessed into a *façade*.

**stylobate:** the substructure on which a *colonnade* stands or, more correctly, the top step of the structure forming the stepped base of a Greek temple.

**Surrealism:** an artistic style in which fantastic visual imagery from the subconscious mind is used with no intention of making the artwork logically comprehensible. Founded by André Breton in 1924, it was primarily a European movement. It included many great artists of the twentieth century, including Jean Arp, Max Ernst, Man Ray, Joan Miro, Rene Magritte and Salvador Dali.

**swag**. See *festoon*.

**Symbolism:** loosely organised movement of painters and sculptors from *c*.1885 who were connected with sentiments expressed through French symbolist poetry. Moréas stated that art should 'clothe the idea in a sensuous form', resolving conflict between the material and the spiritual world.

**tabernacle:** a *canopied niche* in a wall or *pillar*, usually containing a *statue*.

**tablet:** a small slab of stone or metal usually bearing a sculptured design or an inscription.

**taenia:** narrow raised band forming the uppermost member of a *Doric architrave*.

**tempietto:** a small temple-like structure, especially of an ornamental character, set in a garden.

**term:** a sculptured human figure, either just the head, or the head and shoulders, or the figure all the way down to the waist, rising from a pillar. Also known as a **terminal figure**.

**terracotta** (It. 'baked earth'): clay that has been fired at a very high temperature and which is

usually unglazed. It may come in a variety of colours dependent on the amount of iron oxide in the material and can be modelled or *cast* in a number of ways. It is notable for its hardness and was much used for architectural ornament in the second half of the nineteenth century.

**terrossa ferrata**: a type of plaster, strengthened with iron oxide.

**tierceron**: a secondary rib that springs from either the central *boss* or one of the main points from which the arching of the *vault* begins and leads to a place on one of the ridge ribs.

**tondo** (pl. **tondi**): a circular *panel*. Also known as a *roundel* or *medallion*.

**torso**. See *sculpture*.

**torus**: a bold convex *moulding*, semi-circular in section, especially on the *base* of a *column*.

**tracery**: an ornamental form characteristic of *Gothic* architecture, notably in windows.

**triglyph**: on a *Doric frieze*, one of the vertically-grooved blocks alternating with the *metopes*.

**trophy**: a sculptured group of arms or armour commonly found on military *monuments* and war memorials.

**turret**: small tower, usually attached to a building.

**Tuscan order**. See *order*.

**tympanum**: a section over a door or window which is often enclosed by a *pediment*. It has no structural function and so is usually filled with decoration or *relief sculpture*.

**urn**: vase with lid originally made to receive ashes of the dead, but in sculpture, usually decorative.

**vault**: an arched ceiling or roof of stone, brick or concrete, sometimes imitated in wood or plaster.

**verdigris**: a green deposit which forms naturally on the surface of copper, *bronze*, and *brass*.

**Virtues and Vices**: personifications of abstract concepts used in Christian *iconography* intended to instruct about both religious and secular moral conduct. Originating from the Late-Antique allegorical poem by Prudentius Psychomachia, describing the battle between Good and Evil, it was developed into an elaborate allegorical scheme in medieval times. The Seven Cardinal Virtues are divided between the three Theological Virtues, Faith, Hope and Charity, and the Natural Virtues of Justice, Prudence, Temperance and Fortitude. These have often been modified to include other Virtues such as Chastity.

**volute**: a spiral *scroll*, especially on an *Ionic* or *Composite capital*.

**voussoir**: wedge-shaped stone used in *arch* construction.

**wayside cross**. See *cross*.

**West Midlands Arts**: the regional board of the Arts Council of Great Britain for the West Midlands, which provides funding for creative events including performance, exhibitions and conferences. It has been responsible for aiding the commissioning of some public art works in Coventry.

**Westmorland greenstone**: a grey-green *slate*.

**Westmorland marble**: not a true *marble*, but so-called because of its polishability; actually a type of *limestone*.

**white encrustation**: a white crust-like deposit forming on stone where there is atmospheric pollution.

**wrought iron**. See *iron*.

**York stone, Yorkshire stone**: a Carboniferous *sandstone* from quarries to the south of Leeds and Bradford and around Halifax. It is usually light brown in colour, has a fine, even grain and may be highly laminated. This latter quality renders it capable of being split into thin slabs down to an inch thick that are nonetheless strong and durable. It is thus in demand for paving, *coping*, cladding, sills, etc.

# Makers' Biographies

**Kenneth Armitage** (b.1916)
Armitage trained at Leeds College of Art from 1934–7, then at the Slade School of Fine Art, London from 1937–9. He served in the army during the Second World War. Between 1946–56 he was Head of Sculpture at the Bath Academy of Art, Corsham. His first solo exhibition in the United Kingdom was in 1952. In Germany in 1956 he won first prize in the International War Memorial Competition, and in 1958 he won the David E. Bright Foundation Award at the Venice Biennale exhibition. He has since been the subject of several major international exhibitions. During the 1960s and 1970s Armitage worked for several universities including the University of Caracas, Venezuela; Boston University, Massachusetts; and the Royal College of Art, London. His work is predominantly in bronze, and depicts the human figure in abstract or simplified forms. Armitage is represented in public and private collections worldwide, and has enjoyed a reputation as one of the leading British sculptors of his generation.

Sources: Sculpture at Goodwood: British Contemporary Sculpture, www.sculpture.org.uk/; Woolcombe, T. (ed.), *Kenneth Armitage: life and work*, London, 1997; Fils, G., *Recent Sculpture by Kenneth Armitage: October – November 1957*, London, 1957.

Number of works in Catalogue: 1

**Henry Hugh Armstead** (1828–1905)
A student at the Royal Academy schools under Bailey, Leigh and Caray, he exhibited at the Royal Academy and in the principal London galleries from 1851, being elected ARA in 1875 and RA in 1879. Armstead's seated statue of the Law Courts' architect, G.E. Street (1886) is located inside the Law Courts. He worked on Sir George Gilbert Scott's Albert Memorial (1872), where he sculpted the podium frieze and the bronze statues for the canopy (both in collaboration with J.B. Philip). The podium reliefs, in 'campanella' Carrera marble, were actually carved *in situ*. His bronze of Thomas Fletcher Waghorn (pioneer and founder of the overland route to India in 1829) is located in Railway Street, Chatham. Waghorn is depicted with a chart spread across his knee and with a bronze-etched globe on a pedestal.

Sources: Beattie, S., *The New Sculpture*, New Haven and London, 1983; *Dictionary of National Biography*, Second Supplement, vol.1, 1912; Turner, J. (ed.), *Dictionary of Art*, London, 1996; Waters, G.M., *Dictionary of British Artists working 1900–1950*, Eastbourne, 1975; *Who was Who 1897–1915*.

Number of works in Catalogue: 2

**Walter Ashworth** (1883–1952)
Ashworth was Principal of the Coventry Art College and Chairman of the Coventry and Warwickshire Society of Artists. He was best known as a watercolour artist who exhibited several works at the Royal Academy and acted as a war artist in Coventry during the Second World War.

Source: Herbert Art Gallery and Museum/City of Coventry Libraries, Arts and Museums Department, *A Survey of Public Art in Coventry*, Coventry, 1980.

Number of works in Catalogue: 1

**Ted Atkinson** (b.1929)
Atkinson studied at Liverpool College of Art under Karel Vogel 1944–6, 1948–9 and then at the Slade School, University of London under Coldstream, Butler and Moore 1949–52, winning the Slade Prize for Sculpture in 1952. Between 1953 and 1958 he was head of sculpture at Exeter College of Art and became head of sculpture at Lanchester Polytechnic in 1964. Apart from sculpture he also makes etchings and has gained several awards in this field. He has several examples of public art in the United Kingdom as well as public works in Düsseldorf and Hamburg. He was invited to represent Britain at the World Expo 88 in Brisbane along with six other sculptors including Elizabeth Frink and Henry Moore. He has exhibited since 1953 and is also represented in the permanent collections of the Arts Council, Tate Gallery, Manchester City Art Gallery, Kunst Akademie, Dresden and the Museum of Modern Art, New York.

Sources: Mann, G., Ted Atkinson engraving; West Midlands Arts, *Artists, craftsmen, photographers in the West Midlands*, Stoke-on-Trent, 1977; *Who's Who*, 20th edition, 1982.

Number of works in Catalogue: 1

**Nechemia Azaz** (b.1923)
Azaz was born in Berlin and spent his childhood in Palestine. He trained as a stonemason in Bologna initially before studying sculpture in Holland and Paris. He is now based in Berkshire.

Source: University of Warwick, *Sculpture Trail Brochure*, Coventry, 1997.

Number of works in Catalogue: 1

**Thomas Banks** (1735–1805)
Banks is usually known as a small scale neo-

classical sculptor predominantly producing reliefs of classical subjects. From 1772 he worked in Italy, where he was influenced by the artist Henry Fuseli (1741–1825), and by the theories of Johann Winckelmann (1717–68). He was patronised by Catherine the Great of Russia for a year, during which time he lived in St Petersburg. His best-known works include the *Falling Titan* (1784), RA, and *Monument to Sir Eyre Coole* (1784–89), Westminster Abbey.

Source: Gowing, L., *A Biographical Dictionary of Artists*, London, 1983; Bell, C.F., (ed.), *Annals of Thomas Banks, sculptor, Royal Academician, with some letters from Sir Thomas Lawrence, P.B.A. to Banks' daughter*, Cambridge, 1938.

Number of works in Catalogue: 1

## Donato Barcaglia (1849–1930)

Donato or Donatello Barcaglia trained in Milan under Abbondio Sangiorgio, and finished his training in Rome. He worked in marble and was renowned for the quality and detail of his carving. Although working in a neo-classical style, he developed his own stylistic flourishes. He exhibited widely in Europe and America. He won the gran medaglia d'oro [Gold Medal] for his *Amore Acciece* [Cupid Teasing Venus or Love is Blind] at the 1875 Epsizione fiorentina.

Sources; Panzetta, A., *Dizionario Degli Scultori Italiani Dell'ottocento e Del Primo Novocento*, vol.1; *ibid.*, vol.2; *Benezit Dictionnaire* (of painters, sculptors, engravers), 1976.

Number of works in Catalogue: 1

## Samuel Barfield (1830–87)

Barfield was a stonemason living in Leicester who produced statuary, monumental masonry and all types of ecclesiastical furniture and fittings. He enjoyed a long working relationship with architect Joseph Goddard, for whom he executed the carving on the *Paxton Memorial* in Coventry (1868), the figures on the lower stages of the clock tower in Leicester (1868) and the sculpture on the mausoleum to Archibald

Turner in Leicester cemetery (*c.*1870). He also worked for Birmingham architect J.H. Chamberlain, for whom he carved the architectural ornament on the *Memorial Fountain to Mayor Joseph Chamberlain* (1880) and the lillies-and-lattice decoration of the rose window on the School of Art (*c.*1885).

Sources: Cavanagh, Terry and Yarrington, Alison, *Public Sculpture of Leicestershire and Rutland*, Liverpool, 2000; Noszlopy, George T., *Public Sculpture of Birmingham*, Liverpool, 1998.

Number of works in Catalogue: 2

## Percy George Bentham (1883–1936)

Bentham studied at the City and Guilds of London School of Art, the RA schools and in Paris as well as under Alfred Drury and W.R. Colton. His works include portrait busts, statues and many war memorials. He exhibited at the RA from 1915.

Source: *Who Was Who*, 1929–40, London, 1941.

Number of works in Catalogue: 1

## Phillip Bentham (b.1910)

The son of Percy Bentham, he studied at the Central School of Arts and Crafts and Kennington School of Woodworking. He began work in his father's Fulham Road studio. He was in the RAF during the Second World War, spending three and a half years in a Japanese prisoner of war camp. Phillip Bentham was primarily an architectural sculptor working in bronze and stone. His work included the clock figures on Fortnum and Masons in Piccadilly. In 1966 he was based in London but, by 1980, he was living and working in Worthing. He had associations with the Morris Singer foundry.

Source: Herbert Art Gallery and Museum/City of Coventry Libraries, Arts and Museums Department, *A Survey of Public Art in Coventry*, 1980.

Number of works in Catalogue: 2

## Anna Best (b. 1965)

Born in London, Best completed a foundation course at Hounslow Borough College, 1983–4, then studied at the Art Students' League of New York in 1984. Studying under Dick Whall, she gained a first-class honours degree in Fine Art (Sculpture) at Coventry Polytechnic. Her sculptures are designed in whatever medium is most appropriate for their specific location. She has won several awards, including a British Council travel grant to America (1991) and a Sculpture Space Inc., New York, funded residency (1993). In 1988 she established the Red Cow Studios Co-operative. In 1991 she was a participant at the Triangle Artists' Workshop in New York, and in 1992 she was both co-ordinator and participant in the Shave Artists' Workshop, Somerset. From 1989, Best lectured part-time at the Chelsea School of Art and at Hounslow Borough College. Her exhibitions include the McGrigor Donald Sculpture Prize Exhibition and tour, 1990; Lockbund Sculpture Exhibition, Oxford Art Week, and On Site, Bermondsey, 1992, and *Burning Toast*, a collaborative work with Richard Reynolds, 1993.

Source: information from the artist.

Number of works in Catalogue: 1

## William Henry Bidlake (1861–1938)

Architect. Son of the church architect, George Bidlake of Wolverhampton, Bidlake went to Tettenhall College, Wolverhampton and Christ Church College, Cambridge. Articled to Sir Robert Edis and Bodley and Garner, Bidlake was also assistant to Sir Rowland Anderson RSA. He entered the RA Schools in 1883, winning the RIBA Pugin Prize in 1895. Moving to Birmingham in 1887, he joined John Cotton in an architectural partnership and designed many churches in Birmingham and the West Midlands. His works include St Thomas, Stourbridge; St Oswald of Worcester,

Bordesley (1892–3); Branch School of Art, Moseley (1904); St Patrick, Earlswood, Warwickshire (1899–1901); St Leonard, Dordon, Warwickshire, south aisle (1901); Bishop Latimer Memorial Church, Handsworth (1903); St Mary, Wythall, Worcestershire (1903); Emmanuel Church, Wylde Green, Sutton Coldfield (1909); additions to St Stephen, Small Heath, 1910 (since demolished). Bidlake's houses include Withens, 5 Barker Road, Sutton Coldfield (1898); Woodside and The Dean, Bracebridge Road, Birmingham. He was an instructor at Birmingham Central School of Art and helped to form Birmingham College of Architecture, becoming its Director. He was awarded the Gold Medal by the Birmingham Civic Society in 1923.

Sources: Gray, A.S., *Edwardian Architecture, a biographical dictionary*, London, 1985; *RIBA Journal*, obituary, 10 January 1938.

Number of works in Catalogue: 3

## Birmingham Guild of Handicrafts

Established in 1890 by local admirers of Ruskin and Morris, with Montegue Fordham as one of the first directors. W.H. Bidlake, the architect, was an honorary director. The Guild employed about twenty craftsmen and occupied a medieval building, Kyrle Hall, in Sheep Street, Birmingham. The Guild expanded and in 1895 became a limited company with the Right Hon. William Kenrick MP as a director. Arthur Dixon (1856–1929), metalworker, was a chief designer for the Guild and he wrote a summary of the Guild's aims and ideals for *The Quest* (vol.II), a quarterly magazine hand-printed on the premises in Sheep Street. In 1910 financial problems were resolved by amalgamation with the metal-working firm of E. & R. Gittins, who made jewellery as well as the architectural metalwork in which the Guild specialised. The Guild is still in existence and has added agricultural and light engineering work to the architectural work it does.

Source: Anscombe, I. and Gere, C., *Arts and crafts in Britain and America*, London, 1978.

Number of works in Catalogue: 1

## John Blakeley (b. 1946)

Blakeley was born in Blackpool, and studied at the local School of Art between 1962–5. Between 1965–6 he studied at the St Martin's School of Art, and then at the City and Guilds of London Art School (1966–70), becoming a member of the SPS and an associate of the RBS. Currently living and working in Welwyn Garden City, he has taught at the Sir John Cass College, and is mainly noted for his work in clay and stone. Exhibitions include the Harris Museum and Art Gallery, Preston, Guildhall, Royal Exchange, and Mall Galleries.

Source: information from the artist.

Number of works in Catalogue: 1

## William James Bloye (1890–1975)

Bloye studied at Birmingham School of Art 1904–9, receiving the William Kenrick Scholarship for 1905–6 and from early in 1914 until the outbreak of the First World War he studied sculpture at the Royal Academy. In 1917 he became a part-time teacher of modelling at Vittoria Street and City Road Schools – two branch schools of the School of Art. In 1919 he was appointed as the new full-time teacher of modelling at the Central School at Margaret Street, providing that he be allowed time and facilities to continue his own training which had been interrupted by the war. He spent two four-week periods as a pupil of Eric Gill at Ditchling in Sussex in 1921 and 1922, paid for by the Birmingham School of Art. Here he trained in stone carving and letter cutting, both areas in which the School was seen to be deficient by a Board of Education Report of 1921. This acquaintance with Gill proved to be a significant influence on Bloye's work. By about 1925 Bloye had a thriving studio in

Golden Hillock Road, Small Heath, where he was engaged on many public commissions, particularly for architectural carving, and was himself employing no less than seven assistants, all of whom had trained under him at the School of Art. In 1925 Bloye became a member of Birmingham's Civic Society and from this period established himself as the city's unofficial civic sculptor receiving virtually all commissions of an official nature, including work for libraries, hospitals, clinics and the University. He retired from the School of Art in 1956 and moved to Solihull, continuing to execute commissions, mainly fountains and portrait busts, up until his death.

Sources: Information provided by Edward Allen, senior partner of S.N. Cooke, April 1985; *Birmingham Post Yearbook and Who's Who 1967–68*; Royal Academy of Arts, *Student Registers 1890–1922*; *Birmingham Post* [i] 29 May 1967 [ii] 21 March 1952 [iii] 15 June 1938.

Number of works in Catalogue: 3

## Helaine Blumenfeld (b.1943)

Blumenfeld acquired a Doctorate in Philosophy in 1963, and then studied under Ossip Zadkine in Paris during the mid-1960s, where she learnt to work in clay, wood, stone and metal. She moved to England in 1969. Her work is strongly rooted in classical mythology. She states that, 'For me mythology has to do with that knowledge which isn't obvious to us. But which is universal, timeless, and which advances our discovery of who we are and how we fit into the world. I think that we've superimposed a socially constructed mythology which we are supposed to believe, but I don't think helps us in life and understanding the meaning of life. As you know I've been trying, through sculpture to discover a new mythology.'[1] She was the only American member of the Visual Arts Panel of the Arts Council of Great Britain, appointed in 1980. She now lives in Tuscany, and works predominantly in marble.

Sources: Upson, N., *Mythologies: The Sculpture of Helaine Blumenfeld*, London, 1998; Blumenfeld, Helaine, *The New Sculpture of Helaine Blumenfeld 1982–88*, London, 1989; Blumenfeld, H., *Helaine Blumenfeld: Cambridge 1972–1992*, Cambridge and London, 1992.

Number of works in Catalogue: 1

## Bryan Blumer (1925–81)

Born in Sunderland, Blumer was educated at Durham University and the Royal College of Art. In the early part of his career, he taught sculpture at Birmingham College of Art in Margaret Street. During the 1960s, there were opportunities for him to work alongside architects and planners, designing and making works of public sculpture. He set up the company Playspace in order to use his abilities as a sculptor to develop creative play opportunities for children. His works include play sculptures in Chetton Green, Wolverhampton, and Windmill Lane, Smethwick. His socialist beliefs led him to direct his energies towards the development of participatory arts activities during the early 1970s, when he set up a community arts initiative based at Trinity Church, Digbeth, in Birmingham. In 1977, he moved to Corby, Northamptonshire to set up a second community arts company. His aim was to promote a wide range of arts activities, varying from mural painting to a community printshop and local writing and publishing groups.

Source: information from the sculptor's widow.

Number of works in Catalogue: 1

## Joseph Edgar Boehm (1834–90)

Boehm was educated in Vienna, Austria. He grew up surrounded by the extensive fine art collection of his father, the Director of the Imperial Mint. He studied in London, at the British Museum, and travelled to Italy, France and Vienna. He returned to London in 1862, becoming a British citizen in 1865. He was influenced by the drawings of Old Masters and the Elgin Marbles at the British Museum, but he believed that artists should not try endlessly to recreate the classical. Boehm became one of the foremost sculptors and portraitists in Britain, and was made Sculptor in Ordinary to Queen Victoria. During the 1880s he executed most of the public monuments commissioned in London, as well as working on funerary monuments and portraits.

Sources: Speel, B., Sculpture on Bob Speel's Website, www.speel.demon.co.uk/other/sculpt.htm, 1999; Read, B., *Victorian Sculpture*, New Haven and London, 1982; Stocker, Mark, *Royalist and Realist: The Life and Work of Sir Joseph Edgar Boehm*, London, 1988.

Number of works in Catalogue: 1

## John Bridgeman (b.1916)

Bridgeman studied painting at Colchester School of Art 1936–9 under Barry Hart and Edward Moss and then at the Royal College of Art 1947–9 under Frank Dobson. Bridgeman worked as a letter carver on war memorials and for the Design Research Unit organised by Misha Black in 1951, becoming a tutor of sculpture at Bromley, Kent and Willesden, London 1951. He became Head of Sculpture at Carlisle College of Art 1951–6 and then succeeded William Bloye as Head of Sculpture at Birmingham School of Art 1956–81, moving to work in Leamington Spa. Producing figures and groups in bronze, ciment fondu and stone, his commissions include: a bust of *Professor McClaren*, on the occasion of his retirement, for the University of Birmingham Medical School; *Wall Panels*, Swan Hotel, Yardley, now lost; *Madonna*, Coventry Cathedral (1970); *Mother and Child*, All Saints Church, West Bromwich (1981); *Family Group* and *Crucifix*, St Bartholomew's Church, Eastham Community Centre, London (1983); *Boat Children Memorial*, London Embankment (1984–5); and *Fountain Sculpture*, South Staffordshire Waterworks, Walsall (1985). Exhibited at the Festival of Britain in 1951 and at the RA from 1957; Birmingham City Museum and Art Gallery; Compendium Gallery, Moseley, Birmingham; Stratford-upon-Avon; Lincoln; Boston and Leamington Spa with the '79 Group'.

Sources: *Birmingham Post Yearbook and Who's Who, 1961–2*; letter from the artist/sculptor/architect, 1984 and 2 March 1996; *Birmingham Post* [i] 16 November 1968: p.9 [ii] 16 May 1970.

Number of works in Catalogue: 1

## Robert Bridgeman & Sons of Lichfield

Founded in 1879 by Robert Bridgeman, the practice of Bridgeman and Sons of Lichfield specialises in ecclesiastical and architectural work with wood, stone, alabaster and metal. They produce work both to their own designs and also to those of architects, with whom they have a long history of collaboration. Apart from producing pieces for churches, cathedrals, schools and other historic buildings, they also do a range of conservation and restoration work. Their work includes pieces in St Philip's Cathedral and St Chad's Cathedral, Birmingham, and in most cathedrals in England. They also have work in Australia, New Zealand, USA, Italy and Sweden.

Sources: Bridgeman, R., & Sons, *Heritage of Beauty*, undated, publicity leaflet; Keyte, O., *The Annals of a Century, Bridgemans of Lichfield 1878–1978*, Lichfield, 1995.

Number of works in Catalogue: 2

## Thomas Brock (1847–1922)

Brock studied at the Government School of Design in Worcester and at the Royal Academy, from 1867, winning a Gold Medal in 1869. He made numerous portrait busts, funerary monuments and public statues, and achieved a reputation as an establishment sculptor after his master J.H. Foley died in 1874. He was influenced by the young

sculptors, Alfred Stevens, Alfred Gilbert, Alfred Drury and Onslow Ford and his works were always highly competent and in a grand style. Commissions include: *Sir Bartle Frere*, Victoria Embankment Gardens (1888); *Rt. Rev. Henry Philpott, DD, Bishop of Worcester*, Worcester Cathedral (1896); *tomb of Sir Frederick Leighton*, St Paul's Cathedral (1900); *Queen Victoria Memorial*, Buckingham Palace, in collaboration with Aston Webb (1901–9). He exhibited at the RA from 1868 onwards. He was elected ARA (1883); RA (1891); First President of RBS (1905); Hon. DCL Oxford (1909).

Sources: *Country Life*, 16 November 1978; Spielmann, M., *British Sculpture and Sculptors of Today,* London, 1901; Beattie, S., *The New Sculpture*, New Haven and London, 1983.

Number of works in Catalogue: 1

## James C. Brown (b.1917)

Born in Paris, he graduated in law at the École des Sciences Politiques and worked in the Ministry of Finance until 1945, when he took up sculpture. Entirely self-taught, he has developed his own highly idiosyncratic style. His works are largely figurative and depict animals, birds and human figures. Since 1955, he has worked mainly in the new plastic materials.

Source: Mackay, James, *Dictionary of Western Sculptors in Bronze*, Woodbridge, 1977.

Number of works in Catalogue: 3

## Herbert Tudor Buckland (1869–1951)

Architect. Buckland studied at Birmingham School of Art, was first articled to Henry Clere, and subsequently to Bateman and Bateman, both of Birmingham. He was a great winner of competitions, including that for a Birmingham University's Women's Hall of Residence. Influenced by Webb and Lutyens, his works included schools, colleges, university extensions and mansions. With his partner William Haywood, he designed the Royal Hospital School, Holbrook and extended Newnham College, Cambridge. He also designed George Dixon School, Birmingham, St Hugh's College, Oxford, and Nobel House, Buckingham Gate, London. A member of many committees, he was president of Birmingham and Five Counties Architectural Association (1919–22), Chairman of the Allied Societies Conference (1922–5) and Vice-President of RIBA (1923–5). He was also architect to Birmingham Education Committee (1902–34) and a founder member of the Birmingham Civic Society. In the early years of the twentieth century Buckland, as a practising architect, taught at Birmingham School of Art (now part of the University of Central England).

Source: *RIBA Journal*, vol.58 (April 1951).

Number of works in Catalogue: 1

## James Walter Butler (b.1931)

Butler studied at Maidstone School of Art (1948–50), St Martin's School of Art (1950–2) and the Royal College of Art. He worked as an architectural carver (1950–3 and 1955–60) and became a tutor of sculpture and drawing at the City and Guilds of London Art School (1960–75). Major commissions include *Water Feature with Reclining Nude*, Hatfield (1970); portrait statue of *President Kenyatta*, Nairobi (1973); *Monument to the Freedom Fighters of Zambia*, Lusaka (1974); *Richard III*, Leicester, (1980); *Dolphin fountain*, Dolphin Square, London; *The Leicester Seamstress*, bronze, Hotel Street, Leicester. He has exhibited regularly at the Royal Academy since 1958. He was elected RA in 1962, ARA in 1968, RWA in 1980, and FRBS in 1981.

Sources: *Who's Who in Art*, 26th edition, 1994; Strachan, W.J., *Open Air Sculpture in Britain*, London, 1984.

Number of works in Catalogue: 2

## Victor Candey

Exhibited regularly at the RA from 1958. Candey was a sculptor local to Coventry who taught for a considerable time at Coventry Art College, becoming Deputy Principal in 1940. He was also secretary of the Coventry and Warwickshire Society of Artists for thirteen years. Candey's work was mostly exhibited locally, but in 1949 his bust of Alderman Alec Turner was accepted for the Royal Academy Summer Exhibition.

Source: Herbert Art Gallery and Museum/City of Coventry Libraries, Arts and Museums Department, *A Survey of Public Art in Coventry*, Coventry, 1980.

Number of works in Catalogue: 1

## John Cheere (d.1787)

In around 1739, John Cheere, in partnership with his brother, Sir Henry Cheere, took over the business of John Nost, including the yard and moulds for his lead-cast figures. Contemporary accounts describe the figures as life-size, and frequently painted. In 1752, Cheere produced *Mars* for Hampton Court. *Augusta* and *Flora*, 1759, were augmented by seven other mythological subjects in 1768, for Longford Castle. Two large wyverns for the brick gate-piers of Glynde, Sussex were made in 1759, and between 1762 and 1763 lead figures of *Apollo, Venus, Mercury, Livia, Augusta, Flora* and *Fortina* were made for Bowood. Sphinxes were supplied for the bridge at Blenheim in 1773, for Somerset House in 1778, and for Castle Hill, Devon (together with a lion and lioness). For Stourhead he made nine lead statues, including the *River God* in the grotto, often erroneously attributed to Rysbrack. For Castle Howard, he made two lead figures, a *Dancing Faun* and a *Roman Gladiator*. Wedgwood purchased from Cheere busts of Shakespeare, Plato, Homer and Aristotle, and in 1769 he produced the lead statue of Shakespeare which was presented by Garrick to the Corporation of Stratford-upon-Avon, and

which was erected on the north side of the Town Hall. As well as working in lead, Cheere also worked in plaster, producing stock statues and busts of figures such as Homer, Virgil, Socrates, Milton, Chaucer and Shakespeare. His many works in plaster include four casts of classical figures for the Pantheon at Stourhead, 1766. He also made the chimney pieces for Kirtlington Park, Oxfordshire. Following his death in 1787, his nephew, Charles Cheere, offered the Royal Academy the figure of their choice from his uncle's collection, and they selected *Susannah*. Samuel Whitbread purchased a number of the lead statues for Southill Park, Bedfordshire. The figure of Shakespeare was presented by Charles Cheere to Drury Lane Theatre, where it first stood in the portico, but latterly in the entrance hall.

Source: Gunnis, R., *Dictionary of British Sculptors 1660–1851*, London, 1964.

Number of works in Catalogue: 1

## Edward Clarke

Clarke's best-known work was the sculpture in Llandaff Cathedral, carved during the 1860s. It included scenes on the font showing the story of the Flood (destroyed during the Second World War), four relief panels for the pulpit, including St John the Baptist and Moses, figures of the Evangelists in the tympana of the sedilia, and a representation of the Lamb and Flag in the central tympanum of the reredos.

Source: Read, B., *Victorian Sculpture*, New Haven and London, 1982.

Number of works in Catalogue: 2

## Geoffrey Clarke (b.1924)

As a sculptor and graphic designer, Clarke is best known for his large-scale abstract works. He trained at Preston and Manchester Schools of Art before the Second World War. He studied at the Royal College of Art (1948–52) and taught there in the Light Transmission and Projection Department (1968–73). He won the silver medal at the Milan Triennale and represented Britain at the Venice Biennale in 1952, 1954 and 1960. His commissions for a range of new buildings include *The Spirit of Electricity*, Thorn House, London (1958), the ceremonial portals for the Civic Centre at Newcastle upon Tyne (1969) and *Cast Aluminium Relief* for the Nottingham Playhouse. Clarke has works in many permanent collections including Coventry Cathedral, Liverpool and Manchester Universities and the Tate Gallery. He was elected ARA in 1970 and RA in 1976.

Sources: Strachan, W.J., *Open Air Sculpture in Britain*, London, 1984; *Who's Who in Art*, 23rd edition, 1988; Black, P., *Geoffrey Clarke: Symbols of Man: sculpture and graphic work 1949–94*, London, 1994; Buckman, David, *Dictionary of Artists in Britain since 1945*, Bristol, 1998; Yorkshire Sculpture Park, *Geoffrey Clarke, RA: sculpture and works on paper, 1950–1994*, Wakefield, 1994.

Number of works in Catalogue: 1

## Angela Conner

Born in London, she is a self-taught artist who served as an apprentice to Barbara Hepworth. She is a sculptor and painter in stone, bronze, water, light and wind. She has done many portrait sculptures, including *General de Gaulle*, *Camilla Parker-Bowles* and *Dame Elizabeth Frink*. Other commissions include a mobile water sculpture for outside the Heinz Hall, Pittsburgh (1981), a 3–metre tall water sculpture for the public gardens of the Count and Countess Oeynhausen, Bad Driburg, Germany, and the *Yalta Memorial*, Thurloe Square, London (1986). She has had one-woman exhibitions in London, New York and Istanbul as well as having work exhibited at the Royal Academy, the Victoria and Albert Museum, Birmingham Museum and Art Gallery and the Carnegie Museum of Modern Art.

Source: Courtney, C., 'Sculpture by Angela Conner', *Architect (RIBA)*, vol.93, October 1986; *WWA*, 26th edition, Havant, 1994.

Number of works in Catalogue: 1

## Robert Conybear

After studying at Wolverhampton Art College (1969–72), Robert Conybear obtained a master's degree from Birmingham School of Art. During his career, he has received a number of awards from the English Arts Council. He has had one-man exhibitions at the ICA and Serpentine art galleries, London (1975), and his works have been included in group exhibitions at a number of museums, including the ICA, London (1980), the Kulturzentrum, Mannheim (1982–3), Drumcroon Art Centre, Wigan (1994) and the Arts Workshop Gallery, Swansea (1995). He has also held part-time teaching posts in Salford and Swansea. He is currently in partnership with the sculptor Uta Molling. Many of their commissions have been from his home town of Swansea, including a lighthouse sculpture for the marina (1986), a wall mosaic for the sea cadets' headquarters (1991), a figure weather vane for Swansea Observatory (1991), and mosaics for the city centre (1992) and Swansea Mumbles (1993). More recently, they have designed a series of 24 mosaic ceramic panels for Luton town centre (1997) and site-specific sculpture in London (1998) and Coventry (1999).

Source: information from the sculptor.

Number of works in Catalogue: 1

## Dave Cooper

Between 1968 and 1982, Dave Cooper worked as a professional musician, a musical instrument maker, a gardener, a cabinet-maker and a theatre assistant at Walsgrave Hospital in Coventry. He studied art at Coventry University (1982–6), where he chose to

specialise in sculpture. He is a founder member of both Arts Exchange (1987–9) and Coventry Artists' Co-operative (1991–9). He has taught ceramics at Warwick University (1987–9) and Arts and Crafts Studies at Coventry University (1995–8). In 1990 he went on a 12–month cultural exchange to Perth, Western Australia, where he worked in studio ceramics and showed works in the Pommie Potters ceramic exhibition. Since 1987, he has also exhibited in London, Coventry, Glastonbury and Reading.

Source: information from the sculptor.

Number of works in Catalogue: 2

**Jethro Anstice Cossins** (1830–1917)
Born in Kingsdon, Somerset, Cossins was articled to Frederick William Fiddian of London in 1847 and came to Birmingham in 1850. He was in partnership with John George Bland in 1880, and with Peacock and Bewlay c.1900. A member of SPAB, he was also president of the Birmingham Architectural Association.

Source: Colvin, Howard, *Dictionary of British Architects 1600–1840*, London, 1993.

Number of works in Catalogue: 1

**Sean Crampton** (1918–99)
Crampton was born in Manchester, the son of the architect Joshua Crampton. Between the ages of 12 and 15, he took silversmithing classes at Vittoria School of Art, Birmingham, going on to develop this talent in the Sculpture Department of the Central School of Art, Birmingham, and then becoming apprenticed to Fernand Léger in Paris. During the war, he served in the Western Desert and in Italy. He was awarded the George Medal for his bravery during a reconnaissance mission in January 1944, in the course of which he lost a foot. After a long period of convalescence, he was appointed Professeur de Sculpture at the Anglo-French Art Centre in London (1946–50).

His deep commitment to the Catholic faith resulted in his production of many works depicting religious themes. His preferred medium was welded phosphor bronze, and from this he constructed the 14 Stations of the Cross for the Church of St Edmund in Calne, Wiltshire. Other works include figure groups, nude male and female figures, birds and animals. He also created a memorial for his old regiment, the London Irish Rifles. President of the Royal Society of British Sculptors for five years (1966–71), he was also Master of the Art Workers Guild (1978), Chairman of the Governors of the Camberwell School of Art during the 1980s and a governor to the court of the newly-founded London Institute. He had 17 solo exhibitions in London, exhibiting regularly with the Alwin Gallery, and was included in the first RWA Open Sculpture Exhibition, 1993.

Source: *Dictionary of National Biography*, CD ROM version.

Number of works in Catalogue: 1

**Robert H. Crutchley** (b. 1943)
A senior lecturer at Bournville College of Art, Crutchley studied at the Birmingham College of Art. In 1990, he sculpted the statue of St Michael for St Michael's Church, Manor Park. Crutchley's exhibitions include Portfolio, RBSA (1988); Ikon Gallery, Birmingham (1991); 1st RWA Open Sculpture Exhibition (1993). He has exhibited most recently at the Royal West of England Academy in Bristol and the Hochschule für Graphik und Buchkunst in Leipzig.

Source: information from the sculptor.

Number of works in Catalogue: 1

**Edward Cullinan** (b.1931)
Architect. Cullinan was educated at Cambridge University (BA, 1951) and University of California at Berkeley (George VI Memorial

Fellow, 1956). He has taught architecture at University College, London (1978–9), the University of Sheffield (1985–7) and the University of Edinburgh (from 1987). He designed and built Horder House, Hampshire (1959–60), Marvin House, California (1959–60), Minster Lovell Mill (1969–72), the parish church of St Mary, Barnes (1978–84), Lambeth Community Care Centre (1979–84), and the Fountains Abbey visitor centre and landscape (1987–92). All have received awards. He is a Fellow of the Royal Society of Architects.

Source: information from the architect.

Number of works in Catalogue: 1

**John Cundall** (1830–89)
One of Leamington Spa's leading 19th-century architects. He was responsible for the west wing of the Warneford Hospital in 1868, the main building of Warwick School, various churches in Leamington, the extension to Honington Hall, and the School and School House at Sherbourne.

Sources: Leamington Spa Museum Service, Leamington Spa Museum and Art Gallery Information Files; Pevsner, N., *Buildings of England: Warwickshire*, Harmondsworth, 1966.

Number of works in Catalogue: 3

**Clemence Dane** (1888–1965)
Clemence Dane was the pseudonym of Winifred Ashton, a playwright and novelist who had originally intended to make painting her career, studying at Dresden and the Slade. She continued painting and sculpting throughout her life. Her early plays were strongly criticised for the weakness of their central male characters, but she later gained a reputation as a writer of novels and film scripts. She was awarded the CBE in 1953.

Source: Stephens, L. and Lee, S. (eds), *Dictionary of National Biography*, London, 1990.

Number of works in Catalogue: 1

**Eric Davies** (b.1910)
Architect. Born in Chadderton, Lancashire, Davies studied architecture at the University of Manchester, graduating in 1933, and becoming a Fellow of the Royal Institute of British Architects in 1960. During his working life, he worked for the architect's department of the City of Manchester, Derbyshire, Lancashire and East Yorkshire, and later for 14 years as County Architect for Warwickshire. Other appointments include Chairman of the Coventry Society of Architects and Architect for the Central Area Redevelopment of Warwickshire Borough Council.

Source: information from the architect.

Number of works in Catalogue: 5

**Miles Davies** (b.1959)
Davies was educated at Leamington Spa School of Art and and studied Fine Art at Brighton Polytechnic (1978–81). Public commissions include pieces for sculpture trails in the Forest of Dean (1988) and *Open Door*, Ashton Court, Bristol (1989); Millfield Sculpture Commission, Millfield School (1991). Solo exhibitions include: Artiste Sculpture Garden, Bath (1990); Arnolfini, Bristol (1990); Yorkshire Sculpture Park, Wakefield (1991). Recent group exhibitions include: Eisfabrik, Hannover; New Meanings for City Sites, Birmingham Museums and Art Gallery, Birmingham (1991); Road Works II, Bilston Art Gallery, Bilston (1994). He has works in public and private collections in England, France and Germany including, from 1995, the Peterborough Sculpture Trust.

Sources: Information from the artist, 7 February 1996; *Art Monthly*, October 1989; http://wavespace.waverider.co.uk/~scotdave; Yorkshire Sculpture Park, *Miles Davies: sculptor*, Wakefield, 1991.

Number of works in Catalogue: 1

**Bob Dawson** (*fl.* 1900–48)
Dawson was a decorative designer and craftsman who was born in Bingley, Yorkshire. After studying at the Royal College of Art, he taught there for two years. Later, he was headmaster of Belfast Municipal School of Art (1901–18) and then became principal of Manchester's equivalent school (1919–39). He had exhibitions at the RHA, the RA and the Walker Art Gallery in Liverpool.

Source: Buckman, David, *Dictionary of Artists in Britain since 1945*, Bristol, 1998.

Number of works in Catalogue: 1

**Paul De Monchaux** (b.1934)
De Monchaux studied at the Art Students' League, New York from 1952 to 1954, then at the Slade School of Fine Art from 1955 to 1958. His first works were exhibited at the Institute of Contemporary Art in 1961. He has received an Arts Council Major Award (1980) and the Northern Electric Environment Award (1990). Before retiring in 1986 to work full time as a sculptor he taught at Goldsmith's College between 1960 and 1965, and was Head of Sculpture and Fine Art at Camberwell.

Sources: [i] press release, 3 June 1999 [ii] letter, colour images and copies of designs for his works from the artist, 3 June 1999.

Number of works in Catalogue: 1

**Josefina de Vasconcellos** (b.1904)
The daughter of the Brazilian Consul-General to Great Britain, she studied at Regent Street Polytechnic under Brownsward, the RA schools, the French Academy under Andreotti and Bourdelle's studio in Paris. She has exhibited at the Royal Academy, and has a studio in Ambleside. She is a founder member of the Society of Portrait Sculptors.

Source: Buckman, David, *Dictionary of Artists in Britain since 1945*, Bristol, 1998.

Number of works in Catalogue: 1

**Richard Deacon** (b.1949)
Deacon studied at Somerset College of Art (1968–9), St Martin's School of Art (1969–72), the Royal College of Art (1974–7) and Chelsea School of Art (1977–8). Whilst a student Deacon became interested in the modernist ideas of William Tucker who was teaching at St Martin's. Tucker conceived of sculpture as an autonomous object with a poetic dimension. Deacon was also influenced by the writings of Donald Judd, an American artist, who proposed a new category to replace sculpture, the 'specific object' grounded in reality. This relationship between the literal and the metaphoric in sculpture has dominated Deacon's work. He uses simple armatures to allude to poetic and lyrical ideas, normally drawn from literature. Deacon's works tend to incorporate unlikely non-art materials such as linoleum, leather and laminated wood that he glues, rivets or bends in an elegant and craftsmanlike manner. His many one-man exhibitions include the Royal College of Art (1975–6), the Tate Gallery (1985), the Whitechapel Gallery (1989) and the 'New World Order' at the Tate Gallery, Liverpool (1999). He won the Turner prize in 1997.

Sources: Whitechapel Art Gallery, *Richard Deacon*, London, 1988; Ades, D. and Amor, M., *Richard Deacon: Esculturas y dibujos 1984–95*, London, 1996; Spalding, F., *20th Century Painters and Sculptors, Dictionary of British Art*, VI, Woodbridge, Suffolk, 1990; Deacon, Richard, *For those who have eyes: Richard Deacon sculpture 1980–86: a touring exhibition*, Aberystwyth, 1986.

Number of works in Catalogue: 1

**Avtarjeet Dhanjal** (b.1939)
Dhanjal first trained as a signwriter before studying sculpture at the Government College of Arts in Chandigarh. He taught in East Africa before coming to the United Kingdom to study at St Martin's School of Art in London. He now lives and works in Ironbridge, Shropshire. He organised the First International Sculpture

Symposium in India, where he has many works sited outdoors. He has worked on a number of regional and international projects that take as their starting points environmental or community concerns. His work is in collections in the United Kingdom, Brazil, Sloveneja, and India. Works include: *Grown in the Field*, Warwick University Arts Centre (1978); *Untitled*, Bodicote House, Cherwell District Council, Oxfordshire (1981); *Along the Trail*, slate and rope, National Garden Festival, Stoke-on-Trent (1986).

Sources: Welsh Sculpture Trust, *Sculpture in a Country Park*, Margam (Wales), 1983; AXIS, The Axis Database Online, www.axisartists.org.uk/, 1999; Birmingham Museums and Art Gallery Records; Strachan, W.J., *Open Air Sculpture in Britain*, London, 1984; CWN Coventry and Warwickshire Network, Coventry Canal Basin.

Number of works in Catalogue: 3

**Wilfred Dudeney** (b.1911)
He was born in Leicester and educated at St Paul's School. From 1928 to 1933, he studied with Alfred Turner at the Central School of Arts and Crafts. Living in London, he held a number of teaching positions, including one at Isleworth Polytechnic, Middlesex. He has exhibited at the RA, NEAC, RHA, and elsewhere. In 1952 he was elected a Fellow of the RBS. His works include *Boy and Ram*, Derby (1963). His *Falcon* is illustrated in Eric Newton's *British Sculpture 1944–1946*.

Source: Buckman, David, *Dictionary of Artist in Britain since 1945*, Bristol, 1998.

Number of works in Catalogue: 1

**Joseph Durham** (1814–77)
Joseph Durham was born in London and, following his apprenticeship with J. Francis, worked in the studio of Edward Hodge Bailey, first exhibiting at the Royal Academy in 1835. 128 of his works were exhibited at the Royal Academy between 1835 and (posthumously)

1878, and he was elected an Associate of the Academy in 1868. His major works include *Britannia Presiding Over the Four Quarters of the Globe* (1858) (winning first prize in a competition for a memorial for the Great Exhibition); a statue of the Prince Consort, Royal Horticultural Society Gardens, later erected in front of the Albert Hall (1863); *Santa Filomena*, a group sculpture which included a figure of Florence Nightingale (1864); a memorial for the Building Committee of Freemasons' Hall (1871); *Sunshine* (1857). Other works include *The First Dip*; *At the Spring*; *The Sirens and the Drowned Leander*; *Go to Sleep*; *Master Tom* and *Miss Ellie*. He executed many statues, including *Caxton*, Westminster Palace Hotel (1859), *Prince Albert*, Guernsey (1863), and Agricultural College, Framlington (1865), *Stephenson* and *Euclid*, University Museum, Oxford (1867); ideal figures, including *Hermione* (1858) and *Alastor* (1865) for the Mansion House, *Perdita and Florizel*, Walker Art Gallery, Liverpool (1870); busts, including *Jenny Lind* (1848), *Queen Victoria*, Guildhall, destroyed 1940 (1856), and *Hogarth*, Leicester Square (1875). His fountains include those located at St Lawrence Jewry (1866), Somerleyton Hall (1868), Gloucester Gate, Regent's Park (1878); his monuments include that to Thomas Dealtry, Bishop of Madras, Madras Cathedral (1861).

Sources: *Dictionary of National Biography*, CD ROM version; *Art Journal*; *Builder*; *Athenaeum*, 3 November, 1877.

Number of works in Catalogue: 1

**Andrew Dwyer** (b.1967)
Since studying Three Dimensional Design at Carlisle and Exeter Art Colleges, Andrew Dwyer has worked in industrial design, journalism, furniture making and exhibition installation. He took a short course in Public Art run by Free Form Arts Trust in 1997. It was at this time that he designed the *Blue*

*Ribbon Sculpture* in Coventry. Since then, he has continued working in this field.

Source: information from the sculptor.

Number of works in Catalogue: 1

**Georg Ehrlich** (1897–1966)
Erlich trained at the School of Applied Arts in Vienna between 1912–15. He lived in Munich (1919–22), Berlin (1921–3) and Vienna (1923–37). After the Second World War he came to England as a refugee and took British nationality. He began to sculpt in 1926 and is known for his symbolic figures and animals in bronze. He exhibited in several European countries and at the Royal Academy. He won the gold medal at the 1937 Paris Exposition Internationale. In 1961 he was awarded the Sculpture Prize of the City of Vienna, and in 1962 he was elected ARA.

Sources: Turner, J., *Dictionary of Art*, vol.10, London, 1996; Tietze-Conrat, Erica, *Georg Ehrlich*, London, 1956; Spalding, F., *20th Century Painters and Sculptors, Dictionary of British Art*, VI, Woodbridge, Suffolk, 1990; MacKay, J., *Dictionary of Western Sculptors in Bronze*, Woodbridge, Suffolk, 1977; Arts Council Exhibition, 1964; Scottish Arts Council exhibition, 1973.

Number of works in Catalogue: 1

**Sir Jacob Epstein** (1880–1959)
Epstein studied drawing and painting c.1896 at the Art Students' League in New York. He attended night classes in sculpture 1899–c.1901 under George Grey Bernard, and worked by day in a bronze foundry. Between 1902–4 he studied sculpture at the École des Beaux Arts, then at the Académie Julian, Paris, before settling in London. He became a British subject in 1907 and received his first major commission, to carve eighteen life-size figures for the façade of the new British Medical Association building in the Strand, London (1907–8). These became the centre of the first of a number of public scandals caused by the nudity in his early work.

In 1912, while in Paris engaged in the erection of his tomb of Oscar Wilde (1908–12) for the Père La Chaise cemetery, he met Picasso, Brancusi and Modigliani. He became a member of the London Art Group and had his first one-man show at the Twenty One Gallery, Adelphi, London in 1913, briefly being associated with the Vorticist group. Until c.1916 his work tended towards abstraction, but he was also well known for his portrait sculpture. His main subjects were family members, friends, high society people and the famous men and women of the day, busts of whom include: Joseph Conrad (1924) and Albert Einstein (1933), both in Birmingham Museum and Art Gallery; Princess Margaret (1933). Other major works include *Rock Drill* (1913–25), destroyed; bronze cast of *Rock Drill* torso (in Tate Gallery); *Rima for the W.H. Hudson memorial*, Hyde Park (1925); *The Visitation*, Tate Gallery (1926); *Night and Day* for St James' underground station (1928–9); *Ecce Homo*, Epstein Estate (1935); *Lucifer* (1945), in Birmingham Museum and Art Gallery; *Christ in Majesty*, Llandaff Cathedral (1953); *St Michael*, Coventry Cathedral (1959). Exhibitions include Leicester Galleries, London from 1917; Temple Newsam, Leeds (1942); Tate Gallery, London (1952); Memorial Exhibitions – Edinburgh Festival (1961), Tate Gallery (1961). DCL degree (Oxford University) (1953); KBE (1954).

Sources: Epstein, J., *Epstein Centenary*, London, 1980; Gardiner, S., *Epstein: Artist Against the Establishment*, London, 1993; Silber, E.: [i] *The Sculpture of Epstein: With a Complete Catalogue*, Oxford, 1986 [ii] *Rebel Angel, Sculpture and Watercolours by Sir Jacob Epstein 1880–1959*, Birmingham, 1980; Cork, R., *Vorticism and Its Allies*, Haywood Gallery, London, 1974; Chamot, M., *Modern British Painting, Drawing and Sculpture*, vol.1, Tate Gallery, London, 1964; Buckle, R., *Jacob Epstein, Sculptor*, London, 1963; Epstein, Sir Jacob, *Epstein An Autobiography*, London, 1975.

Number of works in Catalogue: 3

## Simon Evans (b.1963)

Simon Evans studied at Blackburn School of Art and Design, and was a student of Coventry Polytechnic (now Coventry University) when he made *Steel Horse* (1986). He also created a 13–metre *Minotaur*, which was temporarily exhibited opposite Coventry Cathedral in 1988. His other works include steel sculptures of a horse in Blackburn, a crow in Tring, a goose in Worplesdon and another horse exhibited at Earls Court, London, in June 2000. He is currently based in Trawden, East Lancashire.

Source: *Coventry Evening Telegraph*, 18 June 1988.

Number of works in Catalogue: 1

## Michael Farrell (b.1964)

Born in Paisley, Michael Farrell was educated at St Helens College of Art and Design and Birmingham Polytechnic, where he obtained a BA in Fine Art. He has held one-man exhibitions at Highcroft Hospital (1986) and the Midland Arts Centre, Cannon Hill Park (1987), both in Birmingham. He has also exhibited at group shows in Brentwood Co-op Hall (1985), Harborne and Perry Barr Baths, Birmingham (1986) and Rufford Art Centre (1987).

Sources: http://wavespace.waverider.co.uk/~scotdave; Timothy Emlyn Jones, *Michael Farrell: The Vision*, Birmingham, 1989.

Number of works in Catalogue: 1

## Derek Fisher

Having graduated from Manchester University with a degree in Geography (1961), Derek Fisher began a career as a town planner and urban designer. He gained a postgraduate diploma in Town and Country Planning in 1963 and has since worked for a large number of local authorities, choosing to specialise in urban design from 1982 onwards. He gained a postgraduate diploma in Urban Design from Oxford Polytechnic in 1982 and took a course

in technical illustration at Bournville College, Birmingham (1985–6). His projects include the Lye Community Regeneration Project (1986–8), the design of the Binley Business Park in Coventry (1990), decorative brick finishes to walls and a canal bridge in Coventry (1992), and the design of spatial forms with a reference to local history and culture in Longford Square, Coventry (1993). When implementing the last of these, he aimed to encourage public involvement as far as possible. From 1990 onwards, he has managed various other public art projects in Coventry.

Source: information from the artist.

Number of works in Catalogue: 1

## Carl Fleischer (b.1968)

Since graduating with an MA in Fine Art from the University of Sussex, Brighton, Carl Fleischer has undertaken a number of urban public commissions including the *Foleshill Blue Ribbon Sculpture* (1998) and the *Watford Memory Wall* (2000). His video installations have been shown in London, Brighton, Amsterdam, Arnheim, Leipzig and Mainz as well as being broadcast on Liquid TV as part of the Brighton International Arts Festival.

Source: information from the artist.

Number of works in Catalogue: 1

## Arthur John Fleischmann (1896–1990)

Fleischmann was born in Bratislava, Slovakia (at that time a part of Hungary) and studied medicine at Prague Academy. He became interested in art and won a scholarship to the Master School of Sculpture in Vienna. He also studied in France and Italy. His work was originally figurative, but became more abstract during the 1960s. He worked in many media, including Perspex. Between 1935 and 1937, he taught art in Vienna, moving on to South Africa, Bali and Australia, before eventually settling in London in 1948. He exhibited with

the RA, the NS and the RBA, and became a Fellow of the RBS. His portraits include those of Kathleen Ferrier, Trevor Howard, and the industrialist Lord Robens. A devout Roman Catholic, his notable achievement is having sculpted four Popes from life. His work is contained in churches and other buildings in Britain and abroad, including galleries in Blackburn, Sydney and Bratislava.

Sources: Barnes, Joanna, *Arthur Fleischmann 1896–1970: A Centennial Celebration*, Fine Art, 1996; Voak, Jonathan, *Sculpture and Light: an exhibition of sculptures by Arthur Fleischmann (1896–1990)*, Westminster Cathedral, 12–27 October 1991, Manchester, 1991.

Number of works in Catalogue: 1

## John Henry Foley (1818–74)

Foley studied at the Royal Dublin Society's School between 1831–4 and entered the RA Schools in 1835, later winning the Silver Medal. In the front rank of British sculptors, he produced statues, busts and monuments in England, Ireland and India. His works include his masterpiece, the equestrian statue of *Viscount Hardinge*, Calcutta (1859), his most prestigious commission, *Prince Albert*, and the group of *Asia* on the *Albert Memorial*, Kensington Gardens (1864–72), and *Prince Consort*, Fitzwilliam Museum, Cambridge (1876). He exhibited at the RA between 1839 and 1861, being elected RA in 1858. He was a member of the Royal Hibernian Society (1861) and of the Belgian Academy of Arts (1863) as well as of the British Institution (1840–54).

Sources: Cosmo, W., *The Works of J.H. Foley*, London, 1875; Underwood, E.G., *A Short History of English Sculpture*, London, 1933; Read, B., *Victorian Sculpture*, New Haven and London, 1982; MacKay, James, *Dictionary of Western Sculptors in Bronze*, Woodbridge, Suffolk, 1977.

Number of works in Catalogue: 1

## Deborah Ford (b.1968)

She attended Coventry Polytechnic as an art student from 1987 until 1990, and subsequently moved into graphics design. She is currently based in London.

Source: information from the artist.

Number of works in Catalogue: 1

## George Henry Ford (1912–77)

Having studied sculpture at Hornsey School of Art under Harold Youngman, Ford exhibited at the Royal Academy, the Royal Glasgow Institute of Fine Arts, the Walker Art Gallery in Liverpool, and elsewhere in Britain. Bradford City Art Gallery holds his carving *Eve*, executed in teak. He was elected a Fellow of the RBS in 1955.

Source: Gowing, L., *A Biographical Dictionary of Artists*, London, 1983.

Number of works in Catalogue: 1

## Jonathan Ford (b.1971)

After graduating from Coventry University with a degree in Fine Art in 1995, Jonathan Ford became a freelance artist specialising in public sculpture in steel and aluminium. His major works include *Schlanke Meth* (1997) and the *Giant Vacuum Cleaner* (1998), both in Coventry, and the kinetic sculpture *Rotor-Relief* (1998) for Wysing Arts in Cambridge. He is currently working on two pieces, a First and Second World War memorial sculpture commissioned by Llandudno Junction Memorial Hall, and *Depth Charges at 500ft* for Wednesfield Way, Wolverhampton.

Source: information from the artist.

Number of works in Catalogue: 1

## Bettina Furnee (b.1963)

Bettina Furnee was born in the Netherlands and studied the history of art at Leiden. She came to Britain to train as a lettering artist under David Kindersley. She designs and executes works in stone, wood, glass and bronze.

Source: University of Warwick, *Sculpture Trail Brochure*, Coventry, 1997.

Number of works in Catalogue: 1

## Hideo Furuta (b.1949)

Sculptor, artist, performer and teacher, Furuta was born in Hiroshima, Japan, and attended the Tokyo Visual Art College between 1969 and 1971, studying mathematics, physics and art. From 1977 to 1978, he studied at the Hijiyama Art College, Hiroshima, where he specialised in etching and engraving, going on to study comparative philosophy and aesthetics at Hiroshima University between 1978 and 1980, and subsequently working as a quarryman at Ishizaki Quarry, Kurahashi Island from 1982 to 1983. Furuta moved to Chile, and then to Wales, where he began working and teaching from 1985, holding such posts as visiting lecturer at Trondheim Art College, Norway (1991) and Henry Moore Fellow in Sculpture at Northumbria University, Newcastle upon Tyne (1992–4). His most recent post was as artist-in-residence at Grizedale Forest (1994). His solo exhibitions include silkscreen prints at Saeki Gallery, Hiroshima (1977); and sculpture, drawing, photography and video works at University Gallery of Newcastle (1997), which included granite and basalt spheres and cones. His many public commissions include a monumental sculpture in white granite and black basalt (*Axiom*) for Gateshead Sculpture Park, Gateshead (1993–6). Collections holding his work include Glynn Vivian Art Gallery and Museum, Swansea; Gallery/Oriel 31, Newtown; Edinburgh Printmakers' Workshop, Edinburgh; Margam Sculpture Park, Port Talbot. He is also noted for his sound works and public performances, which include an African Drum performance in Newcastle, 1993.

Source: University of Warwick, *Sculpture Trail Brochure*, Coventry, 1997.

Number of works in Catalogue: 1

**Sir Donald Gibson** (1908–91)
Architect and planner. Gibson trained at the University of Manchester's School of Architecture and Town Planning, and spent a year in the USA, qualifying in 1932. He spent two and a half years at the Building Research Station in the mid-1930s, when he realised the architectural implications of technology and building programmes. In 1938 he took up the newly created post of Coventry City Architect. The bombing of Coventry during the Second World War made the existing problems of poor housing far more extreme. It was Gibson's task to oversee the rebuilding of Coventry after the War. Between 1955–8 he was the County Architect for Nottinghamshire where he initiated the CLASP system of prefabricated school buildings. From 1958 to 1962 he was the Director General of Works for the War Office, and from 1967 to 1969 he was the Controller General of the Ministry of Public Works. He was knighted in 1962.

Source: Turner, J., *Dictionary of Art*, vol.12, London, 1996.

Number of works in Catalogue: 3

**Eric Gill** (1882–1940)
Gill was apprenticed by his father to the architect of the Ecclesiastical Commissioners in 1900. He studied lettering in evening classes with Edward Johnston, then worked for the typographers Monotype, for whom he designed popular typefaces such as Perpetua and Gill Sans. In 1910 he began to make sculptural works in stone and wood. He was the leader of a religious group of artists, designers and printers, converting to Catholicism in 1913. Gill did not considered himself to be primarily a typographer, though during his life he designed eleven typefaces, some of which are still in use today, and wrote a lengthy and influential *Essay on Typography*. As a sculptor Gill worked directly with his materials rather than initially creating a clay model.

Sources: Yorke, M., *Eric Gill: Man of Flesh and Spirit*, London, 1981; Collins, Judith, *Eric Gill: Sculpture*, London, 1992; Wolseley Fine Art, *Eric Gill 1882–1940: a catalogue of sculpture, inscriptions, drawings, prints, manuscripts and books*, London, 1994; Gill, Eric, *Sculpture and the Living Model*, London, 1932.

Number of works in Catalogue: 1

**William Glanfield** (b.1957)
Glanfield took a foundation course in art at Medway College of Design before studying for a degree in Fine Art at Canterbury College of Art (1979). After several years of sporadic employment, he finally enrolled on a government TOPS course in 1988, gaining a City and Guilds certificate in carpentry and joinery. He then set himself up as a self-employed woodworker, his first work coming by word of mouth. In 1989 he made a sculpted seat, *Oyster Bench*, for his home town of Folkestone. Since this project he has had commissions for many other sculpted wood pieces, a high proportion of which have been in his home county of Kent.

Source: CWN, The Coventry and Warwickshire Network, Coventry Canal Basin.

Number of works in Catalogue: 1

**Joseph Goddard and Son**
A firm of Leicester architects who also carried out church restoration work.

Source: Herbert Museum and Art Gallery, *A Survey of Public Art in Coventry*, Coventry, 1980.

Number of works in Catalogue: 1

**Keith Godwin** (1916–91)
Born in Warsop, Nottinghamshire, Godwin trained at Mansfield Art School (1934–5),
Nottingham College of Art (1935–6), Leicester College of Art (1936–9) and the Royal College of Art (1946–8). He exhibited at the Royal Academy, and was elected RBA in 1950. He sculpted figures and portraits in plaster, cement, stone, terracotta and bronze.

Sources: MacKay, James, *Dictionary of Western Sculptors in Bronze*, Suffolk, 1977; Memorial Exhibition: Woodlands Art Gallery, 1992.

Number of works in Catalogue: 1

**Lord Ronald Gower** (1845–1916)
Lord Gower studied sculpture in Paris, then took his own studio assisted by the Italian Luca Madrassi (*fl.* 1869–1914). He produced statues and statuettes for the Royal Academy, Grosvenor Gallery and the Paris Salon. He was one of a number of later nineteenth-century sculptors who made use of semi-industrialised methods of production.

Sources: Turner, J., *Dictionary of Art*, vol.19, London, 1996; Gower, Lord Ronald, *Records and Reminiscences, selected from 'My Reminiscences' and 'Old Diaries'*, London, 1903.

Number of works in Catalogue: 1

**Nicolette Gray** (1911–97)
The daughter of the poet Laurence Binyon, Nicolette Gray was an art historian and a designer of lettering. Among her notable works is the façade lettering of Sotheby's and Agatha Christie's tombstone. Arguably, her finest work is in Westminster Cathedral: Cardinal Heenan's tombstone, a mosaic over the north-west door, and a tablet commemorating Pope John Paul II's visit in 1982.

Source: The Shakespeare Centre, *Art Work and Design*, publicity leaflet, Stratford-upon-Avon, 1999.

Number of works in Catalogue: 1

**Elizabeth Greenwood** (b.1942)
Greenwood studied at Coventry College of Art, St Martin's School of Art and Goldsmith's

College of Art, subsequently teaching in adult education and youth centres, in London schools and at the Avery Hill College of Education. Her work is light-hearted and related to popular culture, and appears in many mixed shows and exhibitions. Her solo exhibitions include the Proscenium Gallery, the Greenwich Theatre Gallery, and Woodlands Art Gallery (1978).

Source: information from the artist.

Number of works in Catalogue: 1

### Geoffrey Greetham (b.1934)

Born in Yorkshire, he studied at Keighley School of Art and Camberwell School of Art. From 1962 until 1965, he worked as an assistant to Henry Moore. He held a Sculpture Fellowship at Coventry College of Art (1965–7), and had a solo exhibition at the Drian Galleries, London (1969).

Source: Spalding, F., *20th Century Painters and Sculptors*, vol.VI, Dictionary of British Art, Woodbridge, Suffolk, 1990.

Number of works in Catalogue: 1

### Michael Grevatte (b.1943)

Since graduating from Leicester Polytechnic with a Diploma in Fine Art in 1972, Michael Grevatte has worked as a sculptor. He has shown works at a large number of one-man and group exhibitions in London and other parts of England, including Leicester, Warwick, Oxford, Nottingham, Liverpool, Stoke-on-Trent, Yorkshire, Derby, Bristol, Somerset and Worcester. His works include a large stone sculpture for Centre Parcs, Sherwood Forest, Nottinghamshire (1987), a monumental bronze sculpture of a steelworker for Corby District Council, Northamptonshire (1989), a figurative sculpture of ten building workers for the Colin Draycott Group, Six Hills, Leicestershire (1991), a commemorative sculpture of a steelworker, a miner and a railway worker for

Chesterfield Borough Council (1992), two large stone carvings of a swan and a Norman knight on the main road through Mountsorrel (1994), a replica of a medieval stone market cross for Mountsorrel Market Place, Leicestershire (1994), and the carved *Wave Seat* for Coventry Canal (1998).

Source: CWN, The Coventry and Warwickshire Network, Coventry Canal Basin.

Number of works in Catalogue: 1

### W.S. Hattrell & Partners

This architectural firm was active in the 1950s on the development of the precincts in Coventry.

Source: Ritchie, W., *Sculpture in Brick and Other Materials*, Kenilworth, 1994.

Number of works in Catalogue: 1

### William Haywood (1877–1957)

Architect. William Haywood was in partnership for many years with Herbert Tudor Buckland. Their work included the Royal Naval Hospital School at Holbrook, college buildings at Oxford and Cambridge, Carlisle Technical College, and university and school buildings in Birmingham. Haywood was also responsible for the civic decorations for Birmingham's 1937 Coronation celebrations. He taught civic design and town planning at Birmingham University (1918–43), and was a founder member of the Birmingham Civic Society in 1918.

Source: *RIBA Journal*, Vol.65, 1957–8.

Number of works in Catalogue: 1

### Albert Herbert & Son

Founded by Sir Albert Herbert, this machine tool company had become known as Alfred Herbert Limited by 1984. At the time of Herbert's death in 1957, it laid claim to being the largest machine-tool organisation in the

world, employing more than 6,000 workers in four separate factories. A prominent philanthropist, Sir Alfred Herbert made many generous gifts to the City of Coventry. For example, he donated the sum of £200,000 towards the construction of the museum that was to be named after him (The Herbert Art Gallery and Museum). During the First World War, he equipped a hospital for wounded soldiers. He donated £10,000 towards the City Hospital, and gave a covenant of £25,000 towards the rebuilding of Coventry Cathedral. He also gave land in the Butts for a small park, as well as land in the City Centre for Lady Herbert's Garden.

Source: *Dictionary of National Biography*, CD ROM version.

Number of works in Catalogue: 1

### Gertrude Hermes (1901–83)

Born in Kent of German parents, she studied at the Beckenham School of Art (1919–20) and the Leon Underwood School of Painting and Sculpture (1921–5). She began wood engraving in 1922 and took up carving in 1924. In 1926, she married the artist Blair Hughes-Stanton and collaborated with him in producing the wood engravings for *The Pilgrim's Progress* for the Cresset Press. Her other wood engravings include six for *The Natural History of Selborne* for the Gregynog Press (1931) and others for the first volumes of the Penguin Illustrated Classics (1939). She exhibited her work for the first time at the 13th Annual Exhibition of the Society of Wood Engravers at the Redfern Gallery, London, in 1932 – the same year that she designed the mosaic floor and fountain for the Shakespeare Memorial Theatre at Stratford-upon-Avon. She exhibited at the Royal Academy for the first time in 1934, and in 1939 was selected as one of seven engravers to represent Britain at the Venice International Exhibition. In 1939, and again from 1945–60,

she taught wood engraving, lino block cutting and printing at Camberwell and St Martin's Schools of Art, and later at the Central School of Arts and Crafts. She was elected a Fellow of the Royal Society of Painters, Etchers and Engravers (1951) and an Associate of the Royal Academy (1963).

Sources: Norwich Art Gallery, *Careers of ten women artists born 1897–1906*, Norwich, 1992; Stephens, L. and Lee, S. (eds), *Dictionary of National Biography*, London, 1990.

Number of works in Catalogue: 1

**Stephen Robert Hitchin** (b.1953)
After having studied at Liverpool Polytechnic from 1972–6, Hitchin went on to gain a Master's degree at Manchester Polytechnic (1976–7). A sculptor in stone and a draughtsman, he also taught, becoming Head of Art and Design at Glenburn School, Skelmersdale. His work derives from the human form, and includes *Girl's Head*, exhibited at the Walker Art Gallery, Liverpool, during the touring show of Merseyside Artists 3, 1986–7. In 1978, he won a Merseyside Arts Association award. A member of the Liverpool Academy, he exhibited with them in 1980, at the MAFA in 1982, at the Royal Academy and at Liverpool University Senate House in 1986, and with a solo exhibition at Atkinson Art Gallery, Southport, 1981.

Source: information from the sculptor.

Number of works in Catalogue: 1

**Walter Frederick Clarke Holden** (1882–1953)
Architect. After completing his articles in Cambridge, he joined Burgess and Myers of Beaconsfield in 1906, for whom he designed many domestic buildings. During the First World War, he joined the Royal Engineers, gaining the Military Cross for work he undertook as one of the first camouflage officers. In 1920 he became Assistant Architect

to the National Provincial Bank under Frederick Charles Palmer, upon whose death in 1934 he was appointed Chief Architect – a post he held until his retirement in 1947. He was mainly responsible for the large building programme carried out by the Bank between 1921 and 1939. During the war, he was a member of the Royal Academy Committee that made proposals for the rebuilding of London. Although his work was primarily architectural, he exhibited at the Royal Academy in 1920 as a landscape painter.

Sources: *RIBA Journal*, vol.60, May 1953; Johnson, J. and Greutzner, A., *Dictionary of British Artists 1880–1940*, Suffolk, 1976.

Number of works in Catalogue: 1

**Peter Hollins** (1800–86)
Born in Great Hampton Street, Birmingham, Hollins died in the same house on 16 August 1886. He was the eldest son of William Hollins, in whose studios he trained until he went to London c.1822, where he worked under Francis Chantrey. Having come to some notice in 1830 after showing his two group sculptures, *The Murder of the Innocents* (also shown at the Great Exhibition of 1851) and *Cupid and Psyche* at the Royal Academy, he won the Robert Lawley prize at the RBSA for his *Conrad and Medora* in 1831. He visited Italy in 1835 or 1836. Throughout his life he collaborated with his father's studios, and assisted his father in the restoration of St Mary's Church, Handsworth, and with ornamental sculpture at Alton Towers, Staffordshire, both in the early 1820s. He also designed memorial sculptures, of which he produced many throughout the Midlands, even whilst living in London. Considered the leading local sculptor for most of his life, Hollins was a well-known social figure in Birmingham, with acquaintances in local commerce, industry, the arts and on the town council, from which he obtained most of his public commissions. He

closely followed the style of Chantrey, showing both classical and romantic qualities: dramatic poses sculpted sensitively with keen features. Always competently handled, his sculpture can be seen at its best in the monuments to *Lady Bradford*, Weston, Staffordshire (1842) and *Mrs Thompson*, Malvern Priory (1838). He exhibited regularly at the RA 1822–71 and at the RBSA, of which he was Vice-President until 1879. He retired in 1874 due to rheumatism.

Sources: Obituary, *Birmingham Daily Post*, 18 August 1886; Gunnis, R., *Dictionary of British Sculptors 1660–1851*, London, 1964; Penny, N., *Church monuments in romantic England*, New York and London, 1977; Lucas, A., *The Life and Works of Peter Hollins 1800–1886*, MA dissertation, unpublished.

Number of works in Catalogue: 1

**David Hugo** (b.1958)
Studied at Wolverhampton Polytechnic 1977–80, then at the Royal College of Art 1981–4. His first solo exhibition was at the Lanchester Gallery, Coventry. His work tends to contain references to the ancient and the scientific. He explores the links between science and religion, and mythology and discovery.

Sources: Spalding, F., *20th Century Painters and Sculptors, Dictionary of British Art*, VI, Woodbridge, Suffolk, 1990; *Arts Review*: [i] vol.41, 27 January 1989 [ii] vol.40, 23 September 1988; Mead Gallery, *Between Scylla and Charybdis: David Hugo*, University of Warwick, 1988.

Number of works in Catalogue: 1

**John Hutton** (1906–78)
A self-taught artist, glass engraver and teacher, Hutton was born in New Zealand and attended school at Wanganui Collegiate School. He came to London and taught mural painting at Goldsmith's College School of Art, later becoming Chairman of the Society of Mural Painters and, in 1975, joining the Art Workers' Guild. He is primarily noted for his permanent works in public locations, which include a

screen for Coventry Cathedral and doors for Guildford Cathedral. His murals and glass engravings were also installed on the Orient Line ship *Orcades* and the Cunard liner *Caronia*. Exhibitions include the Arts Council, and his work is in the collection of the Victoria and Albert Museum.

Sources: Brentnall, Margaret, *John Hutton, artist and glass engraver*, London, 1986; Hutton, John, *Glass Engravings of John Hutton*, London, 1969.

Number of works in Catalogue: 2

**Graham Ibbeson** (b.1951)
Graham Ibbeson was born in Barnsley, South Yorkshire, and trained in Fine Art at Trent Polytechnic, gaining a BA Hons (1st Class) in 1975. He went on to study sculpture at the Royal College of Art, gaining an MA in 1978. From 1978 to 1981 he worked as a part-time lecturer in the Fine Art Department of Leeds Polytechnic, and was awarded the Madame Tussauds Award for Figurative Art in 1978. Committed to portraying 'real people', Ibbeson explores basic human emotions in his figures. He uses humour as well as humanity to expose relationships, contrasting deception with trust, tranquillity with disorder, *naïveté* with sophistication. He specialises in depicting northern working-class life as he remembers it from his own childhood, often using his own family as models. His statue of *Eric Morecambe* attracted national attention when it was unveiled by the Queen at Morecambe in July 1999. From 1984 he has exhibited his work throughout the United Kingdom and at international venues. Solo exhibitions include Amsterdam (1993), Derby Museum and Art Gallery (1998) and Stratford-upon-Avon (1998). His work is in the collections of the British Council, the Victoria and Albert Museum, the London Toy Museum, and the Canadian Arts Council.

Sources: *Superhuman Two*, Nicholas Treadwell

Publications, 1981; *External Works*, Landscape Promotions Ltd, 1998.

Number of works in Catalogue: 1

**John George Jackson** (1799–1851)
Architect. Jackson was a pupil of P.F. Robinson, and was admitted to the Royal Academy Schools in 1817. He exhibited at the Academy from 1817 onwards and at the Society of British Artists in 1824 and 1831, when he set up in business in Leamington, where he designed the Jephson Gardens (1834), St Mary's Church (1839–40) and the Victoria Bridge (1839–40). He also designed Gaveston's Cross on Blacklow Hill (1832), a new chancel for Leek Wootton church (1843) and the north aisle of Lillington church (1847), all in Warwickshire.

Source: Colvin, Howard, *Dictionary of British Architects 1600–1840*, London, 1993.

Number of works in Catalogue: 1

**David Jacobson** (b.1951)
Born in Windhoek, Namibia, David Jacobson studied at the Camberwell School of Arts and Crafts (1973–7). Since 1977, he has held one-man exhibitions in South Africa, Italy, New Orleans, Bath and London, as well as exhibiting in a large number of group exhibitions. He was the winner of the Barcham Green Printmaking competition (1978) as well as receiving the R.K. Burt Outstanding Printmaker award (1994) and the Wessex Watermark Award (1996). He has taught at several art colleges, including Camberwell School of Arts and Crafts, Chelsea School of Art and Birmingham Polytechnic. He is a past editor of *Sculpture 108*, the journal of the Royal Society of British Sculptors, of which he was elected a Fellow in 1995.

Source: information from the artist.

Number of works in Catalogue: 1

**Alain John** (1920–43)
John was a pupil at Blundell's School in Devon. He joined the RAF as a navigator, and was killed during the Second World War.

Source: Herbert Art Gallery and Museum/City of Coventry Libraries, Arts and Museums Department, *A Survey of Public Art in Coventry*, Coventry, 1980.

Number of works in Catalogue: 1

**Thomas Henry Kendall**
He assisted James Willcox to produce the colossal buffet at Charlecote Park in the mid-nineteenth century. Willcox, wood-carver and gilder, worked in Chapel Street, Warwick, in the 1840s and 1850s, but it seems likely that Kendall had taken over the business by the early 1860s. In 1864, he was described as a wood-carver, designer and furniture manufacturer, having been awarded two prize medals in the International Exhibition of 1862. Kendall was probably a member of the Kendall family of wood- and stone-carvers from Exeter.

Sources: *Kelly's Directory of Warwickshire* 1845, 1850, 1864; *Slater's Directory of Warwickshire*, 1854.

Number of works in Catalogue: 1

**Eric Kennington** (1888–1960)
Kennington, the son of the painter Thomas Kennington, trained at Lambeth School of Art and the City and Guilds School. In 1908 he exhibited at the RA, and also showed at the Leicester Galleries, the Fine Art Society, the Goupil Gallery, ROI and RP, and was elected RA in 1959. On the outbreak of the First World War, Kennington enlisted with the 13th London Regiment. He fought on the Western Front but was badly wounded, sent home in June 1915, and invalided out of the Army. In August 1917, he was employed by the War Propaganda Bureau as a war artist. After the war, he designed many war memorials and depictions of soldiers in action. In 1922 Eric Kennington went with T.E. Lawrence to

Arabia, where he illustrated *The Seven Pillars of Wisdom*. In subsequent years he was to draw many studies of Lawrence. Kennington was also an official artist during the Second World War. During this war he confined himself chiefly to pastel portraits of sailors and airmen, his book of portraits *Drawing the RAF* being published in 1942. His commissions include the British Memorial at Soissons, France, following the First World War, and the memorial at Battersea Park to the 24th Division. Other major works include the head of *T.E. Lawrence* (St Paul's Cathedral, London) and carvings on the Royal Shakespeare Memorial, Stratford-upon-Avon inspired by the calendar carvings on Chartres Cathedral.

Source: Kennington, Eric, *Eric Kennington R.A.: Official War Artist 1914–18 and 1939–45*, London 1985.

Number of works in Catalogue: 1

**Richard James Kindersley** (b.1939)
Kindersley trained at Cambridge School of Art, and in his father, David Kindersley's studio. In 1966 he set up his own studio in London producing sculptural works and lettering. He has made sculptural pieces for British Telecom and Sainsbury's as well as a number of ecclesiastical pieces. He has also created lettering or graphic works for St Paul's Cathedral, Westminster Abbey and London Bridge, as well as works for major shopping centres, universities and court buildings.

Source: Archive, Crafts Council curriculum vitae.

Number of works in Catalogue: 2

**Frederick J. Kormis** (1894–1986)
Born in Frankfurt, Kormis studied at the local high school, and served in the Austrian Army during the First World War. He was captured, imprisoned in Siberia, but escaped, and returned to Frankfurt. He worked mainly as a portrait sculptor, but when Hitler came to

power he moved first to the Netherlands and then to London in 1934. He exhibited at the Royal Academy, the Beaux Arts Gallery, Fieldborne Galleries, and abroad. His work is in the collections of the British Museum, the Imperial War Museum, the Fitzwilliam Museum, Cambridge, and the Royal Air Force Museum, Hendon. He is noted as one of the most distinguished medallists of his era, producing effigies of distinguished figures which include Sir Winston Churchill, Charlie Chaplin, J.B. Priestley, and Golda Meir. He is also known for his figures and portraits in stone, wood, bronze, and terracotta, and his public commissions include the *Shield Bearer* in the Corn Exchange, Stratford-upon-Avon, the *Prisoner of War Memorial*, Gladstone Park, Willesden, and *The Ever-lamenting Harp*, Kiryat Gat, Israel.

Source: MacKay, James, *Dictionary of Western Sculptors in Bronze*, Suffolk, 1977.

Number of works in Catalogue: 1

**Paul Kummer** (1882–1913)
Born in Germany, Kummer was based in London and exhibited between 1882 and 1913, including twice at the Walker Art Gallery, Liverpool, and five times at the Royal Academy.

Source: Johnson, J. and Greutzner, A., *Dictionary of British Artists 1880–1940*, Suffolk, 1976.

Number of works in Catalogue: 1

**Christine Lee**
Christine Lee is one of Britain's outstanding figurative sculptors. She lives in a period farmhouse in the heart of Shakespeare country, where she has her studio. Her best known work is the extraordinary 5½ metre high fountain that stands in front of the Royal Shakespeare Theatre in the centre of Stratford-upon-Avon. This work was inaugurated by the Queen and Prince Philip on 8 November 1996. Following

her degree at St Martin's School of Art, Christine Lee studied painting and drawing with Cecil Collins. Thus her training brings together the classical discipline of a renowned school of sculpture with the philosophical vision of a great English master. These formative influences combined with a very wide range of other elements in her background. For example, while she has been an experienced and sophisticated international traveller since her childhood, her vision is definitively rooted in English surroundings and atmosphere, and has been especially enriched with her constant contact with the landscapes and quotidian patterns of life of Oxfordshire, Warwickshire, Buckinghamshire and the Cotswolds.

Source: information from the sculptor.

Number of works in Catalogue: 2

**John Lennon** (1940–80)
Lennon, a founder member of the Beatles, was born in Liverpool. Rhythm guitarist, keyboard player and vocalist, he collaborated with fellow Beatle, Paul McCartney, as a songwriter. After his marriage to Yoko Ono, his second wife, in 1969, he became active in the Peace Movement, recording *Give Peace a Chance* in 1969 under the name of The Plastic Ono Band, following which he released five more chart singles between 1971–4. He was assassinated outside his New York home in 1980.

Number of works in Catalogue: 1

**John Barry Letts** (b.1930)
Son of the designer, Joseph Letts, John was born in Birmingham and studied at the Birmingham School of Art, 1945–9, under William Bloye, Head of Sculpture. His sculpted work has been exhibited both in London and the Midlands. Residing in Astley, near Nuneaton, he is noted for his statue of George Eliot (born Mary Anne Evans) located in the centre of Nuneaton, close to where she had

lived. The public gallery in Stratford-upon-Avon holds examples of his work.

Source: Spalding, F., *20th Century Painters and Sculptors, Dictionary of British Art*, VI, Suffolk, 1990.

Number of works in Catalogue: 2

## Liliane Lijn (b.1939)

Born in New York, Lijn studied the History of Art at the École du Louvre, Paris, and Archaeology at the Sorbonne in Paris in 1958. She has lived in London since 1966, and began designing and making large-scale public sculpture in 1971. Much of her work is kinetic, and is inspired by industry and industrial processes, but her figures also engage in 'ritual dramas' – they engage with the darknesses of empty space, silence, death, and the unconscious mind. In all her works to date, she has used light (neon, laser or reflected light) in conjunction with materials which are transformed by light reflecting from their surfaces. Materials include water, mild and stainless steel, perforated stainless steel, aluminium, enamelled copper wire, neon, slate, and patinated cast bronze. During the 1980s and 1990s, she has had solo exhibitions in New Zealand, Paris, Cologne, Aberdeen, and London, and her work is to be found in the Tate Gallery, the Victoria and Albert Museum, the Museum of Modern Art, New York, the Fonds Nationale d'Art Contemporain, Paris, and many other international collections. She has received many critical reviews.[1]

Sources: Edward Lucie-Smith, *Movements in Art since 1945*, London, 1969; Frank Popper, *Le Declin de l'Object*, Paris, 1975; Tate Gallery, *Art of the Sixties*, London, 1976; Musee d'Art, *Electra* (catalogue), Paris, 1983; Francis Spalding, *British Art since 1900*, London, 1986; Edward Lucie-Smith, *Sculpture since 1945*, London, 1987; Eugene Roseberg, *Architects' Choice: Art and Architecture in Great Britain since 1945*, London, 1992; Frank Popper, *Art in the Electronic Age*, London, 1993.

Note [1] Barrett, Cyril, 'Art as Research: the Experiments of Liliane Lijn', *Studio International*,

June 1967; Petherbridge, Deanna, 'Interfences en Plein Air', *The Architectural Review*, April, 1982; Bailey, Colette, 'Interview with Liliane Lijn', *Sculpture*, issue V, June 1997; Turner, Flora, 'Liliane Lijn', *Kontura*, July 1997.

Number of works in Catalogue: 1

## Arthur Ling (1913–95)

Architect and town planner. Educated at University College, London, he worked in the office of E. Maxwell Fry and Walter Gropius (1937–9) before becoming a structural engineer with the Corporation of the City of London (1939–41). He was a member of the town planning team responsible for preparing the County of London plan (1941–5) and later became Chief Planning Officer for London County Council (1945–55). He taught town planning at University College, London, between 1947 and 1955. From 1955 until 1964, he was Coventry City Architect. Later he became Professor and Head of Architecture and Civic Planning at Nottingham University (1964–9). He was President of the Royal Town Planning Institute (1968–9).

Source: *Who's Who 1897–1996*, CD ROM version.

Number of works in Catalogue: 1

## Margaret Lovell (b.1939)

Born in Bristol, Margaret Lovell studied at the West of England College of Art (1956–60) and the Slade School of Fine Art (1960–2), where she won the Slade School prize for sculpture and etching in 1962. She was awarded both Italian and Greek Government scholarships (in 1962–3 and 1965–6 respectively). In 1966 she was elected an Associate of the Royal Society of British Sculptors. She works in a number of different media, including bronze, alabaster, copper, marble, plaster, slate, stone and wax, and has exhibited widely throughout Britain as well as in France and Greece. Her public commissions include sculpture for Barclays Bank, the Great Ouse Water Authority,

Plymouth City Art Gallery and Rendcomb College, Cheltenham.

Source: information from the artist.

Number of works in Catalogue: 1

## Sir Edwin Lutyens (1869–1944)

Lutyens was an architect educated at the Royal College of Art (1885–7). His early career was marked by a series of commissions for country houses, many of them obtained through Gertrude Jekyll, for whom he built Munstead Wood (1896). At this time, he was chiefly inspired by the ideals of Phillip Webb and William Morris. Later on, classicism came to play a more important role in his work. His most important work of this period was the New Delhi planning commission that he accepted in 1912, and he designed the Viceroy's House, probably the most important example of European Renaissance architecture in India. However, the characteristic style of the middle period of his career is a simplified version of Queen Anne, relying on fine proportions and mouldings, such as Middlefield, Cambridgeshire (1908). During the 1920s, he designed the Cenotaph and more than 50 other war memorials. From 1926 onwards, he collaborated on many large blocks of flats, including his Westminster housing scheme (1928–30). Other works from this period include the British Embassy in Washington (1926–9) and Campion Hall, Oxford (1934). His most ambitious work of the 1930s was his design for Liverpool's Roman Catholic Cathedral, which was never built. The domed cruciform church would have been second in size only to St Peter's in Rome. Lutyens was elected ARA (1913), RA (1920), and President of the Royal Academy in 1938. He received a gold medal for architecture from the RIBA in 1921, becoming the organisation's vice-president in 1924.

Sources: *Dictionary of National Biography*, CD ROM version; Brown, Jane, *Lutyens and the Edwardians:*

*an English architect and his clients,* London and New York, 1996.

Number of works in Catalogue: 1

**Luca Madrassi**
Born in Tricesimo, Italy, in the mid-nineteenth century, Madrassi studied in Italy and Paris. He exhibited at the Salon des Artistes Français from 1881 until 1896, and at the Nationale from 1896. He specialised in busts, statuettes and allegorical groups.

Source: Mackay, James, *Dictionary of Western Sculptors in Bronze,* Suffolk, 1977.

Number of works in Catalogue: 1

**John McKenna** (b.1964)
McKenna studied at Worcester Technical College, Middlesex Polytechnic and the Sir Henry Doulton School of Sculpture (1987). He now lives in Worcester, where he has his own studio. Has carried out public works for Centro including *Glassblower,* Stourbridge town railway station, in collaboration with Steve Field (1995), and Canley railway station, Coventry (1995).

Source: information given in conversation with Mark Wiles, Principal Planner, Centro, 13 June 1996.

Number of works in Catalogue: 4

**Frederick Edward McWilliam** (1909–92)
Born in Banbridge, Co. Down, Northern Ireland, McWilliam studied at the Belfast College of Art and then under Professor Tonks at the Slade School of Fine Art, London, where he was awarded the Robert Ross leaving scholarship. During 1931, he worked in Paris, where he first encountered Surrealism. In 1932 he returned to Britain, taking up residence at Chartridge, Buckinghamshire, where he began to carve in wood. In 1936 he moved to Hampstead, London, near to the studios of Moore, Read, Nicholson, Hepworth, Penrose and Nash. The following year he visited

Hoptonwood Quarry, Derbyshire, in the company of A.H. Gerrard and Henry Moore in order to select stone. In the same year he began his association with the newly formed British Surrealist Group, exhibiting as a sculptor. His first one-man exhibition was at the London Gallery, Cork Street, in 1939. After the war, he began teaching sculpture, firstly at the Chelsea School of Art and then, from 1947 to 1968, at the Slade School. In 1951 he was commissioned to produce several works for the Festival of Britain, including *The Four Seasons* for the Country Pavilion, South Bank Exhibition. Throughout the 1950s he exhibited extensively in Britain and abroad. During this period, his figures were attenuated and characterised by rough, textured surfaces. He was appointed Associate of the Royal Academy in 1959, but resigned in 1963, wishing to be free of all institutional commitments. During the early 1960s, he produced a series of mechanomorphic bronze figures, some of which recall Moore's reclining works. He continued to exhibit regularly in Britain and abroad, and was awarded the degree of Honorary D.Litt from Queen's University, Belfast, in 1964, a CBE in 1966, and the Oireachtas Gold Medal from Trinity College, Dublin, in 1971. During the 1980s, he turned again to carving in wood.

Sources: Stokes, Adrian, *The Stones of Rimini,* London, 1934; Penrose, Roland and Tiranti, Alec, *McWilliam,* London, 1965; Ulster Museum, *F.E.McWilliam,* catalogue, Belfast, 1981; Warwick Arts Trust, *F.E.McWilliam: Early Sculptures 1935–48 with some recent works,* Warwick, 1982.

Number of works in Catalogue: 1

**Frank Meisler** (b.1932)
Born in Germany, Meisler came to Britain as a Jewish refugee in 1939, later emigrating to Israel and gaining a significant reputation as a sculptor there. His best-known work is an illuminated Torah and shrine in memory of the victims of the Holocaust at the synagogue in Mannheim.

Other works include the fountain in the atrium of the King David Hotel, Jerusalem, and the Holocaust Memorial at Miami, Florida.

Sources: www.frank-meisler.com; www.artcnet/Frank_Meisler

Number of works in Catalogue: 1

**Sanderson Miller** (1716–80)
Amateur architect and landscape designer who experimented with architectural additions on his own estate, Radway Grange (Edgehill, Warwickshire) between 1739 and 1746. He designed a series of Gothic and classical works in Herefordshire and Worcestershire, including some waterworks at Honington Hall (1749) and follies for Hagley Hall (from 1748). Miller suffered from bouts of insanity in his later years and built little after 1760.

Source: Turner, J., *Dictionary of Art,* vol.21, London, 1996.

Number of works in Catalogue: 2

**Jon Mills**
Born in Birmingham, Mills studied art at Wolverhampton Polytechnic (1979–82) before being awarded a grant by the Crafts Council to set up his own craft metal-working business. He has had solo exhibitions at Wolverhampton Art Gallery (1996), Hartlepool Art Gallery (1999) and Kings Lynn Arts Centre (1999), as well as participating in the touring group exhibition *Devious Devices* (1998). He specialises in working in steel in various guises and produces architectural pieces, furniture and mechanical automata as well as sculpture.

Source: information from the sculptor.

Number of works in Catalogue: 1

**Henry Charles Mitchell** (active 1920s)
Mitchell was a monumental mason based in Tamworth who also exhibited at the Royal Academy in 1931 as a landscape painter. He was

then living in Burgoyne Road, London. He has thirteen known war memorials in Derbyshire, Leicestershire, Staffordshire and Warwickshire.

Sources: Johnson, J. and Greutzner, A., *Dictionary of British Artists 1880–1940*, Suffolk, 1976; verbal information from Jane Armer, National Inventory of War Memorials.

Number of works in Catalogue: 1

## William George Mitchell (b.1925)

Born in London, he studied art at the Southern College of Art, Portsmouth and at the Royal College of Art where he won a fourth year scholarship (The Abbey Award) which enabled him to study at the British School in Rome. He established the William Mitchell Design Consultants group and produced sculptures in plastics, concrete, wood, marble and brick. He has been a member of the Design Advisory Board, Hammersmith College of Art, and Trent Polytechnic, and is a member of Formwork Advisory Committee and the Concrete Society. He has many pieces throughout the country, including Liverpool Metropolitan Cathedral entrance; Three Tuns public house, Coventry (1966). Exhibitions include a joint show held at the Engineering and Building Centre, Broad Street, Birmingham (1967), where he showed three over-life-size figures, *The Magi*, which were made from Thermalite load-bearing aerated concrete building blocks, produced by Thermalite Ltd, Lea Marston.

Sources: 'Painter's search for peace', *Birmingham Post*, 11 May 1967; Pereira, Dawn, *William Mitchell*, MA thesis, University of East London, 1998.

Number of works in Catalogue: 2

## Uta Molling

Following practical training in cabinet-making in Germany, she studied for a degree in interior design and architecture at Stuttgart Polytechnic (1979–82). During this period, she worked as an assistant stage designer and film animator. She has had solo exhibitions at a number of art galleries in Germany and Britain, including the Galerie am Reissmuseum (1982–3) and the Galerie Klapsmuehle (1984), both in Mannheim, the Arts Gallery Workshop, Swansea (1990), the Galerie Bernd Heidelbauer, Stuttgart (1992) and the Dylan Thomas Theatre Gallery, Swansea (1993). Her works have also been included in group exhibitions at a number of museums, including the ICA, London (1980), the Kulturzentrum, Mannheim (1982–3), Drumcroon Art Centre, Wigan (1994) and the Arts Workshop Gallery, Swansea (1995). She is currently based in Swansea, where she is in partnership with the sculptor Robert Conybear. Many of their commissions have been from his home town, including a lighthouse sculpture for the marina (1986), a wall mosaic for the sea cadets' headquarters (1991), a figure weather vane for Swansea Observatory (1991), and mosaics for the city centre (1992) and Swansea Mumbles (1993). More recently, they have designed a series of 24 mosaic ceramic panels for Luton town centre (1997) and site-specific sculpture in London (1998) and Coventry (1999). She has also taught part-time at Swansea and Carmarthen Art Colleges.

Source: information from the sculptor.

Number of works in Catalogue: 1

## Lizzie Murphy (b.1959)

After studying at Lanchester Polytechnic (now Coventry University) (1984–7), Lizzie Murphy became a freelance mural painter. Her largest commission, a mural 72m long by 2.4m wide, was installed in the Museum of British Road Transport in Coventry. Another of her works, *The Pattern*, was for the Greenpeace Antarctic Survey ship, the *Gondwana*. From 1993 until 1999, she was the Project Manager for Arts Exchange, working on many community projects as well as painting mountain landscapes and portraits. Lizzie married in 1999, and is now known as Lizzie Alageswaran. She currently works as Arts Development Officer for Coventry City Council.

Source: artist's own statement, 7 July 2000.

Number of works in Catalogue: 2

## Van Nong (b.1971)

Born in Vietnam, Van Nong studied film and sculpture in Coventry, where he sculpted the *Phoenix* outside the University and opposite the Cathedral. Whilst working with Free Form Arts Trust he designed the Rye Lane lamp columns in Peckham, London, that were displayed in the Design Museum. He is now living and working in Australia.

Source: information supplied by Andrew Dwyer.

Number of works in Catalogue: 1

## Ondre Nowakowski (b.1954)

The son of a Polish refugee who arrived in South Wales at the end of the Second World War, Nowakowski studied fine art at Staffordshire Polytechnic 1980–3 and completed his Masters in fine art at Manchester Polytechnic 1983–4. He works from his studios in Sandbach, Cheshire. He produced large wooden figures in states of motion for the National Garden Festival, Stoke-on-Trent (1986). His commissions include one for Butterley Brick PLC, Derbyshire (1987), *A Man Can't Fly*, Stoke-on-Trent City Council (1987), *Sun Dial*, Richard Wilson Art Centre, Gwynedd (1990), and work for the Royal Oldham Hospital (1996). He is currently a senior lecturer in Visual Arts at Manchester Metropolitan University.

Sources: Manchester Metropolitan University and Stoke-on-Trent City Museum and Gallery, *Ondre Nowakowski: Recent Works*, 1995; letter from the artist, 29 January 1996.

Number of works in Catalogue: 1

**Rob Olins** (b.1956)
Having completed a foundation course at
Barnet College (1976–7), Olins went on to gain
a first class degree at Wolverhampton
Polytechnic (1977–80), a certificate in adult
education at the City Literary Institute
(1985–6), and in 1986 undertook a course at
Poplar College in metal casting. He has won a
large number of awards and residencies,
including Prizewinner, the Columbus Art
League (1993); the Symposium in St Lamprect,
Austria (1994); and an award for a wall feature
in the Rutherglen Centre, Sunderland (1994).
He uses a variety of materials in his work,
which are held in a delicate balance by gravity,
friction, magnetism, etc. Olins has produced
abstract and kinetic sculptures for Mercedes
Benz, Sunderland Borough Council, Colchester
Leisure World, and a set of four sculptures for
Unilever (1994). He has exhibited throughout
Britain, Germany and the USA, and his solo
exhibitions include the New Academy Gallery
(1994) and Galerie Glasnost, Munich (1995).

Source: information from the artist.

Number of works in Catalogue: 1

**Yoko Ono** (b. 1933)
Born in Tokyo, Ono moved during her teens to
the USA and studied art at Sarah Lawrence
College, New York. During the 1960s, she
worked as a conceptual artist in New York
City, marrying her third husband, John
Lennon, in 1966. Ono and Lennon collaborated
musically and politically until his death in 1980.
Throughout the 1980s, Ono continued to work
on experimental art and music. In 1995, she
worked on a collaborative project with her
20–year-old son Sean and his rock band Ima.

Number of works in Catalogue: 1

**Mary Jane Opie** (b.1962)
Now living in North London, Opie trained at
the Chelsea School of Art, gaining a BA in Fine
Art at Middlesex Polytechnic in 1985. After
completing her studies she embarked on her
first commission and since then has been doing
a mixture of gallery pieces and commissions in
her own studio in North London. Although
technically the skills involved in producing this
mix of work are the same, the range of materials
she has used has been wide and varied, limited
only by imagination. Examples of her work are
a cow made of living grass, a jaguar made of car
parts, and an elephant created from scaffolding.
Other large works include a geometric mosaic
made out of vinyl tiles and a major piece made
out of clay sewage pipes illustrating the
relationship between gravity and balance, which
was designed to push the material to its limits
before crashing to the floor. Since embarking
on her career she has had a number of reviews
of her work published in the *Observer
Magazine*, and *Design Week*, and *Homes and
Gardens*. In 1991 the *Observer* named her as
one of London's most promising young artists,
and she was also invited in the same year to
exhibit at the Olympia International Art Fair as
part of the 'The Times Young Artists Selection'
organised by Andrew Renton. She staged a
'One Person Show' at the Coopers and
Lybrand Gallery in The Strand in London in
1994, which was very successful. To add to this
she has also ventured into the world of
publishing and written a book on sculpture for
interested amateurs entitled *Sculpture – A
History of International Sculpture Through the
Ages*, part of the Eye Witness series and
published by Dorling and Kindersley in 1994.
More recently her life has become quite hectic
with more commissions and exhibitions, the
latest being the sculpture for the Coventry
Canal Public Art Trail.

Source: profile written by Groundwork Coventry,
January 1997.

Number of works in Catalogue: 1

**Richard Ormerod** (1896–1979)
Ormerod was in partnership with his brother
George Ormerod in the Art Casting Company
of Cox Street, Coventry in the 1930s. The firm
made motor mascots, statuettes, lamps and
similar small sculptural pieces. Both brothers
showed work at the Coventry and
Warwickshire Annual Art Exhibition. Richard
had begun his career as a motorcycle builder
and was the firm's designer. He is best known
for his motor mascots from the 1930s for such
firms as Rover and Alvis.

Source: Herbert Museum and Art Gallery, *A Survey
of Public Art in Coventry*, Coventry, 1980.

Number of works in Catalogue: 2

**Jean Parker** (b.1936)
After teaching religious education in schools for
some years, Jean Parker studied for a degree in
Fine Art at Lanchester Polytechnic (now
Coventry University) from 1982–6. She later
took a Diploma in Printmaking at the Mid-
Warwickshire College of Art, Leamington
(1988–90) and a master's degree in art
(completed 1988). Since the 1980s, she has
worked in the marble yards at Pietrasanta, Italy,
the stone yards of Canterbury and Liverpool
cathedrals, and the Isle of Portland quarry. She
regularly holds sculpture workshops in which
she seeks to emphasise the spiritual strand in
her own work. Her major works include *The
Enfolding* (1985), *In the Stillness* (1995), the
*Memorial Cross* at the Blue Coat School in
Coventry (1996), and *The Eye of the Needle* at
St Augustine's School, Kenilworth (2000). She
plans to hold an exhibition of her work in
Nuneaton during 2001.

Source: information from the sculptor.

Number of works in Catalogue: 2

**Jim Partridge**
Based in Oswestry , he works predominantly in
wood which he turns, carves and chars. He has

worked in Grizedale Forest, Cumbria and on the Chiltern Sculpture Trail.

Sources: *Crafts*: [i] no.140, May/June 1996 [ii] no.74 May/June 1985; Turner, Ralph, *Jim Partridge*, Clwyd, 1993; Cripps, David, *Jim Partridge: wood worker*, London, 1989; http://wavespace.waverider.co.uk/~scotdave

Number of works in Catalogue: 1

## Edward Pearce (Pierce) (*c.*1635–95)

The son of Edward Pearce, a decorative painter, he became a Freeman of the Painter-Stainers' Company by patrimony in 1656. He may have been apprenticed to Edward Bird, an artist who worked for Wren in the painted decoration of his City churches. He may also have been employed by Bushnell to assist him in the statue of Sir Thomas Gresham, one of the three Royal Exchange figures (now in the Old Bailey), finished in 1671. Pearce was, at this time, carrying out carving on the exterior of the Guildhall. He was responsible for the wood-carving in the dining room of Sir Charles Wolseley at Wolseley, Staffordshire, and for much of the wood-carving in the Church of St Lawrence Jewry (destroyed during the Second World War). He also carved the woodwork in St Matthew, Friday Street, where he also made the font (1685). In 1683, he carved the coat of arms and pediment for Lord Craven's seat of Coombe Abbey, and in 1690 he made four chimney pieces for Castle Bromwich Hall, Warwick. For Sir Christopher Wren, he either built or worked on the churches of St Swithun, Cannon Street, St Benet Fink, and St Andrew, Holborn. He worked at St Paul's Cathedral and, together with his partner, Shorthose, built the church of St Clement Dane (1680–1). In 1685 he executed a statue of Queen Elizabeth for the Royal Exchange, paid for by the Fishmongers' Company, one of Edward III for the Skinners' Company and one of Henry V for the Goldsmith's Company. However, his only remaining full-length figure is a wooden statue of Sir William Walworth (1684), a fourteenth-century Lord Mayor, on the staircase of Fishmongers' Hall. He is also noted for his fine busts – he executed two signed busts of Oliver Cromwell (one in marble (1672), in the Ashmolean Museum, Oxford, and the second, a bronze (1672), in the Museum of London). His bust of Sir Christopher Wren (1673) is also in the Ashmolean Museum (a gift from Wren's son), that of Dr John Hamey (1675) is in the Royal College of Physicians, London, and his bust of Thomas Evans (1680) is in the possession of the Painter-Stainers' Company, London. He made several fine marble urns, one with a relief of *Amphitrite and the Nereids*, for Hampton Court, the bronze dragons on the Monument and a fountain for the Privy Garden at Whitehall (1689–95). In 1651 he married a widow, Anne Smith, and resided in Arundel Street. He is buried in his church of St Clement Dane.

Source: Gunnis, R., *Dictionary of British Sculptors 1660–1851*, London, 1964.

Number of works in Catalogue: 2

## Peter Peri (1899–1967)

Born Lazlo Peri in Hungary, he first trained as a stone carver in Budapest. Around 1919, he became a member of the artists' group MA with Moholy-Nagy and worked on Expressionist drawings. However, his work had moved towards Constructivism by the time he fled to Germany in 1920. During the early 1920s, he joined the German Communist Party. He was active in an art congress in Düsseldorf, moved on to Russia and Paris, and then to Berlin. Peri studied architecture there from 1924–8 but moved back to sculpture soon after completing his training. At the Sturm Gallery he exhibited abstract linocuts, but during the mid-1920s, when working for the Berlin City Architects' Department, he returned to realism. Peri fled to England in 1933, set up his studio in Camden and joined the Artists International Association. He became a British citizen in 1939, changing his name to Peter, and joining the British Communist Party. For the remaining 30 years of his life Peri worked on his figure sculptures and etchings. In 1936, he exhibited in *From Constructivism to Realism* at Foyles Gallery. From the late 1930s he became very active as an etcher, but from 1948 he developed a method of making figures in polyester resin, receiving many commissions from churches, colleges and schools. He pioneered the use of modelled concrete in sculpture. Although Peri produced a considerable number of figure sculptures, it is his early work, the drawings and lithographs produced in the period 1918–24 with the other members of the MA group and the Constructivists, that has the greatest significance. His decision to work primarily on figurative sculpture and possibly his move to England had a radical effect and channelled his work away from the direction of its early development. Peri had hoped that his work would be commissioned for the post-war rebuilding of Coventry. An active AIA member, his work is held at the Tate Gallery and the British Museum. Exhibitions include St George's Gallery (1958), Herbert Art Gallery, Coventry (1960), The Minories, Colchester (1970), Gill Drey Gallery (1989), Retrospective, Leicestershire Museum and Art Gallery (1991).

Sources: Leicestershire Museums and Art Gallery, *Peter Peri: a retrospective exhibition of sculptures, prints and drawings: 3 August – 29 September 1991*, Leicester, 1991; Watkinson, Rayond, *Fighting Spirits: Peter Peri and Clifford Rowe*, London, 1987; Spalding, F., *20th Century Painters and Sculptors, Dictionary of British Art*, VI, Woodbridge, Suffolk, 1990; Herbert Art Gallery and Museum/City of Coventry Libraries, Arts and Museums Department, *A Survey of Public Art in Coventry*, 1980; Buckman, David, *Dictionary of Artists in Britain since 1945*, Bristol, 1998.

Number of works in Catalogue: 4

**Richard Perry** (b.1960)
Educated at Leeds Polytechnic, he has works in the public collections of a number of county councils. Works include *Quartet*, life-size bronze figures, the Old Market Square, Nottingham (1990–1); *Thomas Boulsover*, bronze figure, Tudor Square, Sheffield.

Source: information from the artist.

Number of works in Catalogue: 1

**A. John Poole** (b.1926)
Born in Birmingham, he studied Industrial Design at Birmingham School of Art. For two years during the war he worked in William Bloye's studio, where he learnt the art of letter-carving in the tradition of Eric Gill. He later completed his National Design Diploma at Birmingham School of Art (1949–51), and went on to teach sculpture part-time at Mid-Warwickshire College of Art and Walsall School of Art (1952–61). Poole set up his own studio in 1949 and moved to Bishampton, Worcestershire in 1961. Mainly an architectural sculptor and letter-carver, Poole has also worked in stone, wood, concrete and metal. His commissions include *Commemorative Stone*, Tree Lovers' League, Lee Bank, Birmingham (1960), *Figure*, Cannock Central Library (1959), *Abstract*, East Walk, Basildon, Essex (1960), figures of *St Catherine* and *St Mary*, Solihull School Chapel (1961), *Life and Times of Liverpool*, relief, St John's Precinct, Liverpool (1965), gates and doors, Park Tower Hotel, Knightsbridge, London (1973), high altar and ambo, St Helen's Cathedral, Brentwood, Essex, for which he received the Otto Beit Award in 1974, *Sir Basil Spence* and *John Hutton* memorials, Coventry Cathedral (1978), *Field Marshall Wavell* and *Field Marshall Auchinleck* memorials, Wellington Chambers, St Paul's Cathedral, London (1979), and *Madonna and Child*, All Saints Church, Gogowan, Shropshire (1982). Poole's architectural restoration work includes Council House annexe, Edmund Street, Birmingham (1958), and entrance front, Aston Hall, Birmingham (1972). Exhibitions include group shows at the Pershore Millennium (1972), and West Midlands Arts Exhibition, Lichfield Cathedral (1975). ARBS (1958), FRBS (1969). Chairman of the Society of Church Craftsmen, Member of the Arts League of Great Britain.

Sources: West Midlands Arts, *Artists, craftsmen, photographers in the West Midlands*, Stoke-on-Trent, 1977; letter from the artist, 13 April 1984.

Number of works in Catalogue: 1

**John Pritchard** (active 1860s–1900s)
One of two architects in charge of the work at Llandaff Cathedral during the 1860s, the other being John Pollard Seddon. He also worked with Seddon at Ettington Park, Warwickshire.

Source: Read, B., *Victorian Sculpture*, New Haven and London, 1982.

Number of works in Catalogue: 1

**William Pye** (b.1938)
Born in London, he studied at Wimbledon School of Art 1958–61 where he was taught by Freda Skinner, and at the RCA 1961–5. Taught at the Central School of Art and Design 1965–70 and Goldsmith's College 1970–7, becoming a visiting professor at California State University 1975–6. His major works are primarily explorations in the qualities of water, and he has worked extensively in collaboration with architects. In 1990, he formed the William Pye Partnership which is a sculptural and architectural practice. Making abstract metal sculptures that are often kinetic and have highly reflective surfaces, he has said that 'sculpture isn't naturally seductive but the addition of water gives it a sort of mesmeric quality to which people respond sympathetically'. His commissions include the award-winning *Balla Frois*, Glasgow Garden Festival (1988), *Slipstream and Jetstream*, passenger terminals, Gatwick Airport (1988) for which he also won an award, *Water Wall* on the British Pavilion designed by Nicholas Grimshaw and Partnership, Seville Expo (1992), suspended water sculpture, British Embassy, Muskat, Oman (1994), *Confluence*, water sculpture, Hertford town centre (1994), *Cascade*, Market Square, Derby (1995), and *Water Pyramid*, Le Colisée, Paris (1995). He has public works in the USA and Japan, and has worked on light features for Lambeth Palace, London and West India Quay feature for the London Docklands Development Corporation. Pye's films include *Reflections* (1971) and *Scrap to Sculpture* (1975). Awarded the 'Structure 66' prize, Welsh Arts Council (1966), and Royal UENO Award, Japan (1989). Exhibited throughout Great Britain including the Redfern Gallery (1966) and subsequently the Ikon Gallery, Birmingham (1975), British sculpture in the twentieth century, Whitechapel Art Gallery (1981), Welsh Sculpture Trust Inaugural Exhibition, Margam Park, Port Talbot (1983). FRBS (1992), FRIBA (1993).

Sources: Farr, D., 'The patronage and support of sculptors' in Nairne, S. and Serota, N., *British sculpture in the twentieth century*, Whitechapel Art Gallery, London, 1991; Strachan, W.J., *Open Air Sculpture in Britain*, London, 1984; curriculum vitae provided by the artist for the WMCC Peace Sculpture Commission, 1984; Redhead, C., 'Waterworks', *Crafts*, London, vol.104, July/August 1989; 'Zen and the art of water', *Crafts*, London, vol.105, July/August 1990; Amery, C., 'Water: an art form to be tapped' *Financial Times*, 18 September 1995; Watt, J., 'Making waves', *Perspectives*, February/March 1996; letter from the artist, 19 February 1996.

Number of works in Catalogue: 2

**Charles Quick** (b.1957)
Charles Quick trained at Gloucestershire College of Art and Design (1976–7), then studied Fine Art at Leeds Polytechnic where he obtained a first class degree. He claims that his

'aesthetic roots lie with Modernism' and that his work is influenced by Christo, William Furlong and Buster Simpson. He is interested in electricity which he describes 'as not just a physical power but also an economic, industrial and cultural power'. Influenced by pylons and industrial design, particularly by street furniture, he constructs objects that interact with the viewer, usually using a combination of sensors and light bulbs.

Sources: public lecture by Charles Quick, 18 March 1999; curriculum vitae from the artist.

Number of works in Catalogue: 1

## Alma Ramsey (b.1907)

Born in Tunbridge Wells, Ramsey studied at Bournemouth School of Art, and at the Royal College of Art, London 1927–30 under Gilbert Ledward and Henry Moore. She was influenced by their ideas of direct carving in wood and stone. She also studied ceramics with William Staite Murray. A carver in alabaster and other stones, and a draughtsman in chalk, she married the artist Hugh Richard Hosking. Amongst her commissions was the first crib for Coventry Cathedral, and *Christ in Glory* for St Francis of Assisi, Elmdon Heath, Warwickshire. She exhibited widely in mixed shows, and enjoyed a long series of solo exhibitions, beginning with the Peter Dingle Gallery, Stratford-upon-Avon (1966), the Herbert Art Gallery, Coventry (1969), Southwell Minster (1972), Stoke-on-Trent City Art Gallery (1980), and Warwick Museum (1989). Her work is included in the collections of the Herbert Art Gallery and Museum, Coventry, Oxford City and County Museum; Leamington Art Gallery, and Worcester Education Department.

Source: Spalding, F., *20th Century Painters and Sculptors, Dictionary of British Art*, VI, Woodbridge, Suffolk, 1990.

Number of works in Catalogue: 1

## Ian Randell (b.1966)

Since graduating from Lanchester Polytechnic (now Coventry University) with a first class honours degree in sculpture in 1988, Ian Randell has exhibited at the Cartwright Hall, Bradford (1990), the Cliffe Castle Museum, Keighley (1991), the Bradford Arts Festival (1992) and the Bradford Gallery (1994).

Source: information from the artist.

Number of works in Catalogue: 1

## Peter Randall-Page (b.1954)

Peter Randall-Page was born in Essex and studied at Bath Academy of Art (1973–7) before moving to London where he worked with Barry Flanagan for a year. He worked on the conservation of thirteenth-century sculpture at Wells Cathedral, Somerset. In 1980 he was awarded the Winston Churchill Memorial Trust Travelling Fellowship to study marble-carving in Italy. He was visiting lecturer in Sculpture at Brighton Polytechnic from 1982 to 1989. He has exhibited his work regularly in Britain and abroad. In 1989 he began 'Local Distinctiveness', a project concerned with placing sculpture in the environment with particular care for its relevance and sensitive siting. He works mainly in stone, and uses natural forms such as shells, fossils, fruits, eggs and pods, as well as expressive knots.

Sources: Hamilton, James and Warner, Marina, *Peter Randall-Page, Sculpture and Drawing 1977–1992*, Leeds, 1992; Elliott, Ann, *Peter Randall-Page: New Sculpture and Drawings*, London, 1998.

Number of works in Catalogue: 1

## John Ravera

Ravera trained at Camberwell School of Art between 1954 and 1962. He has worked in various materials, but predominantly makes bronzes from clay models. He produces figurative and abstract works for public and private commissions, as well as smaller scale limited edition statuettes of figures and animals. He was elected to the Royal Society of British Sculptors in 1976.

Source: information from the artist, www.jepa.co.uk/ravera/

Number of works in Catalogue: 1

## William Reid-Dick (1878–1961)

Reid-Dick worked mainly in commemorative and portrait sculpture. An example is the memorial of 1939 to King George V at Westminster. His other works include a bust of Sir Edward Lutyens and a statue of *Our Lady of Liverpool*, both of 1933, and statues of Lord Duveen and the Countess of Jersey (1934).

Source: Granville-Fell, H., *Sir William Reid Dick*, London, 1945.

Number of works in Catalogue: 1

## Walter Ritchie (1919–97)

Ritchie was introduced to sculpture at Coventry School of Art by Victor Candey. His first sculptures were modelled and cast, his learning supplemented by a former assistant of Rodin. Ritchie decided that casting debased the original clay sculpture, and turned to working in stone. He learnt techniques from local stonemasons, and at the age of eighteen trained under Eric Gill. Ritchie felt that art should not be seen in isolation, and under the strong influence of Mumford's 'Culture of Cities', he started a career in social and town planning. One of several projects included a Survey of Worcester and a Redevelopment Plan based on the survey. After five years, Ritchie concluded that, '… Planning at this time was a form of national escapism… people enjoyed seeing pictures of urban utopias… there was too much theory and too little experience and humanity', and as a consequence returned to sculpture. He never thought of sculpture in isolation but essentially as part of a social and architectural scheme. From 1947 onwards he worked

primarily for local authorities, making works for schools, fire stations and other civic buildings. Due to a demand for large-scale sculptures with restricted budgets he started experimenting with unusual techniques. These included working metal by repoussé, carving brick walls and flame-cut steel. He always wanted his work 'in the street' as opposed to in an art gallery, believing that, 'it is wrong to concentrate great collections of paintings and sculpture in special buildings rather than use them where they are most needed to enliven the drab and dull places of our cities'. He developed his own ideas about the way art should work, most importantly that art should be individual and diverse, growing from the region it was produced in and for. He felt that, 'We need diversity of art not fashion… art must originate in life and develop free from the nonsense of art theorists and the secondhand influences of museums and galleries.' He worked loosely from charcoal exploratory sketches to draw the work freehand on the material. Notable examples of his work include the *Len Hutton Memorial* at the Oval cricket ground in London (1988–93) and the panels for the Bristol Eye Hospital. The Church of Our Lady of the Wayside in Shirley, Birmingham, has perhaps the most representative collection of his work in all media. Built in the 1960s, it includes a teak *Madonna and Child*, a Portland stone, spun aluminium and ivory *Font*, a Portland stone and granite *Altar*, lettering cut into the brick of the chapel walls and a framed charcoal sketch.

Ritchie did not exhibit frequently during his lifetime. In 1976 he held an exhibition of works in brick at the Building Centre in London to contrast with the national furore over Carl André's bricks at the Tate Gallery. In 1996 he held his first gallery retrospective 'A Love Affair' at Ramsgate Library. In 2000 a major retrospective exhibition was held at Leamington Spa Museum and Art Gallery. He is perhaps now best known for his innovative work in brick.

Sources: Ritchie, W., *Sculpture in Brick and Other Materials*, Walter Ritchie, Kenilworth, 1979; information provided by the artist's widow, Sally Taylor, 11 March 2000; Ritchie, W., *Walter Ritchie: Sculpture*, Kenilworth, 1994.

Number of works in Catalogue: 21

## Ivor Roberts-Jones (1913–96)

Born in Oswestry, Ivor Roberts-Jones studied at Goldsmith's College and at the Royal Academy School during the 1930s. After the Second World War, he taught sculpture at Goldsmith's College until 1978. In 1973 he became a Fellow of the Royal Academy, and in 1974 he was awarded the Gold Medal by the Royal Society of British Sculptors. He is mainly noted for commissioned portraits of distinguished people, the best known of which is his *Winston Churchill Memorial*, Parliament Square, London (1973). Others include the Duke of Edinburgh, Lord Dynevor, Clement Attlee, Augustus John, Somerset Maugham, Yehudi Menuhin, and the Earl of Anglesley. He does not seek to create a close physical likeness of his subject, but instead simplifies form, exaggerating certain aspects of the body or facial features in order to create an evocative and expressive portrait. He works initially in plaster, scraping and pushing the material, which is later cast in bronze, in order to create a textured, 'weathered' surface. Later works include his *Lazurus Gardens* in which spaces are defined by hedges and other organic forms, and which are intended to suggest sculpture which grows out of the ground and out of the landscape instead of being imposed upon it. He has participated in exhibitions such as the 1977 Battersea Park Jubilee Exhibition. He is noted for his monumental equestrian sculpture at Harlech Castle (1983), which celebrates the legend of Bendigeidfran from the *Mabinogion*.

Source: Wolsey Art Gallery, *Ivor Robert-Jones*, exhibition catalogue, Ipswich, 1999.

Number of works in Catalogue: 1

## Adolphus Rost

Rost's works include a bronze bust of Queen Victoria for the London Chest Hospital, Hackney (1900).

Source: Gleichen, Lord Edward, *London's Open Air Statuary*, London, 1928 (reprinted 1973).

Number of works in Catalogue: 1

## Clifford A. Rowe (1904–89)

A native of London, Rowe attended Wimbledon School of Art between 1918 and 1921, winning a scholarship to the Royal College of Art, but leaving after only a year. For two years he was employed in advertising, then becoming self-employed in order to allow more time for his own work as an artist and book illustrator. This, however, impoverished him to such an extent that he came to question the economic basis of society. He began studying Socialist literature, reading the *Communist Manifesto*, and then travelled to the Soviet Union, where he lived for 18 months, designing book covers and undertaking commissioned work for the Red Army. During the late 1930s, Rowe began to depart from Social Realism, finding it too limiting, both in theory and practice, searching for an art which was neither photographic nor too abstract. With Misha Black and others, he founded the Artists International Association, leaving in the 1950s when he felt that it ceased to have a political purpose. He did not exhibit his work frequently, and in 1985 gave much of it to galleries and museums (e.g., the Science Museum, the London and National Railway Museum, Leicester City Art Gallery, and the National Museum of Labour History). His work is also held in the Tate Gallery, and the Electrical Trades Union College owns his *General Strike* and *Tolpuddle Martyrs* murals. In 1983, his work was included in the AIA touring exhibition, organised by the Museum of Modern Art, Oxford. In 1987, together with

Peter Peri, he exhibited in *Fighting Spirits* at the Camden Arts Centre, and in 1995 he was given a posthumous solo show by the National Museum of Labour History, Manchester.

Source: Herbert Art Gallery and Museum/City of Coventry Libraries, Arts and Museums Department, *A Survey of Public Art in Coventry*, Coventry, 1980.

Number of works in Catalogue: 1

## Peter Scheemakers (1691–1781)

The son of the Antwerp sculptor Peter Scheemakers the Elder (1640–1713), Scheemakers trained in Copenhagen under the court sculptor Johann Adam Sturmberg (1683–1741). He briefly studied sculpture in Rome before travelling to London where he gained employment under Francis Bird (1667–1731) and François Plumière (also known as Pierre Denis) (1688–1721). While in London he worked in partnership with Laurent Delvaux (1696–1778). In 1728 Scheemakers, accompanied by Delvaux, returned to Rome where he studied for several years. On returning to England he set up a studio in London. Scheemakers' style was severely classical. His works were prolific including many statues, portrait busts and church monuments. His main rival was the sculptor John Rysbrack (1694–1770), whom he regularly undercut to gain a commission. His brother, Henry (d.1748) and son, Thomas (1740–1808) also worked in England as sculptors. In 1753 Scheemakers announced his retirement with an auction of many of his prints and drawings, followed in the next four years by two more sales of his work. In fact Scheemakers continued to work in England until 1771, when he left the country and returned to Antwerp.

Sources: Gunnis, R., *Dictionary of British Sculptors 1660 – 1851*, London, 1964; Roscoe, Ingrid, 'Peter Scheemakers catalogue', *Walpole Society Journal*, vol.LXI, 1999; Henry Moore Institute, *Peter Scheemakers: the famous statuary 1691–1781*, Leeds, 1996.

Number of works in Catalogue: 1

## Bernard Schottlander (1924–99)

Born in Mainz, Germany, Schottlander came to Britain in 1939. He worked as a welder and plater, attending evening classes in sculpture at Leeds College of Art, then as a structural engineering welder during the war. From 1944–8 he studied at the Anglo-French Art Centre, later attending the Central School of Art and Crafts from 1949–51. From 1951 to 1963, he worked as an industrial designer and metal worker with his own metal workshop. From 1963 he worked full time as a sculptor. He also taught at St Martin's School of Art. At first geometric, after 1977 his work becomes organic, usually in marine paint on steel plate. He participated in the Arts Council's touring exhibition, *Sculpture in a City* (1968), and his solo exhibitions include the Architectural Association (1964), Annely Joda, Hamilton Galleries (1965), Guinness Brewery (open air exhibition) (1972). His *South of the River* (a large, steel sculpture) is located in Lambeth Palace Road, in front of the offices of Ernst & Young, and his work is held in the collections of the Arts Council, Leicester City Art Gallery, and Warwick University. Overseas collections holding his work include the City of Toronto, and the Sackler Foundation, New York.

Source: *Dictionary of National Biography*, CD ROM version.

Number of works in Catalogue: 1

## Gilbert W. Seale (*fl. c.*1900)

Gilbert Seale came from a family of stone carvers. In the late 1880s he carved reredoses and other church work for J.D. Sedding. He also carved the angels flanking the doorway of Reginald Morphew's Marlborough Chambers (now Estate House) in Jermyn Street, London, and the work at Lancaster Town Hall for E.W. Mountford in 1907.

Source: Gray, A.S., *Edwardian Architecture – a biographical dictionary*, London, 1985, p.324.

Number of works in Catalogue: 1

## Tim Shutter (b.1954)

Born in Cambridge, he now lives in Hackney in London. He studied at Bath Academy of Art and finished his BA in Fine Art at Manchester Polytechnic in 1983, specialising in sculpture. More recently he gained an MA from the Wimbledon School of Art in Site Specific Sculpture (1993). Since then he has worked as an assistant to sculptors such as Anthony Gormley and Anish Kapoor while developing his own career. Over the last seven years, he has undertaken a number of commissions and residencies, and had sculptures installed on a number of sculpture trails dotted about the country, including the Chiltern Sculpture Trail, Bradford Urban Sculpture Trail and the Perth Riverside Sculpture Trail. Other examples of his work can be found in Main Street, Failsworth, Greater Manchester, the Tout Quarry Sculpture Park in Portland, Dorset, and the Hyde Park underpass in London. He has also exhibited in numerous exhibitions around Britain, most recently in the Grand Hall Albert Dock, Liverpool (Street Furniture Exhibition), Castlefield Gallery, Manchester ('Jolly Peril Paradise'), Southwark Open Studios, Cupola Gallery in Sheffield and the Sun and Doves pub as part of Southwark Arts Week. He is currently working on a sculpture commission for a public park in Perth and continuing with his stone carving for the Freeform Arts Trust.

Source: information from the artist.

Number of works in Catalogue: 1

## John Skeaping (1901–80)

Born in Essex, Skeaping studied at Goldsmith's College, the Central School of Arts and Crafts (1917–19) and the Royal Academy Schools (1919–20). He first exhibited at the Royal Academy in 1922, but was not elected a Fellow until 1960. In 1924 he married Barbara Hepworth, with whom he exhibited at Alex Reid and Lefèvre, Glasgow, in 1928. He taught

sculpture at the Royal College of Art from 1948 until 1959. His work is notable for its depiction of animals. In its simplicity and elemental quality, it resembles the prehistoric cave drawings found in France and Spain.

Sources: Buckman, David, *Dictionary of Artists in Britain since 1945*, Bristol, 1998; Ackermann, Arthur and Son, *John Skeaping 1901–1980: a retrospective 4 June – 5 July 1991*, London, 1991.

Number of works in Catalogue: 1

### John Skelton (1923–1999)

Born in Norwich, he studied drawing, painting and sculpture at Coventry School of Art 1939–40 and became apprenticed to his uncle, Eric Gill, for a short period in 1940 when he learnt direct carving and a love of lettering. After Gill's death, Skelton became an assistant to the carver Joseph Cribb, 1940–2, and after war service, joined the stone yard studios of Percival Bridgeman of Lewes. In 1950 he set up his own practice in Sussex. His works in stone, wood, bronze and ciment fondu are mainly figurative or figurative abstracts, sometimes using found objects. He has works in Norwich, Portsmouth, Lincoln and Hereford Cathedrals; Christ Church, Coventry (1954–8), Shakespeare Centre, Stratford-upon-Avon (1964), as well as *Aftermath of War*, Herbert Art Gallery, Coventry (1973), *Hands on Lyre*, Watergate Galleries, Washington DC, USA (1970), and *Torso*, exhibited at the RA (1975). He was awarded the RBS Silver Medal for the best work of the year in 1975. More recently he made two memorials to Edward James, poet and benefactor of West Dean, near Chichester (1986), and contributed to the show 'Revelation for the Hands' (1987). He also had many Royal lettering commissions. His exhibitions include the RA from 1952, Chichester Museum (1963), Yugoslavia International Sculpture Symposium (1964), Herbert Art Gallery, Coventry (1965), Alwin (1965), and Sussex University (1966).

Sources: Skelton, J., *John Skelton: A Sculptor's Work*

*1950–75*, Wellingborough, 1977; *Arts Review*, 'Sculpture', vol.38, 23 May 1986; Inch, P., 'A revelation for the hands', *Arts Review*, February 1987; Skelton, John, *Skelton at Seventy: a major retrospective exhibition of work by John Skelton: sculpture, lettering, watercolours and drawings*, Sussex 1993.

Number of works in Catalogue: 6

### Francis Smith of Warwick (1672–1738)

Francis Smith was an architect and builder who originally trained as a mason. In 1697 he and his brother, William, were contracted to rebuild the nave and tower of St Mary's Church, Warwick, to the design of Sir William Wilson, which was carried out between 1698 and 1704. While there would have been opportunities to rebuild a number of public buildings in Warwick following the fire of 1694, the predominant element in Smith's practice was the building of country houses for the gentry. Some of these were built to the design of other architects, including Heythrop House, Oxfordshire (designed by Thomas Archer and built in 1705–8) and Ditchley House, also in Oxfordshire (designed by James Gibbs and built 1720–1). Although his own houses are excellent examples of craftsmanship, he cannot claim a high level of distinction as a designer. Typically, he built three-storeyed rectangular blocks in which the standard late seventeenth-century hipped roof was replaced by an attic storey and crowning parapet, with a repertoire of ornament of a vernacular baroque character applied with varying degrees of restraint. Examples include Buntingdale Hall (1721), Davenport Hall (1726) and Kinlet Hall (1727–9), all in Shropshire. He bought a country estate at Knowle, Warwickshire, and twice served as Mayor of Warwick, in 1713–14 and again in 1728–9.

Source: *Dictionary of National Biography*, CD ROM version.

Number of works in Catalogue: 2

### Keir Smith (b.1950)

Smith is a sculptor in a wide range of styles and materials. He studied at Newcastle University (1969–73) and Chelsea College of Art (1973–5). He taught part-time for several years during the late 1970s at Sheffield College of Art. His exhibitions include Oriel Gallery, Cardiff (1973) and the Ikon Gallery, Birmingham (1982). In 1979–80, he was the resident sculptor at Grizedale Forest, completing the wood and wickerwork construction *The Realm of Taurus* (1980). In 1986, he was commissioned by the Forest of Dean Sculpture Project to produce *The Iron Road*. This consists of a series of 20 carved wooden railway sleepers, each with a symbolic meaning, that recall the original use of the railway line through the forest. He argued that, in this work, he had aimed 'to blur the boundaries between site and sculpture',

Sources: Buckman, David, *Dictionary of Artists in Britain since 1945*, Bristol, 1998; Laing Art Gallery, *The dreaming track: Keir Smith, sculpture and drawings*, Newcastle upon Tyne, 1989.

Number of works in Catalogue: 1

### Thomas Stayner (1668–1731)

Stayner's earliest monument is the signed altar-tomb with recumbent effigies of Richard and Anne Winwood in Quainton, Buckinghamshire (1691). His most ambitious work came much later, in 1714, when he sculpted the monument to Dr Thomas Turner that stands in Stowe-Nine-Churches, Northamptonshire. Other works include the monument to Sir Henry Bendyshe (1717) with its twisted barley-sugar columns and a reclining effigy of Sir Henry with a baby beside him, the monument to Sir Richard Hoare (1725), and the monument to Sir Ralph Radcliffe in Hitchin Church (contract dated 31 August 1721).

Source: Gunnis, R., *Dictionary of British Sculptors 1660–1851*, London, 1968.

Number of works in Catalogue: 1

**George and Isaac Steane** (*fl.* 1876–1919)
Architects based at 22 Little Park Street, Coventry.

Source: Herbert Art Gallery and Museum/City of Coventry Libraries, Arts and Museums Department, *A Survey of Public Art in Coventry*, 1980.

Number of works in Catalogue: 1

**Trevor Tennant** (1900–80)
Born Dudley Trevor Tennant, son of C. Dudley Tennant the painter, he signed his works Trevor Tennant. He trained at Goldsmith's College of Art and at the Royal Academy. He exhibited at the Royal Academy and had a number of one-man shows in London during the 1930s. He taught at Camberwell School of Art (1930–4), Dulwich College (1934–40), Hammersmith School of Art (1946–53) and Guildford School of Art (1947–52). He was a member of the Artists International Association.

Sources: McKay, James, *Dictionary of Western Sculptors in Bronze*, Suffolk, 1977; Herbert Art Gallery and Museum/City of Coventry Liberaries, Arts and Museums Department, *A Survey of Public Art in Coventry*, Coventry, 1980.

Number of works in Catalogue: 5

**Mary Thomas** (b.*c.*1956)
Mary Thomas was an art student at Lanchester Polytechnic (now Coventry University) at the time she made *The Corridor* (1977). She also made a plaque for the Gosford Green Monument in 1976, which was stolen after three days.

Source: Herbert Art Gallery and Museum/City of Coventry Libraries, Arts and Museums Department, *A Survey of Public Art in Coventry*, Coventry, 1980.

Number of works in Catalogue: 1

**William Hamo Thornycroft** (1850–1925)
Born in London, the son of sculptors Mary and Thomas Thornycroft. Although still training with his parents he entered the RA Schools in 1869, winning a gold medal in 1875 for his group *A Warrior Bearing a Wounded Youth from Battle*. He visited Italy in 1871. Influenced by the sculpture of G.F. Watts and Frederick Leighton as well as Alfred Gilbert, he produced marble and bronze classical figures, portrait busts, medallions and memorials. His first major success was *Artemis*, shown as a plaster at the Royal Academy in 1880. He modelled *Fame* and the figures of *Comedy* and *Shakespeare* for the Park Lane fountain of English Poets, London (1873) as well as producing statues of Teucer, RA (1881) and Alfred Waterhouse, RA (1883), a bronze equestrian statue of Lord Mayo, RA (1874) and a bust of Samuel Taylor Coleridge, Westminster Abbey, (1884). His public monuments included the memorial to General Gordon, Victoria Embankment Gardens (1888), *Oliver Cromwell*, outside Westminster Hall (1899), the *Gladstone Memorial*, the Strand (1905), and the *Lord Curzon Memorial*, Calcutta (1909–13). His architectural sculpture includes high relief friezes for the Institute of Chartered Accountants, City of London (1891). He exhibited at the RA 1872–1925; elected ARA 1881; RA 1888; knighted 1917.

Sources: Beattie, S., *The New Sculpture*, New Haven and London, 1983; Manning, Elfrida, *Marble and Bronze: The Art and Life of Hamo Thornycroft*, London, 1982; White, A., *Hamo Thornycroft: the sculptor at work*, Leeds, 1983.

Number of works in Catalogue: 1

**T.F. Tickner** (1866–1924)
Coventry-based architect who carried out a large number of commissions in the city for domestic residences, factories and public houses, as well as submitting the winning designs for the Council House (though this was not built to his plans). He also lectured on architectural history.

Source: Herbert Art Gallery and Museum/City of Coventry Libraries, Arts and Museums Department, *A Survey of Public Art in Coventry*, Coventry, 1980.

Number of works in Catalogue: 1

**Albert Toft** (1862–1949)
The son of Charles Toft, designer and modeller for pottery, he studied at Birmingham, and then at Hanley and Newcastle under Lyme Schools of Art. During this time he was also apprenticed to Wedgwood as a modeller. In 1879 he won a National Scholarship to the National Art Training Schools (now the Royal College of Art), London, where he studied for two years under Lanteri. He had his own studio in London producing portraits, for example *George Wallis* (1890) (in Victoria and Albert Museum) and specialising in genre figures, groups and ideal figures. His first great success was with a figure of *Lilith* (1889) (in Birmingham Museums and Art Gallery). Other major works include his bronze statuette of *Mother and Child*, Preston (1889); *Fate-led* (1862) (in Walker Art Gallery, Liverpool); *Spring* (1897) (in Birmingham Museum and Art Gallery); *The Spirit of Contemplation* (1901) (in Laing Art Gallery, Newcastle upon Tyne); *The Metal Pourer*, Cardiff (1913) and *The Bather* (1915) (Chantrey Bequest, Tate Gallery). He was also a sculptor of monuments including *Queen Victoria*, Nottingham (1905) and the *Welsh National Memorial*, Cathays Park, Cardiff (1909). Throughout his career he continued to produce portrait busts including those of *Sir George Frampton RA* (1915); *Sir Henry Irving RA* (1919) and *Sir Alfred Gilbert MV RA* (1935). He exhibited at the RA from 1885–1947, and was elected a Fellow of the RBS in 1923.

Sources: Spielmann, M.H., *British Sculpture and Sculptors of Today*, London, 1901; Toft, A., *Modelling and sculpture: A full account of the various methods and processes employed in these arts*, London, 1924; *Who's who in art*, 2nd edition, London, 1929; Mackay, J., *Dictionary of Western Sculptors in Bronze*, Woodbridge, Suffolk, 1977.

Number of works in Catalogue: 3

**Sarah Tombs** (b.1961)
She trained at Wimbledon School of Art (1981–4), Chelsea School of Art (1984–5) and the Royal College of Art (1985–7) where she was awarded the Henry Moore Bursary. In 1981 her first exhibition was held at Cannizaro Park, Wimbledon. In 1986 she was appointed Artist in Residence with British Steel. In 1988 she was appointed Artist in Residence with Nicholas Chamberlain Comprehensive School.

Sources: Spalding, F., *20th Century Painters and Sculptors, Dictionary of British Art*, VI, Woodbridge, Suffolk, 1990; http://wavespace.waverider.co.uk/~scotdave

Number of works in Catalogue: 1

**Frank Triggs** (b.1948)
Triggs is known primarily as a wood-carver. He is married with two children and lives on an organic market garden and farm near Oswestry in Shropshire. In 1971 he graduated from Cardiff College of Art and Design with a Diploma in Painting and Sculpture. He later gained a Diploma in Teaching Art and finally an MPhil from Wolverhampton University following his research to establish design criteria for the construction of play equipment and play environments for handicapped children. After that, he designed huge inflatable playthings principally for pop groups, which he then took out into the parks in Cardiff and Brighton. At the same time he became involved in Performance Art, designing and building items such as a dragon for an event for Cannon Hill Park in Birmingham. He started his carving career by repairing antique furniture. He was then asked to do a number of contemporary carving commissions for the National Trust, listed buildings, churches and schools. He has been asked to make a carved bed for the rock musician, Eric Clapton. In 1993 he received two awards in the Architecture and Furniture sections of 'Imagine', an international competition organised by the Swedish/Finnish

Timber Council and the Chartered Society of Designers.

Sources: Dudley Metropolitan Borough Council, *Public Art Guide;* CWN, The Coventry and Warwickshire Network, Coventry Canal Basin.

Number of works in Catalogue: 1

**William Frederick Unsworth** (1851–1912)
Unsworth was an architect from Bath, where he had been articled to Wilson and Wilcox in 1869. He had a keen interest in the architecture of the past, especially French Gothic, and travelled extensively in France before starting in practice in London in 1875 at 13 Buckingham Street, Strand, London with his partner Edward John Dodgshun. Upon receiving the contract for the theatre at Stratford-upon-Avon in 1876, the partners moved to larger premises at 2 Queen Street, Westminster. From 1880, Unsworth's base was in Sussex and then later in Petersfield, Hampshire, where he was in partnership with his son and Harry Inigo Triggs. Among other public buildings Unsworth was to design were the chapel of King's School, Warwick (completed 1895), and the interior designs for the choir of the chapel of Rossall School in Lancashire. He became a fellow of the RIBA in 1891. He exhibited between 1882 and 1902 as a watercolour and architectural painter of London, twelve times at the Royal Academy and once at the RBA.

Sources: Johnson, J. and Greutzner, A., *Dictionary of British Artists 1880–1940*, Suffolk, 1976; Pringle, M.J., *The Theatres of Stratford-upon-Avon, an architectural history*, Stratford-upon-Avon, 1994.

Number of works in Catalogue: 1

**Janet Vaughan**
Janet Vaughan trained in theatre design at Trent Polytechnic, Nottingham. She has designed site-specific and touring theatre and video works, and created artworks for non-gallery and outdoor spaces. Much of her theatre and

video work has been in collaboration with Coventry mixed-media specialists Talking Birds. As one of the two members of Artists in Waiting, Janet undertakes short residencies to produce temporary and semi-permanent works for public waiting-rooms. She is a member of Coventry Artists' Co-operative.

Source: information from the artist.

Number of works in Catalogue: 1

**Paul Vincze** (1907–94)
Born in Hungary, he studied at the State School of Arts and Crafts, Budapest, and later in Rome (1935–7). In 1938, he moved to England and set up a studio in London, where he became an Art Workers' Guild member and a Fellow of the RBS. Vincze exhibited widely, winning a number of awards, including a silver medal at the Paris Salon (1964) and the first gold medal of the American Numismatic Association (1966). Among his output was a prize medal for the Smithsonian Institution, a series of medals for the Shakespeare Birthplace Trust, and two medals struck to commemorate the coronation of Queen Elizabeth II in 1953.

Source: Buckman, David, *Dictionary of Artists in Britain since 1945*, Bristol, 1998.

Number of works in Catalogue: 1

**George Wagstaffe** (b.1939)
Wagstaffe is a local artist who trained at Coventry College of Art (1955–62) and later taught there. From 1963 until 1968, he taught at Caludon Castle School. After a period as an independent sculptor, he began teaching at Stoke Park Community College in 1975. He has had exhibitions at Lanchester Polytechnic, now Coventry University (1978) and at the Herbert Art Gallery and Museum, Coventry (1984). His studio is in Hawkes Mill Lane, Allesley, and his works can also be seen in Birmingham, Oxford, Warrington, Chester and Leicester.

Sources: Herbert Art Gallery and Museum/City of Coventry Libraries, Arts and Museums Department, *A Survey of Public Art in Coventry*, Coventry, 1980; *Coventry Evening Telegraph*, December 1999.

Number of works in Catalogue: 5

## Douglas Wain-Hobson (b.1918)

Associate of the Royal College of Art. Born in Sheffield, Wain-Hobson studied at the Royal College of Art under Richard Garbe, 1938–40, and subsequently with Frank Dobson, 1946–7, winning a College gold medal in 1946, and the Prix de Rome in 1947. He also lectured at the Royal College of Art. He has exhibited at the Royal Academy, LG, and various exhibitions in Yorkshire. His works are in stone, terracotta, bronze and wood.

Source: McKay, James, *Dictionary of Western Sculptors in Bronze*, Suffolk, 1977.

Number of works in Catalogue: 2

## John Wakefield

Based in Gloucester, he has carved in wood for most of his life, but has only earned his living from it since the late 1980s. His commissions have included work for Coventry and Hereford City Councils, the Suzuki Motor Company, Channel 4 TV, Arbortech, Australia and AEG in Germany.

Source: information from the artist.

Number of works in Catalogue: 5

## Katie-Jane Wakefield (b.1975)

She graduated from Nottingham Trent University with a degree in Graphic Design in 1997, and has been working in this field since that date.

Source: information supplied by the artist's father.

Number of works in Catalogue: 1

## T.W. Wills

Together with his brother W.W. Wills he studied at the Royal Academy, and they set up a workshop in London. They exhibited sculpture at the Royal Academy between 1856 and 1884, and completed several commissions for publicly displayed sculpture.

Source: Herbert Art Gallery and Museum/City of Coventry Libraries, Arts and Museums Department, *A Survey of Public Art in Coventry*, Coventry, 1980.

Number of works in Catalogue: 1

## W.W. Wills

Together with his brother T.W. Wills he studied at the Royal Academy, and they set up a workshop in London. They exhibited sculpture at the Royal Academy between 1856 and 1884, and completed several commissions for publicly displayed sculpture.

Source: Herbert Art Gallery and Museum/City of Coventry Libraries, Arts and Museums Department, *A Survey of Public Art in Coventry*, Coventry, 1980.

Number of works in Catalogue: 1

## Henry Wilson (1864–1934)

Wilson trained at Kidderminster School of Art, and was then articled to J.D. Sedding in Maidenhead, later becoming chief assistant and taking over the practice when Sedding died in 1891. Wilson took a particular interest in the design and manufacture of metalwork, which he taught at the Central School of Arts and Crafts from 1896, and then from 1901 at the Royal College of Art. He joined the Art Workers' Guild in 1902 and was its Master in 1917. He showed at the Arts and Crafts exhibition from 1889. His metalwork designs use an original combination of Byzantine and late Gothic forms. He also designed fireplaces and furniture and, in 1905, the bronze doors of the cathedral of St John the Divine, New York. In 1896 he was the first editor of *Architectural Review*.

Source: Jervis, Simon, *Penguin Dictionary of Design and Designers*, Harmondsworth, 1984.

Number of works in Catalogue: 1

## W. Wilson (1641–1710)

William Wilson was the son of a baker and is believed to have served an apprenticeship with a statuary mason and shortly before 1669 carved the statue of King Charles II for the west front of Lichfield Cathedral (taken down in 1877). In 1670 he executed carvings for the entrance porch of Sudbury Hall, Derbyshire; in around 1671 he executed the Wilbraham family monuments in Weston Church, Staffordshire, and in 1679 an equestrian statue of William, Duke of Newcastle, for the north-east front of Nottingham Castle. In 1677 he was commissioned by Jane Pudsey of Langley Hall, Warwickshire, to make a monument to her recently deceased husband. The exceptionally wealthy and influential widow evidently fell in love with him, secured a knighthood for him in 1681, and shortly afterwards married him. The couple lived at Moat House, Sutton Coldfield, which Wilson designed and built himself. Between 1693 and 1697, he was engaged on the building of Sir John Moore's School, Appleby Parva, and from 1698, on the rebuilding of St Mary's Church, Warwick. His other sculptural commissions include allegorical statues over the porch of Castle Bromwich Hall, Warwickshire (1697), the monument to Sir Thomas Gresley in St George and St Mary's Parish Church, Church Gresley, Derbyshire, and a statue of Edward VI (1707, destroyed 1833) for Edward VI Grammar School, Birmingham.

Sources: Cavanagh, T. and Yarrington, A., *Public Sculpture of Leicestershire and Rutland*, Liverpool, 2000, pp.388–9; Pevsner, N., *Buildings of England: Warwickshire*, Harmondsworth, 1966, p.36; Gunnis, R., *Dictionary of British Sculptors 1660–1851*, London, 1964, pp.433–4.

Number of works in Catalogue: 2

## William Winde (d.1722)

Born in Holland, Winde was the son of a Royalist exile. He followed Gerbier as architect of Hampstead Marshall (1662–88), of which

only the gate piers survive, and became, with Pratt and May, a leader of the Anglo-Dutch school. His Buckingham House, London (1705), later destroyed, was very influential.

Source: Fleming, John, Honour, Hugh and Pevsner, Nikolaus, *Penguin Dictionary of Architecture*, Harmondsworth, 1966, p.480.

Number of works in Catalogue: 1

**Greg Wyatt**
A leading American sculptor, Wyatt works mainly in bronze. Several of his public sculptures are located in New York City, and are also in private and corporate collections throughout the United States. He is a director of the Newington-Cropsey Academy of Art, and is sculptor-in-residence at the Cathedral Church of St John the Divine, New York (where his studio is located in the crypt). His bronze *Peace Fountain* is in the cathedral grounds, and is the focus of New York's first outdoor children's sculpture garden. He is a member of the British Society of Sculptors, and his bronze, *The Tempest*, Stratford-upon-Avon, is his first sculptural piece to be located in England.

Source: information provided by the staff at New Place, Stratford-upon-Avon.

Number of works in Catalogue: 1

# References

## Books and Articles

Ackermann, Arthur, and Son, *John Skeaping 1901–1980: a retrospective 4 June – 5 July 1991*, London, 1991.

Adams, K., *George Eliot: A Brief Biography*, Warwick, 1976.

Ades, D. and Amor, M., *Richard Deacon: Esculturas y dibujos 1984–95*, London, 1996.

Amery, C., 'Water: an art form to be tapped', *Financial Times*, 18 September 1995.

Anon, *Blumenfeld Catalogue for Whitefriars exhibition*, Coventry 1986.

Anscombe, I. and Gere, C., *Arts and crafts in Britain and America*, London, 1978.

Arts Council of Great Britain, *Sculpture in a City*, touring exhibition catalogue, London, 1968.

Attwater, D., *The Penguin Dictionary of Saints*, Harmondsworth, 1965.

Balsall Parish Council, *Balsall Parish Council – the first one hundred years 1894–1994*, Balsall Common, 1994.

Barnes, Joanna, *Arthur Fleischmann 1896–1970: A Centennial Celebration*, London, 1996.

Baxter, E.G., *Dr Jephson of Leamington Spa*, Leamington Spa, 1980.

Beard, G.W., 'Castle Bromwich Hall, Warwickshire', *Country Life*, 9 May 1952.

Bearman, R., *Stratford-Upon-Avon, A History of its Streets and Buildings*, Stratford-upon-Avon, 1988.

——, *The History of an English borough: Stratford upon Avon 1196–1996*, Stroud, 1997.

Beattie, S., *The New Sculpture*, New Haven and London, 1983.

Bell, C.F. (ed.), *Annals of Thomas Banks, sculptor, Royal Academician, with some letters from Sir Thomas Lawrence, P.B.A. to Banks' daughter*, Cambridge, 1938.

Billingham, Rosalind, and Lewison, G., *Coventry – New Architecture*, Warwick, 1969.

Black, P., *Geoffrey Clarke: Symbols of Man: sculpture and graphic work 1949–94*, London, 1994.

Blumenfeld, Helaine, *The New Sculpture of Helaine Blumenfeld 1982–88*, London, 1989.

——, *Helaine Blumenfeld: Cambridge 1972–1992*, Cambridge and London, 1992.

Bott, John, *The Figure of the House: an illustrated record of the building of Stratford's theatre*, Stratford-upon-Avon, 1975.

Boutell. C., *Boutell's Heraldry*, London, 1983.

Brentnall, Margaret, *John Hutton, artist and glass engraver*, London, 1986.

Briggs, G. (ed.), *Civic and Corporate Heraldry*, London, 1971.

Brown, I., and Fearon, G., *Amazing Monument*, London, 1939.

Brown, Jane, *Lutyens and the Edwardians: an English architect and his clients*, London and New York, 1996.

Buckle, R., *Jacob Epstein, Sculptor*, London, 1963.

Buckman, David, *Dictionary of Artists in Britain since 1945*, Bristol, 1998.

Burgess, Frederick, 'The Architectural History of Leamington Spa', *Monumental Journal*, October 1957.

*Burke's Landed Gentry*, London, 1875.

Burman, J., *The Story of Tanworth*, Birmingham, 1930.

Cameron, J., *Royal Leamington Spa*, Stroud, 1999.

Campbell, Louise, *Coventry Cathedral: art and architecture in post-war Britain*, Oxford, 1996.

Cavanagh, Terry and Yarrington, Alison, *Public Sculpture of Leicestershire and Rutland*, Liverpool, 2000.

Cave, L.F., *Royal Leamington Spa – Its History and Development*, Chichester, 1988.

Chamot, M., *Modern British Painting, Drawing and Sculpture*, vol.1, Tate Gallery, London, 1964.

Clarke, D.L., *The Story of the Memorial Fountain to Shakespeare at Stratford-upon-Avon*, Cambridge, 1890.

Clarke, Ron, 'Art as a Source for Local History', *Local History Bulletin*, March 1986.

——, *A Survey of Public Art in Coventry*, Coventry, 1980.

Clarke, R.C. and Day, P.A.E., *Lady Godiva: Images of a Legend in Art and Society*, Coventry, 1982.

Coleshill Civic Society, *A Photographic Record of Old Coleshill*, Chorley, 1984.

Collins, Judith, *Eric Gill: The Sculpture*, London, 1992.

Colvin, Howard, *Dictionary of British Architects 1600–1840*, London, 1993.

Cooper, W., *Henley-in-Arden: an ancient market town*, originally published 1946, amended facsimile edition, Buckingham, 1992.

Cork, R., *Vorticism and Its Allies*, Haywood Gallery, London, 1974.

Cosmo, W., *The Works of J.H. Foley*, London, 1875.

Courtney, C., 'Sculpture by Angela Conner', *Architect (RIBA)*, vol.93, October 1986.

Cripps, David, *Jim Partridge: wood worker*, London, 1989.

Darke, J., *The Monument Guide To England and Wales*, London, 1991.

Deacon, Richard, *For those who have eyes: Richard Deacon sculpture 1980–86: a touring exhibition*, Aberystwyth, 1986.

Drew, J.H., *Yesterday's Town: Kenilworth*, Buckingham, 1980.

Dryden, A., *Memorials of Old Warwickshire*, London, 1908.

Dudley, T.B., *A Complete History of Royal Leamington Spa*, Leamington Spa, 1901.

Dugdale, Sir William, *Antiquities of Warwickshire*, 2nd edition, London, 1730.

Dumas, F.G., *The Illustrated Catalogue of the Paris Salon*, London, 1881.

Edwards, Bigwood & Mathews, Auctioneers, *Tudor Grange Solihull, Catalogue of the Furnishings, Contents of the House and Objets D'Art*, 18–21 April 1944, Solihull, 1944.

Ehrlich, Bettina, *Georg Ehrlich, 1897–1966: bronzes, early drawings, lithographs and etchings: 19th April – 6th May 1972*, O'Hana Gallery, London, 1972.

Elliott, Ann, *Peter Randall-Page: New Sculpture and Drawings*, London, 1998.

Epstein, Sir Jacob, *Epstein: An Autobiography*, London, 1975.

Epstein, J., *Epstein Centenary*, London, 1980.

Eustace, K and Pomery, V., *The University of Warwick Collection*, Warwick, 1991.

Farr, D., 'The patronage and support of sculptors' in Nairne, S. and Serota, N., *British sculpture in the twentieth century*, Whitechapel Art Gallery, London, 1991.

Felstead, A., Franklin, J. and Pinfield, L., *Directory of British Architects 1834–1900*, London, 1993.

Fils, G., *Recent Sculpture by Kenneth Armitage: October – November 1957*, London, 1957.

Fleming, John, Honour, Hugh and Pevsner, Nikolaus, *Penguin Dictionary of Architecture*, Harmondsworth, 1966.

Florence, J.W., *Tudor Grange Sale Catalogue*, Solihull, 1900.

Fox, L., *The Shakespeare Birthplace Trust a Personal Memoir*, Norwich, 1997.

Gardiner, S., *Epstein: Artist Against the Establishment*, London, 1993.

Gardner, S.M. and Ibbotson, E.M.H., *History of Ilmington*, Oxford, 1974.

Gibbons, W.G., *Royal Leamington Spa – Images from the Past*, Coventry, 1985.

Gildea, J., *For Remembrance and in Honour of those who lost their lives in the South African War 1899–1902*, London, 1911.

Gill, Eric, *Sculpture and the Living Model*, London, 1932.

Gleichen, Lord Edward, *London's Open Air Statuary*, London, 1928 (reprinted 1973).

Gooding, Mel, *McWilliam, F.E.: sculpture 1932–1989*, Tate Gallery, London, 1989.

Gower, Lord Ronald, *Michael Angelo Buonarroti*, London, 1903.

——, *Records and Reminiscences selected from 'My Reminiscences' and 'Old Diaries'*, London, 1903.

Gowing, L., *A Biographical Dictionary of Artists*, London, 1983.

Granville-Fell, H., *Sir William Reid Dick*, London, 1945.

Graves, A., *Royal Academy Exhibitors 1769–1904*, London, 1905.

Gray, A.S., *Edwardian Architecture, a biographical dictionary*, London, 1985.

Gunnis, R., *Dictionary of British Sculptors 1660–1851*, London, 1964.

Hadfield, John (ed.), *The Shell Book of English Villages*, London, 1985.

Hamilton, James and Warner, Marina, *Peter Randall-Page, Sculpture and Drawing 1977–1992*, Leeds, 1992.

Hannett, John, *Forest of Arden*, Birmingham, 1863.

Harris, J. and Higgott, G., *Inigo Jones: Complete Architectural Drawings*, New York, 1989.

Henry Moore Institute, *Peter Scheemakers: the famous statuary 1691–1781*, Leeds, 1996.

Herbert Art Gallery and Museum/City of Coventry Libraries, Arts and Museums Department, *A Survey of Public Art in Coventry*, Coventry, 1980.

Howard, R.T., *Ruined and Rebuilt: The Story of Coventry Cathedral*, Coventry, 1962.

Hughes, Graham, (ed.), 'Sculpture News', *Arts Review*, vol.38, 23 May 1986.

Hutton, John, *Glass Engravings of John Hutton*, London, 1969.

Inch, P., 'A revelation for the hands', *Arts Review*, February 1987.

Jervis, Simon, *Penguin Dictionary of Design and Designers*, Harmondsworth, 1984.

Johnson, J. and Greutzner, A., *Dictionary of British Artists 1880–1940*, Suffolk, 1976.

Jones, I. and Kent, W., *The Designs of Inigo Jones consisting of plans and elevations for Public and Private Buildings, with some additional designs*, vol.II, London, 1770.

Jones, R., *A Solihull Century*, Studley, 1997.

Jones, Timothy Emlyn, *Michael Farrell: The Vision*, Birmingham, 1989.

Kelly's Directories Ltd., *Kelly's Directory of Warwickshire*, London, 1924.

——, *Kelly's Directory of Warwickshire*, London, 1936.

——, *Kelly's Directory of Warwickshire*, London, 1961.

Kemp, T., *Historic Warwick*, Warwick, 1899.

Kennington, Eric, *Eric Kennington R.A.: Official War Artist 1914–18 and 1939–45*, London 1985.

Keyte, O., *The Annals of a Century, Bridgemans of Lichfield 1878–1978*, Lichfield, 1995.

Kimberley, M., *Lord Ronald Gower's Monument to Shakespeare*, Stratford-upon-Avon Society, 1989.

Laing Art Gallery, *The dreaming track: Keir Smith, sculpture and drawings,* Newcastle upon Tyne, 1989.

Lancaster, Joan, *St Mary's Hall Coventry: A Guide to the Building, its History and Contents,* Coventry, 1948.

Leicestershire Museum and Art Gallery, *Peter Peri 1899–1967. A Retrospective Exhibition of Sculpture, Prints and Drawings* (exhib. cat.), Leicester, 1991.

Leith, Ian, 'The Sculpture of the Third Exchange' in Ann Saunders (ed.), *The Royal Exchange,* London Topographical Society, 1997.

Lines, C., *Britain in Old Photographs: Solihull,* Stroud, 1998.

Lucie-Smith, Edward, *Movements in Art since 1945,* London, 1969.

——, *Sculpture since 1945,* London, 1987.

MacDonald, M., *The Town Hall Stratford-upon-Avon,* Stratford-upon-Avon, 1986.

Mackay, James, *Dictionary of Western Sculptors in Bronze,* Suffolk, 1977.

MacNulty, W.K., *Freemasonry: a Journey through Ritual and Symbol,* London, 1991.

McGrory, D., *Coventry History and Guide,* Stroud, 1993.

Manchester Metropolitan University and Stoke-on-Trent City Museum and Gallery, *Ondre Nowakowski: Recent Works,* Stoke-on-Trent, 1995.

Manning, Elfrida, *Marble and Bronze: The Art and Life of Hamo Thornycroft,* London, 1982.

Mead Gallery, *Between Scylla and Charybdis: David Hugo,* University of Warwick, 1988.

Measures, A., *Visitor's Guide to Warwick,* Warwick, 1995.

Munden, A., *The Coventry Martyrs,* Coventry, 1997.

Musée d'Art, *Electra* (exhib. cat.), Paris, 1983.

Noble, Edgar and Corner, Ronald, *Dale Street: a tale of two worlds,* Leamington Spa, 1976.

Norwich Art Gallery, *Careers of ten women artists born 1897–1906,* Norwich, 1992.

Noszlopy, George T., *Public Sculpture of Birmingham,* Liverpool, 1998.

Odibourne Press, *Kenilworth Past,* Kenilworth, 1993.

Panzetta, A., *Dizionario Degli Scultori Italiani Dell'ottocento e Del Primo Novocento,* vol.1, Turin, 1994.

Penny, N., *Church monuments in romantic England,* New Haven and London, 1977.

Penrose, Roland and Tiranti, Alec, *McWilliam,* London, 1965.

Pereira, Dawn, *William Mitchell,* (unpublished MA thesis, University of East London), London, 1998.

Pevsner, N, *Buildings of England: Shropshire,* Harmondsworth, 1958.

——, *Buildings of England: Warwickshire,* Harmondsworth, 1966.

Popper, Frank , *Le Déclin de l'Object,* Paris, 1975.

Popper, Frank, *Art in the Electronic Age,* London, 1993.

Post, Ellwood W., *Saints, Signs and Symbols,* London, 1962.

Preece, Robert, 'UK's Million Pound Art Bonanza' in *Sculpture,* May 2000.

Pringle, M.J., *The Theatres of Stratford-upon-Avon, an architectural history,* Stratford-upon-Avon, 1994.

Pugh, R.B. (ed.), *Victoria County History of Warwickshire,* vol.VIII, London, 1967.

Randall-Page, Peter, *Sculpture and Drawing 1977–1992,* essays by James Hamilton and Marina Warner, Leeds, 1992.

Read, B., *Victorian Sculpture,* New Haven and London, 1982.

Redhead, C., 'Waterworks', *Crafts,* July/August 1989.

Ritchie, W., *Walter Ritchie: Sculpture,* Kenilworth, 1994.

——, *Sculpture in Brick and Other Materials,* Kenilworth, 1979.

Roscoe, Ingrid, 'Peter Scheemakers catalogue', *Walpole Society Journal,* vol. LXI, London, 1999.

Rosenberg, E. and Cork, R., *Architect's Choice: Art and Architecture in Britain since 1945,* London, 1992.

Royal Academy of Art, *Art Treasures of England* (exhib. cat.), London, 1998.

Rudge, Geraldine (ed.), 'Zen and the art of water', *Crafts,* no.105, London, July/August 1990.

Salzman, L.F. (ed.), *Victoria County History of Warwickshire,* vol.IV, London, 1947.

Saville, G.E., *Alcester: a history,* Studley, 1986.

Scott-Giles, C.W., *Civic Heraldry of England and Wales,* London, 1953.

Seftey, R., *The Weekly Tribune 1895–1995: Images of Nuneaton,* Derby, 1995.

Shakespeare, William, *A Midsummer Night's Dream,* Harlow, 1991.

Shewring, W. (ed.), *The Letters of Eric Gill,* London, 1947.

Silber, E., *The Sculpture of Epstein: With a Complete Catalogue,* Oxford, 1986.

——, *Jacob Epstein: sculpture and drawings,* Whitechapel Art Gallery, London, 1987.

——, *Rebel Angel, Sculpture and Watercolours by Sir Jacob Epstein 1880–1959,* Birmingham, 1980.

Skelton, J., *John Skelton: A Sculptor's Work 1950–75,* Wellingborough, 1977.

——, *Skelton at Seventy: a major retrospective exhibition of work by John Skelton: sculpture, lettering, watercolours and drawings,* Sussex, 1993.

Skipp, V., *The Origins of Solihull,* Birmingham, 1964.

Smith, Albert and Fry, David, *The Coventry we have Lost,* Coventry, 1991.

Smith, C., *Civic Heraldry of Warwickshire,* Coventry, 1973.

Smith, John Thomas, *Nollekens and his times: and memoirs of contemporary artists from the time of Roubiliac, Hogarth and Reynolds to that of Fuseli, Flaxman and Blake,* ed.

Wilfred Whitten, London and New York, 1920.

Soanes, J., *Plans, Elevations and Sections Of Buildings executed in the Counties of Norfolk, Suffolk, Yorkshire, Staffordshire, Warwickshire, Hertfordshire, et caetera*, London, 1788.

Solihull High School for Girls, *Malvern Hall*, Solihull, 1974.

Solihull Metropolitan Borough Council, *A Walk Around Solihull*, Solihull, 1999.

Spalding, F., *20th Century Painters and Sculptors, Dictionary of British Art*, VI, Woodbridge, Suffolk, 1990.

——, *British Art since 1900*, London, 1986.

Spielmann, M.H., *British Sculpture and Sculptors of Today*, London, 1901.

Stephens, L. and Lee, S. (eds) *Dictionary of National Biography*, London, 1930.

——, *Dictionary of National Biography*, London, 1986–90.

Stocker, Mark, *Royalist and Realist: The Life and Work of Sir Joseph Edgar Boehm*, London, 1988.

Stokes, Adrian, *The Stones of Rimini*, London, 1934.

Strachan, W.J., *Open Air Sculpture in Britain*, London, 1984.

Stratton, M., *The Terracotta Revival*, London, 1993.

Stroud, Dorothy, *George Dance, architect, 1741–1825*, London, 1971.

Stuart, Sir Campbell, *Memorial to a King*, London, 1954.

Tate Gallery, *Art of the Sixties*, London, 1976.

Thompson, J, Tazzi, P.L. and Schjeldahl, P., *Richard Deacon*, London, 2000.

Thornson, D., *England in the Nineteenth Century*, Harmondsworth, 1983.

Tietze-Conrat, Erica, *Georg Ehrlich*, London, 1956.

Timmins, E.W., *Rugby: A Pictorial History*, Chichester, 1990.

Toft, A., *Modelling and sculpture: A full account of the various methods and processes employed in these arts*, London, 1924.

Townsend, B., *Southam Through the Centuries*, Warwick, 1979.

Turner, J., *Dictionary of Art*, vol.21, London, 1996.

Turner, Ralph, *Jim Partridge*, Clwyd, 1993.

Tyack, G., *Warwickshire County Houses*, Chichester, 1994.

Ulster Museum, *F.E.McWilliam* (exhib. cat.), Belfast, 1981.

Underwood, E.G., *A Short History of English Sculpture*, London, 1933.

Upson, N., *Mythologies: The Sculpture of Helaine Blumenfeld*, London, 1998.

Voak, Jonathan, *Sculpture and Light: an exhibition of sculptures by Arthur Fleischmann (1896–1990)*, Westminster Cathedral, 12 October – 27 October 1991, Manchester, 1991.

Waddington Galleries, *F.E. McWilliam 1909–1992* (exhib. cat.), London, 1963.

Ward-Jackson, Philip, 'Lord Ronald Gower, Gustave Dore and the Genesis of the Shakespeare Memorial at Stratford-upon-Avon', *Journal of the Warburg and Courtauld Institutes*, vol.50, 1987.

——, 'Lord Ronald Gower, the Shakespeare Memorial and the Wilde Era of London and Paris', *The European Gay Review*, vol.2, 1987.

Warwick Arts Trust, *F.E.McWilliam: Early Sculptures 1935–48 with some recent works*, Warwick, 1982.

*Warwick Town Council Official Guide 1998*, Warwick, 1998.

Waters, G.M., *Dictionary of British Artists working 1900–1950*, Eastbourne, 1975.

Watkinson, Raymond, *Fighting Spirits: Peter Peri and Clifford Rowe*, London, 1987.

Watt, J., 'Making waves', *Perspectives*, February/March 1996.

Well, S., *Oxford Dictionary of Shakespeare*, Oxford, 1998.

Wells, L.V. and Russell, A., *Lawrence Sheriff School 1878–1978*, Rugby, 1978.

Wellswood, F., *An Inventory of the Civic Insignia and other Antiquities belonging to the Mayor and Corporation of Stratford-upon-Avon*, Stratford-upon-Avon, 1940.

West Midlands Arts, *Artists, craftsmen, photographers in the West Midlands*, Stoke-on-Trent, 1977.

West Midlands Federation of Women's Institutes, *The West Midlands Village Book*, Newbury, 1989.

White, A., *Hamo Thornycroft: the sculptor at work*, Leeds, 1983.

Whitechapel Art Gallery, *Richard Deacon*, London, 1988.

Williamson, Dr George C., *The Lord Ronald Sutherland Gower*, London, 1916.

*Who's Who 1982*, London, 1982.

*Who Was Who, 1929–40*, London, 1941.

Wolseley Fine Art, *Eric Gill 1882–1940: a catalogue of sculpture, inscriptions, drawings, prints, manuscripts and books*, London, 1994.

Wolsey Art Gallery, *Ivor Robert-Jones* (exhib. cat.), Ipswich, 1999.

Wood, G., *Public Sculpture in Coventry. A Selected Critique*, unpublished BA dissertation, Coventry, Lanchester Polytechnic, 1986.

Woodhall, J., *The Book of Greater Solihull*, Buckingham, 1990.

Woolcombe, T. (ed.), *Kenneth Armitage: life and work*, London, 1997.

Wotton, E., *The History of Knowle*, Kineton, 1972.

Yorke, M., *Eric Gill: Man of Flesh and Spirit*, London, 1981.

Yorkshire Sculpture Park, *Geoffrey Clarke, RA: sculpture and works on paper, 1950–1994*, Wakefield, 1994.

——, *Miles Davies: sculptor*, Wakefield, 1991.

Yust, Walter (ed.), *Encyclopaedia Britannica*, London, 1957.

## Newspapers and periodicals

*Architectural Review*
*Art Journal*
*Art Monthly*
*Art Review*
*Birmingham Daily Gazette*
*Birmingham Post*
*Builder, The*
*Building News*
*Coat of Arms, The*
*Country Life*
*Coventry Citizen*
*Coventry Evening Telegraph*
*Coventry Herald*
*Coventry Standard*
*Crafts*
*Daily News, Baltimore, The*
*Daily Telegraph, The*
*Engineering*
*European Magazine*
*Evening Tribune*
*Field, The*
*Gentleman's Magazine, The*
*Illustrated London News, The*
*Independent, The*
*Kenilworth Weekly News*
*Knowle Parish Magazine*
*Leamington Observer*
*Leamington Spa Courier*
*Liverpool Post, The*
*London Globe, The*
*London Graphic*
*London News*
*Meteor, The*
*Morning News*
*New York Herald*
*New York Times*
*New York World, The*
*Observer, The*
*Pall Mall Gazette, The*
*Perspectives*
*Philadelphia Evening Telegraph*
*Punch*
*RIBA Journal*
*Rugby Advertiser*
*Shakespeare Pictorial*
*Solihull and Warwick County News*
*Solihull News*
*Solihull Times*
*Stratford-Upon-Avon Herald*
*Stratford upon Avon Journal, The*
*Studio, The*
*Times, The*
*Warwick Advertiser*
*Warwickshire*
*Warwickshire Journal*

## Brochures, leaflets and unpublished material

Anon, inauguration leaflet for Rob Olins sculpture *Net II*.
Barclays Group Archives, *Barclays Spread Eagle*, information leaflet, Manchester, 1999.
Benton, M. and Norbett, C., 'The Story of Stratford's *Alto Relievo* in the Great Garden of New Place', Stratford-upon-Avon, unpublished article.
Bird, V., *I Know a Bank*, Midland Bank Group Newsletter, November 1972.
Bloye, W.H., *Sales Ledger 1932–68*.
Bridgeman, R., & Sons, *Heritage of Beauty*, undated, publicity leaflet.
Centro, *Public Art in Public Transport*, undated.
Director of Homes and Properties, Coventry, Condition Report, 1981.
Groundwork Coventry, *Coventry Canal Heritage Trail Briefing Note*, Coventry, September 1998.
Harvard House public information leaflet.
Leith, Ian, *Public Art Handlist*, unpublished, 1999.
Nuneaton and Bedworth Official Guide.
Polesworth Society information leaflet.
Public Lecture by Charles Quick, Coventry, 18 March 1999.
*Royal Pump Room News*, 1999.
The Shakespeare Centre, *Art Work and Design*, publicity leaflet, Stratford-upon-Avon, undated.
*Solihull War Memorial Subscription Leaflet*, 1920.
Southfields School, Community Sculpture Project and Arts Festival publicity leaflet.
Storer, C., *Honnington Hall*, unpublished BA dissertation, University of London, London, copy also at Stratford Records Office.
Stratford-upon-Avon District Council, *The Armorial Bearings of the Stratford-on-Avon District Council*, information leaflet, undated.
——, *International Exhibition of Working Lampposts*, Stratford-upon-Avon, 1995.
Sumner, J., *The Colehaven Trust: The Founder's Address to the First Trustees*, 20 March 1931.
University of Warwick, *Sculpture Trail Brochure*, Coventry, 1997.
West Wolverhampton Unionist Association, *Souvenir Programme Open-Air Demonstration and Garden Party*, Tudor Grange Solihull, 19 July 1913.

## Archives, databases, collections and surveys

A & E Television Networks, Biography.com, www.biography.com
Art for Architecture, www.a4a.clara.net, /rugby.htm
AXIS, The Axis Database Online, www.axisartists.org.uk/, 1999
Coventry City Council Records, Minutes of Libraries, Art Gallery and Museums Committee
——, Minutes of Planning and Development Committee
——, Minutes of Planning and Redevelopment Committee
Coventry City Council website, heritage2/history/coventry_coat_of_arms/.htm

——, www.coventry.org.uk/heritage2/industry/motor/daimler

CWN Coventry and Warwickshire Network, Coventry Canal Basin.

CWN News and Information for Coventry and Warwickshire, www.coventry.org.uk/

*Dictionary of National Biography*, CD ROM version.

*Encylopedia Britannica Online*, www.members.eb.com

Herbert Art Gallery and Museum, Coventry Public Art Database.

——, various files, correspondence relating to 1980 Public Art Project.

Keifer, J.E., *Biographical Sketches*, www.justus.anglican.org/resources, 2000.

Kings and Queens of England (And Later the United Kingdom) since 802, www.royal.gov.uk/history/since802

*Knowle Guild House records*, Warwick County Record Office, DBR 56/88.

——, Warwick County Record Office, DBR 56/89.

Leamington Spa Museum Service, Leamington Spa Museum and Art Gallery information files.

Listed Buildings Index, Rugby 11/40.

——, Rugby 3/157.

——, Solihull.

Ministry of Housing and Local Government, *Provisional List of Buildings of Architectural or Historic Interest*, Warwickshire, Revised List (Nov. 1959).

*National Inventory of War Memorials,* Imperial War Museum.

*Photograph Collection*, Solihull Library.

Rolls Royce official website, www.rolls-royce.com/ history

Rugby Borough Council, Monuments, Public Sculptures and Public Arts Records.

—— website, www.rugbytown.co.uk

Sculpture at Goodwood: British Contemporary Sculpture, www.sculpture.org.uk

Shakespeare Birthplace Centre, Stratford Record Office files.

Sites and Monument Records.

*Solihull Borough Council Minute Book*, Establishment Committee.

——, Public Works Committee.

*Solihull Metropolitan Borough Council Minute Book*, Education Committee.

——, Land and Economic Development Committee.

——, Land Sub-Committee.

*Solihull Urban District Council Minute Book*, General Purposes Committee.

——, Parks, Allotments and Cemeteries Committee.

Speel, B., Sculpture on Bob Speel's Website, www.speel.demon.co.uk/other/sculpt.htm, 1999

*Who's Who 1897–1996*, CD ROM version.

# Index

Note: Page numbers in **bold** refer to illustrations